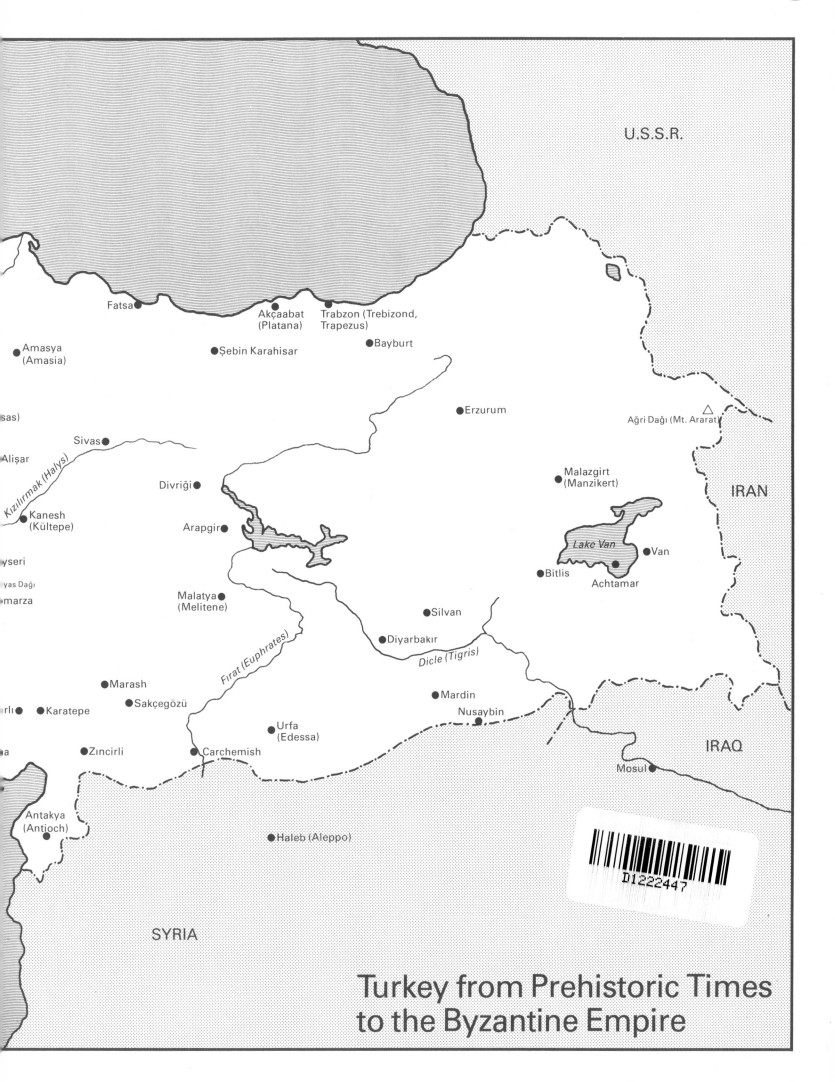

U.S.S.R.

Fatsa

Akçaabat
(Platana)

Trabzon (Trebizond,
Trapezus)

Bayburt

Amasya
(Amasia)

Şebin Karahisar

sas)

Erzurum

Ağri Dağı (Mt. Ararat) △

IRAN

Sivas

Aliṣar

Kızılırmak (Halys)

Malazgirt
(Manzikert)

Divriği

Kanesh
(Kültepe)

Arapgir

Lake Van

Van

yseri

Bitlis

Achtamar

yas Dağı

marza

Malatya
(Melitene)

Silvan

Fırat (Euphrates)

Diyarbakır

Dicle (Tigris)

Marash

Mardin

rlı

Karatepe

Sakçegözü

Nusaybin

IRAQ

a

Zincirli

Carchemish

Urfa
(Edessa)

Mosul

Antakya
(Antioch)

Haleb (Aleppo)

SYRIA

Turkey from Prehistoric Times
to the Byzantine Empire

The Art and Architecture of Turkey

Edited by Ekrem Akurgal

The Art and Architecture of Turkey

Photographs by
Leo Hilber

RIZZOLI
NEW YORK

Photo Credits

Most of the photographs for this book were taken by Leo Hilber; the others were generously provided by M.O. Arık (Pl. 73), A. Kuran (Pl. 52), Gönül Öney (Pl. 80), Asil Yavuz (Pl. 79), The British Museum, London (Pl. 147), and Yapıve Kredı Bankası, Ankara (Pls. 84, 85 and the photograph of the helmet on the jacket).

English translation of the Introduction and chapters 1 and 2:
KATHERINE WATSON

French-language edition:
© 1980 by Office du Livre, Fribourg, Switzerland

English edition published 1980
in the United States of America by:

RIZZOLI INTERNATIONAL PUBLICATIONS, INC.
712 Fifth Avenue/New York 10019

LC 79-56610
ISBN: 0-8478-0273-6

Printed in Switzerland

Contents

Note on the Pronunciation of Turkish Words

In addition to the twenty-six letters of our alphabet, Turkish has one more—the undotted "i" (ı). Several letters can take diacritical marks; for instance, the letter "g," when written as "ğ," is hardly pronounced, but it has the effect of lengthening the preceding vowel as in the name "Niğde" which is pronounced "Niide" as if with two "i"s. When a cedilla is placed under an "s" (ş), it is pronounced as "sh." "C" with a cedilla (ç) becomes a hard "ch."

Editor's Note and Acknowledgments

There have been few books published on the art treasures of Turkey, although a large percentage of the most important finds giving an insight into world history come from Turkey. Ninety-seven per cent of modern Turkey is composed of 760,000 square kilometres in Asia Minor called Anatolia, which gave birth to some of the most important civilizations in the history of mankind. The present book is an attempt to provide a survey of the unique products of 9000 years of Anatolian and Turkish history.

The first chapter, written by the editor,* is concerned with the artistic remains of civilizations from prehistoric times to the end of the Roman Empire (7000 BC to AD 395).

The second chapter, which examines the early Christian and Byzantine epochs (395–1453), was written by Semavi Eyice, professor of Byzantine art at the University of Istanbul. Professor Eyice is the author of many books and articles on architectural monuments in Turkey. His thorough and extensive knowledge of the Seljuk and Ottoman periods make him also an esteemed scholar of the art history of Anatolian Turkey.

Chapter three on Seljuk architecture (1071–1308) is the work of Aptullah Kuran, architect and chairman of the Department of the History of Architecture at the Bosphorus University, Istanbul. Professor Kuran is at present working on a detailed book about the great Turkish architect Sinan; he is also the author of the basic reference work *The Mosque in Early Ottoman Architecture* (Chicago, London, 1968), published by the University of Chicago Press.

The information on architecture in the period of the Turkish emirates and the early Ottoman period in chapter four is provided by Oluş Arık, chairman of the Department of Art History at Ankara University and an authority on Turkish art. Professor Arık has published numerous books and articles in Turkish, in particular the standard work on the Seljuk renaissance as seen in the architectural monuments of south-east Anatolia.

Chapter five an Ottoman architecture of the fifteenth to eighteenth centuries was written by Doğan Kuban, architect and director of the Institute for Architectural History and the Restoration of Monuments at Istanbul's Technical University. Professor Kuban is the author of basic works on Sinan, Turkish baroque architecture and spatial problems in Ottoman religious buildings.

In chapter six, Gönül Öney, professor of art history at the University of Ankara, handles the architectural decoration and minor arts of the Seljuk and Ottoman periods. Professor Öney is a recognized expert on Turkish art. She has written many books, including *Turkish Ceramic Tile Art* (Tokyo, 1975), and the chapter on 'Ceramic Tiles in Islamic Architecture' in volume I of *The World of Tiles* (Kyoto, 1976), both of which have been translated into Japanese.

Ülker Erginsoy presents Turkish metalwork to the reader in chapter seven. She was formerly with the Museum of the Middle East Technical University in Ankara and is now continuing her research independently—she specializes in metal implements. Ülker Erginsoy is the author of a comprehensive work on Turkish metalwork and the chapter 'Anatolian Seljuk Metalwork' in *Architectural Decoration and the Minor Arts in Seljuk Anatolia* (Ankara, 1978) by Gönül Öney.

The final chapter by Filiz Çağman, departmental custodian at the Topkapı Sarayı Museum, Istanbul, acquaints the reader with Turkish miniatures. Filiz Çağman, whose many articles on this subject have established her scholarly reputation, was the joint author with Nurhan Atasoy of *Turkish Miniature Painting* (Istanbul, 1974) and has compiled an important

* Ekrem Akurgal, chairman of the Department of Classical Archaeology at the University of Ankara and editor of this book, is the author of numerous works on early Anatolian cultures, published in Europe, Great Britain and the United States. Only a few of his most important publications are mentioned here: *Die Kunst Anatoliens* (Berlin, 1961), *The Art of the Hittites* (London, Florence, New York, 1961–2), *The Birth of Greek Art* (London, Paris, Milan, 1968), *The Art of Greece: Its Origins* (New York, 1968), *Ancient Civilizations and Ruins of Turkey* (Istanbul, 1969; 4th ed., 1978). [Publishers' note]

catalogue to the Topkapı Sarayı Museum entitled *Guide to the Miniature Section in Topkapı*.

Most of the colour and black and white plates were taken especially for this book by the well-known Swiss photographer Leo Hilber.

I wish to thank sincerely Murat Katoğlu, the general director of Turkish Antiquities and Museums, his successor, Nurettin Yardımcı, and his first assistant vice-director Çetin Anlağan for permission to photograph and reproduce unpublished works of art. Special thanks are also due to our colleagues: Raci Temizer (director of the Archaeological Museum, Ankara), Osman Ersoy (director of the Ethnographic Museum, Ankara), Kemal Çiğ, director, and his successor Sabahattin Batur (Topkapı Sarayı Museum, Istanbul), the deceased director Nezih Fıratlı and his successor Aykut Özet and the custodian Nuşin Asgarı (Archaeological Museum, Istanbul), as well as Nazan Tapan (Museum of Turkish and Islamic Art, Istanbul).

Furthermore, I should especially like to thank Ülker Erginsoy for so willingly arranging for photography in Istanbul. I am also grateful to Miss Aynur Durukan for accompanying the photographer on his trip through Anatolia so that he could carry out the photography programme as planned.

Last but not least, I should like to express heartfelt thanks to our publishers: neither cost nor effort were spared on this project, enabling us to produce a fine book.

Ekrem Akurgal
Ankara, November, 1979

Introduction

by Ekrem Akurgal

The Position and Role of Anatolia in World History

The geography of Anatolia is responsible for the fact that in almost every period of her history several fundamentally different cultures developed there simultaneously. Asia Minor can be divided into seven distinct climatic zones, separated by mountain ranges that are not easily accessible: the Marmara zone, the west coast, the south coast, the central highlands, the south-east zone, the north-east zone and the Black Sea coast.

Asia Minor was, therefore, naturally constituted for the genesis of mutually independent petty states. During the nine thousand years of Anatolian history that are the subject of this book, several cultures, each, in most cases, having its own language and customs, were alive at the same time. These were the Hattian principalities (2500 to 2000 BC), the Hittite petty states (2000–1750 BC), the Late Hittite city states (1200–700 BC), the kingdoms of the Phrygians, Lydians, Carians, Lycians and their contemporaries (750–300 BC), the Greek city states (1050–30 BC), the Hellenistic petty kingdoms (323–30 BC), the Roman provinces (30 BC–AD 395) and the Seljuk Emirate (AD 1308–1515).

Even the Old Kingdom of the Hittites (1750–1450 BC) and the Hittite Empire (1450–1180 BC) retained the character of federative states, as did the empires of Midas (715–675 BC) and of the Seljuks (AD 1071–1308).

The geographical nature of the country has also meant that the immigrating peoples have been able to conquer only one half or the other (the eastern or the western) of the peninsula. Each group of invaders managed to take possession only of that part of Asia Minor where it had entered the peninsula. The Hittites (2000–1180 BC) settled in the eastern half of Anatolia because they came from the east; later the Phrygians (750–333 BC) had to content themselves with a part of the western half of Asia Minor, although they began by penetrating as far as the Assyrian border and settled for a time in the eastern part

of the country. The Phrygians withdrew step by step from their early positions at Alişar and Boğazköy in the bend of the River Halys, to Ankara and Gordion, then to Eskişehir and Sanagrios, for they had come originally from the Balkans, and as their power declined, they had to withdraw to their original positions. In the three centuries before Christ, the Galatians settled only in the western part of the peninsula, because they came from the west and did not want to lose contact with their original homeland.

It is important to realize that these immigrant peoples always remained in political and cultural contact with the areas from which they came. The Hittites were an Indo-European people who came into Asia Minor through the Caucasus and settled on the Anatolian plateau. They first settled near Kayseri at Kültepe, south of the bend in the River Halys. As these parts of Anatolia were in constant touch with Mesopotamia from the mid-third millennium BC at the latest, the Hittites came into the sphere of influence of the Mesopotamian lands and remained adherents of oriental culture until the end of their empire.

On the other hand, the Phrygians who came from the Balkans, but settled at first in the bend of the River Halys, remained fully orientated toward the west, though they were well placed to receive multiple oriental influences. By the mid-seventh century BC, the Phrygians had become an Anatolian people, but they maintained close contacts with the Greek world.

Although they dominated the whole of the peninsula, the Seljuks (1071–1308–1515 AD) and the Ottomans (AD 1299–1923), both Turkic peoples who migrated into Asia Minor from their homelands in central Asia, were perpetually and strongly influenced by the Islamic lands of Persia and Arabia. Not even the advance of the Ottomans to the very gates of Vienna and a long stay in the Balkans could sway them from their oriental culture.

The geographical position of Anatolia — between Europe and Asia — has always caused it to be considered as a bridge between orient and occident. Asia Minor has indeed played an intermediary role between east and

west, but only from time to time and under certain important conditions.

Contact between the western world and the Mesopotamian lands in the third and second millenniums BC was not through Asia Minor but exclusively by the sea route, because at this time there were no powers ruling the whole of the peninsula to insure secure trade routes. Similarly, in the eighth and seventh centuries BC, the Late Hittites—who were centred to some extent in the southern and south-eastern areas of the peninsula—influenced the Greeks not through Asia Minor but by sea trade. Asia Minor first played an intermediary role between east and west in the Persian period (546–334 BC), when the Persians built the great 'royal road' between Susa and Ephesus. This well-policed road was naturally also used for trade. In the Hellenistic period (323–30 BC) too, since the Hellenistic kingdoms held the whole of Asia Minor, Anatolia acted from time to time as a bridge between Syria and Ionia. In this way, influence could flow overland in both directions. The Romans, who built the first stable and permanent road system throughout Anatolia, created the conditions for the peninsula to serve efficiently as a bridge between east and west. The Seljuks, who built new durable roads and splendid caravanserais (inns for long-distance caravans), brought about the first secure and convenient contacts between the western world and both the Far East and the Levant. The role of intermediary that began in the Seljuk period continued during the first centuries of the Ottoman Empire, but slowly dwindled as the power of the empire declined.

Although the geography of Asia Minor did not favour the formation of strong states, it does seem to have favoured the rise of remarkably valuable civilizations. It is a fact that petty states with their perpetual rivalries created a much better atmosphere for cultural development than the gigantic powers of Antiquity, where artistic and intellectual activity and manual crafts were strongly centralized and dependent on the royal court. In the Hittite Empire, for example, and also in the mighty Assyrian and Persian Empires, only one style of art—the imperial style of the royal house—presided, whereas in the Late Hittite or Syrian petty kingdoms of the eighth century BC, several distinct styles could develop side by side in constant rivalry.

It is certainly not fortuitous that the most important civilizations in world history—the Sumerian, Phoenician, Greek and European Renaissance—were all created by small city states. The following sections in this book show clearly how Anatolia became the country of origin of several historical civilizations of the highest importance, thanks to small principalities and their mutual jealousies.

Çatalhüyük, one of the earliest settlements discovered in Anatolia (6500–5500 BC) and the most important centre of Neolithic culture known, must have been one of the many small political units of the peninsula in its time. After a long period of stagnation, the principalities of the Hattian period (2500–2000 BC) were the next important petty states of Anatolia. Certainly they did not rank with the Mesopotamian centres, but directly after those and the Egyptian settlements, taking second place as great

cultural establishments of the late third millennium BC. The petty kingdoms of the Early Hittite period (2000 to 1750 BC) also distinguished themselves, like the Hattian ones before them, as important centres of art and culture in the world of that time. The Hittite Empire (1750 to 1180 BC) was the first power to rule practically the whole of the peninsula in the form of a federation. Though the Hittites were not a creative people of the first rank like the Egyptians, the Sumerians or the Babylonians, they nonetheless produced an original art and culture that have given them a significant place in world history. The Late Hittite city states (1200–700 BC), in their last period (eighth century BC), played an extremely important role when they came in contact with the Babylonian, Syrian, Aramaic and Phoenician centres of culture. The towering masterpieces of Carchemish (Kargamiş), Zıncirli and Sakçagözü affected not only the Urartians and Phrygians but also strongly influenced the Greeks and Etruscans. The figures of Corinthian vase-painting are based on Late Hittite models.

The numerous Ionian city states (1050–323 BC) of western Asia Minor were the most important artistic and cultural centres in the history of mankind. At the time of the natural philosophers (600–545 BC), west central Asia was at the centre of the world, where the first foundations of western thought were taking shape.

Western Anatolia again played a leading part in history in the period of the Hellenistic petty kingdoms and city states (323–30 BC). The greatest and finest buildings and sculptures of the time were created in such cities as Pergamon, Ephesus, Priene and Miletus; later they had great influence on Roman art. In the following Roman period, the city states of the Ionian and Hellenistic periods continued. The superb west Anatolian cities of this time were in no way inferior to Rome.

The many peoples of Asia Minor enjoyed another cultural high point in the fourth, fifth and sixth centuries AD, after the fall of the powerful Roman Empire. Early Christian art originated in the cities of Anatolia. It was a transformation of Roman creations of the third and fourth centuries AD, which continued to develop in Constantinople, where it finally flowered into exquisite Byzantine art. In the south and east of the Anatolian peninsula, centres of Armenian art also produced important works, in particular during the tenth and eleventh centuries.

The periods of the Seljuk Empire (AD 1071–1308) and Seljuk Emirate (1308–1515) stand out as times of prosperity, in which Anatolia was provided with a convenient road system, with solid and well-designed stone bridges and lordly caravanserais, with hospitals, schools and observatories. Seljuk monuments, decorated with fascinating architectural ornamentation, are still numbered among the best works of art found on the Anatolian peninsula.

The mighty Ottoman Empire (AD 1299–1923), in its years of glory, enjoyed the same prosperity and the same high level of culture and science, combined with lively commercial activity, as in the Seljuk period. The Turks of the Ottoman period developed an architecture that is one of the great artistic achievements of mankind, while their

artistic activity in other spheres produced some of the loveliest objects of that time. In the last three centuries of the Ottoman decline, every progressive action was balked by religious fanaticism and, at the end of the First World War, the great mass of the population of the once glorious Empire had sunk to the level of their prehistoric forebears.

Though the Ottomans governed the whole of Anatolia and considered it as one province, they never aspired to cultural unity. Atatürk (1881–1938) was the first man in history to recognize the need to create a unified Anatolian state. His priority was to forge a politically and culturally unified state and, siting the capital in the heartland of the peninsula, he set about realizing this plan by attacking the psychological as well as the geographical barriers to unity. He gave the young nation the spiritual unity to continue his efforts to overcome the contradictions imposed by both nature and history. The great enterprises now under way — dam construction, durable asphalt roads and ports, rationally planned agriculture and the development of industry — promise to free the country from its natural disadvantages and to give a fundamentally new turn to the destiny of the peninsula.

Atatürk, the founder of the Turkish Republic (1923), created a democratic lay state that is wholly western in orientation. Turkey, a member of the Council of Europe and the OECD, as well as a candidate for the Common Market, is now part of the western world and endeavouring to develop a new culture in keeping with the spirit of the west: the first foundations for that western tradition were laid within the very borders of Turkey between 600 and 545 BC by the natural philosophers, who provided a model for modern Turkey — a synthesis of the best in oriental and occidental thought.

Anatolia from the Neolithic Period to the End of the Roman Period

by Ekrem Akurgal

The Neolithic Period (7000–5000 BC)

The civilizations of the first sedentary populations in the history of mankind appear shortly after the beginning of the tenth millennium BC. Hacılar and Çatalhüyük belong, with Jericho in Jordania, among the earliest attempts to develop city life.[1] The two former settlements, excavated by James Mellaart after the end of the Second World War, lie in the southern part of central Anatolia. The earliest indications that these Anatolians had become sedentary and had begun to practise agriculture occur in the fifth habitation level of Hacılar, which radiocarbon dates show to have been founded about 7040 BC. Here, remains of wheat, barley and lentils were found in the houses, and the bones of goats, sheep and horned cattle were recognized under these food remains. In the settlements of Çatalhüyük, roughly in the period from 6500 to 5500 BC, twelve habitation levels, lying one above the other, were uncovered to reveal houses and sanctuaries whose walls were decorated with fascinating paintings and impressive painted reliefs. The wall paintings consisted of pictures of hunting, of dancers and acrobats and, above all, of religious and sepulchral scenes. In one picture there is a hunter wearing a white loincloth and a reddish leopard skin with black spots. He wears a pendant round his neck and holds a bow in his right hand.[2]

In caves in many parts of the world there are wall paintings from much earlier periods, but Çatalhüyük has the earliest painted reliefs of men and animals and the earliest paintings on the walls of a house. The most remarkable painting is one on the wall of a chapel or private sanctuary in Level VII at Çatalhüyük, dated by carbon 14 to about 6200 BC. It appears to illustrate the eruption of a volcano (perhaps the neighbouring Hasan Dağ) and is the earliest known representation of landscape in history.

The dead were buried in the house. The bones, freed of flesh, were buried under the raised parts of the floor that served as benches for sitting, working and sleeping. A fine obsidian mirror was found in the grave of one woman. The sanctuaries were located within a complex of four or five houses, each consisting of a single large room. Ox heads and pairs of ox horns, fixed side by side and in tiers on the walls, serve to distinguish these domestic chapels; here were probably enacted the religious ceremonies of a fertility cult. The principal deity seems to have been a goddess, who often appears with her leopards. She is also a fertility symbol, for she is usually shown giving birth, sometimes to an ox or ram head. Symbols of fertility were a reference to rebirth or to the afterlife. The impressive clay statuettes from Çatalhüyük and Hacılar may be claimed to be the earliest artistic creations in art history. Special preference is shown for naked female figures in different poses: kneeling, lying on one side, sleeping and above all giving birth.

The earliest clay vessels from Çatalhüyük are modest monochrome wares dating from about 6500 BC. They were destined to develop gradually during the late Neolithic and early Chalcolithic periods into a splendid ceramic art. The magnificent painted vessels from Hacılar, produced between about 5400 and 5250 BC, have distinctive patterns that endow them with artistic quality and expressive power.

The quantities of objects of everyday use found at Çatalhüyük provide us with a vivid picture of the remarkably high standard of living already reached by the sedentary peoples of this period. James Mellaart, who excavated Çatalhüyük, gives the following description:[3] '...Owing to the many fires from which people fled for their lives, the abandoned material is rich and varied, but one specific conflagration, that in which the settlement of Level VI A perished c. 5880 BC, fiercer than most, led to the preservation of a quantity of perishable materials, such as cloth, fur, leather, and wood, which are not normally preserved....

All the dead were probably buried in their garments, and wooden bowls, cups and boxes as well as baskets and food, berries, peas, lentils, grain, eggs or a joint of meat are found with the dead irrespective of their sex. Among

the other funeral gifts there are marked differences between those that accompany men on the one hand and women and children on the other....' The priceless art objects found at Hacılar and Çatalhüyük are preserved in the Archaeological Museum in Ankara.

The culture of Çatalhüyük is the first splendid example of a society in its transition from a nomadic to a settled, food-producing way of life. What the archaeological excavations have so far brought to light is only a foretaste of what remains to be discovered. It is be hoped that it will soon be possible to resume the excavation of this Anatolian settlement, which has given evidence of the first astonishing results of man's transition to sedentary life.

The Chalcolithic Period (5000–3000 BC)

In the wake of the outstanding civilization of the Neolithic period, there followed a time of stagnation in Anatolian history, lasting over the fifth and fourth millenniums BC. This retardation of almost two thousand years brought severe consequences for the inhabitants of Anatolia. Until well into the second millennium BC, they fell far behind Mesopotamia in political and cultural importance. While writing was invented in the Near East and Egypt by 3000 BC at the latest, and the oriental populations achieved a stage of high civilization, the whole of Anatolia dragged on in the impoverished life of a prehistoric village culture.

The Bronze Age (3000–2000 BC)

Even in the first phase of the Anatolian Bronze Age, from about 3000 to 2500 BC, there was little development, beyond the gains of the preceding period in the central and eastern regions of Asia Minor. This period has to be reckoned as Late Chalcolithic. The foundation of the first Trojan settlement during the first half of the third millennium BC is of significance, however, and shows close contact with the Early Bronze Age world of the Aegean and the Cyclades (Troy I).

Change did not set in until about the middle of the third millennium BC. This date should be regarded as the beginning of the true Bronze Age of Anatolia. In fact, in this half-millennium we meet two distinctive cultures of the greatest importance: the second settlement at Troy (Troy II) in north-west Anatolia and the petty kingdoms of the Hattian priest-kings in central and south-east Anatolia.

The Second Settlement at Troy (2500–2200 BC)

Troy II is a development of the previously mentioned first settlement.[4] As in Troy I, the features of the new period resemble Early Aegean and Early Cycladic ones, but there are now many signs of contact with the centres in the interior of Asia Minor and with the Near East. The Trojans of this time seem no longer to have been simple peasants but to have been able to exercise control of the sea routes. All their metals — gold, silver, copper and tin — were imported from the central and eastern cultural centres of Anatolia and from the east. The Trojan jewellers learnt the process of granulation, a refined technique of goldsmith's work, and various new methods of metalworking from the artists of the Near East who had already been working in precious metals for at least half a millennium. (The Trojan tube ear-rings, for example, are oriental in type.)

The finest examples of the goldsmith's work of Troy II come from treasure, hidden in a hollow space in the city wall when danger threatened and discovered some 4000 years later by Heinrich Schliemann. This treasure disappeared during the Second World War. Besides a few bronze vessels and weapons, the treasure contained drinking vessels of heavy gold and silver, gold ornaments and bars of silver. The bars were certainly currency. The so-called sauce-boat, 7.5 centimetres high and weighing 600 grams, is definitely Aegean in form. Its double handles closely resemble those of the vessel called a *depas,* which is a specifically Trojan creation. The two elegant beak-shaped spouts are a form known in contemporary Early Helladic ceramic cups with spouts.

The potters of Troy II were acquainted with the two most important technical achievements of their time — the kiln and the potter's wheel. Their work is not outstanding, however.

The first monumental buildings with any artistic value were erected in Anatolia in the Troy II layer. The city walls formed an enceinte of only about 100 metres in diameter but were an impressive structure of finely worked courses of masonry. The great *megaron,* standing at the centre of the fortress at its highest point, must have been especially imposing. Its total length was some 45 metres by 13 metres wide. The walls (1.5 metres thick) suggest that its tall flat roof overlooked the fortifications, making an impressive sight from afar. Other *megara* were built beside it, and the whole complex formed a princely city.

About 2200 or 2100 BC a terrible catastrophe befell the second settlement of Troy. This destruction of the citadel is certainly to be connected with the invasion of Asia Minor by Indo-European tribes, which took place at precisely this period. There are, however, no indications of a change in population in the following insignificant building periods III and IV. It was not until the foundation of the settlement of Troy VI about 1800 BC that a cultural change took place.

The Hattian Culture (2500–2000 BC)

During the period in which the second phase of Trojan culture was developing (Troy II), the centre and south-east of Anatolia was occupied by a people whose name is known to us through later Hittite sources.[5] These were the Hattians. In the fourteenth and thirteenth centuries BC, while conducting cult ceremonies, the priests of the

Hittite capital Hattusas recited traditional sayings, which often they did not understand themselves. In the cuneiform texts, these sayings are set between the lines and glossed with translations. The texts introduce these foreign passages with the statement that 'here the priest is speaking Hattili', i.e. Hattian. Very few examples of Hattian survive. The language is different from all the languages of Anatolia and the Near East hitherto known and is distinctive, particularly in its extensive use of prefixes.

The Hattian people and language, as we learn from the distribution of the Hattian cult, were at home in central and south-east Anatolia in the pre-Hittite period. The first mention of the Hattians comes in the texts of the Akkadian dynasty (c. 2400–300 BC). From then until the time of the Assyrian kings of the late eighth century BC, the peninsula of Asia Minor is called the Land of the Hattian peoples. Even the succeeding Hittites called their empire 'Land of the Hattians', so they have taken their name in history from the Hattians, although the Hittites in fact should be called Nesites.

Hattian influence can be discerned in the succeeding Hittite period in the realm of religion, state cult, court ceremonials and myth. As its name shows, Hattusas, the Hittite capital, was originally founded by Hattians.

Everything points to the Hattians as the autochthonous people of Anatolia and as the most numerous stratum in the population of central and south-east Asia Minor during the Early Bronze Age (2500–2000 BC).

The material remains belonging to that period found in this region should be associated with the Hattians, for it is precisely in the area central to Hattian culture that the finest and most important works of art of the time originated. Forty years ago, the Turkish archaeologists Remzi Oğuz Arık and Hamit Koşay discovered works of art (made of gold, silver and bronze) of exceptional beauty and quality in the royal graves of Alacahüyük near Hattusas. These put Schliemann's 'Priam's treasure' from Troy II in the shade and placed Bronze Age Anatolia in the front rank of historical research. The magnificent finds that came to light as soon as digging started caused a great sensation. The excavators quickly uncovered the graves, and their contents were rich beyond belief: piece after piece of incomparable treasure was brought forth. The first objects to be uncovered were disc standards. The intricate geometric patterns of the pierced latticework stood out in decorative tracery against the grey earth. These were strange mysterious objects, the like of which had never been seen before. They lay side by side in an almost straight line; no one was allowed to touch them. Work continued with great care. Then came the great stag, more animal standards, and a considerable number of objects in gold and in silver. The gold objects also created a sensation; the labourers, humble inhabitants of the little village of Alacahüyük, stood in great awe before the unexpected treasure, believing that a fairyland had been opened before their eyes by a magic wand.

Ripple patterning, used to decorate ceramic vessels since the Chalcolithic period in Anatolia, is basically a method of decorating peculiar to metalwork. The Early Bronze Age goldsmiths of Anatolia achieved delightful effects with manifold linear ripple ornamentation on the surfaces of their work. These fine gold objects, with their balanced elegant shapes and tastefully ordered ripple patterns, give us a glimpse of the cultivated, noble life of that time.

The concentric circles that provide such effective decoration for certain ox and stag figures reproduce a favourite native Anatolian ornament, which served to adorn the fibulae and contemporary stone and clay idols of central Anatolia.

The majority of the objects found in the tombs are cult objects. The sacred import of these strangely impressive and mysterious works of art is particularly felt in the disc or bow-shaped standards. The large ox horns, serving as the base, and the curved arch of the standards, suggesting the vault of Heaven, can hardly be understood as purely ornamental compositions. The ox horns are so fixed that they frame the standards from below and hold them up. Some standards have the edge of the disc decorated with star shapes circling the heavenly vault like satelites. Perhaps the flying birds that adorn the edge of some discs are a sign of the celestial significance of the cult object. One may surmise that these standards as a whole are intended to depict the universe. The ox horns bearing this cosmic structure are reminiscent of the Turkish fairy tale that relates how the world stands on the horn of an ox. Each time the ox shakes its head, the story says, the earth quakes. The precious objects of the Hattian priest-kings may reproduce the earliest illustrations of this idea.

The same idea of the universe borne by an ox appears later in the Hittite period in a variety of images. It is not fortuitous that the gracious quick-moving stag is projected against the 'heavenly vault'. On reliefs of Jupiter Dolichenus that must date back to the religious tradition of the Hattian period, the consort of the Weather god stands, as Hançar has noted, on the back of a stag. This goddess was called Wurusemu by the Hattians and, as her second name, 'Sun goddess of Arinna' shows, she was the ruler of the sky and the universe. Since on these standards the bull must be read as the attribute of the Weather god, we may take it that the stag appearing there is the symbol of his consort who, in the succeeding Hittite period, always accompanies her spouse. The pieces described above from Alacahüyük can be dated between 2300 and 2000 BC and, therefore, are within the Hattian period.

The Hurrian Culture (1800–1270 BC)

Before embarking on a description of the Hittites, it is desirable to look at a people of south-east Anatolia whose empire flourished during the second third of the second millennium and who exercised great influence on the Hittites. These were the Hurrians.[6]

The Hurrians are first depicted in Anatolia on clay tablets of the eighteenth century BC, appearing as foreign merchants. In the early years of the Hittite Empire, the Hurrians were an important element of the population in such towns as Ugarit (Ras Shamra) and Alalah (Tell Açana). Halpa (Aleppo) must have had a similar ethnic

stratum at that time. The influence of the Hurrians is found in a few religious texts of the eighteenth century BC in Mari, the city midway along the River Euphrates. Pilliya, the King of Kizzuwatna and contemporary of King Idrimi of Alalah, bears a Hurrian name. Thus it is probable that the Hurrian element was already playing an important role in this area in the Early Hittite period. At the beginning of the great Hittite Empire, at any rate, Aleppo and Kizzuwatna belonged to the Hurrian Kingdom of the Mitanni.

On the evidence of the Hittite texts, there must have been several Hurrian petty states. In the fifteenth and fourteenth centuries BC, the land of the Hurrian peoples stretched from Lake Van to Assur in the south and to Carchemish, Aleppo, Tell Asana and Ras Shamra in north Syria. The most important state founded by the Hurrians was the Mitannian Kingdom (1500–1270 BC). King Shaushattar of the Mitanni, the son of Parsashattar, reigned in the mid-fifteenth century BC over the area of northern Mesopotamia from Kerkup to Aleppo. Thus the Mitannian Kingdom constituted the greatest expansion of the Hurrians, whose original home was in south-east Anatolia.

In the fifteenth century BC Assyria was subject to the Mitanni. King Shaushattar carried off a door of gold and silver from Assur; this is related in the Mattiwaza text from Boğazköy. He installed it in his palace in Washshukkanni, his capital, somewhere near modern Ras el Aim on the River Khabur. Shuttarna II, the second in succession after Shaushattar, sent the image of the goddess Ishtar from Nineveh to Egypt to cure the Pharaoh. The Hittite king Shuppiluliumas I brought the Mitannian Kingdom to an end. The land of Kizzuwatna was no longer a political force and became incorporated in the Hattian Empire.

From the reign of Shuppiluliumas I, however, the Hurrian influence is even more clearly evident with the use of Hurrian-style names by the Hittite princes and especially by the female members of the Hittite ruling house. Almost without exception from the reign of Tudhaliyas III (late fifteenth century BC), the queens reigning in Hattusas bear Hurrian names. These are Nikalmati (consort of Tudhaliyas III), Ashmunikal (consort of Arnuwanda I), Pauduhepa and Hinti (two successive consorts of Shuppiluliumas I), Malnikal (third consort of Shuppuliliumas), Tanuhepa (Tawananna in the reigns of Murshili II, Muwatalli and Marshili III), and Puduhepa (consort of Hattushili III). Several princes also had Hurrian names. The following are the best known: Sharru-kushuh (son of Shuppiluliumas I) who was King of Carchemish, and Inu-Teshup and Talmi-Teshup, two later Kings of Carchemish. Murshili III also bore the Hurrian name Urhi-Teshup when he was a prince.

Many scribes and several authors of magic texts in Hattusas had Hurrian names. Four clay tablets from Boğazköy contain the translation of a Hurrian text on the training and acclimatization of horses. The writer was Kikkuli from the land of the Mitanni. Hurrian is one of the most distinctive languages of the eastern world. It is agglutinative and differs from the Indo-Germanic and Semitic use of suffixes and from Hattic use of prefixes.

Hurrian culture shows Indo-Aryan and Luwian influences. All royal names of the Mitanni are Indian in origin. Indo-Aryan kings such as Parija-vatri, Suna-sura and Pattatissu reigned in Kizzuwatna. In the text of the horse-trainer Kikkuli, the technical specifications include Indian numerals. We also know that the Mitannian kings called on Indian deities such as Indra, Mithra, Varuna or Nasatya, when taking oaths. The Hurrian people were, therefore, subject to an aristocracy of Indo-Aryan origin. To this nobility, which was apparently not very large, belonged knights who rode in chariots and kept horses. They were called Marianni, and certainly it was they who disseminated the practice of horse-breeding and chariot warfare in the Near East.

At least in the southern regions of Anatolia, the Hurrians seem to have produce a mixed culture in association with the Indo-Germanic Luwians. It has been observed that the language of the hieroglyphic texts is more like Luwian than Hurrian.

The Period of the Hittites (2000–1180 BC)

The peaceful life enjoyed by the peoples of Asia Minor, from the beginning of the true Early Bronze Age for almost half a millennium, came to a violent end about 2000 BC, wrecked by relentless invasion. In Alaca and Boğazköy the destruction of the relevant strata is sealed with a burnt layer. The period following these burnt strata is characterized by marked changes in all spheres of human activity; the cause of the destruction can be imputed to the immigration of the Indo-European peoples whose traces we now meet for the first time in central Asia Minor. The bearers of the new culture were not only the newcomers but also to a large degree the native Hatti. However, the immigrant Indo-Europeans respected the religion, mythology and customs of the autochthonous Hatti and adapted themselves to native conditions: the way the Hittites took over Hattian place names and personal names is a clear proof of the close integration of the two ethnic elements.[7]

The Early Hittite Period (2000–1750 BC)

Almost half a dozen city states of the first quarter of the second millennium BC, ruled by petty kingdoms, are known in central Anatolia from written sources: Kanesh, Kussara, Hattusas, Zalpa and Purushanda. They probably all began, like many other cities yet undiscovered, as princedoms of the native population, that is to say as Hattian petty states. With the Indo-European migrations, they gradually fell into the hands of the Hittite leaders.

At first Kanesh (Neşa) was the most important of these cities; it is modern Kültepe, near Kayseri. The excavations conducted by Tahsin Özgüç have yielded surprising results: writing was found in this city, the first on Anatolian soil, and also quantities of documents, written in Assyrian cuneiform. Sedat Alp has demonstrated from

them the presence of the Hittites in Kültepe. The excavations of Konya-Karahüyük, Acemhüyük, Eskiyapar and Mashat—directed for many years respectively by Sedat Alp, Nimet Özgüç, Raci Temizer and Tahsin Özgüç—contributed considerably to clarification of the Early Hittite period.

The high artistic level reached in the early historical period is best illustrated by the monochrome wares. A type of ewer with a beak-shaped spout is characteristic of this period. The structural articulation of the vessel is unique. The sharp low angle in the body's profile and the clarity of the outline of the separate parts make a delightful contrast with the elegant curves of the whole. A burnished reddish-brown surface enhances the simple strength of the shape. The bowed handle and uplifted spout have a pleasing controlled dynamism. The two angular knobs on the shoulder and the point beneath the end of the spout are not only effective decoration but serve a functional purpose as well. The point catches the drips, and the knobs allow the ewer to be supported by one hand when pouring, while the other holds the handle. The glowing burnish aims at the effect of metalwork, and the finely balanced lines of the form suggest a metal prototype. This shape represents the highpoint of a long development that created a classic type of vessel. No further evolution followed—there were only imitations and degeneration.

Though none has been found, it is evident that large-scale sculpture was already practised in the period of the petty states. Anitta, king of Kussara, boasts of having 'brought back the statue of Shiushummi from Zalpuwa to Neşa [Kültepe]', in the account of his deeds. This probably refers to a large image similar to those found in Mesopotamian cities at that time.

The Turkish excavations of Kültepe, Konya-Karahüyük, Acemhüyük, Eskiyapar and Mashat have brought to light grand buildings which are evidence of the existence of palaces and temples in this early historical period.

The Old Kingdom of the Hittites (1750–1450 BC)

The founding of the Old Kingdom of the Hittites was primarily the work of the Indo-European Nesians. They are described in the cuneiform tablets as the People of Neşa (Kanesh, i.e. Kültepe). Accordingly we should speak not of Hittites but of Nesians; however, the first scholars to decipher the cuneiform tablets of Hattusas (Boğazköy) started with passages that only mentioned the 'Land of the Hatti peoples' and, since their capital was called Hattusas as well, the scholars called these people Hittites. They did not realize then that this was in fact the name of the preceding population of central Anatolia. The terms *Hethiter* or 'Hittites', used respectively by German, English and French linguists, are adopted from the Bible where the 'Sons of Heth' are mentioned (Gen. 10:15 and 23:3).

The Hittites used cuneiform, introduced from Mesopotamia during the eighteenth to seventeenth centuries BC. They also had a pictographic script that appears on seals and public monuments and has connections with Cretan hieroglyphs. Two very important documents in Hittite, from the period of the Old Hittite Kingdom, are preserved.[8] The earliest is the political testament of Hattushili I, written about 1600 BC. The text of Telepinu is from about the beginning of the fifteenth century BC. The former is one of the finest literary texts of early history; the latter is the document on which is based our knowledge of the history of the Kingdom.

In the last few years, German excavations in Boğazköy have uncovered strata of the Old Hittite Kingdom in two sites: one on the citadel (Büyükkale) and another in the northern lower city. The architectural style is a continuation of previous building methods; however, an advance in technique and formal qualities is unmistakable. The occurrence of Cyclopean masonry, which was unknown in Anatolia, is characteristic of this advance.

The newly founded state was so strong at its inception that, within a few generations, Murshili I (c. 1620–1590 BC) conquered first Aleppo and then Babylon and thus brought down the dynasty of Hammurabi.

The Hittite Empire (1450–1180 BC)

Tudhaliyas came to the throne in Hattusas in about 1450 BC. He was a ruler of unknown origin and founder of the dynasty that ruled the land of the Hittites for more than 250 years. His son Shuppiluliumas (1380–46 BC) was the greatest military leader and the most important statesman of the dynasty. During his long reign, he created an Empire that was the equal of Babylonia and Egypt. His son, Murshili II (1345–13 BC), was also one of the most powerful Kings of the Hittite Empire. He was succeeded by his son Muwatalli (1314–1282 BC), who led the famous battle of Kadesh (1285 BC) against the Egyptian Ramses I. The treaty concluding this unresolved conflict was not signed until 1269 BC by Hattushili and Ramses II. This is the earliest known treaty made between two empires.

The reign of Tudhaliyas IV (1250–20 BC), the son of Hattushili III and the influential Queen Puduhepa, was still a part of the prosperous years of the Empire. Art reached its zenith in his reign. Under the next Great King Arnuwanda III (1220–1190 BC), son of Tudhaliyas IV, political events in western Asia Minor moved swiftly against the Hittite Empire. The new texts from Boğazköy, published by Kemal Balkan in 1948, show that one Shuppiluliumas II (1190–80 [?] BC) reigned in Hattusas as Great King, but his reign could not have lasted long. (The events that caused the end of the Hittite Empire will be described in the section on 'Anatolia's Dark Days'.)

The particular contribution of the Hittite people is expressed in their buildings: they were the best fortress builders of the ancient east. The dispositions for offensive defence practised in the Old Kingdom were developed during the Empire into unique fortifications. The imposing walls are executed in consummate masonry. The city walls of early Hattusas show unparalleled mastery in the strategic adaptation of walls to the most difficult terrain

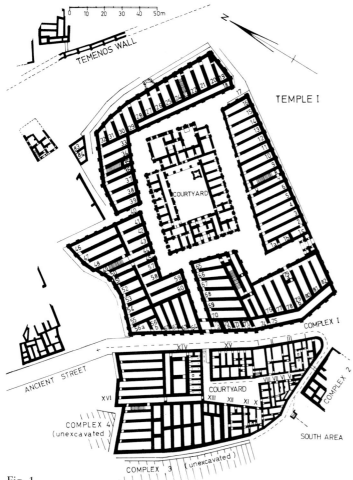

Fig. 1
Plan of the great temple of the Weather god and the Sun goddess of Arinna, Hattusas (Boğazköy), 13th cen. BC.

and in the lay-out of offensive defence works. The city walls are double, with a strong main wall and a lower wall with gates behind it. Projecting square or rectangular towers are placed along the length of both walls. The southern end of the town was relatively vulnerable, since there was no bluff at this point to hinder the attack of the enemy, as there was on the east and the west. Therefore, the wall was set up here as a firm bulwark of offensive defence. At this weak point of the fortress, the defenders could hurry down two steep narrow stairways and meet the enemy outside the town. A postern over 70 metres long served as a sally port against the attackers.

The most important buildings of the capital were without doubt the splendid temples. Five have been discovered so far. The largest is the Temple of the Pl. 7 Weather god and of the Sun goddess of Arinna, and an imposing sight it is. The whole complex with its storerooms, measures 160 metres long by 135 metres Fig. 1 wide. The temple itself consists of a rectangular construction with an inner courtyard and an annex with the shrines in the north-east. The inner court of the temple can be clearly seen in the background of Plate 7, while the shrines are only partly visible. The store-rooms formed an enclosure like a Greek *temenos* wall round the temple. The sanctuary was entered through a monumental gateway in the south-east; the great monolithic thresholds are preserved, as well as the two porter's cells to the

left and the right of the entrance in the first gatehouse. The narrowness of the storerooms suggests that they had an upper storey. The excavators state that traces of a staircase were found in rooms 7 and 8. The rooms must have been used to store provisions and temple treasures. In the rooms on the north and west there were double rows of huge *pithoi* (storage jars), such as are known in Cretan and Mycenaean palaces. Clay tablets in large quantities were discovered in rooms 10 to 12 of the southern area.

The temple itself had a monumental gateway, more splendid than the entrance to the south-east storeroom illustrated above. The great portal of the temple was entered over a monolithic threshold which led into a small vestibule, flanked by two open chambers, each with a deep window. Then followed the gatehouse proper with watch chambers to the left and right. Next came another vestibule flanked by chambers with windows giving on to the courtyard. This portal of Temple I is the best example of the Hittite type of gateway; it is characterized in length and depth by a tripartite plan. The rooms laid out asymmetrically to the left and right of the portal belong to the storerooms on the sides rather than to the façade of the temple.

The plastered court is closed at the far end with a portico, which forms the entrance to the sanctuaries of the Hittite cult. In the north-east corner of the court are the remains of a sacred fountain (?) where the worshippers washed before entering the shrines. The part of the shrines annexed to the north-eastern corner of the temple is made of granite, while the other tracts of the complex are of limestone. This differentiation of the sanctuaries themselves from the building with its courtyard, which is stressed by the difference in building material, can be seen in the whole lay-out. In one of the two largest chambers of this annex on the north-east is a plinth, which must once have supported the statue of a deity. A limestone statue must also have stood in the other large chamber that is arranged symmetrically to the first one. Therefore, this is a temple where two deities were honoured at the same time. In this temple, the largest of the Hittite realm, these statues can only be the two greatest deities of the Hittite pantheon: the Weather god of the Hattian land and the Sun goddess of Arinna. By analogy with the cere- Pl. 8 monial arrangement found in Yazılıkaya, the Weather god would have stood in the left-hand chamber and the Sun goddess of Arinna in the right-hand one.

Secular buildings, the royal palace, library, audience halls and other official buildings of the ruling house were situated on the high citadel to the south-east of the great temple. These were imposing buildings that dominated the city and the whole vicinity.

The erection of great temples and palaces led to the development of plastic arts that ensured its makers an outstanding place in the art of the Near East. Not a single cult image survives from the temples. We have no monumental sculpture in the round from the Hittite Empire. In compensation there are some portal lions and sphinxes and, above all, the imposing relief sculptures.

The most important reliefs of this period are carved on the rock walls in the sanctuary of Yazılıkaya, not far to Pl. 8

18

the north-east of the capital city of Hattusas. This sanctuary includes two natural chambers: a large one to the west and a smaller one beside it on the east. The large chamber, with reliefs of the female and male deities, formed the shrine of the temple that once stood in front of it. The foundations have been uncovered. The rites that were performed in closed rooms in the temples of Hattusas were enacted here, in the open air, before the reliefs on which the complete Hittite pantheon was depicted.

On the rock wall of the large chamber, the female deities are on the east and the male deities on the west, while on the north wall are reliefs of deities, with males and females positioned in the same way. Altogether there Fig. 2 are 42 male and 26 female deities. In the central scene, the chief god on the left stands on two sacred mountains. Facing him is the chief goddess standing on her holy animal, the lion. Both deities are attended by frontal bulls who wear pointed caps. Behind the god on the left stands a second god on cones that are to be interpreted as mountains. The great goddess is followed by a young god, also standing on a lion, and by two goddesses who are placed on one double-headed eagle.

The names of the deities have been identified through the hieroglyphs carved on their outstretched hands. The god standing to the far left is the Weather god of Hattusas, the chief god in the centre of the picture is the Weather god of the Heavens. The chief goddess is Hepat (in Hurrian), that is to say the Sun goddess of Arinna. The young god behind her is Sharruma. These three gods — the Weather god of Heaven, Hepat (Sun goddess of Arinna) and their son — form a trinity. The divine pair with their son is a concept that was already formulated in lead idols of the early Hittite period. This scene has been described as a meeting of deities. It is true that this representation of the gods in procession creates the impression that they are marching to meet each other but, knowing that the Hittites always placed the female deity to the left of the male and that in the Hittite reliefs it was never customary to depict figures frontally, the scene should be read with the gods standing before us, exactly like the mosaics in the Hagia Sophia or in San Vitale at Ravenna, where the figures face us frontally. This is, in fact, a hieratic representation of virtually the complete pantheon, the Hittite 'thousand gods' of which the cuneiform texts speak.

The reliefs of Alacahüyük form a school of sculpture Pl. 9 on their own. On a relief that once decorated the façade of the city wall at the entrance to the city, and is now preserved in the Archaeological Museum in Ankara, is a Hittite king worshipping a bull. He is identified by his curved crook, called *kalmush* in Hittite. The female figure behind him must represent his wife, the queen, since it is known from the texts that the queen always stands beside the king for official and religious ceremonies. The altar in front of the king is probably a *huwashi* stone (a *baitylos*, a meteor, somewhat human in shape, honoured as a god). Textual sources show that the *huwashi* was the earliest object of worship. Behind it is a second altar on which the bull stands. The bull was the attribute of the Weather god and was worshipped itself as a deity in the Hattian

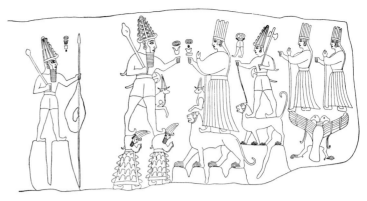

Fig. 2
Rock shrine of Yazılıkaya, near Boğazköy, 1250–20 BC: *centre left, the Weather god; on the right facing him,* the Sun goddess of Arinna.

period. The facial features and especially the curious shape of the king's nose occur on the other reliefs of Alacahüyük and on the reliefs of the vase of Bitik. It can therefore be concluded that there was a workshop in Alacahüyük with a distinctive style.

Foreign Elements in Hittite Culture

It has been stated in previous sections that Hittite culture had strong roots in the native Hattian tradition. However, there were other influences acting on the Hittite culture from the Mesopotamian lands. These are apparent in several spheres.

The most important element that brought Asia Minor into contact with Mesopotamia in the Hittite period was cuneiform; this was used in Hattusas from the time of the Old Kingdom. Some knowledge of Akkadian was needed for the acquisition of cuneiform writing. The Hittites were so strongly under the influence of their Mesopotamian models that they used the corresponding Akkadian, and sometimes even Sumerian, characters for quite common words in their own language. If the reader did not know these Mesopotamian ideograms, he would naturally be unable to understand the Hittite text. Akkadian was used in diplomatic correspondence and state business; fragments of Sumerian-Akkadian-Hittite dictionaries have been found among the tablets at Boğazköy and also some hundred texts entirely in Sumerian or Akkadian or with considerable sections in these languages. Among these are the texts of the legends of the campaigns of Sargon and Naram-Sin in Asia Minor and the epic of Gilgamesh.

Prophecy and magic were serious concerns of the Babylonians and were also adopted by the Hittites. Babylonian influence is the most marked in pictorial art. The considerable influence of Hurrian culture on the Hittites has been discussed in the section on the Hurrians.

The Individuality of the Hittite Culture

Despite the strong influence of Anatolian Hattian, Mesopotamian and Hurrian cultures on the Hittites, they created a culture in Anatolia that was quite individual. It

is astonishing that at the end of the imperial period, a people as much under the influence of the Mesopotamian countries as the Hittites were, could show features so fundamentally different from their oriental neighbours and have a genuinely western point of view in so many spheres of cultural life.

Their idea of a state based on loyalty was one of the principal traits of the Hittites. The king, though hereditary, was only *primus inter pares*. The Hittite Empire remained entirely untouched by oriental absolutism and its concept of divine right. Only at the very end of the empire are the Hittites found tolerating certain specifically oriental elements. But this very slow encroachment of oriental attitudes did little to alter the general character of Hittite culture. In the will of Hattushilis I, it is stated that the high nobility is not subject to royal legislation; conflicts between nobles are to be submitted to the *Pankus*, the community of nobles. In the Ordinance of Succession, proclaimed by Telepinu, the rights of the nobility are accorded deep respect: the king is admonished: 'Thou shalt kill none of the kinsmen; that is not right', and 'if one becomes king and plans evil against [his] brothers and sisters, and if you are the *Pankus* for him, say firmly to him "learn from the tablet how affairs of blood are to be handled." He who wrongs brothers and sisters answers with his royal head. Summon the Assembly, and if there is a sentence, he must atone with his head.'

The Hittite king had a duty to care for the well-being of his country, to be its leader in war and to perform religious rites as high priest. The text of Telepinu shows that the name of the ancestor of the royal Hittite house was Tabarna (also written Labarna); this is a Hattian word. The name was used by later kings as a title (as was Caesar by the Romans).

In time, however, the Hittite kings had to introduce grandiloquent titles in the oriental fashion. This was indispensible to prevent the reputation of the king from being belittled in the eyes of his vassals. Such necessities were the first steps towards the orientalization that increased in pace in Late Hittite times. Albrecht Goetze states that kingship in the Hittite Empire became theocratic and quotes a text: 'The land belongs to the Weather god. Heaven and Earth and the people belong to the Weather god. He made Labarna, the King, his Regent and gave him all the land of the Hittites. So shall Labarna rule the whole land with his hand.' Here can be seen the Hittite idea of kingship assuming an essentially oriental character.

There is no text known to us which states that the Hittite kings were deified during their lifetime, as occurred among oriental peoples. Only deceased kings were deified by the Hittites. Of a dead king it is written in the texts, 'he has become a god.' It does seem, however, that in Hattusas at the end of the Empire, the oriental custom of deifying the king during his life had been adopted. Tudhaliyas IV had himself portrayed as a god on mountains in the great sanctuary of the temple at Yazılıkaya. This relief was doubtless carved during his reign, thus giving an oriental type of apotheosis. Another striking piece of evidence is that the same king's seal was found at Ras Shamra, and on it he is represented wearing a divine cap with horns. A limestone stele with the name Tudhaliyas in hieroglyphs (probably Tudhaliyas IV), found in the shrine on the Büyükkale, is another indication of this king's fondness for setting up his image or his cartouche in holy places. These are clear signs of the orientalization of the Hittites towards the end of the Empire.

One of the most important traits of the Hittites, and one that distinguishes them from their eastern neighbours, is the humane character of their laws. First place must be given, as Albrecht Goetze stresses, to 'a higher estimation of human life and the value of the individual. Degrading punishments such as mutilation, of the kind used in Assyrian justice, are virtually non-existent.' Slaughter and burning of enemies, pyramids of heads, impaling or flaying of prisoners, all cruelties customary under the Assyrians, were unthinkable in Hittite Asia Minor. Neither in the texts nor in art is there evidence of such atrocities. Even their treatment of slaves was humane. Albrecht Goetze writes, 'The law gives slaves the right to contract legal marriages with free women, without the latter having to abandon their free status. The only condition is that the slave must pay the bride price. If such a marriage is dissolved, possessions and children are divided in the same manner as when the partners are both free. Clearly slavery did not prevent the amassing of wealth, and the possession of wealth began to wipe out the distinctions between free men and slaves.'

The elevated social status of women corresponds to another trait of Hittite life that distinguishes them totally from oriental peoples. If the Tawananna, the queen, outlived her husband, she retained her position during the reign of her son. Not until the queen's death did her daughter-in-law rise to that dignity. The word *Tawananna* is Hattic, and the unusually elevated status of the queen, which almost equals that of the king, must originate in the native Hattic tradition. The only harem was in the royal house, and polygamy seems not to have been practised among the people. The Hittite family was organized on a patriarchal basis.

Such cultural traits and outlook give the Hittites an outstanding place in world history. For more than five hundred years they represented a society based on principles of humanity and loyalty, in contrast to the ancient Near East, and here lies their great merit. The Hittites managed, as few other peoples have, to combine their expertise in warfare with skilful diplomacy. Thanks to this exceptional competence and their unrivalled adaptability, which they owed to a strong sense of reality and to the tolerance borne of self-confidence, they were able to dominate a vast number of peoples of different languages and cultures in a firmly integrated state that lasted for half a millennium.[9]

Troy VI (1800–1275 BC)

Almost at the same time that the Hittite Empire was developing on the plateau, the sixth settlement of Troy was flourishing in the north-west of the peninsula. It is

perhaps not fortuitous that at exactly the same period in Hellas the Early Bronze Age ceased and the Middle Bronze Age began. The rise of these new and contemporary cultures in three neighbouring parts of the world at that time was a consequence of the great Indo-European migrations that began towards the end of the third millennium BC and continued into the beginning of the second.

The citadel of Troy VI was certainly one of the finest fortresses of its time. The remains of the ring wall, between three and four metres high, give a vivid idea of what this grand structure originally looked like. Troy VIh i.e. the highest, finest and richest habitation layer of the sixth citadel (1325–1275 BC) is Homer's Ilium, not Troy VIIa, as the excavators thought.[10] The latter, consisting of poverty-striken patched-up houses in a miserable town, cannot possibly have been the splendid Ilion of fame. The wealth and importance of Troy VIh, and its strategic position, as well as the extensive ambition of the Mycenaeans, gave rise to the Trojan war. *The Iliad* is a poetical account of the unsuccessful attacks waged against Troy by the Achaeans. This impregnable fortress was conquered (as was only recounted later in *The Odyssey*) by a military strategem, with the help of a wooden horse. It is just this mythical motif in the epic that proves that the Trojan war really took place. Poetic imagination is inventive, it is true, but how could Homer, or the bards who preceded him, have invented the story of the wooden horse unless the Achaeans had in fact set up an image of a horse in Troy to express their thanks to Poseidon, the Earthshaker, for his destruction by an earthquake of the mighty fortress they could not conquer? Now, thanks to C.W. Blegen's keen observations, we know that Troy was first the victim of a violent earthquake in 1275 BC, and then about 1240 BC fell to Achaean attack. The motif of the wooden horse is thus the historical nucleus of the legend. Success only came to the Achaeans once the city had undergone catastrophe: the Trojans hardly had time to restore their walls and a few of the old buildings, and to put up a few new houses, when the Achaeans came and set fire to the city. The blow suffered by the Trojans at the hands of their hostile relatives brought a tragic end to the power that, throughout the second millennium, had maintained a staunch bulwark for Anatolia against the Balkans and the West. The city soon fell into the hands of the Thracians (Troy VIIb2), who had long coveted the fertile lands of north-west Asia Minor and now, about 1180 BC, hurled themselves in mighty waves against the Hittite Empire.[11]

Migration of the Thracians and the Dark Days of Anatolia (1180–750 BC)

The presence of the Thracians in Troy VIIb2 from about 1200 BC is shown by the *Buckelkeramik* (pottery with wart ornamentation) found in large quantities in this level. The pottery is the characteristic ware of the east Europeans. Written texts cease in Hattusas about 1180 BC, which date fits well with our hypothesis that Hattusas

fell to Thracian attack. A very valuable documentation of the migrations of the south-east European peoples into Asia Minor is provided by the annals of the Assyrian king Tiglatpileser I, who reigned some time during the years 1112 to 1074 BC. These annals reveal that this king warred against the Mushki, who had appeared on the northern frontier of Assyria in the upper region of the River Tigris fifty years before the beginning of his reign. Therefore, these Mushki (perhaps the Mosians of south-east Europe), and probably many other tribes from the Balkans, were posted along the frontiers of Assyria, from about 1170 BC, after they had overrun Hattusas and Troy.

Egyptian sources agree entirely with these dates. Ramses III (1200–1168 BC) called the tribes that penetrated as far as the frontier and coast of his empire 'Sea' or 'Island People'; however, since he also says that they destroyed Arzawa and Carchemish, his account corroborates the Assyrian annals: Carchemish lies directly on the upper River Euphrates; at that time near the frontier of the Assyrian Empire. The Egyptian sources state that these great migrations were not only a movement of the Thracian and south-east Europeans, but that the Sea and Island people also took part in them. (The Doric migrants who arrived on the Greek mainland were another current in this tremendous human tide.)

The consequences of these destructive military movements were catastrophic. The invaders destroyed the civilized societies of Asia Minor quite relentlessly and with elemental force, so that after this incursion a dark age began which lasted 200 years in western Anatolia, and no less than 400 inland. Some years ago this author explained how central Anatolia was very sparsely populated between 1180 and 775 BC and occupied by nomadic tribes who have left no traces. The catastrophe was of such proportions that even the Hittite tradition was completely wiped out in central Anatolia. However, one thing is certain: in the heartland of the Hittite Empire there were no urban settlements until the growth of the Phrygian state (750 BC). None of the modern cities of central Asia Minor—Gordion, Ankara, Yozgat, Corum, Tokat, Boğazköy, Kırşehir, etc.—dates back to the Hittites, as do the cities of southern Anatolia, like Niğde, Adana, Malatya, Marash and Carchemish, which all stem from the Hittite period, and perhaps even earlier.

Late Hittite Art (1200–700 BC)

The art of the Hittite principalities, which rapidly developed in south Anatolia and north Syria after the collapse of the Empire, played a noteworthy part in the cultural world of the ancient near east.[12] Artistically this phase of Hittite art was provincial and conservative and far behind the outstanding monuments of contemporary Assyrian art. Yet the unique linking role played by Late Hittite sculpture during its last stylistic phase, under the influence of Assyrian and Aramaic art, has given it great importance. The geographical position of the Late Hittite principalities and favourable historical circumstances meant that this art was responsible for the birth of the

'orientalizing style' in the early seventh century BC in Greece.

To some extent these small principalities in south Anatolia and north Syria were already in existence before the collapse of the Hittite Empire. Carchemish was an important kingdom even in the second millennium BC, but the majority of the principalities seem to have arisen later.

It may be that the description 'Late Hittite' has no validity from the ethnic or linguistic point of view; nonetheless, in art history it is justifiable: the sculpture of this region in its first stages is completely Hittite in style. There are three stylistic phases of Late Hittite art: traditional, Assyrianizing and Aramaicizing.

The Traditional Style (1050–850 BC)

This style is a continuation of the Hittite art which flourished in Anatolia and north Syria during the second millennium BC. Examples are found primarily among the reliefs of Malatya and Carchemish. The fine head of a goddess from Carchemish and the column lions from the same place can be quoted as characteristic examples of the traditional style. The lions are faithful imitations of a type representative of the imperial period.

The Assyrianizing Style (850–700 BC)

Here the traditional Hittite features are superseded by elements of Assyrian style. The splendid relief of the lion hunt from Malatya, carved in the second half of the ninth century BC, goes back to Assyria for the representations of both chariots and lions. The motif of the wounded lion in that relief is a favourite theme of Assyrian hunting reliefs. The portrait of Katuwas, King of Carchemish, is also executed in Assyrianizing style. The relief of a warrior on a panel from Carchemish, belonging to the late eighth century BC, is based on Assyrian models.

Pl. 11 The statue (3.18 metres high) of a king of Malatya in the Archaeological Museum in Ankara is a typical example of this strong Assyrianizing style. It is a faithful local imitation of Assyrian models: the arrangement of the waves of hair on the head and the treatment of the beard with Assyrian-spiral curls are very similar to Assyrian works. The king is represented bare-headed. The mantle, with its diagonal folds, and the elegant open sandals are faithful copies of the Assyrian manner.

The Aramaicizing-Hittite Style (850–700 BC)

The sculptures at Zıncirli and Sakçagözü are Aramaicizing-Hittite. The old Hittite tradition is to be seen only in representations of animals. Human figures are free of all Hittite influence. The head coverings seen on the reliefs of the Barrekup period from Zıncirli and the one belonging to the god of the Ivriz relief are Aramaic. The same cap appears again on the lion slayer in the lion-hunt relief from Sakçagözü. The Semitic noses of the figures on the

Ivriz relief are another characteristic of this style. The best examples, apart from the sculptures of Sakçagözü, are the tomb reliefs from Marash. From this time survives a masterwork of unusual size, a stele from Marash depicting a married couple in an impressive manner unique in ancient Near Eastern art at that time. This work, and other reliefs from Marash of the early seventh century BC, with their interesting rendering of drapery, may have influenced the Ionian art of the sixth century BC, though intermediary pieces are still unknown. Greek tomb sculpture of the Archaic period also shows formal and iconographic connections with the memorial relief from Marash.

Urartian Art (900–580 BC)

The kingdom of Urartu flourished in the first half of the first millennium in the far eastern part of Anatolia on the high plateau round Lake Van.[13] The great mountain, Agri Dağ, lying close to the modern Soviet frontier, is 5172 metres high, and the lake itself, with its surrounding plateau, is at about 1700 metres above sea level. The name Urartu has been known since the reign of Salmanassar I (first half of the thirteenth century BC).

The annals of the Assyrian King, Assur-bel bala (1082–66 BC) give a list of the states conquered by him, without naming Urartu. The first mention of a King of Urartu (who was called Aramu and resided in Arzaskun) is in the annals of the Assyrian King, Salmanassar III (858–24 BC). The formation of a firmly integrated Urartian state also fell in the reign of Salmanassar III. A powerful dynasty ruled in Urartu, starting with Sardur I (840–30 BC), the son of Lutipri and took advantage of the weak period of the Assyrian Empire (854–745 BC), to become dominant.

This is the period of Menua (810–780 BC) and his successors Argisti (780–60 BC) and Sardur II (760–30 BC). The inscriptions of King Menua are found from the south of Lake Urmia to the borders of Melitene (Malatya) in the west, and as far as the Araxes in the north. They mention campaigns reaching into Transcaucasia. Sardur III, the son of Argisti, conquered Kumahna (Commagene) in the west and Haleb (Aleppo) in the southwest, thus ensuring a secure contact with the Syrian coast of the Mediterranean. The Empire of Urtartu in the mid-eighth century BC was, if only for a short time, the strongest power in the east.

In the time of the great Assyrian King Tiglatpilesar III (745–27 BC), the Urartians were driven back into their mountainous homeland. The Assyrian king Sargon III (721–05 BC) was able to organize a great expedition that penetrated far into the interior of the Urartian Kingdom. The Urartians, thereafter, were content with ruling the mountain zone and thus were able to co-exist with the Assyrians.

The Cimmerian invasion, which is said to have driven Rusa I to take his life (713 BC), must have weakened considerably the Urartian kingdom which also must have suffered severely from the Scythian interruption in the first half of the seventh century BC. But it was the appear-

ance of the Persians in the area that brought it to an end. The final dissolution of the state came about the end of the seventh or even the beginning of the sixth century BC, as a consequence of the Median conquests. This was when Kyaxares I conquered the Assyrian Empire. This late dating of the collapse of the Urartian state (about 580 BC) is convincing because Urartian works of art appear in Scythian graves up to about 580 to 570 BC, and Urartu influenced Ionian art until the early years of the sixth century BC.

The annals show that the Urartian kings acted as deputies of the national god Haldi. In this capacity they waged war against enemies, served the country's gods as high priests and saw to the erection of sanctuaries, palaces, fortresses and irrigation systems. The monarchy was hereditary within the same dynasty, the son succeeding his father.

The provinces were governed by viceroys in the king's name. The excavations of Karmir Blur revealed how they stored grain, wine and sesame oil in national repositories. On the borders of the Kingdom lay vassal states that paid tribute and gave military service but had sovereign rulers.

The Urartians were great builders of irrigation systems. They possessed huge herds of cattle, large and small. Horse raising was carried out on a large scale, perhaps a local tradition going back to the Hurrians. They were also fine artisans: weaving and especially metalwork were among the greatest products of the Urartians.

The Urartians wrote on clay tablets. They used Assyrian cuneiform and also a native pictographic script; few examples of this have survived. The inscriptions are carved on stone stelae, building blocks and rock walls. In these inscriptions, the Urartian kings proclaim their deeds of war, the building of temples and irrigation systems and religious affairs. A very fine example of this kind of inscribed monument is the great Annals' inscription of King Argisti (780–60 BC), written in Urartian, which survives, in splendid condition, on the citadel on Lake Van near the entrance to the southern gorges.

Near the harbour gate in Van, a kind of castle is attached to the western end of the cliff. A part of the wall survives with an inscription by King Sardur I (840–30 BC). Here the first Urartian king immortalized himself in three inscriptions (one in Assyrian), and these are the earliest historical documents on Urartian soil.

The Urartian language was deciphered by means of two bilingual texts. A. Goetze considers Urartian to be a late Hurrian dialect. By this token Urartians were the descendants of the Hurri who had developed one of the great cultures of the second millennium BC in the Near East.

The great inscription on the Mithras Gate near Van, giving information about Urartian religion and a summary of the whole Urartian pantheon, belongs to the joint reign of İspuini and Menua. An important detail is that the Hurrian name of the Weather god (Tesub) appears here, little altered, as Teiseba. The inscription also makes clear the hierarchy of the gods. The greatest gods are Haldi, the national god, Teiseba, the Weather god, and the Sun goddess Siwini. To Haldi are due daily 17 oxen and 34 sheep; to Teiseba and Siwini, 6 oxen and 12 sheep each. The many other gods listed each must be content with one ox and two sheep. The Mithras Gate, built in the form of a niche, represents a shrine, as A. Goetze has demonstrated. Similar rock façades in the form of niches were used as cult monuments in Phrygia.

The Urartians developed a style of sculpture which was strongly influenced by Assyrian art. Their art was very popular in the contemporary world: bronze cauldrons especially, decorated with human heads or primitive animal forms, were exported to Phrygia, western Asia Minor, Greece and Etruria.

The greatest and most original achievement of the Urartians lies in their architecture. The citadels, and particularly the temples, are outstanding buildings of superb execution and impressive monumentality. The relief block from Adilcevaz, now in the Ankara Archaeological Museum, is described by the excavators as a column base. The relief was carved in the eighth century and represents deities in front of an architectural façade. Pl. 10

Phrygian Art (750–300 BC)

Gordion was the capital of the Phrygian people. Ancient sources relate its legendary foundations as follows: 'The ox team of a peasant called Gordios was ploughing, when birds of every kind suddenly swarmed all round it. Gordios had set off in astonishment to ask the soothsayer of a neighbouring town what this meant, when he was met at the city gate by a beautiful damsel of the soothsayer's family, who prophesied that he would become a king and offered him her hand. After the wedding there was an insurrection among the Phrygians. An oracle commanded them to honour as king the first man to approach the temple with a wagon. The man who came to them thus was Gordios, and they at once greeted him as king. But he set up the wagon in which he came, when the royal office was assigned to him, in the temple of the god and dedicated the wagon to him. After Gordios his son Midas reigned.'

Midas, who appears in Greek tradition as a legendary character, is a historical person in the Assyrian sources. He is among the enemies mentioned most frequently by the great Sargon in his sanguinary war reports. In the annal of his fifth year (717 BC), Sargon says that 'Pisiris of Carchemish transgressed against the commands of the great gods and wrote hostilities to Mita, King of Mushki'. Sargon first confronted Mita in 715 BC in the land of Que, later Cilicia. Sargon reports: 'Mita, King of Mushki, in his realm I administered a defeat to him; the cities of Harrua and Usnani, strongholds of Que that he had long ago taken by force, I won back'. Sargon then reports in 712 BC that he founded the frontier cities of the land of the Mushki, whose gates were impregnable. In the report of fourteenth year of his reign (709 BC), Sargon recounts that his governor of Que had thrice taken the field in the realm of Mita and overrun his lands. 'But he, Mita of Mushki, who had not subjected himself to the kings, my ancestors, fell into tribulations in his remote land and henceforth sent his emissaries to do me homage and bring tribute and gifts'. It is clear that Mita was king of a

country distant from Assur, with frontier cities in Cilicia, which probably reached to the sea. That this is obviously the same King Midas as the one who appears in Greek mythology has long been recognized.

Whether the little thick-set man, only 1.59 metres tall, whose skeleton was found in the largest tumulus of Gordion, is this Midas or another important member of the royal family is impossible to know. The skeleton belongs to a man over 60 years old, and as the grave dates from the early seventh century BC at the earliest, it can hardly belong to Gordios, the father of Midas. Gordios, if alive at the time of the Cimmerian catastrophe, must have been long past the age of 60 to 65. The size of the tumulus suggests that it covers a king's grave. The mound has a height of 53 metres and, after the 69-metre high tumulus of Alyattes in Lydia, is the second largest burial monument in the whole of Anatolia.

If this tumulus is not the tomb of Gordios, it is perhaps that of Midas. But then it is very strange that the greatest tumulus of Gordion contains no gold objects. Would it not be anomalous to attribute a grave without any gold treasures to the rich king whose name is irretrievably linked with gold in Greek mythology? It is not surprising that the grave contained no royal insignia; none of the other tumuli that have been excavated in large numbers at Gordion and Ankara and that held rich offerings gives any indication of the identity of the deceased. It presumably was not the custom among the Phrygians. The lack of gold objects may also have an explanation. If Midas did fall victim to the Cimmerian storm, as the Greek sources relate, it is hardly to be expected that his grave would shelter any gold. Even in the ceremonial halls of *megaron* type, with floors decorated in splendid mosaic, no precious objects have been found. The Cimmerian attack must have been of disastrous consequence. The layer of mud walls has been utterly vitrified by fire. Nowhere in this devastated area is there to be found a speck of gold or silver, although all the houses have remained underground, undisturbed since their destruction, until they were excavated. It would seem that the barbarian hordes carried off every piece of precious metal as booty.

Poor King Midas who, according to Greek legend, took his life by drinking bull's blood, was probably left with nothing but his bronze. No more than three bronze cauldrons—and well-used ones—could be found. They had lost their ring-handles, and in two places the lower parts of the tails of the birds had not survived. In other respects, however, the contents of the tumulus were overwhelming: 169 bronze vessels of various forms, magnificently executed and 175 bronze fibulae of exquisite workmanship—apparently objects of no value to the Cimmerians. The burial chamber is an impressive wooden construction, the most splendid in size and craftsmanship of all the examples so far excavated. Perhaps, in that time of distress, the bronze vessels were all that could be procured. If there were a few gold treasures to be found, they were not put in the tomb as before; it was probably considered more fitting now to honour the king with his everyday belongings. The ultimate honour the Phrygians could give their great and meritorious king was to build the largest and tallest mound over his tomb, to serve as a noble monument to his glorious and energetic reign.[14]

In 1900, two German archaeologists, Gustav and Adolf Körte, began excavations in the ruins of Gordion and made the first systematic study of the buried cultural strata of central Anatolia. The second stage of basic exploration of Phrygian culture began with the American excavations in Alişar in 1928, when the Oriental Institute of Chicago provided generous funds for the investigation of Anatolian history. The successful work at Alişar, a ruined site on the River Halys, was directed by H. Henning v.d. Osten and contributed much to Phrygian history. Boğazköy-Hattusas, the Hittite capital, also inside the bend of the River Halys, became an important centre for Phrygian prehistory when Kurt Bittel began the German excavations there in 1931. Turkish excavations in Ankara, Konya and Pazarlı have produced further important results. The greatest advance in our knowledge of the Phrygians has been due to the excavations carried out since 1950 by the University of Pennsylvania.

The finds preserved in the Archaeological Museums of Ankara and Istanbul are now sufficient to give a clear picture of the art and culture of the Phrygians. Mention has already been made of the dark days of the Phrygian, and particularly the Thracio-Phrygian, populations. The Phrygian heritage is especially important and singular in the history of the cultures of Asia Minor. The well-preserved monuments, carved by the Phrygians in the cliffs, with their delightful decoration and elemental grandeur, still compel the admiration of the world.

The organic shapes and lovely geometric decoration of the vessels from the Phrygian excavations make them the show-pieces of Turkish museums. An indication of the power of the culture of this people, only recently converted from nomadic to settled life, is the extent to which their religion, music and dance influenced even their great neighbours, the Greeks.

The language of the Phrygians belongs to the Indo-European group; their script is very similar to the Greek.

The ewer found in the tumulus of a little princess in Pl. 12 Gordion, now in the Archaeological Museum, Ankara, is a fine example of Phrygian pottery of the Midas period. It can be dated to about 700 BC. The ewer shape is Phrygian. The lion, only the head of which is visible in the photograph, goes back, in every detail of iconography, to Late Hittite models. On the other hand, the geometric ornamentation of the ewer is connected with the late geometric vases of Greek art.[15]

Lydian Art (700–546 BC)

After the Cimmerian irruption, wealth and political precedence seem to have fallen from Phrygian into Lydian hands. The legend of Midas (recounted in its entirety in Ovid's *Metamorphoses*) gives, it might be said, symbolic expression to this transfer of wealth. Midas was obliged by Dionysus to bathe in the River Paktolos, near the Lydian capital Sardis, in order to be rid of the charm that made everything he touched turn to gold. The magic was

thereupon transferred from him to the river. Henceforth, the clods and grass on the banks of the Paktolos glittered with the gold carried by the river. Of course, the wealth of the Lydians did not come from the gold they dredged from the river banks but from the princely courts of Anatolia that had previously been subject to the Empire of Midas and now paid tribute to the Lydian royal house.

Lydian has been recognized as an Indo-European language. The script is very similar to Greek. Little is known of Lydian history. As research now stands, the Atyad and Heraclid dynasties mentioned by the Greek historians can be dismissed as legendary. The Mermnad dynasty, however, is historical, as is proved by Assyrian sources. Gyges, who died in 652 BC, was a contemporary of Assurbanipal (669–30 BC) and Psammetich (663–09 BC). It is significant that Homer does not know of the Lydians but calls the Lydian region Maeonia. The earliest mention of Lydia and the Lydians is preserved in Greek poetry of the seventh and sixth centuries BC, in fragments of works by Mimnermos, Sappho, Hipponax and Xenophanes. It may be deduced that the Maeonians and Lydians were clans of one and the same people and that the Maeonians attained power first and the Lydians only later, towards the end of the century.

Nothing remains of the pre-Lydian period. In all probability its first phase goes back to the period of the Hittite Empire, as shown by the Hittite-sounding royal names, Sadyattes and Alyattes. Thus at present we are obliged to describe Lydian art on the basis of the sparse remains known to us from surface finds and excavations.

Since the pre-Lydian period, i.e. the period in Lydia before the eighth century BC, is completely unknown, it is impossible at present to prove the hypothesis that the Etruscans stem from somewhere in Asia Minor around Lydia. The parallels between Etruscan and Anatolian features, quoted as evidence for an origin in Asia Minor, are unconvincing in so far as they refer to a link in the seventh and sixth centuries BC but not to connections in the earlier period, because such shared characteristics occur elsewhere at the same time. The question of whether the origins of the Etruscans are in Asia Minor can only be answered after the material remains of the Lydian region have been excavated for the period 1200 to 700 BC. It is to be hoped that the excavations resumed by the Americans in Sardis will throw light on this extremely interesting problem.

Apart from the Greek wares, the pottery from the tumuli and other Lydian graves can be classified in two groups 1) native Lydian wares, 2) native Lydian wares with weak or strong Greek influence. The vessel form known as *lydion* is a Lydian invention. In these vessels the Lydian ointments, so often spoken of in Greek literature, were exported to every part of the known world. A vessel with a long spout, of the early sixth century BC, certainly has signs of Phrygian influence, but the shape of the foot shows it to be of Lydian manufacture. For the rest, Lydian pottery consists, more or less, of close imitations of Greek vessel forms.

The decoration on the pottery also has Lydian peculiarities: yellow, white or orange slip is characteristic as is the ornamentation, wavy lines and especially the imitia-

tions of marble or glassware. A fine sixth-century BC example is preserved in the Istanbul Archaeological Museum. The simple design and clumsy rendering of the animals are provincial but very effective. Another typical decoration is made up of stripes, painted in red, brown and sometimes white, on vessels of different shapes, especially on skyphoi (a type of drinking vessel). Lydian vessels of the early sixth century BC with painted stripes, are known from the excavations at Bayraklı and Daskyleion. These skyphoi with coloured horizontal stripes are represented in Sardis about 600 BC, and from the first half of the sixth century BC in examples of elegant form. The later versions from graves of the second half of the sixth century BC are of poorer quality, showing that, after the death of Croesus, Lydian vase painting had little to offer.

Lydian vases with figure painting are entirely influenced by Greek art. The fragments of vases with figures of horsemen, preserved in the Metropolitan Museum of Art, New York, are completely in the Greek late-geometric style, the horses depicted showing dependence on eastern Greek models of the third quarter of the seventh century BC. The wide double outlines and crude colour effects, like the yellowish slip, give the vessel its own character that can be termed Lydian.[16]

Lycian Art (600–300 BC)

Lycian art is one of the most original creations of ancient Anatolia.[17] The Lycian tombs, carved out of the living rock, are among the most impressive monuments of Asia Minor. The proportions are beautifully balanced; the detail carefully executed, and the type of structure is quite unique.

Lycian, an Indo-European language, retains many traces of ancient Anatolian. The script has similarities with the Greek alphabet. The name Lycian is identical with the lands and people mentioned in Hittite texts from Boğazköy as Luqqa, and in Egyptian texts from Amarna as Luku. According to the Egyptian sources, the Lycians were allies of the Hittites in the time of Ramses II (1297–30 BC). In the Hittite texts of the fourteenth to thirteenth century BC, the Luqqa are described as coastal folk of Asia Minor. Herodotus states that the Lycians came originally from Crete and called themselves Termiloi. It may be that the Lycians had settled in Lycia from the second millennium and that the Termiloi were a tribe that migrated later from Crete, but that they originally belonged to the same people.

The relation of written to archaeological sources is even less helpful in the Lycian problem than in the Phrygian. The earliest Lycian remains date from the sixth century BC, and Lycian art of the previous seven centuries or earlier, is unknown to us. Unlike the Phrygians, the Lycians have left no pottery. Current excavations by the French have unearthed Greek pottery of the archaic period (of the seventh century BC) but no Lycian pottery. The material remains of the Lycians are limited to the tombs, and their sculptural decoration and reliefs.

The earliest architecture and sculpture of the Lycians

do not seem to date back further than the mid-sixth century BC, as research stands today. The older remains on the citadel of the capital presumably suffered at the hands of the Persian conqueror, Harpagos, in 545 BC. Herodotus states that the Lycians gave battle with 'few against many' near the city of Xanthus. After heroic fighting, they were defeated and driven back into their city. They assembled their women and children and their valuable possessions on the citadel and burnt them all. Then they swore a terrible oath, made a sortie and all died a hero's death. The monuments erected after the mid-sixth century BC give the ruined citadel a strange and impressive aspect. The acropolis of Xanthus with its well preserved Lycian and Greco-Roman buildings is one of the first and most impressive cities of any surviving from ancient Anatolia. The heroic landscape, with cedar trees and mysterious rock-faces, is like fairyland. It only needs a glimpse of its splendid forests and enchanting shores to understand why so many Greek legends are connected with Lycia. Strange visions that had no explanation at home were best located in neighbouring lands. No country was better fitted for that than the lovely, magically remote and inaccessible realm of the Lycians. Thus arose, for example, the tradition that Tiryns had been built by the Lycian Cyclops or that the story of Bellerophon was originally Lycian. The location of the fabulous chimaera in Lycia is scarcely credible in the light of present knowledge, and the other legends and myths of the cult of Apollo contradict the findings of modern archaeology and philology.

Only future investigation can discover whether a grain of truth lies behind these legendary accounts. Even the 'fact' recounted by Herodotus and Nicholas of Damascus that the Lycians were matriarchal is unsupported either by inscriptions or by figural representations. The monuments do show, however, that women had a high status among the Lycians, as they did among the Hittites. Two tombs of the fourth century BC in Limyra each show a married couple: the man on the left and the woman on the right, on either side of the door. Similarly opposed couples often appear in Lycian art. Gerhart Rodenwaldt has already drawn attention to this Lycian motif, to which we have attributed a Hittite origin. The equal status the Lycians afforded a wife in relation to her husband may be the relic of an earlier phase when they took their names from the mother, who left her inheritance to her daughters (not her sons), and when women were more honoured than men.

1 Hattian cult statuette: stag with twelve-branched antlers, bronze, Alacahüyük, 2300–100 BC. Archaeological Museum, Ankara.

2 Hattian cult standard, bronze, Alacahüyük, 2300–100 BC. Archaeological Museum, Ankara.

3 Hattian cult statuette, bronze, Alacahüyük, 2300–100 BC. Archaeological Museum, Ankara.

4 Hattian cult statuette: bull, bronze with electrum, 2300–100 BC. Archaeological Museum, Ankara.

5 Ewer with spout, gold, Alacahüyük, 2300–100 BC. Archaeological Museum, Ankara.

6 Ewer with spout, clay, Kültepe, 18th cen. BC. Archaeological Museum, Ankara.

7 The great temple of the Weather god and the Sun goddess of Arinna, Hattusas (Boğazköy), 13th cen. BC.

8 Rock shrine of Yazılıkaya near Boğazköy: *centre left,* the Weather god; *on the right facing him,* the Sun goddess of Arinna, 1250–20 BC.

9 Orthostat relief from the city walls of Alacahüyük: king and queen making an offering to a bull, 14th cen. BC. Archaeological Museum, Ankara.

10 Urartian relief, Adilcevaz, 8th cen. BC. Archaeological Museum, Ankara.

11 Statue of King Tarhunza in Assyrian style, limestone, Malatya, late 8th cen. BC. Archaeological Museum, Ankara.

12 Phrygian ewer, Gordion, *c.* 700 BC. Archaeological Museum, Ankara.

13 Head of a youth, Samos, marble, *c.* 500 BC. Archaeological Museum, Istanbul.

14 Temple of Artemis, Sardis: general view. The *naos* is from the first half of the 3rd cen. BC; the unfinished ring of 8 by 20 columns is from *c.* AD 150.

15 Temple of Artemis, Sardis: capital of the perfectly preserved corner column, *c.* AD 150.

16 Temple of Athena, Priene; Ionic *peripteros* of 6 by 11 columns, *c.* 350 BC.

17 Temple of Zeus, Olba near Silifke (southern Anatolia): Corinthian *dipteros* of 6 by 12 columns, 3rd cen. BC.

18 Temple of Zeus, Olba near Silifke (southern Anatolia): Corinthian capital, 3rd cen. BC.

19 Temple of Apollo, Didyma: Ionic *dipteros* of 10 by 21 columns. The oracle room and the *naiskos* (baldaquin) inside the open cella are from the early 3rd cen. BC; the walls of the cella and the 3 erect columns are from *c.* 200–150 BC.

20 Detail from Alexander the Great's sarcophagus, late 4th cen. BC. Archaeological Museum, Istanbul.

21 Head of the statue of Alexander from Magnesia on the Sipylos, *c.* 150 BC. Archaeological Museum, Istanbul.

22 Statue of Zeus, Pergamon, first half of the 2nd cen. BC. Archaeological Museum, Istanbul.

23 Standing figure of Baebia in Hellenistic style. Archaeological Museum, Istanbul.

24 Temple of Zeus, Aizanoi near Kütahya: view from the west. Ionic pseudo-*dipteros* of 8 by 15 columns, Hadrianic period (AD 117–38).

25 Temple of Zeus, Aizanoi near Kütahya: view from the south into the *opisthodomos,* Hadrianic period (AD 117–38).

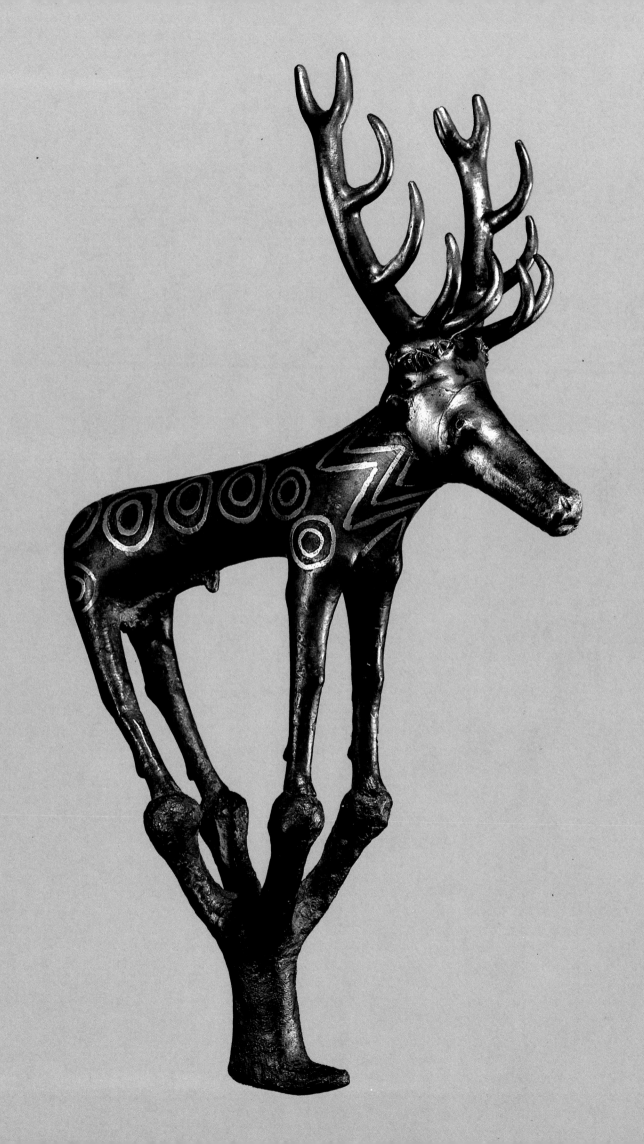

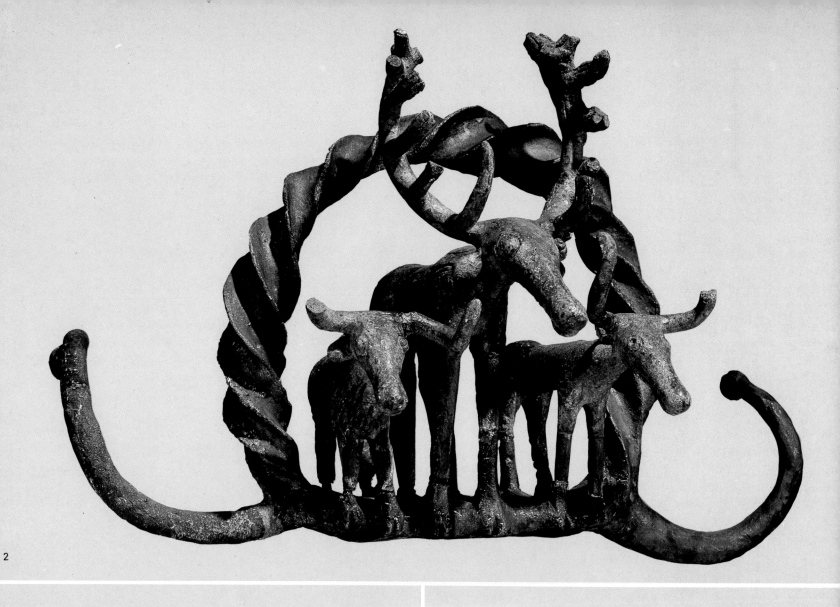

2

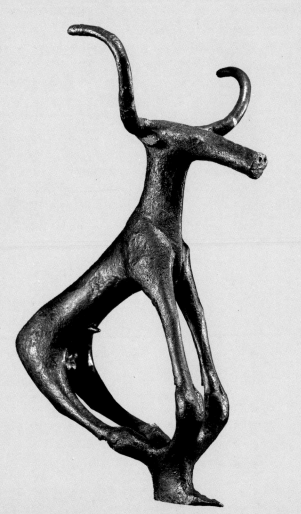

3

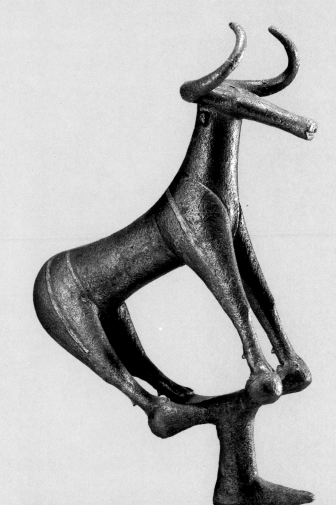

4

5

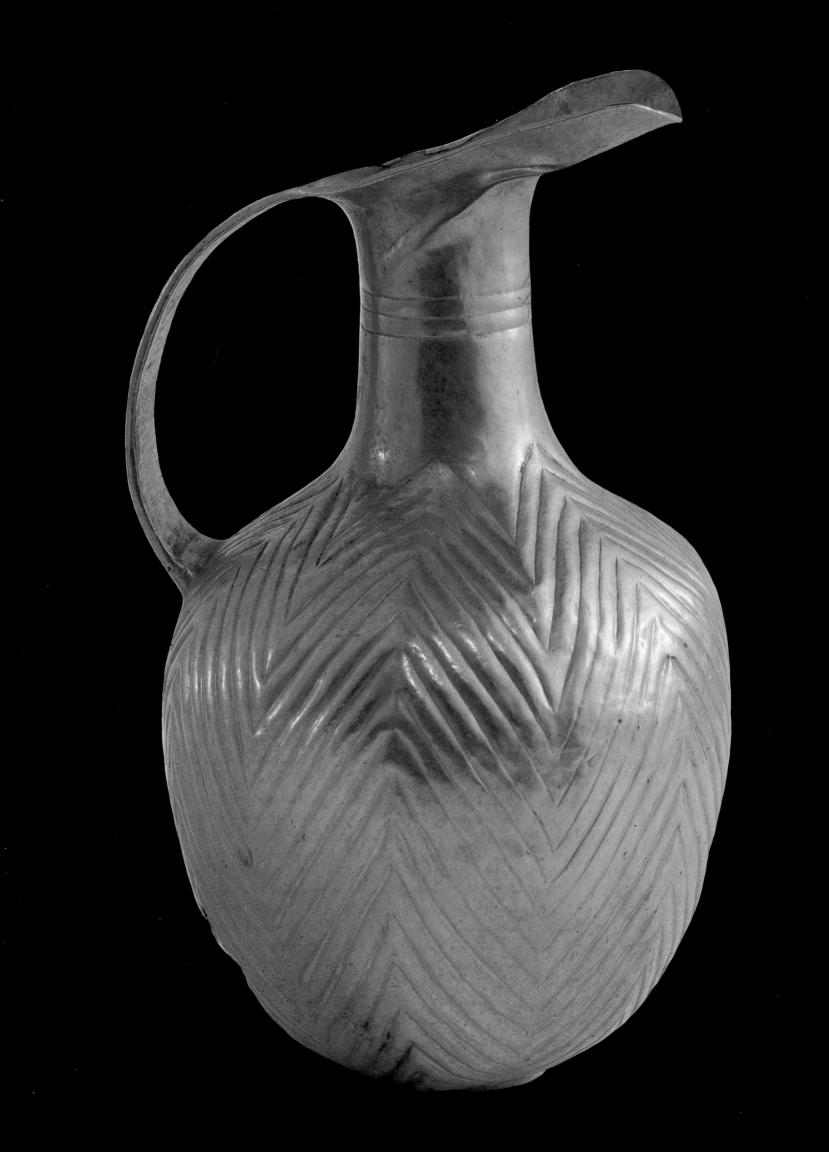

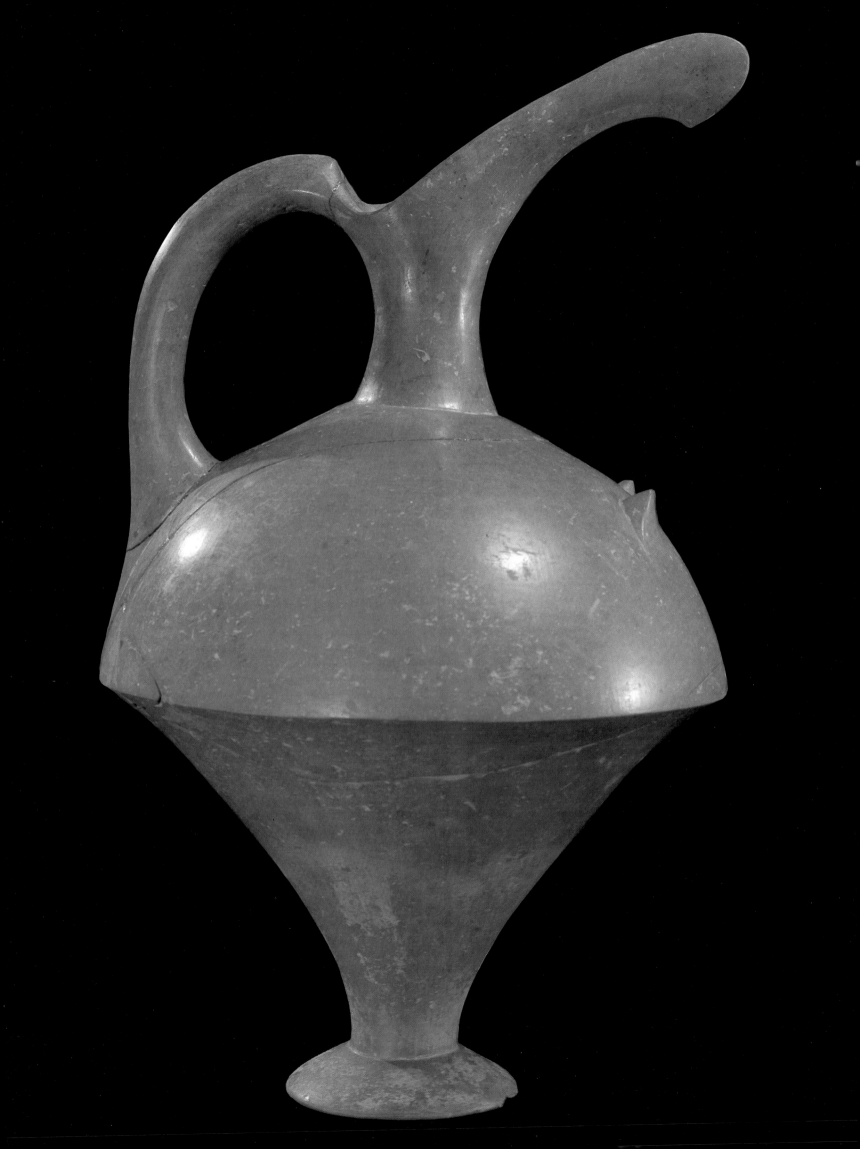

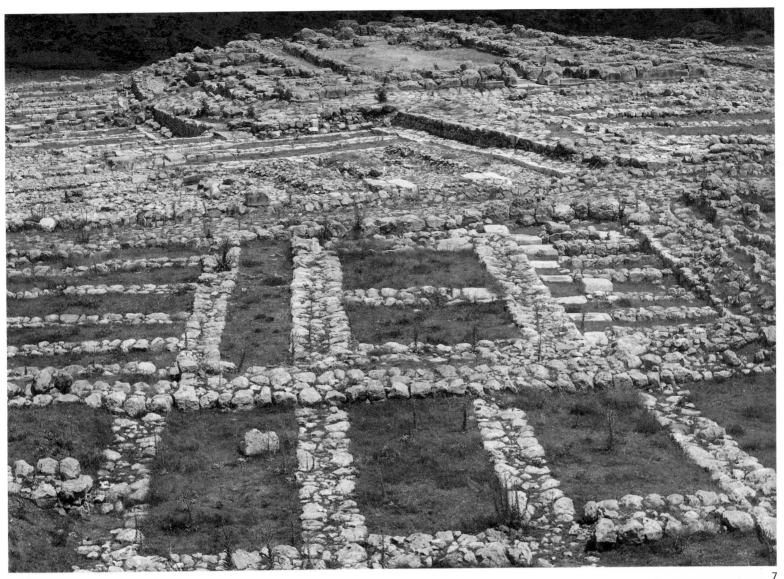

7

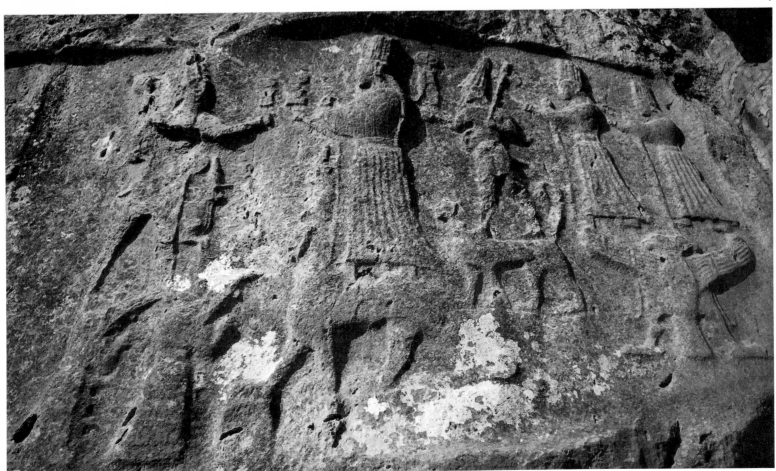

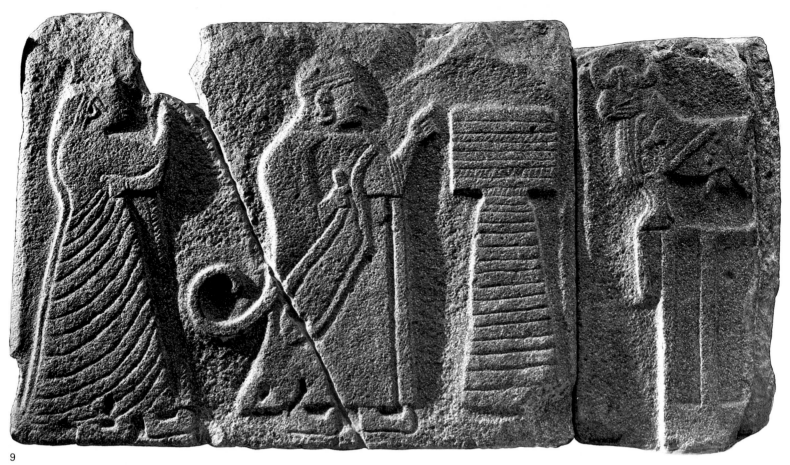

9

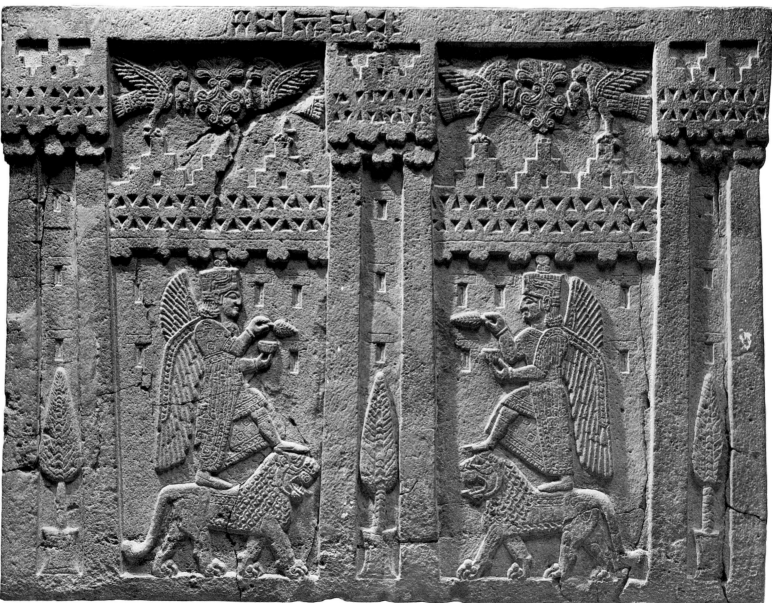

10

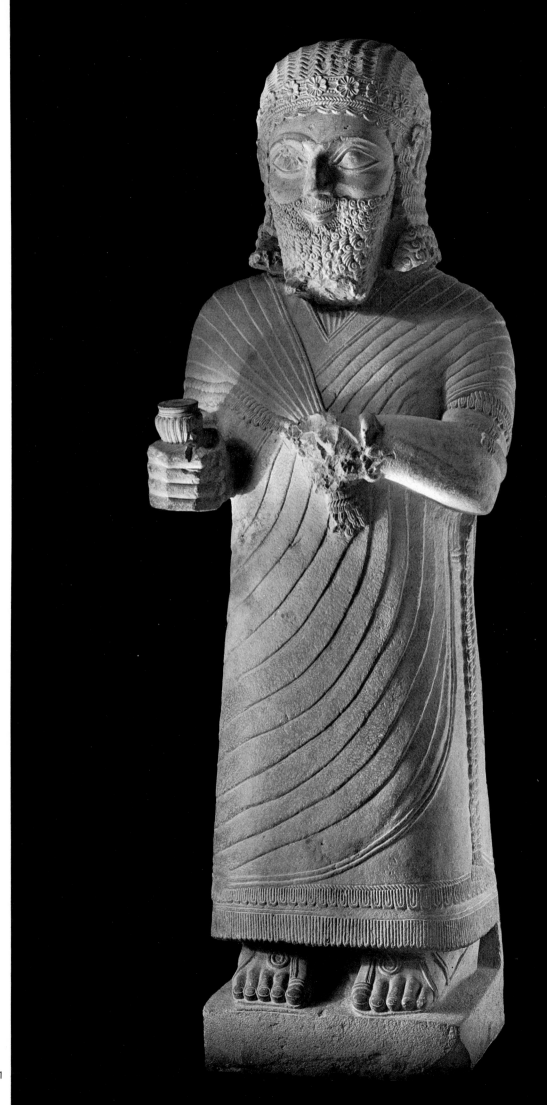

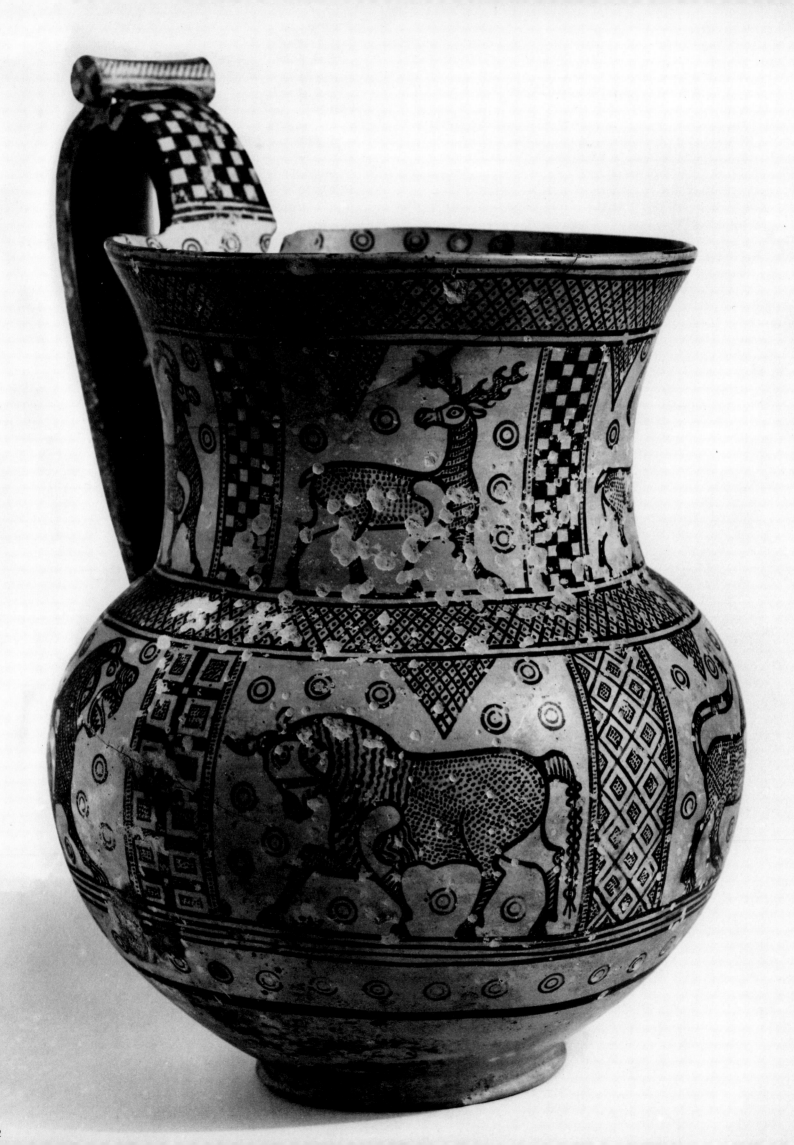

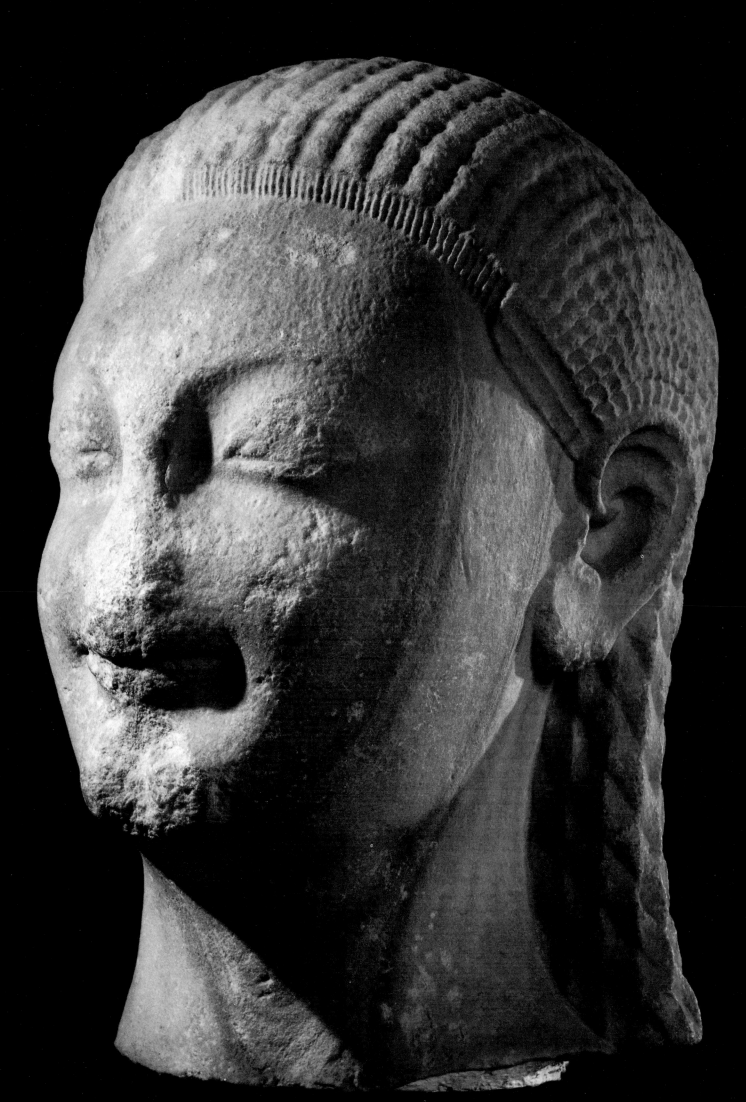

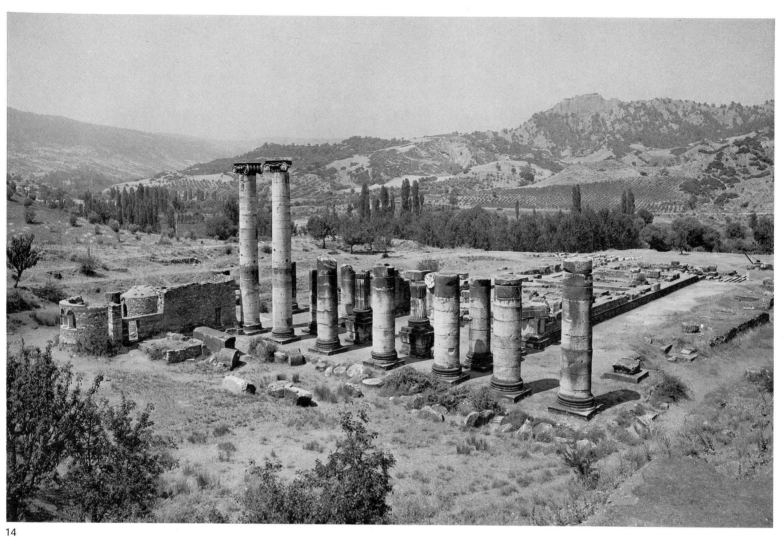

14

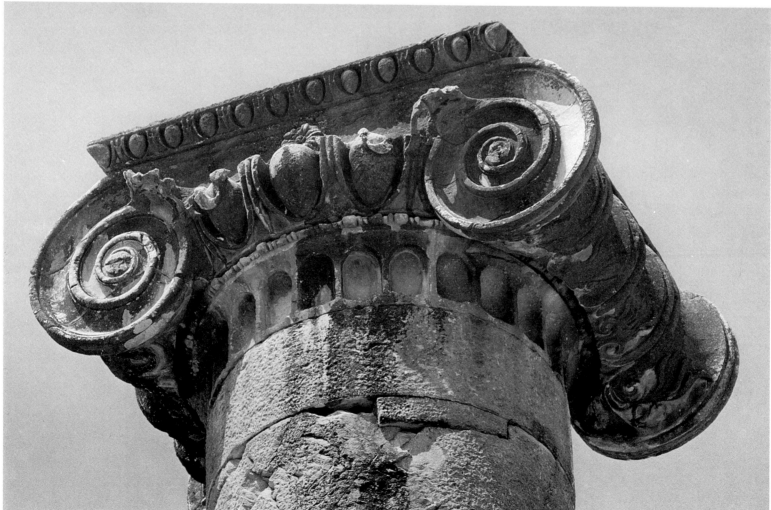

15

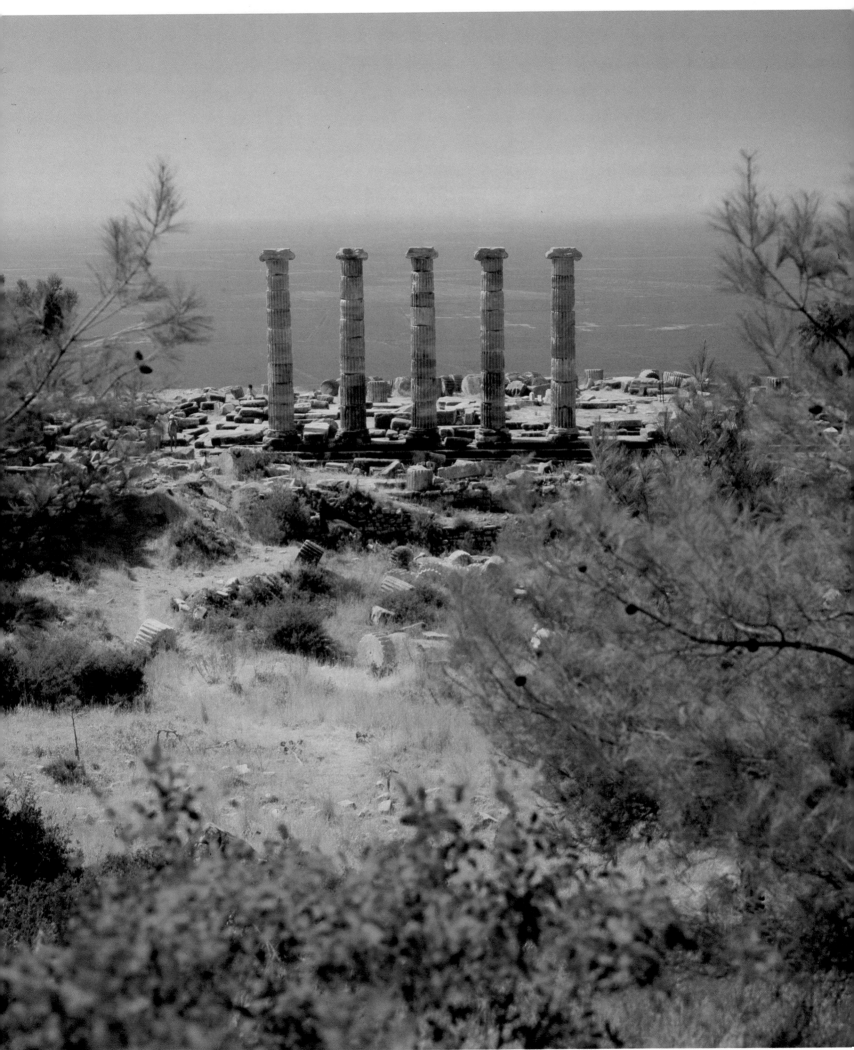

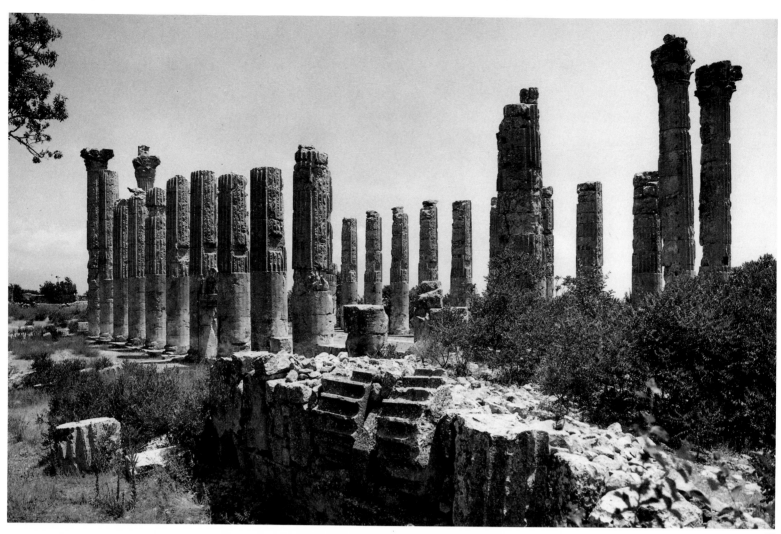

17

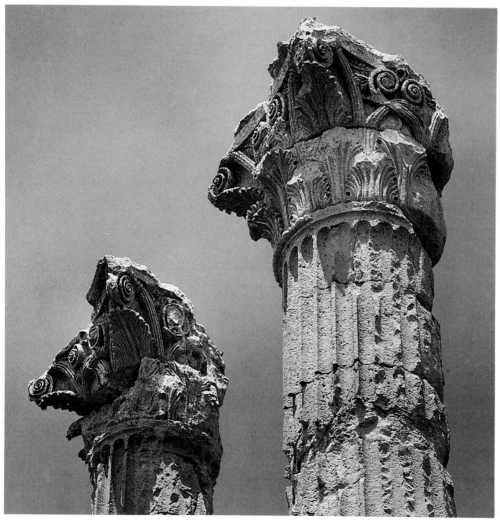

18

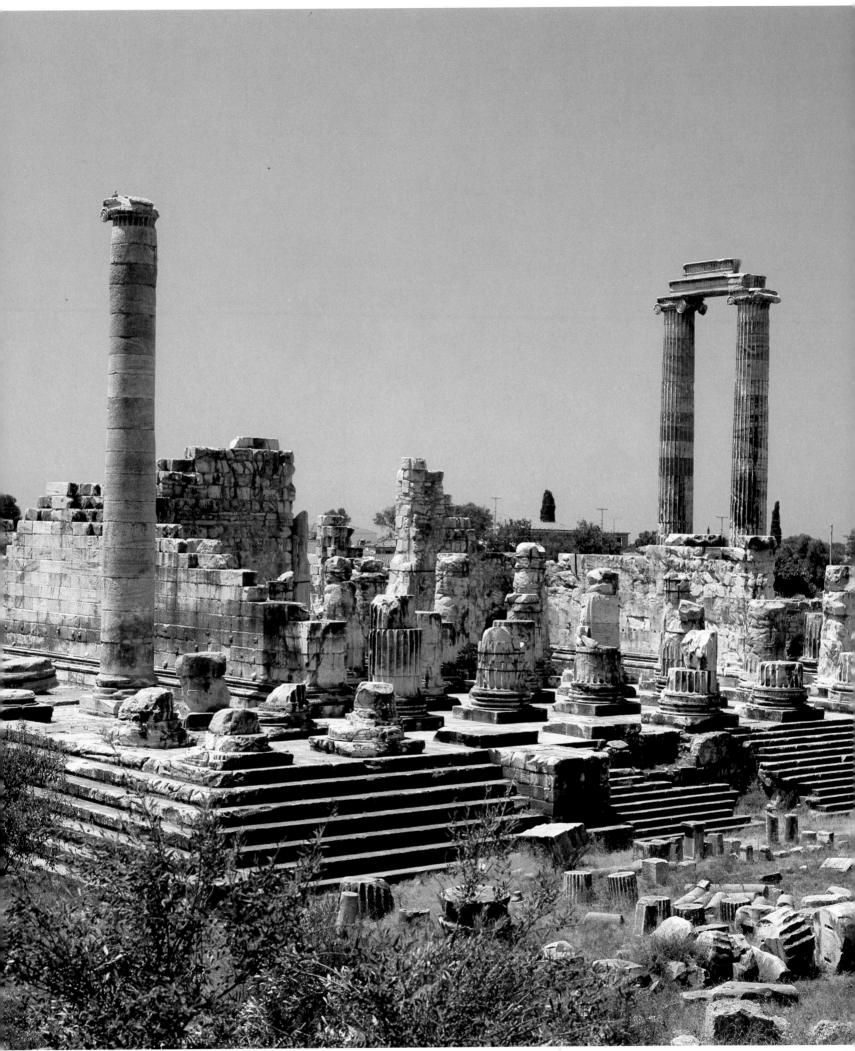

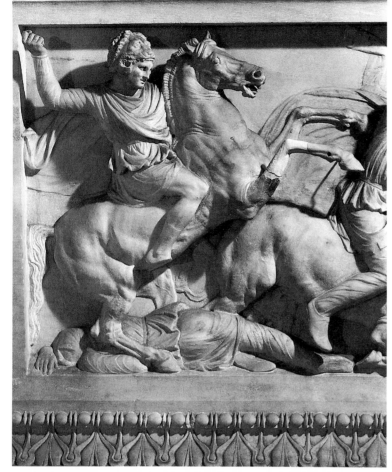

20

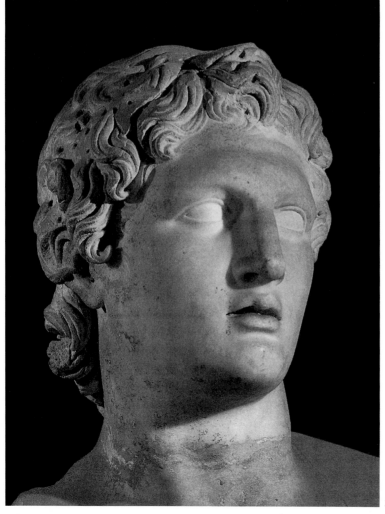

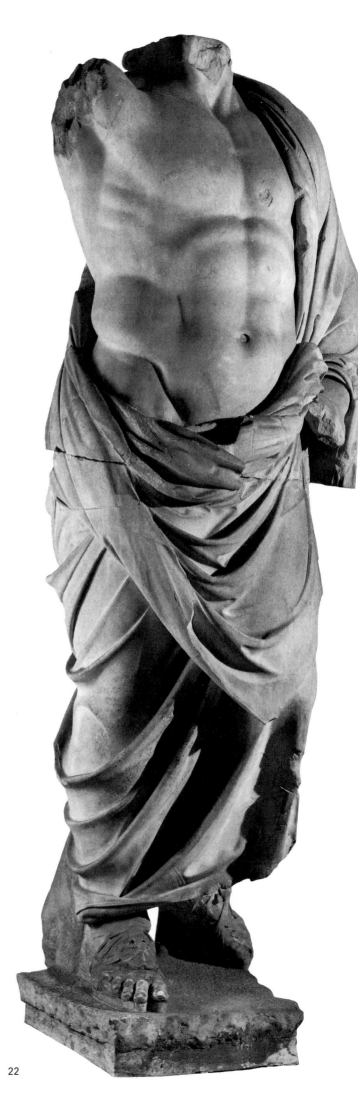

21 22

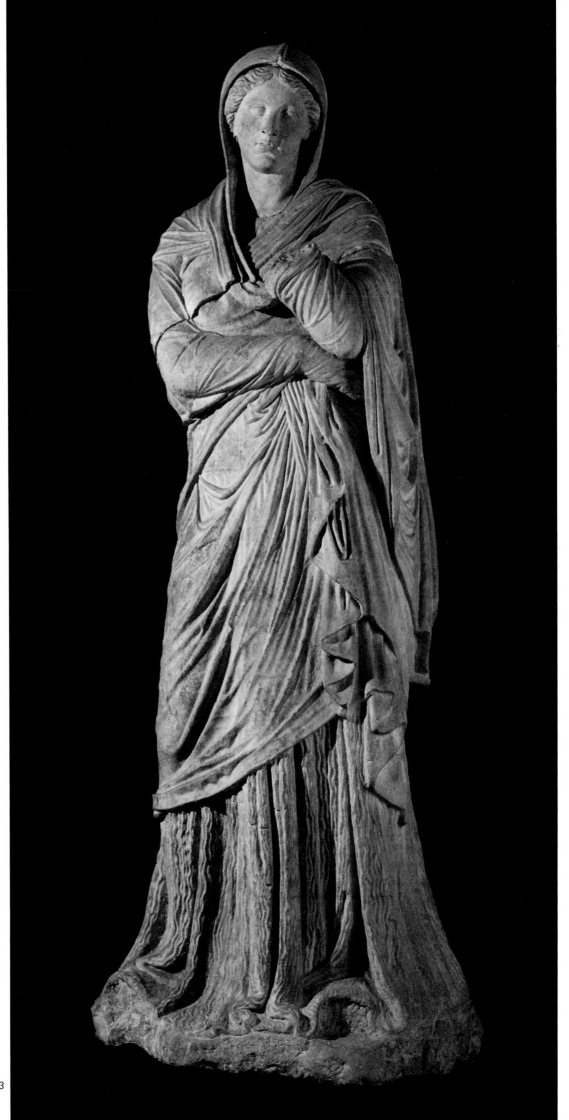

23

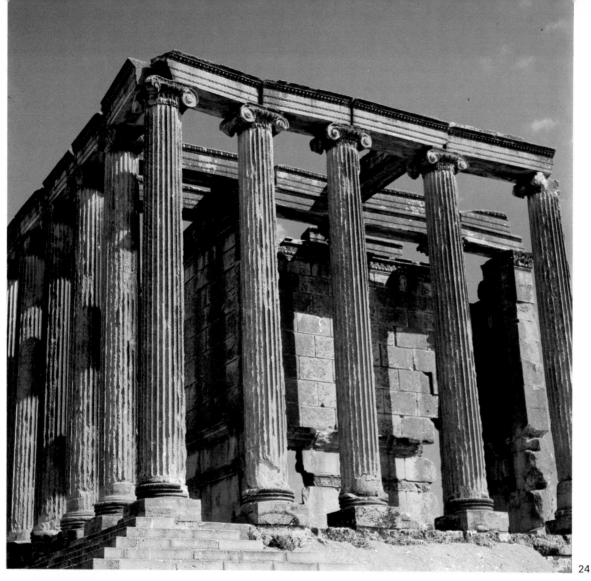

24

25

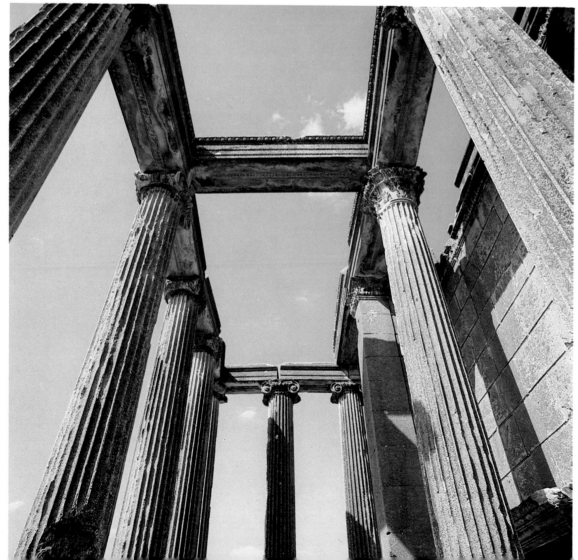

Anatolia under the Persians (546–334 BC)

Anatolia was Persian for more than two centuries, from the conquest of the Lydian Empire by Cyrus (546 BC) until Alexander the Great crossed the Dardanelles (334 BC).[18] In this period the Achaemenid Empire assumed the heritage of the ancient Mesopotamian cultures as the only great power in the east. Its policy is reported briefly, but clearly, by Herodotus: 'The Persians consider Asia and all the barbarian peoples living there, as theirs. Europe and the land of the Hellenes, however, they treat as a foreign land.' He also observes that they counted western Asia Minor within their confines: 'the Hellenes assembled a powerful fleet on behalf of the woman of Lakedaimon, crossed to Asia and destroyed the power of Priam.'

The Persians were the first Asian people to attempt the conquest of the western world by a systematic policy of expansion, and Anatolia was the first stage. The Median King Kyaxares penetrated into the heart of Anatolia and waged a battle in 585 BC, on the River Halys, against the Lydian King Alyattes which resulted in the River Halys being established as the frontier of the two realms. Cyrus, the founder of the Persian Empire, conquered Sardis (546 BC) and defeated the Greeks of Asia Minor.

In pursuance of their plans, the Persians built military roads across Anatolia. These were the first permanent roads of the peninsula, built for strategic purposes, but used for trade as well. The main route, called the 'royal road', began (as Herodotus describes in detail) on the west coast of Asia Minor in Ephesus, went by Sardis through Lydia, and by Gordion and Ankara through Phrygia. After Phrygia it came to the River Halys, where the crossing was protected by a gate. Thence it ran through Cappadocia and the Cilician gates over the River Euphrates, crossed the River Tigris and led through Assyria to Susa. The journey from Ephesus to Susa lasted 93 days.

The roads were built with great skill and situated along them were royal post stations with fine hostels. Herodotus gives these interesting details: 'There is nothing swifter than these messengers, they have organized their service so cleverly. Special horses and men are appointed for each day of the whole journey. From day to day a new horse and messengers is ready; they are not held back by snow or rain, by the heat of the day or by night, from covering their appointed distance at full speed. The first express messenger gives the news to the second, the second to the third. So it goes from hand to hand like the torches at the feast held by the Hellenes to honour Hephaistos.' (From another passage in Herodotus we learn that private letters were censored by the 'postmasters'.) These roads, leading through secure countryside with perpetual military protection, made it possible for Anatolia, for the first time in its history, to play the role of intermediary between east and west, of bridge between Asia and Europe.

The Persian conquest caused the gradual decline of the distinctive Ionian culture. Asia Minor had played a leading part in many spheres of culture within the Hellenic world during the seventh and sixth centuries BC, but it now faded into the background. Only a few provinces, governed by vigorous satraps, managed to take nourishment from ancient sources and create important works. But even these, in comparison with what Ionia had produced in the sixth century BC, were only imitations of Attic models and not independent. Their charm lay in what was native Anatolian in character.

The Period of Greco-Anatolian Civilization (1050–30 BC)

After Troy, and then Hattusas (the capital of the Hittite Empire) had fallen in the early twelfth century BC, the peninsula of Asia Minor stood wide open. Since the late Bronze Age, the Greeks had been founding trading colonies in the south-west, and very probably they also were responsible for the foundation of the Kingdom of Ahhijawa; now they could begin the final colonization of the coastal regions. Around the middle of the eleventh century BC, the Aeolian cities and later the Ionian cities were founded.[19]

The first Greek cities in Asia Minor (1050–750 BC) sustained themselves by agriculture and were simple, primitive settlements. The houses consisted of a single room. In the Homeric period (750–700 BC), the Greek cities began their cultural ascent. The greatest achievement of this period was the development of Homeric poetry. Miletus and Ephesus were the most important centres where works of art were imported from the Levant and a new original culture began to take shape. In Smyrna and Erythrea too, both oriental and Greek products of the first rank have been excavated. The full flowering of the Greek cities of Anatolia did not occur, however, until the Milesians began to found colonies on the coasts of the Mediterranean and the Black Seas, about the middle of the seventh century BC. Trade and increased production brought to Anatolia prosperity that grew throughout the sixth century BC.

Ionian culture arose from the combination of the Greek way of life with that of their Phrygian, Lydian and Carian neighbours. With the aid of the manifold oriental influences abroad at the period, Ionian culture succeeded not only in producing a superlative poetic tradition and important visual arts but also in founding the exact sciences and philosophy that have provided the basis for later western culture.

The natural philosophers Thales, Anaximandros and Anaximenes, who lived in Miletus during the first half of the sixth century BC, are the virtual founders of philosophy and the exact sciences. A large number of the theorems of elementary geometry go back to Thales. He was able, by using observations made in Mesopotamia, to predict the total eclipse of the sun that occurred on 28 May 585 BC. This was the first scientific prediction in history. Anaximandros was the first philosopher to write a book on philosophy and to develop a scientific cosmogony from the ancient poetical creation myth.

Ionian art, like the poetry of the Aeolian and Ionian tradition, brought the Greek motherland under its spell.

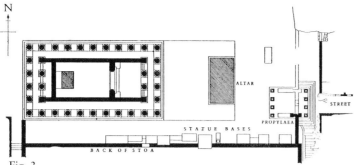

Fig. 3

Plan of the Temple of Athena, Priene, *c.* 350 BC: Ionic *peripteros* of 6 by 11 columns.

The new elements in Attic sculpture of the second half of the sixth century BC, the chiton, the diagonally slanting cloak, the rendering of drapery and the radiant joyous expression of the face are all peculiar to Ionian art.

Pl. 13 The magnificent head of a youth in the Istanbul Archaeological Museum is a splendid example of Ionian sculpture. The fragments of the rest of the figure were discovered in the museum on Samos fifteen years ago. The rounded soft modelling gives a typical Ionian look to the head. The numerous planes of the face make a felicitous contrast with the schematic treatment of the hair. Almond-shaped eyes and the sensuous modelling of the mouth with its enigmatic smile give an exotic expression to the face. The head is a fine portrayal of a self-confident man, a leader or a prince, perhaps even a tyrant.

The beauty and grace of Ionian artistic expression are particularly present in architecture. The grand temples of the mid-sixth century BC in Ephesus and Didyma are far superior in size and splendour to those in Greece. The first monumental sanctuary ever to have been built entirely of marble was the Temple of Artemis in Ephesus, and its dimensions were 55 by 115 metres.

The Ionian style had a second flowering in the fourth century BC, producing such important works as the Nereid monument in Xanthus (*c.* 400 BC), the Mausoleion of Halikarnassos (*c.* 350 BC) and the Temple of
Pl. 16 Athena (*c.* 356 BC) in Priene. The latter was built by the great architect Pytheos and was the exemplar of the late
Fig. 3 classical style of Ionian architecture. The Temple of Athena was a *peripteros* of 6 by 11 columns. The proportions of the temple are clearly and simply related: the module is the Attic foot of 0.295 metres; the whole temple measures 100 Attic feet, the cella 50 feet, the anteroom 30. The height on the long side of the temple was 50 Attic feet, with columns 43 feet high and entablatures seven feet high. The columns were exactly ten times the height of their diameter at the foot.

The Hellenistic Period (323–30 BC)

When Alexander the Great crossed the Dardanelles in 334 BC, a new period of Greek culture began, which was to prove significant world wide and not for the Hellenic peoples alone. This period (323–30 BC) ending with Augustus, was given the name Hellenistic by Droysen. Greek culture now spread into Asia and Africa.

Alexander the Great's cultural policy was one of respect for oriental points of view, but the result was syncretic. The fusion of the oriental spirit with Greek civilization created a world culture that had a Greek aspect, though the inner essence was oriental. Alexander the Great, when in Egypt, was hailed as son of the god Amon. In Persia he introduced Persian clothes and prostration into his court. In the end, this compromise between two radically different attitudes brought about the triumph of oriental religions in Europe.

In Anatolia, where the basis of Hellenic culture was strong and sound, Hellenism found a fertile field for development. Under the aegis of Anatolian-Ionian civilization, there arose a culture whose creations are still impressed deeply on the consciousness of mankind. From this period date the standing remains of the two most important Greek temples of Anatolia – the Temple of Artemis at Sardis and the Temple of Apollo at Didyma. The Temple of Artemis[20] was begun about 300 BC and Pl. 14 underwent two further building phases in the Hellenistic period. The photograph shown gives a general view from the north-east. The *naos*, of which only the outlines exist, was part of the first building phase in the first half of the third century BC. The well-preserved columns of the east façade were erected in the third phase, about 150 BC. The Ionian capital of the corner column is Roman, while the Pl. 15 capital of the other complete column is of the second phase, i. e. of the second quarter of the second century BC (175–50 BC). This temple was a westward-orientated Fig. 4 pseudo-*dipteros*, 23 by 67.5 metres in size, with sides 8 by 20 columns.

The imposing Temple of Apollo at Didyma[21] was built Pl. 19 later in the Hellenistic period than the one at Ephesus. It measures 51.13 by 109.34 metres and was a *dipteros* of Fig. 5 10 by 21 columns. The oracle room and the *naiskos* within the open cella are of the early third century BC. The walls of the cella and the three upright columns are of the first half of the second century BC.

The ruins of the first Corinthian temple stand impres- Pl. 17 sively on Anatolian soil; this is in Olba,[22] north of Silifke on the south coast. The building, a *dipteros* of 6 by 12 columns, is dedicated to Zeus Olbios. The splendid Corinthian capitals are of an archaic type, so the temple Pl. 18 was probably built in the third century BC.

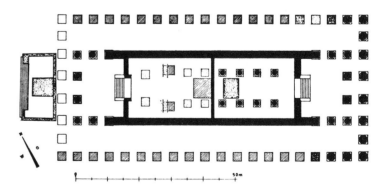

Fig. 4

Plan of the Temple of Artemis, Sardis: pseudo-*dipteros* of 8 by 20 columns, *naos,* 1st half of the 3rd cen. BC; ring of columns *c.* AD 150.

Two other important buildings of the Hellenistic period are the meeting house at Miletus, its ground plan well-preserved, and the theatre of Priene, which has survived in a remarkable condition. Hermogenes, one of the greatest of Greek architects, who was responsible for a series of extensions and advanced restorations in Ionian architecture, lived and worked in Asia Minor in the second century BC. The temples he built in Magnesia on the Maeander and in Teos are well-preserved.

Pergamon was one of the most important centres of art in the Hellenistic period and, during the reign of Eumenes II (197–59 BC), assumed a leading role in Greek art. Cities like Miletus, Ephesus and Magnesia on the Meander, were also advanced centres of Hellenism and exercised a strong influence on the Romans, especially on their temple architecture. The most important features of the Roman temple—axiality, the emphasis on the façade, the podium and its dominant placing—are all features deriving from the Hellenistic art of Asia Minor.

In sculpture, too, the Anatolian cities held a leading place. All the most important and finest free-standing sculpture and reliefs were carved either in Asia Minor or on the neighbouring islands. The reliefs on the altar of Zeus and the Gallic group, as well as the Aphrodite of Melos (Venus de Milo) and the Nike (Winged Victory) of Samothrace are among the best known examples.

Pl. 20 The so-called sarcophagus of Alexander[23] of the late fourth century BC, now in the Istanbul Archaeological Museum, is classical both in form and content. The master who produced this splendid piece was not a famous artist; although he was no pioneer, the work he produced is nonetheless an outstanding work of art. The artist was an excellent craftsman with a rather old-fashioned style that had been current in the mid-fourth century BC. His figures are well proportioned, their poses and movement are graceful and balanced, and the composition is free and pleasantly symmetrical. His animal figures, particularly his horses, are outstanding.

Pl. 21 The Pergamon school of sculpture includes a free-standing full figure of Alexander, from the mid-second century BC, the head of which is illustrated here. It was found in Magnesia on the Sipylos and is preserved in the Istanbul Archaeological Museum. An inscription found in the same place as the statue reads: 'Menas of Pergamon, son of Aias, made [it]'. Alexander is seen in more or less the same pose as the statue of Zeus in the Istanbul Archaeological Museum. The thick hair was bound with a metal wreath, as is shown by the row of drill holes round the head. It must have been a laurel wreath, since Alexander seems to be represented here as the god Apollo; the highly idealized features also reinforce this conjecture. As is seen on the herm by Lysippos in Paris, Alexander had an individual hair style: at the front his hair stood up like a lion's mane and fell down symmetrically on either side of his head. We find the same hair arrangement in the lovely head of Alexander from Pergamon. The smooth, peaceful, facial features and the measured pathos of the eyes are fitting for the divine character of the ruler.

Pl. 22 The statue of Zeus in the Istanbul Archaeological Museum, which probably represents Attalos II of Perga-

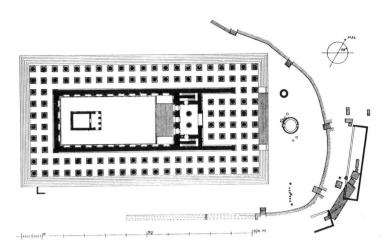

Fig. 5
Plan of the Temple of Apollo, Didyma: *dipteros* of 10 by 21 columns. The *pronaos*, the oracle room with 2 columns and the *naiskos* inside the open cella were built in the early 3rd cen. BC; the inner row of *peristasis* columns and the upper parts of the walls of the cella (with friezes of griffins) date from the 1st half of the 2nd cen. BC; the pilaster capitals of the *pronaos* go back to the 1st half of the 2nd cen. BC, while the outer ring of columns is no earlier than the 2nd cen. AD.

mon as Zeus, comes from the temple of Hera Basileia in Pergamon;[24] like the temple in which it stood, it dates from the first half of the second century BC. Typologically it belongs with the group of half-clothed male figures of Hellenistic art, of which other examples are the standing figure of Poseidon from Melos in the National Museum of Athens and the statue of Alexander the Great in the Pl. 21 Istanbul Archaeological Museum.[25]

The standing figure of Baebia[26] in the Istanbul Pl. 23 Archaeological Museum is one of the loveliest draped statues of Hellenistic art. The pose and the composition of the drapery folds show a brilliant adaptation of fourth-century BC models. The rather dry facial expression, however, is more in the style of the lifeless faces of Roman copies of Greek originals. The statue is dated through its inscription to the year 62 BC.[27]

Roman Art (30 BC–AD 395)

The Greek tradition continued in Anatolia, almost without a break, into the Roman period, so that it is the architecture of this period in Asia Minor that particularly shows originality. The techniques and engineering employed at that time are, however, wholly Roman in character.[28] The Hellenistic architects, even in great cities like Pergamon, often restricted their use of marble solely to decorated elements and contented themselves with volcanic rock (trachyte) for the rest of their monuments. In the Roman period, marble became ubiquitous as a building material. For large utilitarian buildings, a new material was invented: brick bound with mortar and covered by a facing of marble panels.

Large buildings were now no longer erected by terracing and levelling the terrain on foundations of masonry blocks but on substructures with barrel or groin vaults.

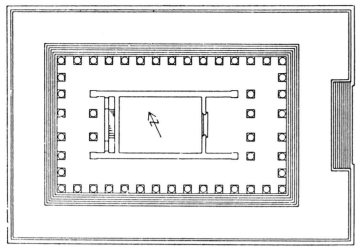

Fig. 6

Plan of the Temple of Zeus, Aizanoi near Kütahya. The *naos* has a *pronaos* with 4 columns in front and a narrow *opisthodomos* with 2 columns at the rear; the capitals of both *pronaos* and *opisthodomos* are composite. The *naos* is surrounded by 8 by 15 Ionic columns arranged as a pseudo-*dipteros*, Hadrianic period (AD 117–38).

Thus, in the Roman period, even theatres were no longer built into the hill side—as had always been the case in the Greek period—but were raised over arcades and barrel-vaulted foundations. The majority of Anatolian architects preferred to continue building their theatres into hillsides, however. It is significant that the theatre at Aspendos lies against the hill side, even though its auditorium is supported completely on arcades and vaults: the builder clearly made a point of adhering to the ancient tradition of placing a theatre against a hill. For the rest, the Anatolian theatres followed Roman models. Even the Hellenistic-period theatres, such as Pergamon and Ephesus, were altered for the new fashion.

The invention of central heating in Rome (about 80 BC), with warm air heating the floor from below and the walls through hollow bricks, led to the construction of gigantic thermae. Large theatres, often combined with a gymnasium, were set up in every city of Asia Minor. The best preserved examples are the Vedius gymnasium in Ephesus and the thermae at Side, which now serve as a museum. Other works of engineering for public use are the great stone bridges and aqueducts. Very few examples of Greek bridges have survived, the best preserved being the stone bridge in Pergamon. Compared with the splendid examples of the Roman period, it is a modest affair. Aqueducts are an entirely Roman invention. One of the finest and earliest aqueducts in Asia Minor is preserved in Ephesus outside the city on the road to Aydın. The amphitheatre—another purely Roman creation—was less widespread in Anatolia; the animal fights and gladiatorial games, for which these were built, were inherently alien to the Greeks. No surviving amphitheatre in Anatolia is well-preserved. The celebrated Roman triumphal arch (more correctly described as an arch of honour) is not represented in Anatolia. On the other hand, city gates were popular in Asia Minor in the Roman period, this type of building being originally of Hellenistic tradition.

The richly articulated monumental façades of market gateways, libraries, fountains and stage walls form a distinguishing feature of the architecture of the Roman period that had its precursors in Hellenism. This type of composition which makes use of elements like columns, gables and niches in projecting and receding planes is purely Roman. Particularly characteristic of Roman art are symmetrically alternating round, pointed or rounded half-pediments between faceted niches and semicircular conches. This fracturing of architectural members is a new concept of Roman art, born of efforts to develop new ideas from Greek architecture. The most important Roman transformation of the original Greek columnar architecture can be seen in the way the strongly horizontal emphasis of Hellenistic façades is replaced in the Roman period by vertical articulations.

One of the great innovations of Roman architecture is the combination of the arch and arcading into a very effective element. Arcading gives an entirely new and original aspect to the exterior of a building. Its main contribution, as on the theatre at Aspendos, was to relieve the monotony of façades. On the whole the Anatolian architects were sparing in their use of these innovations. They preferred niches and horizontal architraves over columns to arcading. In spite of the obviously strong Roman influence, the market gate of Miletus and the stage wall of the theatre at Aspendos remained faithful to the native taste for horizontal and gable-shaped terminals and pediments. Yet the arch as a solution for a gate leading to a market may well have been the invention of Asia Minor: the arch of the market gate at Priene, the arched gate of a hall in Sillyon and the double gate to the theatre terrace at Pergamon seem indeed to represent the first attempts. The Gate of Hadrian in Athens is probably linked with these Hellenistic solutions.

The Roman engineers built magnificently by covering interior spaces with barrel vaults or domes. The Pantheon in Rome is a peak in the architecture of the ancient world. The Temple of Asklepios in Pergamon, which has a cylindrical lower storey like the Pantheon, is doubtless an imitation of the great Roman model. Colonnaded streets are also a remarkable invention of Roman architecture. They signify a great advance in city planning and lend a dignity and stateliness to city life. Several Anatolian cities acquired grandiose colonnades, whose ruins still impress us today.

The Greco-Anatolian temples of the Roman period remained in the local tradition; they adopted nothing of Roman art into the layout or ordering of space. They are so dependent on Hellenistic models that it is often extremely difficult to distinguish between the Hellenistic and Roman period. This is the case with the Temple of Athena in Ilium and the shrine of Roma and Augustus in Ankara.

The Temple of Zeus at Aizanoi near Kütahya is one of Pl. 24 the best-preserved monuments of the Roman period in Asia Minor.[29] The *naos* has a *pronaos* with four columns Fig. 6 along its front and a narrow *opisthodomos* with two columns at the rear. Both the columns of the *pronaos* and of the *opisthodomos* have composite capitals. The Pl. 25 podium has 11 steps and is 2.86 metres high, with an area

of 35.48 by 53.28 metres. The *naos* is surrounded by 8 by 15 columns in pseudo-*dipteral* arrangement. The temple was built in the reign of Hadrian (AD 117–38).

The Anatolian cities of the Roman period, with their impressive colonnades and splendid market halls, council chambers, gymnasia, palaces, thermae, theatres, stadia and aqueducts, are among the most important urban achievements of their period. It can be said with little fear of contradiction that Anatolia kept pace with Rome. The sculpture of Asia Minor also developed splendidly in Roman times; there were schools of sculpture active in Aphrodisias, Tralles, Ephesus, Pergamon and Side, which produced work that is considered to be among the best and finest of the Roman period.

NOTES

[1] James Mellaart, *Earliest Civilizations of the Near East*, London, 1965, pp. 77–118; James Mellaart, *Çatal Hüyük: A Neolithic Town in Anatolia*, London, 1967; U. Bahadır Alkım, *Anatolia I*, Geneva, 1968.

[2] Mellaart, *Çatal Hüyük*, p. 188.

[3] Mellaart, *Çatal Hüyük*, pp. 208, 210.

[4] C. W. Blegen, *Troy and Trojans*, London and New York, 1963.

[5] Ekrem Akurgal, *Die Kunst der Hethiter*, Munich, 1961, pp. 7–18.

[6] Akurgal, *Hethiter*, pp. 54–5.

[7] Akurgal, *Hethiter*, pp. 18–89; see also, Kurt Bittel, *Les Hittites*, Paris, 1976.

[8] Akurgal, *Hethiter*, p. 30.

[9] Akurgal, *Hethiter*, pp. 54–8.

[10] Ekrem Akurgal, *Ancient Civilizations and Ruins of Turkey*, 4th ed., Istanbul, 1978, p. 60.

[11] Akurgal, *Turkey*, pp. 59–60.

[12] Ekrem Akurgal, *Die späthethitische Bildkunst*, Ankara, 1949; idem, *Orient und Okzident*, Baden-Baden, 1966; W. Orthmann, *Untersuchungen zur späthethitischen Kunst*, Bonn, 1971.

[13] B. B. Piotrovski, *Iskusstvo Urartu* (Urartian Art), Leningrad, 1962; Ekrem Akurgal, *Urartäische und altiranische Kunstzentren*, Ankara, 1968.

[14] Ekrem Akurgal, *Phrygische Kunst*, Ankara, 1955.

[15] Akurgal, *Phrygische*; idem, *Die Kunst Anatoliens*, Berlin, 1961, pp. 70–121.

[16] Akurgal, *Anatoliens*, pp. 150–9.

[17] Akurgal, *Anatoliens*, pp. 122–49.

[18] Akurgal, *Anatoliens*, pp. 167–74.

[19] Akurgal, *Anatoliens*, pp. 175–298.

[20] Gottfried Gruben, *Die Tempel der Griechen*, 2nd ed. Munich, 1976, pp. 394–400; Akurgal, *Turkey*, pp. 127–32.

[21] Gruben, *Griechen*, pp. 365–75; Akurgal, *Turkey*, pp. 225–30.

[22] Akurgal, *Turkey*, pp. 342–3.

[23] Akurgal, *Turkey*, pp. 43–5.

[24] Akurgal, *Turkey*, p. 90.

[25] Akurgal, *Turkey*, pp. 45–6.

[26] Doris Pinkwart, *Antike Plastik*, vol. XII, (ed. F. Eckstein), Berlin, 1973, pp. 149–58.

[27] Pinkwart, *Plastik*, pp. 152, 158.

[28] Bernard Andreae, *L'Art de l'Ancien Rome*, Paris, 1973.

[29] Rudolf Naumann, *Der Zeustempel zu Aizanoi*, Berlin, 1979; Akurgal, *Turkey*, pp. 267–70.

Byzantine Art in Turkey

by Semavi Eyice

Introduction

The eastern part of the immense Roman Empire, divided by the Emperor Theodosius I in AD 395, may be said to have been born under a lucky star; it had a life of a thousand years, spanning the whole of the Middle Ages. To distinguish this eastern half of the Empire, modern historians call it by the name of its capital city, Byzantium (now Istanbul). From the sixth century AD, the Eastern Empire, termed in modern historiography the Byzantine Empire, adopted Greek—the language then current all round the eastern Mediterranean—as its official language, but for long continued to keep alive the traditions and institutions of the vanished Roman Empire: until its collapse in 1453, the Byzantine Empire considered itself the successor of the Roman Empire, and its sovereigns assumed the title of 'Emperor of the Romans'.

Byzantine art arose in the territory of the earlier Roman Empire and included elements inherited from it. Native artistic skills and oriental influences were grafted on to this traditional stock from which flowered the Christian art of the east – Byzantine art; it had a long life. There were a number of local schools with styles differing from each other in varying degrees, and even after the Empire was no more, its influence continued to affect neighbouring peoples. Though the capital, ancient Byzantium, remained a most important artistic centre, Asia Minor was the motive force, forming a natural bridge between Europe and Asia on which one civilization followed another for centuries. The people who lived in Asia Minor though they were not Greeks, became 'Byzantines' by adopting the Christian faith. Their beliefs, like the artistic traditions they had inherited, were not completely obliterated but rather altered and adapted to the new faith and its aspirations. Thus in some regions, especially those remote from the coasts, Byzantine art appears in a local, one might almost say a more original guise, very different from classical Christian art. In this brief review, a concise description will be given of Byzantine art in the capital and within the territory of

modern Turkey. The diversity of styles, the lengthy chronology and extensive geography allow no more than broad generalization about the character of this art.

Byzantine Art in the Capital

On a Spring day, 11 May 330, took place the solemn consecration of a new city that was to occupy the site of ancient Byzantium. The older city on the Bosphorus, on the confines of two continents, had attracted the attention of Constantine the Great for political and social reasons as well as for military and economic ones. As ancient Byzantium was transformed into Constantinople, it rapidly became the centre of a culture that is commonly called 'Byzantine' and characterized by an amalgam of Graeco-Roman art mixed with infiltrations from the civilization of the Near East. This mixture was brought to life by the teaching, needs and aspirations of Christianity. By the beginning of the sixth century, Christianity had gained adherents that it was never to lose. At the inauguration of the new capital, the deities of the pagan religions were properly honoured, but the important event was also marked by Christian ceremonies—the (alleged) Edict of Milan having legitimized them.

Walls

Constantinople soon spread beyond its bounderies, which tradition said had been traced by the hand of Constantine himself, who was inspired by an angel. In less than a century, Theodosius II, the grandson of the Theodosius who had finally divided the Roman Empire in 395, charged the prefect of Constantinople, Anthemios, with the construction of a new wall some kilometres west of the divinely inspired wall of Constantine. This is the Pl. 26 wall, running for over five kilometres, 'from sea to sea' — from the Propontis (now called the Sea of Marmara) to the Golden Horn—that still is admired today. The Byzan-

48

tines were wont to give their capital the epithet *theophylaktos* (city protected by God), believing that the city, guarded by the *Theotokos* (the Mother of God), was safe from all dangers behind the walls and towers of the Theodosian enceinte. Many a time they had seen barbarian hordes and regular armies — the Avar or Sassanian fleets, the Arabs or Bulgarians, Russians or Turks — turn tail before those impregnable walls; just as so many bold usurpers had come to grief in the turbulent history of the Everlasting Empire. Even today the imposing picturesque ruins of these ramparts, breached by the Turkish artillery in 1453 and crumbling with age, surround Istanbul with their crenellated silhouette. Though they were set up with military intent, they are not without aesthetic appeal. The defensive system of these fortifications — a moat and a double wall with projecting towers — repeats on a grander scale the system used by the military architects of the Hittites at their capital, Boğazköy.

The traveller who approached Constantinople by the ancient Egnatian Way encountered the imperial majesty of the city in the form of a white gateway visible from afar. The Golden Gate, very Roman in style, still stands. It is in the form of a triumphal arch with three openings, flanked by two enormous pylons faced with splendid blocks of marble. It is still possible to make out on their polished surface the traces of the acclamations, written in red letters, wishing 'Long life to the Emperor'. It was through this monumental gateway that the emperor made his triumphal entries when returning from successful expeditions, and behind this gate was the main artery of the city, the Mese, which crossed the whole length of Constantinople to the Augusteion — a square bounded by Santa Sophia, the Hippodrome and the entrance to the great Imperial Palace. But the Augusteion was more than a square; it was the centre of the Byzantine world, for here 'the emperor had his palace, the clergy Santa Sophia and the people the Hippodrome.' It was within this triangle that the whole political, social and religious history of the Empire unfolded throughout the centuries.

Public Squares

Like the Augusteion, the other public squares of the Christianized Roman Empire — the Forum Constantini, the Forum Arcadii, the Bovis, the Forum Tauri — together with the colonnaded streets that linked them, have all disappeared. A few isolated monumental columns still stand, however, with occasional vestiges of masonry to mark the vanished sites. The Hooped Column *(Çemberlitaş)* is no other than the colossal porphyritic column of Constantine the Great which adorned the oval forum raised in his honour, and the Maiden Stone *(Kıztaşı)* is the unassuming monument set up by the prefect Tatianus in AD 46 for the Emperor Marcian. The fine Column of the Goths standing on Seraglio Point *(Sarayburnu)* is said, on a defaced inscription, to have been raised during the Roman period in honour of the goddess Fortuna, in memory of a victory over the Goths. The proud monument to Arcadius which once stood at the centre of his forum was demolished in 1711, having been damaged by

fire and worn with age, but its base, though ravaged and burnt, still gives an idea of its huge dimensions. The shaft is seen in a rare drawing preserved in Paris. Like the monument of Marcus Aurelius, or Trajan's Column in Rome, the monument to Arcadius was decorated with a continuous spiral band of reliefs recording the 'high deeds' of the Emperor: deeds which, in fact, have sunk into obscurity. The majesty of imperial Rome is represented, once more, by a triumphal arch (or gate or tetrapylon?) belonging to the Forum Tauri; its remains were brought to light in 1928 and again in 1955.

The Hippodrome of Byzantium was the scene of many a tumult and massacre. Sometimes the booty from successful expeditions was heaped before the public gaze, but on other occasions the mutilated corpse of a fallen emperor would be dragged there in derision. The two sports teams and the supporters of their charioteers held greater power than the political parties of modern times. By 1453 the Hippodrome had vanished, though the remains of the semicircle at one end of the course and three monuments that lined its axis (the Spina round which the chariots careered) still exist: the obelisk of Thutmosis III made of pink granite from far-off Karnak in Egypt, set up under Theodosius I on its present base — a labour lasting 30 (or 32) days — still bears witness to imperial majesty and power. Among the reliefs carved on its marble base the Emperor Theodosius I (379–95) can be identified with his two sons and the Co-emperor Valentinian II watching games, mime and the erection of the obelisk itself. Not far from the obelisk is the bronze Serpent Column from Delphi, cast with the trophies of the victory of Plataeus in 478 won by the confederation of Greeks against the invading Persians and brought to the site by Constantine the Great. The remains of the one surviving head are in the Archaeological Museum. The third monument is the Stone Obelisk, said to have been set up by Emperor Constantine VII Porphyrogenitus in the first half of the tenth century. It lost its bronze sheath during the Latin occupation (1204–61), and its mass of stone contrasts strangely with the inflated style of its inscription comparing it with the famous Colossus of Rhodes and speaking of it as a 'wonder'.

To conjure up a picture of the chariot races and their all-powerful drivers, one has to visit the Archaeological Museum and examine the bases of two monuments raised in honour of the charioteer Porphyrios and his horses. Originally these bases bore statues of Porphyrios, a victorious hero of chariot races in the Hippodrome.

Palaces

The Great Palace of the Byzantine emperors comprised a city that was continually embellished, enlarged and restored from the sixth century to the end of the tenth. Towards the end of the eleventh century, this immense residence was abandoned for another which was built in the north-east, in the ancient quarter of the Blachernae, close to the city walls. Of the Great Palace, where almost all the dramas of the Byzantine court were enacted, there remains a splendid mosaic pavement of a great colon-

Fig. 7

Plan of the foundations of the Palace of Bryas, Istanbul, 1st half of the 9th cen.

naded courtyard. The pavement has a rich border of masks, extraordinary in design and colour, and scrolls issuing from cornucopiae frame a uniform white field, over which seemingly unconnected motifs and scenes with very varied subject matter are scattered. Except for insignificant remains, the only vestige of the imperial residence is a ruined pavilion with arcades on the sea walls. It is now described as the house occupied by the Sassanian prince Hormisdas when he took refuge at the Byzantine court, and by the young Justinian before he acceded to the throne. (He is said to have included it later within the palatine enceinte.) This pavilion consisted of halls running one into the other, with windows opening on to the glistening horizon of the Propontis. A few door frames and capitals with delicate carvings are all that remain of a splendour long departed. At the other end of the city, a

Pl. 27 ruin called the Tekfur Sarayı, the 'Princely Palace', stands as the only — important — representative of the complex of palaces of the Blachernae quarter, where the Byzantine emperors lived from the eleventh century until the end of their Empire. It is a pavilion raised on high to dominate the Golden Horn (Haliç). Though attached to the ramparts and closed in on two sides by massive walls, it has such a sumptuous exterior that it gives no impression of being dominated by fortifications. Strangely enough, this unique specimen of an imperial palace has not yet been identified. It is commonly called the palace of Constantine Porphyrogenitus, but there is no convincing reason for doing so. In spite of later restorations that have left their mark, this pavilion may well be a monument of the eleventh to twelfth centuries, that is to say of the

Comnenian period. It would indeed be satisfactory to see in the pavilion the 'high palace' that Manuel I Comnenus (1143–80) had built on a site designed to dominate the city, the sea, and the open country beyond the walls. The main façade opens on to a courtyard bordered by two walls. Here, the arcades of the double opening on the ground floor and the windows of the two upper floors are framed richly with carved ceramic discs. The friezes marking the storeys, the lunettes and the spandrels of the discharging arches are decorated with harmonious geometric motifs formed by light-coloured ashlar stone blocks and brick.

Of the imperial palace of the Mangana quarter, only the basement survives, giving no indication of the plan of the superstructure.

Recent excavations have brought to light the remains of a few private palaces, those of Lausus and of Antiochus for example. The mosaics discovered during the excavations for the City Hall (Belediya Sarayı) of Istanbul seem to belong to the floor of the palace of Princess Juliana Anicia. She was the patron of the great church of St Polyeucte built in the early sixth century, of which vestiges are close by. Among the palaces of the suburbs, there are remains of the Palace of Bryas, visible Fig. 7 near Bostanci, an Asian suburb of Istanbul. The foundations are impressive, but their plan leaves us in the dark about the design of the superstructure. The building was strikingly like Umayyad and Abbasid palaces, and it is known that Emperor Theophilus (829–42) built it on the model of contemporary Arab palaces.

Aqueducts and Cisterns

The majestic aqueduct of Valens, with its line of arcades extending for 971 metres, is an example of utilitarian architecture. Both in style and in technique it is directly related to the city walls of Theodosius. In earlier times, water collected outside the city ran along several aqueducts that still exist and was carried in underground conduits to the town, where it was first accumulated in enormous reservoirs before being distributed throughout the city. The reservoirs were open to the sky, and three of them are still to be seen. A fourth, which provided water to the Hebdomon quarter, is sited outside the enceinte. It is especially remarkable for the masonry of its walls and for its façade which is reinforced by a series of round-headed niches, an essential factor in counteracting the pressure of the water inside. Conduits outside the enceinte were destroyed in the seventh century, and covered cisterns increased in importance. These were built in large numbers and were also used as esplanades or as terraces for buildings of some importance. Among these underground structures, the famous so-called 'Basilical' Cistern of Justinian, with its forest of 336 columns and enormous dimensions, earned it the well-deserved name 'Buried Palace' (Yerebatan Sarayı) given it by the Turks. Another important large cistern is one probably built by Senator Philoxenus, one of the leading men who followed Constantine to his new capital. The Turks named it the Thousand-and-One-Columns (Binbirdirek),

though in fact its vaults are supported on 224 plain but elegant columns. There are also reservoirs whose columns are capped with finely carved capitals and others built only with re-used material. In the heyday of the empire, the Byzantines had been forced to use almost all basements as reservoirs, and thus crypts or the basements of churches or public buildings had been converted into water storage areas.

Churches and Monasteries

In AD 451 the Council of Chalcedony proclaimed the parity of the church of Constantinopole with that of Rome; this was the beginning of the great schism that later separated the eastern or Orthodox Church from the western or Roman Catholic one. The metropolis of the eastern church was the city founded by Constantine, 'the Great Emperor among the saints', where tradition said that the Apostle Andrew had preached. Here, the Emperor Justinian, 'of illustrious memory', raised the most imposing Christian place of worship between the years 532 and 537. It was dedicated to the Holy Wisdom (*Hagia Sophia*) and was the successor of several other sanctuaries that, one after another, had been destroyed by fire. On 27 December 537, Justinian inaugurated the daring work of two Anatolian architects—Anthemios of Tralles and Isidorus of Miletus. Justinian was proud of this monument which surpassed even the 'Temple of Solomon' in size and grandeur. The Great Church, *Ayasofya* as it is now called, is arranged as a basilica covered, not by a wooden roof but by a central brick dome 31.24 metres to 33 metres in diameter, with two half-domes abutting it. The dome was a bold enterprise which attracted much praise and admiration. People believed that it was not supported on its four enormous piers but rather 'suspended on a golden chain from heaven'. Towards the beginning of the eighth century, Asia Minor was the centre of a religious controversy that included among its adherents the emperors reigning from 746 to 842. These iconoclasts declared a merciless war on monachism and on the reverence for icons, hence their name. Apart from a short period of calm from 775 to 811, iconoclasm held the field with strength throughout more than a century. After 842, Saint Sophia was redecorated with new mosaic panels, parts of which have been revealed since 1932. The victory of the Church had subdued the arts and given then an austerely hieratic character. Numerous details in the mosaics of Saint Sophia, however, show that this submission to the church was not always total. The mosaic panels in the narthex represent Emperors Constantine and Justinian before the *Theotokos,* or the Emperor Leo VI prostrate at the feet of Christ Almighty, the *Pantokrator* in glory. The arch of the bema is decorated with an archangel draped in a sumptuous royal garment, and in the conch of the apse the slender figure of a very lovely Madonna can be made out, which probably dates from the ninth century. It is in the upper south gallery that the range of mosaic art is best displayed. A superb panel, damaged in part, shows the scene of the *Deisis* (the central part of the Last

Pl. 28

Pl. 32

Fig. 8

Church in the form of a Greek cross: Church of Saint Thekla (?), now Atik Mustafa Pasha Mosque, Istanbul, 9th cen. (Church formerly identified as that of SS Peter and Mark.)

Judgment). The group consists of Christ, flanked by Mary and John the Baptist supplicating His mercy for humanity; it is of remarkable execution and has admirably graded colours and style. The survival of the influence of ancient Hellenistic painting is in evidence in this eleventh- or twelfth-century mosaic panel. In the same gallery are life-like portraits of two imperial families. One portrait depicts the celebrated Zoë, who, as recorded by a chronicler, appeared 'at a very advanced age in all the freshness of a young girl'; she is in this panel with her third and last husband, the handsome Constantine IX. In fact this mosaic painting has a long story: traces of reworking of the mosaic show that only the face belongs to Constantine IX; the body and the titles of the inscription belong to another emperor, probably one of the earlier husbands of this formidable Byzantine empress. A window separates Zoë's panel from the next one, which portrays the good puritan Comnenus, John II, with his fair Hungarian wife Irene. Rigid in her ceremonial robes, she seems to convey how difficult it was for a foreigner to become accustomed to the rituals of the Byzantine court. This panel also includes the portrait of the young, consumptive prince, Alexios.

Pl. 31

To view the richest collection of Byzantine mosaics of the last Golden Age of Byzantine art, we must repair to

51

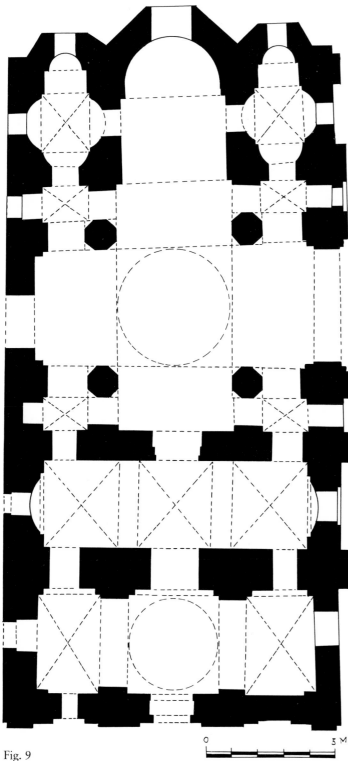

Fig. 9

Church with Greek-cross plan; the vaults and central dome are supported on 4 columns: church of the Monastery of Pantepoptes, Istanbul, now the Eski İmaret Mosque, late 11th cen. At a late date, the columns must have been removed and replaced by masonry piers.

gave way here to architectural motifs and landscapes in Hellenistic manner, lending to the scenes of the Mary and Christ cycles, a familiar, picturesque and exceedingly sentimental character. These mosaics, contemporary with Giotto's frescoes in the Capella degli Scrovegni (Madonna dell'Arena) in Padua, enhance the fine balance of their composition with a wide range of colours. The aesthetic subtlety of a Dormition of the Virgin *(Koimesis),* Pl. 30 set over the entrance to the shrine is particularly pleasing. The two narthexes contain scenes from the Apocrypha. The funerary chapel, annexed to the south side of the church, is adorned with frescoes among which the Last Pl. 29 Judgment scene attracts attention by its magnitude. The majestic energy present in the Descent into Limbo makes this scene one of the most important examples of medieval Byzantine art; it is certainly a masterpiece of Christian painting. When the building was used by the Muslims, the mosaics and frescoes of the church were only partly covered over and thus have long been well known. They were cleaned and restored in the years following the Second World War, thanks to the Dumbarton Oaks Byzantine Research Institute. The exterior of this monument of the 'Byzantine Renaissance' is of architectural importance.

The successive phases of development in religious architecture can be followed in a series of churches that still exist although some have been converted into mosques and others are in ruins. The ancient Basilica of Pl. 33 John the Baptist (İmrahor İlyas Bey Mosque), dated 454 to 463, which was part of the famous convent of Studios, is notable for its sober elegance. The interior, divided by rows of columns of green breccia into one nave and two aisles, is preceded by an attractive portico. The right-hand row and the colonnades of the tribunes were destroyed by fire in 1782, but the nave still preserves remains of a marble floor richly ornamented with geometric interlacings, which probably dates from an eleventh-century restoration. The central plan of the Church of SS. Sergius and Bacchus (Küçük Ayasofya Pl. 34 Mosque) was built about 530 by Justinian, tradition says in fulfilment of a vow after a miracle by St Sergius. A fine epigraphic frieze mentions the names of Emperor Justinian and his wife, 'the very pious Theodora'. The type of plan is the same as that of San Vitale in Ravenna, and its construction and architectural decoration are in the classical tradition. The Church of Saint Irene, which was within the same enclosure as St Sophia, served as the church for the patriarchs. Though its plan is longitudinal like a basilica, it has all the elements of the Greek-cross plan, and its nave is roofed by two domes. The conch of the apse is adorned with a great cross in mosaic, which almost certainly dates from the time of the iconoclasts. There are the small churches of Greek-cross plan, rather heavy and archaic in construction such as the shrines of the Virgin Diakonissa of the Monastery of Akataleptos (Kalenderhane Mosque), St Thekla (Atik Mustafa Pasha Fig. 8 Mosque), St Theodosia (Gül Mosque), or the examples of the type in a later stage of development where the vaults and central dome are supported on columns which were replaced by pillars or piers in the Turkish period. This second group is represented in Istanbul by the Church of

the exquisite little church of the former monastery of Chora, the present Kariye Mosque. Rebuilt under the Comneni, it was expanded and decorated between 1310 and 1320 by the Great Logothetus Theodorus Metochitus. The mosaics and frescoes covering the walls and vaults are amazingly vivid and fresh. The inevitable uniformly coloured background of the previous period

the Convent of Myralaion (Bodrum Mosque), an endowment of Romanos I (920–44), or the Church of Christ Pantepoptes (Eski İmaret Mosque) built in the late eleventh century by Anna Dalassena, mother of the founder of the Comneni dynasty. The same architectural arrangement was employed for the two sanctuaries of the triple church of the Convent of Christ Pantokrator (Zeyrek Kil-se Mosque) which was founded in the twelfth century by the Hungarian Empress Irene and by her husband John II Comnenus, whose portraits appear on the wall of the upper gallery in St Sophia. The foundations apart, nothing remains of this famous convent that included among its dependencies a library and a hospital with 50 beds, but the church group, dominated by multiple domes, still stands in massive majesty. In the southern church, a pavement with an *opus sectile* design of coloured marbles (discovered after 1950) bears witness to the luxury of the Golden Age of the Comneni—their tombs, and some of the Paleologi as well, were in the crypts of the three adjoining buildings. Here fragments of stained glass with figural decoration were brought to light. These are among the rare examples proving the existence of stained glass in Byzantine art.

The designs of the churches of the last phase of Byzantine art are more varied. The southern church of the Monastery of Constantine Lips (Fenari İsa Mosque), where the members of the Paleologus family were mostly buried, the church of the monastery of Pammakaristos (Fethiye Mosque) and its funerary chapel, erected by the wife of the founder for her husband Michael Glabas, 'the light, the breath of her life', and the harmonious exonarthex of an anonymous church (St Theodorus?) known by its Turkish name, Vefa Kilise Mosque, which dates from

1261 to 1325, are distinguished by the delicate and elegant polychrome texture in building. During this period, the use of carved ceramic decoration obliterated the rigid and compact appearance of earlier façades. The architecture of this period, like the contemporary mosaics and frescoes, is full of life, colour and movement.

Besides the figural decoration of the Kariye Mosque, fine mosaics have been found in the domes of the exonarthex of the Vefa Kilise Mosque and, more recently, in the funerary chapel of the Fethiye Mosque.

Byzantine Art in Museums

The collections of the museums of Istanbul contain numerous examples of the minor arts of Byzantium. Though many illustrated manuscripts have been taken to the west, the library of the former palace of the Sultans *(Topkapı Sarayı)* possesses some important manuscripts, among which the Octateuch, the so-called Seraglio *(Seragliensis)*, is outstanding. It was prepared during the first half of the twelfth century for the Sebastocrator Isaac Comnenus (whose portrait appears in a mosaic in the Kariye Mosque), the son of Alexis Comnenus (1081 to 1118), and illustrated with numerous scenes from the Old Testament. A fine paten, found at Lampsakos (Lapseki) on the Dardanelles, is exhibited in the Archaeological Museum, Istanbul. It is a particularly interesting example of its type, because it is decorated with an allegorical figure whose attributes show it to represent India. The same museum has a rich collection of Byzantine pottery and fragments of faience tile revetments. Much can be learned about interior decoration from these fragments, discovered during excavations of Byzantine buildings.

Sculpture is represented by a fine figure, with all the characteristic features of fifth-century art, of a young prince of the late Roman period, perhaps Emperor Arcadius (395–408). The head is remarkable in both the quality of the stone and the craftsmanship of the carving. Statues of the high ranking officials of Aphrodisias, exhibited in the Archaeological Museum, are responsible for the hypothesis that a local school of sculpture existed in the fifth century. From the sixth century, Byzantine art abandoned monumental statuary, but the traditions of classical art continued in rare examples of low reliefs. The fine marble icon of the Virgin, called the Madonna of Gülhane, is the most striking testimony to this survival. It probably belongs to the eleventh century and was found in a damaged condition in 1922. The drapery of the icon is treated with such delicacy that it is impossible to deny the persisting influence of the classical or Hellenistic style. The Byzantine collection of the Archaeological Museum contains two ambones from Salonika: one was carved from a monolithic block of green breccia; the other is particularly noteworthy for the reliefs, with figures of the Three Kings carved on its sides. There is also a problematic icon of St Eudoxia made of polychrome stones, cut out and set into an intaglio of marble—a very rare technique.

Similar porphyritic sarcophagi in the Archaeological Museum of Istanbul are likely to belong to the emperors

Fig. 9

Pl. 31

Fig. 10

Pls. 35, 36

Pl. 38

Pl. 37

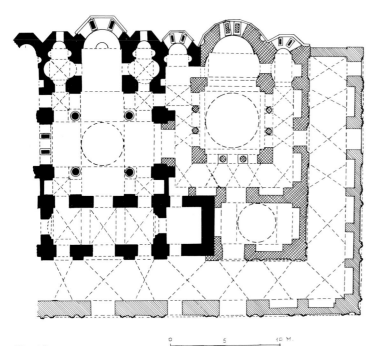

Fig. 10

Plan of the double church of the Monastery of Lips, Istanbul, now the Fenari İsa Mosque. The earliest northern church (early 10th cen.) is in the form of a Greek cross with 4 columns; the southern one (hatched) dates from the end of the Byzantine Empire (late 13th cen.) and has side aisles.

of the fourth and the fifth centuries. Other sarcophagi, exhibited in the 'Byzantine Room', are of modest dimensions but decorated with figures of Christian symbols. A marble trough has on its long sides genii bearing chrism; on the short side, figures of the apostles in relief. It is probably a work of the fifth century belonging to a rather rare group and may have been made to contain the ashes of a prince.

A group of figured slabs, mostly from the Church of Studios, forms a more unusual series. They are plaques that imitate the small columned sarcophagi in their decoration, but are in fact each a single side of a sort of trough composed of separate slabs. Among the troughs exhibited in the Archaeological Museum, there is one which has its main surface subdivided by pillars and decorated with stylized trees and a vase from which vine scrolls rise. This demonstrates the extent of variations in the typology of Byzantine sarcophagi. Since the monument was secularized, the courtyard of St Sophia is an open air museum, a *lapidarium* with an exhibition of architectural styles. Among them are the remains of the façade of the Theodosian St Sophia and numerous capitals of every kind found in the city.

Byzantine Art outside the Capital

Although the capital was the supreme artistic centre, it drew its creative inspiration from Asia Minor. Starting with the peace of the Church, there was no hesitation in transforming almost every pagan temple into a basilica. The huge temple of Didyma, the celebrated temple of Augustus at Ankara, the Roman basilica of Bergama (Pergamon), the temple of Zeus at Uzuncaburç (formerly Diokaisarea), and many more, were adapted to the needs of the Christian religion. Often this involved no change in architectural form; for example at Side the Christian basilica was built around the temples left within the atrium. Sometimes, as at Uzuncaburç, the pagan sanctuary became a Christian basilical church by means of extremely ingenious innovations, but large numbers of churches were also built with regional peculiarities in technique, style and structure.

Eastern Thrace

Before considering Asia Minor, it is useful to review briefly some aspects of Byzantine art in the territory of eastern Thrace where the style of building was, in general, directly dependent on the Byzantine capital. However, there are some late works with characteristics that make them unlike the usual architectural styles.

The walls of the limes (line of fortifications), said to have been built by Anastasius (507–11), which cut off Thrace in order to protect the city of Byzantium in the west, had no strategic importance. A few traces of these fortifications remain, but they have none of the impressive effect of the land ramparts of the capital. Among the small fortresses, those of Enez (Ainos), Vize (Bizye), Kıyıköy (Midea), etc. have retained their medieval

Fig. 11

Plan of the monastery, church and holy well *(Hagiasma)*, Midye-Kıyıköy (eastern Thrace), 8th–9th cen. (?).

character. At Safaalanı, still in eastern Thrace, there are the remains of a network of aqueducts that furnished the capital with water.

Religious architecture in eastern Thrace is represented by the great church of Vize, now a mosque called Suleyman Pasha Mosque or simply *Ayasofya*. Here a mixed type of construction emerges, resulting from the superposition of two different architectural concepts. The ground plan is that of a basilica; the superstructure and the system of roofing follow the principles of the Greek cross. Thus, this restored and altered church is an application of an architectural method much in vogue, especially at Mistra, in the thirteenth and fourteenth centuries. Another important church from the point of view of Byzantine art is one in a ruined state at Enez, near the Greek frontier. It is a large-scale variation of the Greek-cross type. The western arm of the cross is excessively elongated, which makes the building seem like a basilica. This is an arrangement that can only be observed among contemporary churches in a very distant area – Trabzon (Trebizond), which from the thirteenth to the mid-fifteenth century was the capital of the Comnenian kingdom. The large church of Enez had an exonarthex with its western façade forming a portico. Thus this building is an example of a style very popular in the thirteenth and fourteenth centuries, as can be seen on the Paregoritissa of Arta in Epirus, the Church of Pojani in Albania, the Holy Apostles of Salonika, St Sophia of Ochrid, the Vefa Kilise Mosque in Istanbul, and even a Turkish building in Bursa, the Hüdavendigar Mosque.

Art and architecture carved out of living rock in this part of Turkey is represented by a sanctuary thought to be of the eighth or ninth century. Midye (now Kıyıköy) is a village on the shore of the Black Sea; it has a church with Fig. 11 monastic dependencies and a holy well *(Hagiasma)* all of which are carved out of the mountain side. The interior decoration of this church is unique. Everything is hewn out of the rock, including a very rich and varied deco-

ration of delicate relief carving. There are other rock shrines in various places, but none has the regular plan and subtle decoration of Midye (Kıyıköy); these are natural caves that have been turned into sanctuaries with little alteration, for examples the cave of Yarımburgaz near Küçükçekmece, and the monastic complex at Vize. The latter is remarkable for its little trefoil chapel; however, the main church is nothing but a great natural cavern with no precise form.

Byzantine Bithynia

To appreciate the extent and diversity of Byzantine art, we must travel to Asia Minor. The regions east of Istanbul have no local styles; they are closely linked to the artistic school of the capital, like eastern Thrace. The Byzantine Empire erected a series of military fortifications along the gulf of Izmit (Nikomedeia) to defend the capital; only one of the fortresses — Eskihisar at Gebze (Dakybiza) — is well preserved. It was built under the Comneni and extended under the Paleologi to form a medieval castle that controlled the route from the east and dominated the sea. The masonry of later sections shows the polychrome technique of the Paleologus period. On the south shore of the gulf of Izmit, near Yalova, which was already famous in the sixth century for its hot springs, is the ruin called Karakilise. This is a huge edifice built entirely of brick in the form of a Greek cross topped by a vast dome. It is a curious building, and its original function is not known. It seems to belong to the sixth century, but during the high Byzantine period it was converted into a church.

The most famous Byzantine monument of Bithynia is certainly the bridge of Justinian, built about 559 to 560 on the River Sakarya (Sangarios). According to the contemporary writer Procopius, the Emperor had it built 'by divine cooperation'. It is 430 metres long and was built to span the river in twelve arches. (Several centuries ago the river changed its course.)

There are several villages in the region of Bursa with important Byzantine buildings. The Church of the Archangels at Kumyaka (Sigi), though much altered in 1818, is of the so-called 'ciborium' type in the central portion. At Zeytinbağı (Tirilya) the chief mosque of the village is an ancient structure that must date back to the sixth century, judging by the fine capitals decorating the exonarthex, but its architecture (a Greek-cross plan with four columns) indicates a later period (eighth century?). The small Church of Pantobasilissa in the same village is badly ruined. One of its walls is still decorated with a large fresco representing St George, and the moulded clay decoration of the east façade is sufficient to assign this church to the period of the Lascaris of Nicaea and the first Paleologi of the restored empire.

The most important centre of Byzantine Bithynia is Iznik (Nicaea), a little town by a lakeside, which was the capital of a small Byzantine principality in the thirteenth century, when the Latins of the Fourth Crusade dismembered the Empire. The wall surrounding the Roman city was rebuilt and reinforced in the Byzantine period.

Fig. 12
Mosaic pavement of the Church of St Sophia (Ayasofya), Iznik, 11th to 12th cen. (after a drawing by Y. Demiriz).

The great basilica marking the centre of the town was altered later; domed cells were built on either side of the apse, and the floor of the nave was replenished with a magnificent *opus sectile* mosaic, the remains of which Fig. 12 were revealed in 1955. The second important church in this little town was the Church of the Dormition of the Virgin *(Koimesis)*: it fell victim to the Turco-Greek war in 1922. It was a church of the aisled-'ciborium' type. Its mosaics, which must have been from the eighth century, no longer exist, but the complete plan can still be seen, as well as the remains of the marble pavement of the main nave.

Western Anatolia

In the cities of western Asia Minor famous in the classical period, Byzantine art is often relatively poorly represented. In Bergama (Pergamon) for example, excavations revealed only insignificant buildings. At Sardis, in the ruins of a large basilica 63 metres long dating from the fifth century, a little church with a Greek-cross plan had been set up in the thirteenth century. Along with several other little churches and the so-called cathedral, this building is devoid of characteristic or interesting features, but in the same town, an imposing synagogue standing on the main street is remarkable for its mosaic pavement and basilical shape. One of the rare surviving examples of Pl. 39 a princely Byzantine residence stands near the road leading from Izmir to Kemalpaşa (Nymphaion). This palace, built in the thirteenth century by the Lascaris of Nicaea, is a massive building of several storeys, which has

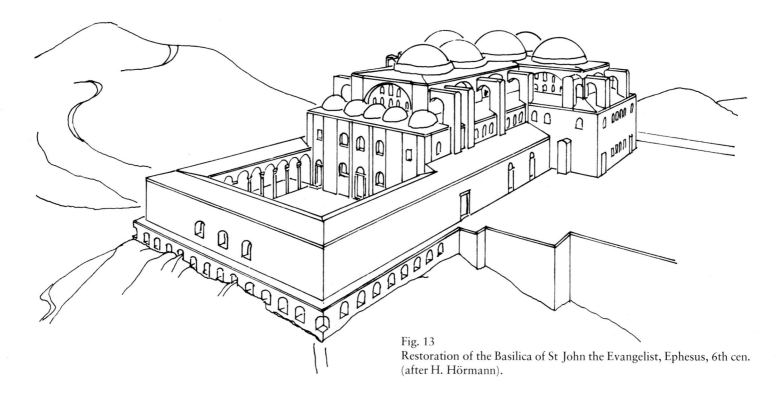

Fig. 13
Restoration of the Basilica of St John the Evangelist, Ephesus, 6th cen.
(after H. Hörmann).

Pl. 27 a general similarity with the Tekfur Sarayı palace in Istanbul.

Among the ancient cities of western Anatolia, Ephesus holds a leading position as a Byzantine town. Here the cult of the Mother of God replaced that of the goddess Artemis. The great basilica dedicated to the Virgin, in which the famous Council of 431 was held, was erected on the remains of an immense ancient building. Later this classical type of basilica (called Hellenistic with three aisles) fell in ruins, and another basilica of much more modest size was built on its remains. Later the basilica was reduced in size again, and within the nave of the early Christian church, a small shrine was set up with its central part in the form of a 'ciborium'. The sanctuary of the Virgin at Ephesus is a most curious example of successive stages in church building.

The Christian town had another church of equal importance, for here on what is believed to be the very tomb of St John the Evangelist, was built a 'ciborium'
Fig. 13 that was later surrounded by an enormous basilica. The basilica was cruciform in plan, reminiscent in its broad outlines of the pilgrimage church built round the column of St Simon Stylites at Qal'at Saman near Aleppo. In the sixth century, however, the Emperor Justinian ordered that on the side of this complex building, a very large church be built in the form of an open Latin cross; it was to be composed of six compartments roofed with domes. This plan was a slightly altered replica of the church of the Holy Apostles at Byzantium, and it became the proto-type of several western cathedrals such as St Mark's in Venice and St Front at Perigueux in the Dordogne. Outside the town is a place of pilgrimage connected with the legend of the Seven Sleepers. Here, a Christian cemetery became a centre of pilgrimage in the fifth century, frequented from then until the mid-fifteenth century by innumerable people. The centre of this vast funerary complex is occupied by a basilica with a crypt which, according to the legend, held the tombs of the Seven Sleepers. Among the secular buildings of Ephesus a bath of the fifth or sixth century and two fountains are worthy of note.

Priene, one of the flourishing cities of antiquity, did not expand in the same way as Ephesus in the Byzantine period. Its few modest medieval buildings are of slight artistic importance. The great basilica itself was built of materials taken from older buildings. The hills of the region are crowned by fortresses, some of which are of the Byzantine period. The most curious of these is the fort built over the ancient theatre of Miletus. This important metropolis of antiquity lies near the mountain of Beşparmak, ancient Latmos or Latros of the Byzantines. Here the Lake of Bafa with its banks and islands was highly suitable for the foundation of monastic complexes. In the seventh century, the monks of Sinai emigrated here, and the convents they founded were fortified in the ninth century for protection against Arab incursions. On the fortified islet of Kahve Asar adası, stands a lovely little church. It has remarkable brick decoration on its west Pl. 40 façade: sufficient reason to assign it to a late date. It is another church with a Greek-cross plan. On Ikizada and Kapıkırı, there are also fortified monasteries, and in the surrounding mountains are the ruins of the monasteries of Stylos, where St Paul the Younger had lived (he died in 955) and Yediler, which is probably the Convent of Kelli-baron mentioned in Byzantine sources. The latter also has the aspect of a vast fortress traversed by a stream. Within the walls there are four churches. One in the form of an open cross, resembles the religious buildings of the region of Hasan Dağ, near Kayseri in central Anatolia; it provides evidence for an infiltration of styles from the east.

Towards the interior of Anatolia, Pamukkale (Hierapo-lis) was an important urban centre in the Byzantine period. The so-called cathedral is a large basilical

building with aisles separated by pillars which must have been built before 535. As in the churches of Binbirkilise near Karaman, the side aisles would have been covered by ribbed barrel vaults reinforced by wall arches. The nave was subdivided into three compartments covered with domes. Though in a ruined state, the 'cathedral' of Pamukkale marks an important stage in the development from roofed to domed basilica. Another building outside the walls is also a three-aisled basilica, similar to the Basilica of Maxentius in Rome. Like the one in Rome the side aisles are provided with passages through the transversal piers. In the necropolis, Italian archaeologists have unearthed traces of a large centrally planned building of the fifth century, which is perhaps the Martyrium of St Philip. Vaulted cells and triangular chapels are arranged round an octagon of 20-metre diameter; the whole is within an enclosure of 60 by 62 metres.

In the same area of western Turkey, near Uşak at Selçikler, an important Byzantine church has been discovered in recent years. It repeats the usual Greek-cross plan but is noteworthy for its exceptional decoration of stone and pieces of glass set into intagliated marble.

Southern Anatolia

The southern shore of Turkey is extremely rich in Byzantine monuments. The mountains of ancient Lycia and Cilicia are scattered with medieval ruins among which appear churches built in ashlar. In Lycia, the Basilica of the Archangel Gabriel at Alacayayla, with a chapel annex, has finely carved decoration. At Karabel, Fig. 14 to the north of Demre, the great basilica ends, as do some Coptic churches of Egypt, with a trilobed choir. This is a very rare feature in Asia Minor, but it occurs quite frequently in Lycia, e.g. Dikmen, Devekuyusu, Alacahisar. In southern Anatolia almost every ancient city became a Byzantine town of some importance, and Byzantine art was represented by secular or religious buildings both small and large. While some of the very prosperous cities may have only banal and carelessly constructed buildings, there are obscure villages of no significance, where imposing and ambitious buildings can be found.

On the shores of the Mediterranean at Demre (Myra) stands the sanctuary placed under the invocation of St Nicholas. It is a large domed church that seems to be from the end of the first period of Byzantine art. The original central dome was replaced during restorations of the last century by a vault which, unfortunately, has no connection with the principles of Byzantine architecture. Recently, traces of pictorial decoration have been found and fragments of the pavement. Near Demre, but beyond the mountains, at a place called Dereağzı near Kasaba, are some very interesting ruins of a church of the eighth or ninth century, which is thought to have been built by the inhabitants of Demre who had fled from the raids of the Arab fleet. This large building, which rises in a completely isolated spot, is a perfect Greek cross in plan. A large dome, 9 metres in diameter, dominated the nave. With its fine proportions and perfectly balanced regular

plan, this church stands out among similar buildings as the most monumental example of this architectural type.

Further east stretches Pamphylia, whose most important town was Antalya (Attaleia). Here, a large basilica dedicated to the Virgin was erected on ancient foundations; it was altered and restored many times before becoming a mosque (the Kesik Minare Mosque or Korkut Mosque). This important monument, in ruins now for more than a century, had a raised part in the form of a domed tower, which was at the centre of its principal nave. It is not known whether the dome was originally of stone or of wood. The exceptional spatial and formal

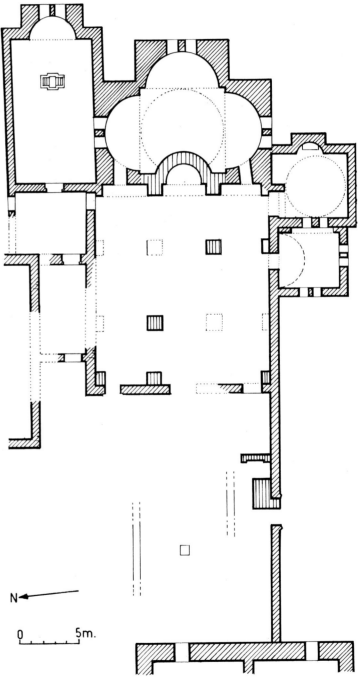

Fig. 14
Plan of the Basilica of Karabel, north of Demre, 6th cen. The choir of the original basilica is trilobed; later, a smaller church was built within it (after Harrison).

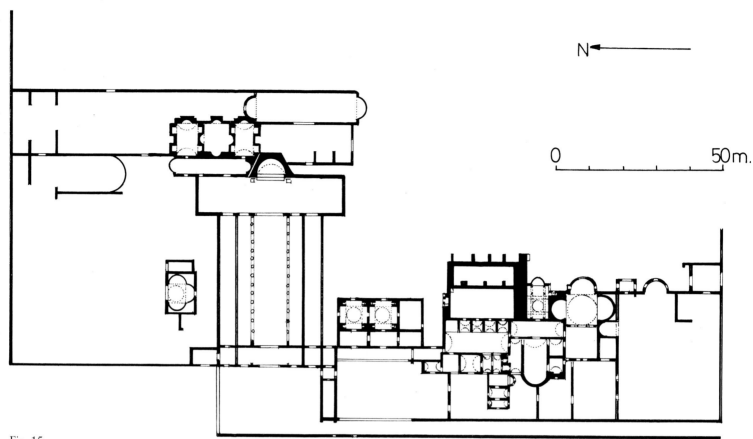

N←

0 50m.

Fig. 15
General plan of the architectural complex, Side near Antalya (southern Anatolia), 6th cen. A baptistry is attached to the great basilica with transept; on the other side, the rooms and private chapel of the episcopal palace are aligned (after A. M. Mansel).

arrangements of this large church make it a link in the architectural evolution of religious buildings.

The remains of very large basilicas of Hellenistic type are found at Perge, an important town in classical times and famous for the pilgrimages of St Paul. The remains of these imposing basilicas, one of them with a transept, still dominate this ghost town.

Still further east is the town of Side, which also had a port. Near two ancient temples dedicated to Artemis and Apollo, a basilica of very mediocre construction was raised. After it fell into disuse, a very small church was erected in the middle of the nave in the eleventh century. Fig. 15 The great episcopal Basilica of Side is particularly important because of the buildings annexed to it. Among these is a fine baptistry of quatrefoil plan and a huge episcopal palace consisting of several vaulted halls and a private chapel. Near this complex there is another modest church on a Greek-cross plan with a dome on four columns. It well may be one of the first examples of this architectural type, which was to become popular from the ninth century on. In the Byzantine period, ancient houses continued to be used, but others were built as well. A large building of two storeys with intercommunicating rooms was, perhaps, the hospital built by the Emperor Justinian in Pamphylia that is mentioned by Procopius.

The Cape of Alanya (Korasion) is topped by a romantic and majestic citadel-fortress. Much of the ramparts, as well as the imposing keep dominating the port and the sheds of the naval yard are from the Seljuk period, but the small domed, trefoil church standing at the summit of the fortress bears witness to a Byzantine past. Near Silifke (Seleukia) on the Cape of Ovacık (Aphrodisias), a basilica has recently been discovered with a magnificent mosaic pavement. Silifke itself was famous in the early Christian period for pilgrimages in memory of St Thekla. Over the natural cave where the saint, as one legend claims, had disappeared, a large classical basilica was built first and followed by a second domed one. Very few traces of these two churches now remain. Excavations carried out in 1909 have not answered every question, though the results published do bring some clarification to what seems quite obscure on the ground. There are other monuments close to Silifke, which are perhaps less famous but are perfectly preserved. The first is the monastery complex called Alacahan, near Mut (Claudiopolis), on the road leading from Karaman to Silifke. Here, on a narrow terrace admirably sited on a mountainside, the monastic buildings are aligned; tombs cut out of living rock, a basilica, a baptistry, a large church and a processional road running past them all. This basilica is remarkable in early Christian art for the relief decoration round the door frame, where elements of classical decoration and Christian motifs and symbols are combined in local style. The Baptistry is of a unique kind, being composed of the two single-nave chapels. The main church is a relatively well-preserved domed basilica, one of the masterpieces of Anatolian Byzantine architecture. It is built of finely finished ashlar, and in 1671 it aroused the admiration of the Turkish traveller Evliya Çelebi, who described it as a '...building which seems just newly delivered by its architect....' The superstructure of the

central nave is elevated by means of a square tower that contains squinches at four corners. This section was the zone of transition to a dome above. The dome must have been constructed in light material, perhaps wood, judging from the remains in the zone of transition. This fine church is probably of the first half of the sixth century. Again near Mut, on the ancient and now disused road from Karaman, stand the remains of a large town that may well have been Koropissos. The hamlet, now known as Dağpazarı, was a flourishing city in the Byzantine period. Excavations, carried out by M. Gough, in a ruined basilica have uncovered a fine mosaic pavement, but there was also a church built of ashlar with aisles separated by pillars, clearly demonstrating the existence of a local style very different from the classical basilica. Formerly there was a wall above the chantry arch, which proves that the nave was originally covered with a four-pitch roof or a dome. Further west, in the ancient town of Isaura, perched on a mountain top in an enchanting site, the influence of the Byzantine period can be seen in a large octagonal building.

Eastwards from Silifke, the coast is littered with ruins of the Byzantine period. The celebrated cave of Korykos had been a sacred place from time immemorial. A pagan temple raised beside it was converted into a church and behind, just at the entrance to a cavern leading down to a subterranean river, a little shrine, dedicated to the Virgin, was built. This church has an apse decorated with frescoes and is unique in Christian art; it has no roof other than an overhanging mass of rock. A short distance from the coast, in the Taurus Mountains in the village of Canbazlı, stands one of the best-preserved basilicas of Asia Minor. It has never been restored or altered and is, therefore, perfect for studying the superstructure and roofing system of the Byzantine period. The apse and several storeys of the annexes are all flush with the straight wall of the chevet. The aisles, surmounted by tribunes, were covered with a double-pitch roof: here we see the characteristic features of the local school. There are many other Byzantine sites with houses and churches (hitherto unpublished), some of them disproportionately large, to be found in the surrounding mountains.

Korykos was a very prosperous city. The island facing the port was fortified under Byzantine rule, but later the kings of Lesser Cilician Armenia restored and completed the military structures that now form an extremely picturesque medieval castle. The great fortress facing the island on the mainland has Roman, Byzantine and

Pl. 41

Fig. 16

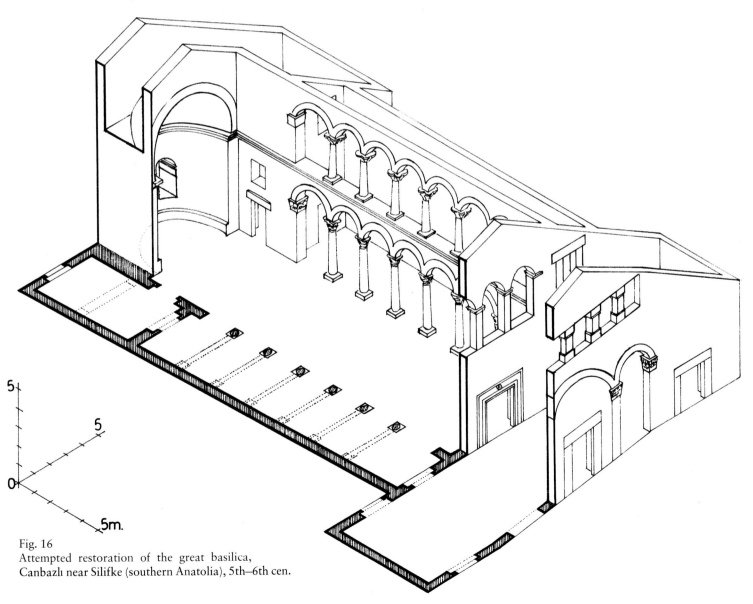

Fig. 16
Attempted restoration of the great basilica,
Canbazlı near Silifke (southern Anatolia), 5th–6th cen.

Armenian sections. The Byzantine town proper stands somewhat inland from the shore. Here an extensive necropolis and large basilicas show how important this Christian metropolis once was. Four of the churches are well preserved and display the peculiarities of the local style: triple-arcaded entrance, monumental façades, apses that do not project beyond lateral walls, etc. The semi-circular stone porch-roof, protecting the side entrances in one of these churches, add an interesting feature. A few kilometres to the east, at Kanlıdivan (Kanytelleis or Kanytelideis), is another Byzantine village or small town with classical antecedents. A natural depression was first venerated by the pagans, and later by Christians, who built four basilicas, one of them on a complex plan with a pseudo-transept. This church was connected to the rear of the cave by means of a tunnel, cut into the rock.

At Kadirli, near Adana, is a curious basilica of grandiose dimensions. It is a building of classical origins, on which a three-aisled basilica in ashlar, flanked by external galleries, was erected later. In the period of the Armenian kingdom, the central nave was transformed into a small single-nave chapel. The pavement of the earlier Byzantine church still has fragments of mosaic decoration. At Misis (Mopsuhestia) a mosaic pavement has been uncovered which seems to have belonged to an Early Christian basilica that has otherwise completely disappeared. This quite unique pavement depicts Noah's Ark and the various animals. Antakya (Antioch), however, is the place famed for its rich mosaic pavements of the early Roman period. Most of them have been shared out between the west European and transatlantic museums, but those that have remained *in situ* and are exhibited in the local museum provide adequate evidence of the beauty and richness of this decoration. In the suburbs of Antakya stood the church of Kaoussiye, erected in 386 in the form of an open cross. The same

26 Theodosian walls of Byzantium: *in the foreground,* the moat (almost totally filled in).

27 Tekfur Sarayı (Palace of the Ruler): main façade with polychrome geometric decoration.

28 Interior of the Hagia Sophia (Ayasofya), Istanbul, built in 532–7 by Anthemios of Tralles and Isidor of Miletus.

29 Fresco in the side chapel of the church of the Monastery of Chora (Kariye Mosque), Istanbul, 1310–20: the Last Judgement *(at the centre)* Christ, *(at His feet on the right)* the elect and Paradise, *(on the left)* the damned, engulfed in a river of fire.

30 Mosaic panel from the church of the Monastery of Chora (Kariye Mosque), Istanbul: Dormition of the Virgin *(Koimesis),* 1310–20.

31 Mosaic panel in the south tribune, Hagia Sophia, Istanbul: Virgin and Child, with the 12th-century Emperor John II Comnenus, his wife the Empress Irene and the sickly Prince Alexios.

32 Mosaic panel in the south tribune, Hagia Sophia, Istanbul: 12th-century *Deisis* (central part of the Last Judgement).

33 Basilica of St John the Baptist (İmrahor İlyas Bey Mosque) in the Monastery of Studios, Istanbul, 454–63. The row of columns and the tribune that should run above the right side aisle no longer exist; the row of windows round the upper part of the apse dates from the 18th century.

34 Dome of the Church of SS Sergius and Bacchus (Küçük Ayasofya Mosque), Istanbul; the central building was erected under the Emperor Justinian, *c.* 530. All the decoration is of the Turkish period.

35 Funerary chapel of the Church of Pammakaristos (Fethiye Mosque), Istanbul. In the background, the principal dome of the church, early 14th cen.

36 Interior of the funerary chapel of the Monastery of Pammakaristos (Fethiye Mosque), Istanbul, early 14th cen. Church in Greek-cross plan with mosaic decoration on the central dome.

37 Byzantine sarcophagus: *in the centre,* a cross framed in vine scrolls, 7th cen. (after G. Mendel). Archaeological Museum, Istanbul.

38 Paten found at Lampsakos (Lapseki) near the Dardanelles, 5th cen. Judging by its attributes, the allegorical figure represents India. Archaeological Museum, Istanbul.

39 Palace of the Lascaris dynasty on the road from Izmir to Kemal-pasha (Nymphaion), 13th cen.

40 Church of the monastery on the island of Kahve Asar in Lake Bafa near Latmos (western Anatolia), 12th–13th cen. (?). Note the masonry of the façade in mixed stone and brick.

41 Church of the Virgin, built at the entrance to the *Cennet* (Paradise) natural rock shelter, Korykos, 5th cen. This unusual church never had a roof.

42 Interior of the principal church of the Alacahan Monastery near Mut (Claudiopolis), 5th–6th cen.

43 Rock-cut church of Ayazin near Afyon Karahisarı, 10th–11th cen. The projecting apse and half-dome resemble those of churches built in stone.

44 Landscape near Göreme in Cappadocia.

45 Interior of the rock-cut chapel at Saklıkilise in Cappadocia. The oratory is dug into the tufa, and its walls are decorated with frescoes.

46 Frescoes at Karanlıkkilise in Cappadocia, *c.* 1200. The main scene represents the Crucifixion.

47 Rock-cut chapel of St Barbara in Cappadocia: in the form of a Greek cross with extremely simple monochrome decoration on the walls.

48 Fresco in chapel no. 28 at Göreme in Cappadocia, *c.* 1070, representing, in a local style, the Emperor Constantine, his mother 'Saint' Helena and two warriors slaying a dragon. All the figures wear the clothing and insignia of the mid-Byzantine period.

49 Üçayak (tripod) double church near Kırşehir, built entirely of brick, 9th and 10th centuries.

50 Apse of church no. 31 of the Binbirkilise (Thousand and One Churches), Degle near Karaman, 5th–6th cen. (?), built entirely in ashlar.

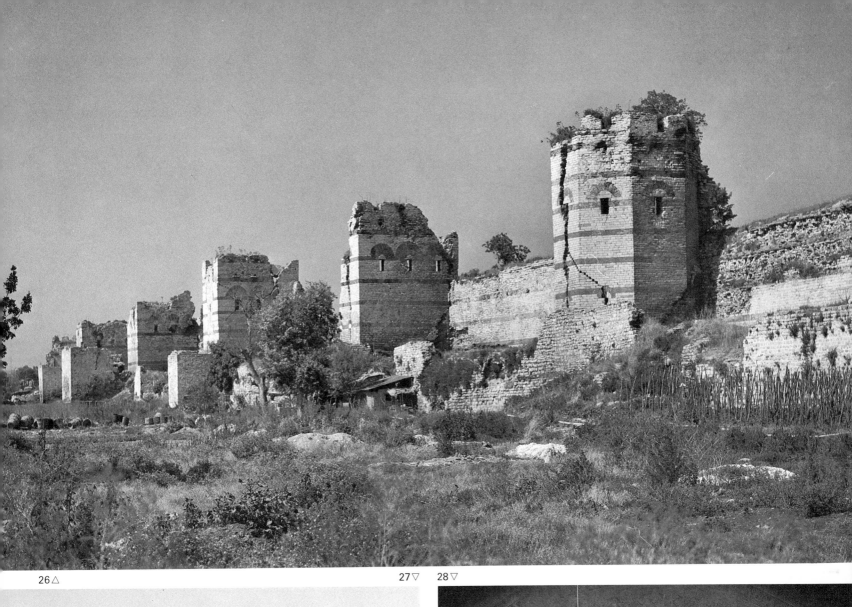

26△ 　　　　　　　　　　　　27▽ 　28▽

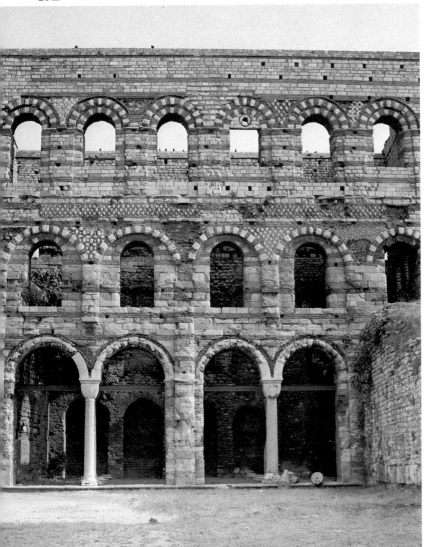

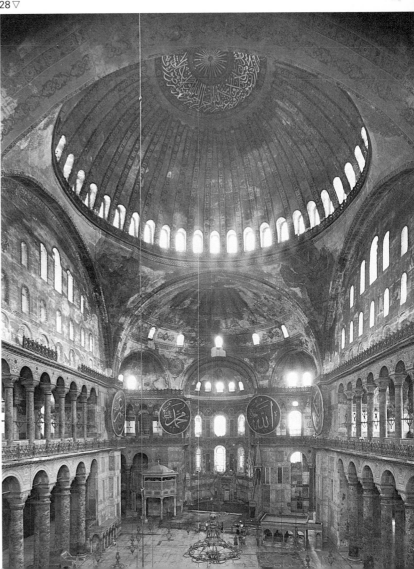

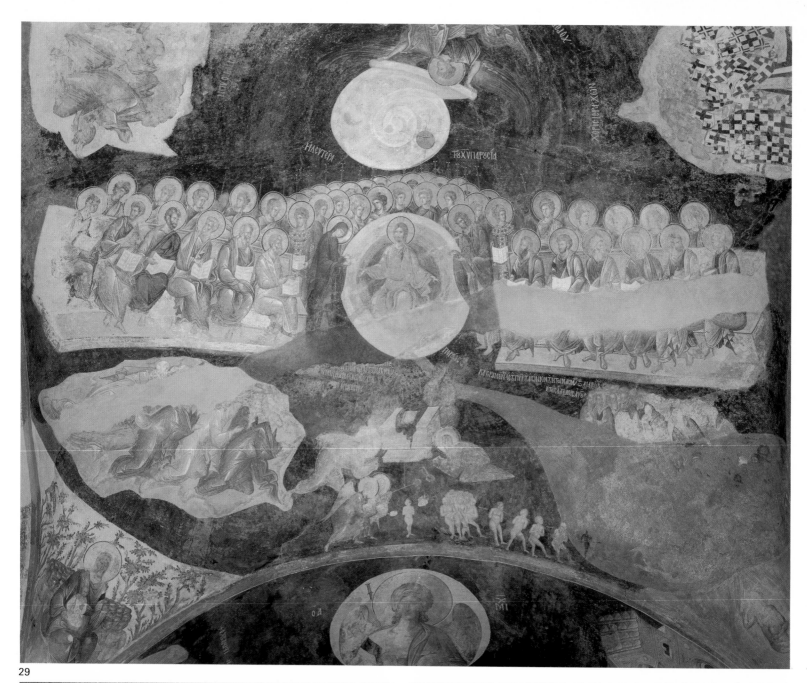

29

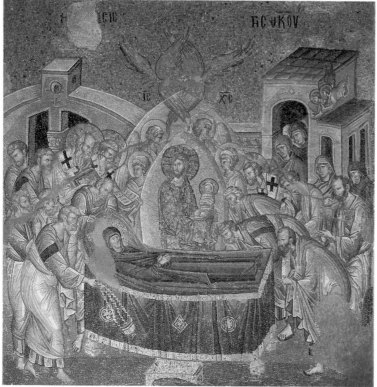

30

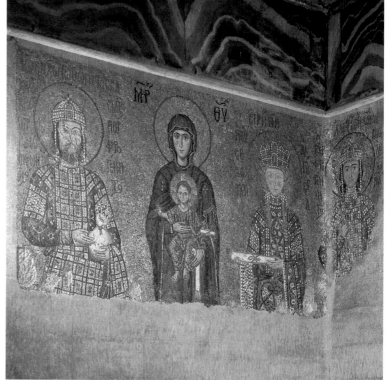

31

32

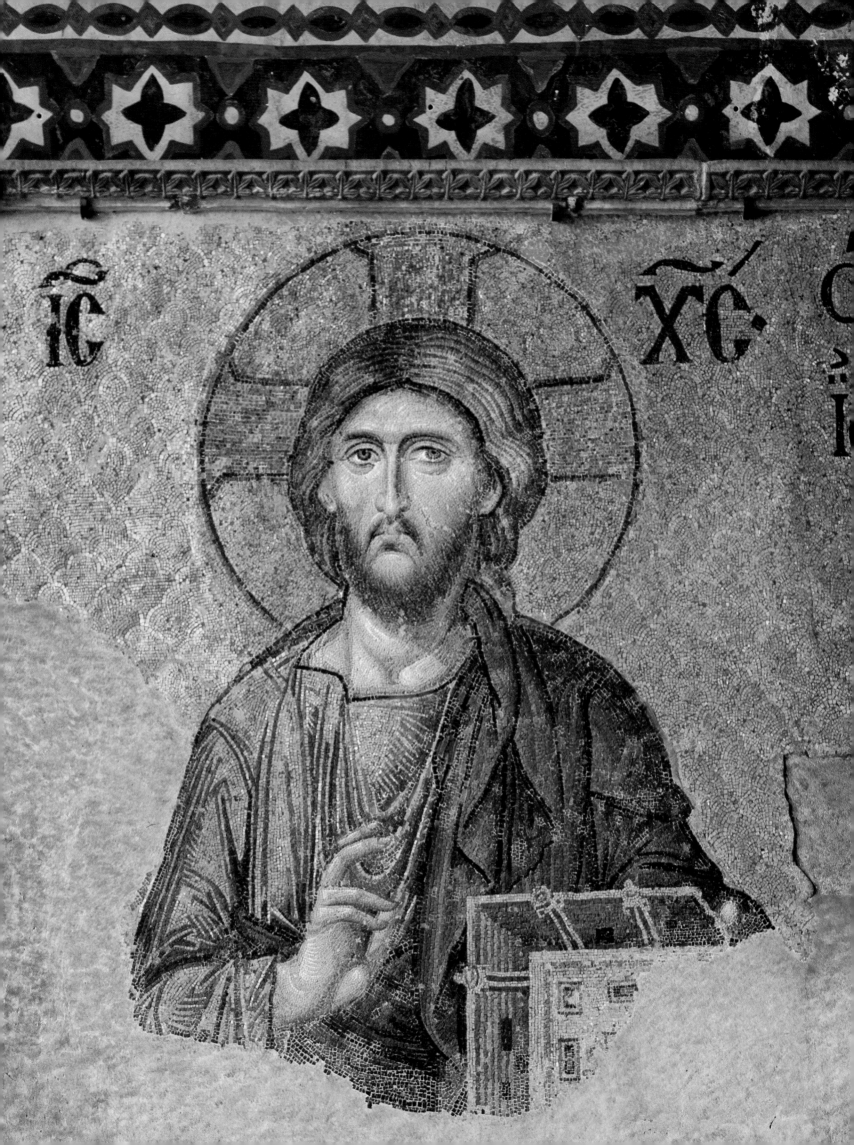

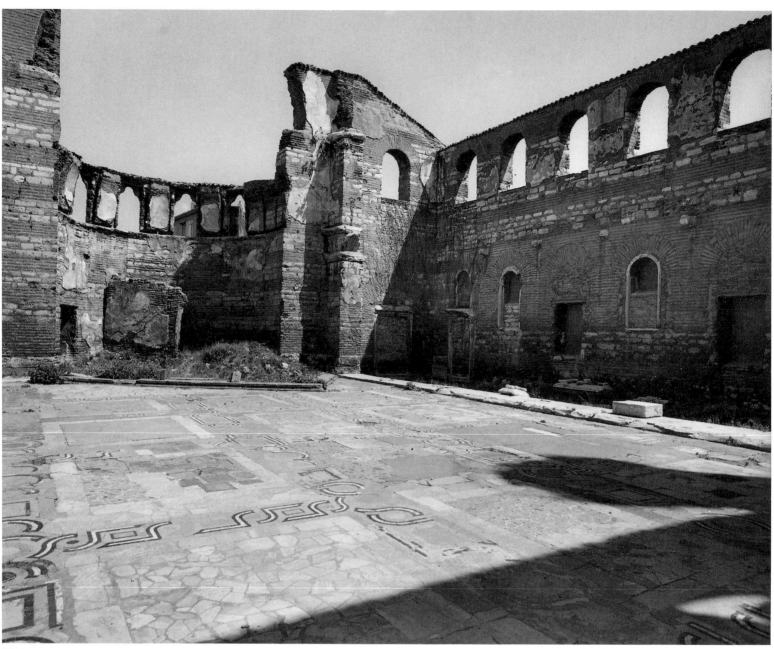

33

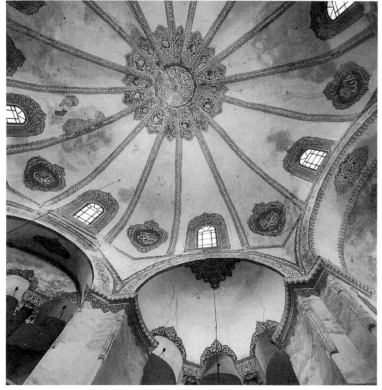

34

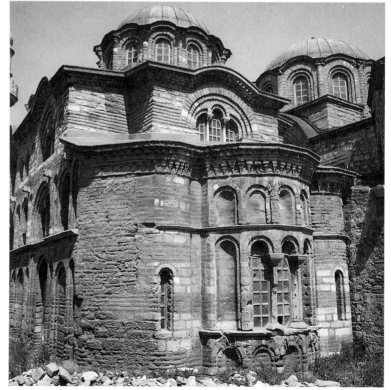

35

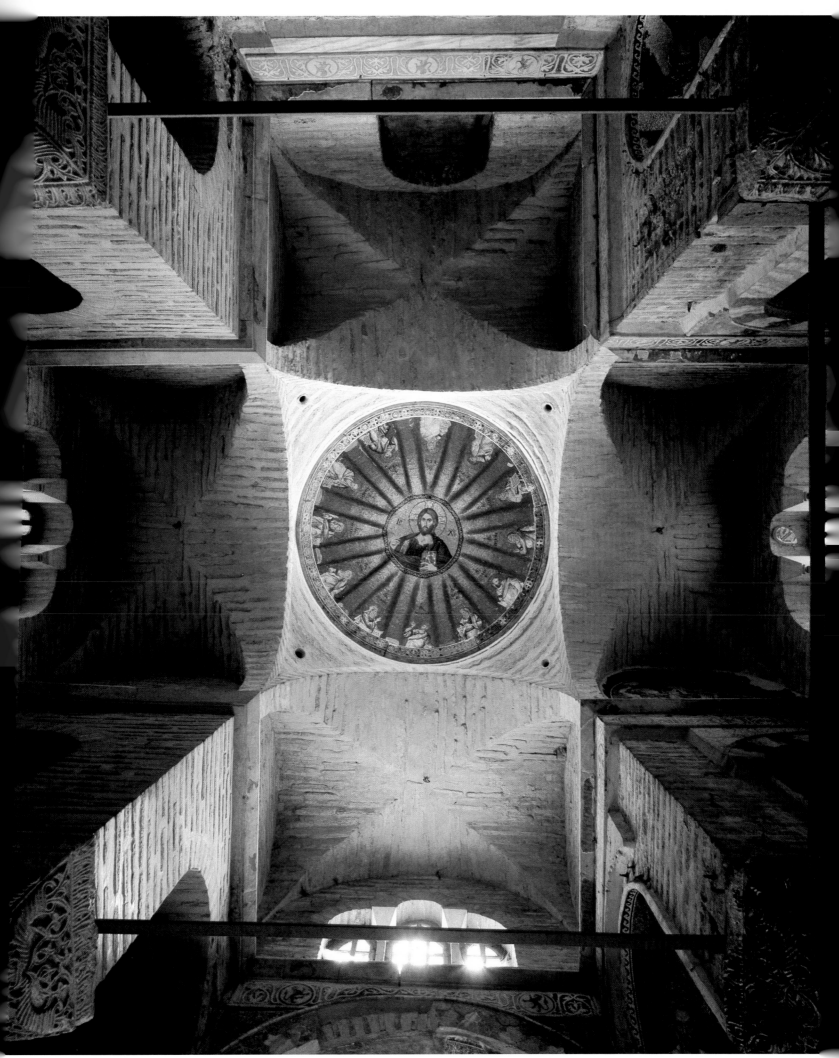

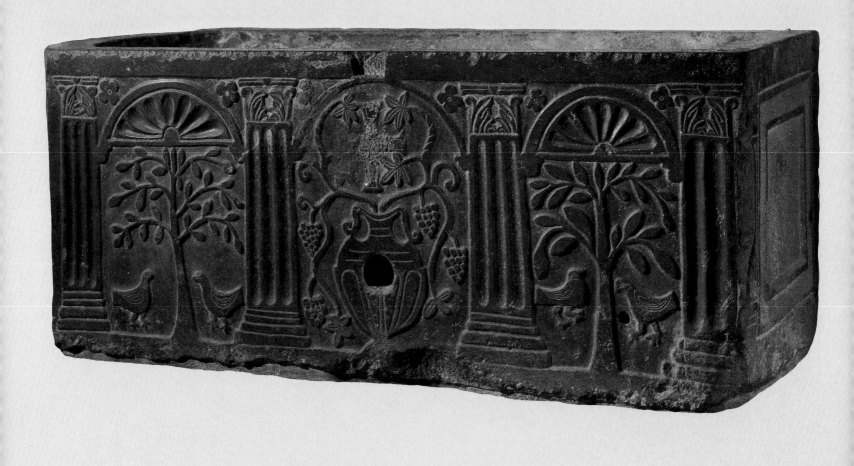

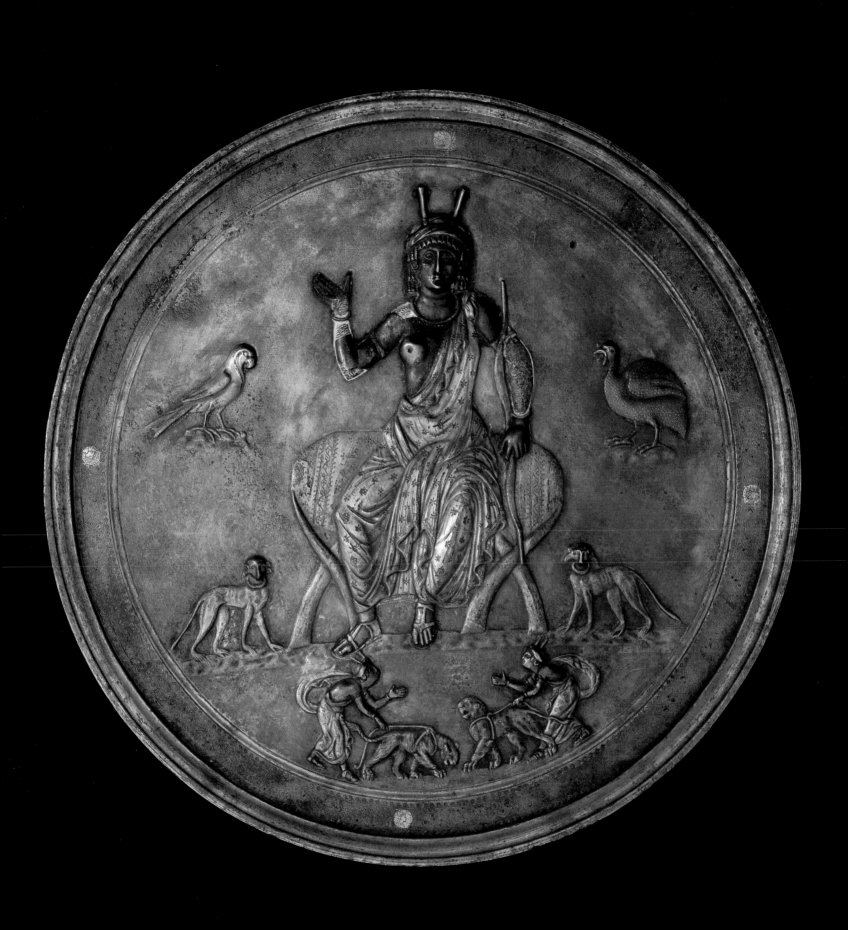

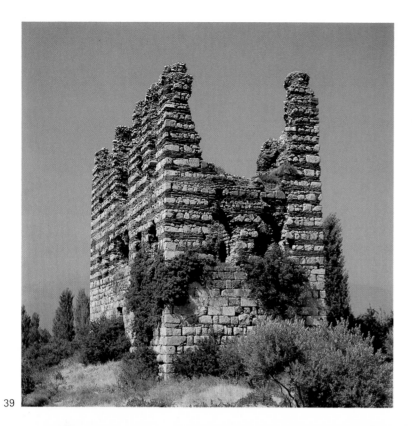

39

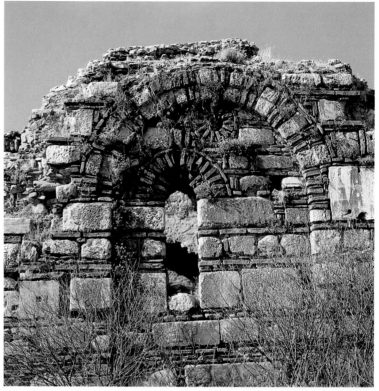

40

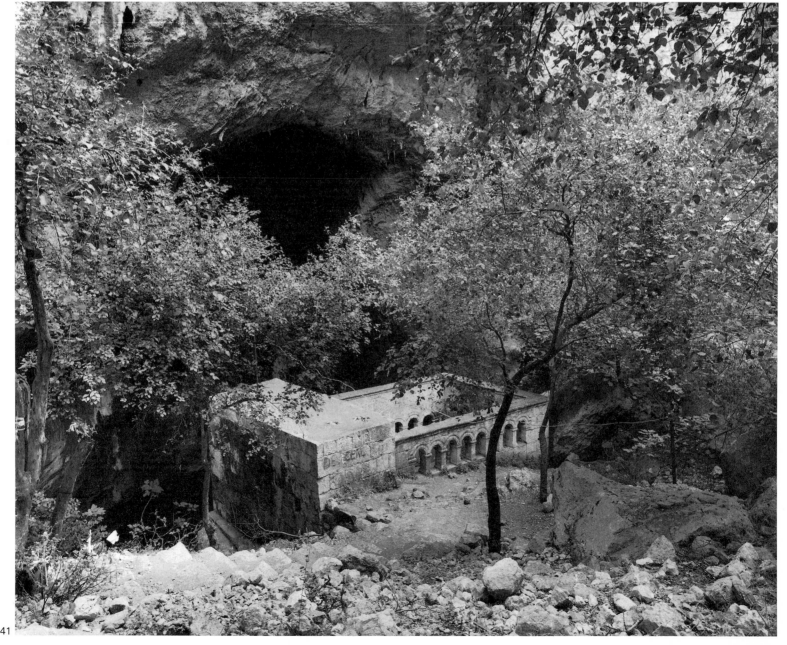

41

42

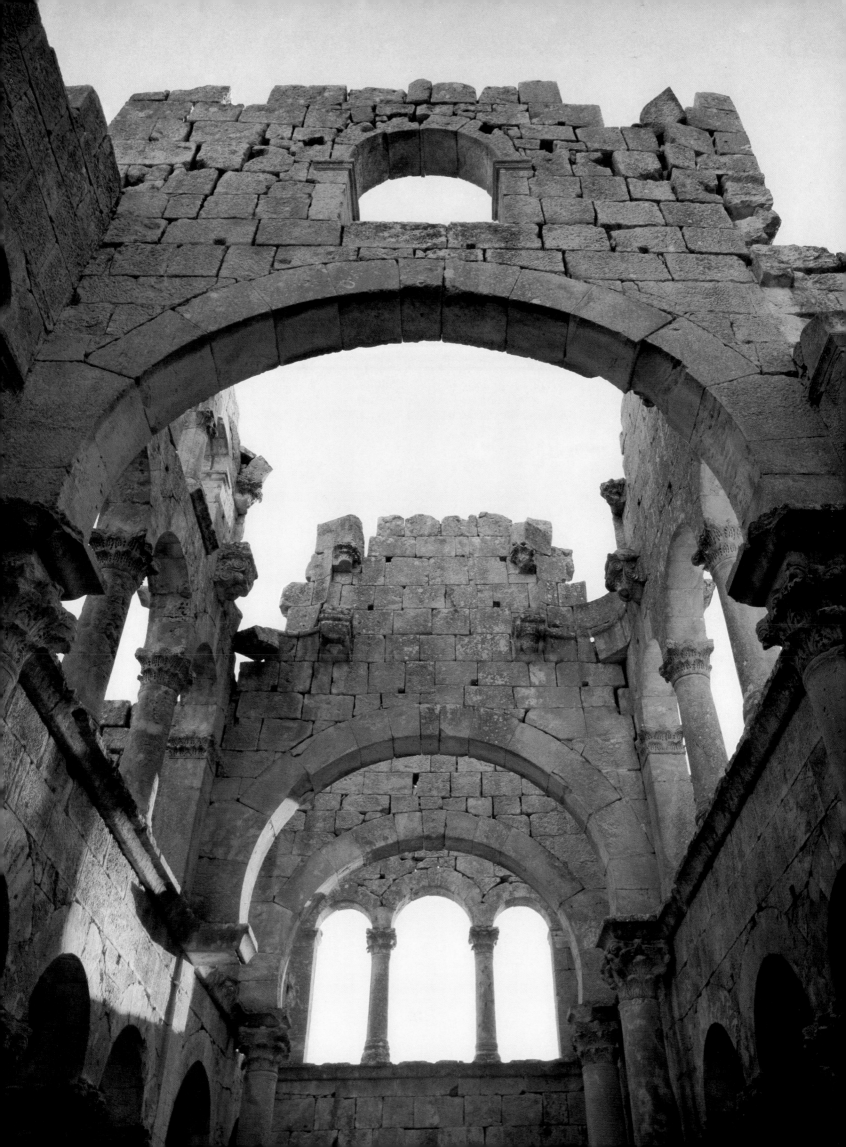

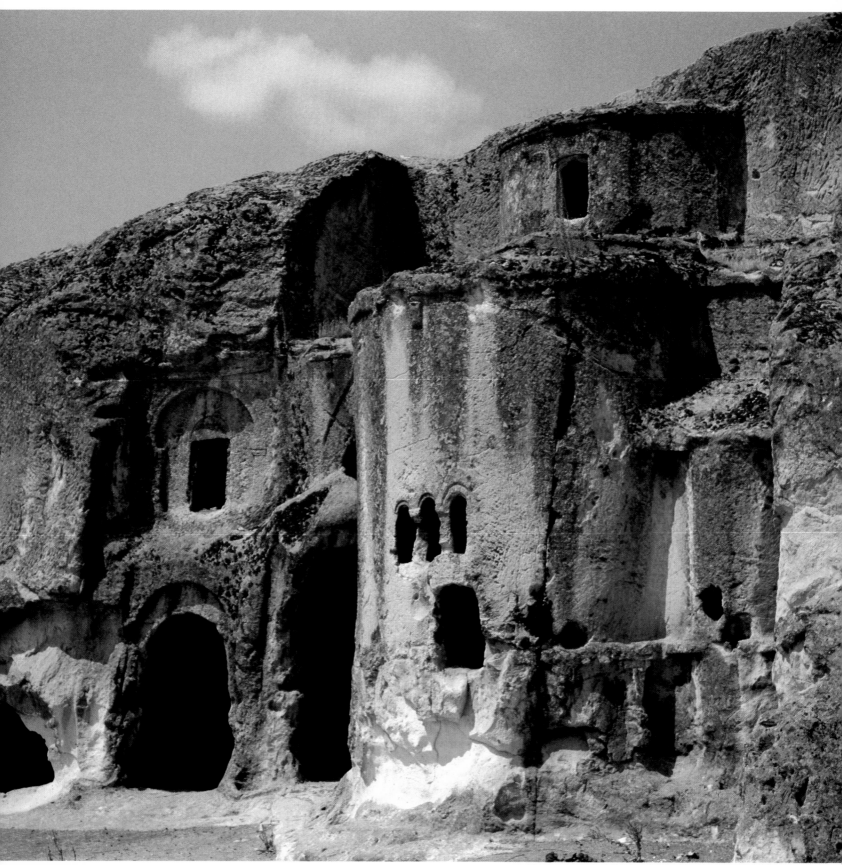

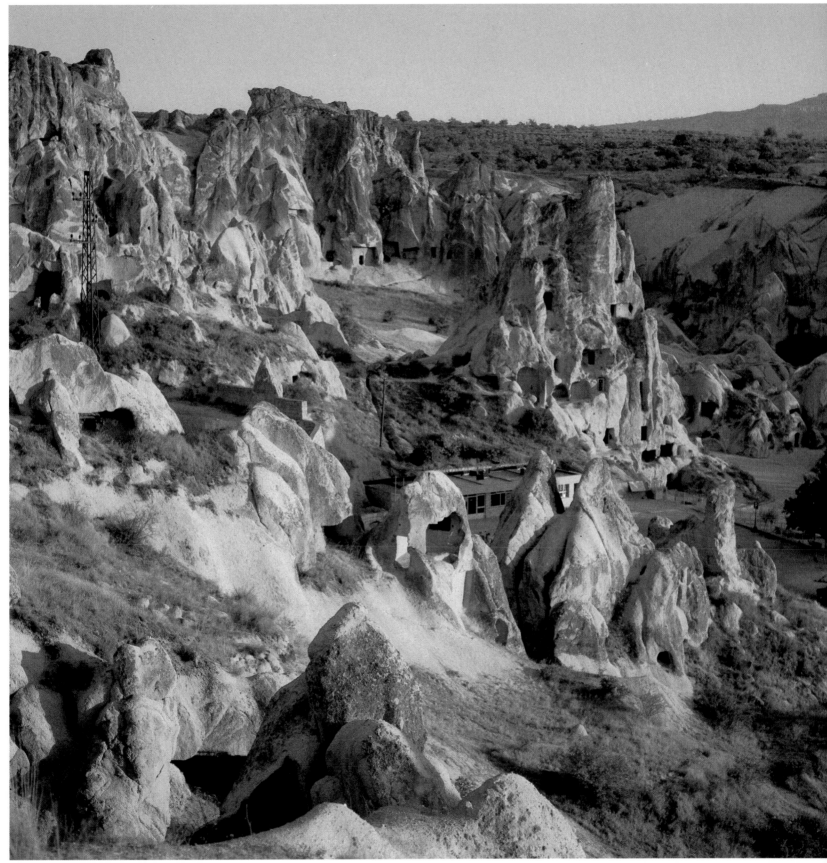

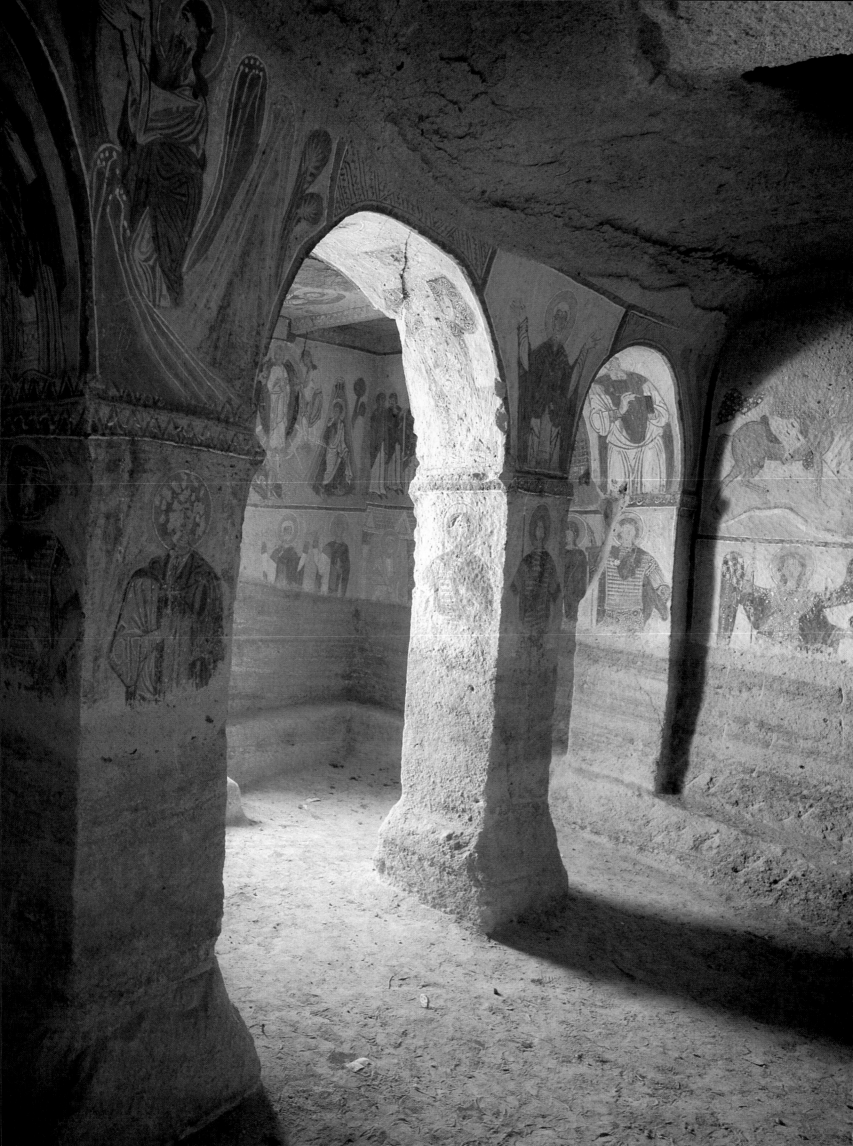

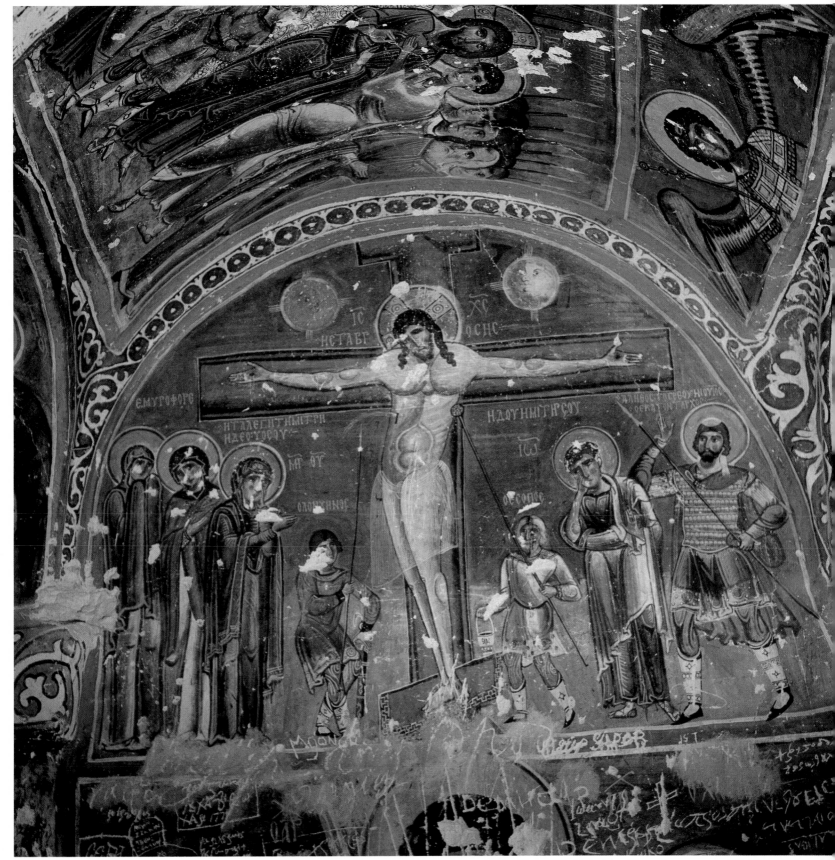

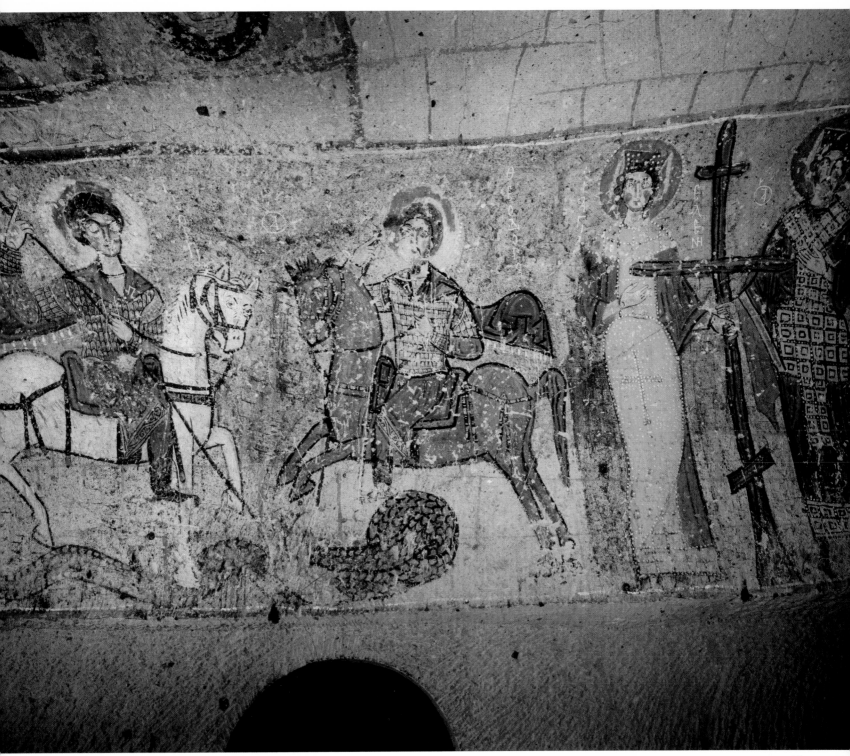

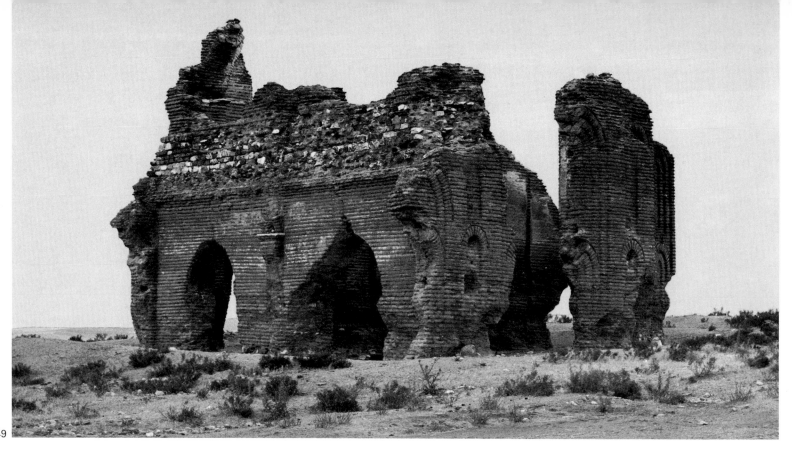

49

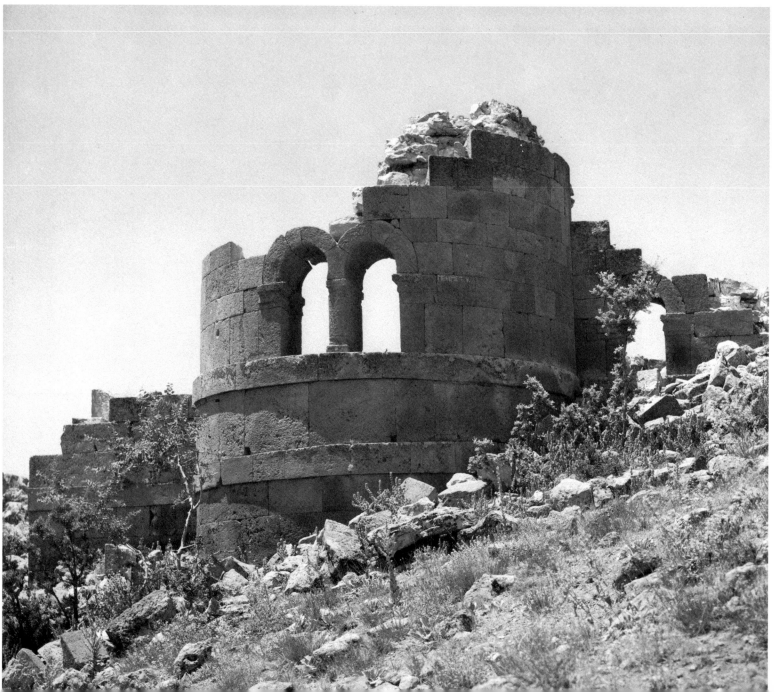

50

plan was used on a larger scale in the sixth century for the sanctuary built around the column on which had lived St Simon Stylites the Younger, one of the many emulators of St Simon the Elder. This large pilgrimage church, 18 kilometres outside Antakya, stands at the top of the Mons Mirabilis and is a replica of the church, dedicated to St Simon the Elder, at Qal'at Saman near Aleppo. Here again the centre of the architectural complex is an octagonal open courtyard, with a central column on which the ascetic saint lived. Basilicas were attached to this central octagon.

Central Anatolia

Near central Anatolia, there are a number of fortifications that are interesting from the point of view of Byzantine military architecture. The town of Kütahya (Kotaion) for example, is crowned by a medieval citadel mainly of Byzantine construction. At Ankara (Ankyra) the stonework of the city walls is patently Byzantine in character, and this attribute is borne out by inscriptions mentioning the Emperor Michael, one of the three ninth-century rulers of that name. Father G. de Jerphanion describes it thus: 'One of the peculiarities which give the citadel of Angora its special character — at the same time as its strength — is certainly the pentagonal towers arranged at more or less regular and very close intervals along the enceinte. It is perhaps the only application of a principle in fortification (expounded by the 'Taker of Cities', Philo of Byzantium) which, however, has only rarely been put into practice.' To the south, at Afyon Karahisarı (Akroenos?), on a perpendicular rock, stretches a fortress which is Byzantine in origin. One of its water tanks, dug out of the rock, bears a foundation inscription. In this region are troglodyte monuments dating from the Byzantine period. North of Afyon at Ayazin, in the centre of a site dotted with ancient tombs cut into the sides of hills, is an extremely interesting Byzantine church. It is also hollowed out of the rock

Fig. 18
Lateral façade and plan of the Byzantine church in local style, Fisandon (Dereköy).

following the Greek-cross plan, but its projecting eastern end is so carved that the rock looks like masonry.

In the centre of Asia Minor, the region of Konya (Iconium) was particularly rich in monastic foundations. Several Fathers of the Church, notably St Gregory of Nazianze, St Gregory of Nyssa, and St Basil, came from central Anatolia. Near Konya are the remains of the Convent of St Chariton, named Akmanastır in the Turkish period; the famous Muslim mystic, Mevlana Celaleddin, spent a period in meditation at the convent. It was a huge establishment, partly dug into the mountain side. The main church is conceived according to the Greek-cross plan. However, it is not the equal in either delicacy or ingenuity of execution of another troglodyte sanctuary at Ayazin. A little further west at Sille, there are a fair number of troglodyte monastic foundations, which are interesting for the frescoes covering their walls as well as for their plans. The rock churches mentioned so far show that this type of establishment was not limited to Cappadocia.

Ancient Cappadocia, which extended all round the towns of Kayseri and Nevşehir is celebrated for churches, dwellings, chapels, hermits' cells and sometimes convents

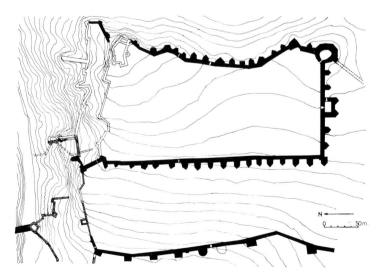

Fig. 17
Plan of the citadel of Ankara (Ankyra): note the polygonal towers.

of large size, all hollowed out of the tufa. The walls of these sanctuaries were decorated with frescoes by artists of varying ability. Most of the paintings date after the iconoclastic period. In some, the style approximates the Hellenistic tradition of the capital; in others, on the contrary, the primitive execution and iconography belong to a local school of naive and hieratic character. The church called Tokalıkilise at Göreme is interesting because it has a combination of both styles. Representations of St Helena, Constantine and St George hold a preponderant place in Cappadocian iconography. Some rock churches of Cappadocia have clear-cut plans (eg. Kubbelikilise at Soğanlı), and others are simply roughly excavated caves. The monastic church of Eski Gümüş, near Niğde, has exceptionally careful 'architecture', completed by very rich figural decoration, whereas the cave-church of Aloda, near Alacahan, is no more than a natural cavern decorated with non-figural frescoes that must be accepted as works of the iconoclastic period. It may be useful to add that of all the rock-cut sites of Cappadocia, the valley of Inlara is outstanding for its wealth of monuments, enchanting situation and diversity of buildings.

Apart from monastic life, this part of central Anatolia also had a secular side. Underground urban centres consisting of large numbers of storeys connected by climbing shafts, were hollowed out of the porous tufa. From Kırşehir in the north to Karaman in the south, there are valleys where such dwellings can be encountered − dwellings that, in the Byzantine period, held a large population. The best known of these underground rock villages is at Derinkuyu.

Central Asia Minor did not entirely abandon aboveground architecture. The sides of Mount Erciyas (Argeos) are rich in buildings in ashlar executed in local style. This local character can be seen throughout the region in both the plans and superstructures of buildings. An example is the Basilica of Eski Andaval from the sixth century, where the classical form was given quite individual appearance. The ruined Church of the Virgin at Tomarza, south-east of Kayseri, is notable for the fine masonry of its ashlar façade. It was built in the fifth century and was cruciform in plan; a square tower originally roofed with a dome on squinches marks the crossing. Other examples of this type of plan in the same region prove that it is of local architectural conception.

The same arrangement, with slight variations, appears at the church called Kızılkilise of Sivrihisar, east of Aksaray. However, at Akhisar, near Aksaray, amidst the rock-cut tombs and chapels, stands a ruined church (probably of the ninth century) called Çanlıkilise which repeats the architecture of the Byzantine capital. It is built on a Greek-cross plan with four pillars and has façades decorated with blind arcading.

A strange church called Üçayak, to the north of Kırşehir, also has the characteristic features of the architectural school of the capital. On terrain without tree or dwellings, this isolated sanctuary was apparently built in the tenth or eleventh century as an ex-voto by two co-emperors. It is a double church built entirely of brick; each church has a single nave in the form of a 'ciborium'.

Two domes, whose remains were visible until the earthquake of 1938, covered each nave.

We have already observed that the Byzantine architecture of Anatolia is rich in regional variations; for example, the buildings of Binbirkilise (the Thousand and One Churches), near Karaman, form one such separate group. The monuments scattered at the foot and on the heights of the mountains called Kara Dağ give a clear demonstration of how the principles of early Christian architecture were grafted on to the local artistic taste. In this case, the basilicas are not all like those of Hellenistic type. The aisles are not covered with wooden roofs with two or four different pitches, but with masonry vaults. The apses have twin bays, and the entrances have a double arch separated by a squat column. The capitals belong to commonly known categories. The best preserved building, and the most characteristic of the local type, is Basilica no. 1. In this area, which can be identified with ancient Barata, there are also some buildings with central plans, of which the most important was an octagonal church (no. 8) with four salient wings. It is to be regretted that this building, which so well fits the definition of the 'ideal' Martyrium of Arethas, should have recently fallen into ruin. Church no. 10 is slightly oval in shape. A little to the south of Karaman, the village of Fisandon (now Dereköy) possesses a mosque converted from a church on the Greek-cross plan of the capital, but the superstructure is built in entirely local style.

Eastern Anatolia

The Byzantine art of eastern Anatolia is known only scantily. The two churches of Silvan − one dedicated to the Virgin, the other to St Sergius, built, according to the sources, by the Emperor Maurice in 591 − no longer exist. The Church of the Virgin survives in a number of photographs, however, and was of the greatest importance. A floor mosaic, discovered at Malatya (Melitene), and the bridge of Karamağara near Ağın, south-east of Arapgir, are the slight evidences of the spread of Byzantine architecture to this region. The bridge is single-arched with a span of 14.50 metres and bears a Byzantine inscription, which unfortunately does not name the founder. Further south at Viranşehir, near the frontier, can still be seen the remains of a large Martyrium with a central plan. It is a building of the fourth or fifth century on a grandiose scale and is located in the midst of a Byzantine site where mosaics and inscriptions have also been found. Two of the inscriptions relate to the foundation of two hospices. East of Viranşehir, between Mardin and Nusaybin, can be seen the ruins of the town of Dara-Anastasiopolis, founded in 507 by the Emperor Anastasius (491–518). Here, the city walls, large cisterns, tombs and dwellings are particularly interesting. The town of Urfa (Edessa) is also significant for the Syrian mosaic pavements which have been uncovered. The Syrian school dominates the area that used to be called Tur Abdin, round the towns of Mardin, Midyat, etc. The Christian art found there is so different from Byzantine art that it is beyond the scope of this review.

Pl. 50

Fig. 18

The Black Sea Coast

A few towns on the Black Sea have Byzantine monuments. At Ereğli (Herakleia) a basilica of Hellenistic type, with a salient apse and two rows of columns inside, now serves as a mosque. The walls surrounding the old town date from the Byzantine period, as is attested by inscriptions. Among these, a long text relates the construction of a lighthouse by a Porphyrogenitus. Further east is the little town of Amasra (Amastris), which was a Genoan colony from the fourteenth century until 1461. The fortress dominating its two ports was built with material taken from Roman buildings. It is highly probable that this fortress was erected after 861, following a raid by the Rus (the Vikings of southern Russia) who had burnt and pillaged the town. These ramparts are still adorned with many Genoese coats of arms, testimonials to the Italian occupation. Within the walls there are two little churches, later mosques, modest buildings with a single nave under a roof; they are of no architectural distinction. On the same shore near Fatsa, at Bolaman, an ancient Turkish house is perched on a Byzantine church overlooking the sea. The chapel is not a work of any architectural importance, but its situation and its combination with later dwellings make it unusual and romantic.

Provincial Byzantine art is represented a little further to the west, at Trabzon (Trebizond or Trapezus), which from 1204 to 1461 was the capital of a little kingdom separate from the Empire. Only one section of wall, with a few twin bays, remains of the Palace of the Comneni, but there are a number of quite well-preserved churches to show religious architecture. The oldest is probably the Church of St Anne, restored, according to an inscription, about 885 by Emperor Basil I. It is a modest church with three aisles, covered with barrel vaults, similar to those at Binbirkilise. Originally, the Cathedral of the Virgin Khrysokephalos (now Ortahisar Mosque) was probably a basilica to which pillars and a supporting dome were added. The church has thus assumed the aspect of a Greek-cross building of elongated form. The Church of St Eugene (now Yeni Cuma Mosque) is another ashlar building on a Greek-cross plan, dominated by a dome on a high drum. The existence of barrel vaults over the corner cells is a characteristic feature of the local architectural school. The Church of St Sophia outside the town was originally a monastic church built in the thirteenth century. Unique in Asia Minor, the church has an isolated belfry which is perfectly preserved. This tower has several storeys, one of them with a salient apse forming a chapel. The inner walls of the belfry are divided into several registers covered with frescoes painted in 1444. The church is built on the Greek-cross plan but in

local style, apparent in the façades, the proportions of the exterior profile, the salient porches, the shape of the drum and the dome, etc. The carved decoration is totally foreign to Byzantine art, showing rather the influence of the Caucasus (Armenia and Georgia) or even of Seljuk Turkey. The floor of the central nave is decorated with a magnificent pavement with geometric interlacings carried out in multicoloured natural stones. An English team has recently exposed all the pictorial decoration of the frescoes in the church, which were painted about 1260. In general the style follows the artistic tradition of Constantinople, with few local variations, but the distribution of the scenes differs from 'western' Byzantine art. In the centre of the half-dome of the apse is a *Pantokrator* framed by an inscription from a passage of the Psalms (CII: 19–20). The lower part of the dome contains figures of angels, while the pendentives are covered with the four Evangelists and scenes of the Nativity, the Baptism, the Crucifixion and the Descent into Limbo (*Anastasis*).

The hills dominating the town of Trabzon are covered with monasteries and hermits' caves. At Akçaabat (Platana) near Trabzon are two large churches one of which has an *opus sectile* pavement. The largest monastery of the region is the Convent of the Virgin Soumela which was built on the mountain side around a natural cave that served as a church. This cave church seems to date from the fourteenth century, though the buildings of the vast monastic complex are from the last century. The frescoes covering the outer walls of the church are strikingly similar to the paintings in Moldavian churches, which had close connections with the Convent of Soumela. It is easily seen, however, that under this later decoration there is a much earlier layer, probably of the Comnenian period; the earlier iconography is completely different from the paintings of the upper layer. Towards the interior, in the mountain region, there are many more Christian monuments. Very important monuments exist at Bayburt and at Shebin Karahisar. Further west at Amasya (Amaseia), the apse of a large basilica converted into the Fethiye Mosque can be seen, and there are Byzantine frescoes in one of the earlier tombs. The local museums have examples of minor arts and, more especially, a large number of architectural fragments dating from the Byzantine period. The collections of the museums of Izmir, Bergama, Konya, Bursa, Iznik, Afyon Karahisarı, Adana, etc. are very rich in this material. The fine collections of mosaic pavements exhibited in the museums of Adana and Antakya (Antioch) cannot be left unmentioned, nor can a collection of metal objects from the treasure of a sixth-century church at Kumluca, at present on display in the museum of Antalya.

Anatolian-Seljuk Architecture

by Aptullah Kuran

Historical Background

Islam began to penetrate into central Asia towards the end of the seventh century. While the Arabs continued their conquest of that region, nomadic Turkish tribes began to accept the Islamic faith. The Turks were good soldiers, famous for their skill in archery and on horseback. This fact did not escape the notice of the Abbasids. From the second half of the ninth century, Turks replaced the Persian soldiers serving under the Abbasid caliph of Baghdad. Within a short time, Turkish officers rose to be commanders of the Abbasid armies: for instance Ahmet ibn Tulun, who virtually ruled Egypt as an independent state at the end of the ninth century, was a soldier of Turkish origin.

By the first half of the eleventh century, the first Turko-Islamic state (founded in 977 by Sebük-tekin, with its capital at Ghazni) had expanded to the Indus valley, and the Ghaznevids had established Turkish sovereignty over peoples of non-Turkish origin. Further to the north, the Karakhanids succeeded in uniting the Turkoman tribes in Transoxiana and founded the first truly Turko-Islamic state. To the west of the Karakhanids' territory were the Oghuz (Ghuzz) Turks from whom the Seljuks are descended. The Seljuk dynasty derives its name from Seljuk, an Oghuz nobleman, who embraced Islam towards the end of the tenth century, and soon afterwards declared *jihad* (holy war) against the pagan Turkish tribes in the area. Upon Seljuk's death, the family divided into two branches: his son Arslan established himself in Bukhara; his two grandsons, Chaghri and Tughrul, moved towards Khorassan. By 1028, the two brothers had taken the cities of Merv and Nishapur, and when they defeated Sultan Mas'ud of Ghazni in the Battle of Dandanakan in 1040, the whole Iranian plateau lay open to the Seljuks.[1]

Tughrul annexed Isfahan in 1050 and five years later entered Baghdad as the protector of the Abbasid caliph, who conferred upon him the title of Sultan al-Mashrik w'al-Maghrib (the King of the East and West), giving him the right and the mission to conquer all Muslim territories and especially those that did not recognize the Abbasid caliphate.[2]

When Tughrul died in 1063, he was replaced by Chaghri's son, Alp Arslan. The new sultan proved to be as capable a military commander as his uncle. He planned a campaign into Syria and Palestine. His objective was to capture Egypt and to put an end to the Fatimid Shiite rule there. In order to protect his rear against attack when he moved south, he annexed the Kingdom of Armenia. The Seljuk expansion on their eastern frontier so troubled the Byzantines that they decided to retaliate by force. The Emperor Romanos IV Diogenes met Alp Arslan in the plain of Malazgirt (Manzikert) on 26 August 1071, and by the evening of that same day the Seljuks had dealt a severe blow to the Byzantine armies. Alp Arslan's victory at Malazgirt opened the gates of Anatolia to the Seljuks, and Turkoman tribes began to move into this new territory without meeting much resistance.

After the Battle of Malazgirt, Alp Arslan did not personally take charge of the conquest of Anatolia; he entrusted this task to Emir Suleyman, a distant relative. Emir Suleyman crossed Anatolia from one end to the other, and by 1078 he had captured Iznik (Nicaea) and had taken this important Roman and Byzantine city as his capital. Anatolia had become a province of the Great Seljuk Empire, whose most brilliant period was during the reign of Malikshah and his famous vizier Nizam al-Mulk, but which disappeared from history after the death of Sultan Sanjar in 1157. However, the Anatolian Seljuks (also known as the Seljuks of Rum) continued to exist as a political entity for another hundred and fifty years; then they dissolved into a number of *beyliks*, principalities or emirates.

If the Battle of Malazgirt opened the gates of the Anatolian peninsula to the Seljuks, a second decisive victory against the Byzantines, one hundred and five years later, marked another significant turning point in Anatolian history — for after the Battle Myriakefalon, Byzantine forces were never again to challenge the Seljuks

in a major battle. It was after 1176 that the Turkish civilization began to flourish in Anatolia and that Konya, the Seljuk capital, became a cultural centre.

The reigns of Gıyaseddin Key-husrev (1204–11) and his son, İzzeddin Keykavus (1211–19) were years of rapid development. When Keykavus died of tuberculosis in his mid-thirties, he left behind a formidable army and a well-organized, efficient administration. An intelligent ruler with foresight, Keykavus refrained from executing his capable but troublesome younger brother Alaeddin. This benevolent decision proved to be a good one for the future of the state, because Alaeddin Keykubad, who succeeded his brother, was to turn his eighteen-year reign (1219–37) into the Golden Age of the Anatolian Seljuks.

At the time Alaeddin Keykubad ascended the throne, Mongol expansion in Asia had already begun. Sensing that the Mongol invasion would extend as far as Asia Minor, Keykubad sought to strengthen the Seljuk state militarily, politically and economically. His reign was distinguished not only by his successful military campaigns and political moves, but it was also an era of economic prosperity, growing trade and refined cultural achievement.

The untimely death by poisoning of Alaeddin Keykubad proved most unfortunate, for the son (Gıyaseddin Key-husrev II, 1237–47) lacked his father's intelligence and strong character. Nevertheless, the momentum of the Keykubad period continued for a few more years. Seljuk armies defeated the Ayyubids who were forced to recognize the supremacy of the former. On the other hand, internal strife caused by the religious Babai order left Anatolia in turmoil. The Babai uprising turned the Turkomans against the Seljuk state. Although the revolt was suppressed, the wounds it opened were deep. The Mongols did not miss this opportunity. They marched into Anatolia, seized Erzurum in 1242 and dealt a severe blow to the Seljuk forces a year later at the Battle of Köse Dağ. The important cities of Sivas, Erzincan, Tokat and Kayseri fell to the Mongols and were pillaged. Key-husrev II retreated to Antalya. The Seljuks accepted defeat and requested a settlement. In return for heavy yearly tributes, the Mongols agreed to evacuate the captured Seljuk territory.

The Anatolian-Seljuk state continued to exist for another sixty-five years but with diminishing power emanating from Konya. When Hülagü, the Ilkhanid (Persian Mongol) ruler, captured Baghdad, razed it to the ground and put an end to the Abbasid caliphate in 1258, Anatolia received her share of renewed Mongol attacks. Konya was seized, sacked, and the sultan was deposed as other sultans would be in later years at the whim of the Mongols. However, despite continuing Ilkhanid pressure from the east, the Seljuks managed to survive by maintaining good relations with the Ilkhanids, while looking for ways to save Anatolia from their yoke. The Seljuks were able to conclude an alliance with the Mameluke sultan Baybars, and in 1277 the Seljuks and Mamelukes together defeated the Ilkhanids at Elbistan. The victory, however, was short-lived. Sensing a strong retaliation, Baybars pulled back his troops from Anatolia. Left alone, Seljuk forces were easily overpowered by the Ilkhanids, who openly dominated the Seljuk state from 1279 onwards. In 1281, the Ilkhanids replaced Key-husrev III with Mas'ut II. During the next sixteen years, while the authority of the Seljuk royal house weakened and the state disintegrated into a number of principalities, Mas'ut II had an uneventful reign, but in 1297 he was forced to abdicate in favor of his cousin, Alaeddin Keykubad III. Keykubad III transferred the capital from Konya to Sivas and ruled from this city until his death in 1302 when Mas'ut II was reinstated. Settled in Kayseri, Mas'ut II died there in 1308. This time, the Ilkhanids did not even bother to install a new sultan: the Ilkhanid Uljaitu Muhammad Hudabanda (1304–16) assumed the mantle of the Seljuks himself – Anatolia had become a province of the Ilkhanid Empire. The Anatolian-Seljuk sultanate had totally collapsed.

Towns and Countryside

Unlike the complex, architecturally sophisticated cities of the Sassanians and the Byzantines, which they dominated by the end of the seventh century, the cities that the Arabs founded during the first century of Islam were in harmony with their serious disposition and with their simple, nomadic, military life. Kufa and Basra, the two towns in Iraq founded during the time of the Caliph 'Umar, were built around a core composed of the Great Mosque, the governor's residence and the administrative offices. Those buildings were initially constructed of dry mud but soon afterwards rebuilt in brick.[3] Beside the mosque was the camel or sheep market, which served as the centre of social activity.

In founding Baghdad (AD 762), the Abbasid caliph al-Mansur perpetuated the simple and unpretentious Arab tradition. To establish a well-protected seat of government, he had it fortified by a wide and deep ditch and a massive double wall. The circular city was approximately 600 metres (1000 cubits) in diameter, had four gates (one at each end of the major streets) that formed a cross and divided the city into four quarters, and in the centre were the caliph's residence, the Great Mosque and the administrative offices, expressing the intimate relationship between religion and state.[4]

Arab expansion into central Asia, and the subsequent impetus Islam had on the converted Turks not only inspired them to extend the boundaries of the Faith but also stimulated urbanism. For Islam, like all universal religions, favoured sedentary societies.

Under Ghaznevid rule, Ghazni became one of the important centres of culture in Asia. The Mosque of Arus al-Falak (Bride of Heaven), built by Mahmut at Ghazni, was a great hall of red and gold wooden pillars richly decorated with lapis lazuli.[5] The palace complex of Lashkar-i Bazar, near the citadel of Bust, is another example of Ghaznevid urbanization with a core of several palaces, a Great Mosque and a bazaar.[6] The semi-legendary Karakhanid ruler, Satuk Bughra Khan, led a nomadic tent life with his troops, known as the 'ordu', but the Khan attached great importance to enriching the towns

within his state with mosques and other architectural works.[7] The Seljuks, too, although initially they were a nomadic people, began to settle in the towns they seized and to endorse extensive building programmes. The Khrossanian towns of Tus, Merv and Nishapur and, further to the west, Rayy and Isfahan were adorned with mosques, madrasahs and other public buildings.

In Anatolia, the Turks found established urban centres linked by trade routes. Roman cities and fortified Byzantine towns, though impoverished and in poor repair, existed in abundance, and there was little need for the Seljuks to found new towns.[8] During the eleventh century in Anatolia, the central authority of Constantinople had already disintegrated. The Seljuks, after consolidating their power, were able to re-establish order, revitalize the economy, restore and enlarge the towns and recreate the healthy environment essential to the commercial and cultural activities of urban living.

The largest town under the Seljuks was Konya, the old Roman *castrum* of Iconium. When Barbarossa's Crusaders came there in 1190, one of them described Konya as the size of Cologne, with walls and a citadel.[9] However, these fortifications were judged inadequate by Alaeddin Keykubad I who had them more or less completely rebuilt in AD 1221 (AH 618).[10] The outer walls, built by Keykubad, were roughly circular in shape, and there were 144 towers[11] constructed of finely cut stone and decorated with antique columns on which were elephants, lions, deer and dragons in high or low relief.[12] At the centre of the walled city was a mound that was also almost round and fortified. It contained a Great Mosque and the palace of the sultan. Although the mosque is extant, the royal palace and the inner fortress, with the exception of one tower, have disappeared. The outer fortifications have also been demolished completely so that no walls remain. This round Anatolian-Seljuk city emulated Baghdad and the ideal Muslim urban scheme.

On the other hand, the walls of Diyarbakır (Amida), the capital city of the Artukids, remain almost intact. The city is roughly elliptical in shape, extending 1700 metres from east to west and 1300 metres from north to south. Buttressed by round and square towers, the walls measure ten to twelve metres in height and three to five metres in thickness. There are four gates placed on the cardinal points of the compass, and the city was divided into four quarters by two arteries that stretched from east to west and north to south, between the gates. The Great Mosque, with its spacious forecourt surrounded on three sides by arcades and public buildings, is situated slightly to the north-west of the intersecting arteries. The Malik's palace is placed inside the citadel which overlooks the River Tigris to the north-east of the city.

Konya and Diyarbakır were large cities enclosed within walls, but they were the exceptions, since most Anatolian-Seljuk cities sprawled beyond their fortified boundaries. In general terms, the typical Anatolian-Seljuk city comprised three parts: the fortress, the inner town and the suburbs.

An interesting aspect of Seljuk town planning in Anatolia is its lack of geometric order, axiality and articulated spatial organization, which, in all probability, stems from the amorphous character of the pre-Seljuk towns. The Seljuks seemingly had little concern for domestic architecture and physical planning at the urban level. On the other hand, a keen sense of planning at the regional level can be observed, for the Seljuks created a vast communication system in Anatolia, which not only revived the historical land routes between Europe and Asia but also linked their cities and towns, encouraging social and economic intercourse and highlighting Anatolian-Seljuk civilization.

During the Seljuk-Byzantine wars and the crusades, the security of the Anatolian highways had diminished, and trade between Europe and Asia had shifted to the costlier but more reliable sea routes. Declining Arab superiority in the eastern Mediterranean, and expansion in the volume of intercontinental trade in the aftermath of the crusades, did not escape the notice of the Seljuks.[13] Realizing the importance and the economic rewards of intercontinental trade, Kılıçarslan II and his successors charted and launched an ambitious project to encourage merchants to return to the Anatolian routes. They adopted the Roman and Byzantine highway network, repaired old roads and bridges, built new ones, lowered custom dues, safeguarded the security of the caravans by armed escort and developed a simple insurance system whereby any trader who was robbed within Seljuk waters or territory was reimbursed for his stolen goods by the Seljuk State Treasury.[14]

But perhaps the most formidable measure of all were the *hans* (caravanserais) that were built on the highways. Seljuk *hans* were fortified buildings with a dual function: in times of war they served as armouries and military barracks, but they were primarily used as rest houses for caravans. Located approximately a day's journey from one another, they differed considerably in the services they offered. The largest ones, founded by the sultans, had stables for camels and horses, comfortable quarters for travellers, a mosque and a bath. Some had a resident physician, a library for the learned and chess sets for the illiterate. Those of modest size offered only food and shelter. But large or small, they were free of charge. Whether he be a merchant or a pilgrim, illiterate or learned, poor or well-to-do, each traveller was lodged and fed for up to three days as a guest.[15]

The old Roman road system in Anatolia was modified by Justinian so that the major caravan routes went to and from Constantinople. Likewise, the Seljuks effected their own modifications and created a new network in which all major roads converged in Konya. The caravanserai-building programme emanated from the capital, and within half a century, all important Seljuk cities were linked by caravan routes studded with *hans*.

Needless to say, the major arteries functioned not only as conduits for commercial and political activity in the medieval world but also as channels of cultural exchange between the Islamic and the Christian world. Thus Anatolia, where east and west came into close contact, was revitalized once again by the Seljuks, who injected into this ancient land a new spirit imbued by the Turko-Islamic civilization, as attested by the unique art and architecture that they created.

Architectural Works

Early Islamic architecture was simple and modest, as we have seen, reflecting the indigenous construction materials and building technique of the Hijaz. Seventh-century buildings, such as the Mosque of Amr ibn al-As, built in 641 to 642 at Fustat (Cairo), were nothing more than mud-brick walled sanctuaries, covered with a thatching of palm-leaves on beams supported by posts of palm-trunks.[16]

During the eighth century, Islamic architecture in Syria came under the influence of the local Byzantine culture. Mosques in Syria were often converted basilicas, and even the original buildings, dating from the Umayyad period (661–750), bear strong resemblances to those built in this region during the Byzantine rule. Likewise, the mosques of Qairwan in Tunisia or Cordoba in Andalucia show that the Byzantine-inspired Umayyad architecture found a wide and rapid growth in the Maghreb.

During the Abbasid period (750–1258), when the centre of power in the Islamic world shifted from Damascus to Baghdad, Byzantine influence gave way to that of the Sassanians. The eighth-century fortress-palace of Ukhaidir or the ninth-century Great Mosque of Samarra are related to Mesopotamian rather than Mediterranean architecture. Abbasid buildings incorporated iwans (vaulted recesses open on one side) that served as vestibules to square halls. This feature is seen in Sassanian as well as in Parthian architecture, but it was imported to Mesopotamia from Khorassan.[17] So, as Islam penetrated further to the east, the iwan assumed a more prominent position in Islamic architecture.

The cruciform plan had been used in Afghanistan since ancient times.[18] As the Turko-Islamic states emerged in central Asia, it was only natural that this regional system of architecture should play an important role in monumental works and that manifestations of the cross-axial four-iwan scheme can be seen in Ghaznevid palaces, Karakhanid ribats (dervish convents) or Seljuk caravanserais, madrasahs and mosques.

It is interesting to note that although the four-iwan scheme played an important role in Anatolia, it was not the key feature of Anatolian-Seljuk architecture. In fact, it would be inappropriate to attribute this architecture to any one source or to a single model. That it owed a clear debt to the east cannot be disputed: traces from central Asia, Iran, Mesopotamia and Syria can readily be observed, but equally evident are influences from Anatolia itself. For this reason, Anatolian-Seljuk architecture should be viewed not as an extension of the Great-Seljuk architecture in Iran but as a new synthesis of Turko-Islamic civilization.

Unlike Great-Seljuk buildings in Iran, which were essentially of brick, Anatolian-Seljuk buildings were almost invariably built in stone, and it is obvious that the Seljuks adopted certain local masonry techniques along with local building materials. It is equally obvious that the Seljuks must have been inspired by the wealth of architecture in Anatolia, because certain stylistic influences in their works can be traced to Anatolian

sources. But unlike the Umayyads, who fully embraced the Byzantine style, or the Artukids, who adopted early Islamic models that emerged in Syria and Iraq, Anatolian-Seljuks developed their own architecture, which has a distinctive form, spatial organization and decoration.

Mosques

The oldest mosque within the borders of Turkey is the Ulu Cami (Great Mosque) of Diyarbakır, which is dated to the seventh century. However, according to the several inscriptions on its walls, it was reconstructed by Malik-shah in 1091 to 1092 (AH 484) and underwent major restorations at the turn of the twelfth century and again in 1224 to 1225 (AH 518), during the Inalid period.[19] The Great Mosque of Diyarbakır has a high central hall covered by a timber-trussed roof and flanked by lateral aisles running at right angles to it. The Great Mosques of Urfa (Edessa) and Cizre (1155–6/AH 550), on the other hand, have cross-vaulted prayer halls and both are accented by a dome above their mihrabs. The dome of the first is modest, but that of the second may be considered the precursor of the monumental mihrab domes to come, since in this mosque (which consists of four lateral aisles) the diameter of the mihrab dome is equal to the depth of two aisles. In the Great Mosques of Silvan (Meyyafarikin), probably completed in 1157;[20] of Mardin, dating from the last quarter of the twelfth century, and of Kızıltepe (Dunaysir), dated 1204 to 1205 (AH 601), the dome has an additional bay in the rear.

Twelfth-century mosques in eastern and central Turkey, unlike those in south-eastern Turkey that follow a pattern of distinct development, may be defined as unrelated experiments in building rather than products of a definite architectural style. The Great Mosque of Bitlis, which was probably built in 1150 to 1151 (AH 545)[21], has an oblong rectangular mass with a small dome above the mihrab. The Great Mosques of Harput and of Niksar, both dating from mid-twelfth century, also have small mihrab domes. But of particular significance in these mosques are the small courtyard and the brick minaret of the first mosque and the longitudinally oriented rectangular mass of the second one. Another mid-twelfth century structure, deeper than it is wide, is the Great Mosque of Kayseri. This mosque has an inner organization consisting of a nave flanked on either side by double aisles. There are two domes: one in front of the mihrab and another further down the nave. The mihrab dome is old, but the second dome dates from the nineteenth century and covers what was originally an open-topped bay that served as a light-well and as an air vent.[22]

A most important Seljuk work in central Anatolia is the Old Mosque, or the east wing of the Mosque of Alaeddin, in Konya. It is believed to have been built by Mas'ud before 1155 — the date of its inscribed minbar (pulpit). The Old Mosque comprises a trapezoidal interior, studded with rows of Hellenistic and Byzantine columns, tied together by pointed arches that run parallel to the mihrab wall in a manner not unlike that found in the seventh-century Arab mosques. Another early Seljuk

Fig. 19

Fig. 20

Fig. 21

Pl. 52

83

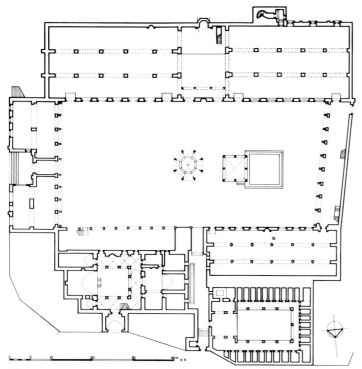

Fig. 19
Plan of the Great Mosque (Ulu Cami), Diyarbakır, 7th cen., rebuilt in
1091–2 and restored later.

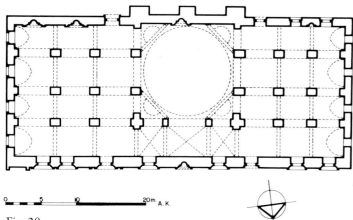

Fig. 20
Plan of the Great Mosque, Meyyafarikin (Silvan), finished c. 1157.

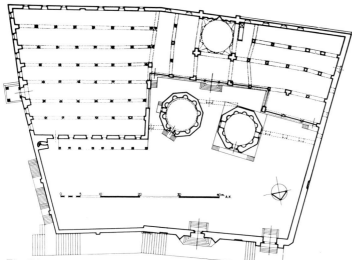

Fig. 21
Plan of the Mosque of Alaeddin, Konya, before 1155: *on the left*, the
Old Mosque.

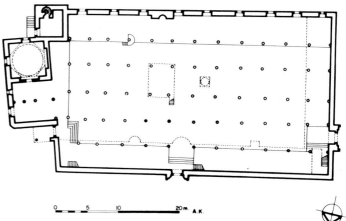

Fig. 22
Plan of the Great Mosque, Sivrihisar, 1274.

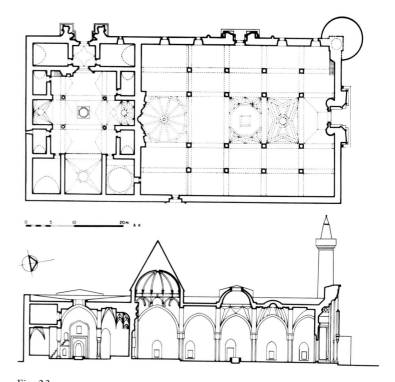

Fig. 23
Plan and longitudinal section of the Great Mosque and hospital,
Divriği, 1228–9: *on the left*, the hospital, *on the right*, the Great
Mosque.

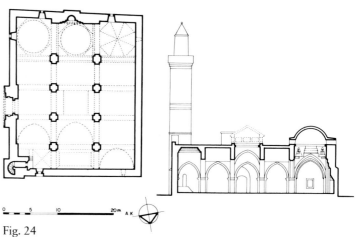

Fig. 24
Plan and longitudinal section of the Alaeddin Mosque, Niğde, 1223.

84

mosque, built according to its inscription in 1196 to 1197 (AH 593), is situated in Sivas. It is also organized in the form of a series of aisles, but unlike the Old Mosque in Konya, the aisles in Sivas are defined by arched stone piers that run at right angles to the mihrab wall, i.e. counter to the basic mass of the building that is a rectangle placed laterally with respect to the qiblah axis.

In simple architectural terms, the traditional type of mosque, with a laterally set transept, continued to be built during the thirteenth century, as exemplified by the Great Mosques of Sinop (1267?) and Sivrihisar (1274/ AH 637). But more often than not, thirteenth-century Anatolian-Seljuk mosques are of the basilica type, with the longer arm of the rectangular structure placed on the qiblah axis. Then, too, the light-well, situated approximately halfway down the nave, becomes an important feature. Although these light-wells were subsequently covered by masonry domes or wooden roofs, the light-well of the Great Mosque in Divriği (1228–9/AH 626) was originally surmounted by an open-topped dome, and a fountain-pool was placed directly beneath the oculus. An articulated and refined Great Mosque of the axial or basilica type, the Great Mosque of Divriği is one of the most interesting and ornate thirteenth-century buildings in Anatolia. Its wide nave is separated from the double aisles on either side by four rows of four octagonal stone pillars. In front of its ornate mihrab, there rises a twelve-ribbed dome, encased in a dodecahedral stone cap. Halfway down the nave is another dome, this one having an oculus. The remaining twenty-three bays are surmounted by cross vaults; a large number of them are in the form of four-pointed stars of varying designs.

Another basilica-type mosque, the Alaeddin in Niğde (1223/AH 620), is three bays wide and five bays deep. In this mosque, all three bays along the mihrab wall are covered by domes. A similar triple-dome scheme is seen in the Great Mosque of Sinop, which has two lateral rows of seven bays. Of the total of fourteen bays, nine are cross-vaulted and five are domed. Two of the domes are placed at the rear corners of the prayer hall; the others cover the three middle bays of the first row.

In Niğde and Sinop, triple-domes occur along the mihrab walls. In the Burmalı Minare (spiral minaret) Mosque in Amasya (1237–46), the three successive domes are placed lengthwise along the nave. But the most significant development in the use of the triple-dome scheme is seen in the Gök Madrasah Mosque in Amasya, dating from the third quarter of the thirteenth century, where the upper structure consists of a series of triple-domed units arranged longitudinally and transversally, with vaulted bays in between. This mosque may well be considered the prototype of the multi-domed, early Ottoman Great Mosque, whose interior is divided by pillars into equal square units, each of which is surmounted by a dome.

In the second group of mosques from the Seljuk period, the interior is studded by a great many wooden posts. The upper structure is also of wood, and the roof is protected by two feet of soil put on top of wooden slats and straw matting. This type of mosque has an unassuming external appearance. The windows, cut into crudely built stone walls, are generally devoid of ornamentation, and with the exception of the portal, there is little to suggest the wealth and warmth of the space within. In at least two of the Anatolian Great Mosques of this type, we see Hellenistic or Byzantine marble capitals on top of the wooden posts. In many of them, similar antique capitals are used as post bases; in others, the capitals are either beautifully carved or built of small pieces intricately nailed together, the best example being those of the Great Mosque of Afyon (1272?) and the Eşrefoğlu Mosque in Beyşehir (1299–1300/AH 699).

During the eleventh and twelfth centuries, mosques with carved wooden posts are known to have existed in central Asia. It is also known that carved wooden posts were used as supports in Turkoman tents.[23] We can reason, therefore, that when the nomadic Turkomans in central Asia were converted to Islam, they initially prayed in tents, and these portable prayer tents were a source of inspiration for the mosques in the Turkomans' sedentary future. This leads us to believe that, unlike the Anatolian-Seljuk mosques with stone pillars, in the evolution of which local materials and methods played an important part, the mosques with wooden posts are a direct contribution of Turkish culture to the Anatolian architectural heritage.

Masjids

Masjid, in Turkish usage, is a small neighbourhood mosque without a minbar (pulpit). An Anatolian-Seljuk masjid is often a square building surmounted by a dome. Its walls are constructed of brick or rubble, but where the latter is used, the façade is often finished with cut stone. Its dome, on the other hand, is invariably built of brick, and the transition from the hemispherical dome to the square base is effected by squinches or a row of prismatic consoles called Turkish triangles. In some masjids, the domes as well as the squinches and Turkish triangles are decorated with glazed bricks or faience mosaic. However, those which collapsed were often crudely reconstructed, and the brick work was covered with a coat of plaster.

The basic unit of the Anatolian-Seljuk masjid—a domed-cube—was generally built with an anteroom or a porch having two or three bays. With one exception, upper parts of thirteenth-century masjid minarets have collapsed. However, old photographs, showing some of them intact, indicate that masjid minarets were very high in proportion to the domed prayer room and, unlike mosque minarets that have only one balcony, they had twin balconies.[24]

The Masjid of Ferruh Shah in Akşehir (1224/AH 621) is a tiny stone structure supporting a hemispherical dome. The Hacı Ferruh in Konya (1215–16/AH 612) presents a more developed form: it has an additional vestibule preceding the domed sanctuary. At the centre of the cut-stone façade, the portal is flanked by two windows, and the same system is repeated on the inner wall of the vestibule. Today, the square prayer room has an upper structure of horizontal timber beams topped by a flat earthen roof, but the fan-shaped pendentives supporting

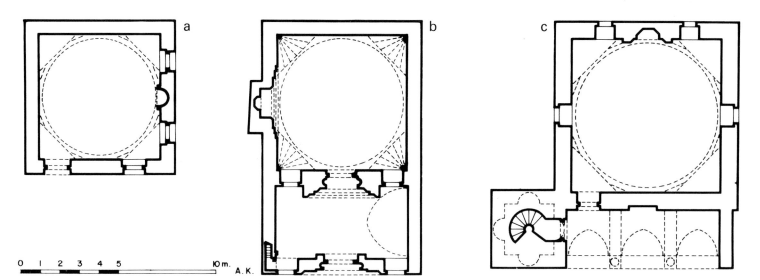

Fig. 25
Plans of masjids: a) Ferruh Shah, Akşehir, 1224 b) Hacı Ferruh, Konya, 1215–6 c) Hoca Hasan, Konya, 2nd half of the 13th cen.

the octagonal transition belt of alternating blind arches and Turkish triangles clearly show that the prayer room was originally covered by a dome.

Fig. 25c In the Masjid of Hoca Hasan (third quarter of the thirteenth century), also located in Konya, the anteroom is a wooden shed on posts but was formerly a stone porch. The most important feature of this masjid is its minaret, located to the left of the porch. The lower part of the minaret's base is of stone, but the upper level of the base as well as the shaft, built in a Greek-cross plan, are of red brick. Traces of ceramic debris under the balcony show that it was initially decorated with faience mosaic, and the existence of stairs inside the slim, grooved shaft above the balcony suggests that the minaret formerly had twin balconies. In short, the Hoca Hasan is the perfect model of a thirteenth-century Anatolian-Seljuk masjid: a domed prayer room, a porch with (probably) three bays and a minaret.

Another type of small mosque is the citadel masjid. A good example is the Citadel Masjid of Divriği which, according to its inscription, was built in 1180 (AH 576) by the Mengücek ruler Şahin Shah. It is a rectangular

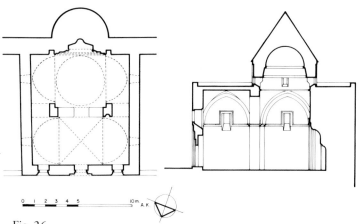

Fig. 26
Plan and longitudinal section of the Citadel Masjid, Erzurum, 12th cen.

structure, three bays wide and four bays deep. The bays of the nave are cross-vaulted, and those of the side aisles are domed.

A second example from eastern Turkey is the Citadel Fig. 26 Masjid of Erzurum, dating from the twelfth century and the Saltukid period. This masjid, too, is a rectangular structure, and it is built against the walls of the inner fortress with the mihrab fitted into a turret. The interior consists of a nave, flanked by single aisles with barrel vaults, while the two central bays are covered by a cross vault and a hemispherical dome. The latter is encased inside a high drum whose surface is decorated by blind arches and topped by a conical cap, not unlike those of the Armenian or Georgian churches in the region.

In the previous section, the columnar east wing of the Mosque of Alaeddin in Konya was discussed. The east Fig. 21 wing constitutes the oldest section of that mosque and dates from the mid-twelfth century. On the other hand, the west wing, or a portion of it, is known to have been built during the first quarter of the thirteenth century. At the centre of this wing, there is a domed bay in front of the mihrab. That hemispherical dome rests on a belt of Turkish triangles faced with multicoloured faience mosaics. The absence of ceramic decoration on the dome's inner surface shows that the original shell collapsed and was rebuilt at a later date. Likewise, at the end of the nineteenth century, the mihrab niche was completely redone in white marble. Fortunately, the wide frame was spared so that, despite this intrusion, at least a portion of the elegant, thirteenth-century mosaic work in faience remains. The domed square space (maksura) in front of the mihrab and the bay to the north of it are the only architecturally refined sections of the west wing: the rest of the bays and aisles lack symmetry and order. It does not seem possible that the poorly organized, unarticulated west wing can be, in its entirety, the work referred to as mosque, masjid and Beytullah ('House of God') in various inscriptions placed on the mosque's forecourt walls, bearing the names of the Sultans İzzeddin Keykavus and his brother and successor, Alaeddin Keykubad. What Keykavus started in 1219, and Keykubad completed a year later, is more likely a small, ornate masjid comprising a domed prayer room preceded by a

86

vestibule, like the Masjid of Hacı Ferruh or a three-aisled mosque with a wide nave and a richly decorated dome in front of the mihrab, flanked by vaulted aisles in the manner of the Citadel Masjid in Erzurum. This 'House of God' was, in all probability, the private masjid of the Seljuk royal palace, and it must have been amalgamated with Mas'ut's Old Mosque during the fourteenth century, after the palace was evacuated and left to ruin.[25]

Turbehs

Funerary structures, called turbehs or *kümbet*, occupy a special place in Anatolian-Seljuk architecture. Among the Turks, the practice of venerating the dead has its roots in central Asiatic traditions. Excavations at Pazyryk, in the Altai region, brought to light tombs dating from the fifth century BC. Chinese chronicles mention that the shamanist Gök Turks mummified the dead and kept bodies in a funerary tent for six months before burying them.[26] It is also known that, in the eighth and ninth centuries, Buddhist Uighurs built domed tombs not unlike Sassanian *chahr taqs,* which consist of a dome resting on four corner pillars.

The earliest known Islamic funerary structure in central Asia is the Mausoleum of the Samanids in Bukhara, built before 907. It is a domed cube built of brick, with rounded corners topped by four small ovoid domes. Karakhanid tombs from the tenth century are also domed cubes. On the other hand, the *Gunbad-i Qabus* in Gurgan, dating from 1006 to 1007 (AH 397), is a brick tower 55 metres high, buttressed by ten flanges terminating with a conical cap. The only decoration on the memorial is two belts of Kufic inscriptions between the flanges. A similar funerary tower, the *Gunbad-i Tuqhrul,* dating from 1139, is located at Rayy, the capital city of the Khorassanian Seljuks.

Unlike the single-chamber tombs built by the Great Seljuks, the Anatolian-Seljuk turbeh is a two-storeyed structure, consisting of a prayer chamber above a crypt. Entered through a separate door a few steps below ground level, the partially buried crypt housed one or more mummified bodies laid on a wooden table.[27] Reached by a double staircase, the prayer chamber with a mihrab contained an ornate masonry sarcophagus, commemorating the personage for whom the memorial was built.

Anatolian-Seljuk turbehs can be separated into two general groups. In the first group the upper chamber is a square, polygonal (generally octagonal) or circular chamber surmounted by a dome encased respectively in a tetrahedral, polyhedral or conical cap. The second group consists of rectangular turbehs whose prayer rooms take the form of an iwan. The Anatolian-Seljuk turbeh was built as an independent structure, but it was also integrated with another type of building when the patron wished to be remembered for his benevolence and good deeds.

Most of the earliest Anatolian tombs are located in north-eastern Turkey. Two that date from the twelfth century are the turbehs of Melik Gazi and Hacı Çıkrık in

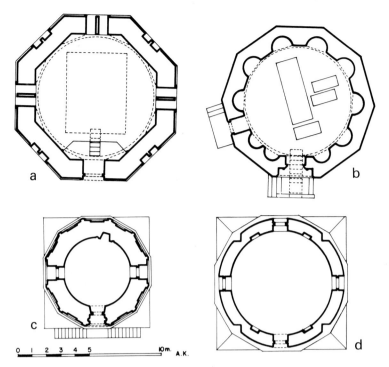

Fig. 27
Plans of turbehs: a) Emir Saltuk, Erzurum, 12th cen. b) Kılıçarslan II, Konya, last quarter of the 12th cen. c) Döner Kümbet, Kayseri, last quarter of the 13th cen. d) Ulu Kümbet, Ahlat, last quarter of the 13th cen.

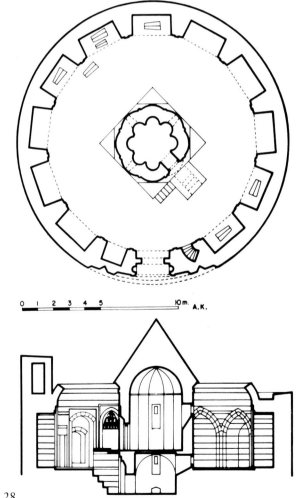

Fig. 28
Plan and section of the Turbeh of Mama Hatun, Tercan, 1st quarter of the 13th century.

Niksar. They both have square chambers and tetrahedral caps. The first is a rubble and brick structure, but the second is constructed of rubble and cut stone. Another important twelfth-century tomb is that of Halifet Gazi in Amasya, which is built entirely of cut stone. It is an octagonal structure supporting an octahedral cap. Among other octagonal tombs dating from the twelfth century are the turbehs of Kulak in Niksar, of Kamereddin and of Sitte Melik in Divriği and of Emir Saltuk in Erzurum. According to its inscription, the turbeh of Sitte Melik was erected in 1195 to 1196 (AH 592) for the Mengücek prince, Emir Suleyman. It is an ornate building with a delicately carved door, two belts of geometric decoration below a stalactite cornice under the octahedral cap and high niches with rounded arches cut into each face of the octahedral structure. The turbeh of Mengücek Gazi, built entirely of brick, is yet another octagonal structure. Of interest in this turbeh are the rounded corner piers, the cylindrical interior and an unusual crypt with an octagonal pier at the centre. A significant deviation from the prototype is found in the turbeh of Emir Saltuk: the cap is not octahedral but conical and rests on top of a high cylindrical drum. The drum and the walls of the main building are constructed of alternating courses of finely cut pale-yellow and brown stone. At the centre of each pedimented face is a bipartite window, and there are eight triangular niches on the cylindrical drum, corresponding to the corners of the octagonal body.

Fig. 27a

Fig. 27b

One of the two turbehs within the forecourt of the Alaeddin Mosque in Konya also dates from the last quarter of the twelfth century and was built by Sultan Kılıçarslan II. It is a decagonal structure surmounted by a hemispherical dome encased in a decahedral cap. The walls are of cut stone, but the cap is constructed of brick. Reached by double staircases on the north-east, the door is placed inside a shell with recesses in the shape of rounded arches. The shell is decorated with engaged columns and a finely carved frame of intricate geometric design. Inside the prayer chamber, there are ten semicircular niches (one at each corner) and eight stone sarcophagi, four of which are covered with faience inscriptions written in white letters on a cobalt-blue background.

Pl. 57

The turbeh of Mama Hatun in Tercan, which is ascribed to the first quarter of the thirteenth century, is a unique Anatolian-Seljuk funerary structure: not only is it surrounded by a wide, circular enclosing wall, but the faces of the octagonal tomb are composed of cylindrical segments and the conical cap is likewise fluted. The segmental articulation continues in the interior, built in the form of eight semicircular niches and framed by mouldings that converge at the centre of the dome. Except for the portal, the circular enclosing wall has a plain exterior, but on the inside (facing the ambulatory) are eleven deep niches shaped like pointed arches, which were obviously designed to house the sarcophagi of Mama Hatun's family or relatives.

Fig. 28

Among tombs dating from the second quarter of the thirteenth century, the turbeh of Ebu'l-Kasım in Tokat (1223–4/AH 631) is significant because the octahedral cap of this tomb rests on a square and not on an octagonal body. Another turbeh that deviates from the prototype is the Melik Gazi in Kırşehir, where the octagonal body is surmounted by a conical cap.

The turbeh of Cemaleddin Yavtaş Bey in the village of Reis, near Akşehir, is a rectangular structure with a barrel-vaulted crypt built of stone, below a barrel-vaulted brick iwan. The external brick construction is plain, but remnants of an inscription in red and blue paint can be seen on the plastered interior walls. The glazed-tile decoration of the iwan arch, however, has completely fallen off. A similar turbeh (the Gömeç Hatun) in Konya still retains some of its glazed-tile decoration on the iwan arch. The turbehs of Boyalıköy and of Saya Baba, both in the province of Afyon, may be mentioned as further examples of thirteenth-century iwan-type tombs. Although it cannot be included among this type of tomb, the turbeh of Turumtay in Amasya, dated 1278 to 1279 (AH 677), may be considered a variation on the same theme nevertheless. It is a two-storeyed rectangular structure, much like an iwan turbeh, but its vaulted upper level is organized as an enclosed chamber whose walls are richly decorated with ornamental pilasters and rows of palmettes.

Fig. 29a

Fig. 29b

A few more important examples from the last quarter of the thirteenth century must be mentioned. The Döner Kümbet in Kayseri is cylindrical on the inside and dodecagonal on the outside, with a conical cap resting on stalactite cornices. Grooved mouldings, accentuating the corners of the dodecagonal body interlock to frame each of the sides with a pointed arch and to produce a circular base for the conical cap to sit on. The abundance of ornamental stone-carving is remarkable. Apart from geometric and floral decorations, there are several figural reliefs, such as winged leopards with human heads or double-headed eagles on a date-palm, flanked by a lion at either side. According to its inscription, the Döner Kümbet was built for Şahcihan Hatun. There is no date; however, it can be ascribed to the last quarter of the thirteenth century because of its similarity with some turbehs in Ahlat.

Fig. 27c

The largest and the most striking of the Ahlat turbehs is the Ulu Kümbet. It has no inscription but is almost identical with the inscribed turbehs of Hasan Padişah,

Fig. 27d

Fig. 29
Plans of turbehs: a) Boyalıköy, Afyon, 2nd quarter of the 13th cen. b) Turumtay, Amasya, 1278–9.

Hüseyin Timur and Esen Tekin, and Boğatay Aka and his wife Şirin Hatun (dated 1274–5/AH 673; 1279–80/AH 680 respectively), which clearly show that the Ulu Kümbet also dates from the same period. All four of the Ahlat turbehs have a cylindrical body terminating in a conical cap. In the Ulu Kümbet, the four cardinal points are marked by three windows and a door, with niches shaped as rounded arches in between. The rotunda is enriched by rounded arches and grooved mouldings. The conical cap is also decorated with successive rows of diminishing ornamental arches.

Khankahs

Khorassanian dervishes played an important role in the spread of Islam in Anatolia. These dervishes took part in the conquest of Anatolia, then helped Turkoman groups settle in the captured territory. In time they began to accept various religious orders, and the residences of the sheiks developed into centres where the rituals of a certain order were practiced. Given such names as khankah, ribat or *zaviye,* the dervish monastaries were often established outside the cities and towns and, besides being religious institutions, performed a social function.

Fig. 30a The oldest khankah building in Anatolia is located near the town of Afşin in Marash. It is known as the Ribat of Eshab-ı Kehf. This unique two-storeyed khankah is constructed of stone at ground-floor level, but the building material changes to brick on the upper part. It consists of a masjid, dervish rooms and penance cells. The inscription, placed above the richly carved portal, bears the names of the Sultan İzzeddin Keykavus I and of Nureddin, the emir of the Turkoman tribe of Afşars, and is dated 1215 to 1216 (AH 612).

Fig. 30b The Boyalıköy Khankah in the district of Sincanlı, in Afyon, has no inscription. However, this khankah is presumed to have been built by or for Seyyid Kureyşi, whose tomb is located across from it, and if this were the case, then it could be ascribed to the first half of the thirteenth century.

Another important khankah, dating from the second half of the thirteenth century, is that of Sahib-ata in Konya. It was built adjacent to the Larende Mosque in 1279 to 1280 (AH 678). The central space of this khankah consists of a central hall surmounted by an open-topped dome on Turkish triangles, with three iwans of different widths and depths opening on to it. The iwan with a mihrab on the south is a masjid; the one across from it functions as an antechamber to the domed turbeh of the founder, located behind it. The largest iwan (on the west) is the common room of the khankah, and on the east, instead of an iwan, a barrel-vaulted corridor links the central hall with the ornate portal. Unfortunately, the rooms of the Sahib-ata Khankah, which occupied the corners of the building, have disappeared so that today only the cross-shaped core of the original square mass remains.

There are a number of khankahs dating from the late thirteenth century in and around the province of Tokat. One of these, called the Zaviye of Açıkbaş, is located on

Fig. 30
Plans of khankahs: a) Ribat of Eshab-ı Kehf, Marash, 1215–6 b) Boyalıköy, Afyon, 1st half of the 13th cen. (?) c) Zaviye of Sünbül Baba, Tokat, 1291–2.

the Tokat-Samsun highway. It is a linear building, composed of a hall covered by a dome on Turkish triangles: there is a room on the right, an iwan on the left and a domed turbeh adjacent to the iwan.

The Khankah of Ebu Şems, situated within the city of Tokat, is a slightly larger building, dating from 1288 (AH 687). The Zaviyes of Sünbül Baba and Halifet Gazi Fig. 30c also date from the same period, since they were both built in 1291 to 1292 (AH 691).

Judging by the surviving examples of khankahs from the Anatolian-Seljuk period, the common denominator in this type of building is the domed central hall with one or more iwans. Archaeological excavations carried out in central Asia revealed foundations of houses dating from the tenth and eleventh centuries which consisted of four iwans opening on to a domed hall with rooms at each corner.[28] Since khankahs were basically the houses of the sheiks and served as domestic buildings, and since the Turkoman dervishes came to Anatolia from the Khorassan region, it is quite possible that central-Asian domestic buildings may have been the model for the architecture of the Anatolian-Seljuk khankahs.

Madrasahs and *Şifaiyes*

In the Islamic world, in addition to its role as a place of worship, the mosque has often functioned as an educational institution. Between prayer times, teachers would sit in front of a column or a pillar with students gathered in a circle in front of them. According to the hadiths, this type of school—called the *halka* (ring)—goes back to the Prophet's time.[29] The madrasah (college) came into existence much later, and its emergence did not eliminate the *halka* system. Quite often a mosque and a madrasah were built in close proximity, and educational activity was carried on in both. The main difference between the two systems was that the madrasah had a structured curriculum. Furthermore, while no differentiation was made between primary and secondary levels of education in mosque *halkas*, madrasahs were institutions of higher learning only.

The madrasah was an endowed establishment. Any well-to-do person in the Islamic world, whether a sovereign, a member of the ruling family or a commoner,

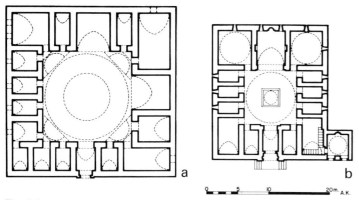

Fig. 31
Plans for enclosed madrasahs: a) Çukur Madrasah, Tokat, mid 12th cen. b) Taş Madrasah, Çay, 2nd half of the 13th cen.

could build a madrasah, provided that he created a pious foundation for its maintenance. The foundation's charter specified the wages of the professors, the teaching assistants and the other functionaries of the institution. Not only was tuition free of charge, but all the students received scholarships paid out of the endowment funds. The charter of each pious foundation included administrative and legal provisions, and the sources of income as well as its dispersal were clearly specified.

During the period of the Great Seljuks, Nizam al-Mulk, the famous vizier, founded a well-organized state-supported educational institution of high standard called the *Nizamiya*. The *Nizamiyas* were not solely theological colleges. Besides courses relating to Islamic studies and canonical jurisprudence, they offered programs in philosophy, mathematics, astronomy and medicine.[30] The most famous of all was the Nizamiya of Baghdad, which Nizam al-Mulk had built specifically for the renowned scholar Abu Ishak Shirazi, whom he appointed as its first professor in 1066. Others were located in the cities of Basra, Mosul, Rayy, Isfahan, Nishapur, Merv, Herat, Tus, Balkh and Khargird. Unfortunately, the *Nizamiyas* were all burnt down and destroyed during the Mongol invasion. What we know of their architecture is due to André Godard, who excavated the Khargird Nizamiya (dated 1087) and discovered it to be a building organized around a large courtyard with four iwans.[31] It is quite possible that the Mustansariya in Baghdad, dating from 1232, was patterned after the *Nizamiyas* and emulated

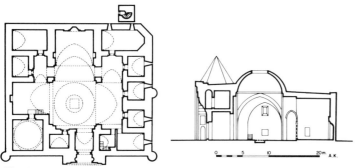

Fig. 32
Plan and longitudinal section of the Caca Bey Madrasah, Kırşehir, 1272–3.

their architecture. It has also been argued that the architecture of the *Nizamiyas* was inspired by Buddhist monasteries with large open courtyards called vihara.[32] On the other hand, the model for the smaller madrasah, with enclosed courts like khankahs, might have been derived from eleventh-century central-Asian houses. It could well be that initially the professors taught students in their own homes and that the architecture of early madrasahs closely followed domestic architecture.[33] But when the madrasahs became too large for the court to be covered with a dome, the madrasah with an open courtyard developed.

The two oldest enclosed madrasahs in Turkey are located at Niksar and Tokat and date from the mid-twelfth century. They were both built by the Danishmendid ruler Nizameddin Yağı-basan and are composed of two interlocking L-shaped sections of different depths placed around a domed court. In both madrasahs the L (comprising student cells) forms the forward and left-hand sides of the square court, while the deeper L contains the communal rooms and two iwans (one at the center of each arm) that are similar in width, depth and height. The madrasah at Niksar is in a ruinous state, but the other — called Çukur (sunken) Madrasah — has escaped the rigours of time and survived in fairly good condition with its open-topped central dome intact. Fig. 31a

The madrasah built by Mubarizeddin Ertokuş, the famous Seljuk commander, in the small town of Atabey near Isparta is dated 1224 (AH 621). The court in this madrasah is also covered by an open-topped domical vault but, unlike the Çukur Madrasah in Tokat, where the dome sits directly on the inner walls, the domical vault here is detached from the rectangular structure that envelopes the court and rests on four corner columns.

In central Anatolia a group of madrasahs built according to a similar scheme shows that the Anatolian-Seljuk enclosed madrasah reached its maturity during the second half of the thirteenth century. The Karatay and Pls. 59, 60 the İnce Minareli (slender-minareted) Madrasahs — both in Konya — or the Taş (stone) Madrasah in Çay, dating Fig. 31b from 1278 to 1279 (AH 677), are all madrasahs with one iwan. The iwan is situated at the rear of the court with domed rooms to the right and the left of it and rows of cells flanking the court on either side. In all three madrasahs the transition from the inner walls to the central dome is effected by fan-type pendentives. A deviation from this model is seen in the Madrasah of Caca Bey Fig. 32 in Kırşehir, dated 1272 to 1273 (AH 671), which has a Pl. 61 more complex internal organization with an uneven and unsymmetrical four-iwan scheme.

One further enclosed madrasah is worthy of notice. This is the Yakutiye in Erzurum — an Ilkhanid work dated 1310 to 1311 (AH 710). Like the Ertokuş Madrasah, the central court in Yakutiye is not surmounted by a dome but by a cross vault decorated with *mukarnas* and resting on four-cornered pillars. Again, like the Ertokuş Madrasah, a turbeh is placed behind the main iwan. While the earlier Seljuk madrasah has only a single iwan, there are three iwans in the Yakutiye Madrasah. Also unlike the first example, whose court is well illuminated by a large oculus, the latter madrasah has a dark interior

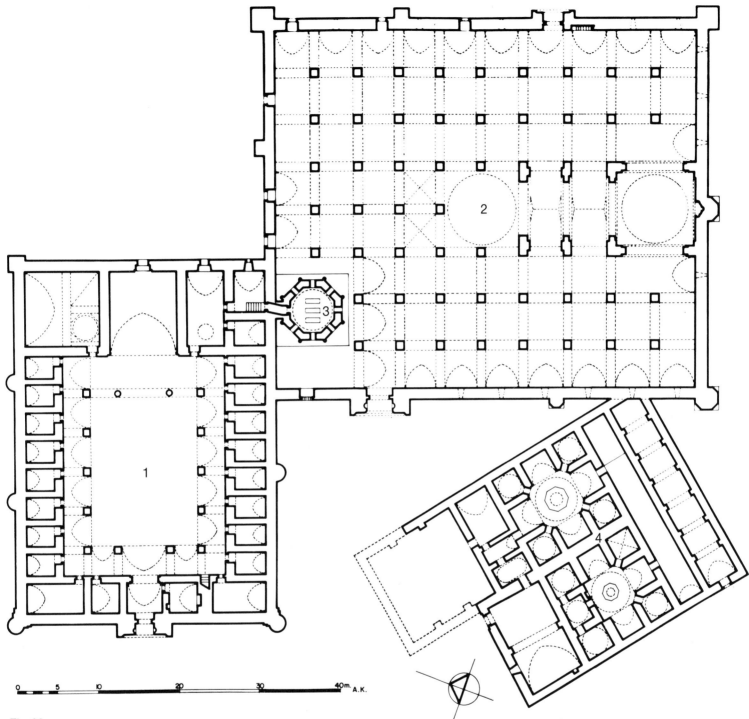

Fig. 33
Plan of the Huand Hatun complex, Kayseri, 1237–8: 1) madrasah
2) mosque 3) turbeh of the founder 4) double *hamam*.

since the cross vault covering the central court is only
pierced on top by a tiny lanterned hole.

Unlike the enclosed madrasah, the earlier examples of
which are found in northern Anatolia, the oldest madra-
sahs in Turkey, each with an open court, are located in
the south-east and were built by the Artukids. A good
example is the Zinciriye (or Sincariye) Madrasah in
Diyarbakır, dating from the end of the twelfth century. It
is built around a small arcaded court with two iwans
opening onto it on the longitudinal axis. The entrance-
iwan is cross-vaulted, while the larger main iwan across

from it is covered by a barrel vault. Five rooms — four of
them narrow and rectangular, one square and domed —
flank the main iwan: three to the right and two to the left.
A row of student cells and a large masjid occupy the right
and the left sides of the court respectively.

Apart from the Caca Bey, enclosed Anatolian-Seljuk
madrasahs are generally buildings with one or two iwans.
The larger madrasahs with open courts, however, have
two or four iwans. In the madrasahs with two iwans, the
iwans are placed across from each other on the main axis,
as in the Zinciriye Madrasah. The Huand Hatun and Fig. 33
Hacı Kılıç Madrasahs are of this type. So too are the
Sırçalı (faienced) Madrasah in Konya, the Karatay
Madrasah in Antalya, the Suleyman Pervane Madrasah in
Sinop and the Gök (blue) Madrasah in Tokat.

91

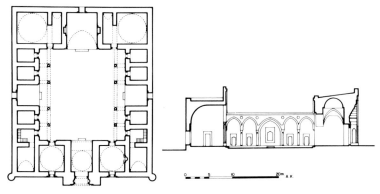

Fig. 34
Plan and longitudinal section of the Buruciye Madrasah, Sivas, 1271–2.

The most notable examples of madrasahs with a four-iwan scheme are the Sahabiye in Kayseri, the Buruciye and the Gök Madrasahs in Sivas and the Çifte Minareli (double-minareted) Madrasah in Erzurum. Built, according to its inscription, by the vizier Sahib-ata Fahreddin Ali in 1267 to 1268 (AH 666), the Sahabiye has a well-proportioned façade with round corner turrets constructed of large cut-stone blocks. It has a deep and intricately ornamented portal. The court is arcaded in the front and on either side. Of the two communal halls flanking the main iwan, the one on the right is barrel-vaulted, but the other is surmounted by a dome on squinches.

Fig. 34 From the point of view of architectural design, the most articulate and symmetrical madrasah in Anatolian-Seljuk architecture is undoubtedly the Buruciye Madrasah, dated 1271 to 1272 (AH 670). In this madrasah, the entrance-iwan is accented by a high dome, but the main and side iwans are covered by barrel vaults in keeping with tradition.

Pl. 62 The Gök Madrasah in Sivas resembles the Buruciye Madrasah in many respects and, according to its inscription, was also completed in 1271 to 1272. It is a structure with four iwans. Here, too, the sides of the court are arcaded, and the arches in front of the side iwans are wider than the others. Again, the front iwan is accented by a star-shaped vault; the iwan is flanked by a domed masjid on the right and by another domed room on the left.

Unlike the Buruciye Madrasah, however, the Gök Madrasah does not have an orderly composition. The rooms and cells are neither well organized nor symmetrical, and the outer walls are much too high for the structure they envelop. This strongly suggests that the Gök Madrasah was not built according to an original design but was a reconstruction of an earlier, partially ruined building.[34] The most interesting feature of the Gök Pl. 69 Madrasah is its portal with twin minarets. Constructed of white marble, this portal is richly ornamented with intricate raised interlacings, mouldings and panels of geometric designs. On the walls of the portal niche are eight-pointed stars above naturalistic motifs composed of flowers, leaves and pomegranates framed by arches. The shafts on the twin red-brick minarets rising on either side of the portal have vertical pipes made of turquoise-glazed

ceramic. The windows flanking the portal are also built of white marble, and delicately carved corner turrets as well as the arched fountain with three spouts enliven the façade to make the Gök Madrasah one of the most ornate buildings in Anatolian-Seljuk architecture.

A third madrasah in Sivas, dating again from the same year, is the Çifte Minareli (double-minareted) Madrasah built by the Ilkhanid vizier Şemseddin Cuveyni. Only the imposing front wall remains, the rest of the building having been destroyed some centuries ago. Recent excavations, however, showed that it was a two-storeyed structure with four iwans and an adjacent hospice on the left as well as a second building, thought to be a bath, attached to it on the right.

Another madrasah with twin minarets is located in Erzurum. Like the Çifte Minareli in Sivas, this madrasah too has four iwans, is built on two levels and probably dates from the last quarter of the thirteenth century. But unlike the Buruciye or the Gök Madrasahs in Sivas, here the front iwan is covered by a simple barrel vault, while the side iwans are enriched by star-shaped decorative vaulting. Since the iwans are high, the first floor galleries do not surround the court but are terminated at the iwan walls. For this reason, the student cells are grouped in four sections, each section being served by a separate staircase. The spacious main iwan has collapsed, but the cylindrical turbeh behind it is intact.

The Çifte Minareli Madrasah in Erzurum is an ornate building. The pillars and arches of its arcaded court, as well as the doors and windows, are decorated with carved designs. The twin minarets of red brick, inlaid with glazed ceramic piping, recall those of the Gök Madrasah in Sivas. The portal is also worthy of notice, and the four depictions of the tree of life and the double-headed eagle motif — the coat of arms of the Seljuks — on portal walls are of special interest.

The Çifte (double) Madrasah in Kayseri, as its name suggests, consists of two adjacent buildings (each one organized around its own arcaded court), connected internally by a passage-way. The one on the west — or on the left-hand side — is a şifaiye (hospital), while the other is a medical madrasah. Both sections have their own portal, and each is decorated in the style of the early Seljuk period. The şifaiye is inscribed. According to this inscription it was completed in 1205 to 1206 (AH 602) by Gıyaseddin Key-husrev I at the bequest of his sister Gevher Nesibe Hatun.[35]

A similar şifaiye-madrasah complex is located in Sivas. Unfortunately, only the foundation walls of the madrasah section remain, but the şifaiye is still in fairly good condition. It is a large building arranged around a court, flanked on either side by five-arched arcades. The arcaded galleries are unusual; they extend to the outer walls at both ends on one side and at one end on the other, providing access to patients' rooms. Except for its front arch, the main iwan has collapsed. The deep entrance-iwan as well as the small, shallow side iwan on the left are intact, and opposite the latter is a turbeh decorated with turquoise and purple faience mosaics on a white background. The brick dome, which rests on Turkish triangles inside, is girdled by a high, octagonal

drum and capped by an octahedral spire. According to the inscription placed on its portal, this *şifaiye* was built by the Sultan İzzeddin Keykavus I in 1217 to 1218 (AH 614). A second inscription on the turbeh is dated 2 December 1220 (AH 4 Shawwal 617). This shows that the turbeh was not part of the original design but that the right-hand side iwan was converted into a turbeh after Keykavus's death in 1219.

Pl. 65 Unlike those in Kayseri and Sivas, the Şifaiye of Turan Melik in Divriği adjoins the Great Mosque and not a madrasah, and the *şifaiye* has an enclosed court. Beyond the deep ornate portal is a square hall covered by a star-shaped vault. The hall is flanked by barrel-vaulted rooms on either side and, through a second doorway, leads to an enclosed court. The main iwan across from the entrance hall, is surmounted by another star-shaped stone vault. To the right of the main iwan is a barrel-vaulted room similar in size and shape to those flanking the entrance hall, but the other side is reserved for a domed turbeh. Like the main iwan and the entrance hall, the side iwans are also placed between two small rooms and sur-mounted by decorative vaults. The court's dome is detached from the walls and rests on four octagonal stone pillars, one in front of each side iwan. The oculus, beneath which is an octagonal pool, was subsequently covered by a lantern. This interesting *şifaiye*, rationally and symmetrically designed, was built according to its inscription, in 1228 to 1229 (AH 626) by Turan Melik, the daughter of Fahreddin Behram Shah and the wife of the Mengücek ruler Ahmet Shah, who built the adjacent Ulu Cami of Divriği.

Hamams

In terms of architectural organization and technical detail the Anatolian-Seljuk bath, called *hamam*, has many simi-larities to Roman thermae. It consists of a dressing hall, tepid and hot bathing sections and a furnace room. The dressing room is generally a domed hall with a marble pool at the centre and a high stone seat along its walls. Often the tepidarium would include several small rooms, while the calidarium comprises iwans and *halvets* (private chambers) arranged around a smaller domed hall. Iwans and *halvets* are equipped with wash basins with hot and cold faucets. The water is transferred through clay pipes placed low on the walls, and the hot smoke from the furnace is circulated underneath the calidarium floor to heat the paving before it is discharged.

Turkish baths located in small towns or neighbour-hoods are generally single buildings serving men and women at different hours or on alternate days, but in large centres they often contain separate sections for each sex and offer their services simultaneously. Such a double Fig. 33 *hamam* is found in the Huand Hatun complex in Kayseri. The changing hall of the *hamam*'s men's section has been destroyed, but the tepidarium (comprising a large barrel-vaulted room and a small domed toilet) as well as the calidarium are well preserved. Built on the four-iwan scheme, the calidarium consists of four barrel-vaulted iwans, four domed *halvets* filling the corners of the cross,

and a large central hall, which is also surmounted by a dome with a pentagonal oculus. This oculus is open today, but it was originally covered by a domical lantern, perforated with light-holes and topped by glass cups. Unlike the men's section, the women's smaller *hamam* retains its changing hall. This is a long barrel-vaulted space with a supporting arch in the middle. The narrow room placed at an angle to the façade is another changing area, possibly for the private use of the founder herself. One enters the three-unit tepidarium through the chamber on the right. The chamber on the left is a *halvet*, and the one in the middle serves as the vestibule of the calidarium, which comprises three iwans and two *halvets*.

Of special interest in this bath are the glazed ceramic tiles of the tepidarium, discovered under coats of plaster in 1969. These tiles, found around the calidarium door and the three walls of the *halvet*, are in the shape of eight-pointed stars and crosses (see p. 175). The *halvet* is also decorated with hexagonal and triangular floor tiles made of white-glazed and turquoise-glazed terra-cotta respec-tively. The date of the Huand Hatun Hamam is not known; however, excavations showed that a corner of this building was cut to make room for the Huand Hatun Pl. 63 Mosque. Since the construction of that mosque began in 1237, the *hamam* must predate it by some years.

Other Anatolian-Seljuk baths worthy of note are the single *hamams* of Gülümser Hatun near Kütahya and the Sahib-ata in Ilgın, and the double *hamams* of Cemaleddin Firenkshah in Kastamonu, Sahib-ata in Konya, Pervane in Tokat and Eşrefoğlu in Beyşehir. The Hamam of Gülümser Hatun is located on the Kütahya-Tavşanlı highway, seventeen kilometres from the former city, and is dated 1233 to 1234 (AH 631). That of the Sahib-ata in Ilgın was built in 1267 to 1268 (AH 666). Both are *ılıcas*

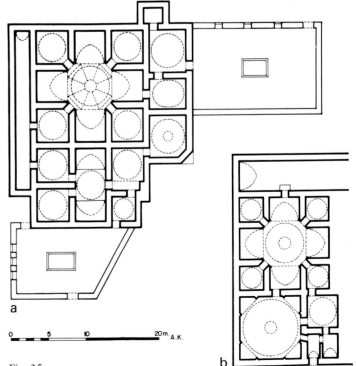

Fig. 35
Plans of double *hamams:* a) Pervane, Tokat, *c.* 1270–9 b) Eşrefoğlu, Beyşehir, 1296–7 (only partially intact).

93

(spas). The double *hamam* of Cemaleddin Firenkshah, which has recently been excavated and restored, stands below ground level in the main square of Kastamonu and is believed to date from 1262. The Sahib-ata Hamam in Konya may have been built any time from 1258 to 1285. This *hamam* is considered a part of the Sahib-ata complex near the Larende Gate in Konya and stands across the street from the mosque-turbeh-khankah group.

Fig. 35a The date of construction of the Double Hamam of Pervane in Tokat also cannot be accurately determined, but it was probably built between 1270 and 1279. The

Fig. 35b Eşrefoğlu Hamam in Beyşehir has an inscription dating it to 1296 to 1297 (AH 696).

Architecturally speaking, the Seljuk bath is a modest building, unlike the imposing Roman thermae. Its exterior is simple; to protect privacy and conserve heat, it seldom has windows. In fact, more often than not, it would not be noticeable from the outside, owing to rows of shops built against its walls. The organization of the calidarium is predetermined: it consists of a single-domed central space augmented by four barrel-vaulted iwans and four domed or cross-vaulted bathing chambers placed at the corners to complete the square. In other words, the basic four-iwan scheme was applied to Anatolian-*hamam* architecture during the twelfth and thirteenth centuries, and where a smaller calidarium was required — as in the women's *hamam* of the Huand Hatun complex — both the hot and tepid sections were fitted into the basic cruciform scheme, resulting in a variation on the same theme.

In the *hamams* of this period, the domes rest directly on the walls, and the transition is effected by simple squinches or Turkish triangles. The only exception is the Huand Hatun Hamam, where the central dome of the calidarium as well as the smaller dome of the private bathing chamber in the tepidarium sit on a belt of saw-toothed corbels. This is obviously because the Huand Hatun Hamam was a royal building. The presence of ceramic-tile decorations is due to the same reason. On the other hand, embossed motifs that exist on the *halvet* walls of some Seljuk *hamams* show that the use of decoration was not confined to royal baths but found some application in market baths as well. It must be understood, however, that wall decorations inside Seljuk *hamams* were kept to a minimum, not only because of the humidity, but also because the *hamams* were poorly illuminated, the sole vehicle for daylight being a few cup-shaped glass-covered holes placed in the shell of the upper structure.

Palaces

The Royal Palace at Konya was situated within the inner Pls. 109 fortress and, except for the remains of a pavilion built on 110, 112 top of one of the inner fortress towers, it has disappeared completely. This pavilion comprised a single square room surrounded by a balcony on consoles. According to Evliya Çelebi, it was built in 1173 to 1174 (AH 596) by Kılıçarslan II, and its walls were covered with ceramic tiles inside and out.[36] The tower itself was faced with cut stone, and on its façade were two ornamental niches with lion figures inside them.[37] Unfortunately, all that is left of the Kılıçarslan Pavilion are the structural core of the tower, a few of the balcony consoles and some fragments of the wall tiles. The latter are exhibited in the Konya Museum. Some ten years ago, the tower was placed under a reinforced concrete shell to protect it against further deterioration.

We know that Alaeddin I built himself a summer palace in Alanya, but not even the location of this building has yet been discovered. However, two other royal

51 Interior of the Great Mosque (Ulu Cami), Divriği, 1228–9: the central aisle, looking south to the mihrab.

52 East wing of the Mosque of Alaeddin, Konya, built before 1155: rows of columns compiled from pre-Islamic ruins in Anatolia.

53 Alaeddin Mosque, Niğde, 1223: view from the north-east.

54 Domes and vaults of the Gök Madrasah Mosque, Amasya, 3rd quarter of the 13th cen.

55 Turbeh of the Gök Madrasah Mosque, Amasya, 3rd quarter of the 13th cen. The turbeh, rising above a stone plinth, is constructed of red brick and inlaid with glazed terra-cotta tiles.

56 Interior of the Great Mosque, Afyon, 1272 (?): carved wooden posts and beams.

57 Turbeh of Kılıçarslan II, inside the forecourt of the Alaeddin Mosque, Konya, last quarter of the 12th cen.

58 Entrance of the Döner Kümbet, Kayseri, last quarter of the 13th cen.: looking from the north-east.

59 Portal (detail) of the Karatay Madrasah, Konya, 2nd half of the 13th cen.

60 East façade of the İnce Minareli Madrasah, Konya, 2nd half of the 13th cen. The upper part of the shaft of the minaret on the adjoining masjid has twin balconies and was destroyed by lightening.

61 Main iwan of the Caca Bey Madrasah, Kırşehir, 1272–3: looking from the domed central hall.

62 West façade of the Gök Madrasah, Sivas, 1271–2.

63 Huand Hatun complex, Kayseri, 1237–8: general view from the west.

64 Sultan Han, near Aksaray, 1228–9: arcades of the courtyard.

65 Hospital of Turan Melik, Divriği, 1228–9: portal.

66 Courtyard of the Sultan Han, Tuzhisar, 1236–7: *at the centre*, the elevated masjid and the portal of the rear section.

67 North portal of the Great Mosque, Divriği, 1228–9.

68 West portal of the Great Mosque, Divriği, 1228–9.

69 Portal of the Gök Madrasah, Sivas, 1271–2.

70 Portal of the Alaeddin Mosque, Niğde, 1223.

94

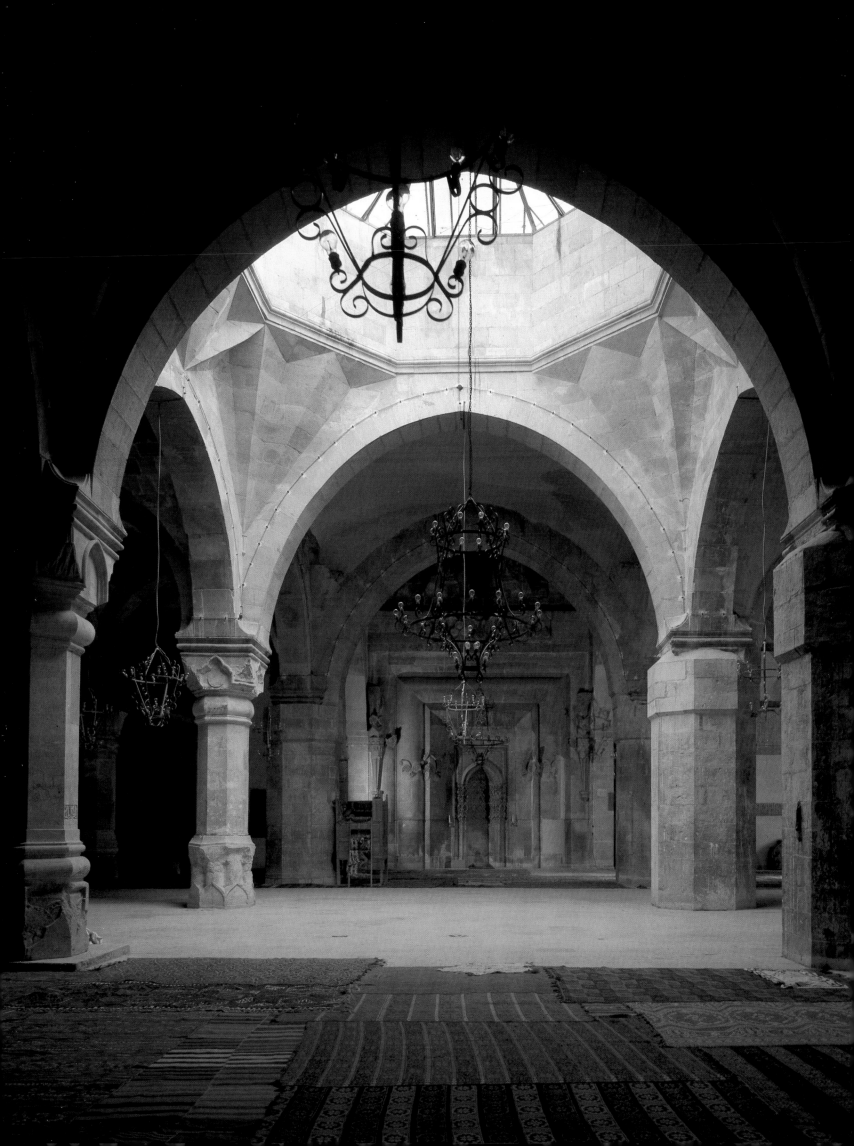

52

53

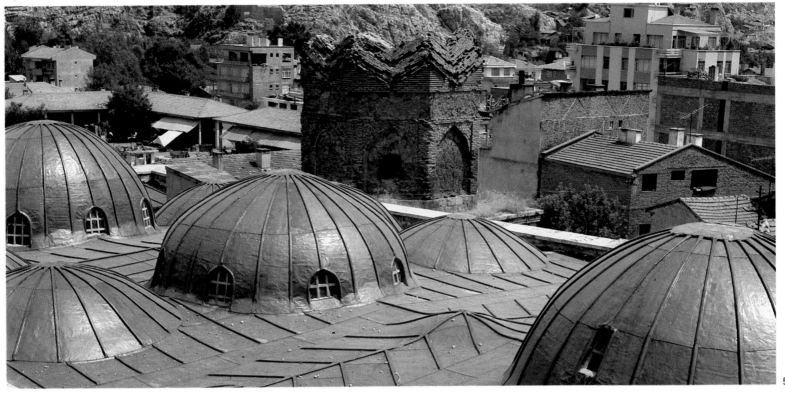

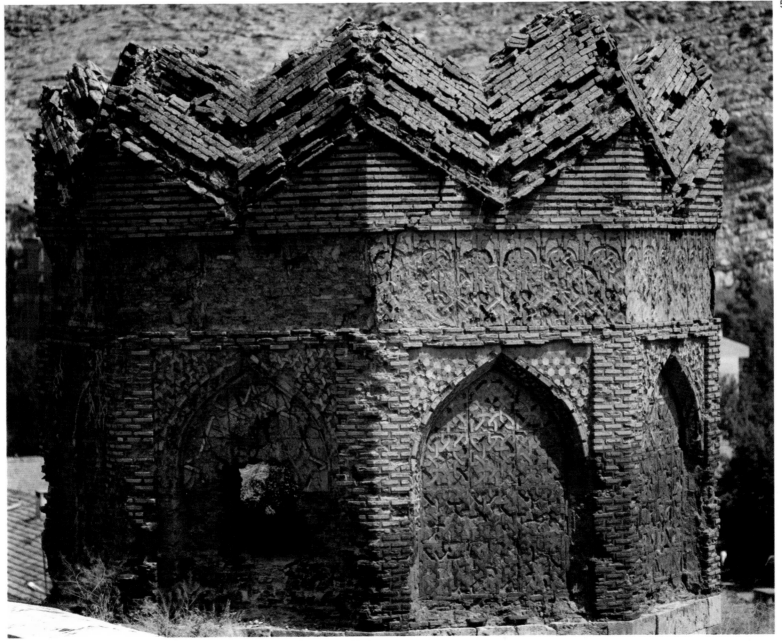

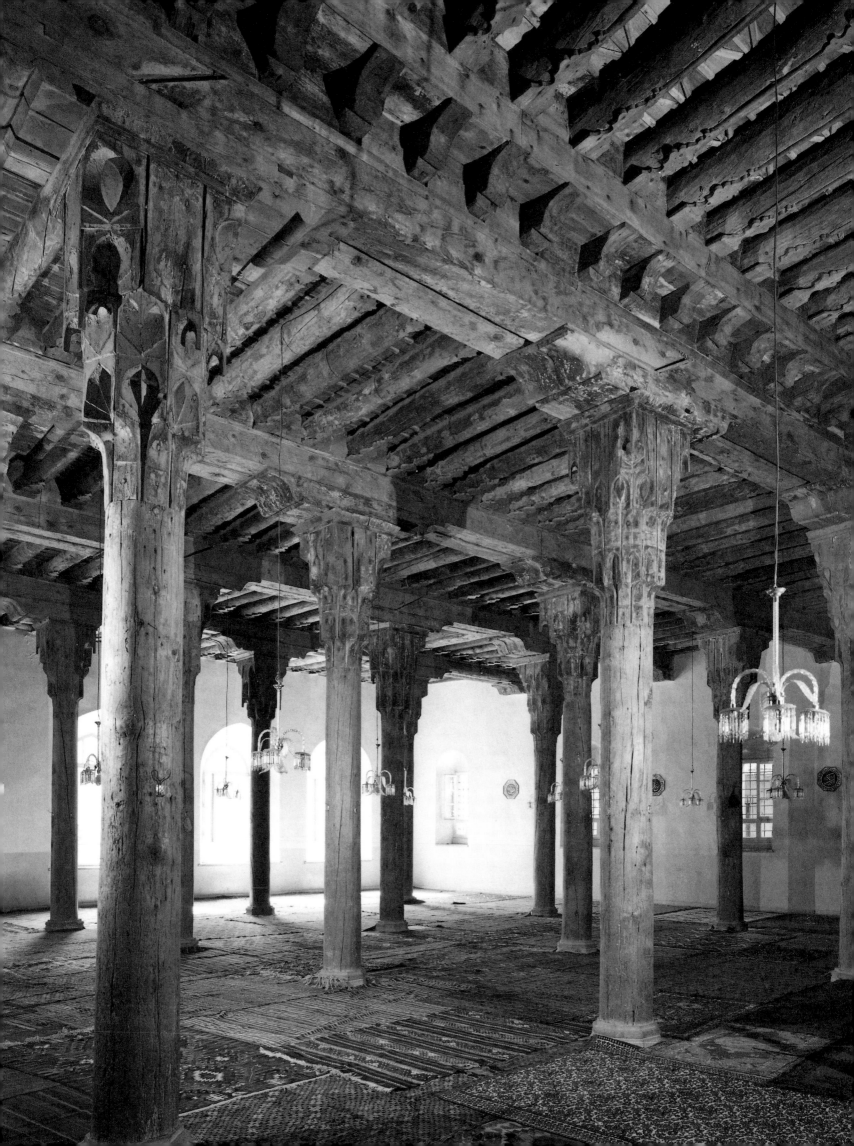

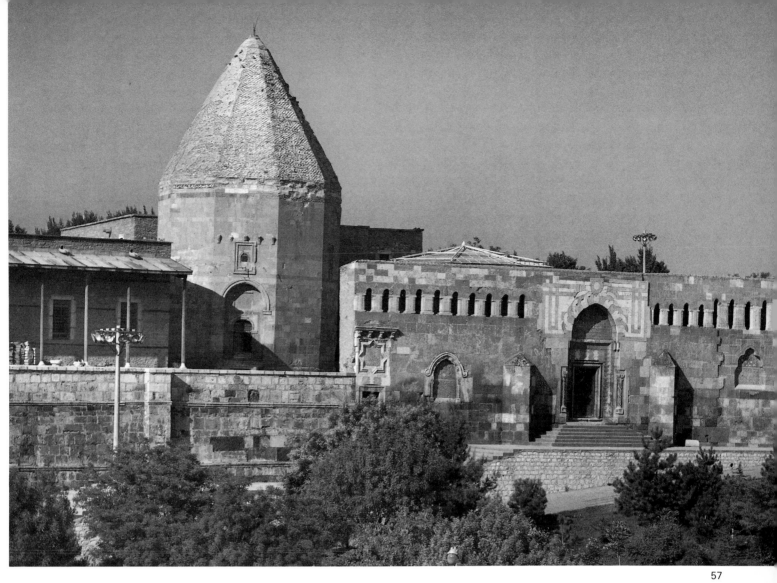

57

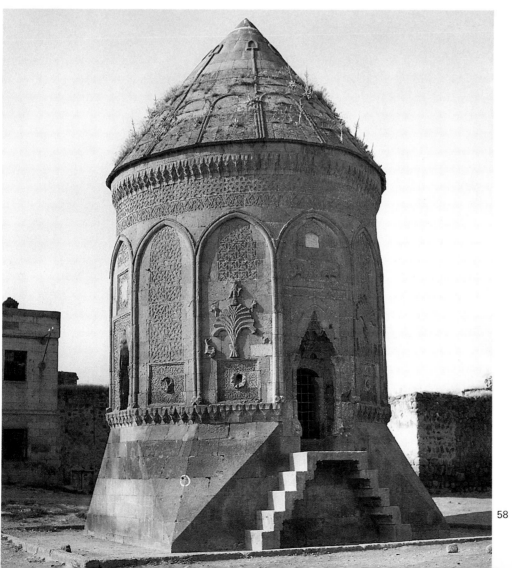

58

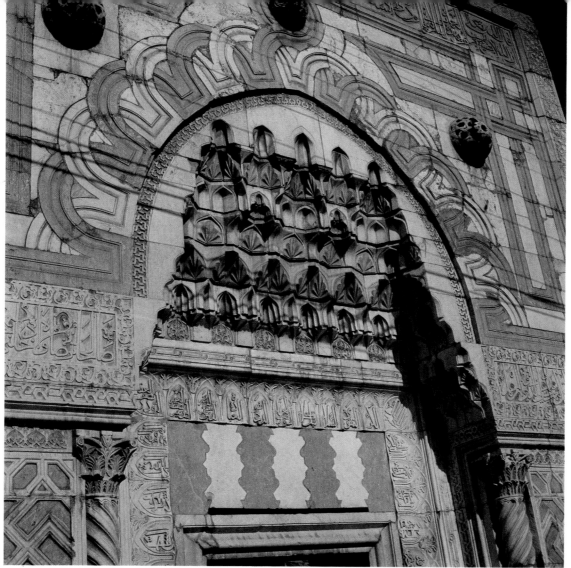

59

60

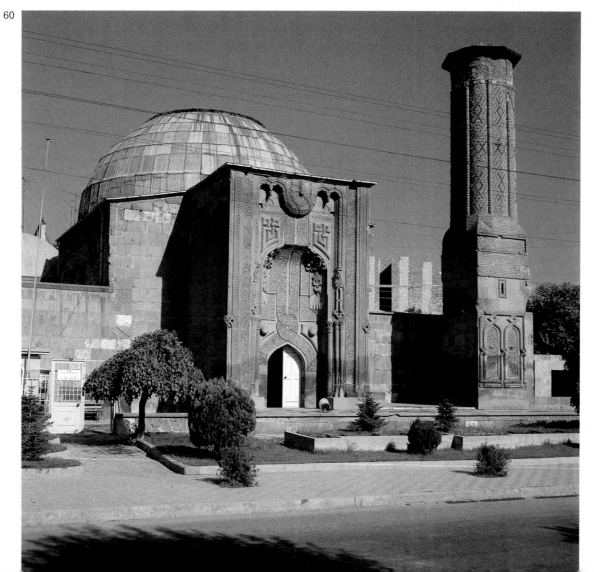

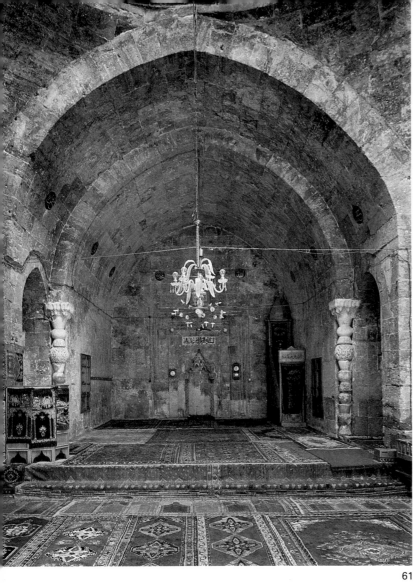
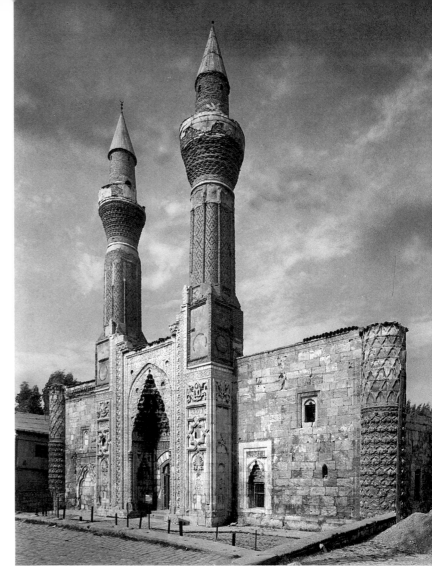

61 62

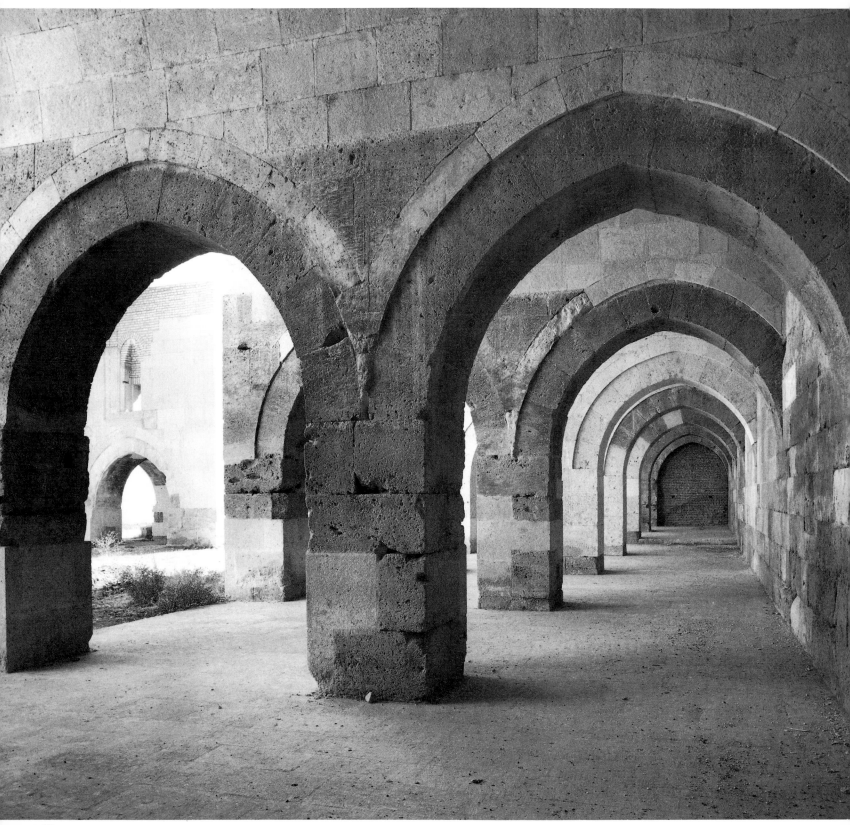

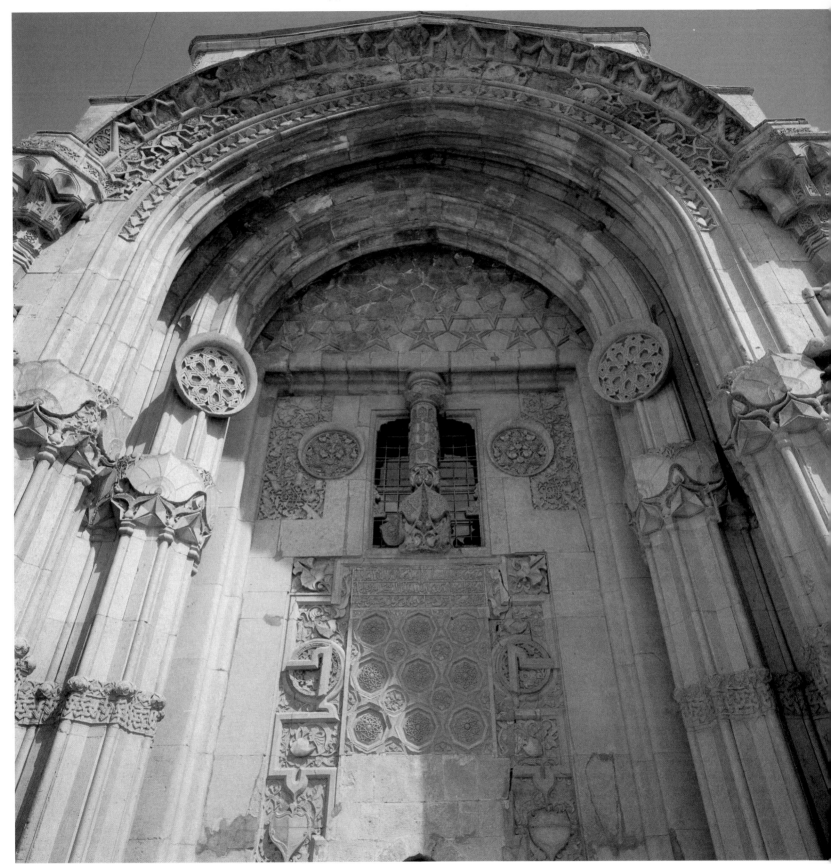

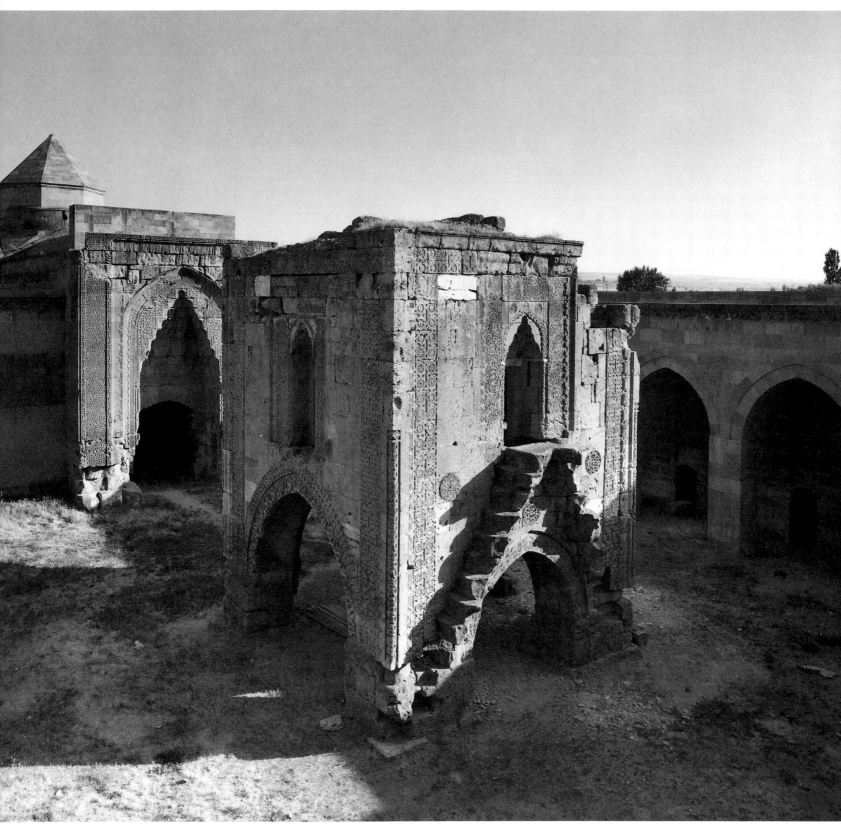

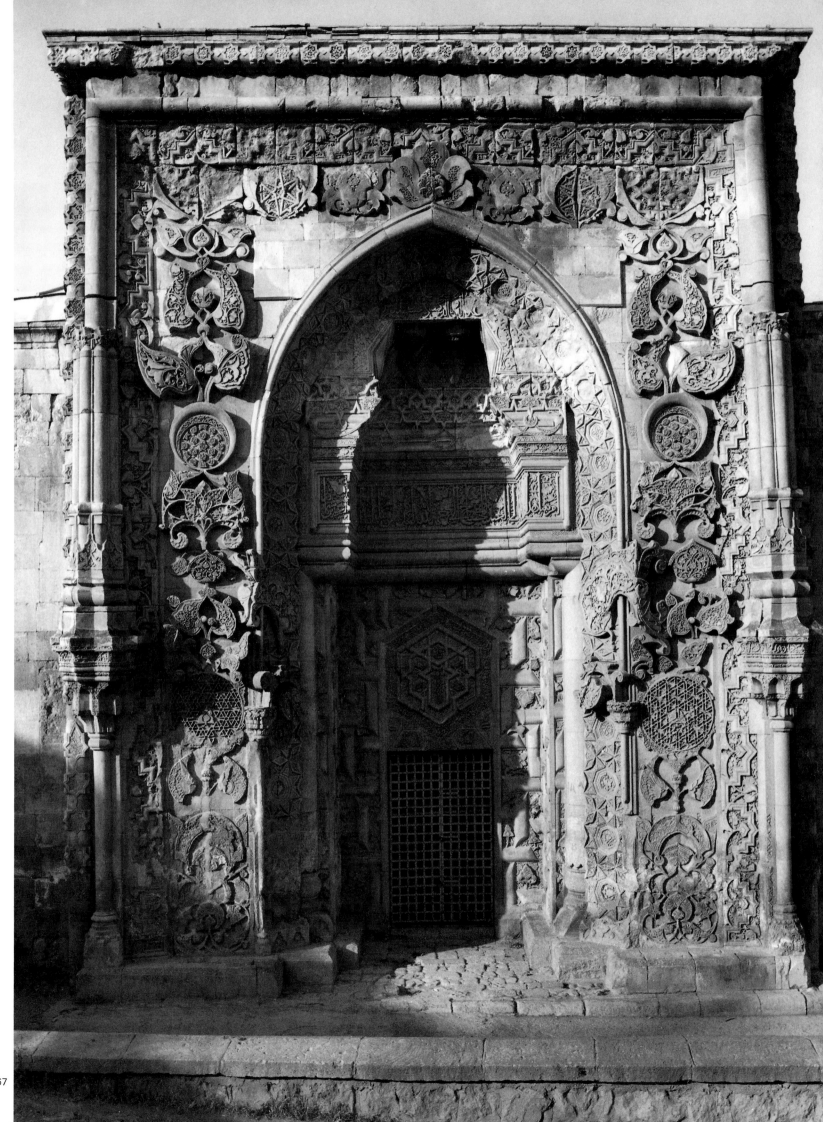

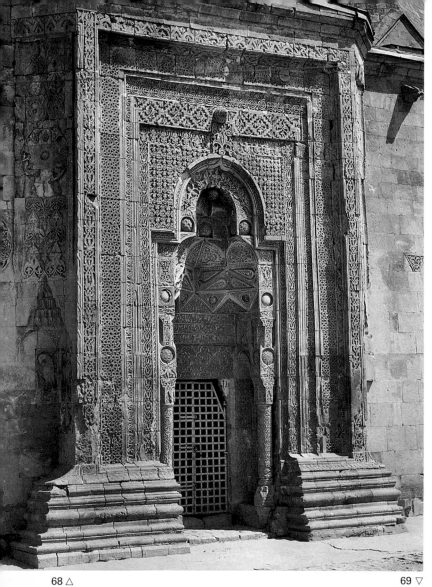

68 △

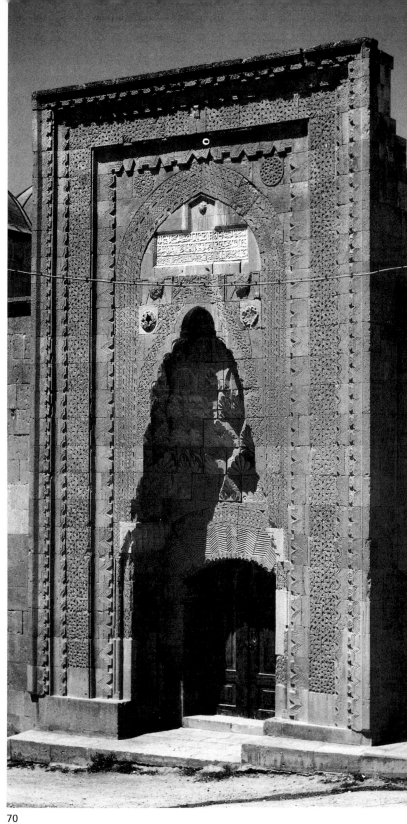

69 ▽

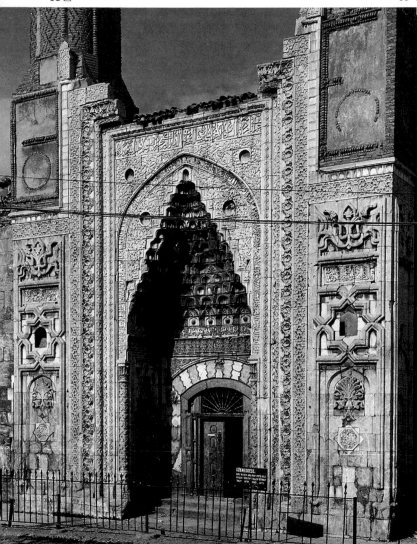

70

residential complexes, built by the same sultan, were found and excavated during recent years. The smaller of the two—known as Keykubadiye—consists of three separate buildings near an artificial lake. The first building is a three-bay structure surmounted by barrel vaults. It stands right on the lake's shore, and the stone pier in front of it indicates that it was a boathouse. The second is a small, square structure elevated on four corner pillars and was obviously a masjid. The third is a rectangular hall preceded by a small chamber devoid of decoration, but the large hall was decorated with multicoloured tiles with an underglaze of turquoise, blue and dark purple.[38]

The Kubadabad Palace, located on the western shores of Lake Beyşehir and built twelve years after the Keykubadiye, is a much larger complex containing within its fortification walls at least sixteen structures. Excavations, begun in 1965, revealed two royal residential buildings.[39] The small palace has rows of rooms on three sides of a rectangular courtyard. The main palace consists of two sections. Entrance to the main palace is through a paved courtyard, with rooms of varying sizes placed along its south and east walls, and the private quarters of the sultan begin on the other side of a gateway in the north wall. The inner section of the palace contains a large hall, a high iwan faced with brick and the harem rooms. Like the Keykubadiye, the main living spaces of Kubadabad Palace are decorated with panels of ceramic tiles in the shape of eight-pointed stars between crosses. On the star-shaped panels, human figures and real and mythological animals and birds (including double-headed eagles) are depicted in rich colours, while the crosses that frame them have simple black decorations under turquoise glaze.

Pls. 117, 118

Although it is not possible to comment on the Royal Palace at Konya, the palaces of Kubadabad and Keykubadiye, both of which were built during the height of those persons' power, show clearly that the Anatolian-Seljuk sultans did not favour ostentatious living, as their palaces are neither monumental nor geometrically imposing in their symmetry and grand design. Compared with the Abbasid palaces, or even those built by the Ghaznevids in Laskhar-i Bazar and organized around huge four-iwan courtyards, Anatolian-Seljuk palaces seem modest and unassuming. They lack a sense of orderly planning: they are composed of various buildings dispersed throughout the site in a haphazard manner, thus reflecting an attitude of passing fancy instead of stately permanence.

Caravanserais

The architectural relationship between the Anatolian-Seljuk caravanserai and the central-Asian ribat is generally accepted by historians of art. During the first few centuries of Islam, the ribat was strictly a fortified military installation. As of the tenth century, however, its function changed, and ribats, in addition to being military strongholds, also served as guest houses for traders, pilgrims and wandering dervishes. Later still,

ribat came to mean khankah or *zaviye*, since some dervish monasteries were called by that name.

From the point of view of architectural organization, the typical Anatolian-Seljuk caravanserai usually comprises a forward section that includes rooms, cells and arcades around a courtyard and an enclosed rear section built in the form of a large hall with pillars. Some caravanserais consist simply of the pillared hall; others have only a courtyard and no rear section, and in a few the plan and arrangement of masses is innovative and outside the basic scheme.

The oldest known caravanserai in central Anatolia is the Okla Han between Konya and Aksaray, dated to the reign of Kılıçarslan II between 1156 and 1192. The earliest Anatolian-Seljuk caravanserai with an inscription, however, is that of Altun-aba, dated 1201 to 1202 (AH 598). Today this *han* (located on the Konya-Beyşehir highway) stands inside an artificial lake with only a small part of its structure above the water. The Altun-aba Han is rectilinear and measures 45 metres in length and 17 metres in width. Its forward section is three bays wide and five bays deep. On the longitudinal axis, the central bay is uncovered and serves as a courtyard. The structure of the forward section is repeated in the enclosed hall behind it: it is divided into three barrel-vaulted aisles by two rows of five arches resting on four pillars.

A noteworthy aspect of the Kızılören Han, dated 1206 to 1207 (AH 603), is its two-storey façade. The upper level, reached by a double staircase on the inside (on the right and left of the gateway), consists of three rooms: the one on the right being the masjid that protrudes from the mass of the building to rest on three arches that spring from the two corner pillars in front.

A caravanserai that resembles the Kızılören Han is situated near the town of Gelendost on the Akşehir-Antalya highway. The Hekim Han in Malatya, the Ak Han in Denizli, the Durak Han near the town of Duragan in Sinop, and the Kesik Köprü Han located 18 kilometres Fig. 36a

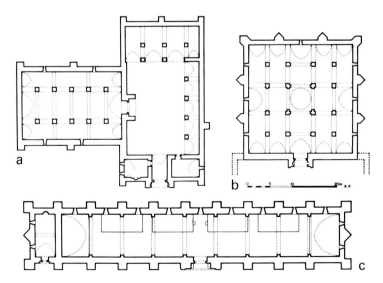

Fig. 36
Plans of caravanserais: a) Kesik Köprü Han, near Kırşehir, 1st half of the 13th cen. b) Çay Han, Çay (province of Afyon), 1278–9 c) Şerefza Han, on the Alanya-Antalya highway, 1236–7.

to the south of the city of Kırşehir, follow the same model with minor deviations from it.

In all the caravanserais mentioned so far, the common denominator has been a width of three bays. In the next group to be considered, this module is increased to five bays, resulting in broader buildings containing spacious courtyards with elevated masjids at their centre. The most celebrated caravanserais in this group are the two sultan *hans* built by Alaeddin Keykubad I near Aksaray and Kayseri.

The sultan *han* on the Konya-Aksaray highway is located 42 kilometres from Aksaray. According to the two inscriptions placed on the outer and inner portals, the construction of the caravanserai began in 1228 to 1229 (AH 626) and, after a serious fire, it was restored during the reign of Gıyaseddin Key-husrev III. The spacious courtyard is entered through a magnificently ornate portal. On the right side of the courtyard is an arcade with ten arches; it functioned as an open stable for the animals. Across from it are the guest quarters, a *hamam* and storerooms. In the middle of the courtyard is a masjid elevated on four corner pillars. The inner portal that gives access to the rear section is smaller than the first section but equally ornate. Its pillared hall, with five aisles, is nine bays deep. All of the thirty-two pillars have square sections and are tied by arches in both directions. The barrel vaults of the twin side aisles run at right angles to the wider central aisle, whose vaulting system extends along the longitudinal axis and supports a small dome at its centre. The dome sits on a high, octagonal drum with four windows. These, plus eleven slit windows cut into the walls, are the sole source of light and air for the huge pillared hall.

The second sultan *han* is located near the village of Tuzhisar on the Kayseri-Sivas highway and was completed in 1236 to 1237 (AH 634). It is slightly smaller than the other, both its sections having a depth of seven bays, but it has a more symmetrical plan and a much

better-preserved, elevated masjid. The other large caravanserais, with elevated masjids at the centre of their courtyard, are the Ağzıkara and İshaklı Hans. Pl. 66

Another large and important caravanserai dating from 1240 to 1241 (AH 628) is the Karatay Han on the Kayseri-Malatya highway located 50 kilometres to the east of Kayseri. This caravanserai resembles the sultan *han* near Tuzhisar except in one aspect: its masjid is not situated at the centre but at the front of the courtyard.

A large caravanserai that deviates from the prototype is the Zazadin (Sadeddin) Han, which exhibits an unusual asymmetrical organization. This caravanserai has two inscriptions. The one on the inner portal gives the date of 1235 to 1236 (AH 633); the other, above the outer portal, is dated 1236 to 1237 (AH 634). These inscriptions indicate that in the two-section caravanserais, the pillared hall was built first. Although quite a number of Anatolian-Seljuk caravanserais consist only of pillared halls, there were some designed with forward sections, but these sections were destroyed at a later date or were never built.

A good example of the first category is the Alay Han between Kayseri and Ürgüp, which has no inscription. The remains of walls in front of the pillared hall (five bays wide and seven bays deep) clearly show that this was originally a caravanserai, possibly of the Karatay group. Another example is the İncir Han on the Burdur-Antalya highway, dated 1238 to 1239 (AH 636); a third is the Çay Fig. 36b Han built in 1278 to 1279 (AH 677), which is of particular interest because of its completely symmetrical, square, pillared hall (five bays deep and wide).

A unique caravanserai consisting only of an enclosed section, is the Şerefza Han built by Gıyaseddin Key- Fig. 36c husrev II in 1236 to 1237 (AH 634) on the Antalya-Alanya highway, 15 kilometres from the latter town. It is a building that stretches from east to west and is composed of two parts: the larger part consists of a long, narrow barrel-vaulted hall divided into nine bays by arches reinforced outside by buttresses; the other part is a masjid with a single bay, situated at the east end of the structure.

The oldest extant caravanserai in Anatolia, built around a courtyard without a rear section, is the Evdir Han, located 18 kilometres to the north-west of Antalya. According to its inscription, it was built upon the order of İzzeddin Keykavus I, which dates it to between 1211 and 1219. The Evdir Han is a rectilinear building with three iwans. Its ornate portal leads to an entrance-iwan which opens into a spacious courtyard: 48 metres deep by 34 metres wide. One suspects that there was a fourth iwan in the middle of the destroyed rear wall and that this was originally a four-iwan courtyard surrounded on all sides by arcades.

Kırkgöz Han on the Antalya-Burdur highway, is a Fig. 38 better preserved example of the same type of caravanserai. In this *han* the arcades occur on only two sides of the courtyard. There are two rooms at the rear corners, and a barrel-vaulted hall covers the entire width of the courtyard between these two rooms. This enclosed hall is not oriented along the longitudinal axis of the building, as in the two-section caravanserais, nor does it have

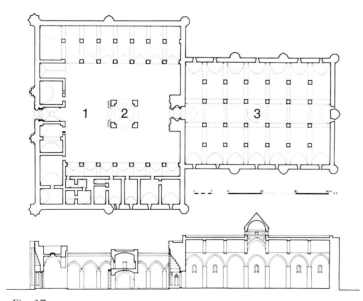

Fig. 37
Plan and longitudinal section of the Sultan Han, Tuzhisar, 1236–7: 1) courtyard 2) masjid 3) enclosed section.

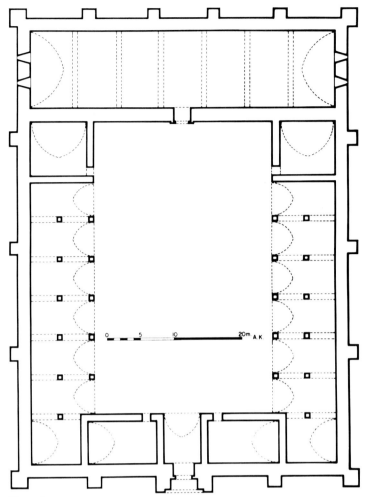

Fig. 38
Plan of the Kırkgöz Han, on the Antalya-Burdur highway, 1st half of the 13th cen.

pillars inside, for it is a hall with a single aisle like that of the Şerefza Han.

In the Evdir Han there is no hall; in the Kırkgöz Han the linear hall has a transversal disposition with its long arm facing the rear of the courtyard. In the Tercan Han, which dates from the first half of the thirteenth century, not only are there two halls instead of one, but they are oriented longitudinally behind the rows of rooms that flank the courtyard on the left and right.

A similar courtyard arrangement is seen in the Alara Han near Alanya, dated 1231 to 1232 (AH 629). As in the previous caravanserai, the courtyard of the Alara Han is narrow and flanked on either side by a row of alternating iwans and rooms, but the Alara Han shows a more organized plan in that here a U-shaped hall surrounds the courtyard on three sides.

Anatolian-Seljuk caravanserais consisting of a pillared hall only, offered nothing more than a secure shelter, since they had no provision for an enjoyable stay, other than raised platforms on which to sleep. The double-section caravanserais provided more comfort: the animals were housed in the stables at the back, while travellers enjoyed separate, enclosed or open quarters to rest and a courtyard for communal living. As there is no direct historical precedent for the single-section, enclosed

caravanserais, it may be argued that this type of building emerged in Anatolia and, like mosques with pillared aisles, was the result of the local building style adapted to a new function. The single-section, open caravanserais, on the other hand, were obviously derived from the central-Asian ribat. Among this group, the closest to the prototype is the Evdir Han with its near-square plan and courtyard with four iwans. However, the others deviate from the prototype in many aspects, and the Alara Han, for instance, can hardly be considered to emulate the model of the central-Asian ribat. The double-section caravanserai may also have had its roots in central Asia. But, here again, we are not faced with direct borrowing but with subtle utilization and development of an architectural idea, for the Anatolian-Seljuks excelled in the construction of monumental, double-section caravanserais perhaps more than in any other type of building, as attested by the sultan *hans* that are not only the kingpins of a distinctive architectural style but also reflections of the level of civilization the Anatolian-Seljuks achieved during the thirteenth century.

Conclusion

Apart from the turbehs built as memorials to the dead and made to be viewed from the outside, Anatolian-Seljuk architecture can best be described as rectilinear and introverted. As Tamara Talbot Rice observed, rectilinear Seljuk buildings are almost classical in their uncompromising directness.[40] In the earlier stages of development, the rectilinear mass is externally plain and flat except for the ornamental portal. The roofing system of the building generally sits directly on the walls and, where large halls are required, the walls are perforated by arch-shaped openings to integrate the adjacent compartments of space. In western Anatolia, the use of columns to support part of the upper structure is prevalent. In the Boyalıköy Khankah, for instance, the dome over the central hall does not rest on the walls but on four columns of Byzantine origin which are placed in front of the inner walls. Thus, in the formative period of Anatolian-Seljuk architecture, uncharacteristic columnar interiors begin to appear inside the plain, flat, rectilinear mass, which was unadorned save for the ornamental portal.

Up to the second quarter of the thirteenth century, internal space arrangements are unsophisticated, but as the style matures, the interiors become articulated, and decoration on masonry or wooden surfaces increases. Entire walls or inner shells of vaults and domes begin to be covered by faience mosaics and glazed tiles. Delicately carved pillars and door and window frames appear. Although the severity of the external rectilinear form continues, portals assume monumental dimensions and often rise above the level of the cornices of the buildings. The door is set inside a deep, *mukarnas*-crowned niche that has small mihrabs on its sides—and the portal is framed by decorative bands of geometric and floral designs. At times, not only the portal, but the whole façade is adorned (as illustrated by the Gök Madrasah in

Sivas), and the front corners are marked by carved turrets. In mosques and masjids, tall decorative minarets provide a strong vertical accent that contrasts with the basic horizontality of the rectilinear mass as a whole.

During the twelfth century, Seljuk architecture in Anatolia was understandably modest. It was a time of continuous warfare and instability. But once the Seljuks consolidated their power in Anatolia, building activity began on a large scale. The Seljuk passion for architecture was so intense that even during the decline of the sultanate it was not disrupted. Nor could it easily be forgotten, for the architectural style of the Seljuks continued to flourish in Anatolia long after their sultanate was dissolved.

NOTES

[1] Claude Cahen, *Pre-Ottoman Turkey*, London, Dublin, New York, 1968, p. 22.

[2] Cahen, *Turkey*, p. 24.

[3] Saleh Ahmad El-Ali, 'The Foundation of Baghdad' in *The Islamic City* (ed. by A. H. Hourani and S. M. Stern), Oxford, 1970, p. 89.

[4] El-Ali, 'Baghdad', p. 93. The Arabic city was obviously influenced by those built by the Sassanians.

[5] Oktay Aslanapa, *Turkish Art and Architecture*, London, 1971, p. 55.

[6] This palace complex was unearthed by Daniel Schlumberger in 1948. A drawing of the layout is given in his article: 'Le palais ghaznévide de Lashkari Bazar' in *Syria*, XXIX (Paris, 1952): 251–70. Also see: Aslanapa, *Turkish Art*, p. 59.

[7] Cahen, *Turkey*, pp. 11–12.

[8] Cahen, *Turkey*, p. 289, observes that, 'despite the undeniable hiatus in their history formed by the period of the Turkish conquest, the Seljukid towns more or less correspond to the ancient Christian towns, either because occupation had been uninterrupted or because the site had been re-occupied: in a country which had been highly urbanized, geographical conditions rarely permitted the choice of an entirely new location'.

[9] Cahen, *Turkey*, p. 201.

[10] İbrahim Hakkı Konyalı, *Konya Tarihi* (History of Konya), Konya, 1964, p. 136.

[11] Konyalı, *Konya*, p. 134.

[12] The walls of Konya, though in poor repair, still existed during the nineteenth century and were described and sketched by various travellers. Friedrich Sarre presents a good account of the city in Seljuk times in *Konia: Seldschukische Baudenkmäler*, Berlin, 1921.

[13] Osman Turan, *Selçuklular Tarihi ve Türk-İslâm Medeniyeti* (The History of the Seljuks and Turko-Islamic Civilization), Ankara, 1965, p. 262.

[14] *Loc. cit.*

[15] Turan, *Selçuklular Tarihi*, p. 263.

[16] K. A. C. Creswell, *A Short Account of Early Muslim Architecture*, Harmondsworth, 1958, p. 11.

[17] André Godard, *The Art of Iran*, London, 1965, p. 141.

[18] *Loc. cit.*

[19] Max von Berchem and Josef Strzygowski, *Amida*, Heidelberg, 1910, pp. 53, 56, 59.

[20] Albert Gabriel, *Voyages archéologiques dans la Turquie orientale*, Paris, 1940, p. 228.

[21] M. Oluş Arık, *Bitlis Yapılarında Selçuklu Rönesansı* (Seljuk Renaissance in Bitlis Buildings), Ankara, 1971, p. 13.

[22] Albert Gabriel, *Monuments turcs d'Anatolie*, vol. I, Paris, 1931, pp. 34–5.

[23] Boris Deniké, "Quelques monuments de bois sculpté au Turkestan occidental" in *Ars Islamica*, II, Sect. I (Ann Arbor, 1935): 69.

[24] See Konyalı, *Konya*, pp. 380, 381.

[25] This thesis is discussed in detail in my article, 'The Mosque of Alaeddin in Konya' in *Turkish Treasures*, vol. I, Istanbul, 1978, pp. 42–9.

[26] Faruk Sümer, 'The Seljuk Turbehs and the Tradition of Embalming' in *Atti del secondo congresso internazionale di arte turca*, Naples, 1965, pp. 247.

[27] Sümer, 'Seljuk Turbehs', p. 246.

[28] For floor plans of these houses, see: G. A. Pugachenkova, *Puti razvitiya arkhitektury yuzhnogo Turkmenistana* (The Architectural Development of Southern Turkmenistan), Moscow, 1958.

[29] J. Pedersen, *Encyclopedia of Islam*, 1st ed., vol. 3, London and Leiden, 1936, p. 350.

[30] Turan, *Selçuklular Tarihi*, p. 239.

[31] Godard, *Iran*, pp. 287–91.

[32] Turan, *Selçuklular Tarihi*, p. 238.

[33] André Godard, 'Origine de la madrasa, de la mosquée et du caravansérail à quatre iwans' in *Ars Islamica*, XV–XVI (Ann Arbor, 1949–50): 1–9.

[34] Gabriel contends that it was originally a two-storeyed building: *Monuments turcs d'Anatolie*, vol. II, Paris, 1934, pp. 157–8. For my argument see: *Anadolu Medreseleri*, vol. I, Ankara, 1969, pp. 94–6.

[35] Halil Edhem suggests that this inscription was placed on the portal at a later time: *Kayseriyye Şehri* (The City of Kayseri), Istanbul, 1334 (AH), p. 31. Gabriel does not agree and shows that the style of the inscription is in keeping with that of the portal: *Monuments turcs*, vol. I, p. 62.

[36] *Evliya Çelebi Seyahatnamesi* (Travels of Evliya Çelebi), Istanbul, 1315 (AH), vol. 3, p. 24.

[37] Friedrich Sarre, *Der Kiosk von Konia*, Berlin, 1936.

[38] Oktay Aslanapa, 'Kayseri'de Keykubadiye Köşkleri kazısı 1964' (Excavation of Keykubadiye Kiosks in Kayseri 1964) in *Türk Arkeoloji Dergisi*, XIII, no. 1 (Ankara, 1964): 19–40.

[39] Katharine Otto-Dorn [and collaborators], 'Bericht über die Grabung in Kobadabad 1966' in *Archäologischer Anzeiger...*, LXXXIV, no. 4 (Berlin, 1969): 438–506.

[40] Tamara Talbot Rice, *The Seljuks*, London, 1961, p. 130.

Turkish Architecture in Asia Minor in the Period of the Turkish Emirates

by M. Oluş Arık

Dating

First of all, it may be well to define the period of the Turkish emirates, though it is impossible to be precise in separating historical periods, for the initial signs of a new historical development can emerge in the course of the most flourishing period of an age of a different character.

When, in fact, did the period of the Turkish emirates begin? How long did it last, and when did it come to an end? It is generally accepted that the period of the emirates or Turkish emirates extended over two centuries from the late thirteenth century or the beginning of the fourteenth (when Seljuk rule collapsed and Anatolia was divided) until the sixteenth century, when Turkey was reunited under Ottoman rule. This is the most correct and realistic determination possible for our main concern, which is the history of architecture.

During the period of the Turkish emirates, new architectural attempts, marked by some regional differences, were made while the mature Seljuk style still continued to flourish. Anatolia, in the period of the emirates, was a political and artistic patchwork. In each of the emirates scattered throughout various regions, new forms were being created, and the pre-Turkic cultural heritage of each particular region made contributions of varying importance to the developments in Turkey.

As time passed, one of the emirates (the Ottoman Emirate) expanded and united Anatolia. In due course, and parallel with historical and political developments, growth in post-Seljuk art coalesced along definite lines. Consequently, a classical, mature style evolved that spread throughout almost the whole of Anatolia, which had been unified in the sixteenth century. However, as previously stated, at the same time that this new 'classic Ottoman' style was developing and spreading, the art of the Turkish emirates—a heritage of the Seljuks—could still be found here and there. Moreover, even in the eighteenth century, in some conservative regions, the Seljuk style persisted and evolved trends of its own. The exact beginning of the Ottoman period is still open to discussion and cannot be given a definite date. But, to a large extent, the initial development of the Ottomans was concomitant with that of the other emirates of Anatolia.

Historical Background

The following is a summary of general historical events during the period of the emirates.[1]

During the first quarter of the thirteenth century, the Anatolian-Seljuk dynasty eliminated or took over from the other Turkish dynasties that had been set up by the men who had first conquered Anatolia. This united Anatolia disintegrated during the period of the emirates. The Artukids acquired the rights of a separate state in the south-east, and in every region (particularly in west Anatolia) the Turkoman emirs, who had been responsible for new conquests, formed small independent states. As if this were not enough, some of the commanders of the invading Mongols, some former Seljuk statesmen, and even Ayyubids and Mamelukes participated in the contest for sovereignty over Anatolia.

East Anatolia was under the direct rule of the Ilkhanids of Persia. The Eretna Emirate was established around Cappadocia and Sivas. The Dulkadır Emirate was founded in the buffer zone between south-east and central Anatolia, i.e. the Marash and Gaziantep region. In central Anatolia, which could be considered a Seljuk metropolis, the Karamans were the rulers. In the area stretching from the Mediterranean coasts and the Taurus range towards central Anatolia, the Hamid Emirate ruled. The Germiyan Emirate developed in west Anatolia, around Afyon and Kütahya, and the Ottoman Emirate in the north-west, in the area extending to the Byzantine metropolis. The Candar Emirate extended from central Anatolia northwards to the Black Sea coasts. The Menteşe Emirate was located in west Anatolia and contained in the southernmost part (in the Milas, Xanthus and Halikarnassos areas) the superb towns of classic civilization. The Aydın Emirate covered the area from Aydın (Tralles) to Izmir, and the Saruhan Emirate was north of this, running from Bergama to Manisa.

Under these complicated political circumstances, especially in east and south-east Anatolia, complete anarchy seems to have prevailed. In view of their intermingling and continous clashes, it is almost impossible to conceive of the movements of the Turkish tribes within an orderly framework of historical geography. The Karakoyunlu

and Akkoyunlu Emirates first appear in Anatolia, later, each of them in turn became for a short time an (Iranian) empire, extending as far as central Asia. Then the Anatolian territories of these new but short-lived empires were reduced to mere provinces. The Safavids, who enabled Iran to regain national unity, established their sovereignty with the support of the Alevi Turks, who had been moved from Anatolia to Iran.[2] The Ramazan Emirate, which appeared at the same time as the Dulkadırs in the buffer zone, occupied Cilicia and made it their home. Even the Menteşes probably moved to Lycia from this buffer zone.

This complex panorama inside Anatolia gained its dynamism from the close relationships maintained with Iran and central Asia. There were migrations to Iran from central Asia and a considerable flow of people between Iran and Anatolia. This migratory movement, in which all sorts of people — peasants, nomadic tribes, soldiers, philosophers, artists and adventurers — participated, changed the character of Anatolia once again. Since each emirate harboured the desire of becoming an important state, each one used these immigrants as a labour force to re-organize and improve the environment. Thus, the result of so much political disunion was that Anatolia became Turkish on an even wider and deeper scale than hitherto. At the same time, events enabled the Turks to own more of Anatolia, speeding up the formation of a new nation.

Architectural Styles

The individual emirates had no particular style of their own. As in the Seljuk and Ottoman periods, when Anatolia was united under a single ruling dynasty, the factors that played a basic role in the emergence of various styles were the regional conditions affecting artists of different origins and the different foreign political units with which relations were established. All such developments were based on traditions of the Seljuk period; therefore, the architectural works of the period of the emirates can be studied without distinguishing among the emirates, by classifying the works according to their building techniques and by investigating typology and regional distribution. This is the most logical approach to the architecture of the period of the emirates.

Architectural works can be divided roughly into two categories: religious and secular. First we shall deal with the architecture of sanctuaries, which has been the official architectural representative of every society throughout history.

Mosques

The mosques of the Seljuk period, described in the foregoing chapter, are of five basic plans: single-domed cubic masjids or 'single-unit mosques'; mosques of the 'transept' type, resembling the Ulu Cami in Damascus of the Omayyad period, or an attempted amalgamation of this type of mosque and the large-domed cubic Asiatic mosque; transversally planned, rectangular mosques,

divided monotonously inside and generally called 'Qufa'-type; longitudinally planned, rectangular mosques, divided into longitudinal aisles with pillars and bearing traces of former Byzantine basilicas; the iwan mosque with its traditional open central courtyard. The standard Great Friday Mosque in Iran consisted of four iwans and a central court and was a contribution of the Great Seljuk Empire to mosque architecture. One might expect that this plan would be used first in Anatolia, but surprisingly enough, with the exception of the Ulu Cami in Malatya, it never was. (Even here the lateral iwans were discarded.) The iwan mosque was not used during the period of the Turkish emirates in Anatolia, but the other four types of mosque continued to exist.

Now let us survey the mosques of the emirate period by types, including the conventional mosques and the newly emerging types.

Single-Domed Cubic Mosques

This traditional type of building, which was especially used in the turbehs (mausolea) of central Asia and Iran — cradle of pre-Anatolian Turkish culture — was also applied to the Great Friday Mosque in Basra, constructed during the Great Seljuk Empire. It was the most dominant type of mosque in Anatolia, and although other styles have been favoured at one time or other, the single-domed cubic mosque has been used continuously both in medium or small-sized district mosques and later, even in large-sized Great Mosques (Ulu Cami). In some of them, as in the Kubbeli Mosque of the Germiyan Emirate in Afyon (dated 1330), a simple plan and construction, without a porch or any kind of entrance space, can be observed. In others, as in the Hacı Özbek Mosque (dated 1333), built by the Ottomans in Iznik, there is a kind of entrance space on the east side of the mihrab axis, and in others, as in the Ak Masjid of the Germiyan Emirate (dated 1397), there is a monumental porch on the north side along the mihrab axis. Later a porch with domes supported by arches became the standard on the north façade, a style used first in Ottoman mosques. Although some early mosques have porches with two bays, three-domed and five-domed porches became more common later.

In the Seljuk period, when moving in the zone of transition from a square volume to a circular one like a dome, squinches, fan-shaped corner triangles (one of the best examples is the Karatay Madrasah in Konya dated 1251) or bands of triangles pointing alternately upwards and downwards were the principal structural methods used. These methods continued to be used during the period of the emirates. In the cubical masjids of this period, however, fan-shaped triangles (whose function is similar to that of the pendentive) are not often encountered. Bands of triangles were what was chiefly used. The earliest examples of this type of zone of transition known to us at present in the period of the emirates are the Kubbeli Mosque in Afyon, and the Alaeddin Mosque of the Ottomans in Bursa, dated 1335. Bands of triangles were used throughout the fourteenth and fifteenth centuries in many

Fig. 39 buildings in the emirates, such as in the Yelli Mosque at Peçin (near Milas), which is probably of the late fourteenth century, and a new variation on this type of transition emerged: *baklava kuşağı* (the lozenge-shaped belt). This also is composed of triangles, but here each triangle is divided to obtain double triangles, and these are arranged in bands that form a facetted belt of triangles. Probably the earliest example of this method is the Hacı Özbek Mosque. Lozenge-shaped belts were later used in many domed cubical mosques, such as the famous Ottoman Yeşil Mosque in Iznik (dated 1378), the Ak Masjid and the İshak Fakih Mosque (1433) of the Germiyan Emirate at Afyon. In over one third of the mosques, squinches were used; they were the transition elements traditionally employed in Asia. It is interesting to note that, although the Ottomans introduced more sweeping innovations than the other emirates, they used an element as traditional as the squinch more frequently than the others. In the other emirates, the squinch is only

Pl. 71 encountered in a small number of examples, such as in the İlyas Bey Mosque (1404) of the Menteşe Emirate at Miletus (Balat), the İklime Hatun Mosque (1480) of the Dulkadır Emirate at Marash or the Şeyh Matar Mosque (1500) of the Akkoyunlu Emirate at Diyarbakır. The inner faces of the squinches are of different shapes. In the İlyas Bey Mosque at Miletus, they are filled with exquisite

Fig. 40 stalactites. In the Yıldırım Beyazıt Mosque of the Ottoman Emirate at Mudurnu, the squinches continue down as pilasters and form exedrae, which make the interior more impressive. Another feature that started

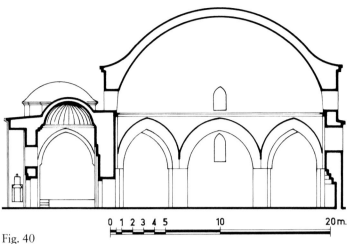

Fig. 40
Section of the Mosque of Yıldırım Beyazıt, Mudurnu (after E. H. Ayverdi).

with mosques of the Ottoman Emirate is the transition to the dome through pendentives. Almost a third of the cubical masjids use the pendentive, for example the Hoca Yadigar Mosque (1374) in İnönü. In the mosques of the other emirates, however, it is seldom encountered, e.g. the Ağca Masjid (1409?) of the Ramazan Emirate in Adana.

At first, the minarets resembled those of the Seljuk period; the location of the minaret had not become fixed. From the examples known, it is seen that a minaret can be situated almost anywhere except on the south-east corner of the mosque. In many of the mosques — as in the Seljuk period — there is no minaret. These mosques are comparatively small buildings such as the Kubbeli Mosque at Afyon, the Hacı Özbek Mosque at Iznik, and the İlyas Bey Mosque (1362) of the Saruhan Emirate at Manisa. A minaret is attached to the north-west corner of the masjid in the Alaeddin Mosque at Bursa, the Orhan Mosque (second half of the fourteenth century?) of the Ottoman Emirate at Gebze, the Kurşunlu Mosque (1377) of the Germiyan Emirate at Kütahya and the Narin Mosque (1384) of the Aydın Emirate at Tire.[3] As seen on the Kasim Pasha Mosque (1478) at Edirne and the Firuz Ağa Mosque (1490) in Istanbul, this application was continued on the structures built during the later Ottoman period. The Şeyh Matar Mosque (1500) of the Akkoyunlu Emirate in Diyarbakır, has a minaret raised on six columns and separate from the main buildings.[4]

While the single-domed cubic mosque is a mature and balanced whole, when the domed cubical unit is used alone it is too simple a construction and not suitable for enhancing large spaces. With the materials and technology of an earlier age, it was impossible to use this type of building for the Ulu Cami (Great Mosque), which had to accommodate large congregations in a spacious complex. In that age, when reinforced concrete had not been invented, the dome was the most advanced and elegant means of covering large compartments without supports. In the search for buildings that would be appropriate for Islamic worship and would maintain the congregation in an undivided group, there arose in Turkish architecture a passion for the domed structure.

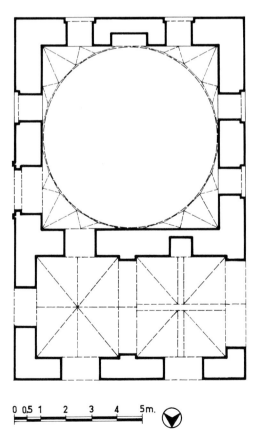

Fig. 39
Plan of the Yelli Mosque, Peçin near Milas, late 14th cen. (after A. Arel).

113

Fig. 41
Plan of the Sultan Orhan Mosque, Bilecik (after A. Kuran).

Within the framework of single-domed cubic structures, various means were used to overcome limitations on the inner space. They can be explained as a search for ways to develop new spaces and effects and modes of expression.

Fig. 41 In the Mosque of Sultan Orhan in Bilecik, built by the second leader of the Ottoman Emirate, a baldaquin consisting of a dome resting on four wide arches constitutes the basic structure, which can clearly be recognized. Prominent corner triangles below the low drum of the dome were used for the transition. The corner triangles are constructed with the corners of bricks forming a pattern, produced by each row of corners projecting above the other one; this results in a surface covered with stalactites. Four pillars and arches carry the dome. The external walls encircle the pillars, thus enlarging the interior beyond the span of the arches. A dynamic cross plan with a central dome is produced by means of these arches; the resulting iwans are shallow. Because the thrust of the dome is transmitted to four sound corners through arches instead of a heavy wall, the exterior walls are simply non-load-bearing curtain walls. This advanced structural technique, which produced varied organic spatial compositions, is a Byzantine influence. Although the potential of this structural principle is not readily apparent, because of its modest size and form, it underlies the brilliant development of later Ottoman architecture.

During this period, the interior space is further articulated by the addition of a sort of vestibule, reminiscent of the 'endo-narthex'. Mosques with this particular feature go beyond the concept of a single-unit building; they are variations showing the search for larger and more varied spaces. The majority of such experiments can be observed during the Ottoman Emirate; the Yeşil Mosque at Iznik is one of the earliest and most beautiful examples.

The Ferraşoğlu (Gazazhane) Mosque in Tire (dated 1446) has both an external porch and an internal vestibule. The Davut Pasha Mosque in Istanbul (dated 1485) has a half-domed iwan apse of polygonal plan added to the cubical prayer hall. These two examples illustrate the extent of such variations in the Ottoman architecture. In the Davut Pasha Mosque, the apse and the *zaviye* (convent) rooms also have a complex exterior recalling the different classifications of mosque forms. Actually, a significant number of this kind of mosque were to be found in the emirates, though most belong to the Ottoman Emirate. They provide examples of forms with complex masses. No such phenomenon has been recorded from the Seljuk period. In some examples, there is a large frontal space that seems like an additional building, with side annexes in the form of regular or irregular additions; in others, the complexes achieve a well-arranged, expansive composition.

The Kale Mosque at Mardin, which was built in the period of the Akkoyunlu Emirate, looks as though it was composed of two different types of building: a domed cubical unit and a transversally planned three-unit mosque.[5]

Rooms that have been added to a core in a large group of mosques give the impression of a reverse-T plan. The majority of them are early Ottoman buildings. Though they are fewer in number, it is still possible to see this type of mosque in other emirates, e.g. the Uzun Hasan Mosque — probably of the Akkoyunlu Emirate — in Fethiye, near Malatya.[6]

Fig. 42
Plan of the Karakadı complex, Tire (after İ. Aslanoğlu).

In early Ottoman architecture, along with other large types of mosque, a new variation was tried in some domed cubical mosques of the fifteenth century: a monumental courtyard with a portico was added to the front of the domed cubical structure, as in the Başçı İbrahim Mosque (1490) at Bursa. The complex of the Mosque of Sultan Beyazıt II in Edirne (1484), which is the second vast complex after that of Fatih, is also such a building. Large dimensions had never been attempted in single-unit mosques before; therefore, this mosque is exceptional. We regard it as the peak of the development for this type of mosque.

A new complex came into being when the front court-yard of a mosque was also used as the courtyard of a ma-drasah. The Molla Arab Complex (1492), erected at Tire by the Ottomans after capturing the territory of the Aydın Emirate,[7] is an example of such organic composition formed by combining two buildings in such a way that they seem to belong together naturally. Perfection in this type of building is a speciality of Ottoman architecture; however, complicated planned works, like the Hacı Kılıç Mosque and Madrasah of the Seljuks in Kayseri (1249) and the Shahidiye Madrasah of the Artukids in Mardin, followed a tradition that can be traced to the Ayyubid complexes in Syria, which must have been their source.

A very special group of mosques at Tire, with prayer halls composed of a space covered with a single dome, must also be considered during the period of the emirates: Fig. 42 the prism-shaped Karakadı Mosque, resembling the Mosque of Sultan Orhan at Bilecik, has a baldaquin-form structure; however, here the baldaquin is hexagonal, and the arches are walled in. This is the main part of a complex composed of such buildings as a turbeh and madrasah rooms.[8] In the same town there are several examples of single-domed octagonal mosques, such as the Gucur Mosque and the Pir Ahmet Mosque.[9]

Mosques of the 'Qufa' Type

It appears that the first monumental mosque buildings of the Islamic world were encountered around Qufa (or Kufa) and Basra on the Persian Gulf. The supports of the superstructure in the prayer hall and along three sides of the large courtyard were situated at equal intervals. In Anatolia, as in these early examples in Iran, either with or without a standard forecourt, mosques with rectangular prayer halls of transverse plan and with similar monotonous partitioning have been called 'Qufa'-type mosques by some art-historians,[10] and this term is used here.

In large mosques, at least in those that can be said to be of monumental dimensions, there is the simplest type of interior division, and for this reason, there is no need to look for its source of influence. Similarly planned mosques, which appeared in the Seljuk period (influenced either by Syria or by Mesopotamia), were encountered generally in central Anatolia. This was also the case during the period of the Turkish emirates. It is even possible to state that, apart from one or two exceptions, these buildings all belonged to the Karaman Emirate. The

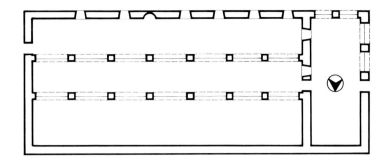

Fig. 43
Plan of the Ulu Cami (Great Mosque), Ermenek, 1302 (after O. Aslanapa).

archaism and conservatism of the Karaman Emirate are notable and are interpreted as the result of their claims to be the heirs to the Seljuk dynasty. In Ermenek, the first important centre of the Karaman Emirate, are the earliest known examples of such mosques in the period of the emirates: the Akça Masjid, assumed to have been built around 1300, the Ulu Cami of Ermenek (dated 1302) and Fig. 43 the Sipas Mosque (dated 1306). These are all buildings without courtyards, like those seen in the Seljuk period. The Ulu Cami of Ermenek is the earliest known example both of this type and of the Anatolian multi-unit mosque with a vestibule from the period of the emirates. Situated on a slope running from south to north of the charming town of Ermenek, the qiblah wall of the Great Mosque commands a view of the landscape and has windows on both sides of the mihrab. Extending from the qiblah wall is the two-arched entrance to the vestibule on the west wall of the mosque. Many mosques belonging to the Karaman Emirate are of this style: the Arapzade Mosque in Karaman (from the end of the fourteenth or the beginning of the fifteenth century), the Meram Masjid in Konya (dated 1486), the Hacı Beyler Mosque in Karaman (1358), the Ulu Cami in Aksaray and the Meydan Mosque in Ermenek (dated 1436).

Apart from the relatively large, multi-unit mosques like these, there are small buildings with fewer partitions in small neighbourhoods in various locations in Anatolia. They are not all of the same period. These buildings are the small-scale replicas of the large, standard type of mosque. The Shah Masjid (1343) and the Hanım Masjid (1452) in Niğde of the Karaman Emirate[11] are of this type. Each building has masonry walls, a transverse rectangular plan, two columns bearing the superstructure and a prayer hall that is divided into two aisles. In the Shah Masjid, the columns supporting the timber roof are also timber and have stalactite capitals. This timber construction continues the Seljuk tradition. The best example is found in the Ulu Cami in Afyon. In the Hanım Pls. 56, Masjid, the columns are of masonry with reused antique 128 capitals. Ankara, which was under the rule of semireligious craft and merchant guilds called Ahi, has masjids that can be regarded as small-scale examples of the 'Qufa' type, for instance the Molla Büyük Masjid.[12]

The Dulkadır and Ramazan Emirates produced monumental examples of the 'Qufa'-type mosque in south Anatolia, where Syrian influence prevailed. The Ulu Cami Pl. 73

in Adana of the Ramazan Emirate (dated to the first half of the sixteenth century) and the Ulu Cami in Tarsus (1574)[13] exhibit a deep devotion to the Ayyubid and Mameluke styles, particularly in their decorated façades with high-quality masonry work, in alternating courses of black and white marble blocks and attractive portals and the minarets. At the time when the great architect Sinan created the world-renowned masterpieces of Ottoman architecture, these buildings had no features that reflected classic Ottoman style except the porticos of the court-yards which were covered with a row of domes.

Multi-Unit Mosques with Bays of Similar Size

Mosques with richly programmed spatial designs could not be expected to develop from the rather monotonous and simple mosques of the 'Qufa' type. However, an interesting example of early Islamic architecture (the Bu-Fatata Mosque in Tunisia) has shown that, despite the monotonous partitioning, a further monumental expression could be obtained by developing a complex super-structure.[14] An example similar to this experimental mosque, which remained unique in Arab countries (particularly in the early Islamic period), is found in east Islamic architecture in the Muğak Attari Mosque, built in the twelfth century by the Karakhanids in Bukhara, Turkistan.[15] It is not known whether these two mosques are related attempts or not. The prayer halls in both were partitioned by equidistant piers, but the square spatial units were defined by means of arches between each of the four piers, and each unit was covered with a dome, making them appear as a group of baldaquins of equal dimensions.

During the period of the Turkish emirates in Anatolia, individual examples reminiscent of these mosques but with no traceable relations, can be observed. The first definitely dated example is the Yivli Minare Mosque (built in 1387) of the Hamid Emirate in Antalya. It has the form of a group of baldaquins. The space is divided into two rows of three domes on each. There are some

Fig. 44

mosques featuring the same formal principle — although they have been severely tampered with — in south-east Anatolia and in Bitlis. The first constructions may be traced as far back as the fourteenth century to the Artukid, Karakoyunlu and Akkoyunlu Emirates.

Apart from these examples, the multi-unit mosque definitely belongs to the Ottoman Emirate. The oldest and the most splendid example is the Ulu Cami in Bursa, built in 1396 to 1399 by Yıldırım Beyazıt I. The Eski Mosque (1403–14), which can be considered as the first Great Mosque in Edirne, is another colossal monument. (These two significant buildings will be dealt with in detail in the next chapter on Ottoman architecture.) There are other such monumental buildings, e.g. the Şeyh Sinan Mosque in Alaşehir, which must have been built in 1482, and the Zincirlikuyu Mosque, which was built in the late fifteenth century in Istanbul. In addition to these, there are some small-scale versions, based on the repetition of cubical units of equal size or of baldaquins, for example the Saraçhane Mosque (1399) in Amasya and the Abdal Mehmet Mosque (around 1450) in Bursa. In these two mosques the transverse rectangular prayer hall has been divided into two equal squares by means of a large arch set on pilasters that face each other between the qiblah wall and the north wall.

Fig. 63

'Basilical' Mosques

A different style of mosque, considered 'archaic' in Anatolian Turkish architecture, crystalized in the Seljuk period. The interior of the mosque is divided into small sections by a large number of supports. Rather than having a transversal prayer hall, the mosque (perhaps under the influence of the Christian mode of building) is planned longitudinally in the direction of the qiblah. The prayer hall is divided into aisles running lengthwise so that the whole resembles a basilica. This type of mosque is encountered mainly in the central regions of Anatolia. The Ulu Cami of Beyşehir was erected by the Eşrefoğlu Emirate in 1299, at a time when the Seljuks were still nominal rulers. A direct successor to Seljuk architectural styles, it is generally considered to belong to the Seljuk period; however, it was built by a leader of a small local state that was independent of the Seljuks. Hence it may be considered the first monumental mosque of basilical composition from the period of the emirates. The Beyşehir mosque, studied in a later chapter, has magnificent examples of wood carving and painted and tile decoration. Other basilical mosques followed throughout the fourteenth and fifteenth centuries in Anatolia. Some of them are monumental works of art, constructed entirely of cut-stone masonry, as in the case of the Sungur Bey Mosque in Niğde, and others are lovely buildings which follow the Seljuk tradition observed in the Eşre-foğlu Mosque mentioned in the previous chapter on 'Anatolian-Seljuk Architecture'. They have wooden columns and ceilings and coloured decorations. An example is the Mahmut Bey Mosque of the Candar Emirate at Kasabaköy near Kastamonu. Small neigh-bourhood masjids, e.g. the Hacı İvaz Masjid in Ankara,

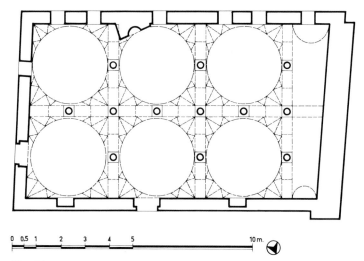

Fig. 44
Plan of the Yivli Minare Mosque, Antalya, 1387 (after M. Tuncel).

were also built on these lines. The portal of the Sungur Bey Mosque (1335) in Niğde is on the east side of the building, as in the case of the famous Seljuk monument, the Alaeddin Mosque, in the same town. The Sungur Bey Mosque is the second mosque in Anatolia known to have a portal with double minarets; the earliest known one being the Sahib-ata Mosque in Konya of the Seljuk period. Unfortunately one of the minarets is missing from the Sungur Bey Mosque. This work of art, whose interior partitions and superstructure have been destroyed, is an interesting type of basilical mosque. The nave was covered with multiple domes, as seen in the reconstruction drawn by Gabriel, a French archeologist.[16] The Seljuk tradition can be seen in the masonry ornamentation which is of a very high quality, and the Gothic influence can be observed on the ornaments of some of the arches and windows. This is assumed to be due to influence from Cyprus and is an example of the experimental and eclectic character of the period. The Mahmut Bey Mosque (1366) at Kasabaköy near Kastamonu, on the other hand, displays a worldly richness in its interior: the timber construction and decoration are confined within simple masonry walls.

No documents on the construction of the Mosque of Orhan Bey at Peçin near Milas have been found, although the mosque is mentioned in various sources. In the excavations we have been engaged in since 1974, in the ruins of Peçin, features of the foundations and the floor pavement have been brought to light. The results imply a basilical plan with a timber roof that was at least partially supported by timber columns.

Mosques of the 'Transept' Type

The Ulu Cami of Diyarbakır from the Seljuk period was the oldest and most magnificent monument of its kind in Anatolia. During the period of the Turkish emirates, this type of mosque was less favoured than the other 'archaic' styles of large mosque. We know of only one such building, and it has a pretentious monumental quality: the İsa Bey Mosque (1374) of the Aydın Emirate in Ephesus. This mosque is the most developed example of the 'transept'-type of mosque as far as architectural space is concerned. Because it has fewer inner divisions, its overall articulation is better expressed. The intersecting nave on the qiblah axis is divided into two equal squares by means of an arch in line with the arches of the aisles. Each of these squares is covered by a dome, creating the effect of a central domed space. The triangles for transition to the dome are covered with tile mosaics in the Seljuk tradition. The courtyard in front of the prayer hall, is encircled with porticos, except on the south side. Two monumental portals are located at the junction of the courtyard and the prayer hall. The central section of the north façade reflects the nave behind it by means of a pediment. This treatment of the façade, together with the plan, is reminiscent of the Ulu Cami in Damascus. The architect of the mosque was certainly from Damascus. The treatment of the façade of the courtyard — as if it were a continuation of the prayer hall — is the forerunner of the monumental courtyards of classical Ottoman mosques. Composed in an eclectic style, the elegant columns of the building recall antique models; each

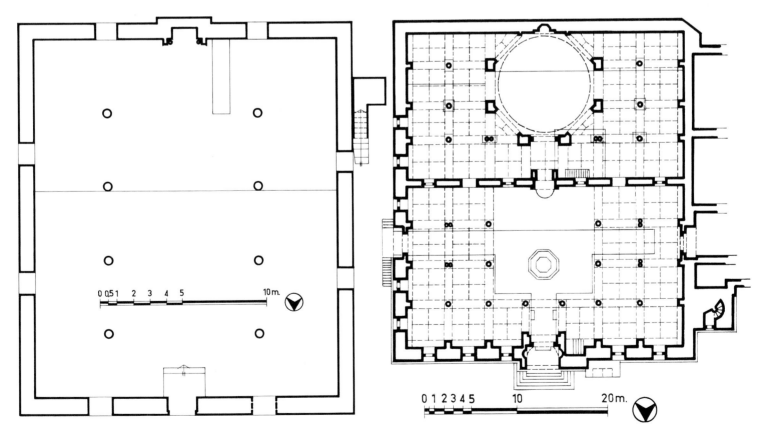

Fig. 45
Plan of the Mosque of Orhan Bey, Peçin near Milas (after M. Tuncel).

Fig. 46
Plan of the Ulu Cami, Manisa, 1366 (after A. Kuran).

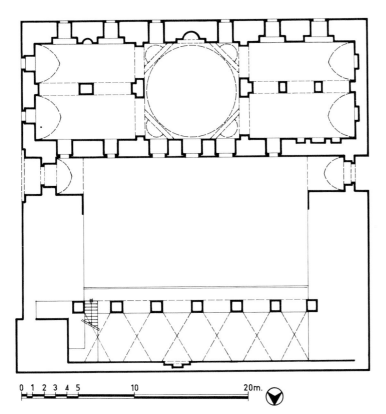

Fig. 47
Plan of the Latifiye Mosque, Mardin, 1371 (after A. Altun).

window could be regarded as a decorative element, and the portal brings to mind Ayyubid and Mameluke compositions.

During the period of the emirates, this plan was adapted, becoming a sort of metamorphosis of the proto-type. These developments began well within the Seljuk period. In many mosques of the Seljuk period of whatever type, there might be a domed bay in front of the mihrab. In some, the bay is bigger than the other units of the prayer hall; its arches, piers and dome are more richly

organized, acquiring a special connotation. This special form, which is called *maksura*, can also be encountered in the period of the emirates. The prayer hall of the mosque in Gevaş, which was built on the south coast of Lake Van in the fourteenth century by İzzedin Şir of the Hakkariye Emirate, is a simplified example of the Ulu Cami from the Seljuk period in Erzurum. It was constructed with uniform stone blocks, but the building retains a simple provincial style. The plan, however, recalls contemporary mosques that are also pioneers in their style of structure. The front court, though simple, has been designed as a madrasah.

Also on the banks of Lake Van, among the ruins of the city of Van, there are remains of a sizeable building that was obviously once a magnificent work of art: the Ulu Cami of Van.[17] It was built between 1389 and 1400 during the time of Kara Yusuf, a ruler of the Karakoyunlu Emirate. In the almost square prayer hall, the piers form monotonous partitions resembling those of the 'Qufa'-type mosques. In front of the mihrab, a rather large space is covered by a cloister vault constructed with large stalactites. The surfaces of these stalactites, as well as the walls and the mihrab, have been decorated with brick and tile mosaics and stucco, creating a very original and magnificent variation of the *maksura*. As far back as the Seljuk period, in the 'transept'-type mosque, the most popular kind was a nave that was transformed into a *maksura*. In the Artukid Ulu Cami in Meyyafarikin Fig. 20 (Silvan), this scheme had developed to such an extent that it provoked trials with centrally domed spaces. An advanced phase of this development can be seen in the Ulu Cami in Manisa from the period of the emirates. In Fig. 46 this mosque, which was built in 1366 by İshak Bey of the Saruhan dynasty, a large part of the transversal rectangular prayer hall is taken up by a domed bay, which resembles a baldaquin set on eight piers. This Great Mosque has a front courtyard that repeats the prayer hall scheme. It marks the revival of the courtyard that had not been very much in favour in the mosques of the Seljuk

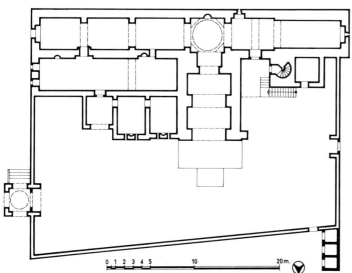

Fig. 48
Plan of the Ulu Cami, Hısn Keyfa, before 1398 (after A. Gabriel).

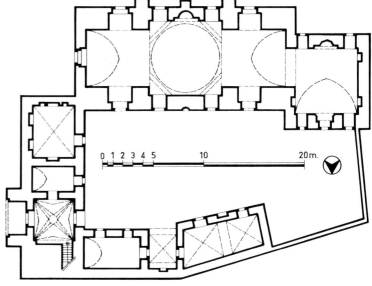

Fig. 49
Plan of the Mosque of Bab-üs-Sur, Mardin, 1st half of the 14th cen. (after A. Altun).

118

period. There were many reused columns in this building: *riwaqs* (arcading) resting on double columns from the Byzantine period and a portal, reminiscent of the influence of a style developed in North Africa and Egypt at the time of Fatimids. This mosque is the first step along the road leading to classic Ottoman mosques, which have the most developed spatial composition. They are referred to as 'centrally domed mosques' (to be dealt with in the next chapter on Ottoman architecture).

Fig. 47 In south-east Anatolia, ruled by the Artukids, where the idea of combining the nave and the *maksura* originated, a similar development has not been observed. Mosques like the Latifiye Mosque (1371) in Mardin are well-implemented examples with a regular plan and high-quality stonemasonry.[18]

Fig. 48 In addition, some transverse rectangular mosques that cannot readily be classified are also encountered. They are variations derived from the 'transept'-mosque prototype. The Ulu Cami of Hısn Keyfa, which must have been built before 1398 during the time the Ayyubids penetrated into this region, has a transversal prayer hall in a very elongated, thin rectangle.[19] There are no supports inside it. The long rectangle is covered with a barrel-vault flanking a dome at the centre and two rib arches on its sides. Outside the mosque, in front of the domed section, an entrance iwan projects into the large and irregular courtyard. The resulting scheme is reminiscent of Seljuk mosques (a dome in front of the mihrab and the iwan in front of that), while the transverse prayer hall and large front courtyard show devotion to the Syrian tradition. This building, where various influences are used disharmoniously, is a typical example of the eclectic and experimental character of the building during the period of the emirates.

There is yet another group of mosques, encountered most often in south-east Anatolia, in which special spatial peculiarities are common. These mosques are also a variation of the 'transept'-type mosque.

The transversally planned, rectangular prayer hall is not subdivided by supports, while the superstructure is symmetrically divided into three parts on the vertical axis. The central square section is completely covered by a dome, and the side sections have transversal barrel-vaults, thus producing a central space enlarged by two side iwans. The Ulu Cami of Eğil, built by the Artukids near Diyarbakır in the thirteenth century, is probably the

Fig. 49 first of its kind. The Mosque of Bab-üs-Sur in Mardin, a monumental building built by the Artukids during the first half of the fourteenth century, is of a similar plan.[20] It is the main building of a complex, composed of elements such as turbehs, a *zaviye* and iwans organized around a common court — a typical feature of south-east

Pl. 79 Anatolian architecture. The Zinciriye Madrasah of Sultan İsa of the Artukid dynasty (1385), also in Mardin, is another complex consisting of different institutions.[21] The units that could be separate buildings — school, *zaviye*, turbeh and mosque — are clustered together into a single entity. The mosque has a prayer hall of the type mentioned above. This comparatively small mosque acquires a monumental quality because of its decoration (influenced by the Ayyubids) and the high-quality stone

masonry. The Kasımiye Madrasah in Mardin, which was most probably completed by Sultan Kasım (one of the princes of the Akkoyunlus) at the beginning of the fifteenth century, is a similar complex. The mosque is the same as that of Sultan İsa. The masjid of the Taş Madrasah in Marash, from the last quarter of the fifteenth century, is a modest example.

Zaviye *Mosques*

There are mosques which, it is generally agreed, have developed with some differences in plan and use from madrasahs with domed central courts, which first appeared in the Seljuk period. These mosques were of two standard plans, and, apart from one or two exceptions, both were more common in the Ottoman Emirate. In the first type, the central unit, corresponding to the domed court of some Seljuk madrasahs, is the dominant part of the building. A second unvarying feature is the qiblah iwan, corresponding to the main iwan of Seljuk madrasahs. The Orhan Mosque in Bursa, dating from the fourteenth century, is the earliest known, and in this and in all other examples, the iwan projects like an apse towards the qiblah. Thus the superstructures of the central hall and the iwan form a central mass that dominates the entire building. In addition, there are always side iwans. Cubical chambers adjacent to the side iwans symmetrically complete the two wings. The function of these chambers, which vary in number according to the size of the building and sometimes are non-existent, is not fully known. They may have been used as offices, courts of justice or for religious education; most probably they were used for the convent chambers that are associated with the colonizing dervishes.

Fig. 50 Two rare examples of similar structure outside the Ottoman Emirate are the Yakub Bey İmaret (dated 1411) of the Germiyan Emirate in Kütahya and the Ayni Minare

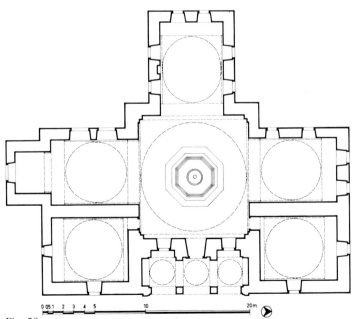

Fig. 50
Plan of the Yakub Bey İmaret, Kütahya, 1411 (after A. Kızıltan).

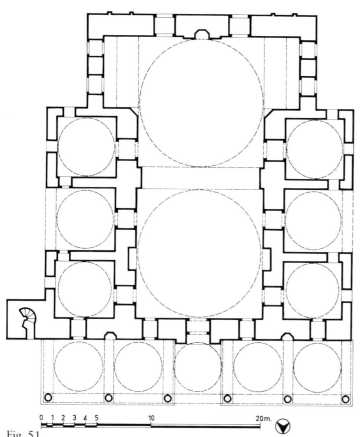

Fig. 51

Plan of the Mosque of Gedik Ahmet Pasha, Afyon, 1472 (after A. Kuran).

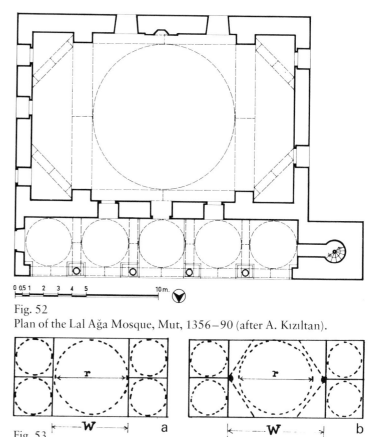

Fig. 52

Plan of the Lal Ağa Mosque, Mut, 1356–90 (after A. Kızıltan).

Fig. 53

a) Type of mosque the author expected to develop: W=r b) Plan of the Üç Şerefeli Mosque: W>r.

Mosque (dated around 1489) of the Akkoyunlu Emirate in Diyarbakır.

The characteristics of the second standard multi-functional mosques are as follows: the domed hall is the same as in the first type, but the main iwan is a repetition of the central hall on the qiblah side. Thus, the rectangular prayer hall extending towards the qiblah is composed of two domed cubical units that open into one another via a large arch. The secondary spaces may differ from one building to another. The Firuz Bey Mosque in Milas, built in 1394 by Firuz Ağa, who was assigned as an administrator to the Menteşe region by the Ottomans, was probably the first such building. The Beyazıt Pasha Mosque (1419) of the Ottoman Emirate in Amasya belongs to this type too. Furthermore, the cupboard niches that cover an entire wall in the side rooms have a rich stucco decoration resembling that found in Seljuk palaces.[22] The İsmail Bey Mosque (1454) of the Candar Emirate in Kastamonu is one of the rare examples built Fig. 51 outside the Ottoman Emirate. The Mosque of Gedik Ahmet Pasha (dated 1472) of the Ottoman Emirate in Afyon resembles the plan of the Çinili Köşk of Mehmet II in Istanbul, with its side iwans opening outside.

Centrally Planned Mosques

In the Islamic liturgy the congregation comes into the presence of God as one body. It is interesting to note that the search for a spatial composition which would symbolize this unity can be followed most easily in Turkish architecture. Some experiments from various periods and regions can be singled out as an indication of such spatial exploration. The efforts to make the dome not only a motif crowning the superstructure but a definitive and governing element of the spatial organization, are more evident in Turkey than in other Islamic countries. From the Lashkar-i Bazar Mosque of the Ghaznevids (in Afghanistan) to the Great Friday Mosque of the Great Seljuks in Isfahan, Iran; from the Ulu Cami of the Artukids in Meyyafarikin (Silvan) to the Alaeddin Fig. 20 Mosque of the Seljuks in Konya, there have been many Fig. 21 buildings in which an attempt has been made to combine the dome either with the 'transept'-type mosque or with the 'four-iwan' type mosque so that it dominates the whole. In the period of the Turkish emirates, such exploration can be said to have given birth to a new spatial arrangement. The Lal Ağa Mosque, which was Fig. 52 probably built between 1356 and 1390 during the Karaman Emirate in the town of Mut on the Karaman-Silifke road, merits special attention—especially after the change in plan of the Ulu Cami in Manisa (Fig. 46). If the plan and construction of the former building are original, it can be considered in advance of its time in volume and Pl. 72 mass. Each of the massive arches resting on the qiblah wall and the front wall has a narrow symmetrical division like an aisle running lengthwise on either side of it; this forms a central square covering a large part of the prayer hall. Four large pendentives at the four corners of the central area create the transition to the dome overhead. A

monumental porch is located at the front. The relatively modest dimensions of the building, and the massive walls built of ashlar masonry, give an archaic aura to the whole, despite the new, advanced spatial organization. The idea of a composition based on the *maksura*, which started in the Seljuk period, gained remarkable magnitude in the mosques with transversal rectangular plans that were consecutive developments of that idea; however, these experiments were immature.

Fig. 66 Then, between 1437 and 1447, the Üç Şerefeli Mosque of Sultan Murat II was built in Edirne. This building (discussed in the next chapter) has an extremely advanced spatial composition that is quite beyond comparison with previous experiments. Despite this, it is obvious that the plan developed from a transversal rectangular prayer hall with a large *maksura* between the symmetrical aisles. The Üç Şerefeli Mosque was the apex of this development and, moreover, marked a rapid leap forward. The starting point in this development was the use of the undivided nave of the *maksura* in a symmetrical 'transept' scheme. The aisles, as a result, were divided less and became more compact, whereas the *maksura* became larger and larger and finally dominated the entire Fig. 53 mosque. A mosque in which the aisles were reduced to two domed units on each side (with a central cubical unit taking the place of the *maksura* and covering most of the prayer hall) could be expected as the consequence.

Before such a prototype came into being, something new, the Üç Şerefeli Mosque, was completed: the aisles developed as expected, but the central unit had a hexagonal plan making it possible to cover a larger space than a dome would allow. (In the prototype I expected to develop, the width of the central space is equal to the diameter of the dome; whereas in the Üç Şerefeli Mosque the width of the central [hexagonal] space is larger than the diameter of the dome.) The plan of the Üç Şerefeli Mosque, however, was not used again. Instead, a style of building that one would have expected to appear much earlier became popular. Many of these buildings are early Ottoman, such as the Çaşnigir Mosque (1474), the İvaz Pasha Mosque (1484) and the Hatuniye Mosque (1488–9) in Manisa, the Ulu Cami in Akhisar and the Fig. 54 Fatih İbrahim Bey Mosque in Urla,[23] near İzmir, from the

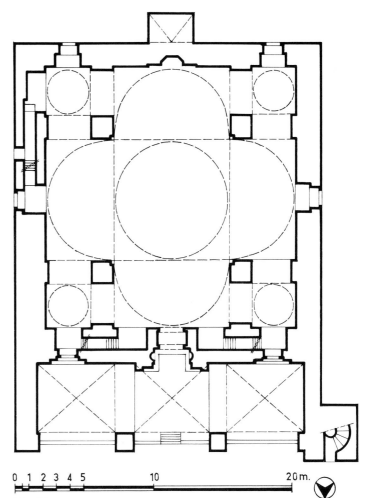

Fig. 55
Plan of the Ulu Cami, Elbistan, 1515 (after M. Sözen).

second half of the fifteenth century. The excellent spatial composition of the magnificent sultan mosques of classic Ottoman architecture was a result of a development pursued in the Atik Ali Pasha Mosque (1496) and the Sultan Beyazıt II Mosque (1505) in Istanbul. However in the Ulu Cami in Elbistan (1515) of the Dulkadır Emirate, Fig. 55 built (before the Şehzade Mosque [in Istanbul] by the great Ottoman architect Sinan), the plan for a magnificent structure with a central dome, in full symmetry to both axes, was created. There does seem to be a resemblance between the Şehzade scheme and the Diggaron Mosque (eleventh century) of the Karakhanid Turko-Islamic state in central Asia,[24] though there are no examples or data to prove it.

Madrasahs of the Period of the Emirates

Madrasahs were built in the simplest and most practical design – a building with disunited volumes. Basically they are composed of rows of chambers (or cells) surrounding a large central court. Among the rows of chambers are iwans. The standard schemes are those with four iwans (one in the middle of each side of the court), with three iwans (one in the middle of three sides leaving out the fourth side [the entrance]) or with only two iwans (leaving out two sides). The main iwan, which is opposite the entrance, and the central court are the indispensable

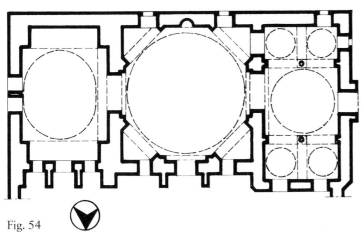

Fig. 54
Plan of the Fatih İbrahim Bey Mosque, Urla near İzmir, 2nd half of the 15th cen. (after A. Arel).

121

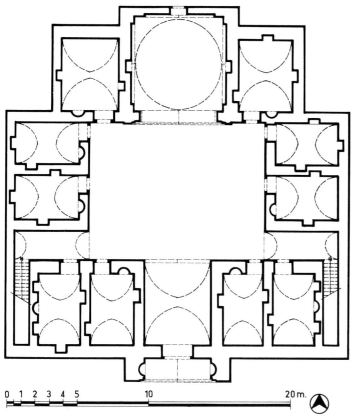

Fig. 56
Plan of the Ahmet Gazi Madrasah, Peçin near Milas, 1375 (?) (after A. Arel).

elements of a madrasah. Every madrasah has *riwaqs* extending along at least two sides of the court. There are some madrasahs with a second storey that repeats the same scheme.

The buildings called *şifaiye* (hospital) are in no way different in plan; for this reason they are included in this section.

All these standard types of Seljuk buildings continued to be built during the period of the emirates.

In the Karaman and Hamid Emirates and in east and south-east Anatolia, traditionalism and conservatism were embodied by a continuation of the Seljuk style, which was also reflected in madrasahs. The earliest example of these traditional madrasahs was built by Dündar Bey of the Hamid Emirate in Eğridir (1302). Like many Seljuk madrasahs, it has main and entrance iwans and an open central court. The finely worked pieces of a ruined portal from a Seljuk caravanserai have been looted and remounted in the madrasah's portal. There are many other types of madrasah in the region extending from central Anatolia to Iran, which remained under the direct rule of the Ilkhanids for a very long time. The *bimarhane* Pl. 108 (lunatic asylum) in Amasya was built in 1308 to 1309, in the name of Yıldız Hatun, the wife of Sultan Uljaitu Mohammad Hudabanda, the Ilkhanid emperor. In the shape of a madrasah with a *riwaq* on the two sides of the open court, it also has an entrance and a main iwan. The symmetrical façade and its ornamentation are taken from the rich classic Seljuk style that had matured during the last quarter of the thirteenth century.

There are many buildings in this traditional Seljuk style; however, the number of iwans employed and the style of decoration varies.

New forms peculiar to the period of the Turkish emirates were first seen in west Anatolia. On paper the plans of some buildings resemble the conventional Seljuk madrasahs; however, the building that resulted from this plan, the adornments on the walls, the complex composition and particularly the row of domes on the *riwaqs* embracing the court, gave a new architectural identity to the original plan. One of the earliest examples of such a madrasah is the Ahmet Gazi Madrasah (1375?) of the Fig. 56 Menteşe Emirate in Peçin, near Milas. It has an open court and two iwans. The main iwan is so large that it dominates the entire building, and it is topped with an

71 Façade of the İlyas Bey Mosque, Balat (Miletus), Menteşe Emirate, 1404.

72 Qiblah wall of the Lal Ağa Mosque, Mut, Karaman Emirate, 2nd half of the 14th cen.: *in the foreground at the right,* the Büyük Turbeh.

73 Façade of the prayer hall of the Great Mosque, Adana, Ramazan Emirate, 16th cen.

74 Portal (detail) of the courtyard of the İsa Bey Mosque, Selçuk (Ephesus), Aydın Emirate, 1374.

75 İsa Bey Mosque, Selçuk (Ephesus), Aydın Emirate, 1374: general view.

76 Façade of the İbrahim Bey İmaret, Karaman, Karaman Emirate, 1432–3: a domed madrasah.

77 Turbeh of the İbrahim Bey İmaret, Karaman, Karaman Emirate, 1432–3.

78 Portal of the Ak Madrasah, Niğde, Karaman Emirate, 1409: gallery composed of twin arches.

79 Madrasah of Sultan İsa, Mardin, Artukid Emirate, 1385: general view.

80 Mausoleum (Turbeh) of Zeynel Mirza, Hısn Keyfa, Akkoyunlu Emirate, 2nd half of the 15th cen.

81 Mausoleum of the Hudavend Hatun, Niğde, Karaman Emirate, 1312.

82 Façade of the Aşık Pasha Turbeh, Kırşehir, Ertena Emirate, 1322–3 (?).

83 Entrance of the so-called Sultan Mes'ut Turbeh, Amasya, 14th cen. (?).

84 Mausoleum of Halime Hatun, Gevaş (Lake Van), Karakoyunlu Emirate, 1358.

85 Baldaquin-type turbeh, Van, Karakoyunlu Emirate (?), late 15th cen. (?).

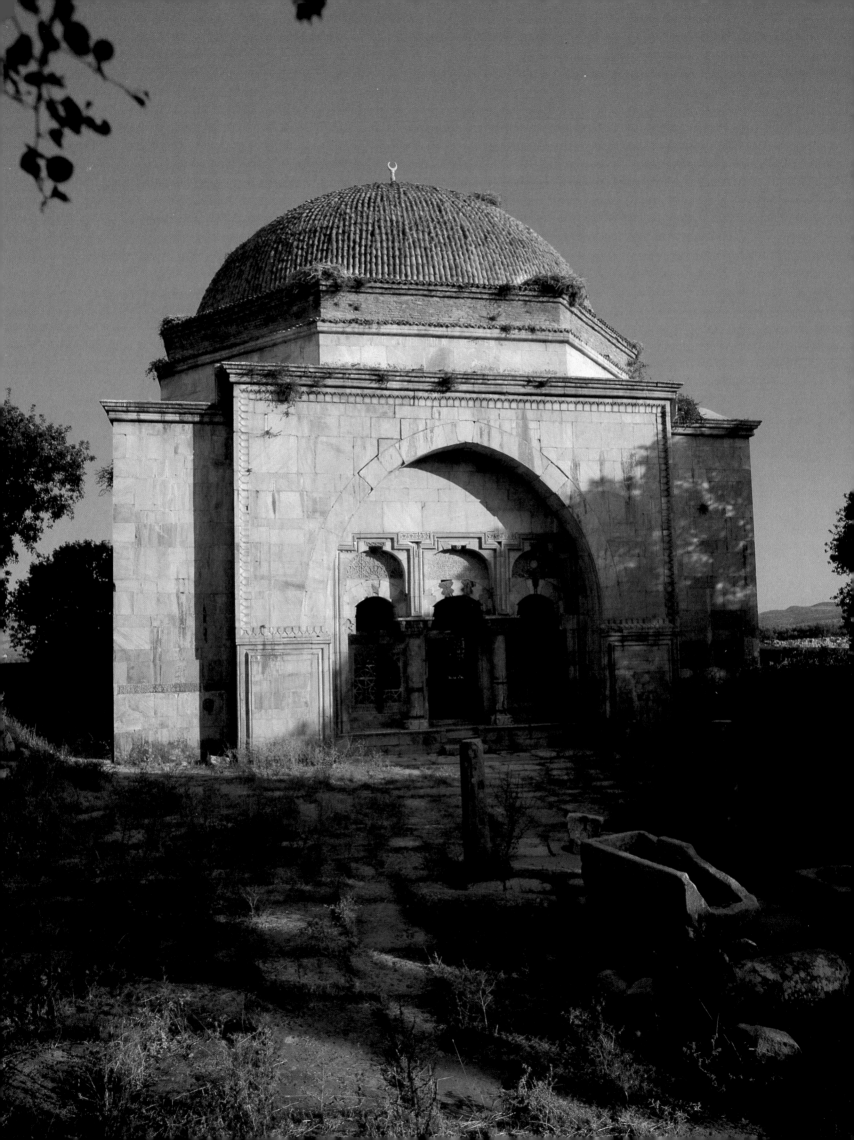

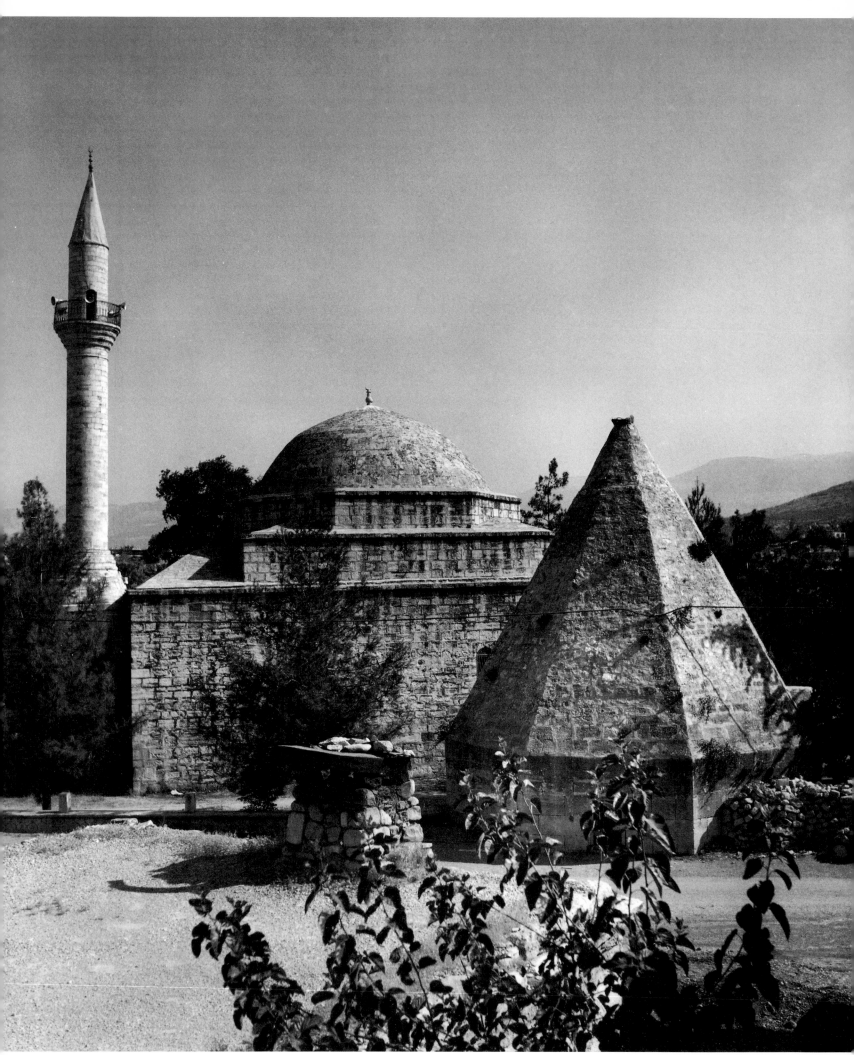

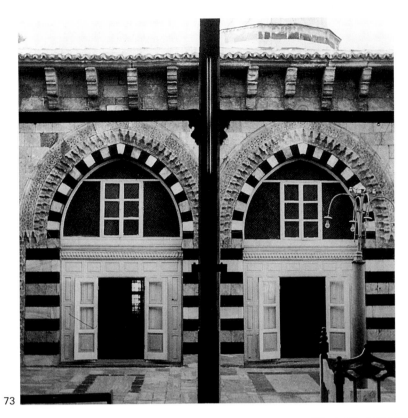

73

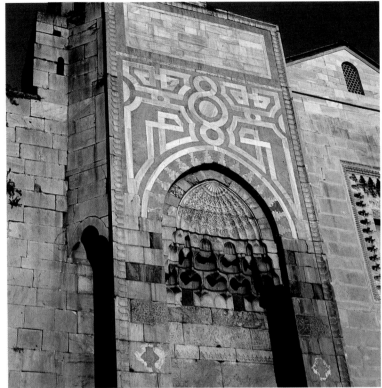

74

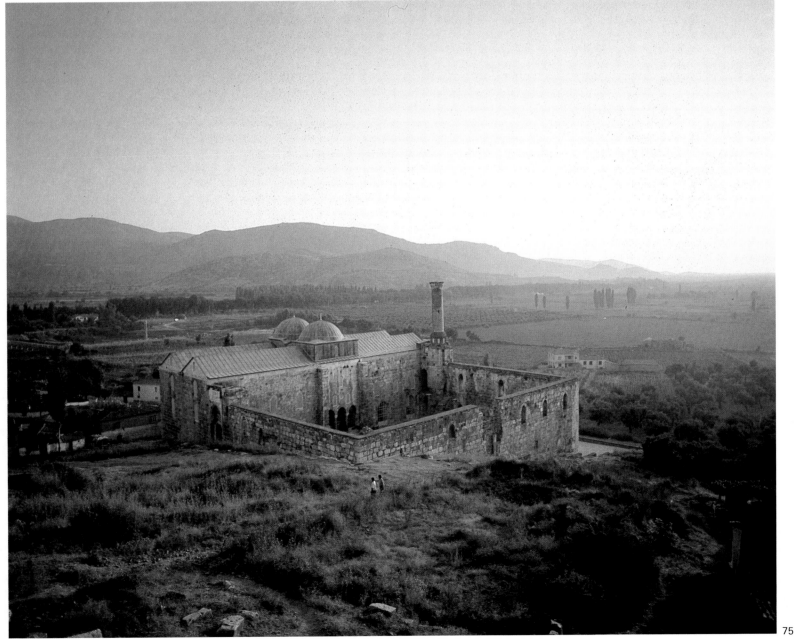

75

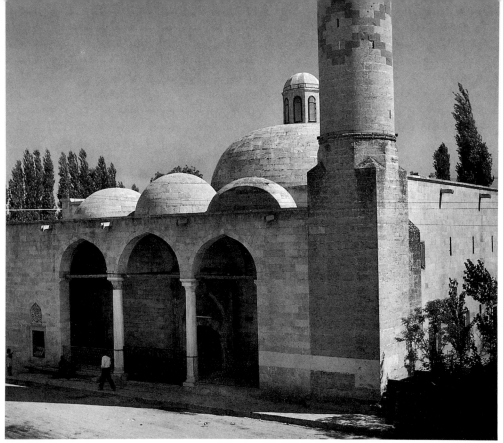

76

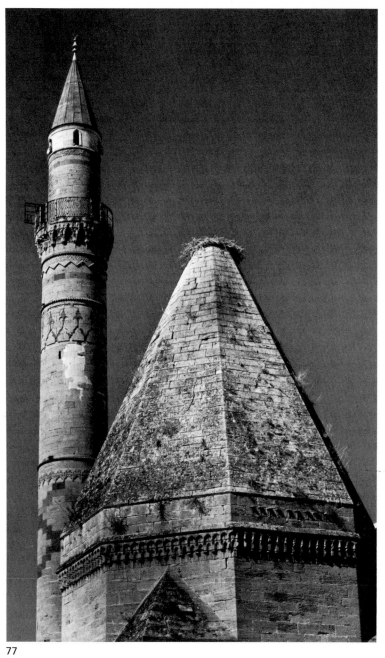

77

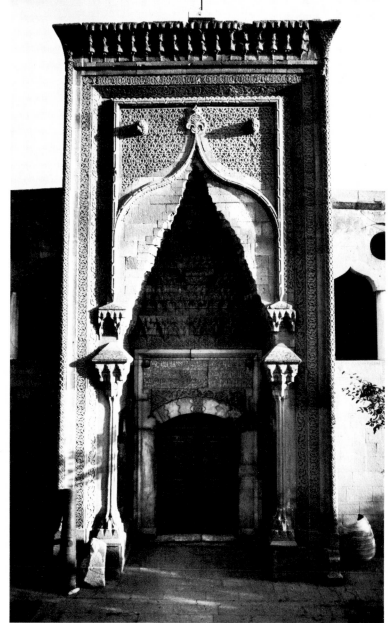

78

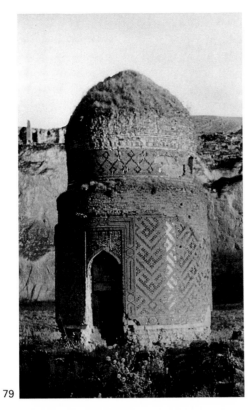

79

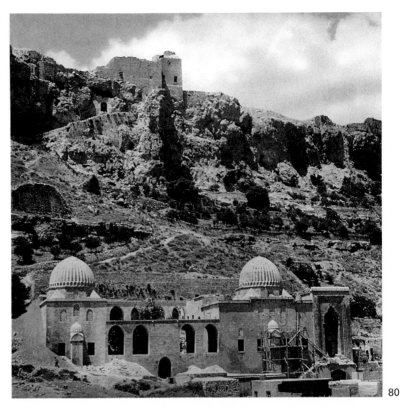

80

81

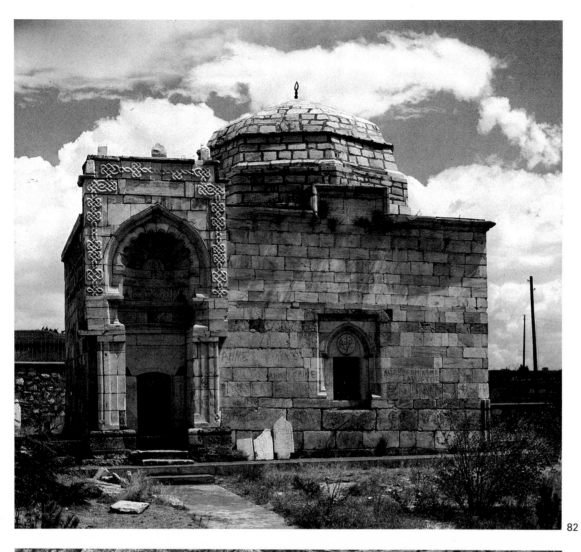

82

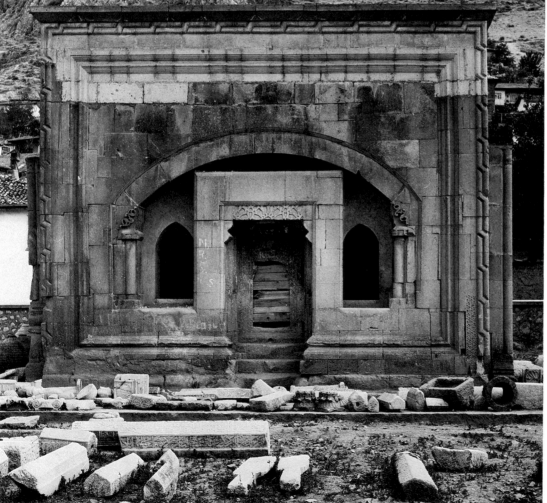

83

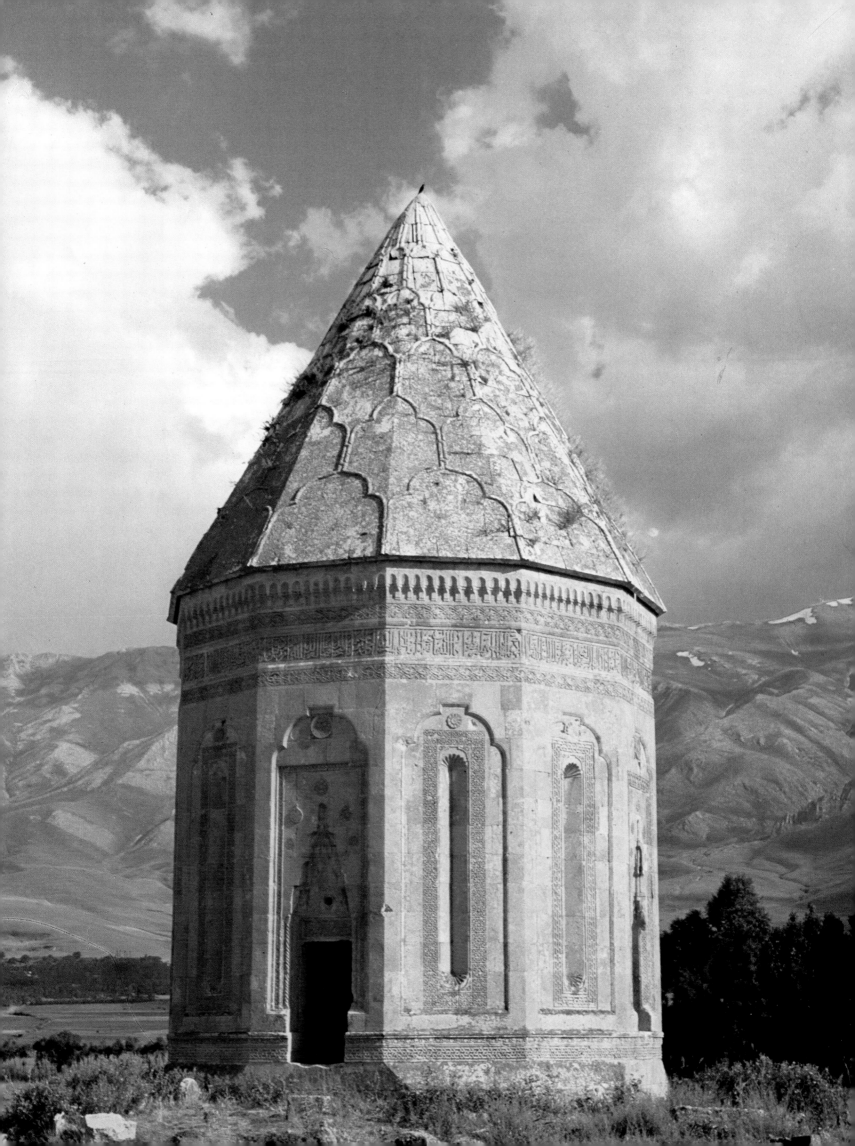

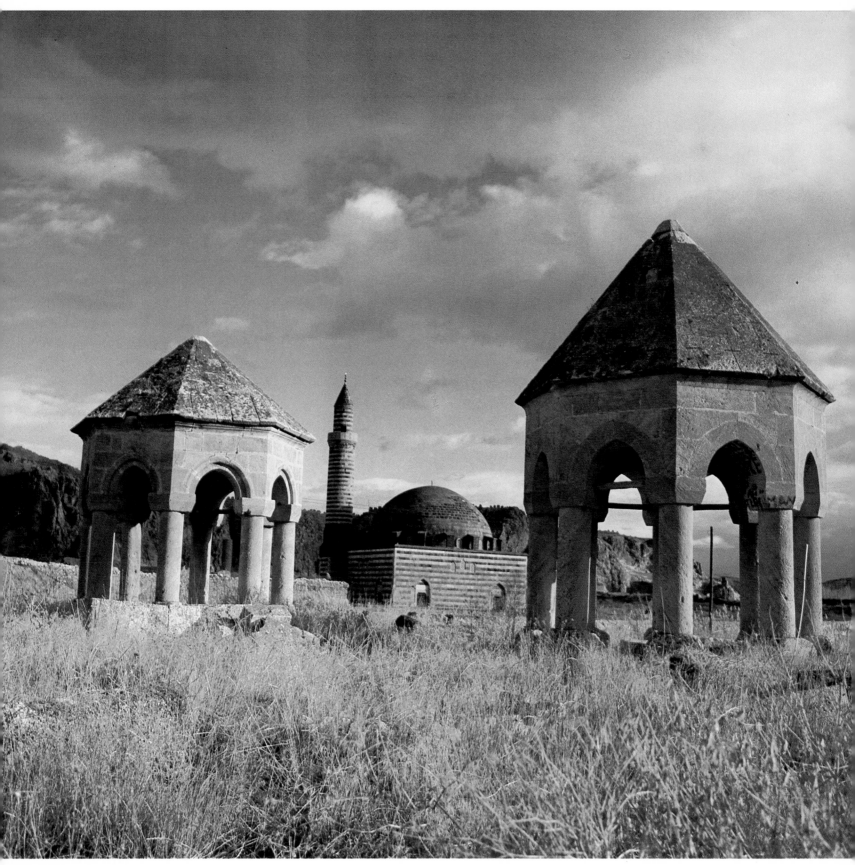

immense dome that consolidates the dominating influence. Being almost as large as the courtyard, the iwan gives the impression of a domed cubical mosque with a front courtyard having *riwaqs*.

There are various madrasahs where the main iwan was developed on its own as a monumental building. In both the *Şifaiye* and the Madrasah of Yıldırım Beyazıt I, a complex in the Ottoman capital of Bursa, the main iwans over-reach the rectangular mass of the main building. This became a typical feature of Ottoman madrasahs that lasted several centuries. From the madrasah of the famous Yeşil complex of Sultan Mehmet I in Bursa to the madrasah of the Selimiye complex of Sinan in Edirne, there are many buildings of this type. The Suleyman Pasha Madrasah (1331) in Iznik is the earliest Ottoman example illustrating a special application of this form: by cutting out the front wing of the standard madrasah, a new U-shaped plan was developed.[25] Also it became progressively popular to use this type of madrasah as a front courtyard for a mosque, thus forming an organic complex. This became one of the characteristics of classic Ottoman architecture of the sixteenth century. Moreover, as in the Fatih complex in Istanbul, L-shaped buildings composed of only two arms in a standard madrasah scheme have been found.

The most interesting form of the Seljuk period is a building called the 'domed madrasah' or the 'madrasah with a covered courtyard'. In these, the central hall that corresponds to a courtyard is a large single-unit cubicle space with its dome resting on the walls, or a centrally planned multi-unit space divided by pillars and arches. This plan can also be seen in the period of the emirates. The Vacidiye Madrasah (1308–14?) of the Germiyan Emirate in Kütahya was probably an observatory;[26] its central hall is a huge single-unit domed cubicle. The Ahmediye Madrasah (1314) of the Ilkhanids in Erzurum, and the Hatibiye Madrasah (first half of the fourteenth century) in Bitlis, are two buildings of this type which resemble each other. They are small but built of high-quality stone.[27] The İbrahim Bey İmaret (1433) of the Karaman Emirate in Karaman resembles the famous İnce Minareli and the Karatay Madrasahs of the Seljuks in Konya; however, the front part of the building was built in two storeys. As its name implies, the İbrahim Bey İmaret must have been a multi-functional building where education and various social activities took place. It brings to mind inverted T-type mosques.

The İhlasiye Madrasah (1589) of Şeref Han V, a member of a local despotic family in Bitlis, was built at a time when the Ottoman Empire had developed a universal style that spread throughout a large area and when the great architect Sinan had already died. Despite this, it is the only example of a madrasah with a domed hall but without *riwaqs*. The shape of the central hall, with its immense dome resting on four huge blind arches and pendentives, is to a certain extent representative of classic Ottoman architecture, but the other parts, especially the façade and style of stone decoration, derived from the Seljuk period.

The first madrasah of the period of the emirates with a central hall with *riwaqs* and a multi-unit space (as in the Atabey Madrasah in Isparta and the Şifahane in the Ulu Cami in Divriği from the Seljuk period) was built in the reign of the Ilkhanid Emperor Uljaitu; it is the Yakutiye Madrasah (1308–10?) in Erzurum. With a portal decorated in high relief and a massive undecorated façade, it is a building of archaic character. The mantle system of the middle part of the central hall is a stalactite vault, similar to that in the Ulu Cami in Erzurum. The Emir Musa Madrasah, probably built at the latest in 1352 by the Karaman Emirate, was of this style.

There were also two unique Ottoman experiments: polygonal madrasahs. The Kapı Ağası Madrasah, built in Amasya in the second part of the fifteenth century during the time of Sultan Beyazıt II, is a building with an octogonal plan and an open courtyard, calling to mind a caravanserai of the Great Seljuk Empire, the Ribat-i Malik in Iran. The *bimarhane* in the magnificent complex of Sultan Beyazıt II (1484) in Edirne is a centrally domed hexagonal building with six iwans.

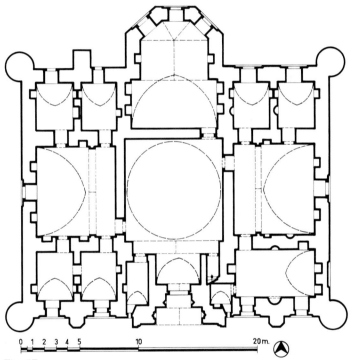

Fig. 57
Plan of the İhlasiye Madrasah, Bitlis, 1589 (after M. O. Arık).

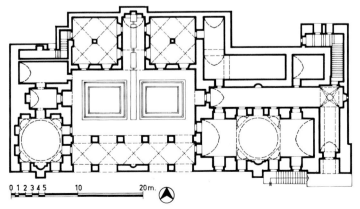

Fig. 58
Plan of the Sultan İsa Madrasah, Mardin, 1385 (after A. Altun).

131

The Ak Madrasah (1409) in Niğde, built during the time the Karaman Emirate ruled in Cappadocia, is a two-storey building with two iwans, constructed according to the traditional scheme. The masonry and ornamentation is of high quality. It also has new features that deviate from the conventional madrasah. There is an extremely Pl. 78 high and narrow portal in the middle of the façade. The decorative arch is reminiscent of the flamboyant style. A gallery was built on the upper floor on both wings of the façade; it opens on to the outside. Here there are two blind arches, each subdivided into twin arches. This façade is reminiscent of the façade of the Murat I Mosque in Bursa.

When dealing with mosques, frequent reference was made to complex madrasahs in south-east Anatolia. Combining separate buildings into one building to form an organic complex became characteristic of such buildings from the time of the Artukid Emirate, when the Şahidiye Madrasah was built in Mardin (still during the Pl. 79 Seljuk period). Two of the most magnificent examples of Fig. 58 such complexes are the Sultan İsa Madrasah (1385) of the Artukids and the Sultan Kasım Madrasah (1487 to 1507?) of the Akkoyunlu Emirate, both in Mardin. The plans of these buildings are not symmetrical, but they have a madrasah, a turbeh, a mosque and a *zaviye* located in a balanced manner around an open courtyard. Here the main iwan is somewhat different; inside there is a continuous flow of water from a fountain through a channel to the pool in the courtyard. Because of the shade provided by the deep iwan, this must have been a resting place.

Turbehs of the Period of the Emirates

Seljuk turbehs (mausolea) are quite plain beside the variety of different shaped turbehs of the emirate period. Turbehs of the Seljuk period continued into the period of the emirates too. But, beside these, innumerable variations of the old protoypes were tried out, and completely new types of turbehs were developed.

During the Seljuk period, there were several unique turbehs. If we take a general look at the turbehs of the emirate period, it seems that a new shape was experimented in every building. It is difficult to give a comprehensive and fully detailed classification of the hundreds of turbehs of this period with their variety of shapes. A very rough list of the turbehs that are of monumental appearance, lending character to their vicinity, follows.

Turbehs with vertically oriented cylindrical and polygonal shafts containing the prayer chamber were still the most widespread type during the period of the emirates. As was the case in the Seljuk period, these can also be divided into sub-groups. Some turbehs in Erzurum are a little like the turbehs of the Seljuk period in Ahlat and belong to the Ilkhanids of the fourteenth century. Among these, one of the anonymous turbehs of the Three-Kümbet group (which was the symbol of Erzurum) and Fig. 59 the Cimcime Hatun Turbeh have cylindrical shafts with conical caps. Both were built in the same way with regu-

larly cut masonry. On the surface of these turbehs are decorative arches made of strongly profiled ribs forming twelve blind façades. Still built by the Ilkhanids, the Togay Hatun Kümbet (fourteenth century) in Kemah, near Erzincan and the Sırçalı Kümbet (mid-fourteenth century) in Kayseri [28] from the time of the Ertena Emirate are two dignified and simple monuments in which the purest effect of cylindrical construction is manifest; there is a rectangular composition around each door.

The Zeynel Mirza Turbeh in Hısn Keyfa,[29] built in the Pl. 80 second half of the fifteenth century for an Akkoyunlu prince, is a unique building among turbehs with a cylindrical shaft. It is covered with brick and tile mosaic decorations and roofed with a cap that resembles an onion dome. It looks like contemporary Timurid buildings in central Asia.

In Ahlat, a traditional town, is another unique turbeh, also built for an Akkoyunlu prince: the Emir Bayındır Turbeh (1481–92?).[30] More than half the cylindrical shaft is open like a gallery, which is composed of small, flat arches standing on squat columns. Here, perhaps, the Armenian influence must be considered.

In Erzurum, there is one more group that resembles the cylindrical turbehs of Ahlat (from the Seljuk period) but that deviates from the prototype. The corners of the cubical basement are cut and transmitted to a twelve-sided (dodecagonal) prismatic shaft. Each face of the shaft is framed with decorative blind arches, made of strongly profiled ribs. On the shaft above these arches, the turbeh turns into a cylinder; it is completed by a conical cap.[31] The first example of this type was the Döner Kümbet in Kayseri from the Seljuk period. In the Fig. 27c period of the emirates, this type of turbeh is seen exclusively in Erzurum. The turbeh, added to the back of the main iwan of the magnificent twin-minaret madrasah built by the Ilkhanids in the late thirteenth or early fourteenth centuries, is the first turbeh of this kind in Erzurum. It is one of the biggest turbehs in Anatolia and was built with white limestone and marble. Its decoration

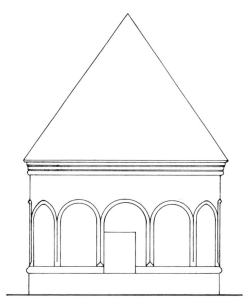

Fig. 59
Elevation of the Cimcime Hatun Turbeh, Erzurum, 14th cen. (after M. O. Arık).

132

gives it a simple but strong plastic effect which, added to its two-storey windows, contrives to provide classical beauty. The main iwan of the Yakutiye Madrasah also has a similar turbeh added on to it at the back. This and the Karanlık Kümbet (1308), the Gümüşlü Kümbet and the third of the 'Three-Kümbets' form a group of dark-coloured turbehs, built with uniform blocks, that strongly resemble each other.

Turbehs with octogonal shafts, a common design during the Seljuk period, were in evidence throughout the period of the emirates. However, although they were abundant they did not remain the dominant type of turbeh as once they had been, and very many styles were developed. In the turbeh (1301) in Eşrefoğlu, there is a sixteen-sided low drum and a conical cap on the octag-
Pl. 114 onal shaft. The inner dome is covered with a tile mosaic in a brilliant continuation of the Seljuk style. The building
Pl. 72 called Hocendi, or Büyük Turbeh, near the Lal Ağa Mosque in Mut, dating from the Karaman Emirate (in the middle of the fourteenth century), leaves a different impression with its very high pyramidal cap, resting on a low octagonal shaft. The inner dome is also pointed.

One of the most richly decorated masterpieces of Anatolia and one of the most interesting variants of the
Pl. 81 octagonal turbeh is the Hudavend Hatun Turbeh (1312) in Niğde. On every façade of the octagonal shaft are projections formed by stalactites. Above these, the shaft is converted into a sixteen-sided belt complete with a sixteen-cornered pyramidal cap.

Despite the fact that a drum is only seen in cubical turbehs in the Seljuk period, a drum was also used in the period of the emirates on some buildings with octagonal shafts such as the Yeşil Turbeh (1421) of the Ottoman Emirate in Bursa, and the Emineddin Turbeh (1452) and the Kızlar Turbeh (last quarter of the fifteenth century) of the Karamanid Emirate.

In many examples, (the Yeşil Turbeh in Bursa, the turbeh [1310?] in Ephesus from the Aydın Emirate, and the Hatuniye Turbeh [1449] of the Ottoman Emirate in Bursa), there is a monumental portal as high and wide as the shaft, that gives the impression of an iwan. Annexed to the front of standard octagonal turbehs, other monumental entrance constructions can also be observed. The Ali Cafer Turbeh (mid-fourteenth century)[32] of the Ertena Emirate in Kayseri has an entrance in the form of a closed room added to it. On its lateral faces a projecting cornice and windows create a strong sculptural effect. The richly decorated portal of the main turbeh opens into this room. The Şah Sultan Hatun Turbeh (about 1500) in Çandır, near Yozgat, which was built by Shah Ruh (one of the Dulkadır princes) for his wife, and the Çerkes Bey Turbeh (1588) in Çayıralan near Yozgat have, in fact, an entrance iwan.[33] Although rare in other emirates, the most elegant entrance construction is a single single-domed portico that was popular in the Ottoman Emirate, e.g. in the Kızlar and Emineddin Turbehs in Karaman.

Turbehs with dodecagonal, hexagonal and pentagonal shafts were first developed in the period of the emirates. Those with dodecagonal shafts are buildings from the Karakoyunlu Emirate with rich and elegant stone deco-

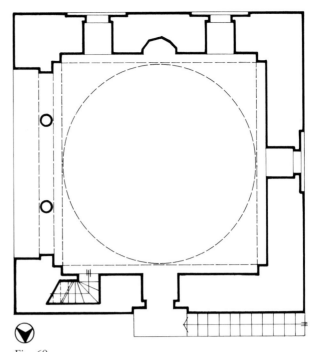

Fig. 60
Plan of the Mausoleum of Suleyman Bey, the so-called Garib Turbeh, Dulkadır, 1440–59 (?) (after M. O. Arık).

rations; they are found principally around Lake Van. The Halime Hatun Turbeh (1358) in Gevaş; the Erzen Hatun Pl. 84 Turbeh (1396–7) in Ahlat; the Yar Ali Turbeh (1458) in Erciş and the anonymous turbeh on the Van-Patnos road (from the end of the fourteenth or the beginning of the fifteenth century), all have dodecagonal pyramidal caps. This type has a long tradition around Lake Van, as

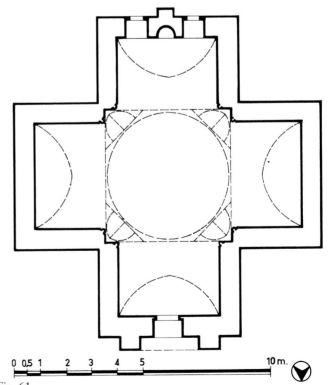

0 0,5 1 2 3 4 5 10 m.

Fig. 61
Plan of the Mausoleum of Sultan Hamza (Hamza-i Kebir Turbeh), Mardin, 1438–9 (after A. Altun).

proven by the archaistic turbeh, called Şehidlik, that was built in Bitlis in the eighteenth century. Apart from these, the sole example in central Anatolia is the Turbeh of Alaeddin Bey of the Karaman Emirate (dated 1391).

The Bulgaç Hatun Turbeh in Tokat, which was built in the fourteenth century,[34] in the Ilkhanid period, has a hexagonal shaft and a cylindrical drum; it is crowned with a pointed dome. There is a blind arch on every face and one pediment above each. The style of the ceramo-plastic decoration on the blind arches is reminiscent of both eleventh-century Karakhanid art in central Asia and of Byzantine art.

The shaft of the Yörük Dede Turbeh in Ankara, built for one of the Ahi sheiks at the end of the fourteenth century, is shaped like a pentagonal prism.

The most common and lasting form of turbehs (as in the case of mosques) are the ones with square shafts. From the middle of the tenth century, when Islam became dominant among the Turks, until recently, such turbehs could be seen everywhere. In the period of the emirates, there were also turbehs where the transition from the cubical building to the drum was by means of corner elements of a triangular pyramidal shape that looked like a squinch, exposed on the outside. Examples are the Pl. 77 turbeh added to the İbrahim Bey İmaret in Karaman, the Nureddin İbn Sentimur Turbeh (1314) in Tokat, built by the Ilkhanids, the Turbeh of Alaüddevle Bozkurt Bey (1479–1515) from the Dulkadır Emirate, which was added to the Taş Madrasah at Marash, the Turbeh of Ahi Şerefeddin (1330), the leader of the Ahi community near the Arslanhane Mosque in Ankara, and the Devlet Hatun (1413–14) and the Gülşah Hatun Turbeh (1486) in Bursa.

In some turbehs, however, the shaft was joined to the drum by cutting the upper corner into oblique triangles. This method was implemented in the Gazi Alemshah Turbeh (1308) in Sivrihisar, in the Gündoğdu Turbeh (1343) in Niğde, in the Şerefhan IV Turbeh (1533) in Bitlis, and in some anonymous turbehs in Kayseri, Mut and Ahlat.

In the Musa Sevdakar Turbeh in Tokat and in the Emir Ali Turbeh in Ahlat (both from the fourteenth century), the front of the cubical building was opened like an iwan. An example of this interesting variation is the Sahib-ata Turbeh of the Seljuk period in Konya.

Some of the cubical turbehs are also remarkable for the Pl. 82 size and shape of their entrances. The Aşık Pasha Turbeh (1322–33?) in Kırşehir, the tomb of the famous theoso-phist, which was probably built during the Ertena Emirate, has a vestibule in the form of a corridor with a pointed barrel vault that extends along the north edge of the cubical room. The western end of this vestibule is similar to the continuation of the west façade of the turbeh, but it is higher and in the form of a magnificent portal. The whole building is adorned with white marble slabs. The portal niche is crowned with a stylized oyster motif. This monumental composition, slanting to the side on the façade, is influenced by the style developed by the Fig. 63 Fatimids in Egypt. In the Ottoman Yıldırım complex in Bursa, the Turbeh of Sultan Beyazıt I, with its three-domed classical portico supported by monumental

colomns and arches, resembles a medium-sized cubical mosque.

The baldaquin-shaped turbehs, with one arch opening on each façade, are also one of the innovations of the period of the Turkish emirates. Like the Devlet Hatun Turbeh (1413–14) in Bursa, some of them are square and constitute a four-arched baldaquin. A great many are polygonal with multiple arches around the baldaquin, such as the Balım Sultan Turbeh in Hacı Bektaş, Cappa-doccia, the Karabaş Veli Turbeh in Karaman and the two turbehs in Van that are probably works of the fifteenth Pl. 85 century from the Karakoyunlu Emirate.

Variations built with a very high drum and conical cap resting on square turbehs leave an entirely different impression. One that seems to have two different shafts — one on top of the other — is in Sivas; it is called the Güdük Minare Turbeh (1347) of Şeyh Hasan Bey, who was emir of Ertena.[35] The façades of the cubical section are framed with huge profiled cornices. Above these, a band of alternating triangles has been placed on the outside this time (they are inside many mosques). Still further above these is a high cylindrical drum and conical cap. In this construction, the crypt is cross-shaped in plan. Beneath tiny window-shaped air vents, there are stone carvings on each of the four walls. It is quite astonishing to encounter such ornamentation in the crypt, which is very dark, and closed to visitors.[36]

In their present forms, the Mevlana Celal al-Din Rumi Turbeh in Konya and the Seyyid Mahmut Hayran Turbeh in Akşehir seem to have been built in the form of the Güdük Minare Turbeh in Sivas; however, their drum and cap sections are original in shape — they might be called a series of circular planes. The two former constructions were first built in the Seljuk period. Historical sources indicate that both were rebuilt in their present forms by the Karaman emirs during the first half of the fifteenth century.[37]

When viewed from the outside, the Turbehs of Murat I and Murat II look like square buildings with domes. Inside, under the dome, there is a central domed space; each of the sides is composed of two arches. The central section[38] is surrounded by an ambulatory area.

Near Pinarbaşi on the Kayseri-Malatya highway in a place called Koçcağız, there is a building of the Dulkadır Emirate called the Garib Turbeh (1440–59?).[39] This Fig. 60 turbeh, which belonged to a Suleyman Bey, was built in the form of a two-storey square box. A door, reached via a single-flight staircase, leads to the chamber upstairs; immediately below this staircase is the crypt door. A cornice with a projecting profile winds round the two storeys like a line dividing the building, all of which is above ground level. The upper chamber is covered with a dome that rests on four blind arches on the walls; the transition is by means of pendentives. The eastern façade opens on to the outside like an iwan with a large arch. Inside, this arch is subdivided by a set of triple arches — two small ones on either side of the large one in the centre — which creates the impression of a gallery domi-nating the landscape. With its interesting shape, this building seems more like a belvedere, a last reminder of the Seljuk palace in Konya rather than a turbeh.

The iwan, apart from being a means of creating various types of turbehs, was also used independently. An iwan with a crypt underneath first appeared in Seljuk architecture. There are many examples of this Seljuk prototype, such as the Aşıklı Sultan Turbeh (fourteenth century) of the Candar Emirate in Kastamonu, the Şad Geldi Pasha Turbeh (dated 1382) in Amasya and the Beş Parmak Turbeh in Kayseri, probably of the Ertena Emirate. A feature peculiar to the period of the emirates is seen in the buildings where iwan arches take on various shapes. In Pl. 83 the anonymous building called the Sultan Mes'ut Turbeh (fourteenth century?) in Amasya, an imposing balustrade and door profile have been mounted within the low arch of the iwan. This composition is reminiscent of the portals and balustrades on the porticos in early Ottoman architecture, e.g. the Yeşil Mosque in Iznik. The iwan arch in the Beylerbeyi Turbeh in Niğde (dated to 1325 from its inscription before it collapsed and vanished) was subdivided by smaller twin arches. The inscription that was on the plaque on the tympanum of the huge arch can still be seen in photographs.[40] This type of partitioning, recalling the Gothic style, must be a characteristic of this period; it can be observed in many buildings of the Pl. 78 emirates, such as the Murat I Mosque in Bursa, the Ak Madrasah in Niğde and in Mameluke architecture in Egypt.

Many more turbehs hardly conform at all to typological classifications. A last example is a unique funerary Fig. 61 monument, the Hamza-i Kebir Turbeh (1438–9?) in Mardin, which was built for the son of Kara Yülük Osman Bey, who was the founder of the Akkoyunlu dynasty.[41] This turbeh was situated within a convent complex. Today, although the complex is in ruins, the turbeh is still standing and has been converted into a mosque with ugly annexes which mar its appearance. It is an interesting monument with a central unit in the shape of a domed square. Each of the four units of the interior has been set as an iwan, opening on one of the cardinal points of the axis, thus forming a cross-shaped, centrally domed building. The portal is situated on the north façade of the arms; inside a mihrab is placed exactly in the middle of the qiblah wall. In the central unit, the basic decoration is composed of corner columns, the stalactites of the squinches, the mihrab and the portal. The building, built of regularly cut-stone masonry, reflects this plain and dignified style. The outer aspect of the divided dome became typical of eastern Mediterranean Islamic countries from the time of the Sidi Okba Mosque in Qairwan, Tunisia. With regard to plan and general mass, the most analogous buildings are the four semi-domes of the Armenians in east Anatolia.

Conclusion

In the previous chapter on Seljuk architecture, many important secular buildings were considered, for instance, caravanserais that insured transportation and increased and maintained the country's trade. A new phase in Turkish history had begun. This new environment, coupled with the deep-rooted traditions of the autochthonous people, created an entirely new set of circumstances for the Turks. They had to maintain their own personalities and traditions and also adapt to new conditions and a different way of life. At the same time, there was the problem of assimilating the native population of Anatolia so as to form a harmonious society.

To resolve all these problems, it was necessary to organize the common people, to educate them. The most important role in this reorganization was played by sheiks and dervishes, who endeavoured to enlighten by mysticism. They were the intellectuals and men of art of the period. *Tekkes* (dervish convents) and khankahs, the centres of the communities they established, were the intellectual clubs of that period. The highest culture in that medieval society also had a voice in the palaces that housed the heads of the state. It is a pity that not very much is known about the physical aspects of these religious buildings for the period of the Turkish emirates. Historical sources do indicate that such institutions continued working into the period of the emirates. Khankahs and *tekkes* became more numerous, better organized and progressively more important in the life of the society.

The palaces of the period of the emirates are still relatively unknown; several studies published recently on Ilkhanid buildings[42] give only sporadic and inadequate information. As for khankahs and *tekkes,* all of them were reshaped by the restorations and additions of the Ottoman period, but their original shapes in the period of the emirates have not yet been properly established. The evolution of buildings in all these categories can best be traced under the Ottomans, the subject of the next section on Ottoman architecture.

The impression gained from buildings in the period of the emirates can be summarized in a few sentences. No matter what type of plan or function the buildings had, they were usually constructed in an archaic fashion. Generally the composition was based on the principles of symmetry. The monumental features, reflecting advanced culture, were concentrated mainly on the façade. Rigid forms—the result of grouping cubical or rectangular units—dominated the entire building. This method continued for a long time, then construction techniques and structural forms evolved that enabled builders to create greater heights and varied spatial effects. Much later, mass and spatial compositions with organically coalesced units were favoured. The pioneers of both the organically planned buildings and the organically coalesced building complexes were from the Artukid region. Zengid, Ayyubid and Mameluke influences, coming from neighbouring Syria, must have played a role in this. Later these influences were felt in the western regions, too. The direct contacts with Syria, Egypt and some European countries via the Aegean and the Mediterranean Seas may even have had an effect on the architecture of the emirates in the Aegean region.

In the south-east, the Islamic period started before the Turkish conquest. There, the old, deeply rooted traditions that had adapted to Islamic culture were dominant. Consequently, in this region, no matter how dynamic the media, there is always a traditionalism. This is also true in

architecture: no matter how varied the experiments, conservatism (at least on the exterior) is dominant.

The emirates in west Anatolia did not encounter any local Islamic traditions; therefore, they conducted more original experiments and united the habitual shapes of the population directly with the heritage of classical culture.

In the Ottoman Emirate bordering the Marmara region — a Byzantine metropolis in a medieval age — more complicated international relations played a role. The Ottoman dynasty had a closer relationship than the other emirates with the 'Sufi' orders of Islam (the Ahi guilds being the first). For this reason and due to the environment, the Ottomans were faithful to the old Turkish traditions. But they also maintained close relations with Byzantine civilization and with the Balkan cultures, which they had recently conquered. Under such circumstances, it is possible that these civilizations affected Ottoman art. Perhaps for this reason, most new forms and technical experiments are to be found in the architecture of the Ottoman Emirate. All the architectural experiments of the period of the emirates in Anatolia were crystalized by the Ottomans into several outstanding principal features. At the beginning, the Ottoman Emirate was an unimportant and modest presence, but in a very short time its growth was rapid in every field. This growth and development in all fields is a feature of Turkish history and especially of Turkish architecture.

NOTES

[1] İ. H. Uzunçarşılı, *Anadolu Beylikleri*, Ankara, 1937; idem, *Kitabeler*, 2 vols., Istanbul, 1927–9; O. Turan, *Doğu Anadolu Türk Devletleri Tarihi*, Istanbul, 1973; P. Wittek, *Das Fürstentum Mentesche*, Istanbul, 1934.

[2] F. Sümer, *Safevî Devletinin Kuruluşu ve Gelişmeşinde Anadolu Türklerinin Rolü*, Ankara, 1976; idem, 'Bozok Tarihine Dair Araştırmalar' in *Cumhuriyetin 50. Yıldönümünü Anma Kitabı* (Ankara, 1974): 320.

[3] İ. Aslanoğlu, *Tire'de Camiler ve Üç Mescid*, Ankara, 1978, pp. 45–7.

[4] M. Sözen, *Diyarbakır'da Türk Mimarisi*, Istanbul, 1971, pp. 55–8.

[5] A. Altun, *Mardin'de Türk Devri Mimarisi*, Istanbul, 1971, pp. 23–6, Plan 2.

[6] S. Eyice, 'Zaviyeler ve Zaviyeli Camiler' in *İktisat Fakültesi Mecmuası* 23, nos. 1, 2 (Istanbul, 1962–3): 44, 74, Fig. 40; Evliya Çelebi, *Seyahatname*, vol. 4, Istanbul, 1314 AH (1896), p. 6.

[7] Aslanoğlu, *Tire'de Camiler*, p. 61, Fig. 48.

[8] Aslanoğlu, *Tire'de Camiler*, pp. 16–20.

[9] Aslanoğlu, *Tire'de Camiler*, pp. 20–4, Figs. 13–16.

[10] K. Otto-Dorn, *Kunst des Islam*, Baden-Baden, 1964, pp. 13, 62.

[11] A. Gabriel, *Monuments turcs d'Anatolie*, vol. 1, Paris, 1931, pp. 135–6, Fig. 89.

[12] G. Öney, *Ankara'da Türk Devri Yapıları*, Ankara, 1971, pp. 34–5.

[13] K. Erdmann, 'Zur türkischen Baukunst seldschukischer und osmanischer Zeit' in *Istanbuler Mitteilungen* 8 (Istanbul, 1958): 1–39.

[14] K. A. C. Creswell, *Early Muslim Architecture*, vol. 2, Oxford, 1940, pp. 246–7, Figs. 195–6.

[15] M. Cezar, *Anadolu Öncesi Türklerde Şehir ve Mimarlık*, Istanbul, 1977, pp. 160–3, Figs. 106, 124, 177.

[16] Gabriel, *Monuments turcs*, vol. 1, pp. 123–35, Figs. 77, 80.

[17] O. Aslanapa, 'Kazısı Tamamlandıktan Sonra Van Ulu Camii' in *Sanat Tarihi Yıllığı* 5 (Istanbul, 1972–3): 1–25.

[18] Altun, *Mardin'de Türk*, pp. 41–5.

[19] A. Gabriel, *Voyages archéologiques dans la Turquie orientale*, Paris, 1940, p. 61, Fig. 46.

[20] Altun, *Mardin'de Türk*, pp. 41–5.

[21] Altun, *Mardin'de Türk*, pp. 89–95.

[22] Y. Demiriz, *Osmanlı Mimarisinde Süsleme*, Istanbul, 1979, pp. 151–66, Ills. 15–21.

[23] A. Arel, 'Üç Çerefeli Cami ve Osmanlı Mimarisinde Tipolojik Sınıflandırma Sorunu' in *Mimarlık* no. 116 (Istanbul, 1973): 17–20, Fig. 5.

[24] O. Aslanapa, *Turkish Art and Architecture*, London, 1971, p. 46, Plan I/a.

[25] G. Goodwin, *A History of Ottoman Architecture*, London, 1971, p. 39, Figs. 31–3.

[26] A. Sayılı, 'The Wâjidiyya Madrasa of Kütahya' in *Belleten* 12, no. 47 (Ankara, 1948): 667–77.

[27] A. Kuran, *Anadolu Medreseleri*, vol. 1, Ankara, 1969, pp. 127–8; M. O. Arık, *Bitlis Yapılarında Selçuklu Rönesansı*, Ankara, 1971, p. 53.

[28] Gabriel, *Monuments turcs*, vol. 1, pp. 79–81.

[29] Gabriel, *Voyages*, pp. 80–1; M. O. Arık, 'Türbe Forms in Early Anatolian-Turkish Architecture' in *Anatolia* XI (Ankara, 1967): 109.

[30] Gabriel, *Voyages*, pp. 245–6; Arık, 'Türbe Forms', p. 109.

[31] Arık, 'Türbe Forms', p. 109.

[32] Gabriel, *Monuments turcs*, vol. 1, pp. 81–2.

[33] Sümer, 'Bozok Tarihine', pp. 320, 337, 340, 342–4, Ills. 7, 16, 19, 24.

[34] S. Eyice, 'Quatre édifices mal connus III: Un mausolée musulman"?" à décoration céramoplastique à Tokat' in *Cahiers Archéologiques* 10 (Paris, 1959): 252–6.

[35] A. Gabriel, *Monuments turcs d'Anatolie*, vol. 2, Paris, 1934, pp. 162–4.

[36] M. O. Arık, 'Erken Devir Anadolu-Türk Mimarisinde Türbe Biçimleri' in *Anatolia* XI (Ankara, 1967, 1969): 85.

[37] Arık, 'Türbe Forms', pp. 110–11.

[38] A. Gabriel, *Une capitale turque: Brousse (Bursa)*, Paris, 1958, pp. 60–2, 116–18.

[39] Sümer, 'Bozok Tarihine', p. 346, Ills. 29–31.

[40] H. Ethem, *Niğde Kılavuzu*, Istanbul, 1936, p. 17; Gabriel, *Monuments turcs*, vol. 1, pp. 148–50.

[41] Altun, *Mardin'de Türk*, pp. 105–7.

[42] R. H. Ünal, 'Notes sur l'ancien réseau routier entre Malatya et Diyarbakır' in *5th International Congress of Turkish Art (1975)* Budapest, 1979, pp. 881–9.

Architecture of the Ottoman Period

by Doğan Kuban

The Pre-Conquest Period

The historical significance of Ottoman architecture lies in the fact that two different cultural spheres—eastern Islamic and Mediterranean—interpenetrated during its evolution. This gave birth to a distinct style in which the Mediterranean spirit, imbued with classical rationalism, prevailed over the medieval attitude of Islamic architectural styles. Turkish architecture in west Anatolia was based on eastern precepts but executed with local construction techniques within an environment of classical and Byzantine inheritance. In time this new cultural milieu created a style that diverged from the path traced by earlier Anatolian Turkish development.

The Ottoman rulers rapidly united west Anatolia under their leadership, and through an unrelenting policy of religious warfare against infidels (jihad), they extended their territory at the expense of Byzantium and the Balkan states. During the reign of Orhan Bey (1324–61), the Ottoman state was on the road to organizing itself as a potential empire. The first secular law code was introduced by the sultan's brother, and the first coin was struck in 1328. At the court, poets, theologians and mystic sheiks had been creating the makings of a new courtly culture, while a folk culture combining the traditions of the nomadic Turks and the indigenous population was also coming into being.

The previous two centuries of Turkish rule had provided a secure base for these new developments. The Turkish language was giving further unity to a large geographical area. The dervish orders and Ahi guilds were on the increase. In the rude atmosphere of the Turkish emirates, Anatolia saw the intermingling of a multitude of races and provided a fertile atmosphere for vigorous new creations. When the political and economical situation became more stabile, building was resumed, and there was a new fervour for novel composition.

Building at the time of the first Ottoman ruler, Osman Bey (1281–1324), appears to have been very pragmatic. Reconsecration and utilization of existing Byzantine buildings were common practice; construction techniques were not very precise. While pursuing his military activi-ties, Osman Bey built many forts around Bursa and Yenişehir and, as an incentive for the settlement of the nomads, he ordered the building of several convents (zaviye) for the famous saintly dervishes and conferred land grants upon them. At Karacahisar, his first capital, Osman Bey converted a church into a mosque.

After the death of Osman Bey, his body was taken by his son, Orhan Bey, to the recently conquered city of Bursa and was buried in a Byzantine chapel in its citadel. Following the example of his father, Orhan Bey built many convents for the mystic orders. He opened a public kitchen at Iznik, converted the Hagia Sophia of Iznik into a mosque, added a madrasah to it and built two other mosques at Iznik and Bursa. His viziers founded other madrasahs, one of which (the Madrasah of Suleyman Pasha) is the only surviving madrasah from this period. Under Orhan's administration, the building programme was well-established: mosques, madrasahs, public kitchens (imarets), convents, mausolea (turbehs), hans and public baths were constructed in the larger towns.

During the reign of Murat I (1360–89) and his son Beyazıt I (1389–1402), larger and more pretentious buildings with more refined materials were erected. Important centres such as Bursa, Iznik and Yenişehir were bestowed with many new buildings. The architecture of this period is, however, not marked by structural daring or constructional originality.

Walls were constructed according to a local technique and consisted of alternate brick and stone layers. Cut-stone facing was used only in very important buildings and only towards the close of this period. The essential element of vaulting—the dome—was employed, together with the traditional transition elements: Turkish triangles and decorated squinches. Decorative techniques (mukarnas) and materials (glazed brick or faience tiles) followed the Seljuk tradition.

Despite the marked use of traditional and local techniques and materials, the fourteenth century nevertheless constitutes the formative period of Ottoman architecture. The following period, between the battle of Ankara (1402) and the conquest of Constantinople (1453), witnessed the rise of the new imperial style.

Fourteenth-century Mosques [1]

In west Anatolia, several mosques were apparently built in the tradition of the old columnar mosque: a simple rectangular hall covered with timber roofs on timber posts. Major buildings such as the Ulu Cami [2] at Birgi, the Ulu Cami at Manisa, or the İsa Bey Mosque (Hagia Theologos) at Ayasuluk had features that link them directly to eastern examples. The largest of the mosques in the Ulu Cami tradition was built at Bursa at the end of the fourteenth century, when many other types of mosque were being developed.

The Ulu Cami at Bursa (built between 1395–1400), although it is still reminiscent of the primitive form of Islamic prayer halls, has a well-defined, judiciously lighted interior. The exclusive use of domes to cover each of the twenty square bays points to the Ottoman fascination with domes, as well as to the characteristically Ottoman approach to the rationalisation of structure. The unadorned domes rising above simple pendentives are supported by massive piers without capitals. Although the original decoration is still unknown, it seems safe to assume that structural and spatial considerations prevailed over decorative aspects. The mosque owes its expressive monumentality primarily to the simple geometrical and balanced nature of the structure and not only to its dimensions.

However, the Ulu Cami type of mosque, of which the Bursa example must be considered the final and supreme expression, does not represent the true visage of fourteenth-century religious architecture. In the first half of this century, the architecture of the west emirates was, as stated above, of simple design and crude construction. With few exceptions, it consisted of single-room buildings constructed to serve all purposes. A square or rectangular room, covered by a single dome, perhaps with a vaulted recess, was the functional form of small mosques, mausolea and even small convents. [3]

There were many traditional sources to hand for the domed square, which had been one of the most common architectural schemes since the Zoroastrian fire temples of Iran. Moreover, brick dome construction enjoyed a vigorous tradition in Anatolia. Yet the dome only predominated in the Ottoman style, where it became the major form-giving element for great architectural schemes. In the evolution of the new style, the Yeşil Mosque at Iznik (built for the Grand Vizier Hayreddin Pasha, between 1378–91) is a developed example of the simple domed square and a significant monument. [4] It is the work of an architect called Hacı Musa and formed part of a building complex. The prayer room (sahn) is a domed square, enlarged on the entrance side by an ante-room. The porch provides an ample entrance space for the prayer room. Raised platforms (sofas) on both sides of it were used as a covered waiting area before prayers. The ante-room, separated from the domed square by a triple arcade, confers a certain dignity to the prayer room that is not possessed by the countless other single-domed mosques. The walls are covered by a marble dado, and the marble mihrab with its traditional mukarnas niche rises above the level of this facing.

The age-old Mediterranean tradition of marble facing no doubt continued. The proximity of regional quarries and the convenience of obtaining marble from the existing ruins must have been a factor in the development of the widespread use of marble. After this period, marble mihrabs steadily replaced the older stucco or faience mihrabs, although there were other outstanding examples of traditional faience mihrabs in the fourteenth to sixteenth centuries.

The Yeşil Mosque draws together, within a newly conceived composition, familiar forms from the past such as mukarnas capitals, Turkish triangles in the zone of transition and glazed brick minarets. The completely developed porch and the integration of the minaret into the body of the mosque are important features of its design. Thus, notwithstanding its archaism, this mosque must be counted as one of the forerunners of the new Ottoman style.

The small or large single-domed mosque, where the dome is supported by the outer walls, continued to evolve until the close of the Ottoman period. Inside, the proportion between the supporting walls, the transition elements and the dome made up the primary medium through which spatial quality was expressed. The zone of transition, composed of continuous bands of triangular prismatic elements or squinches, was emphasized by decoration. The walls were painted, although there is no extant original decoration from this early period. Outside, the porch and the minaret were incorporated into the main body of the mosque, transforming these simple domed buildings. Nevertheless, the possibilities of this plan are inherently limited, and its formal evolution was concluded at the close of the fifteenth century.

A third type of mosque design merits a more elaborate analysis of its functional aspects, since these mosques were multi-purpose buildings, and they provided for activities other than worship alone.

The Ulu Cami type of mosque, discussed above, was an impressive princely building or, at least, it was the largest mosque in a given town. On Fridays, the name of the ruler was pronounced in it in the prescribed pulpit address, the Khutbah. The simple domed square, on the contrary, was most commonly the mosque of a city quarter, the masjid in every day speech.

The zaviye-mosque or multi-purpose mosque, Ahi mosque or Futuwwa-type mosque, in contrast to these, came into being as the result of a new social phenomenon [5] in the first half of the fourteenth century, most likely in the Ottoman domain. The first known example is the Mosque of Orhan at Iznik (now ruined). [6] Written documents are not clear about their specific uses, but recent studies confirm that they were centres for Ahi guilds as well as mosques. Since, in the heyday of the Ahi guilds, in the fourteenth and fifteenth centuries, Ottoman sultans were also members of these organizations, this type of mosque became the most carefully executed building of that period. In some of them, the sultans and other leading personages had special apartments and lodges. In addition, there were some rooms totally separate from the prayer hall that were probably used for informal gatherings and, possibly, as guest rooms.

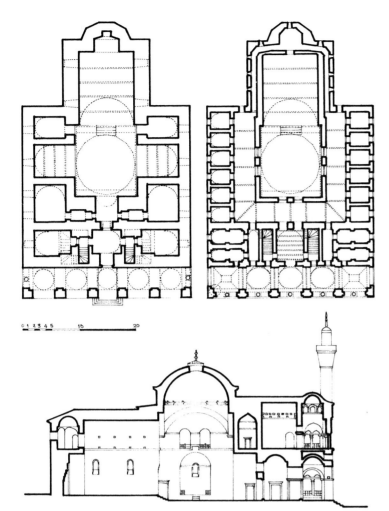

Fig. 62
The Mosque-Madrasah of Murat I, near Bursa: plan of the ground floor and the first floor, section through the main axis.

Fig. 62 The Mosque of Murat I at quite a distance from Bursa is a unique and curious example of this kind of mosque combined with a madrasah.[7] It has a ground plan directly derived from the covered madrasahs of the Seljuk period: an iwan on three sides of a central dome-covered hall and three rooms on either side of the main axis. The main iwan serves as the prayer room. Of all such surviving mosques, only this one has a barrel-vaulted main iwan, which demonstrates its direct lineage from a Seljuk madrasah. The Mosque of Murat I differs from the early madrasahs principally in the size of the main iwan, which covers a relatively larger space than the Seljuk ones and projects from the main body of the building. On the entrance side, a two-storey porch gives a secular aspect to the mosque. At each side of the vestibule, two stairs lead to the open gallery on the upper floor, from which passages lead to the cells of the madrasah that are sited along narrow corridors running round the centre of the mosque.

Several of the architectural features, such as the two-storey porch, the square drum hiding the main dome and the arched friezes are unique in Ottoman architecture and are related to medieval architectural traditions in the Balkans and in Byzantium. Once again a traditional Muslim building programme and a traditional building scheme incorporated the architectural motifs of a new cultural realm.

To complete the Mosque-Madrasah of Murat I, a public kitchen (imaret), now ruined, and nearby a kaplıca (a spa over a hot spring) were also built. The mausoleum of the founder was built by his son. Until the building of the Üç Şerefeli Mosque at Edirne, all the major mosques built by the ruling sultans were of the zaviye type, with minor variations. A second complex, again on the outskirts of Bursa, was built by Beyazıt I who ascended the throne in 1389.[8] It was a large complex consisting of a mosque, a separate madrasah, a hospital, a bath, a convent, a public kitchen, a han, the mausoleum of the founder and a kiosk. The mosque and most of the buildings were enclosed within a wall. An enumeration of the various kinds of buildings suggests that the foundation of such complexes (around which living quarters would be established) was the result of a policy of urbanization by the rulers. Not unexpectedly, it has been established that such complexes or mosques and convents always formed the core of new quarters in the development of Anatolian Turkish cities. Beyazıt I, as an astute statesman and great builder, seems to have readily understood the social importance of founding such centres.

Fig. 63

The mosque in this complex was completed in 1395, but apparently due to the wars conducted by Beyazıt I at the end of his reign, the final decorative touches were never added.

The Mosque of Yıldırım differs little, on the ground floor, from that of Murat I. The rooms on both sides of

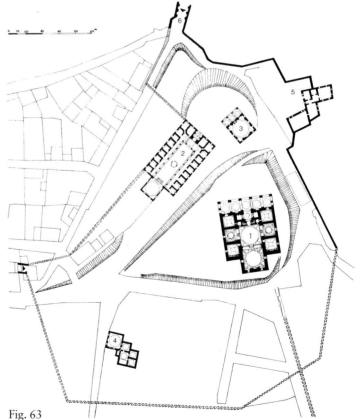

Fig. 63
Plan of the complex of Beyazıt I, Bursa, 1389–1402: 1) mosque 2) madrasah 3) tomb of the founder 4) bath 5) remains of a kiosk 6) gateway.

139

the prayer hall have fireplaces and closets and are clearly designed for special meetings. Two rooms on the entrance side, probably intended as hostels, have ante-rooms. Two stairways give access to the upper floor where there are two more rooms. The main space inside the mosque has lost the appearance of a covered madrasah. All the iwans and bays are covered by domes, and the two large domes over the main axis accentuate the direction of the qiblah. In keeping with its conception as a rich monument, this mosque has a facing of finely cut stone and marble. According to nineteenth-century travellers, the wall inside had a facing of faience, the fragmentary remains of which show a developed technique. From the outside, this mosque is a relatively large building fronted by an imposing porch that gives a sort of archaic massiveness to the main façade.

Similar but simpler plans with slight variations in the vaulting system were utilized for various types of buildings in the fourteenth and fifteenth centuries. One important building of the fourteenth century which might be mentioned in this connection is the Public Kitchen (*Imaret*) of Nilüfer Hatun at Iznik, built by Murat I in memory of his mother in 1388 to 1389.[9] The overall plan is a T-shape preceded by a large porch. The main room consists of a longitudinal space covered by a large dome at the entrance, followed by two smaller domes over large arches. On both sides, two large rectangular rooms with large chimneys served as kitchens: The exterior of this public kitchen is the finest extant example of a public building of the late fourteenth century. The procession of domes emphasizing the main axis, the tile-covered roofs common in that period, the alternate stone and brick texture of the walls, the decorative brick motifs and the heavy mouldings of the pilasters on the central arch of the porch, all make this an extraordinarily attractive and highly instructive architectural specimen of that period.

Madrasahs and Tombs

The Ottoman madrasah is a direct descendant of earlier Anatolian madrasahs, with a few basic but distinctive features. The Madrasah of Yıldırım at Bursa, built in the complex already mentioned, is characteristic of this distinctiveness. The entrance is a dome-covered square, but only a shallow recess remains of the original entrance iwan on this side. The side iwans no longer exist; the main iwan has become merely a square room open to the courtyard. Outside, the rectangular block-like mass of the earlier madrasah has been replaced by a more articulated composition with a rhythmical sequence of domes and chimneys, so familiar an aspect of Ottoman madrasahs. The fact that the hospital of Yıldırım (now dismantled) in the same complex had a plan similar to the madrasah indicates that the use of the same plan for other functional types of buildings was still a common practice.

The funerary architecture of this early period is quite well documented. Although, as was stated above, Osman Bey was buried in a Byzantine chapel, from the middle of the fourteenth century onwards, domed square or polygonal rooms — sometimes with the addition of a porch —

constituted the most popular scheme for Ottoman mausolea (turbehs). Their prototype may be traced back to central Asia where square-domed tombs were usual. In some instances this scheme was reduced to its simplest expression: a square baldaquin open on four sides. An undated but early example of an open baldaquin is the tomb attributed to Sarı Saltuk at Iznik. Because of its simplicity and irreducible form, this type of memorial building remains one of the purest examples of memorials.

The Mausoleum of Murat I was built by his son Beyazıt I at the end of the fourteenth century. As it stands, the mausoleum has a central dome supported by eight columns; it is built on a square plan, surrounded by a vaulted ambulatory. The building, restored and altered in the eighteenth century and afterwards, may still be considered to retain the original plan if it is compared with the Mausoleum of Murat II, which is arranged similarly.[10]

Baths and Commercial Buildings

After Orhan Bey conquered Bursa, it became the capital of a new state. According to Ibn Battuta, it was 'a great city with fine bazaars and broad streets, surrounded by orchards and running springs.'[11] By the Byzantine period, Bursa had become famous for its thermal establishments; there are numerous baths to be found throughout the city. In the Islamic religion, ritual cleanliness is an obligation; therefore Muslim rulers gave much importance to the building of baths (*hamam*) in their cities. In the case of the Ottomans, baths almost became a symbol of power.

The double bath of Orhan Bey at Bursa is the earliest of the large public baths. Repaired many times, it probably retains its original plan and displays the nearly classical plan of the Ottoman bath.[12] It is composed of a great domed room, which served as an apodyterium (the place where one undresses), and from it one enters the tepidarium (*ılıklık*), followed by the warm bath proper (*sıcaklık*), the caldarium of the Romans, which was, in most cases, symmetrical. The bath was generally built on a cross-shaped plan: the corners were utilized as small private rooms (*halvet*) and were the hottest part of the bath. The heating system of the floors was like that of Roman baths: hot air circulating under the floor. Separate bathing quarters for men and women and ornate private baths were common.

A few words about the decoration of these baths is in order, because one of the major decorative techniques of the fourteenth and fifteenth centuries was employed in them. Most of the domes and vaults of the baths were decorated in stucco with *mukarnas* or projecting niches, prismatic forms and other imaginative tri-dimensional geometric forms of large proportions to create fascinating impressions on the inside. In several baths in Bursa, Edirne and Istanbul this kind of stucco decoration has been preserved in part. A well-known example is the private bath of İsmail Bey at Iznik, possibly from the end of the fourteenth century.[13]

Fig. 63

Fig. 64

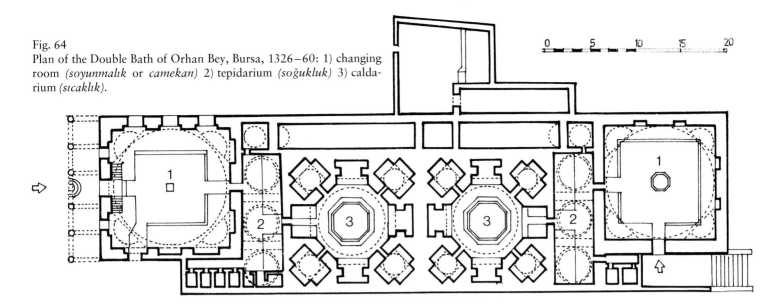

Fig. 64
Plan of the Double Bath of Orhan Bey, Bursa, 1326–60: 1) changing room *(soyunmalık* or *camekan)* 2) tepidarium *(soğukluk)* 3) caldarium *(sıcaklık).*

Secular buildings of importance, *hans* (caravanserais) and *bedestens* (covered bazaars) were also established building types. The commercial *hans* in the cities were generally unadorned two-storey buildings, consisting of rows of rooms and open galleries around a central courtyard. They might also have shops surrounding them. The merchants found places for themselves and their goods in these buildings. In Bursa the earliest *han,* the so-called Emir Han, was built during Orhan's reign.

The *bedestens,* where luxury goods were sold, were rectangular buildings of two aisles, separated by heavy stone pillars, and generally covered with two rows of domes. They are surrounded on the outside, like the *hans,* by small shops. Bursa has an imposing *bedesten* built during the reign of Beyazıt I.[14]

The Development of Mosque Design before the Conquest of Constantinople

A decade of disorder followed the Battle of Ankara (1402), when Beyazıt I fell prisoner to Timur. Mehmet I was, at least, able to restore order, and the Ottoman state resumed its imperial destiny with renewed energy. During the reigns of Mehmet I and his son, Murat II, there was great building activity, no longer concentrated in Bursa, but in the new centres of the empire. Two cities, in addition to Bursa, offer monuments of great importance from the pre-conquest period of Ottoman architecture.

The city of Amasya (ancient Amaseia) was an important government centre, the residence of royal princes, and famous for its educational institutions. There, the Grand Vizier Beyazıt Pasha had his mosque built between 1414 and 1419.[15] It is a simplified version of the Ahi-type mosque. The prayer room consists of an articulated rectangular space covered by two adjacent domes. The mosque is made especially attractive by its monumental porch. Dominating the exterior, a massive arcade of five arches encloses a cubic body delineated by strong lines of stripes and arches of contrasting colour. Its domes are decorated by geometrical motifs in stucco.

Fig. 65 Another building, unique in plan and very expressive of its function, is the convent called Pir İlyas Tekkesi (or

Yakup Pasha Mescidi ve Tekkesi)[16] built in the first quarter of the fifteenth century for a famous sheik. It has cells for the dervishes, a common ceremonial hall, a prayer room, a room for the sheik and another that contains the tomb of the first sheik. The plan was organized along two perpendicular axes. This unusual composition is the result of a well-developed skill in devising new compositions with familiar elements and demonstrates the inherent flexibility of the dome-covered square plan.

Three well-known examples of early fifteenth-century sultan mosques are the Mosque of Mehmet I (Yeşil Mosque) at Bursa, built between 1415 and 1422, and Pl. 87 two Mosques of Murat II, one at Bursa (1424–6) and the other at Edirne (1434). The Yeşil Mosque is based upon the same model as the Yıldırım Mosque but has a more developed entrance section, with a sultan lodge on the second level and two ground-level loggias. The porch was

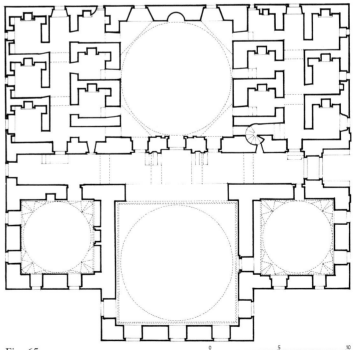

Fig. 65
Plan of the Convent (Tekkesi) of Pir İlyas, Amasya, 1st quarter of the 15th cen.

141

not completed, but the finished façade, with its rich mouldings and sensitive carvings, shows superior workmanship. Since the Yeşil Mosque is renowned for its mosaic decoration in faience, it is proper to give a short account of the use of ceramics here, as ceramics played a major role in the decoration of that period.[17]

The extensive use of tile facings combined with painted stucco and white marble elements creates a very colourful atmosphere. The tile decoration is entirely subordinated to the architectural lines. The walls are faced with green monochrome tiles to the height of the upper sill of the windows. The faience mihrab—the main focal point of the interior—is executed in a sophisticated faience technique. At both sides and above the entrance door, the loggias are covered with faience mosaic in darker tones of predominantly blue and green. The delicate decorative motifs on the tiles and on the surfaces of the faience mosaic harmonize with the colour scheme of the interior. The large ante-room leading to the prayer hall is decorated with dark green hexagonal tiles; the central portions of both sides display large rosettes filled with elegant 'rumi' (abstract floral) motifs in white, yellow and blue, which produce a strong decorative effect in the dark atmosphere of the ante-room. The contrast in lighting between the prayer hall and the ante-room is underlined by the colour schemes of both. This overt emphasis of architectural qualities and the harmony of the colours with the architecture produce a superbly unified eloquence.

The Yeşil Mosque and the Mosques of Murat II were built as part of complexes consisting of a madrasah, a bath, a public kitchen and the tomb of the founder—as in Yıldırım. The individual buildings do not present much variation among themselves, except the Mausoleum of Murat II, mentioned above.

Conquered in 1361, Edirne served as the second major capital of the Ottoman state after the death of Beyazıt I. Since it functioned as an administrative centre, ranking second only to Istanbul for many centuries, it is the only city to possess a continuous line of important monuments from the end of the fourteenth century to the eighteenth. This gives Edirne a unique place in the history of Ottoman architecture.

The Ulu Cami there is a simplified version of the one at Bursa, completed by a massive porch and a grandiose minaret that is detached from the body of the mosque. Several of the mosques of Edirne such as the Gazimihal Mosque (1422), the Beylerbey Mosque (1429), the Şahmelek Pasha Mosque (1429) and the Mosque of Murat II, with its incomparable mihrab of faience mosaic are of the Ahi-type. The most important contribution to the development of Ottoman architecture made at Edirne, however, is incorporated in the Üç Şerefeli Mosque built between 1438 and 1447.[18]

Fig. 66

It seems that during the fifteenth century, traditional formulas had lost their ability to create new variations. Though the dome was widely employed, none of these experiments fully achieved the monumentality inherent in domed structures.

Fig. 53

In the Üç Şerefeli Mosque, the unknown architect made an attempt to attain monumentality by covering a

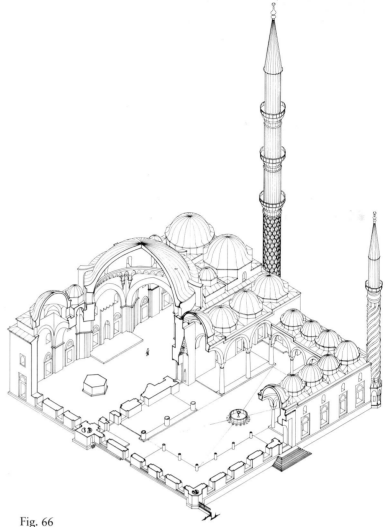

Fig. 66
Axonometric perspective of the Üç Şerefeli Mosque, Edirne, 1438–47.

great rectangular prayer hall with a very large central dome (26 metres in diameter), raised on a hexagonal base and having four corner domes. This became the foundation of both plan and structure in the experiments of the classical period. The new image of the mosque became a single dome dominating a grouping of different-sized domes on cubical bases. In spite of this innovation, the plan of the Üç Şerefeli Mosque is a direct descendant of the great medieval mosques of Anatolia and may be regarded as the final version of the plan of the Ulu Cami at Manisa and the culmination of a long tradition that began with early Islamic mosques. Here, however, especially inside, the impression produced by the dome is overwhelming. The central space, opening onto the side aisles through the great structural arches of the hexagonal baldaquin, is a first step towards the spatial arrangements of the great classical mosques.

In the Üç Şerefeli Mosque, for the first time in Ottoman architecture, a courtyard was introduced into the design of the mosque. It is a longitudinally oriented, rectangular courtyard with arcades (riwaqs) arranged about its four sides. This atrium-like courtyard can be seen as yet another expression of a Mediterranean cultural environment. From then on, it became an essential element of major mosques, as was the porch. Another innovation in the Üç Şerefeli Mosque is the attempt to integrate the minarets into the general composition. They

142

are no longer simply appended towers or secondary elements rising from the roofs of the building but part of the total silhouette, although their size is out of proportion and a certain clumsiness is still evident in the composition.

Architecture after the Conquest of Constantinople

The spirit of the post-conquest period (during the rule of Mehmet II, the Conqueror) was one of triumphant confidence and of acute consciousness of the heritage of both the Islamic and the Mediterranean past. A Turkish sultan sat on the throne of the Caesars. He no doubt hoped to dominate the whole Mediterranean basin, as had the Roman emperors, and turn it into an Islamic empire. As the heir to the Roman emperors, the sultan probably wished to cultivate the Mediterranean element. Cultural relations with the West took a new turn, and several Italian artists of the Renaissance were invited to Mehmet's court.[19] In the meantime, the Turkish army was making its first attempt to conquer Italy by landing at Otranto in southern Italy. The Balkans had been totally subjected. In the East, the Ottoman Empire was praised highly by other Muslim states. Mehmet the Conqueror returned victorious against the Akkoyunlu, and the Empire of Trebizond fell to the Turks in 1465.

The state was rich, and the arts were flourishing. The tolerance which the Turkish emperor showed to all subjects of the empire — Christians and Muslims; local, alien, new and old — made a contribution to the culture of the new universal state and led to a sudden increase in artistic production.

Two relevant contributions to the development of Ottoman architecture from this period are the rationally planned *külliye* (socio-religious complex) and the adoption of the half-dome as a major structural element for covering the Great Mosques. Both were introduced into the grandiose scheme of the complex of Fatih in Istanbul, built between 1462 and 1470.[20]

The *Külliye* of Fatih and its Followers

Fig. 67 The complex of Fatih was within a walled precinct and consisted of a mosque (destroyed in the eighteenth century and replaced by one of a different plan), sixteen madrasahs, a Koran school, a library, a hospital (Dar üş Şifa), which had its own masjid, a hostel *(tabhane)*, a public kitchen *(imaret)*, possibly a caravanserai and the mausolea of the sultan and his wife.

It has been observed that, in the imperial complexes at Bursa, the arrangement of buildings was not systematic. In contrast the Fatih complex, built on the site of Justinian's Church of the Holy Apostles, is the first social complex composed on a geometrical and symmetrical plan. This layout may be considered representative of the prevailing spirit of Mediterranean rationalism. It is also possible that the great Timurid compositions in central Asia had some influence on it.

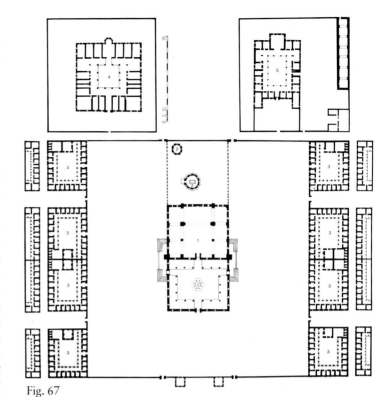

Fig. 67

Plan of the complex of Mehmet II, the Conqueror (so-called Fatih complex), Istanbul, 1462–70: 1) mosque, 2) mausolea of Mehmet II and of his wife 3) principal madrasahs 4) hospital 5) hostel.

Since most of the major monuments of the following period were part of the great complexes of the sultans and the high officials of the state, it is necessary to give a short description of some of the important complexes and their social character in order to evaluate the history of monumental Ottoman architecture in its social context.

Beyazıt II, son of the Conqueror, founded three *külliyes* (complexes): in Istanbul, Edirne and Amasya. The complex at Edirne, in view of the number of buildings involved and the size and quality of architecture, is by far the most important of the three.[21] Built between 1484 and 1488, it comprises a mosque, two hospices *(tabhane)* adjacent to the mosque, a large public kitchen (composed of the kitchen proper, a refectory, a bakery, and a very large storehouse for food), a medical school, a hospital, a mental asylum and other facilities. The complex is composed of two groups of buildings: one is the health service group; the other includes the hospices and kitchen facilities connected with the mosque.

The first group is placed asymmetrically within a large walled enclosure. A monumental porch gives access to the outer courtyard. The mosque, with a hospice on either side, is situated on the main axis of the entrance. The succession of various sized courts, the spatial perspective culminating in the high hexagonal hall in the hospital section, the proportions of the buildings and the functional approach to design, work together to make this complex of Beyazıt II one of the major realizations of Ottoman architecture.

The first *Külliye* of Beyazıt II in Amasya, built between 1486 and 1488, was of smaller scope and size.[22] The third of Beyazıt's *külliyes* is the one connected with his

Pl. 88 mosque in Istanbul; in comparison with the complex at Edirne it lacks unity of design. The series of great imperial complexes is continued by the complex of the Şehzade, built by Sinan, the most renowned Turkish architect.[23] That complex is better known for its mosque and mausoleum than for its other buildings, which include a hospice, a public kitchen, a Koran school, a madrasah and a bakery.[24]

Two years after the completion of this complex, Sinan began, by order of the sultan, the construction of the largest building complex of Ottoman architecture, the Fig. 68 Suleymaniye. While this complex follows the example of the Fatih complex in the architectural quality of its individual buildings, it is vastly superior to it. The mosque of the Suleymaniye is again in the centre, but separated from the other buildings by an outer courtyard in the form of a garden. In a walled enclosure behind the qiblah wall, there are the mausolea of Suleyman, called the Kanuni (Law-giver), and his beloved wife, Haseki Hürrem Sultan, and a building for the caretakers of the tombs. Around the outer courtyard of the mosque, but separated from it by regular streets, are a Koran school, two madrasahs for different grades of education, a medical school and a large hospital *(bimarhane)* on the west, a public kitchen, a hospice and a caravanserai on the north, and on a terraced slope on the east, two additional madrasahs for higher levels of education, a hadith school and a bath. On the east and west, streets complete the complex; on the sloping terrain, rows of small shops were set up. The whole composition was masterfully situated on terraces. That the whole programme was carried out between 1550 and 1557 is a good measure of the economical and organizational power of that period.[25]

These complexes were intended to be important centres for the social and religious life of the citizens. They were in fact the forerunners of modern social centres and the outcome of a social welfare programme based on religious precepts. The complexes were sponsored by powerful, wealthy monarchs; however, the construction of such complexes should not be viewed as individual attempts at self-aggrandizement, born of the wealth and desires of the rulers. The social system that was instrumental in the establishment of these *külliyes* was already fully developed in earlier Muslim social institutions. The system, called *waqf* (*vakıf* in Turkish, an Islamic religious or charitable foundation, created by an endowment) was the essence of the Muslim social welfare system; it was ultimately founded on the religious concept of obligation towards one's fellow men. At the same time, conveniently for the rulers, these complexes symbolized the authority and munificence of the state. Especially after the ascendancy of the Turks, *waqf* buildings played an important role in the creation of monumental Turkish cityscapes.

In the history of Ottoman society, this system became the pivot of social welfare aid in the cities, a secular and municipal institution rather than a religious one. It has been estimated, for example, that in the *Külliyes* of Beyazıt II, more than a thousand people were employed and regularly paid, from the teachers of the madrasahs to the simple keepers. In Istanbul during the second half of the eighteenth century, about 30,000 persons were given two meals daily by the *waqf* foundations. Mosques, schools, libraries, hospitals, sanitary installations and fountains were all of *waqf* origin. In the absence of a municipal organization, the *waqf* was the basic social and urban institution.[26]

The Development of the Great Sultan Mosques[27] Fig. 69

Schematically speaking, the mosque of the complex of Mehmet II is directly derived from the Üç Şerefeli Figs. 66, Mosque. The design of Mehmet the Conqueror's mosque 69 introduced the half-dome as a new element for covering domed spaces of great dimensions. The half-dome in conjunction with a central dome brings the whole interior under the spell of a single dome; the spatial possibilities of half-domes were experimented with within a series of mosques.

The logical successor to the Fatih Mosque was the Fig. 69c, e, mosque of the complex of Beyazıt II in Istanbul, built Pl. 88 between 1501 and 1506. There the central dome was counterbalanced by two half-domes on the qiblah axis, as in the central nave of Hagia Sophia. The side aisles were covered by four smaller domes. The whole plan was designed on a modular system, one module being one fourth of the central dome. The covered hall was a perfect square, and the courtyard was another square; the proportion 1:2 has been established for the height. Side by side with this novel approach to the rational plan of the mosque itself, the traditional hospice quarters *(tabhane)* were included in the plan (as at Edirne), and the facades remained as unarticulated as before. Nevertheless, the architect Yakub Shah bin Sultan Shah made a decisive step—with this mosque's perfect geometrical layout and well-balanced spaces inside and out—towards the ultimate solution for centralized buildings which was finally realized by the Mosque of Şehzade. In the mosque of the

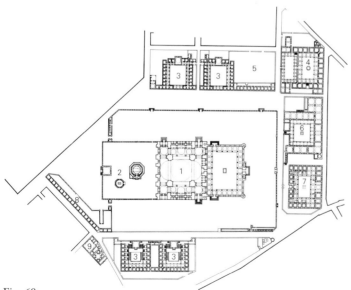

Fig. 68

Plan of the complex of the Suleymaniye, Istanbul, 1550–7: 1) mosque 2) mausolea of Suleyman the Magnificent and of his wife, Hurrem Sultan 3) madrasahs of different grades 4) hospital 5) medical school 6) public kitchen 7) hostel 8) Koran school 9) bath.

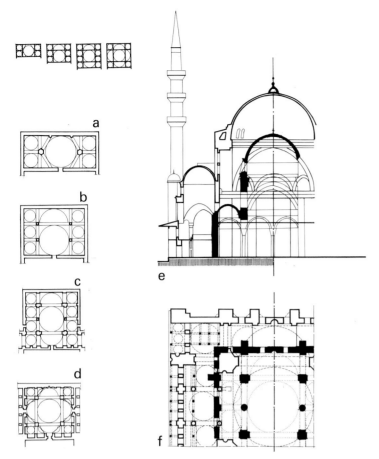

Fig. 69
Comparative plans of the Great Mosques and their development:
a) Üç Şerefeli Mosque b) Mosque of Mehmet II c) Mosque of
Beyazıt II d) Şehzade Mosque e) section of the Mosque of Beyazıt II
(black) and the Sulemaniye f) plans of the Mosque of Beyazıt II (black)
and the Suleymaniye.

Pl. 89 complex of Şehzade, Sinan produced a centralized
domed space. The central dome, carried by four interior
pillars, was buttressed by four half-domes on its four
sides, and the four corners were covered by smaller
domes.

The symbolic five-domed scheme had been in existence
since the Iranian fire temples of the Zoroastrians.
Byzantine churches with so-called cross-in-square plans
and similar plans in Renaissance architecture are also
well-known. Generally, the cross arms are covered by
barrel-vaults. In the rare instances where half-domes were
used, the buildings had cross-shaped exteriors, and in
many other examples of church architecture in the east,
the corner rooms were completely closed off from the
central space. The Şehzade Mosque was the first realiza-
tion of the cross-in-square plan, in which the arms were
covered by half-domes and the corners were an integral
part of the central space. This large square hall with
internal supports was the finest expression of Sinan's
centralized scheme and one which achieved universal
significance in the history of architecture.

The exterior of the Şehzade Mosque denotes the real
beginning of the classic Ottoman style. The exterior walls
were no longer simply massive supports for domes. Two
side galleries were added to the mosque to enhance the
façades and to bring a strong note of chiaroscuro. The
buttresses and the minarets with their plastic character,

decorative surfaces and harmonious proportions make
this first royal work of Sinan a masterpiece.

Sinan, who dominated the whole course of the six-
teenth century with the several hundreds of buildings he
executed, continued to play with an exceedingly wide
range of large, structurally expressive buildings. The
Şehzade was followed by the Suleymaniye (1551–7), the Pl. 90
Great Mosque of the complex of the same name.[28] After Fig. 68
experimenting with totally centralized space, Sinan's
interest turned to the creation of more expressive and
dynamic space. Again he adopted the theme of the
Beyazıt Mosque and hence that of Hagia Sophia: the
central nave was covered by a central dome, abutted by
two half-domes, and the side aisles were covered by five Pl. 91
domes of varying dimensions. The great system of
buttresses on the east and west was integrated into the
composition by the judicious use of inner and outer
galleries. Despite the existence of two central columns
carrying the domes of the side aisles, which produces a
loose screen effect, the interior is a single whole. The four
minarets, placed at the four corners of the courtyard,
facilitate the integration of the large body of the prayer
hall and of the courtyard. The mosque, which is
surrounded by the numerous domes of the buildings of
the complex, dominates the glorious silhouette of Istan- Pl. 90
bul with its pyramidal configuration. The greatest artists
of the period worked on the decoration of the interior of
the Suleymaniye; the walls and domes were painted with
floral decoration and with inscriptions in bright colours,
most likely dominated by red. Tile facings were used
sparingly; the windows of the mihrab wall provide the
best example of Turkish stained glass. The whole deco-
ration was, however, entirely subordinated to structural
lines.

Sinan's fascinating experiments with domed spaces
having square, hexagonal or octagonal baldaquins
exploited the full extent of their possibilities, without
abandoning the basic functional form—a rectangular
prayer hall.[29]

Experiments with Domed Space

In the laterally developed plan of the Mihrimah Mosque Fig. 70a
at Üsküdar, where the central dome is counteracted by
three half-domes, the square baldaquin is found. In
another Mosque of Mihrimah Sultan[30] (again a laterally Fig. 70b
developed hall), the huge single dome and three smaller
domes on each side made it possible to give the exterior
an extraordinary monumentality.

In a series of medium-sized buildings, starting with the
Sinan Pasha Mosque (1555), which was an imitation of Fig. 71a
the Üç Şerefeli Mosque but on a different scale and pro-
portion, Sinan experimented with hexagonal baldaquins.
For example in the Mosque of Ahmet Pasha, the main Fig. 71b
supports are pillars connected to free-standing columns;
this doubling of supports and the creation of a kind of
ambulatory around the centre was an ancient device. To
inscribe a hexagonal baldaquin in a rectangular enclo-
sure, half-domes were used to cover the four corners. The
solution to the problem of the side aisles (covered by

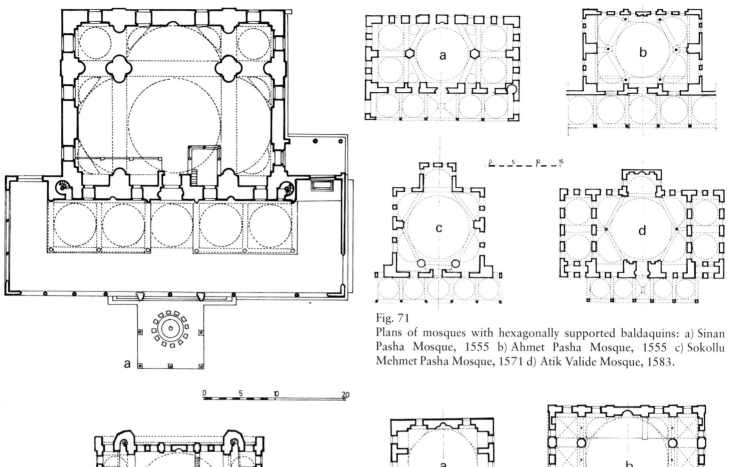

Fig. 71
Plans of mosques with hexagonally supported baldaquins: a) Sinan Pasha Mosque, 1555 b) Ahmet Pasha Mosque, 1555 c) Sokollu Mehmet Pasha Mosque, 1571 d) Atik Valide Mosque, 1583.

Fig. 70
Plans: a) Mosque of Mihrimah Sultan at Üsküdar, Istanbul, 1547 b) Mosque of Mihrimah Sultan, Edirnekapı, c. 1555.

Fig. 72
Plans of mosques with octagonally supported baldaquins: a) Hadım İbrahim Pasha Mosque, 1551 b) Rüstem Pasha Mosque, 1565 (?).

octagonal baldaquins inscribed in a square. In the Rüstem Pasha Mosque this is clearly visible on the outside as well as inside. This is the only example of a mosque entirely decorated with tile revetments that reach to the springing of the domes; they are among the finest examples of classical ceramic art.[32]

The same plan was used in other buildings with different plastic effects. An interesting example is the mosque of the Sokollu complex at Lüleburgaz, a preparatory design for the Selimiye at Edirne.

The Selimiye at Edirne and its Aftermath

Sinan's great masterpiece, the Mosque of Selimiye at Edirne (1569–75), is the pinnacle of structurally defined domed buildings.[33] The thrust of a cupola 31.50 metres in diameter could only be counteracted by a double system of buttressing: an interior system of great pillars standing at the inner core and a system of buttresses against this core. The task of organizing the outer system

Fig. 73

small domes in this mosque) is found in the Sokollu
Fig. 71c Mehmet Pasha Mosque, where the side aisles are elimi-
Pl. 92 nated. This small, extremely well-designed masterpiece by Sinan should also be remembered for its beautiful mihrab wall, decorated with tiles.[31]
Fig. 72a The Mosque of Hadım İbrahim Pasha (1551) and the
Fig. 72b Mosque of Rüstem Pasha (1565?), both in Istanbul, have

without destroying the effect of the main core dominated by a single dome is the main theme of composition at the Selimiye. The central baldaquin, the system of buttressing and the curtain-like walls have been united to produce an absolute space under the dome.

Pl. 94

Pl. 93
On the outside, the dome is not perceived as a semisphere set upon a cubic base of walls but, aided by a well-distributed pilaster system, the movement of the dome progresses downward below the octagonal level of transition. The walls touch close to the outer limits of the dome, thus dissolving the separation between the vaulting and the walls; therefore, the enclosing elements form a continuous boundary for the interior space. The flow the observer feels on the outside is enriched by the rhythmical quality of the alternation of arches and small domes. All the architectonic elements have their place in this well-designed continuum, which is very close in spirit to the theoretical bases of classical Renaissance architecture.

After the Selimiye, few words remain to be said about traditional domed buildings. The religious architecture of the following centuries produced variations on the same theme; yet the capacity for great building efforts had still not been exhausted. At the end of the sixteenth century and the beginning of the seventeenth, two large royal mosques and their dependencies were begun. The Yeni Mosque was designed by Davut Ağa, a pupil of Sinan, as a variation on the Şehzade, but work was suspended in

Pl. 95

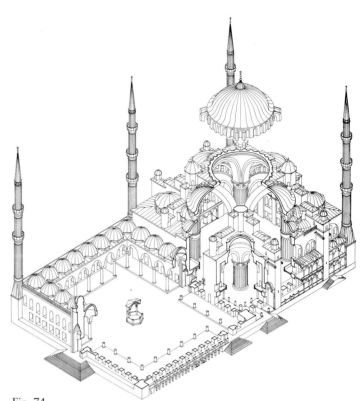

Fig. 74
Axonometric perspective of the Mosque of Sultan Ahmet, Istanbul, 1609–16 (after Nayır).

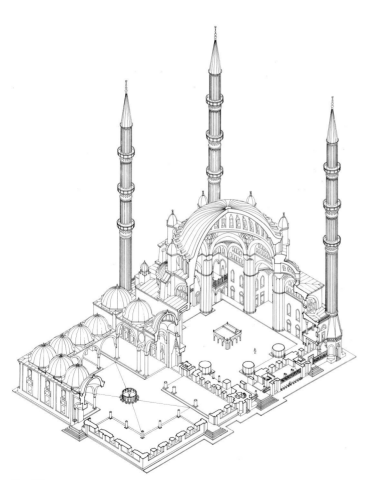

Fig. 73
Axonometric perspective of the Mosque of the Selimiye, Edirne, 1569–75.

1603 and not resumed until 1660–3 by the architect Mustafa Ağa.[34] The Mosque of Sultan Ahmet (the "Blue Mosque") and its dependencies were built by Mehmet Ağa, between 1609 and 1616, again with the same plan as the Şehzade.[35] The numerous refinements exhibited by both buildings include smoothness of contours, play with the interior transition elements, more rational distribution of the buttresses, original placement of exterior galleries and greater emphasis on the vertical. Fig. 74

The completion of the Yeni Mosque also marks the end of a rather stable phase of classical Ottoman history. With the disastrous end of the second siege of Vienna, the Ottoman economy could no longer permit grandiose plans on the sixteenth-century scale. Only the Mosque of Yeni Valide at Üsküdar, built in 1708 to 1710, achieved a certain royal stature. As is usual towards the end of a classical period, architecture was marked by a certain mannerism and delicacy of forms; these were characteristic of the Tulip period.[36]

The classical mosques in different parts of the Ottoman Empire are minor variations or imitations of the mosques in the capital: the simple dome on a square plan with a porch was the most common type. Cut stone for the facing was *de rigueur*, decoration was concentrated on the portals, capitals, tympana of the arches over the doors and windows and on the mihrabs. Mihrabs were usually in marble, but tile panels around them on the qiblah wall and other tile panels enhanced and underlined the structural articulation of the mosque interiors. The walls and especially the domes were painted, although the original painting has in most cases been redone and very little of the original survives.

147

Other Buildings of the Classical Period

Madrasahs and other types of buildings on similar plans were built according to fourteenth-century plans: an open courtyard surrounded by arcades, giving access to student cells or other rooms, with a central dome-covered room for common study and possibly for prayer and services in one corner. This was the usual plan—with variations dictated by function—for madrasahs, hospitals, public kitchens (imarets) and hostels (tabhanes). In some instances the layout was arranged like a cross, e.g. the Madrasah of Mehmet I at Merzifon, or as an octagon, e.g. Büyük Ağa (1488) at Amasya or the Rüstem Pasha in Istanbul. Architectural licence was directed towards creating interesting spatial arrangements by various means, such as entrances (the hostels of the Suleymaniye complex) or adaptation to the slope of the terrain (found in the northern madrasahs of the Suleymaniye). But Ottoman madrasahs belong essentially to the universal type of Muslim madrasahs: they had very little decoration except for the mukarnas decorations, used particularly at the entrance niches. During the late sixteenth and seventeenth centuries, an interesting group of small complexes of delicate design such as the Gazanfer Ağa, the Köprülü, the Karamustafa Pasha and the Amcazade Hüseyin Pasha (containing madrasahs, small masjids, libraries, fountains and sometimes the tombs of their founder[37]) were important contributions to the cityscape.

Small library buildings should be discussed as a separate group. The majority are from the seventeenth century or later. Attached to madrasahs or to a school building, they generally took the form of a single-domed room with a large porch, the shelves occupying the centre of the room. With their large overhanging eaves, low proportions and well-lighted interiors, these libraries are quite different from any other single-domed building. The library of Köprülü (1161) is a good example.

Ottoman architecture did not create a tradition of monumental memorial buildings comparable to its predecessors the Seljuks, the Mongols or the Mamelukes. Funerary buildings (turbehs) were square or polygonal in plan and domed; they might have a porch. Some sixteenth-century tomb buildings such as the Hüsrev Pasha or the Şehzade Mehmet in Istanbul were reminiscent of the tower tradition. There were some exceptional examples such as the Mausoleum of Suleyman, in which the octagonal plan, with an interior ambulatory and an exterior gallery, speaks of a specific antique origin—in this instance that of the Mausoleum of Diocletion at Spalato. Obviously the configuration of Suleyman's mausoleum was entirely different, but the source was Mediterranean. Polygons with interior ambulatories were employed in some other large mausolea such as the Turbeh of Selim II. Sometimes the tombs were decorated with beautiful tile panels. The two mentioned above—those of Hüsrev Pasha and the Şehzade—were also pre-eminent in the decorative treatment of their exterior.

Imposing commercial buildings (the hans) followed older traditional patterns. Although the Seljuk caravanserais continued to be used during this period, some Ottoman caravanserais are larger and better equipped than the medieval Seljuk ones. The latter were built on the main commercial roads or military roads, for the safety of armies, commercial caravans and pilgrims. Usually the caravanserais were built at the halting-places on the main roads and consisted of covered halls, open

Fig. 75
Fig. 76

Pl. 96

Pl. 97

86 Courtyard of the mental asylum of the Beyazıt II complex, Edirne, 1484–8.

87 Interior of the Yeşil (Green) Mosque, Bursa, 1415–22: view of the entrance and the sultan's lodge in the upper storey.

88 Mosque in the Beyazıt II complex, Istanbul, 1501–6; general view.

89 Interior of the Şehzade Mosque, Istanbul, 1543–8; built by Sinan.

90 Suleymaniye Mosque, Istanbul, 1551–7: general view; built by Sinan.

91 Interior of the central dome of the Suleymaniye Mosque, Istanbul, 1551–7; built by Sinan.

92 Interior of the Sokullu Mehmet Pasha Mosque, Istanbul, 1571–2; built by Sinan. In the middle, the mihrab and the minbar.

93 Selimiye Mosque, Edirne, 1569–75: general view; built by Sinan.

94 Interior of the Selimiye Mosque, Edirne, 1569–75; built by Sinan. In the background, the mihrab and the minbar.

95 Façade of the courtyard of the Yeni Mosque, Istanbul, 1594–1603; begun by Davut Ağa in 1594–1603; finished by Mustafa Ağa in 1660–3.

96 Complex of Gazanfer Ağa, Istanbul, 1599: partial view, including madrasah, mausoleum of the founder and well-house.

97 Turbeh of Husrev Pasha, Istanbul, 1545–6; built by Sinan.

98 Domes: an obsession with domes is one of the basic characteristics of Ottoman style.

99 Arcade and Marble Pool of the Baghdad Kiosk in the Topkapı Sarayı, Istanbul; built in 1639 under Sultan Murat IV.

100 Interior of the Kiosk of Revan in the Topkapı Sarayı, Istanbul; built in 1636 under Sultan Murat IV.

101 Nuru Osmaniye Mosque, Istanbul, 1748–55: general view. Begun under Sultan Mahmut I and finished under Sultan Osman III.

102 Overhanging roof on the Fountain of Sultan Ahmet III, Istanbul, 1728, at the entrance to the Topkapı Sarayı: elegant floral ornamentation of the Tulip period.

103 The Yalı (summer residence) of Sadullah Pasha in Çengelköy on the Bosphorus.

104 Façades of houses, Istanbul: in the eclectic style of the 19th cen.

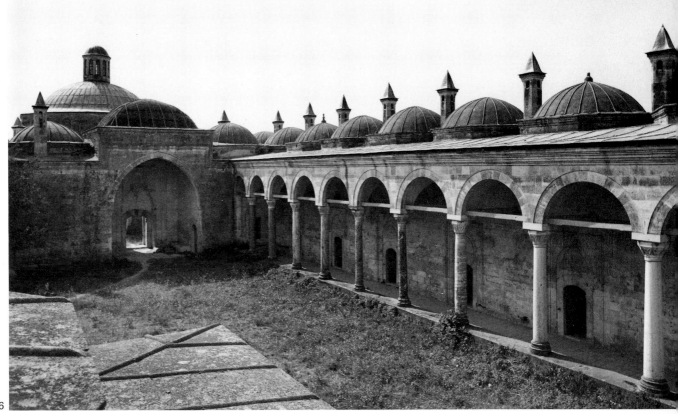

86

87

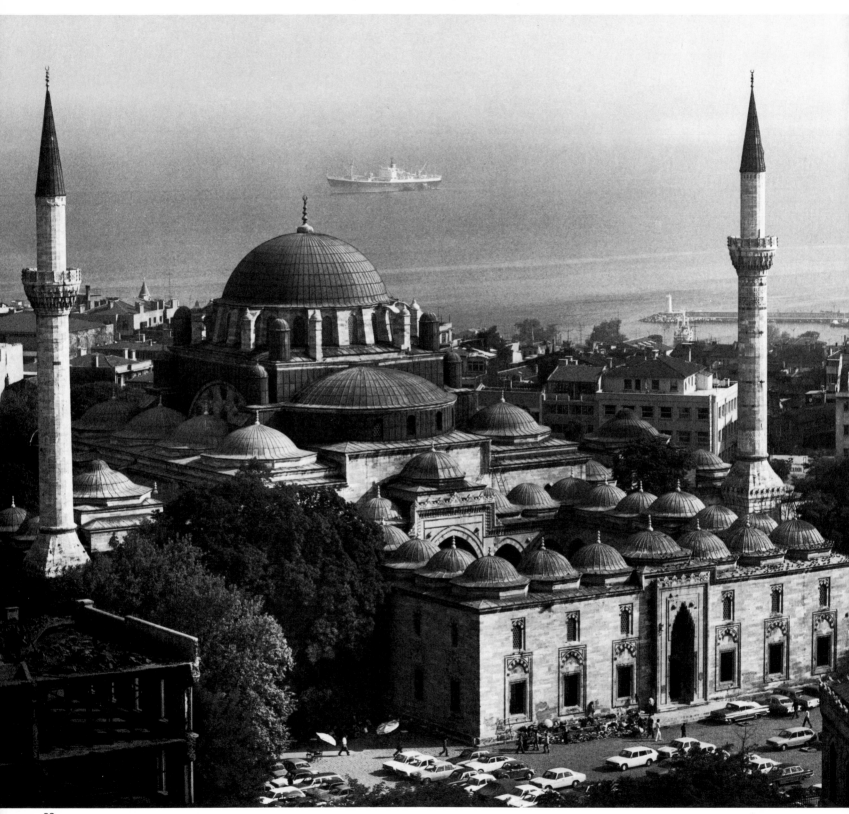

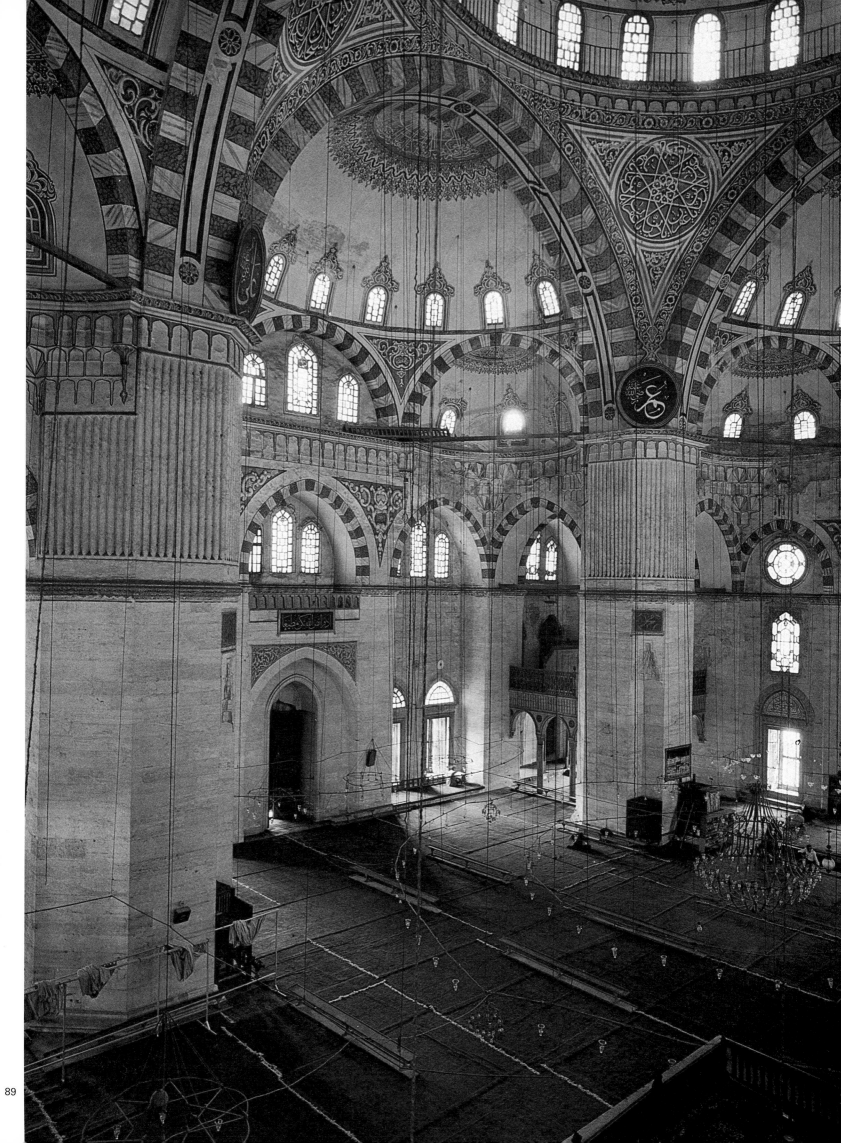

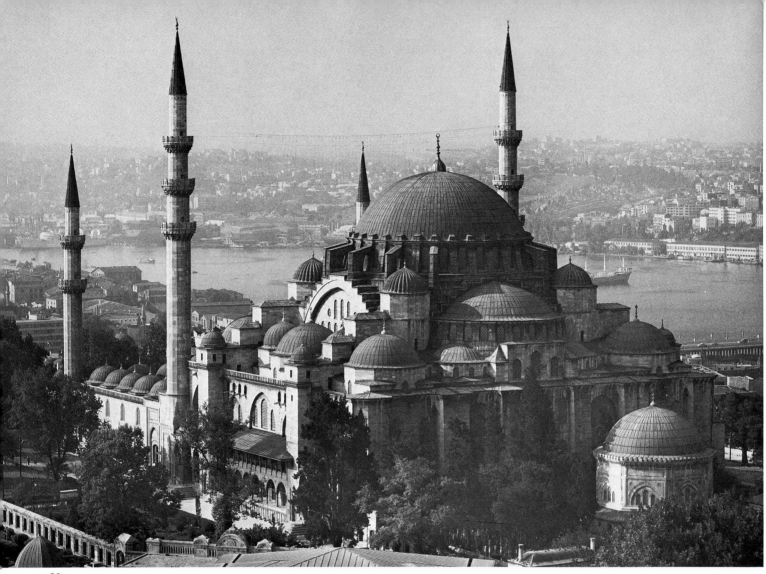

90

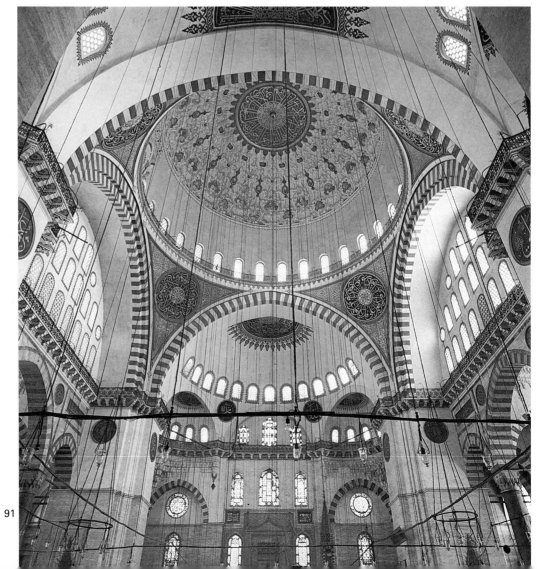

91

92

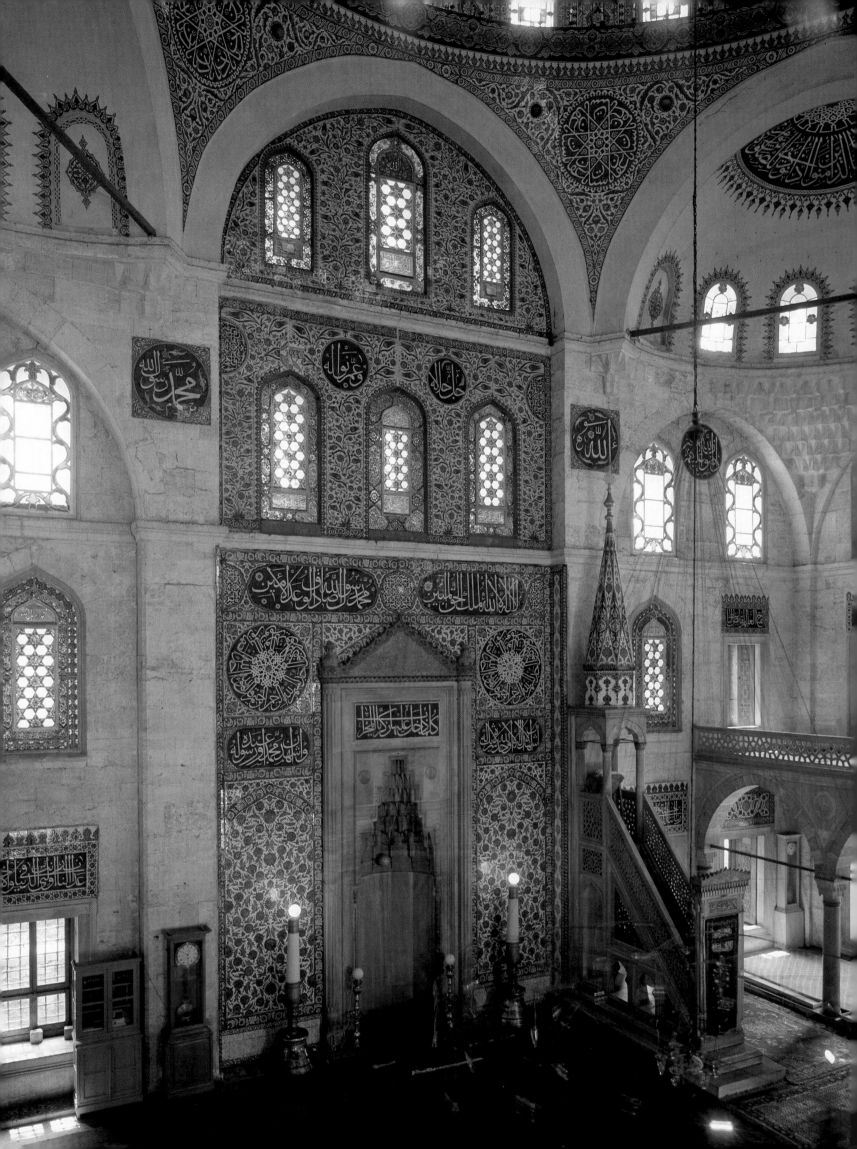

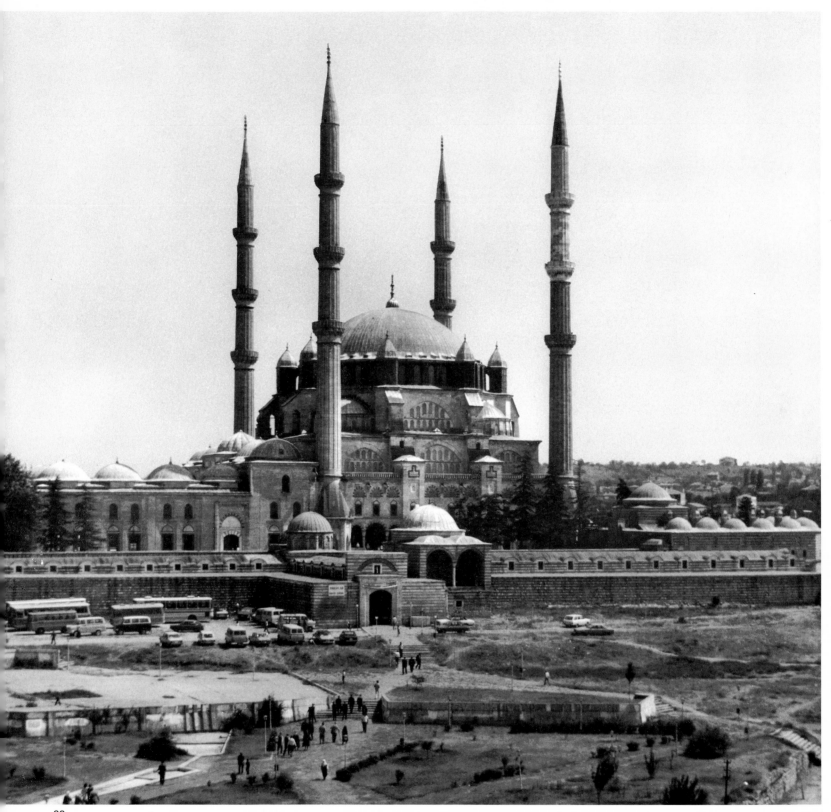

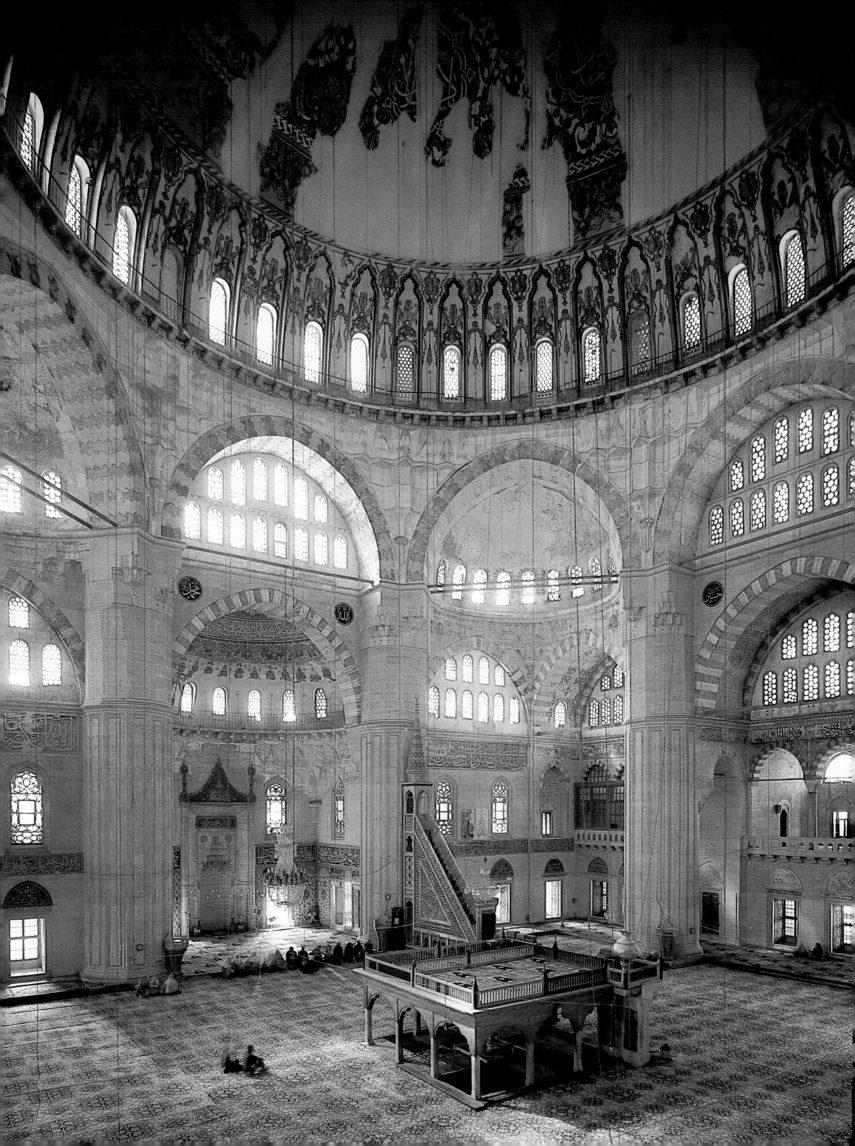

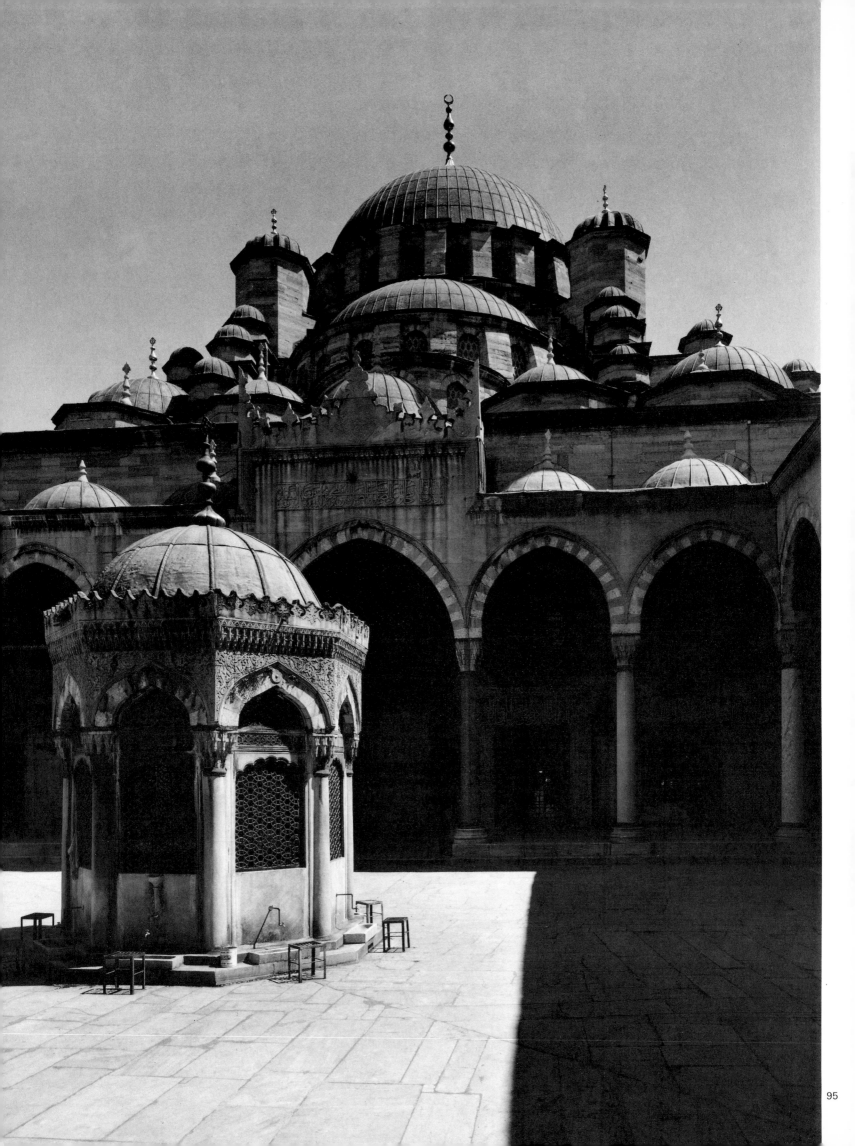

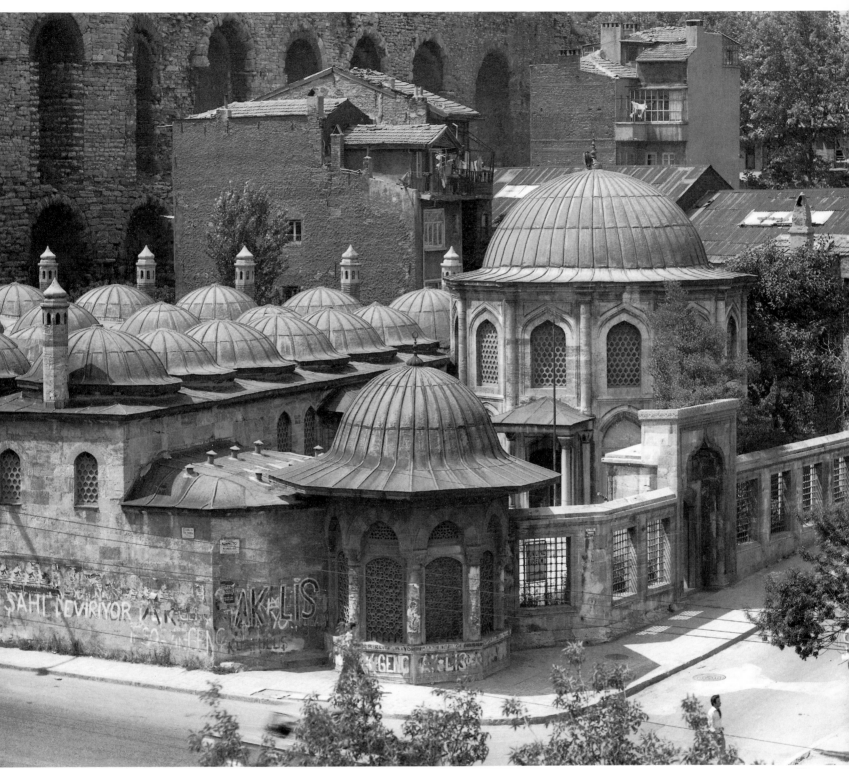

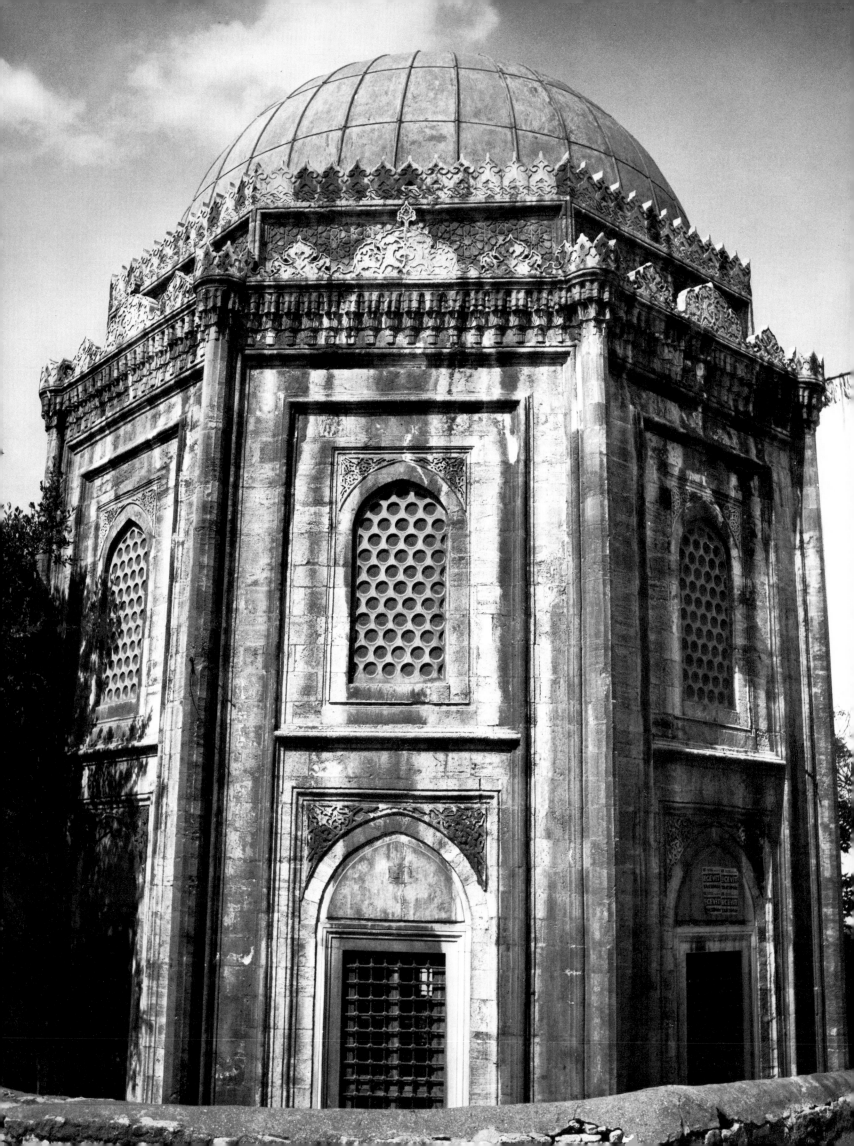

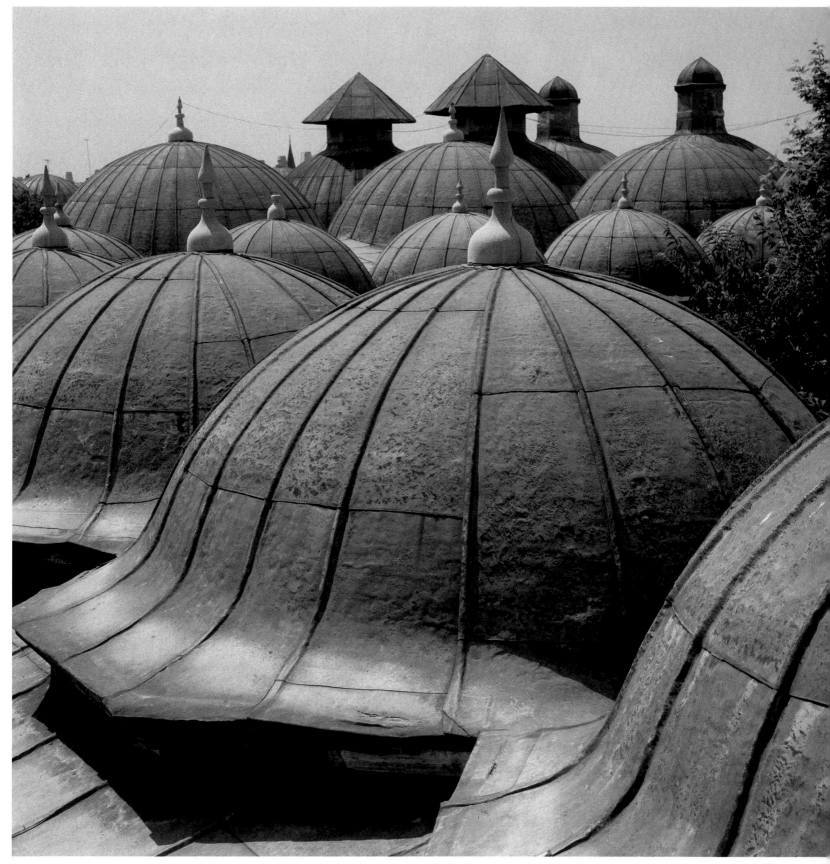

98

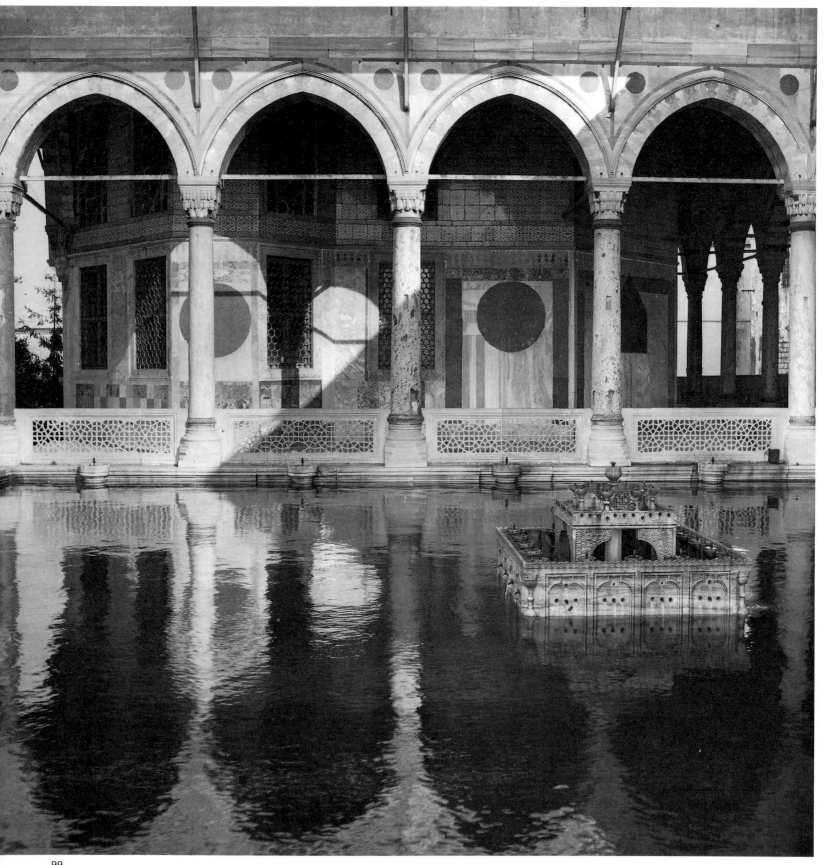

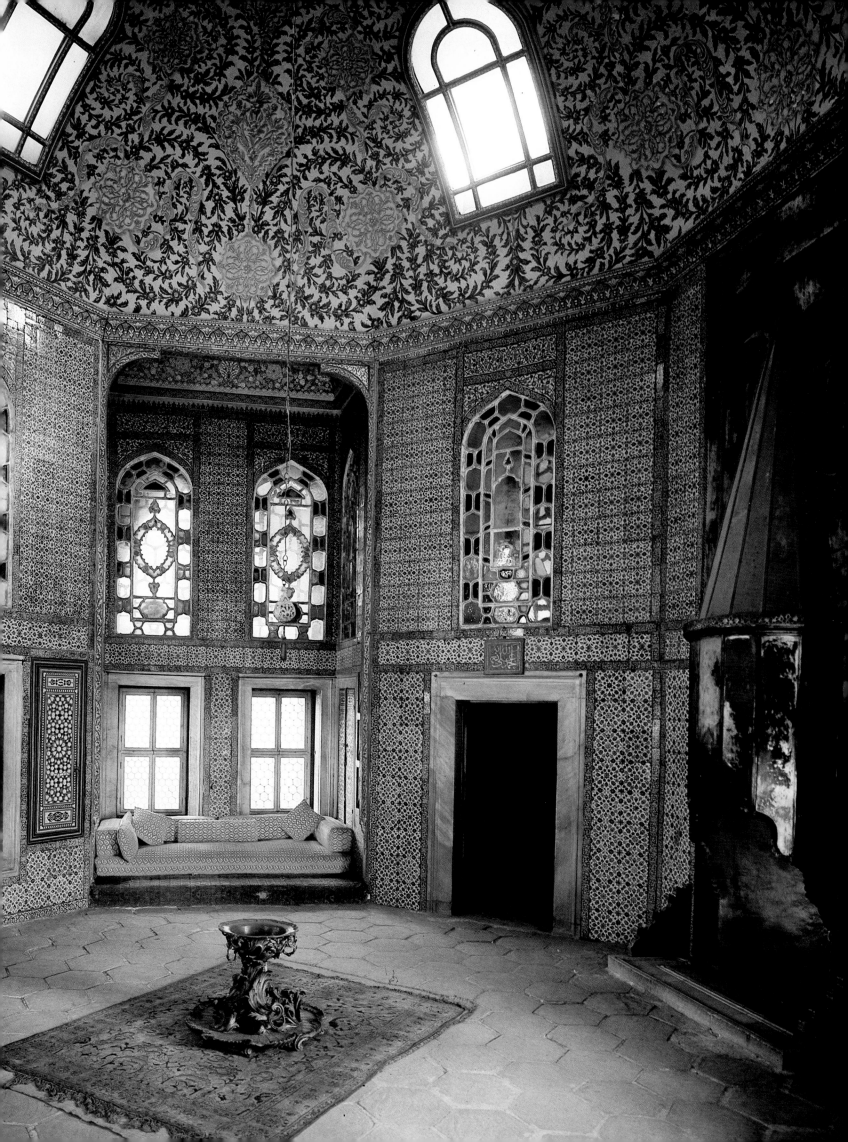

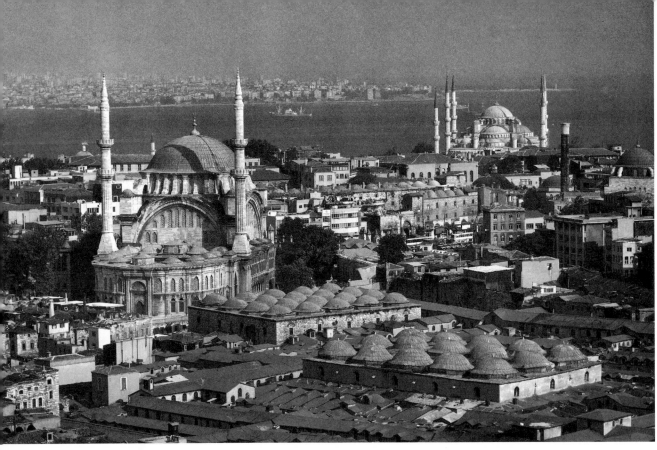

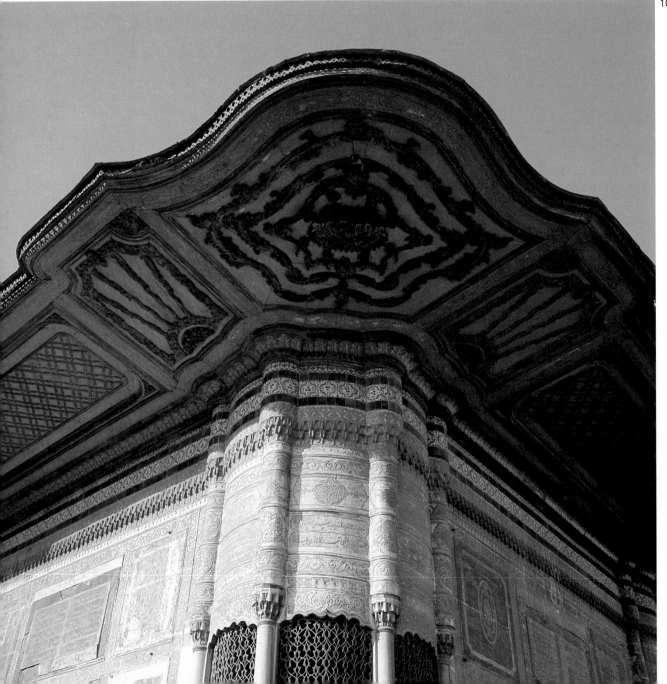

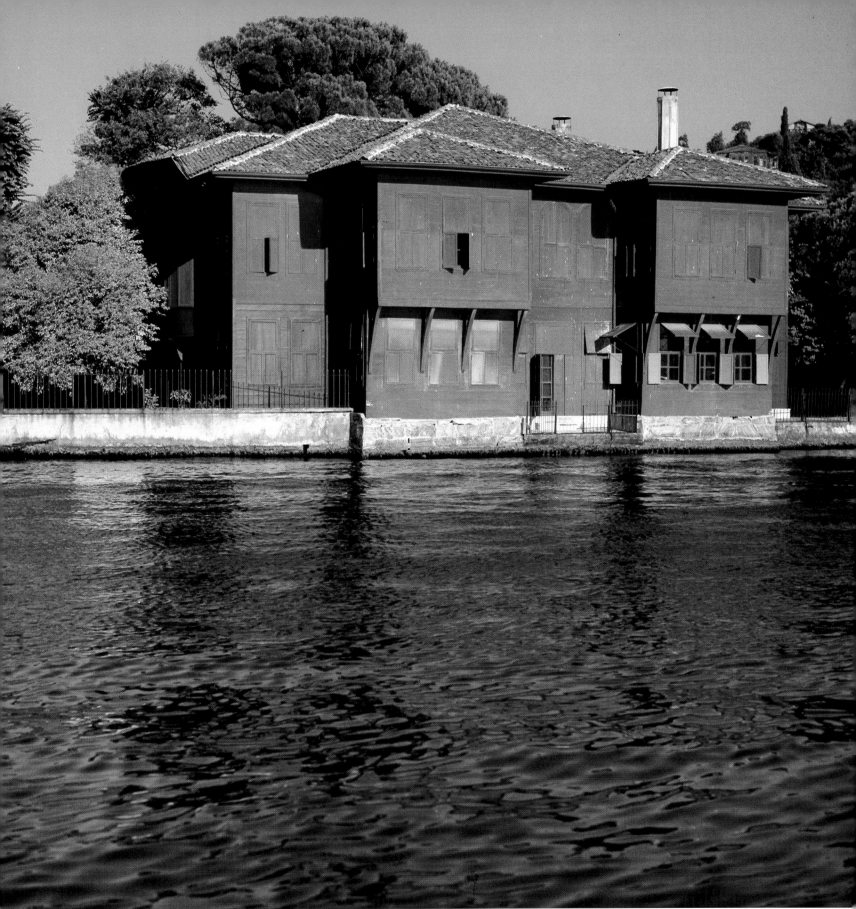

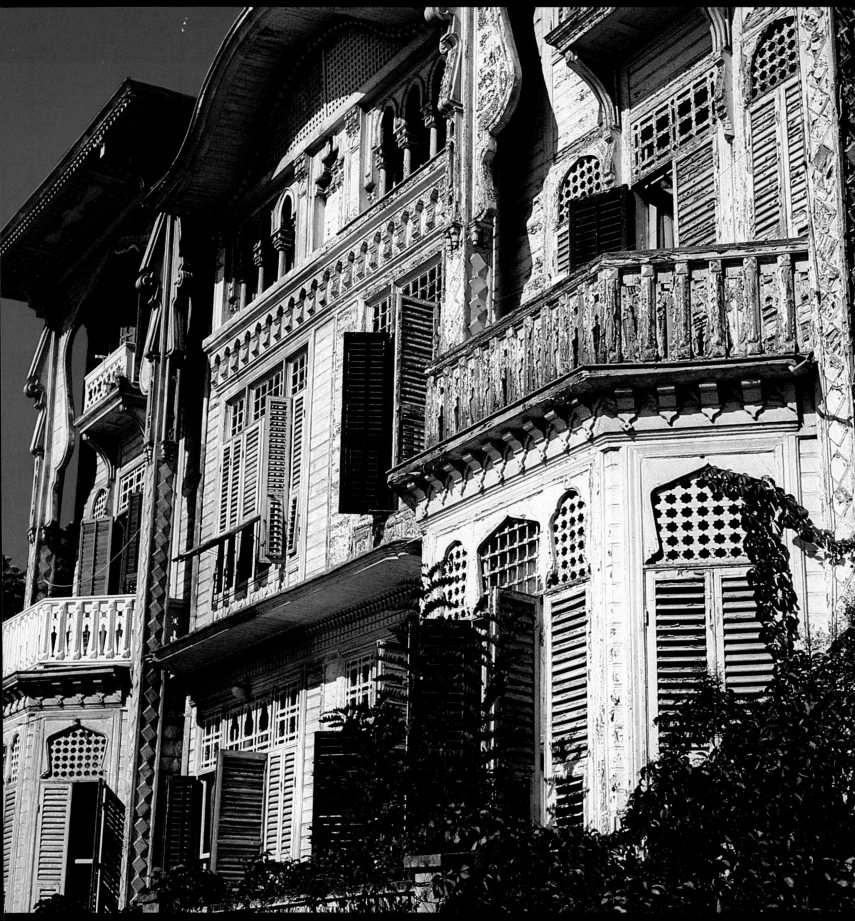

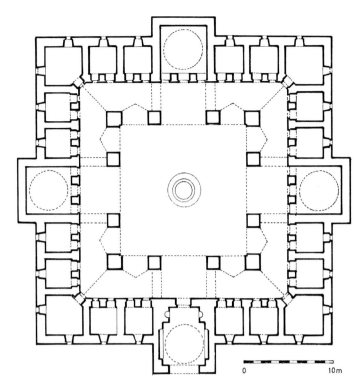

Fig. 75
Plan of the Madrasah of Mehmet I, Merzifon, 1418–9.

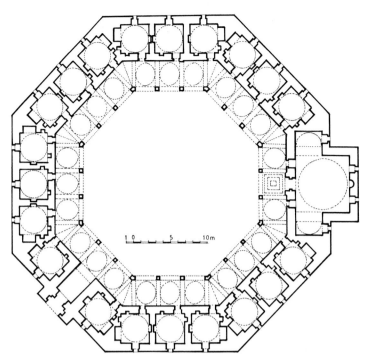

Fig. 76
Plan of the Madrasah of Büyük Ağa, Amasya, 1488.

courts, baths, masjids and shops. They varied in plan and could be quite elaborate compositions. Some of them constitute great complexes such as the Sokollu Mehmet Pasha Han at Payas and the Merzifonlu Karamustafa Pasha Han at Incesu.[38]

As for the commercial buildings in the cities, the shops were generally one-storey wooden constructions. Even in the capital in the fifteenth and sixteenth centuries, many great bazaar areas were merely simple rows of wooden shops. Very picturesque examples of this kind of bazaar can still be found in Anatolia and in the Balkans. The *bedestens* (covered halls for expensive goods) were dome-covered rectangular buildings surrounded by shops. The urban *hans* were built in conformity with the older forms, i.e. generally large two-storey courtyard buildings. Galleries on both the ground floor and first floor surrounded the courtyards, and the upper storeys were reached by monumental staircases. The buildings served as warehouses as well as hostels. Among the most impressive examples of *hans* are the Rüstem Pasha at Edirne and the Büyük Valide Hanı at Istanbul. Many provincial cities still have exciting examples of lesser commercial *hans* in fairly good condition but in need of repair, e.g. the Ekmekçioğlu Ahmet Pasha Hanı at Edirne, the Cinci Hanı at Safranbolu and the Taş Han at Merzifon.[39]

All the great stylistic developments were based on a few essential elements. In its initial and classical phases, the hallmark of Ottoman architecture was the structural clarity of the domed space. Thus variations in space and exterior configuration were obtained by manipulating the formal relationship between the main dome (or a series of domes) and the other elements of the composition. Since the cubical space covered by the dome was invariable, the composition was determined by the method of buttressing the main dome or by the combination of domed modules, which influenced the spatial character of the

interior as well as the rhythm of the exterior. The interior was not complex: the whole geometrical structure and the spatial boundaries could be clearly perceived. Lighting was functional and appropriate. Decorative effects were totally subordinated to the structural articulation. Applied to all types of buildings from Great Mosques to simple Koran schools, the Ottoman style was consistent and throughly developed to the limits of its potential.

Fig. 77
Plan of the Sokollu Mehmet Pasha Han, Payas (central Anatolia), 1574.

Palaces

Of the large number of great palaces of Ottoman sultans and officials of the Ottoman state, only the palace of Topkapı and some minor kiosks of secondary importance remain. The palace at Edirne, second only to the Topkapı and representing primarily the reigns of Mehmet II and Mehmet IV, was destroyed in the nineteenth century. From old descriptions, miniature paintings and the existing remains at the Topkapı, it may be assumed that the idea of an single integrated monumental palace was alien to the Turkish spirit. Examples influenced by renaissance or baroque palaces did not exist in the Ottoman domains until the eighteenth century.

Topkapı Palace,[40] the main residence of the Turkish sultans, is composed of small kiosks and suites of various dimensions around interior courtyards with separate kitchens, barracks for the guards, eunuchs' apartments, meeting halls, baths and libraries, all constructed at different periods and re-modelled and re-decorated several times. The construction of the palace of Topkapı started after the conquest, on the site of the old citadel. The Topkapı is placed in a great enclosure; the main entrance is through the imperial gate to the outer courtyard of the palace. The first courtyard was a service courtyard with some service buildings, including the palace bakery and a few barracks. From this courtyard, access was gained to the great outer garden of the palace. The main palace gate led to another courtyard surrounded by several arcades, one side of which was occupied by the palace kitchen, while on the opposite side at one corner, was the Imperial Council Room with access to the Treasury. This courtyard was planted with cypress trees and adorned by several fountains. From this courtyard one reached a third courtyard where, just opposite the gate, the audience room of the sultan was situated with the Pavilion of the Holy Mantles of the Prophet, the mosque of the palace and the palace school, where all the important members of the administration were trained. It is evident from this description that the palace was also the administrative centre of the Ottoman empire.

The private quarters of the palace (the harem) were entered either from the third or from the second courtyard. They were on the north side of the complex and consisted of some three hundred rooms of different sizes and on several levels around terraces and small courtyards. The harem and the third courtyard opened onto the northern gardens of the palace where several detached kiosks were built. In this garden on the shore, there was also a summer palace, again consisting of various interconnected pavilions, now totally destroyed.

From an architectural point of view, the most imposing elements of the palace are the great gates, the suites of Mehmet II dominating the north-east corner (composed of three domed rooms of royal proportions and open loggia) and the monumental kitchens built by Sinan. Yet the real beauty and intimacy of the palace is found in the harem: rooms with subdued light, walls decorated with Pls. 120, 121 delicate paintings, faience panels, elegant chimneys, flat or domed, richly decorated ceilings enhanced with gilt,

divans along the walls covered with embroidered fabrics, colourful cushions, rugs, fine woodwork and ivory-inlaid cupboards all created a rich atmosphere of so-called oriental nonchalance. The two kiosks in the garden, the Revan Köşkü and the Baghdad Köşkü, both from the Pls. 99, 100 reign of Murat IV, represent this type of architecture at its best.

It is difficult to reconstruct the domestic architecture of the classical Ottoman period. In many regions of the Ottoman Empire, regional styles continued to flourish. The house form that is accepted as a creation of Anatolian Turkish culture was a wooden construction, and examples from before the eighteenth century are extremely rare.

Ottoman Architecture under European Influence

During the reign of Ahmet III (1703–30) in the Tulip period, palace architecture was first exposed to the influence of French rococo by the enthusiastic reports in letters from the first Turkish ambassador to France, who described the exquisite atmosphere of the French court to the sultan. The first creations of this imported style were short-lived, because they were destroyed by the mob that dethroned the sultan. The new decorative style, however, was not lost. On the contrary, it replaced the old ornamentation in just a few decades. Starting with the use of acanthus leaves, scallop motifs, cartouches and the characteristic rococo S and C curves on the surfaces of fountains and in wooden carvings, it eventually changed the traditional visage of Ottoman architecture.[41]

Called Turkish baroque or rococo, the new style produced its first major monument in the Mosque of Nuru Pl. 101 Osmaniye (1748–55).[42] Although it was built on the simple traditional plan of a single-domed square, this mosque was directly influenced by Western baroque: daring cornices, rich mouldings, decorative arches, unorthodox articulation of façades, original abstract carvings decorating doorways, minarets with balconies, the incredible plasticity of baroque taste and a unique circular courtyard. The public kitchen, the library, the fountains and the tomb of the complex, with their undulating curved lines and fantasy of design, herald the end of the classical Ottoman style. In the second half of the eighteenth century, Turkish architects adhered to the new style. The chief architect of Mustafa III, Mehmet Tahir Ağa, typified the interpretation of the new style by Turkish architects in the complex of Laleli (1759–63), although he greatly restrained his decorative zeal. The other Mosques of Mustafa III, Ayazma and Beylerbey, (built on the Asiatic shore of Istanbul) developed the rococo spirit of the eighteenth century. The latter mosque became the prototype for all nineteenth-century mosques.

A similar preponderance of curved forms and foreign motifs can be observed in every kind of building. Among the characteristic examples of Turkish baroque architecture are the complex of Minrishah (mother of Selim III) at Eyüp (composed of a mausoleum, a public kitchen, a

Koran school and a fountain); the public libraries such as the Koca Ragıp Pasha, the Murat Molla; the complexes of Hasan Pasha and Beşir Ağa and the *hans* of Simkeşhane and Hasan Pasha Han.

Pl. 102

Buildings continue to have all the essential characteristics of plans of the earlier periods, yet the approach to design expresses a lofty spirituality and curved elegance characteristic of rococo. Doorways, windows, niches and large eaves were decorated with rococo motifs. At this point, it is appropriate to make special mention of the public fountains of the eighteenth and nineteenth centuries. Fountains had been perennial elements of city life, yet their design had always been purely functional. By the eighteenth century, with the elegant life style of the court of Ahmet III, fountains started becoming more conspicuous elements of the cityscape. After the erection of the well-known monumental fountains of Ahmet III and Mahmut I, fountains such as the Sebil of Mehmet Emin Ağa, that of Nuru Osmaniye and of Abdul Hamit I in the eighteenth century proved to be very suitable public buildings for the new decorative style in which Turkish stonecarvers were playfully interpreting rococo motifs.[43] At the very end of the eighteenth century some exuberant decoration, reminiscent of French and Austrian rococo and even approaching the late rocaille style of Louis XV, can be found, especially in the harem of the Topkapı Palace.

Pl. 103

The new fashion for large private mansions and palaces was inaugurated by the numerous pleasure buildings constructed at the time of Ahmet III. A single example, partly altered at the end of the century, was the summer pavilion of Ahmet III (called Aynalıkavak) on the Golden Horn. In the palace of Topkapı, the kiosk called the Sofa Köşkü (1752) may be regarded as the most characteristic example of the association of classical Turkish and rococo spirits. The plan of these large mansions and palaces synthesized traditional and new elements, creating a new style that prevailed until the end of the Ottoman period. Large oval central halls, prominent staircases and symmetrical placement indicate Western influence. The well-known engravings of Melling, the architect employed by Selim III's sister, Hatice Sultan, illustrate the impressive architecture of the capital at the beginning of the nineteenth century.

From a cultural point of view, it may be said that the gradual Westernization of Turkey, which was first seen in the physical environment, originated in the radical change in decoration. This was followed by the introduction of European buildings at the end of the eighteenth century — starting with military barracks where the imitation was obvious.

At the beginning of the nineteenth century, the elegant Mosque of Selimiye at Üsküdar, constructed at the same time as the huge barracks of the recently founded modern army units of Selim III, was marked by both the rococo spirit and the emerging influence of the French empire style.

Baroque in its major lines but with empire details, the Nusretiye Mosque of Mahmut II (1822–6) sharply contrasts with traditional mosque designs. It no longer has a courtyard; instead, a palace-like façade of two storeys, consisting of the sultan's apartments and other rooms, was added to the entrance. All the nineteenth-century mosques, such as the Mosque of Bezmialem Sultan (1853) and the Ortaköy Mosque (1871), exhibit strong neo-baroque influences.

European eclecticism was characteristic of Ottoman architecture after the second half of the nineteenth century. One mosque might be baroque in style; another was a mixture of neo-gothic and Islamic motifs, such as the Valide Mosque in Istanbul. Nineteenth-century mausolea show the same miscellany of style: the Turbeh of Nakşıdil Sultan has a baroque façade; the Mausoleum of Mahmut II is of sober empire design, and the Mausoleum of Grand Vizier Fuat Pasha is a curious interpretation of the neo-Muslim style.

Pl. 104

With the re-organization of the Ottoman Empire, buildings of monumental dimensions unknown until then (mostly neo-baroque and neo-classical in style) crowded the old capital and other large cities of the empire. New military foundations, schools, ministeries, stations, industrial buildings and new palaces of the sultans, new row houses and apartment houses of the rising middle class and, in time, large banks and office buildings represented the Westernized façade of the Ottoman Empire.

The colossal neo-classical and neo-baroque barracks of Selim III, the Selimiye at Üsküdar, the Kuleli on the Bosphorus and those built by Sultan Abdul Aziz still dominate the silhouette of Istanbul.

The palace of Dolmabahçe, built on the site of the empire-style palace of Mahmut II, the palace of Beylerbey and the Çırağan are eminent examples of international eclecticism. The first university was a colossal neo-Greek building. The Archaeological Museum represents geometrical neo-classicism. All this large-scale building activity expresses the increasing influence of Western culture. The architects of these great buildings were foreigners or architects from the ethnic minorities who had European training. Sultan Abdul Hamit (1876–1909) had a keen interest in foreign architects, and during his reign the well-known Italian art-nouveau architect Raimondo d'Aronco built a number of very interesting buildings, e.g. some of the buildings of the Palace of Yıldız, the Italian Embassy on the Bosphorus, the interesting complex of Şeyn Zafir (1905–6) and several private apartments and houses.

The architecture of the Ottoman Empire ended with a return to traditional forms at the hands of European-trained Turkish architects, imbued with nascent nationalism. The most important name among those who were replacing the foreign and minority architects was Kemalettin, a designer of many important buildings, among which was the large office building Dördüncü Vakıf Hanı, designed before the First World War.[44]

The Turkish House

During the turmoil that sealed the fate of the Ottoman Empire, the cities of Anatolia and other distant parts of the empire did not greatly change their traditional ways of building. Vernacular architecture in particular kept its

Fig. 78
Turkish houses

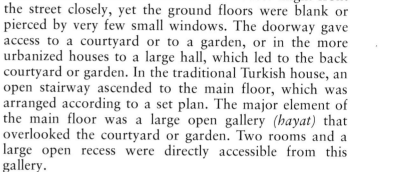

typical plans

two examples of plans

The structure of Turkish cities of the Ottoman period was closely related to the early settlements of Turkoman nomads and to the simple requirements of an agricultural economy. The formal aspects of the residential quarters were a direct reflection of the requirements of family life: the exclusion of women from public life, their existence within the walls of a single house; the various domestic chores performed by women and the size of the extended paternal family necessitated the organization of the house around open interior spaces, carefully enclosed and kept hidden from the outside world. The houses might front the street closely, yet the ground floors were blank or pierced by very few small windows. The doorway gave access to a courtyard or to a garden, or in the more urbanized houses to a large hall, which led to the back courtyard or garden. In the traditional Turkish house, an open stairway ascended to the main floor, which was arranged according to a set plan. The major element of the main floor was a large open gallery *(hayat)* that overlooked the courtyard or garden. Two rooms and a large open recess were directly accessible from this gallery.

Many types of house plans were devised by varying this basic plan. The rooms, or one of the rooms, were placed Fig. 78 with a commanding view over the street and therefore generally projected over the ground floor. From here (concealed by wooden lattice-work screens) women could observe activities on the street. The traditional Turkish house created a wholly functional organization; formal symmetry was not one of its characteristics. The rooms were multi-purpose; anyone of them could be converted into sleeping quarters. Consequently cupboards served an important function: in the daytime bedclothes were put away in them, and the rooms were used for day-to-day home activities. These rooms had built-in divans, fireplaces and small wall niches. Very little movable furniture was required. The fireplaces, the cupboards and the ceilings were decorated with carving.

All the service areas, including those necessitated by a nearly rural life, were placed on the ground floor, the plan of which, therefore, was dictated by purely functional necessities in addition to those due to considerations based on plot or site. These traditional Turkish houses were not symbols of wealth or power, and they rarely had more than two storeys. Since they were built of timber, their plastic character was of a geometrical nature. Their arrangement, size and decoration were always austere. Even more than the great imperial mosques, Turkish houses—the outcome of a long evolution that took place under historical circumstances peculiar to Anatolia and to the Ottoman culture—speak of the social and economical character of traditional Turkish society and of the functional and vigourous aesthetics of Turkish culture as defined by the people themselves.

physiognomy until the First World War. Thus the Turkish house as it appeared from the eighteenth century onwards[45] can be studied and described.

In the Ottoman Empire, which encompassed many countries around the Mediterranean Sea and in the Balkans, several regional cultures with their own traditional materials and building forms lived side by side. However in Anatolia and in the Balkans, the Turkish period saw the birth of a type of house that does not exist in any other Muslim country. It has a tradition of great originality that will be described here.

NOTES

¹ The period before the conquest of Constantinople: 1300–1453.

² *Ulu Cami* means Great Mosque: it is the congregational mosque where the Friday's *Khutbah* address (containing an acknowledgment of the sovereignty of the reigning prince) is given; in lands dominated by the Turks, the Great Mosque is generally a multi-pillared type of hall.

³ A. Arel, 'Batı Anadoluda Birkaç yapının tarihlendirilmesi ve XV. Yüzyıl Osmanlı Mimarisi Hakkında' in *Anadolu Sanatı Araştırmaları* II (Istanbul, 1970): 82–96.

⁴ K. Otto-Dorn, *Die Islamische Iznik*, Berlin, 1941, pp. 20–33.

⁵ S. Eyice, 'İlk Osmanlı Devrinin Dinî-İçtimai bir Müessesesi: Zâviyeler ve Zaviyeli-Camiler' in *İktisat Fakültesi Mecmuası* 23, nos. 1–2 (Istanbul, 1963): 1–80; Ahmet Doğan, *Osmanlı Mimarisinde Tarikat Yapıları, Tekkeler, Zaviyeler ve benzer nitelikteki Fütüvvet Yapıları*, Istanbul, 1977.

⁶ O. Aslanapa, 'İznikte Sultan Orhan Camii Kazısı' in *Sanat Tarihi Araştırmaları* I (Istanbul, 1967).

⁷ A. Gabriel, 'Bursada Murad I Camii ve Osmanlı Mimarisinin Menşei Meselesi' in *Vakıflar Dergisi* 2 (Ankara, 1942): 37–43.

⁸ A. Gabriel, *Une capitale turque: Brousse (Bursa)*, vol. I, Paris, 1958, pp. 51–60, 65–77; E. H. Ayverdi, *Osmanlı Mimarisinin İlk Devri (1230–1402)*, Istanbul, 1966, pp. 231–64, 419–40, 447–60.

⁹ Ayverdi, *Osmanlı*, pp. 320–28.

¹⁰ Gabriel, *Brousse*, pp. 60–2, 116–18; Ayverdi, *Osmanlı*, pp. 290–3.

¹¹ Ibn Battuta, *The Travels of Ibn Battuta* (trans. by H. A. R. Gibb), vol. 2, The Hakluyt Society, Cambridge, 1962, p. 450.

¹² For Orhan's Bath see: Ayverdi, *Osmanlı*, pp. 111–16; for Turkish baths in general: H. Glück, *Die Bäder von Konstantinopel: Probleme des Wölbungsbaues*, Part I, Vienna, 1921; K. Klinghardt, *Türkische Bäder*, Stuttgart, 1927; K. A. Aru, *Türk Hamamları Etüdü*, Istanbul, 1949.

¹³ Otto-Dorn, *Iznik*, pp. 95–100.

¹⁴ Gabriel, *Brousse*, pp. 191–3; Ayverdi, *Osmanlı*, pp. 469–71.

¹⁵ A. Gabriel, *Les Monuments turcs d'Anatolie*, vol. II, Paris, 1934, pp. 25–31; E. H. Ayverdi, *Osmanlı Mimarisinde Çelebi ve II. Sultan Murad Devri*, Istanbul, 1972, pp. 4–25.

¹⁶ Gabriel, *Monuments*, vol. II, pp. 51–3; Ayverdi, *Çelebi ve II. Sultan Murad*, pp. 26–33.

¹⁷ Gabriel, *Brousse*, pp. 79–104; Ayverdi, *Çelebi ve II. Sultan Murad*, pp. 46–94; for ceramics see: K. Otto-Dorn, *Türkische Keramik*, Ankara, 1957, pp. 61 ff.

¹⁸ R. Anhegger, 'Beiträge zur frühosmanischen Baugeschichte, II: Moscheen vom Bautyp der Üç Şerefeli Cami in Edirne' in *Istanbuler Mitteilungen* 8 (Istanbul, 1958): 40–56; A. Kuran, *The Mosque in Early Ottoman Architecture*, Chicago, 1968, pp. 177–81; Ayverdi, *Çelebi ve II. Sultan Murad*, pp. 422–61.

¹⁹ F. Babinger, *Mehmed der Eroberer und seine Zeit*, Munich, 1955.

²⁰ The literature on the first Fatih Mosque is copious. The most detailed analysis of the building and its complex is to be found in E. H. Ayverdi, *Fatih Devri Mimarisi*, Istanbul, 1953.

²¹ C. Gurlitt, 'Die Bauten Adrianopels' in *Orientalisches Archiv*, vol. I (Leipzig, 1910–11): 54 ff.; O. Aslanapa, *Edirne'de Osmanlı Devri Abideleri*, Istanbul, 1949, pp. 62–82.

²² Gabriel, *Monuments*, vol. II, pp. 33–41.

²³ For works on Sinan see: E. Egli, *Sinan, der Baumeister osmanischer Glanzzeit*, Zurich, 1954; Ahmet Refik Altınay, *Mimar Sinan*, Istanbul, 1931; İ. H. Konyalı, *Mimar Koca Sinan*, Istanbul, 1948; R. M. Meriç, *Mimar Sinan, Hayatı, Eseri, Eserlerine Dair Metinler*, Ankara, 1965; D. Kuban, 'Mimar Sinan ve Türk Mimarisinin Klasik Çağı' in *Mimarlık* 40 (Istanbul, 1967): 13–34.

²⁴ For the complex of Şehzade see: C. Gurlitt, *Die Baukunst Konstantinopels*, vol. I, Berlin, 1912, pp. 68 ff.; Anon., *İstanbul Abideleri*, Istanbul, 1940, pp. 113 ff.

²⁵ On the Suleymaniye complex: Gurlitt, *Konstantinopels*, pp. 69 ff.; Anon., *Istanbul*, pp. 109 ff.; Egli, *Sinan*, pp. 77 ff.; S. Eyice, *Istanbul: Petit Guide à travers les monuments byzantins et turcs*, Istanbul, 1955, pp. 49–52.

²⁶ On the *wakf* institution: H. B. Kunter, 'Türk Vakıfları üzerine mücmel bir etüd' in *Vakıflar Dergisi,* I (Ankara, 1938): 103–29; F. Köprülü, 'Vakıf Müessesesinin Hukuki Mahiyeti ve Tarihi Tekamülü' in *Vakıflar Dergisi,* II (Ankara, 1942): 1–35 [with bibliography].

²⁷ For spatial conception and its development in the Mosques of Beyazıt and Şehzade see: D. Kuban, *Osmanlı Dinî Mimarisinde İç Mekân Teşekkülü*, Istanbul, 1958, p. 39; for Beyazıt Mosque: Gurlitt, *Konstantinopels*, p. 64; Anon., *Istanbul*, pp. 21 ff; for Şehzade Mosque: Egli, *Sinan*, pp. 63 ff.

²⁸ Kuban, *Osmanlı Dinî Mimarisinde*, pp. 32–6; for the construction of the Suleymaniye: Ö. L. Barkan, *Süleymaniye Camii ve İmaret İnşaatı*, vol. I, Ankara, 1972.

²⁹ D. Kuban, 'Les Mosques à coupole à base hexagonale' in *Beiträge zur Kunstgeschichte Asiens: In Memoriam Ernst Diez*, Istanbul, 1963, pp. 35–47; S. Batur, 'Osmanlı Camilerinde Sekizgen Ayak Sisteminin Gelişmesi Üzerine' in *Anadolu Sanatı Araştırmaları* I (Istanbul, 1968): 139–66.

³⁰ Gurlitt, *Konstantinopels*, p. 80; Anon., *Istanbul*, p. 68; Kuban, *Osmanlı, Dinî Mimarisinde*, pp. 44 ff.

³¹ D. Kuban, 'An Ottoman Building Complex of the Sixteenth Century: The Sokollu Mosque and its Dependencies in Istanbul' in *Ars Orientalis* VII (Ann Arbor, 1968): 19–39.

³² W. Denny, 'Ceramic Revetments of the Mosque of Rüstem Pasha' in *5th International Congress of Turkish Art (1975)*, Budapest, 1979, pp. 269–90.

³³ D. Kuban, 'Selimiye in Edirne: Its Genesis and an Evaluation of its Style' in *IV. Congrès international d'Art turc* (Université de Provence, Aix-en-Provence, 1976): 105–9.

³⁴ Z. Nayır, *Osmanlı Mimarlığında Sultan Ahmet Külliyesi ve Sonrası*, Istanbul, 1975, pp. 135–68.

³⁵ Nayır, *Osmanlı*, pp. 35–133.

³⁶ The Tulip period *(Lâle Devri)* is the period of Ahmet III (1703–30). See the chapter 'Turkish Miniature Painting' for more details.

³⁷ Nayır, *Osmanlı*, pp. 169–94.

³⁸ F. Akozan, 'Türk Han ve Kervansarayları' in *Türk Sanatı Tarihi Araştırma ve İncelemeleri*, I (Istanbul, 1963): 133–67; see also Nayır, *Osmanlı*, pp. 227 f.

³⁹ Nayır, *Osmanlı*, pp. 232–6.

⁴⁰ S. Emler, 'Topkapı Sarayı Restorasyon Çalıçmaları' in *Türk Sanatı Tarihi Araştırma ve İncelemeleri*, I (Istanbul, 1963): 211–312; H. E. Eldem, *Topkapı Sarayı*, Istanbul, 1931; N. M. Penzer, *The Harem: An Account of the Institution as It Existed in the Palace of the Turkish Sultans, with a History of the Grand Seraglio from its Foundation to the Present Time*, London, 1936; F. Davis, *The Palace of Topkapı in Istanbul*, New York, 1970.

⁴¹ For information on the baroque period see: D. Kuban, *Osmanlı Barok Mimarisi Hakkında Bir Deneme*, Istanbul, 1954; A. Arel, *Onsekizinci Yüzyıl İstanbul Mimarisinde Batılılaşma Süreci*, Istanbul, 1975.

⁴² Ahmet Efendi, *Tarih-i Cami-i Şerifi Nuruosmaniye*, Istanbul, 1922; Kuban, *Osmanlı Barok Mimarisi*, pp. 27 ff.

⁴³ For further information on the fountains of Istanbul: I. H. Tanışık, *İstanbul Çeşmeleri*, 2 vols., Istanbul, 1954.

⁴⁴ S. Cetintaş, 'Mimar Kemalettin Mesleği ve Ülküsü' in *Güzel Sanatlar Mecmuası* 5 (Istanbul, 1940): 160–73.

⁴⁵ The bibliography on the Turkish house is extensive. For books and articles published up to 1973 see: A. Ödekan, *Türkiyede 50 Yılda Yayınlanmış Arkeoloji, Sanat Tarihi ve Mimarlık Tarihi ile ilgili Yayınlar Bibliyografyası*, Istanbul, 1974, pp. 360–7; see also: S. H. Eldem, *Köşkler ve Kasırlar*, 2 vols., Istanbul, 1969; 1973; idem, *Saadabad*, Istanbul, 1977.

Architectural Decoration and the Minor Arts

by Gönül Öney

Architectural decoration and the minor arts in Turkish Anatolia are extremely innovative, producing novelties and developments in Islamic art by experimenting with new materials and techniques in stonework, figural carving and reliefs, faience, woodcarving, carpets and fabrics.

Anatolian Turkish architectural decoration and the minor arts present a unique synthesis, combining the characteristics of Turkish art in central Asia with both the contemporary and earlier Islamic art of Iran, Iraq and Syria and with the legacies of Byzantine and Armenian art in Anatolia. Remnants of earlier civilizations (antique material) were re-used occasionally; nevertheless, Anatolian Turkish art always retained its own special, distinctive character and continued to develop and flourish through experiment and innovation.

The Seljuk period was the first phase of Anatolian Turkish art—an era of distinguished artistic development. A turning point in this art was reached in the fourteenth century with the disintegration of the Seljuk state into independent emirates that were formed by different Turkish tribes. Due to incessant fighting among the various tribes, the period of the Turkish emirates produced comparatively few works of minor art, which were often less ostentatious than their Seljuk counterparts. Thus, at first glance, the period of the Turkish emirates appears to be one of stagnation after the brilliant Seljuk era; however, the search by the artisans and craftsmen of the competing emirates for new forms of artistic expression provided a basis that eventually led, from the fifteenth century onwards, to the glorious developments in architecture, architectural decoration and the minor arts of the Ottoman period.

There was a resurgence of Turkish Anatolian art during the sixteenth and seventeenth centuries, when the Ottoman Empire consolidated its power and attained economic strength. During this period, a classic Anatolian style was developed, the impact of which was felt throughout the conquered lands of the Ottoman Empire from Hungary to Egypt.

During the 'Westernization period' in the eighteenth and nineteenth centuries, an oriental style— basically Anatolian—emerged, yielding numerous interesting examples in both architectural decoration and the minor arts.

Stone Carving

Stone was the main construction material in Anatolian Turkish architecture. In the Seljuk period, stone workmanship had reached a peak with fine stone carving decorating the portals, mihrabs, minbars, consoles, arches, iwans, window frames, lintels, vaults and capitals.[1] Stone was the dominating element in Anatolian Seljuk works and largely replaced brickwork, which was used so extensively in Iranian Seljuk architecture. Carved-stone decoration in the form of figural and ornamental compositions appeared on both religious and semi-religious works such as mosques, masjids, madrasahs, mausolea (turbehs), tombstones and secular works such as caravanserais. There is remarkable harmony in style and form throughout Anatolia, with no appreciable regional differences. It should, however, be noted that stonework in Divriği, Sivas and Erzurum displays bolder motifs in high relief, while buildings in the Konya and Kayseri regions are decorated in low relief with fine decoration, reminiscent of embroidery. Thirteenth-century Seljuk tombstones—especially those of Ahlat, Konya, Akşehir, Sivas and Tokat—display very interesting relief work.[2]

The thirteenth century marked a distinct move towards more complex and intricate stonework decoration, embroidery-like low relief being especially common during the first half of the century. The main characteristics of such decoration were dense geometric interlace, angular motifs and Kufic inscriptions, together with large rosettes within the spandrels of the niche arches and stalactites hanging from the niche's ceiling. During the second half of the thirteenth century, decorative carving became more plastic and baroque in character with large, seemingly inflated palmettes and semi-palmettes, lotuses and arabesques over dense foliate backgrounds. Naskhi and Kufic inscriptions were used as borders to frame these richly embroidered ornaments; different motifs and compositions seemed to be superimposed on each other. Towards the end of the thirteenth century, foliate decoration gradually became the dominating factor in stone relief. This development can be followed in various buildings such as the İnce Minareli Madrasah (1260–5), the Karatay Madrasah (1251) and the Sahib-ata Mosque (1258) in Konya, the Eşrefoğlu Mosque in Beyşehir

Pl. 108 (1298), the Çifte Minareli Madrasah in Erzurum (end of the thirteenth century) and the *bimarhane* (lunatic asylum) in Amasya (1308–9).[3]

Pls. 67, 68, 105-107 There are, however, exceptions to this general trend. Of special interest are the portals of the Ulu Cami and the Dar-üş-Şifa of Divriği (1228–9), where the extremely baroque character of the stone reliefs is even more marked than on those dating from the end of the century. Thus they may be regarded as prodigious works of their period.

Pls. 51, 61 The majority of the mihrabs of the Seljuk period in Anatolia were made of cut stone.[4] Mihrabs of faience mosaic constitute the second noteworthy group. In some cases, such as the Ulu Cami of Silvan (Meyyafarkin, 1152–7), there is more than one mihrab. This is a characteristic of Seljuk works in east and south-east Anatolia.

The mihrabs from the Seljuk period were decorated in the same manner as the portals of that period, with identical ornamental motifs and foliate compositions framed by borders of inscriptions that adorned the portal-like recesses. The half-dome of the niche was usually crowned with stalactites.

The decorative stone carving of the Anatolian Seljuks can best be described as an independent decorative art based on Seljuk architectural decoration in Iran, yet achieving its own character in a different medium, i.e. in stone instead of brickwork and stucco.[5] Despite variations in details, there is remarkable discipline and conformity in the system and style of decoration; the same iconographical programme was repeated; only the compositions varied. In spite of this basic uniformity, innovative differences provided subtle changes and eliminated Pl. 66 the danger of monotony and dullness. A caravanserai, for example, with two portals (an inner and an outer one) never has identical designs on both façades.

While foliate compositions, geometric patterns and inscriptions were used abundantly, figural motifs were rare. In foliate compositions, trefoil palmettes were the motifs most frequently used; sometimes they were shown as semi-palmettes against a background of floriated interlace and dense arabesque compositions. Borders of lotus-like foliated patterns and acanthus leaves, deriving from Pl. 52 those found on re-used Byzantine capitals, can also be seen. Large compositions in high relief, resembling foliate Pls. 105-107 relief sculpture and bearing themes from the tree-of-life myth, adorn the portals of the Ulu Cami in Divriği, the Pl. 60 İnce Minareli Madrasah in Konya, the Çifte Minareli Pl. 108 Madrasah in Erzurum and the *bimarhane* of Amasya.

Other decorative elements were chain-like borders, geometric patterns and rosettes. A pair of large rosettes usually appeared on portals, one on each spandrel. These large rosettes were occasionally encircled by other smaller rosettes that were probably symbols of planets. The pair Pl. 70 of large rosettes they encircled depicted the sun and the moon. Until the middle of the thirteenth century, inscriptions appeared on tablets. Later they became part of decorative compositions in the form of interlace borders. In the earlier form, inscriptions were generally in Kufic and free from foliate motifs. Later they began to appear superimposed over an arabesque background, giving the impression of multi-layered ornamentation.

Stalactites, which normally appeared in the mihrab niche and on portals in Seljuk architecture, eventually became important decorative elements on consoles, arches, window lintels, cornices and capitals — the last being one of the most successful mediums of decorative stonework during the Seljuk period. It was also a common practice to re-use capitals taken from antique buildings with Pl. 52 Seljuk capitals and other elements of Seljuk stonework.[6]

As stated previously, decorative stonework in Anatolia has its roots in the brickwork, stucco and moulded terracotta decoration of the Great Seljuks of Iran. It should also be noted that the architectural decoration of the Artukids of south-east Anatolia bears some resemblance to Syrian Zengid and Ayyubid art. Under the Seljuks, the Artukids reigned in the Mardin-Diyarbakır area from 1101 to 1312. The Great Mosques in Diyarbakır (1091–1118), Silvan and Dunaysır (Kızıltepe) (1184 to 1204) are typical examples of their art.

With the period of the Turkish emirates, stone carving became much simpler;[7] however, traditional Seljuk decoration continued in east Anatolia and in the region of Karaman without any noteworthy change. In west Anatolia, the marble grill work, profiled moulding and close stalactite work in such mosques as the İsa Bey at Selçuk (Ephesus), the Firuz Bey at Milas and the İlyas Bey at Milet show a definite trend towards an Ottoman character. As the tiles from the same period show, the floral motifs contained realistically shaped leaves and flowers from the more stylized and richer decoration of the Seljuk period. Geometric interlace and less ornate but more realistic foliate patterns became the dominant features of stone carving in the period of the emirates. This trend towards plainness continued in a marked manner in the Ottoman period during the sixteenth and seventeenth centuries. Mouldings, hanging stalactites, cornices, and window and door friezes had limited decoration in the form of arabesques in shallow relief. Emphasis shifted to the architecture itself, with its more imposing but well-balanced dimensions, while stone and marble carving as decoration became supplementary, enhancing the unity and harmony of the architectural whole. Clever use was made of two-coloured stone and marble as decorative elements.

The eighteenth century marked a new era of intensive Westernization, and stone decoration was largely replaced by stucco in interior decoration. Baroque interlace and motifs of Western origin such as floral rosettes, bouquets, 'S' and 'C' scrolls and leaves appeared in moulded stucco. However, stone still retained its importance as the main building material and as an exterior decorative element with motifs similar to those found in stucco.

Figural Reliefs and Sculpture

There is a widely held, but quite erroneous, belief that the representation of figures is prohibited by the Koran and that as a result no figurative painting, relief or sculpture is to be found in Islamic art. Precepts issued in the ninth

century discouraged the representation of any living beings capable of movement, but it was not until the fifteenth century that the more rigid application of such precepts led to a decrease in the number of figurative paintings and reliefs. In fact, there was a remarkable development in figurative art between the eighth and the fourteenth centuries. Figural art is especially rich in stone and stucco reliefs of the Seljuk period, adorning both Pl. 119 secular and religious buildings and particularly palace tiles. The subjects included court nobility, servants and guards shown in palace scenes, astrological signs as well as various symbolic or legendary figures such as sphinxes, Pls. 109, sirens, dragons and double-headed eagles. These figural 111, 112 representations are proof that old central-Asian traditions and shamanistic religious beliefs survived. In Seljuk figural art, symbols of much complexity can often be interpreted in more than one way. Such figural representations rapidly disappeared from architectural decoration in the fourteenth century.

The human figures encountered in Seljuk architectural decoration in Anatolia were the sultan, high court officials and, in some cases, women connected with the palace. These figures have full cheeks, almond-shaped eyes, small mouths and long hair. They are usually shown sitting cross-legged, wearing a caftan and various types of headgear. Sometimes, they have a halo over their heads, and often they are shown holding a symbol of eternity and fertility such as the pomegranate, an astrological symbol such as the fish or a musical instrument. In some cases — the reliefs on the Cezire ibn Umar bridge (1164) — the figure is sitting beside a sign of the zodiac.

Occasionally, human heads occur in the form of rosettes representing the sun and the moon. The rosettes on Pl. 70 the portal of the Alaeddin Mosque in Niğde (1223) are typical.[8] The large numbers of various types of rosettes on Seljuk portals and mihrabs apparently represent the planets which, according to old central-Asian tradition and shamanistic religious beliefs, are symbols of the other world.

In Seljuk architecture, small human heads are sometimes scattered among arabesques decorating capitals and portals, for instance at the Karatay Caravanserai in Kay-Pl. 81 seri (1240) and the Hudavend Hatun Mausoleum in Niğde (1312).[9] These human heads, almost completely hidden in the decoration, apparently acted as charms or amulets.

Another common motif was a hunter on horseback holding a falcon on his wrist. Such figures are often found on tombstones at Konya, Kırşehir, Akşehir and Afyon and probably indicate that the deceased was a good hunter.[10]

Pl. 111 Lions were the most commonly used motifs in Anatolian Seljuk sculpture. Roughly cut but highly stylized sculptures of lions adorned and guarded Seljuk castles like the ones at Kayseri (1224), Konya (1220), Diyarbakır (1208–9) and Divriği (1236–42) and palaces like the ones at Konya (thirteenth century), caravanserais like the Sultan Han at Kayseri (1232–6), the Ak Han and the Çardak Han at Denizli (1253/1230) and the Alara Han at Alanya (1229–32), as well as other buildings.[11] Far from looking wild and fierce, Seljuk lions look comical with small heads, large almond-shaped eyes, fat cheeks and large flat noses that seem to link the eyebrows. Lions are also often found in reliefs or as water spouts. They are sometimes depicted with wings or with a tail that ends in a dragon's head, and often they are set in symmetrical pairs facing each other. They appear in combat scenes with bulls who were representative of the enemy and of darkness or are depicted together with the sun rosette as an emblem or as a sign of the zodiac.

The lion has always been the symbol of strength, and representations of lions have been used in palaces, castles and on city walls to give protection against enemies and evil spirits. Apart from this obvious characteristic attributed to the lion, it was believed that water from a lion's mouth was health-giving and could be used for ablutions. This gave rise to the common practice of carving water spouts in the form of lion's heads. The lions on tombstones are symbols of spirits who, according to shamanistic beliefs, guide the souls of the dead on their journey to Heaven.

Single and double-headed eagles constitute another Pl. 112 widespread motif in Anatolian Seljuk art.[12] The eagles are usually set in symmetrical pairs. They are seen on fortresses, palaces, mosques and tombstones. Double-headed eagles often have pointed ears, curved beaks and large wings with a crescent placed between the body and the tail. The eagle motif can be traced to shamanistic beliefs and the traditions of central Asia where the eagle was regarded as a holy bird, a protective spirit, the guardian of Heaven and a symbol of might and power. The eagle was also believed to be a symbol of potency and fertility. Barren women prayed to the eagle to acquire fertility. Thus, the eagle motifs seen on mosques, fortresses, palaces and caravanserais may be regarded as charms, protective powers, symbols of strength or totems. It appears that eagles were also used in the design of coats of arms for the sultan, as testified by a relief from the Konya fortress (now in the İnce Minareli Madrasah Museum) where *Es Sultan* is written between a pair of eagles.

Eagles on tombstones and mausolea, however, display Pl. 58 a different sort of symbolism: according to the shamanistic beliefs of the central-Asian tribes, the souls of the dead rose up to Heaven in the form of birds.[13]

The tree-of-life motif is yet another significant ornamental element in Anatolian Seljuk architecture.[14] Sometimes, the tree is surmounted by an eagle (in the Çifte Minareli Madrasah at Erzurum or the Döner Kümbet at Pl. 58 Kayseri, end of the thirteenth century), while in other examples, like the Gök Madrasah at Sivas (1271), small Pl. 69 birds sit on the branches. The tree-of-life motif sometimes appears in conjunction with a pair of lions or dragons, for instance in the Çifte Minareli Madrasah and the Yakutiye Madrasah (1310) at Erzurum. The tree of life is also shown in the form of a stem or as a part of the arabesques forming the background behind double-headed eagles and lions.

According to shamanistic beliefs, the tree of life is the centre of the world and serves as a ladder leading either to Heaven or to the bottom of the earth. The eagle on the tree is the bird accompanying the shaman in his celestial

172

travels. It may also symbolize the eagle of Heaven or even the shaman himself.

Pomegranates on the branches of the tree of life are symbols of paradise while, according to Islamic beliefs, the birds are birds of paradise. In the earlier shamanistic cult, the birds were regarded as the souls of the shamans. The rosettes around or on top of the tree of life probably symbolize the planets.

Dragons were a common motif in Chinese art. They appear in Seljuk art in a different style and with another symbolic significance.[15] Dragons are frequently shown in pairs, and often form the tails of lions or sphinxes or the end of eagles' wings. Dragons also appear together with human heads or bulls or in tree-of-life compositions. A typical feature of Seljuk dragons is the exaggerated length of their bodies, usually shown in knotted form, the dragons being presented in pairs with a head at each end. They have pointed ears, large eyes, open mouths, protruding chins extending in a helical twist, pointed teeth and forked tongues. According to ancient central-Asian beliefs, the harmonious motion of the heavens depended on a pair of dragons of opposite sexes bound under the seven planets. Thus the dragon may be regarded as a symbol of motion, harmony and order. The dragon is also regarded as a symbol of fertility as in China.[16]

Anatolian Seljuk dragons are found in secular and religious works. They are particularly dominant in fortresses (Konya, *c.* 1220), caravanserais (Karatay Han, 1240 and Sultan Han, 1232–6, at Kayseri), and palaces (Kubadabad and Alaeddin Palaces, *c.* 1236). Dragons also appear on tombstones, such as those in Ahlat.

Pairs of dragons, alone or together with planets and signs of the zodiac, may also represent the fight against darkness and evil. Thus it follows that they were possibly used on buildings such as caravanserais (*hans*) and palaces as talismans to prevent the entry of the enemy or of sickness. The lions under the tree of life, as seen in the Çifte Minareli Madrasah at Erzurum, may well represent guardians protecting the tree of life.

Among Anatolian Seljuk figural reliefs, the angels, sirens, sphinxes and harpies constitute a rare but interesting group that can be seen at the Konya fortress and in palaces. They all have long hair and a crown on their heads.[17] The wings and tails of sphinxes and harpies usually end in spirals. These magical creatures, too, were believed to be endowed with supernatural powers enabling them to protect the palace or the fortress from all sorts of evil.

In the rich figural world of the Anatolian Seljuks, various birds, peacocks, bulls, fish, unicorns and all kinds of hunting animals are also encountered.[18] Since the purpose of this treatise is to give an overall view, we cannot go into details; however, as the short explanation above indicates, the figural art of the Seljuks is very rich and complex. Sometimes the multi-purpose symbolism had its roots in the quasi-magical world of central-Asian shamanism adapted to Islam. It is interesting to note that the effects of the shaman cult persisted for a long time after the adoption of Islam by the Turks. The Mongol raids, which brought a fresh wave of central-Asian spirit and tradition to Anatolia, undoubtedly played a signifi-

Pl. 110

cf. Pls. 117, 118

Pls. 110, 112

cant role in regenerating some of the ancient customs, traditions and beliefs and in incorporating them into the world of Islam.

The Museum of the İnce Minareli Madrasah at Konya and the Museum of Turkish and Islamic Art in Istanbul Pl. 109 have a rich collection of figural reliefs and lion sculptures from the Seljuk period.

Stucco Decoration and Mural Painting

Stucco, one of the basic decorative elements of early Islamic (mainly Iranian Seljuk) architecture, is rarely seen in Anatolian Seljuk architecture. The most interesting stuccoes appear in palace decoration, and the greatest number are to be found in the Kubadabad Palace near Beyşehir and the Alaeddin Palace at Konya, where human and animal figures in moulded stucco are presented in low relief.

Knowledge of Anatolian stucco was broadened considerably by the discovery of a fine stucco wall shelf during the excavations conducted in 1964 and 1965 at the site of Kubadabad Palace—the summer residence of the Seljuk Sultan Alaeddin Keykubad—on the shores of Lake Beyşehir (*c.* 1236).[19] This stucco shelf, currently displayed in the Karatay Museum at Konya, is decorated with geometrical interlace, rosettes and long-tailed peacocks. Another significant piece of work unearthed during the Kubadabad excavations is a stucco panel with a hunting scene. The haloed hunter on horseback, wearing a caftan, was probably a court personage. He is accompanied by an angel of luck at his rear and a greyhound alongside his mount. This panel, recovered intact and displaying fine workmanship in relief, is a fitting addition to the iconography of hunting scenes so richly represented by portrayals of game on tiles from the same palace.

Stucco reliefs from the Alaeddin and Felekabad Palaces at Konya, on display in the İnce Minareli Madrasah Museum at Konya and the Museum of Turkish and Islamic Art in Istanbul, are sufficiently similar to those from the Kubadabad Palace, in both technique and subject matter, to indicate that they are contemporary.[20]

Double-headed eagles, sirens, paired dragons, peacocks and lions, symbolic animals and hunting birds representing protective power and strength are among the motifs found on the stuccoes of the Konya palaces. Other panels from the same palaces depict various animals of the hunt such as the hare, fox, antelope, wolf and deer. Presented on a field of arabesques, these stylized animal figures are always shown in graceful motion.

The human figures on the panels symbolize court personages. Wearing caftans, these figures are shown sitting cross-legged or standing and sometimes holding a fish—an astrological symbol—reminiscent of similar figural representations in earlier Islamic art.

Apart from that found in palaces, stucco decoration is rarely encountered in Seljuk Anatolia. However, some stucco fragments belonging to the mihrab of the Ulu Cami in old Malatya (1247) and the Eşrefoğlu Suleyman Bey Hamam in Beyşehir (end of the thirteenth century)

have been discovered. The stucco mihrab friezes of the Sahib-ata Khanigah Madrasah at Konya (1279-80) give an idea of an intact mihrab with a stucco border. A unique and well-preserved mihrab with a stucco border is the one in faience mosaic in the Arslanhane Mosque (1289), Ankara.[21] These stuccoes exhibit a totally Iranian character and are unrelated to general trends in Anatolian art; however, the use of stucco together with tile mosaic is an Anatolian innovation.

Although stucco was used in a limited way during the Seljuk period, there was a remarkable revival of stucco decoration during the period of the emirates, between the fourteenth and fifteenth centuries. Stucco mihrabs from small masjids, especially those from Konya, Ankara, Kastamonu und Sivrihisar (fourteenth to fifteenth centuries) are decorated with moulded geometrical interlace in low relief, rosettes and stylized plant motifs. Sometimes, glazed ceramic plates or bowls in various shades of blue ('Milet' ware) are embedded in plaster, e.g. in the Örtmeli Masjid in Ankara.

Stucco mantels or shelves became fashionable in buildings in the period of the emirates, as can be seen in the Yeşil (Green) Mosque in Bursa (1421). The technique used represents a continuation of Seljuk-period stucco with moulded low reliefs; however, the designs, with their flower-and-leaf motifs and arabesques, have a more realistic touch.

In classical Ottoman architecture, stucco is a rare decorative element. In the eighteenth century, during a period of intensive Westernization, stucco became fashionable again. Arranged in 'S' and 'C' scrolls, profiles, floral rosettes displaying Western influence, bouquets, leaves and characteristically baroque interlace are formed in stucco and heavily painted. In many mosques and masjids from this period, there are also stucco mihrabs with unusually elaborate and rich decoration. The Cihanoğlu Mosque in Aydın (1834) displays typical examples of such overdone and crude ornamentation. Stucco was also used in residences (köşks) and houses.

Fresco-like paintings constitute a relatively less well-known aspect of Seljuk architectural decoration. Rendered as wall paintings with geometrical and foliated motifs, such decoration covered domes, vaults, arches, supports and walls. Paintings were either made directly on the wall surface or on mortar. All examples are in very poor condition, and their contents are hardly discernible. Such frescoes are found in the Alaeddin Mosque at Konya (c. 1220), in the masjid of the Kızılören Caravanserai on the Konya-Beyşehir road (1206), in the Emir Yavtaş Turbeh at Akşehir (c. 1236) and the Boğatay Aka Turbeh at Ahlat (1281).

In the architecture of the period of the emirates and the early Ottoman period of the fourteenth to fifteenth centuries, frescoes composed of plant forms and inscriptions began to appear on such parts as domes, vaults, arches, buttresses, etc. This trend was extended during the sixteenth and seventeenth centuries to cover all surfaces of buildings. The motifs—realistic leaves and flower compositions—display a development parallel to tile art. The dominant colours are black, blue, red, dark blue and brown.

The trend to Westernization of the eighteenth century inevitably affected frescoes and architectural painting.[22] The French style became especially fashionable. Baroque and rococo started to invade Ottoman architecture throughout the century, with Istanbul as the centre. Portrait and landscape painters were invited from Europe to work in Ottoman palaces, and their style influenced local painters. Landscapes, mostly representing the Istanbul area, as well as views of other towns and villages and pictures of mosques were painted directly on plaster and were usually encircled with baroque motifs. Murals in the harem of the Topkapı Palace and those in private residences (köşks) and houses from the eighteenth century must have been the earliest examples of this new decorative style. Naturalistic landscapes with birds, boats and streams in the Western-influenced three-dimensional style were painted chiefly in green, brown and blue. Human figures did not appear until the end of the nineteenth century. Vast landscapes, with great depth, and large panoramas of Istanbul, with numerous mosques, adorned walls and ceilings.

In the second half of the nineteenth century, preference shifted from landscapes to oil paintings of houses and other buildings. Animals, birds, hunting scenes and even human figures made these architecturally motivated paintings come alive.

This new style of painting spread rapidly from the capital throughout the Ottoman Empire during the reign of Selim III (1789-1807). Higher officials and wealthy people in the provinces followed the fashion in the capital and decorated their homes with similar paintings. This new type of decoration spread and included mosques, mausolea (turbehs), government offices and other public buildings. The great similarity to works found in Istanbul indicates that artists from Istanbul were commissioned at the start; landscapes showing Istanbul were especially popular. Subsequently, during the nineteenth century, local artists began to paint in a similar fashion, influenced by artists from Istanbul but at the same time managing to retain their own personal touch. This unique folk art covered the walls and ceilings of buildings. Sometimes, elongated panels appeared as friezes along the edge of ceilings. Of special interest in Istanbul are the paintings in the harem wing of the Topkapı Sarayı and in residences and houses, especially the waterfront residences (yalıs) along the Bosphorus. In Anatolia, mural paintings are found everywhere and sometimes in unexpected places (for instance at Datça, on the tip of a peninsula in southwest Anatolia).

Glazed-brick and Tile Decoration

Anatolia was the centre for tiles in the Islamic world of the thirteenth century. Glazed bricks and tiles were widely used in the decoration of mosques, masjids, madrasahs, mausolea and palaces.[23]

Konya was the first important centre for tile manufacturing in Anatolia, and many fine specimens still adorn the Seljuk-period buildings there. Recent findings indicate that tiles were also manufactured in Kubadabad (near

Beyşehir), in Akşehir, Kayseri and Ahlat. The style and subject matter of Anatolian Seljuk tiles is remarkably uniform and consistent. It appears that one or two main centres were responsible for this overall style.

Before discussing tiles further, it is appropriate to dwell on glazed bricks, widely used by Anatolian Seljuks. Glazed bricks were used to decorate minarets, domes and mausolea during the Seljuk period. Employed mainly as exterior decorative elements, glazed bricks were ingeniously placed among unglazed red bricks, forming various geometrical patterns, rings and Kufic lettering. The use of glazed bricks on minarets is one of the most distinctive features of the Seljuk period. Rectangular, square or round glazed bricks adorned most minarets producing graceful designs. In contrast to glazed bricks, very few tiles appear to have been used on twelfth-century Seljuk minarets. Examples from the first half of the thirteenth century consist of turquoise-glazed tiles forming a very simple tile decoration.

At first, tiles were used only under the balcony *(sherefe)* of the minaret and in borders with Kufic inscriptions. From the middle of the thirteenth century onwards, tile decoration on minarets began to show a greater wealth of form, colour and design. Typical development in the tile decoration of minarets can be seen on the minaret of the İnce Minareli Madrasah (1264) in Konya, which is covered by turquoise and violet glazed bricks with tile mosaics under the balcony. The grooved minaret on the Gök Madrasah at Sivas (1271-2) is a noteworthy example of this new type of decoration.

Tile mosaics had a significant place in Seljuk architectural decoration. Developed mainly in Anatolia, tile mosaic, as the name implies, involves patterns formed by small tile fragments. Monochrome tiles are cut into small pieces and placed on a flat surface to form the desired pattern with their glazed sides down. Subsequently, mortar is applied to hold the pieces together. The tile pieces are tapered and moved slightly apart before the mortar is applied to secure a firm bond. The whitish mortar appears as jointing on the finished surface, creating a contrasting background for the turquoise, purple, dark blue or black of the tiles; turquoise was the most widely used colour. Since tile mosaics could be applied to curved surfaces with ease, they were used extensively to decorate domes, vaults, iwans, arches and mihrabs. The material was particularly well-suited to the rounded forms found in plant designs, arabesques, spirals, geometrical patterns and inscriptions in both Naskhi and Kufic script. Tile mosaics were used primarily as decorative elements in interiors, but they also appeared on minarets, mostly as mosaics made of glazed bricks.

Sometimes, an imitation-mosaic technique was also used. This was achieved by scraping off the glazed surface to form the desired patterns. Thus, the greyish white of the unglazed tile appeared as jointing around the glazed parts.

Mosaic tiling is used frequently in the decoration of mihrabs,[24] an Anatolian Seljuk innovation. Such mihrabs are in the form of a niche with stalactites. Geometrical patterns, plant designs and borders with inscriptions in Naskhi or Kufic lettering adorn them. Generally speaking, early mihrabs are more simple and have only geometrical patterns. However, in the second half of the thirteenth century, the ornamentation became richer because of the addition of arabesques, Naskhi inscriptions and double-layered decoration.

The mihrabs of the Ulu Cami in Akşehir (1213), the Sadrettin Konevi Mosque (1274), the Sahib-ata Mosque (1258), the Alaeddin Mosque (1220-37) in Konya and the Arslanhane Mosque in Ankara (1289-90) are some of the outstanding examples that display brilliant use of tile mosaics.

During the Seljuk period, brick was used skilfully in the construction of domes and transitions to domes. Brickwork, which in itself is decorative, was often embellished with glazed bricks and tile mosaics forming various geometrical patterns. The main colour used in glazed bricks was turquoise, although some were cobalt blue and eggplant violet. Tile mosaics were limited in use, appearing mostly at the centre of the dome, along the drum and in the pendentives forming the transition to the dome. The drum often contained a band of tile mosaic with motifs inspired by Kufic inscriptions. The dome of the Ulu Cami (1247) at Malatya, the Karatay Madrasah (1251), the İnce Minare Madrasah (1264) at Konya and the Taş Madrasah (1278) at Çay are typical examples.

Glazed monochrome tiles were used to cover broad surfaces in palaces and religious buildings, on walls, arches, colonnades, iwans, sarcophagi and the sides of mihrabs. Turquoise was again the preferred colour with black, dark blue, eggplant violet and green being used occasionally. The shapes of glazed monochrome tiles varied: square, rectangular or hexagonal tiles were the most common, but triangular and star-shaped ones also existed. Occasionally, gilt was applied to plain tiles, as in the Karatay Madrasah at Konya.

Tile facings on sarcophagi attain importance in Islamic art with the Anatolian Seljuks. Square or rectangular monochrome tiles in turquoise, dark blue or eggplant violet fully covered the sarcophagi. Sometimes, embossed tiles were used, as in the Turbeh of Kılıçarslan II at Konya. The embossed tiles usually had white lettering in relief on a cobalt-blue background. Tile mosaics were also used, as on the sarcophagi in the Mevlana Museum at Konya.

However, it is in palaces that the richest collection of Seljuk tiles is found. No palace of the Seljuk period has survived, but recent excavations have yielded stunning finds. The richest collection was found at the site of Kubadabad Palace on the shores of Lake Beyşehir.[25] Seljuk palace tiles are different from other Seljuk tiles in both shape and decorative approach, displaying a broad range of figural representation. These star-shaped tiles were applied to walls in a star-and-cross pattern. They were connected by cross tiles with arabesque decoration. Usually made in the underglaze technique, the star tiles contain an extremely rich figural design, depicting the sultan, the elite of the palace and animals of the hunt as well as imaginary or so-called 'fabulous' animals. (See figural reliefs and sculptures, p. 171.)

The sultan and the palace notables, including in some cases the palace women, are shown sitting cross-legged in

Pl. 60

Pl. 62

Pl. 116

Pl. 119

the Turkish tradition. In most cases, the figures hold in their hands a symbol representive of eternal life — a pomegranate or opium branch or an astrological symbol like the fish. It is interesting to note the parallels with the same motifs in Anatolian Seljuk architecture.

As the Kubadabad tiles indicate, perhaps the most interesting figures appearing on Seljuk palace tiles are the various animals related to hunting and the imaginary or magical animals. Various animals that can be categorized as game are shown in widely varying and highly artistic compositions. Sometimes, these figures are stylized; at other times, they are more naturalistic, but in all cases they are shown in graceful motion, running or jumping. Hunting dogs, panthers, foxes, wolves, hares, antelopes, wild mountain goats, wild asses, bears and horses present a colourful menagerie. Also included are various birds and ducks, depicted in remarkably clever and highly artistic compositions.

Among the representation on palace tiles from Kubadabad, the 'fabulous' animals have a special place. A magical world of imagination is reflected on the walls by Pls. 117, sphinxes, sirens, griffins, double dragons and double-118 headed eagles. These protective animals impart an out-of-this-world touch, making the palace seem like a corner of paradise. (See figural reliefs and sculpture, p. 172.)

While star tiles with underglaze decoration display such a great variety of figural representations in striking colours with beautiful contrasts, the cross tiles that serve as connecting pieces are quite uniform. Cross tiles with underglaze decoration have black arabesque designs under a transparent turquoise glaze.

Pl. 117 Examples of tiles with underglaze decoration can be found in all the palaces but lustre tiles are less common, having been found only at the Kubadabad (c. 1236) and Alaeddin Palaces at Konya (1156–92). Lustre tiles display the same figural repertory as the tiles with underglaze decoration, but their colour scheme is more limited. The star tiles are in brown and yellow, while the Pl. 119 cross tiles are violet. *Minai* tiles constitute the rarest group. They have been discovered only in the Alaeddin Palace at Konya and are in the form of stars, crosses, lozenges and triangles.[26] Seven different colours have been used on them, some applied in the underglaze, others in the overglaze technique. The glaze employed was usually transparent and colourless, or very rarely, turquoise or dark blue.

Compared to the preceding Seljuk and the following Ottoman periods, the tile art of the period of the emirates is rather modest. The Seljuk tradition was continued in various buildings at Karaman, Konya, Beyşehir and Ermenek. Konya may well have continued to be the centre of tile manufacturing throughout the period of the emirates, but tiles from Iznik and Bursa began to assert their place in Turkish tile production. During the period of the emirates, tiles were used sparingly and confined to the interiors of religious buildings.

Apart from a few exceptions, glazed brick decoration on minarets became more limited and much simpler during the period of the emirates. The minaret of the Ulu Camis at Birgi (1312) and Manisa (1376), the Yeşil Mosque at Iznik (1391) and the Yeşil İmaret (1441) at Tire constitute the exceptions and have relatively richer decoration. The dominant colours of the glazed bricks continued to be turquoise, eggplant violet and blue, but yellow and green began to appear too. The intricate patterns, bands of tile mosaics and inscriptions seen on Seljuk minarets began to disappear.

Although Konya lost its earlier importance during the period of the emirates, tile decoration in the old Seljuk tradition persisted. With the exception of the Eşrefoğlu Pl. 114 Mosque and Turbeh at Beyşehir (1297–9, 1301), there was a general tendency towards a simpler type of tile-mosaic decoration with greater emphasis on geometrical forms. Furthermore, a marked increase in the use of dark-blue tiles occurred in addition to the traditional turquoise and eggplant violet.

The only novelty introduced during the period of the emirates was the practice of embedding turquoise, dark blue and violet plates in stucco mihrabs of the fourteenth and fifteenth centuries, as can be seen in the Örtmeli and Molla Büyük Masjids in Ankara. Tiles are rarely found in the mausolea of the period of the emirates, and the use of tiles on sarcophagi became much more limited.

The Ottoman period was the high point of Turkish tile art. From the fifteenth to the eighteenth centuries, tiling developed as an important decorative element in Ottoman architecture. Tiles were used lavishly in diverse buildings such as mosques, masjids, madrasahs, mausolea, public kitchens *(imarets)*, baths *(hamams)*, palaces, pavilions, churches, libraries, residences and fountains. During the early days of the Ottomans, the political capital of the Turkish state moved from Konya to Bursa. At the same time, tile-manufacturing activities also moved to the Bursa area, and Iznik became the main centre, producing beautiful tiles and pottery of the highest quality from the fifteenth century to the seventeenth — making the word Iznik synonymous with the best in tiling and pottery throughout the world. During the same period, Kütahya gradually gained fame and importance as a secondary centre and proved to be more durable than Iznik, for production continues today.

During the fifteenth century, Bursa was probably the main centre for the production of tiles with polychrome glazing. However, some tile-manufacturing activities Pl. 121 eventually moved to Istanbul after its conquest in 1453. This was only natural, since the new capital was to be the main site of large-scale architectural projects; nevertheless, local centres like Iznik and Kütahya continued to flourish, supplying the capital and the other parts of the growing empire with quality products. It is also interesting to note that tiles closely resembling Iznik underglaze ware were manufactured in Diyarbakır during the sixteenth century. Future excavations may well lead to the discovery of other centres in Anatolia.

Although tile decoration was very rich on Ottoman-period buildings, tiling no longer appeared on domes and minarets, and far fewer tiles were employed on mihrabs. Instead, walls were often completely covered with tiling. Pl. 120 Tiles were also employed to decorate the frames and corners of arches, the inner faces of doors and windows, columns and occasionally the pendentives forming the

transitions to the dome. On walls, the tiles were placed as far up as the tops of the windows, forming panels of various colours and patterns, each panel being surrounded by a border of contrasting design and colour. Figural motifs practically disappeared, and floral designs became predominant.

The use of glazed monochrome tiles continued during the fifteenth century in early Ottoman architecture in a more extensive manner than during the preceding Seljuk period and the period of the emirates. Walls were fully covered by tiling up to the level of the top of the windows. The main colours employed were turquoise and green, with dark blue or violet tiles being used as supplementary colours. Various geometrical patterns were formed by hexagonal tiles, sometimes surrounded by triangular, square and rectangular border tiles. It was also common to find tiles with monochrome glazing and plant designs made from red earth; these were most probably manufactured in Iznik and Kütahya.

The Yeşil Mosques at Iznik and Bursa (1339 and 1421) and the Yeşil Turbeh (1421) and Murat II Mosque (1425) at Bursa are richly decorated with glazed monochrome tiles.

Pl. 121 Tile mosaics lost their earlier significance with the emergence of the Ottoman state. There are a few examples in fifteenth-century Ottoman art that continued the tradition of tile mosaics; however, these are easily distinguished from the Seljuk tile mosaics which have much bigger pieces of tile and form larger compositions. The colours of the tiles are also somewhat different; white, green and yellow were added to the traditional turquoise, blue, black and violet. Another feature was the lack of any space between the tile pieces for jointing with mortar.

Glazed coloured tiles in the *cuerda seca* technique decorate Ottoman buildings of the fifteenth to the middle of the sixteenth centuries. White, yellow, gilt and pistachio green began to appear along with the traditional turquoise, blue, eggplant violet and black. The contours of the tiles were in black or red. The use of unglazed surfaces together with glazed ones was yet another innovation. Tile mosaics were sometimes used side by side with *cuerda-seca* tiles in Bursa.

In the *cuerda-seca* technique, the design is applied either by means of a mould or by engraving. The tile is then fired; afterwards the glaze is applied and the tile is refired. In order to prevent the different-coloured glazes from mixing during firing, they are separated by a thin line of wax or by a mixture of wax and vegetable oil.

The floral motifs are more realistic than those of Seljuk design, and Sülüs (Thuluth) tended to replace Kufic lettering. This more advanced technique permitted much more intricate and close-textured compositions, sometimes in three layers. On some tiles from Bursa, coloured glazing has been applied over surfaces embossed by moulds. Glazed coloured tiles are found in fifteenth-century works at Bursa, of a slightly later date at Edirne and in Istanbul at the beginning of the sixteenth century. The place of manufacture of *cuerda-seca* tiles is the subject of dispute. Excavations in Iznik have not yielded any glazed coloured tiles. Most probably, the original place of manufacture was Bursa, where these tiles first appeared; however, similar tiles, used later at Edirne and eventually in Istanbul, must have been manufactured locally. Since these three cities have successively served as the citadel (capital) of the Ottoman state, it appears logical that the craftsmen moved from one town to the other when the capital shifted.

It should be noted that *cuerda-seca* tiles from Istanbul are simple and single-layered; there is overglazed red painting on some tiles. The Yeşil Mosque and Turbeh at Bursa (1421), the Mosque of Murat II at Edirne (1436), the Sultan Selim Mosque (1522) and the Çinili Köşk of the Topkapı Sarayı (1472) in Istanbul are adorned with fine specimens of *cuerda-seca* tiles. Pl. 121

A new type of high-quality tile introduced by Ottoman art is the blue-and-white tile. Manufactured in Iznik and Kütahya, it first appeared during the first half of the fifteenth century. Production of these quality tiles continued until the early sixteenth century.[27]

The designs are in various shades of blue and turquoise on a white background under a transparent glaze or in white on a dark-blue background. These tiles are reminiscent of fifteenth-century Ming porcelain and, in addition to peonies and other flowers, display a number of Far Eastern motifs such as the Chinese cloud and dragon. Their resemblance to porcelain is carried further as they are made of hard, white clay of fine quality. In a special group (erroneously believed to have been manufactured at the Golden Horn in Istanbul and thus known as Golden Horn ware) blue or black spiralling ivy with small leaves adorns the tiles.

Blue-and-white tiles are hexagonal (22.5 centimetres in diameter); rectangular tiles are used only in the borders. In early blue-and-white tiles, a lovely lilac colour sometimes appeared along with the more usual shades of blue. These tiles may be regarded as the forerunners of the Damascus-type ware manufactured later in Iznik, in which lilac was used more extensively. Fine quality blue-and-white tiles decorate the Mosque of Murat II at Edirne (1436), the Valide Mosque at Manisa (1522), the Şehzade Mustafa Turbeh (1474) and the Şehzade Mahmut Turbeh (1506) at Bursa.

On the exceptionally fine early sixteenth-century tiles in the Circumcision Room in the Topkapı Sarayı, Istanbul, lilac has been replaced by turquoise, and the same change appears on later tiles. Far Eastern influence is evident in this group in the Chinese cloud motifs, three-balls motifs and peonies.

During the seventeenth and eighteenth centuries, the blue-and-white tiles from Iznik and Kütahya gradually lost their old colour and radiance and turned pale. The beautiful blue colours became greyish, and the turquoise took on a faded appearance. The glazing was inferior and the contours were smudged. Designs too became uninteresting. A monotonous series of medallions or bouquets of flowers in vases was often repeated, as can be seen in certain parts of the Topkapı Sarayı, Istanbul.

By far the most common and best known Ottoman tiles are those with a polychrome underglazed decoration of up to seven colours. They were manufactured in Iznik from the middle of the sixteenth century to the end of the Pl. 120

105 North portal of the Ulu Cami (Great Mosque), Divriği, 1228–9: stone decoration. The style is reminiscent of the stucco work on the Gunbad-i Alaviyan at Hamadan in Iran, which is also from the (Iranian) Seljuk period.

106 Portal of the Dar-üş-Şifa (hospital) of the Ulu Cami, Divriği, 1228–9: stone decoration.

107 Portal of the Dar-üş-Şifa of the Ulu Cami, Divriği, 1228–9: stone decoration.

108 Portal of the *bimarhane* (lunatic asylum), Amasya, 1308–9: stone decoration.

109 Sphinx with long hair, hair ornament and necklace, fortress, Konya (?), *c.* 1220, H. 58 cm, L. 75 cm, W. 25 cm. Museum of Turkish and Islamic Art, Istanbul, inv. no. 2552.

110 Angel (one of a pair) with a three-pointed crown, long plaited hair, caftan and *tiraz* bands on his arms in the traditional Turkish style, stone relief, fortress, Konya, *c.* 1220. H. 130 cm, W. 120 cm. Museum of the İnce Minare Madrasah, Konya, inv. no. 883.

111 Lion (one of a pair) with a broken head, stone, fortress, Divriği, 1236–42. H. 130 cm, L. 110 cm, W. 40 cm.

112 Double-headed eagle, stone relief, fortress, Konya, *c.* 1220. H. 125 cm, W. 94 cm. Museum of the İnce Minareli Madrasah, Konya, inv. no. 881.

113 Façade of the Keykavus Turbeh, Sivas, 1219–20: decoration of brick, glazed brick and relief tiles.

114 Tile mosaic on the dome of the Eşrefoğlu Turbeh, Beyşehir, 1301.

115 Brick dome of the *maksura* in the Eşrefoğlu Mosque, Divriği, 1297–9: decoration of geometrical patterns made of glazed brick.

116 Mihrab of the Arslanhane Mosque, Ankara, 1289–90: decoration of tile mosaic and stucco.

117 Siren on a star-shaped tile, underglaze painting, Kubadabad Palace, *c.* 1236, D. 22 cm. Karatay Madrasah Museum, Konya.

118 Sphinx on a star-shaped tile, lustre technique, Kubadabad Palace, *c.* 1236, D. 22 cm. Karatay Madrasah Museum, Konya.

119 Throne scene on a star-shaped tile, Iranian-Seljuk *minai* technique, Alaeddin Palace, Konya, 1156–92 (Kılıçarslan II period), D. 8.5 cm. The sultan, sitting cross-legged on his throne, is holding a pomegranate in one hand; there are *tiraz* bands on his arms and two guards next to him. Karatay Madrasah Museum, Konya.

120 Polychrome tiles, underglaze painting, harem of the Topkapı Sarayı, Istanbul, 16th cen.

121 Tile mosaic on the entrance iwan of the Topkapı Sarayı, Istanbul, 1472. Çinili Kiosk Museum, Istanbul.

122 Wood carving in relief and *kündekari* technique on a side panel from the minbar of the Ulu Cami, Siirt, late 13th cen. Ethnographic Museum, Ankara.

123 Wooden lectern *(rahle)*, mother-of-pearl inlay, 16th cen. Museum of Turkish and Islamic Art, Istanbul, inv. no. 103.

124 Wooden door panel, wooden and ivory inlay, Hacı Bayram Mosque, Ankara, 15th cen. Ethnographic Museum, Ankara.

125 Wooden window panel for a door, relief decoration, İbrahim Bey İmaret, Karaman, late 13th cen. A large rosette is framed *(on top)* with two winged lions and *(underneath)* with two griffins; *(above and below)* two humans sitting cross-legged. Museum of Turkish and Islamic Art, Istanbul, inv. no. 248.

126 Polychrome plate, underglaze painting, Iznik, 16th cen. Topkapı Sarayı, Çinili Kiosk Museum, Istanbul, inv. no. 1266.

127 Polychrome mug, underglaze painting, Kütahya, 18th cen., Topkapı Sarayı, Çinili Kiosk Museum, Istanbul, inv. no. 41/141.

128 Wooden columns, stalactite capitals and roof beams in the Ulu Cami, Afyon, 1273.

129 Inner face of a wooden lectern *(rahle)*, lacquered, dated 1278; decoration of a double-headed eagle and a lion on a background of arabesques. H. (of eagle) 35 cm. Mevlana Museum, Konya, inv. no. 332.

130 Carpet with cock motif, Konya, 2nd half of the 15th cen., 215×108 cm, 1600 knots per 10 cm². Ethnographic Museum, Konya, inv. no. 841.

131 Seljuk carpet, Eşrefoğlu Mosque, Beyşehir, late 13th cen., 170×254 cm, Gördes knot, 627 knots per 10 cm². Ethnographic Museum, Ankara.

132 Lâdik prayer rug with tree-of-life motif, 18th cen., 177×117 cm, 1200 knots per 10 cm². Museum of Turkish and Islamic Art, Istanbul, inv. no. 797.

133 Kız Gördes prayer rug with double niches, 18th–19th cen., 210×130 cm, 1600 knots per 10 cm². Museum of Turkish and Islamic Art, Istanbul, inv. no. T 921.

134 Bergama carpet ('Holbein IV' type), 18th cen., 1476 knots per 10 cm². Museum of Turkish and Islamic Art, Istanbul, inv. no. 329.

135 Kırşehir prayer rug, 19th cen., 191×131 cm. Museum of Turkish and Islamic Art, Istanbul, inv. no. 1595.

136 Uşak carpet ('Holbein I' type), early 16th cen., from the Kılıçarslan Turbeh of the Alaeddin Mosque, Konya, 196×300 cm. Museum of Turkish and Islamic Art, Istanbul, inv. no. 303.

137 Silk-brocade caftan belonging Sultan Mehmet the Conqueror (1451–81). Topkapı Sarayı Museum, Istanbul, inv. (archives) 2/4412.

138 Silk-brocade caftan with gilt thread belonging to Sultan Beyazıt II (1481–1512). Topkapı Sarayı Museum, Istanbul, inv. (archives) 2/164.

139 Silk-brocade caftan with gilt thread belonging to Sultan Murat IV (1622–39). Topkapı Sarayı Museum, Istanbul, inv. (archives) 35/660.

178

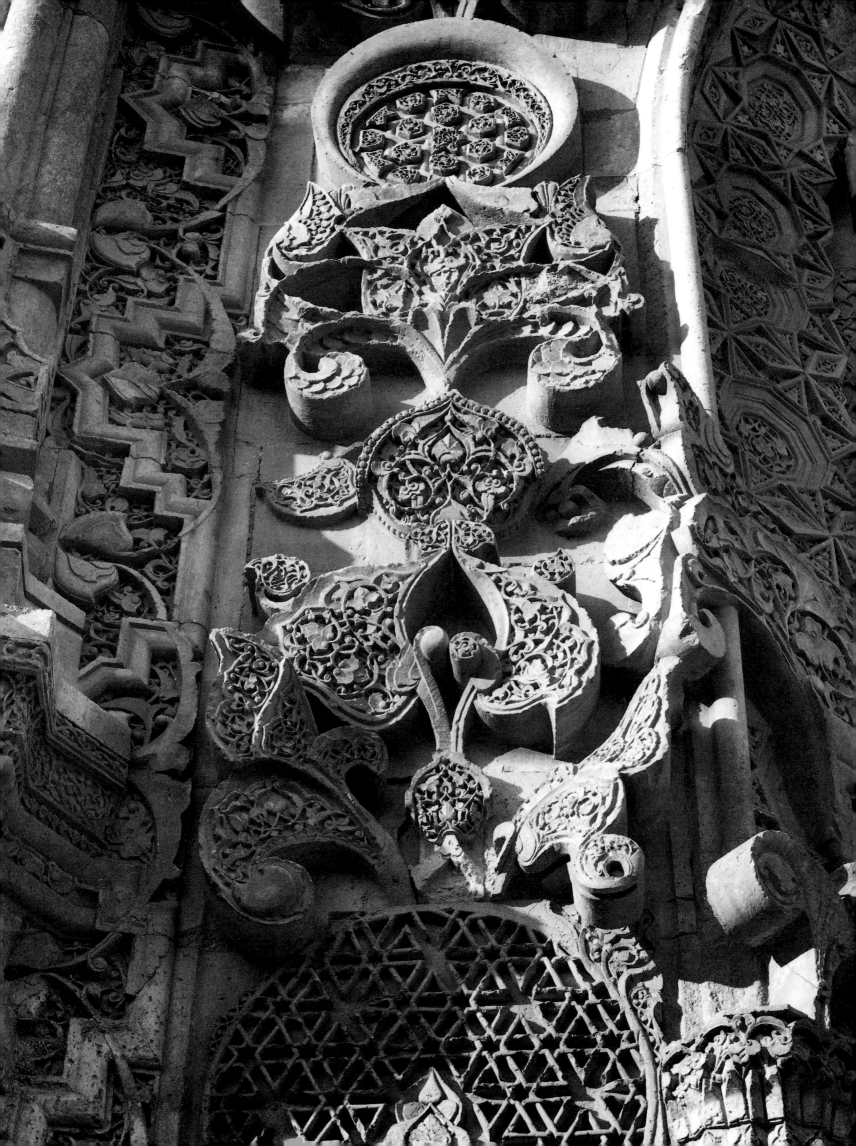

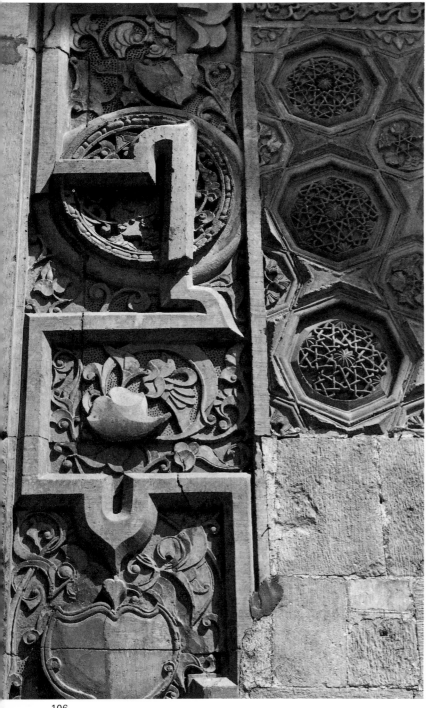

106

107

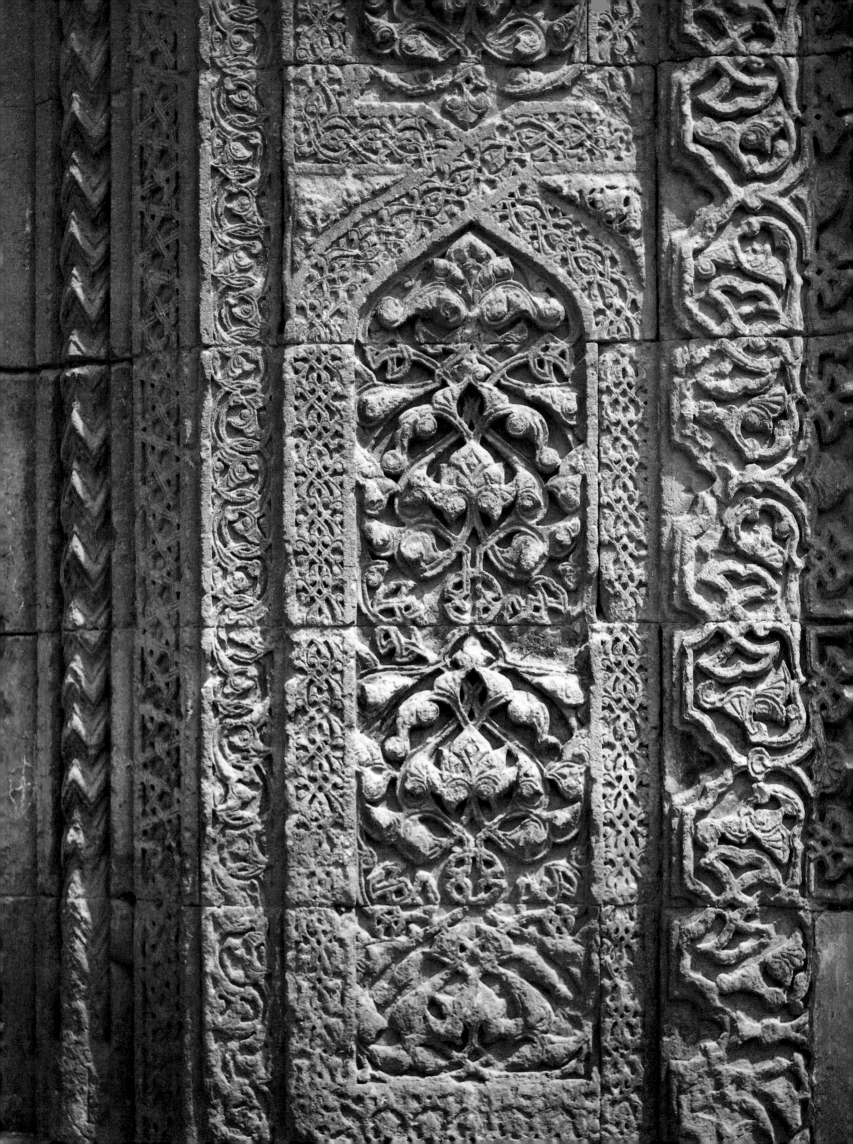

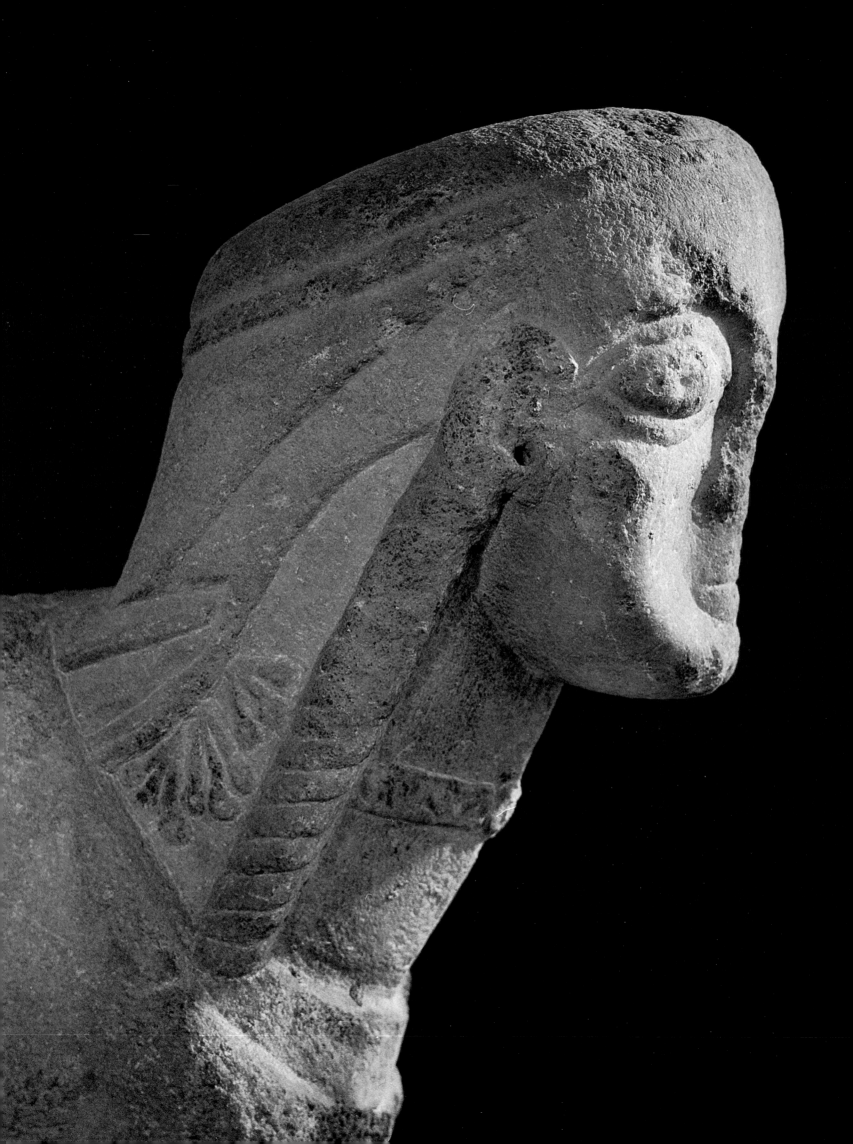

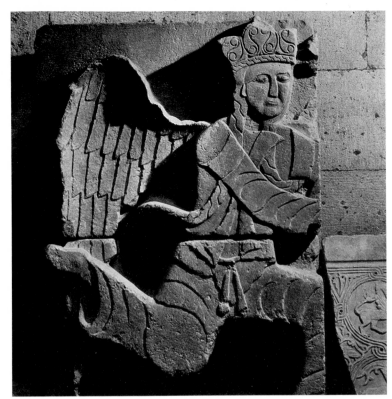

110

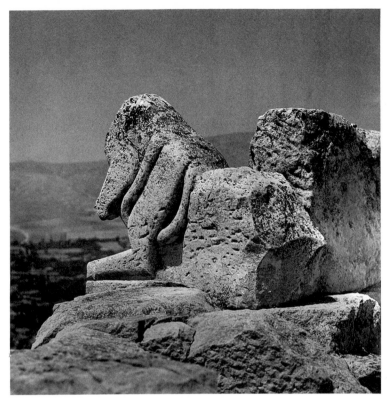

111

109

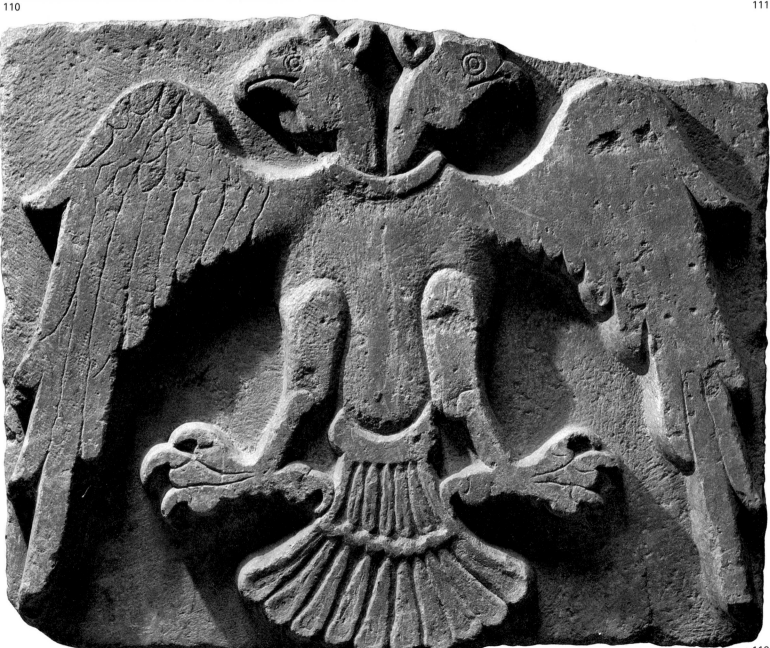

112

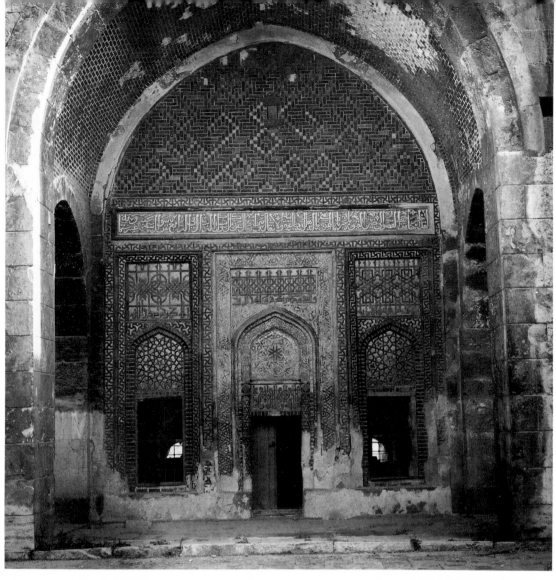

113

114

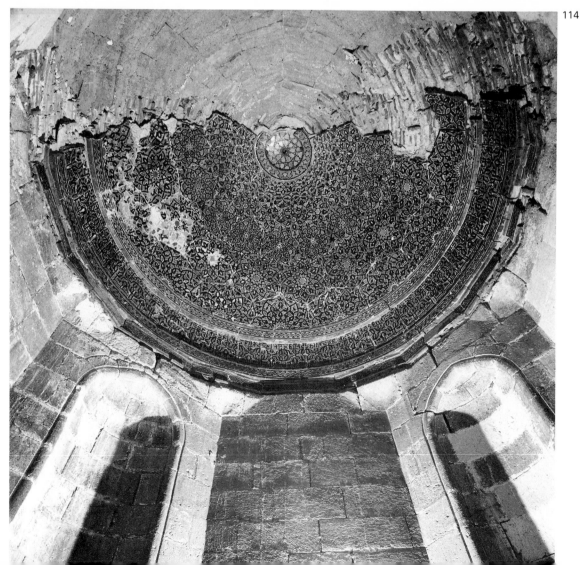

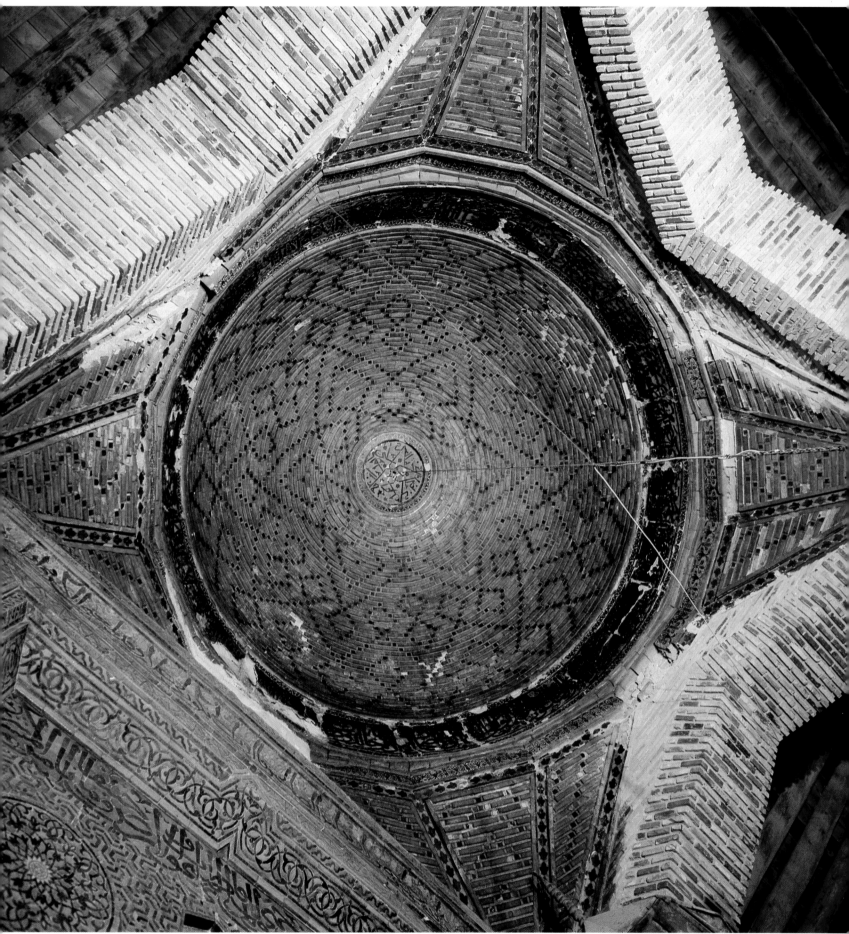

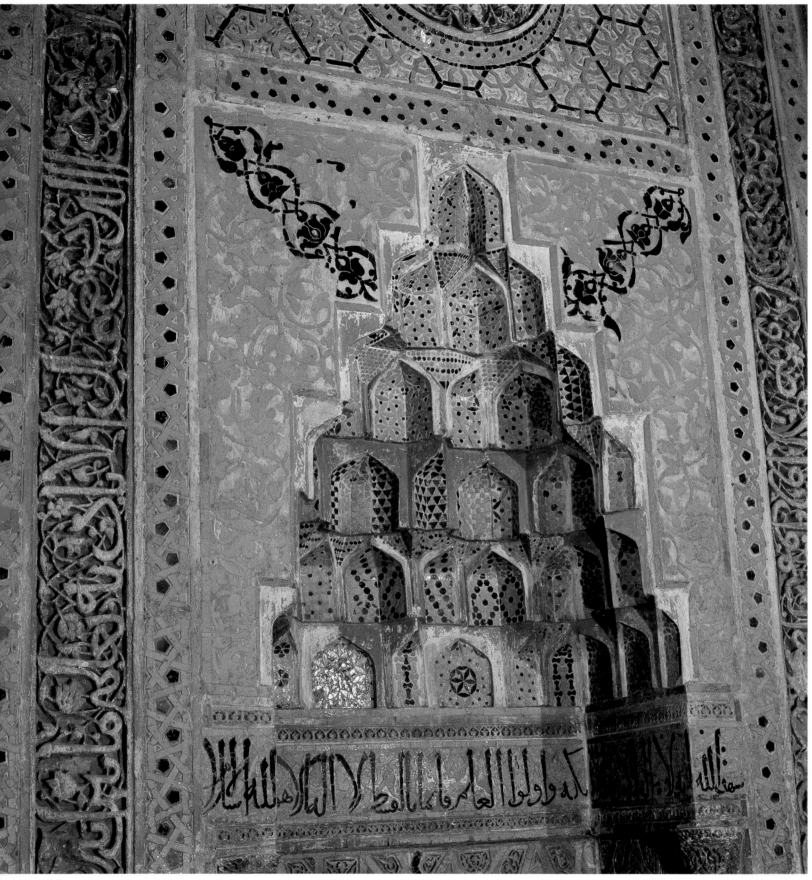

117△ 118△ 119▽

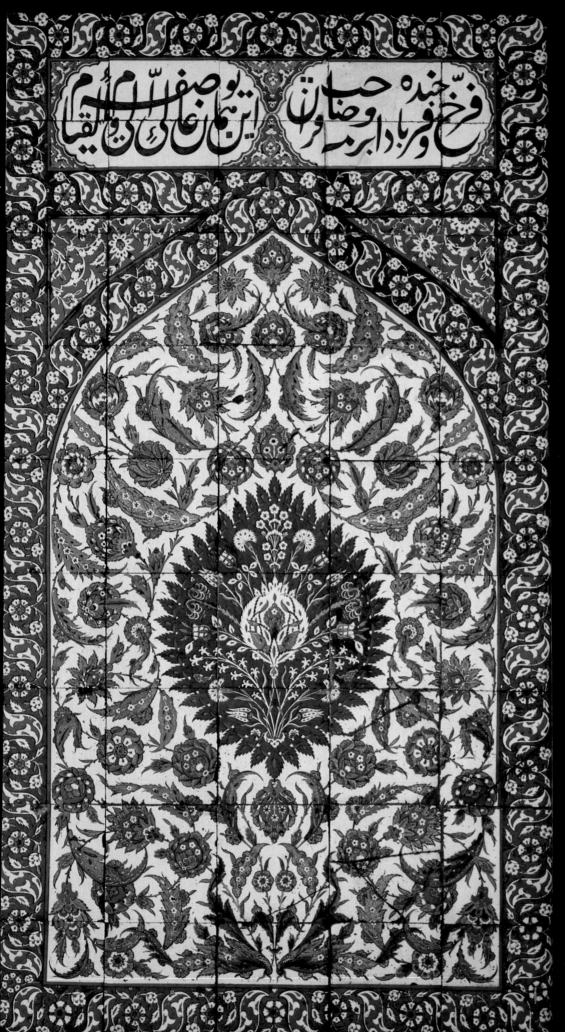

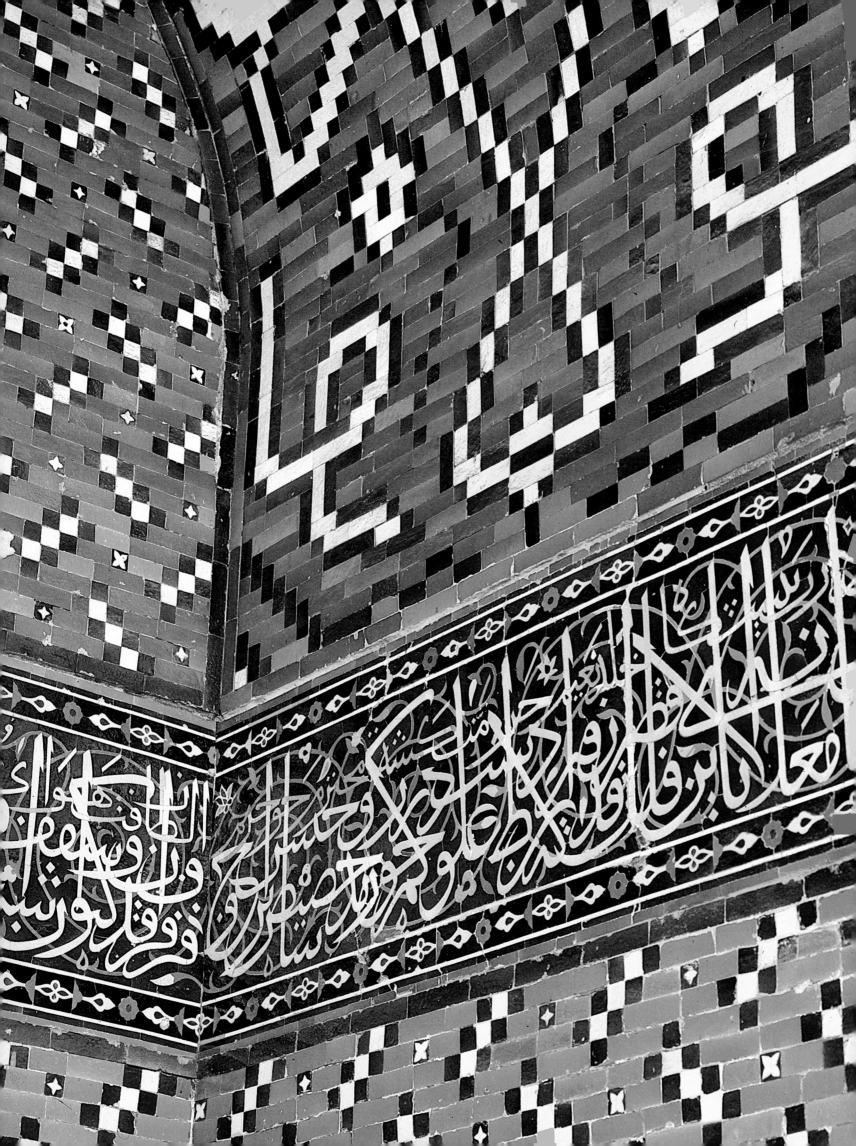

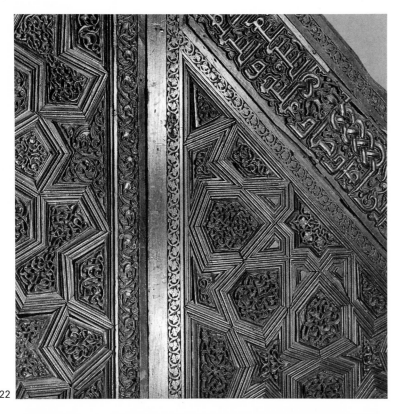

122

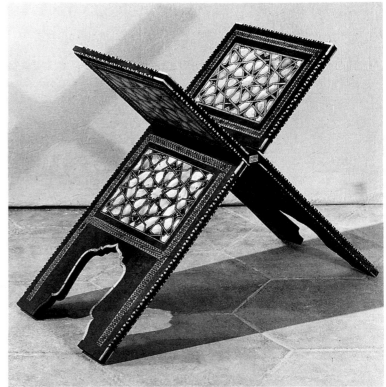

123

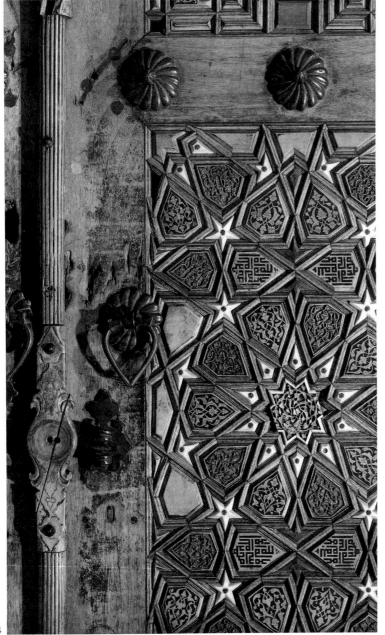

124

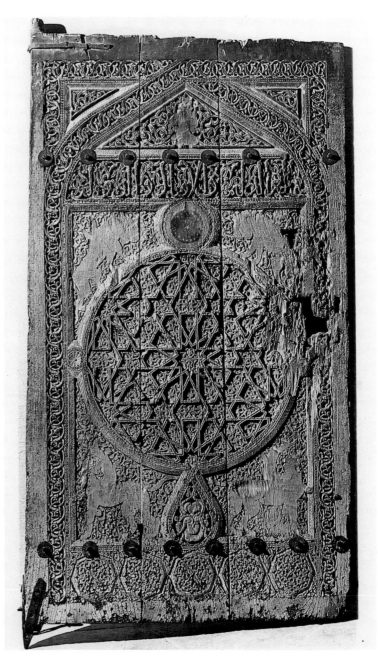

125

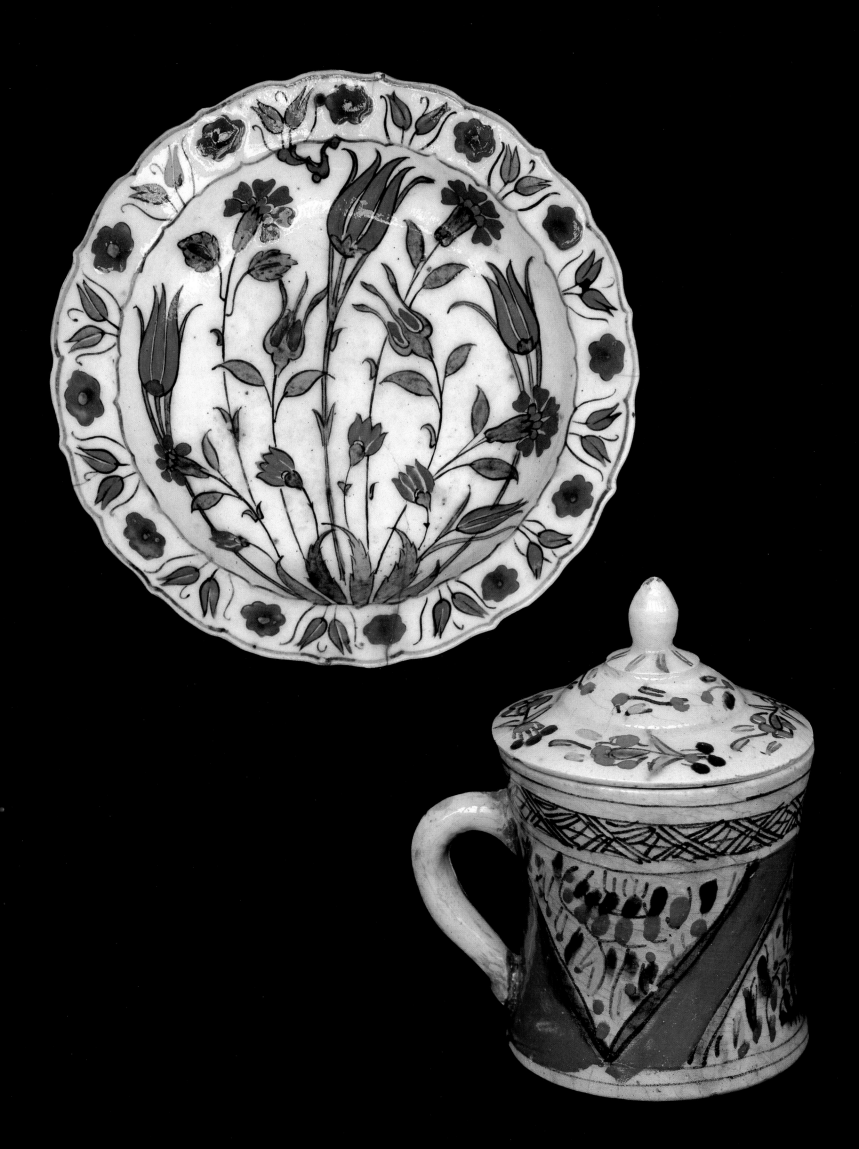

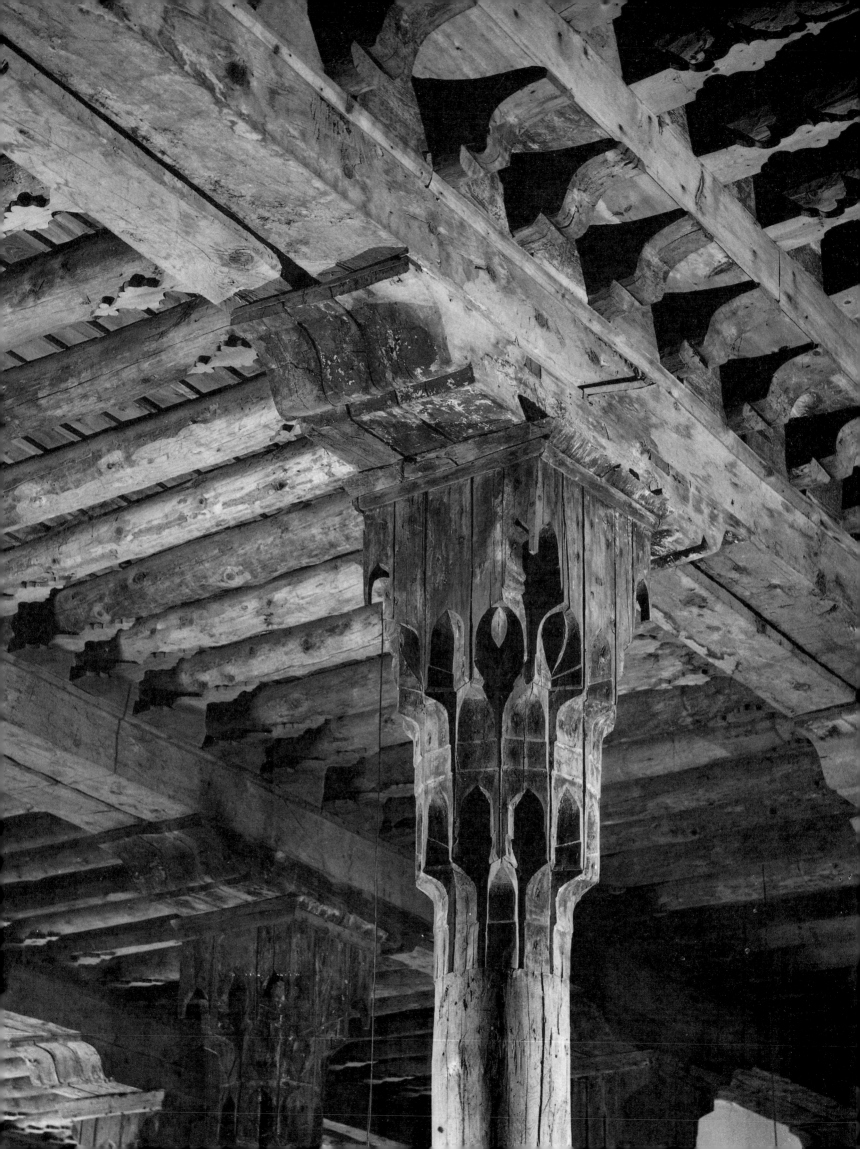

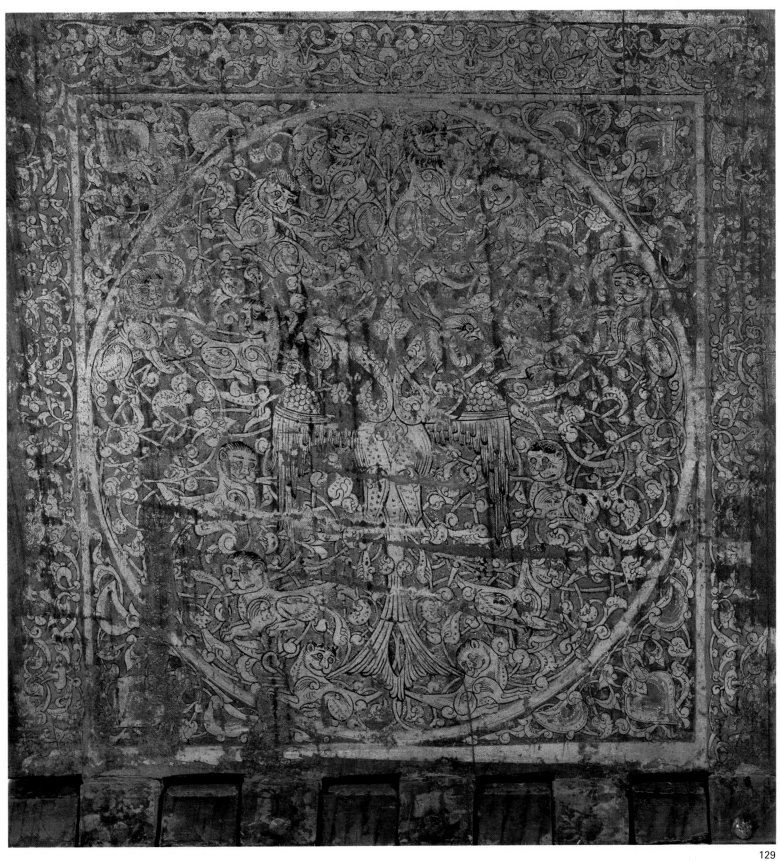

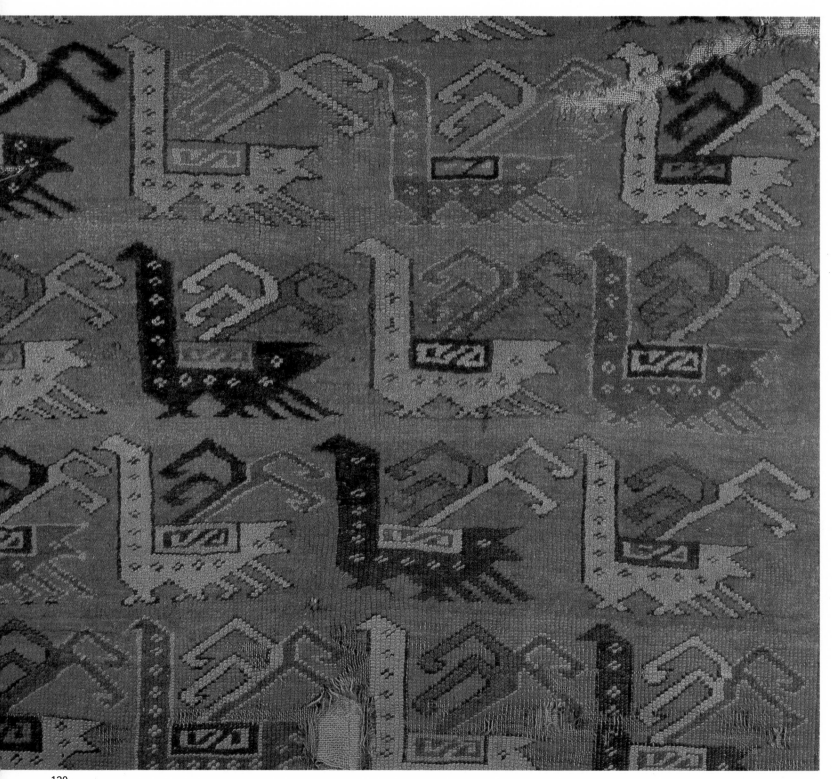

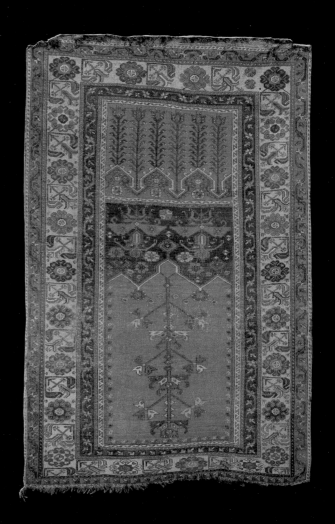

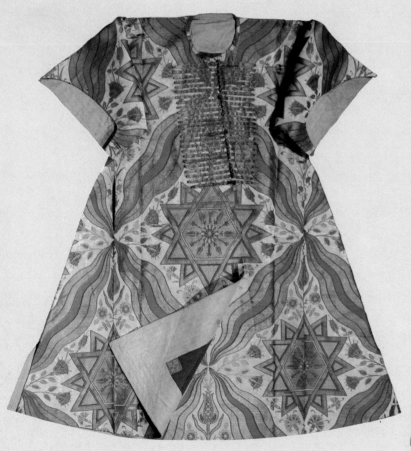

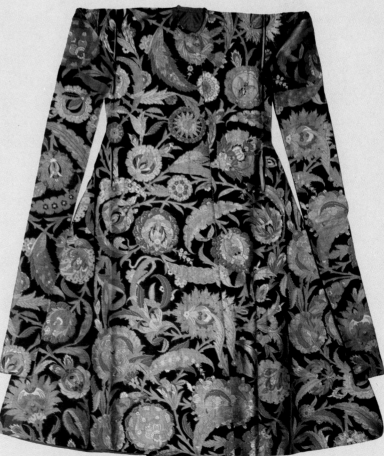

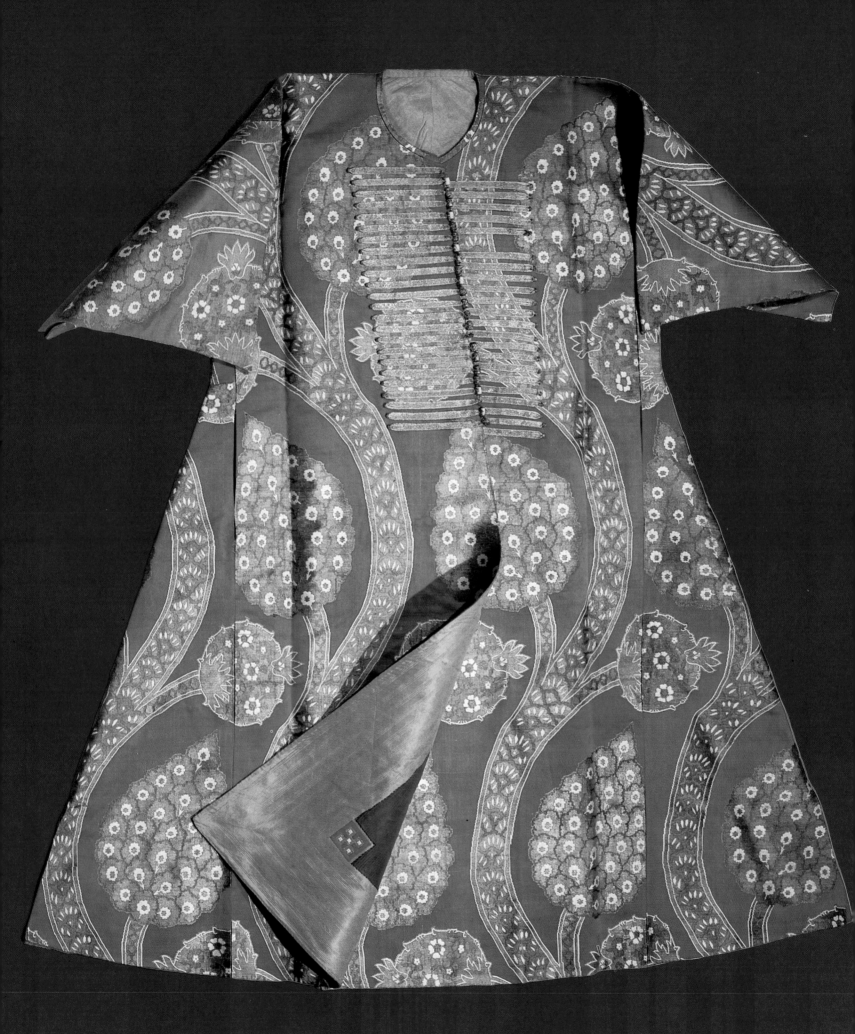

seventeenth. These colourful tiles of high quality are made from a hard white clay. Their most distinctive feature is a unique red colour applied on slightly embossed surfaces. The technique for producing this strikingly radiant Bolus red was unfortunately lost forever after the middle of the seventeenth century. In addition to the famous red; white, blue, turquoise, dark blue, green and black were used with white slip under a clear, high-quality glaze, which made the colours more lively and brilliant. All seven colours were not always employed together; some designs have only two or three colours, while inscriptions are usually in white over a dark-blue background. The designs contain realistically drawn tulips, carnations, roses, rosebuds, violets, hyacinths, pomegranate blossoms, peonies, spring branches, apple and cypress trees, bunches of grapes, flower bouquets, vases, mosque lamps, large palmette leaves, medallions, arabesques, large Sülüs lettering, imitation marble, animal figures and birds. Chinese-inspired motifs also continued to be used. The overall effect achieved on the walls was a re-creation of the Garden of Paradise.

The hexagonal tiles of the fifteenth century were replaced by square tiles measuring 24 by 24 centimetres or 23 by 24 centimetres with rectangular border tiles 14 by 20.5 centimetres or 8.5 by 24 centimetres. Excavations have proved that Iznik was the main centre of manufacture for these tiles, and it may safely be assumed that Kütahya was the second major source of supply. In fact, Kütahya rapidly rose to prominence from the middle of the sixteenth century onwards.

There are strong indications that similar tiling was also manufactured locally in more remote regions of the empire, for instance Diyarbakır. The larger tiles with underglaze decoration in similar designs (33 by 33 centimetres; border tiles 15 by 33 centimetres) adorning various mosques in Diyarbakır were apparently manufactured locally; this assumption is corroborated by the discovery of old kilns in the vicinity.

Examples typical of the fine-quality tiles with polychrome underglaze decoration from the sixteenth century can be seen today in the Ulu Cami at Adana (1552), the Safa (1513) and the Behram Pasha (1564) Mosques at Diyarbakır, the Suleymaniye (1550-7) and the Rüstem Pasha (1561) Mosques at Istanbul and the Selimiye Mosque (1571-4) at Edirne.

After the middle of the seventeenth century, there was a rapid decline in the quality of Iznik tiles with underglaze decoration. The exquisite Bolus red was replaced by a dull brown, and the other colours were paler and often ran into each other. The background was dirty and stained, and the quality of glazing was poor. There was a noticeable resurgence of Chinese motifs during the seventeenth century, but the designs were generally less skilfully rendered.

A new approach to tile decoration occurred during the seventeenth century with the pictures of the Kaaba and Medina made at Iznik and Kütahya.[28] A picture was sometimes contained within a single tile, while at other times it was spread over a whole panel of several tiles. Inscriptions indicate that these pictorial representations of the holy places were made to order. On these tiles, the

Kaaba is framed by an outline in the form of a keyhole and the courtyard is surrounded by a colonnade. In the courtyard, there are various buildings symbolizing the various sects, minbars, holy water (zemzem) wells and a sundial. There are usually six or seven minarets, arranged differently in each example. The pictorial representations of Medina are rare, and the only surviving examples are from the seventeenth century. Interesting examples of Kaaba pictures on tiles can be seen in the Topkapı Sarayı, the Çinili Köşk and the Museum for Turkish and Islamic Art in Istanbul, as well as in the Staatliche Museen in East Berlin.

Around the middle of the sixteenth century, another group of tiles appeared. These high-quality tiles have pastel shades of blue, lilac and olive green on a white background or sometimes white, lilac, blue and pistachio green on a dark-blue background. Since these tiles adorn various buildings in Damascus, they came to be called 'Damascus ware'; however, recent research has shown that Anatolian tiles of this type were manufactured at Iznik. Professor Oktay Aslanapa excavated considerable quantities of the 'Damascus pottery' at Iznik.[29] Although numerous specimens of Damascus pottery have been found in Anatolia, tiles are encountered today only in the Turkish Bath (Yeni Kaplıca) at Bursa.

The closing of the tile workshops at Iznik in the eighteenth century left Kütahya as the only major tile-manufacturing centre; however, Kütahya could never recapture the past glory of Iznik. The late Kütahya ware is a rather poor imitation of the early Iznik originals. Underglaze red is replaced by brown, and the other colours are smudged and run into each other. The background is dirty and coarse; the quality of glazing is rather poor, and the designs are uninspiring and monotonous: a series of medallions, cypresses, bunches of carnations and arabesques are repeated over and over again. Such tiles decorate the Yeni Valide (1708) and Beylerbey (1778) Mosques in Istanbul, the Nakiboğlu Mosque (1753) at Konya and the Hacı Bayram Mosque (eighteenth century) in Ankara.

A noteworthy group of Kütahya tiles from the eighteenth century with a distinctively different subject matter is that manufactured by Armenian craftsmen for use in churches.[30] Instead of the traditional designs, religious motifs such as crosses, saints, angels and cherubs are presented, together with scenes from the Old and New Testaments. These tiles also contain inscriptions in Armenian and Greek. The most interesting collection of such tiles is in the Armenian Cathedral of St. James in Jerusalem; it consists of forty-five pieces (c. 1719). The predominant colours on these tiles are greyish blue and dark blue. Figural tiles also display bright yellow, green, blue, pink and red, outlined in black on a white background. Tile manufacturing in Kütahya entered a period of stagnation at the end of the eighteenth century; revival came at the end of the nineteenth century, and production continues to this day. There is a general tendency to return to traditional Iznik designs, but quality remains poor.

During the reign of Sultan Ahmet III, Grand Vizier İbrahim Pasha wanted to revive the art of tile-making and

ordered a workshop, modelled on the famous Iznik workshops, to be set up in Istanbul. The Byzantine Palace of Tekfur near Eyüp was chosen as the site, and tiles with underglaze decoration began to be produced there by craftsmen from Iznik. The earliest specimens are found in the mihrab of the Kasım Pasha Mosque in Eyüp (1724-5). As a result of political upheavals, interest in the Tekfur-Palace workshops was lost. Tekfur-Palace tiles are easily distinguished by their slightly larger dimensions (25 by 25 centimetres). They aim at perpetuating the old Iznik style but are definitely of poorer quality. The colours are not as lively, and the surface is often dirty and stained. The glazing is poor in quality with a tendency to crack. However, they introduced some new designs such as baroque flowers, large roses, slender tulip motifs (resembling a sheaf of wheat) and three-dimensional pictures of the Kaaba drawn in miniature style.

Tekfur-Palace tiles decorate the Hekimoğlu Ali Pasha (1734), the Üsküdar Kaptan (1727) and the Eyüp-Cezeri Kasım Pasha (1822) Mosques in Istanbul and parts of the Topkapı Sarayı.

Pottery

As an integral part of a building, tiling has a more permanent character than pottery and can usually be dated more accurately together with the building in question. There is, of course, a certain correlation between tiling and pottery, the latter somewhat harder to trace and to classify as one goes back in time. For example, very little pottery remains from the Seljuk period, and excavations are the only source yielding any information. Recovered fragments indicate that, in the Seljuk period, various unglazed vessels such as vases, decanters, bowls, plates and large jars were manufactured from rather soft reddish clay. Sometimes, such articles were decorated with moulded or engraved human or animal figures, masks, rosettes and arabesques. Glazed plates, bowls and oil lamps were also manufactured from a hard, yellowish pink clay and turquoise or yellowish monochrome glazing was used.

However, the most common type of pottery in the Seljuk period was sgraffito pottery, known in Islamic art from the ninth century onwards. In cream or yellowish-brown monochrome or in variegated colours, such pottery was sometimes decorated with stylized plant or geometrical motifs or with birds and human figures in the characteristic Seljuk style. Most probably the high-quality pottery with black designs and turquoise underglaze decoration—typical of thirteenth-century Syria—was also manufactured in Anatolia. Fragments of such pottery can be found in various Anatolian museums.

It is interesting to note that while large quantities of lustre tiles can be found in Anatolian Seljuk palace decoration, no Anatolian lustre pottery has been discovered except for fragments recently recovered from a kiln excavated in Ahlat. With their white clay, other rare fragments in Turkish museums suggest that they were imported from Iran; they are very similar to the thir-

teenth-century lustre pottery of the Iranian Seljuks from the standpoint of both design and material.

Ceramic ware from the period of the Turkish emirates and the early Ottoman period (fourteenth to the end of the fifteenth centuries) apparently came from different centres. These wares were initially called 'Miletus ware', since the first examples were discovered by F. Sarre at Miletus. However, subsequent excavations conducted at Iznik by Professor Oktay Aslanapa have proved that the main centre of manufacture was Iznik.[31] Underglaze decoration was generally used on this type of pottery. The predominant colours were cobalt blue, purple, turquoise, green and blue. The patterns were applied by brush with finely drawn or engraved contours, reminiscent of Chinese paintings. The decoration appears principally on the inner faces of plates and bowls and consists of plant and geometrical motifs or radial curves. Stylized leaves, flowers, rosettes, fans, spirals and geometrical patterns are common.

Pottery with designs in the so-called slip technique was probably manufactured at Iznik after the middle of the fourteenth century. Fragments recovered during excavations consist of shards with blue, green, dark or light-brown slip and arabesques, stylized flowers and leaves.[32]

Blue-and-white pottery was manufactured at Iznik and Kütahya at the end of the fifteenth and in the early sixteenth century. Objects such as bowls, plates, pitchers, vases, lamps, etc. were apparently manufactured in large numbers for the first time in Anatolian Islamic art. They are of the highest quality and, with their hard, flawless clay, resemble porcelain. The decoration is very skilfully rendered with a hint of Chinese Ming pottery of the fifteenth century.[33] Most specimens have Chinese motifs under a hard, transparent glaze of very fine quality; however, a great variety of other motifs such as naturalistic birds, flowers and animals can also be found. In early examples, the blue colours are dark, and the motifs intricate, while later works are blue or turquoise in colour and have less dense compositions. Formerly it was assumed that this type of pottery was made at Kütahya; however, subsequent excavations have shown that Iznik was the main centre of manufacture.

There is a special group of blue-and-white pottery decorated with spirals and small leaves that resemble hooks. Formerly called 'Golden Horn ware' under the erroneous assumption that it was manufactured there, this rarer type of pottery was actually made in Iznik, again proved by the excavation of kilns there. Kütahya was a secondary centre of manufacture. The existence of a number of pottery specimens with Armenian inscriptions indicates that Armenian craftsmen worked side by side with the Turks.[34]

In the 'Damascus' pottery (see p. 179) blue, olive, green, lilac and turquoise underglazes were used on a white clay of high quality. Although Chinese-inspired designs are found, the floral motifs similar to those on the red Iznik tiles of the sixteenth century are more common; however, the colours—set against a white or blue background—are more pastel.

By far the best-known Ottoman pottery is the Bolus-red coloured ware, which has its parallel in tiles (see

Pl. 126 p. 179) and was manufactured at Iznik and Kütahya. The astonishingly lively and radiant red appears in slightly embossed form along with the traditional cobalt blue, green, turquoise, white and black as well as with the occasional pink, brown and grey. The use of the unique red colour was relatively short-lived, appearing for five decades around the middle of the sixteenth century. Like the tiles, the most popular pottery designs displayed naturalistic floral motifs, while Chinese-inspired motifs continued to be used. The decoration seen on pottery was richer than the tile decoration and displayed much greater variety. Galleons, smaller sailing boats and various animals such as deer, hare, birds, dogs, hunting animals, sphinxes, monkeys and fish, as well as combat scenes between lions and bulls or lions and stags, adorned this group of pottery.

Parallel with the decline in contemporary tile manufacture, there was a rapid deterioration of quality in pottery after the middle of the seventeenth century. Manufacture finally stopped in the eighteenth century. The closing of the kilns at Iznik in the eighteenth century spurred the production at Kütahya, where two main groups of pottery continued to be manufactured. The first group was composed of high-quality ware belonging to the first half of the eighteenth century. It had remarkably fine colours and designs and was usually in the form of small Pl. 127 cups, cup holders, inkpots, bowls, ewers, decanters, goblets, rose-water flasks, oil lamps, censers, incense holders, decorative eggs and plates. In this type of Kütahya pottery, a hard white clay was used with an underglaze decoration of brush-applied designs featuring floral and animal motifs, human figures in national costume and girls with flowers in their hands. Pictures of men with big moustaches and wearing turbans are also encountered. The floral compositions became much freer in design compared to examples from the sixteenth and seventeenth centuries. The colours were vivid, with an obvious preference for shades of blue on a white background. Chinese influence can be observed in the intricate use of hollows made with rice and in the embossed lozenges, as well as in the bird designs and the shape of some of the vessels.

The second main group consists of lower quality ware from the second half of the eighteenth century. The decline in quality of pottery is clearly visible. Lilac disappeared and was replaced by dark purple and other dark colours, and the designs became coarser. The workmanship was rough, and the clay used was whitish and soft. The designs generally consisted of stylized leaves, dots, lines and zigzags. They were painted with a brush, the predominant colours being cream, beige, turquoise, purple, purplish brown and yellow. In some examples, rosettes were decorated with bosses and lozenges in relief. Such ceramic wares continued to be manufactured until the beginning of the nineteenth century.

Pottery wares were also made by Armenian craftsmen for church use.[35] They were decorated with scenes from the Old and New Testaments, angels, cherubs and saints together with Armenian inscriptions. Of particular interest are the lamps, censers and incense holders in the form of Easter eggs presented to pilgrims going from Kütahya to Jerusalem. Often these bore the name of the pilgrim and his destination. Most of such pieces were eventually hung as ornaments in the Cathedral of St. James in Jerusalem.

Çanakkale emerged as an important centre for manufacturing pottery around the middle of the eighteenth century and continued its production until the beginning of the twentieth century.[36] The most interesting and common Çanakkale pottery consists of plates, usually 23 by 33 centimetres in diameter, with a design covering the centre. Sailing boats, pictures of mosques, pavilions, landscapes, animals, bunches of flowers, fruits, flower rosettes — all in stylized form and drawn with an astonishingly modern approach — adorn these charming plates. Bowls, jars, decanters, pitchers and vases were also produced. Purplish brown, orange, reddish orange, yellow and blue were the colours used on a cream background with a transparent glaze. Sometimes, only one or two colours were employed. Pottery produced until the middle of the nineteenth century was of good quality. The underglaze decoration was applied to a rough red or occasionally beige clay; however, during the second half of the nineteenth century, there was a decline in both quality and taste. Strange shapes suggestive of gaudy popular art started to appear, and overglaze painting replaced the underglaze technique.

Wood Carving

Anatolian Seljuk wood carving exhibits high-quality workmanship and was used extensively in architecture and the minor arts. The woodwork of the period of the emirates follows the same tradition. Thus, fine examples of wood carving appeared on Seljuk and emirate-period minbars, lecterns, balusters, door and window panels, columns, capitals, beams and consoles. Apart from those still surviving in mosques and other buildings, some very fine specimens are presently among the collections of the Ethnographic Museum in Ankara, the Museum of Turkish and Islamic Art in Istanbul, the Topkapı Sarayı Museum in Istanbul, the Mevlana and İnce Minareli Madrasah Museums in Konya and the Staatliche Museen in East Berlin. The woods most frequently used were walnut, apple, pear, cedar, ebony and rosewood.

The minbar or pulpit, which is placed to the right of the mihrab in mosques, usually has the most elaborate and interesting wood carving. The wooden minbar is constructed in the so-called *kündekari* technique based on Pl. 122 tongue-and-groove construction. This technique was presumably developed simultaneously in Egypt, Syria and Anatolia during the twelfth century. Minbars with side panels and sometimes doors, constructed by using this technique, are omnipresent in Anatolia.[37]

Authentic *kündekari* consists of tongue-edged, lozenge-shaped octagonal and stellate panels covered with arabesque reliefs. These panels have been joined with grooved frames and without using pins or glue. The use of panels with grains running perpendicular to those in

the frame prevented subsequent warping. The joined panels were further supported by a wooden sub-structure.

Examples of real *kündekari* from the Anatolian Seljuk period can be seen in the minbars of the Alaeddin Mosque, Konya (1155–6), the Ulu Camis of Malatya and Siirt (both from the thirteenth century and both presently in the Ethnographic Museum in Ankara), the Ulu Cami of Sivrihisar (1275) and the Eşrefoğlu Mosque at Beyşehir (1297–9).

The Seljuk tradition of *kündekari* technique continued throughout the period of the Turkish emirates and the early Ottoman period; however, a generally finer, more intricate and shallower jointed carving with boss-like rosettes began to appear, as can be seen in the minbars of the Ulu Cami (1332) at Birgi, the Ulu Cami (1376) at Manisa and the Ulu Cami (1399) at Bursa.

Since real *kündekari* demanded meticulous workmanship — wood cut into small pieces with great precision so that the tongues and grooves were coupled tightly — various types of false *kündekari* emerged, all purporting to give the same appearance but demanding less care in the making. Panels were made of solid blocks that were carved to form the desired patterns (usually octagonal, lozenge-shaped and stellate reliefs). These slabs were then mounted on to structural elements forming the skeleton of the minbar. This, however, did not prevent warping and, in time, slits appeared between the panel blocks. Minbars constructed using this technique can be seen in the Alaeddin Mosque, Ankara (1197–8), the Ulu Cami, Kayseri (1205), the Huand Hatun Mosque, Kayseri (1237), the Kızılbey Mosque, Ankara (thirteenth century, presently in the Ethnographic Museum, Ankara), the Ulu Cami, Divriği (1228–9) and the Arslanhane Mosque, Ankara (1289–90). In some rare late examples of elementary, easily constructed, false *kündekari*, like the minbar of the Ahi Elvan Mosque in Ankara (1382), both the geometric relief and the frame have been pinned or glued on to wooden blocks.

Deeply cut, flat and rounded reliefs were the most common techniques used on window panels, lecterns, daises and cenotaphs during the Seljuk period and the period of the emirates. Deeply cut incisions on flat or levelled surfaces can be seen on the door panels of the minbar of the Ulu Cami at Kayseri, the window panels Pl. 125 from Karaman in the Museum of Turkish and Islamic Art, Istanbul (end of thirteenth century) and the cenotaph of the Ahi Şerafeddin in Ankara (1350, presently in the Ethnographic Museum, Ankara).

Deeply cut rounded reliefs with an undulated surface were commonly used for panels of inscriptions and reliefs with arabesques, such as those on the door of the minbar in the Arslanhane Mosque in Ankara. Carvings of this type — particularly bands of inscriptions over the doors of Pl. 122 minbars — seem to be double-layered reliefs, the inscription being enmeshed in a field of dense arabesques. A typical example is the band of inscriptions over the minbar in the Alaeddin Mosque in Ankara.

Bevelled reliefs, so popular in early Islamic wood carving, were rare in Anatolia. Among the few existing examples, the minbars of the Ulu Cami at Malatya (thir-

teenth century, presently in the Ethnographic Museum, Ankara) and the Sare Hatun Mosque at Ermenek (twelfth century) are notable.

Latticework was commonly used for the balustrades of minbars, and occasionally polygonal or stellate panels filled with large-scale arabesque relief were set between the struts. The so-called open latticework was generally found above the lintels or doors of minbars and on the *rahle* or lectern, the pedestals of which were decorated with arabesques in open or pierced latticework.

The Seljuk-period Koran lecterns have a special place in the wood-carving art of Anatolia. Collapsible when not in use and therefore portable, these handy objects display very fine workmanship. Seljuk lecterns of high quality are presently in the Museum of Turkish and Islamic Art in Istanbul, the Mevlana Museum at Konya and the Staatliche Museen in East Berlin.

During the period of the Turkish emirates and the Ottoman period, Seljuk wood-carving techniques were perpetuated in a limited way. Apart from rare examples, wood carving appeared only on door and window panels. Inlay work became more fashionable in wooden decoration.

The inlay technique was introduced into Anatolia during the fourteenth century as a type of limited decoration on small panels. Its popularity rapidly increased during the fifteenth century as can be seen on the original door of the Hacı Bayram Mosque, Ankara, today in the Pl. 124 Ethnographic Museum in Ankara. From the sixteenth century, Ottoman panels were used extensively to decorate minbars, doors, windows, lecterns and drawers. Entire panels were embellished with inlaid mother-of-pearl, bone, ivory and jade ornamentation. Several examples of such inlay work can be seen in the Museum of Turkish and Islamic Art in Istanbul. It is generally Pl. 123 accepted that inlay work originated in Damascus in the late thirteenth century and eventually moved into Egypt then under Turkish Mameluke rule, where it flourished as an art form in the fourteenth century during the reign of Sultan Hasan.

Woodwork was employed interestingly in the 'wooden mosques and masjids' of the Seljuk period and the period of the emirates. Built with wooden structural elements, these works have fine examples of wood carving on columns, capitals, roof beams, consoles and wall panelling.[38] The Arslanhane Mosque in Ankara (1289–90), the Ulu Camis at Afyon (1273), Sivrihisar Pls. 56, 128 (1274), Ayaş (thirteenth century), the Eşrefoğlu Mosque at Beyşehir (1397–9), the Örtmeli, Geneği, Hacı İvaz, Sabuni, Eyyubi and Poyracı Masjids in Ankara (fourteenth and fifteenth centuries) and the Candaroğlu Mahmut Bey Mosque at Kasabaköy, near Kastamonu (1366) can be cited as typical examples.[39] These mosques were probably based on the wooden pillared mosques of Turkistan, which were in turn derived from the tents of central Asia.

The wooden structures had traces of both highly stylized foliate and floral motifs that were painted and of geometrical patterns in red, dark blue, yellow and white. In some cases, intensive paintwork of fine quality is clearly visible. An unusual lacquered wooden *rahle* Pl. 129

202

(lectern), dated to 1278 and presently in the Mevlana Museum, Konya, displays a double-headed eagle and lion over a field of arabesques on both the inner faces on which the Koran is placed.[40]

A frequent occurrence in early Ottoman art, for instance at Bursa and Edirne, was painted decoration on wooden cornices, ceilings, minbars, doors, drawers and chests. With time, this decoration was enriched with motifs parallel to those found on the ceramics of the period: naturalistic flowers and leaves flourished in the eighteenth century, and with Westernization, began to be seen on secular architecture. Alongside Western-influenced floral motifs, trees and vases depicting richly coloured scenic views and still-lifes can be seen.

Carpets

After a long interval, the first knotted carpets (with a history extending from their origins in the third century BC to nomadic central Asian and Turkish art) were found in Anatolia at Konya, the thirteenth-century capital of the Anatolian Seljuks. In 1905 the German Consul Löytved discovered in the Alaeddin Mosque at Konya eight thirteenth-century carpets of the Anatolian Seljuk period.[41] These carpets were double knotted with the Turkish or Gördes (Ghiordes) knot. They were all worn; three are complete and five are in fragments. Today they are in the Museum of Turkish and Islamic art, Istanbul. Originally they must have measured about fifteen square metres. Most probably, they were presented to the mosque by Alaeddin Keykubad.

In 1930, in the Eşrefoğlu Mosque at Beyşehir, R. Riefstahl found three more fragments of Seljuk carpets. Two are presently in the Ethnographic Museum, Konya (and were previously in the Mevlana Museum); one is in London in a private collection. In 1935, about one hundred Anatolian carpet fragments from the thirteenth to fifteenth centuries were found in Fustat, old Cairo. A small group of them went to the Benaki Museum, Athens, and most were taken by C. Lamm to Sweden. Seven of these carpet fragments that were illustrated by Lamm are from the Seljuk period in Anatolia.

Three of these Seljuk carpets are whole; the rest are in fragments. Their colours are red, blue, dark blue, beige, light green and yellow. Only two of the carpets are identical; they all have very stylized geometrical designs. Lozenges arranged in horizontal and vertical rows, geometrical foliate forms, eight-pointed stars, hooked octagons and Kufic inscriptions are the typical decoration. The large Kufic borders with pointed, arrow-like tips on the lettering are especially characteristic.

No examples of carpets are known from the period of the Turkish emirates in the fourteenth century. In the fourteenth and fifteenth centuries, European — mainly Italian and Flemish — painters depicted in their paintings details from Anatolian Turkish carpets (that had been exported) with animal motifs.[42] In the fourteenth and the first half of fifteenth centuries, the motifs consisted of very stylized geometricized cockerels, birds perched on both sides of a tree and motifs of animals in combat. The motifs were usually placed in a large geometrical rosette. The most famous existing examples are a carpet with facing birds and a tree-of-life motif (in the Swedish History Museum) that was found in the Swedish village of Marby in 1925,[43] a carpet showing a dragon and griffin in combat in the East Berlin Staatliche Museen that was purchased by Wilhelm Bode in Rome,[44] a carpet decorated with stylized cockerels in the Ethnographic Museum (and previously in the Mevlana Museum) at Konya and a carpet with stylized deer in the Istanbul Vakıf depot. All these examples are from the fifteenth century.

Pl. 130

In the fifteenth century, the first serial prayer rugs (safs) of the Islamic world appeared in Anatolia. The main motifs of three prayer rugs in the Istanbul Museum of Turkish and Islamic art are Kufic writing, mosque lamps and rosettes. The colours in the fourteenth and fifteenth-century carpets were red, blue, dark blue, yellow and beige.

In Italian, Flemish and Dutch painting from the end of the fifteenth century, carpets, with geometrical designs, and prayer rugs replaced figural carpets.[45] Since these rugs were seen especially in the paintings of Hans Holbein, they are known as 'Holbein' carpets. Geometrical carpets were, in fact, represented in earlier Italian paintings, but the attribution of Holbein's name to this group of carpets has mistakenly survived. The 'Holbein' carpets were made in Uşak or in west Anatolia. The group consists of four different types of carpets, not all of which are represented in Holbein's paintings. The same types can be seen repeatedly in many renaissance paintings. The oldest group has been dated to the fifteenth and sixteenth centuries. The carpets in this group are decorated with offset rows of hexagons alternating with lozenge rosettes; the inner fields are filled with stylized floral and leaf motifs, generally in cream, dark blue or red on a dark-blue or red background. The border derived from Kufic inscriptions is white on a red field.

Pl. 136

The second type of 'Holbein' carpet, from the fifteenth to the end of seventeenth centuries, generally has a red background with offset rows of octagons that have no outlines, cross motifs in a stem pattern and interlaced floral tendrils. The white Kufic border on a red background, seen in the first group, was also common in this group, but sometimes the cloud motifs of traditional Uşak borders were used. Some carpets were six metres in length. These carpets take their name from similar ones that are often seen in Lorenzo Lotto's paintings. They do not occur in Holbein's paintings.

The third type of 'Holbein' carpet consists of two or four large squares or rectangles that are gabled or contain octagonal rosettes with star-and-arabesque infill. This developed throughout the fifteenth century and has continued into the present as the 'Bergama' carpet.

Pl. 134

The fourth group is decorated with large gabled squares or octagons in the central field, flanked by smaller octagonal motifs. The third and fourth types of 'Holbein' carpets are the most lively in appearance with their strong dark-blue, blue, red, yellow and green colouring.

From the sixteenth century until the middle of the eighteenth century, a very rich and varied group of carpets, which has not been extensively studied, attained fame as 'Uşak' carpets. These carpets were woven as large floor carpets — as long as ten metres — in dark blue, red, cream and yellow. The 'medallion' Uşak carpet consists of a medallion in the central field with four medallions (one in each corner) filled with close floral-tendril interlace. The second Uşak group, called 'star' Uşak, has continuous offset rows of alternating star-and-octagonal rosettes; the fields of these carpets are covered with naturalistic plant motifs. These carpets disappeared after the seventeenth century and are now very rare. Carpets with bird-like stylized motifs on a cream field were called 'birded' Uşak. They were made from the middle of the sixteenth century to the eighteenth century. In fact, the bird-like motif is composed of two symmetrically arranged leaves in red and blue. The carpets with Chinese clouds and spotted triad motifs on a white, blue or red field were termed Chinese-influenced Uşaks. The borders of Uşak carpets are decorated with tendril interlace, floral devices and Chinese clouds. At the end of the eighteenth century, the patterns rapidly degenerated. The Museum of Turkish and Islamic Art in Istanbul is in possession of some very fine examples of Uşak carpets. All the carpets mentioned in the various groups were woven with the Turkish double (or 'Gördes') knot.

In the second half of the sixteenth century until the eighteenth century, side by side with traditional Anatolian carpets, small 'palace' carpets (*saray* carpets) became famous. Made with the single Iranian 'Sine' (Senneh) knot, they are of a very fine soft quality that resembles velvet. In general, these carpets are similar to the medallion Uşak carpets with Persian and Mameluke influence. They are decorated with tendril interlace and floral devices of naturalistic character. The prayer rugs have mihrabs with green, red or cream-coloured interiors. The surrounding field is covered with an intricate floral design in pastel colours. The contrast in colours and the plain mihrab field with densely decorated borders are typical characteristics of these carpets. 'Palace' carpets were made in Istanbul and Bursa; they were also woven in Cairo from cartoons sent from Istanbul. 'Palace' carpets are very popular in Turkey and are still made to this day.

At the end of the seventeenth and during the eighteenth century, various functional prayer rugs of good quality and with mihrab motifs began to be produced. These were once again made with double-knots (Gördes knots). The most famous group was made in Gördes in west Anatolia. In prayer rugs from Gördes, the mihrab arch is stepped. On top there is a square cartouche, inscribed or decorated with leaf patterns. The outer field around the mihrab arch is filled with stylized flowers in red and cream. From the centre of the arch a floral bouquet, lamp, fish or similar motif hangs down into the niche. The spandrels are filled with stylized carnations. The mihrab niche may be in red, green, dark blue or cream. The borders are filled with red, grey or white ribbons, dotted with very small flowers. There may be up to seven borders. Those types of carpet with columns in the field around the niche were called 'Marpuçlu Gördes' (spiral-stemmed Gördes); those with an opposed pair of niches, 'Kız Gördes' (Girl Gördes). Pl. 133

Kula prayer rugs were manufactured in the vicinity of Gördes. They are very similar to Gördes carpets but of a more sober appearance, in very dark blue, yellow and beige. The field of the central niche is covered with dotted motifs, houses or cypress trees. Generally, the niche is divided into two parts by the central axis of a hanging motif which looks like a spine.

Prayer rugs from Lâdik near Konya appeared in the Pl. 132 seventeenth and eighteenth centuries. They are very soft carpets with lively red, dark blue, yellow and green colouring. In quality they are inferior to Gördes and Kula carpets. Typical of their design is a single or triple mihrab with a long line of stemmed tulips, side by side on the upper or lower side of the mihrab; of the three niches, the central one is the biggest. The niches are supported by thin columns.

The prayer rugs made in Kırşehir are, in design, a Pl. 135 combination of Lâdik and Gördes carpets, with a large, broad-leafed plant device in the interior of the mihrab niche and a hooked motif above the arch. Their colours are very bright: red, yellow, blue and green. In quality, they are inferior to Gördes, Kula and Lâdik carpets. Prayer rugs from Mucur, near Kırşehir have a characteristic lilac colour.

The carpets of Milas, in west Anatolia, are soft in texture; their colours — rust brown, yellow, beige and light green — have a particular sheen. They are remarkable for a large lozenge-shaped crown above the mihrab niche. Milas carpets have a lively appearance with lozenge shapes and floral borders.

Hereke, a small town near Izmit, was famous for its very fine carpets in Persian and also European styles. The manufacture was initiated by Sultan Abdul Mecit in 1844. Today, manufacturing is continued by the Sümerbank, a state-owned public company.

There are many other varied groups of prayer rugs and carpets in Anatolia. The carpets of Kayseri (Yahyalı, Maden) Sivas, Konya, Bergama (Yağcıbedir), Balıkesir, Çanakkale (Ezine), Bandırma, Izmir, Isparta, Antalya (Döşemealtı), Fethiye (Megri) and Niğde (Taşpınar) are still famous. One especially famous group of carpets is decorated with designs of triple dots and animal-skin motifs. The traditional Anatolian art of carpet weaving has been preserved in contemporary nomadic carpets from east and south-east Anatolia; they are decorated with a great variety of geometric designs and brightly coloured compositions. Chemical dyes are used for bright pink, yellow and orange colours; these are combined with natural dyes from plants, making the carpets even more interesting and lively. The unbelievable richness and variety of the geometrical patterns should be noted. These carpets are usually very thick and durable.

Fabrics

Textile-making was especially advanced in Turkey from the fifteenth until the seventeenth century. Our infor-

mation on Seljuk fabrics during the twelfth to thirteenth centuries is insufficient.[46] A well-known fragment of a silk chasuble in the Textile Museum at Lyons, France, has been dated from its inscriptions, which contain the name of Alaeddin Keykubad (1219–37). In a central rosette on this piece of red brocade, a pair of addorsed lions with tails ending in arabesques are woven in gold. This piece is said to have come from an abbey in the Auvergne. On Sassanian, Iranian Seljuk and Byzantine silks, figural decoration was placed inside large rosettes in a similar fashion.

Another unique Seljuk brocade is at Siegburg, in the shrine of Saint Apollinaris in the Church of Saint Servatius. Today a piece of the same cloth is in the Kunstgewerbe Museum of the Staatliche Museen in West Berlin. These red silks are decorated with double-headed eagles within shields. The surrounding field is covered with arabesques and dragon's heads. The motifs have been woven in gilded thread. Similar double-headed eagles and dragons appear on the stone reliefs of the fortress at Konya. These silk fragments were most probably woven at Konya in the thirteenth century. The fabric-weaving centre of the Anatolian Seljuks is thought to have been Konya and its vicinity. The historian Ibn Battuta praises the fabrics of Lâdik, in the Konya region. Marco Polo, who travelled through Anatolia in 1271 and 1272, also praises Anatolian silks. In the figural tiles at the Kubadabad Palace in Beyşehir, Seljuk nobility in the palaces can be seen wearing richly patterned caftans. These caftans are decorated with large flowers, water drops, rosettes and stripes.

Our knowledge of fabrics from the fourteenth-century period of the Turkish emirates is very limited, but from the fifteenth century onwards, the development of textile art in Turkey can be followed. The Topkapı Sarayı contains a treasure of Ottoman textiles. It was traditional, after a sultan's death, to label and store his clothes in bales. These bales have remained intact to this day, and they constitute an accurate and continuous source of information. Thus, it is possible to study the development of textile-weaving from the fifteenth century to the eighteenth century. The earliest example of sultan's clothing in the Topkapı Sarayı belonged to Osman Bey (1299–1326). Nine white-cotton caftans that belonged to Osman Bey are decorated mainly with very large yellow pomegranate motifs and leaves.

There are also rich collections of Ottoman fabrics in the Mevlana Museum at Konya, the Victoria and Albert Museum in London, the Royal Scottish Museum in Edinburgh, the Benaki Museum in Athens, the Textile Museum in Lyons and other museums in Paris, Washington, D.C., Moscow and Bucharest.

According to existing sources, the fabric-producing centre from the fifteenth century onwards was Bursa where, eventually, there were more than ten thousand workshops. However, it is clear that this centre was transferred to Istanbul after the mid-seventeenth century. Velvets, silk velvets, brocades and taffetas from Bursa were famous in Europe, Iran and Russia. In 1502, a law to protect the quality of Bursa fabrics was proclaimed. Textiles were most probably also manufactured in Edirne.

The *kutni* (silk-cotton stripes) of Soma and Bergama, the *sof* (thin mohair) of Tosya and Ankara, the *chatma* (two-pile velvet) of Üsküdar and Amasya and the brocade and silk of Aleppo, Damascus and Khios were also famous.

The motifs on Ottoman fabrics included naturalistic and enlarged floral compositons—the tulip, carnation, hyacinth, anemone, rose, pomegranate, peony, pine cone, enlarged coiled leaves, artichokes, pineapples, rosettes—Chinese clouds and dotted triad motifs. During the sixteenth century, fabrics from Venice and other European centres, and from Baghdad and Damascus, within the Ottoman borders, were brought to Istanbul. The textiles from Europe (especially from Italy) introduced some Western-influenced motifs into Turkish fabric design, for example the artichoke and crown motifs. Pls. 137-139

Plain and patterned silk, cotton and wool were woven. The patterned fabrics were used chiefly for caftans, the plain materials for shirts and underclothing.

From the fifteenth century onwards, up to seven colours—made from plant dyes of high quality—were used in Turkish fabrics. The most widely used colour was red, followed by blue, green, pink, yellow, cream and black. Strips of gold and silver metal were used like thread. During the seventeenth century, plain fabrics increased in number, and the quality of the fabrics wrought with gold and silver thread declined. The tulip motif appeared less frequently and changed its shape, but the use of fan-like carnations and medallions increased; the variety of colours, however, lessened. Pls. 137-138

The most precious Ottoman fabrics were velvet, brocade, taffeta and satin. They are named according to the methods of weaving: *seraser* (silk-and-metal thread), *zerbaft* (heavy silk brocade), *kamha* (silk brocade with gold thread), *mukaddem* (brocade), *kutni* (silk-cotton stripes), *canfes* (thin latticed silk), *atlas* (mercerized satin), *hatai* (stiff silk brocade), *gezi* (watered silk), *selimiye* (striped silk decorated with small flowers), *chatma* (two-pile velvet), *sof* (thin mohair) and *sereng* (tricolour weave). The most valuable cloth is the *seraser*, in which there are five varieties of brocade. *Seraser* caftans were worn as ceremonial robes. They were woven in a pattern with a warp of gold and silver threads. The *chatma*-type of velvets were also very famous; they were used for cushions, curtains and similar objects. Pl. 139

In the eigtheenth century, there was a notable deterioration in the manufacture of textiles. Some good-quality velvets and cloth were produced in the reigns of Sultan Ahmet III (1703–30) and Sultan Mahmut I (1730–54). In order to reduce the amount of silver circulating, Ahmet III forbade the use of silver thread in fabrics. Designs became smaller, colours plainer, the old red turning into a pale pink. In the eighteenth century, the market was saturated with European fabrics. Floral motifs and designs of baroque and rococo influence, but in a cruder style, became fashionable.

The art of fabric-making and embroidery in Turkey declined still further in the nineteenth century. Documents relate that Üsküdar *chatmas* and *selimiye* cloth was sent to the Paris (World Fair) Exhibition of 1855. In 1843, a factory was set up at Hereke to manufacture silks.

Glass

Although the art of glass-making was quite developed in early Islamic art, very little is known about Anatolian Seljuk glassware. The Anatolian Seljuks used locally made coloured glass, embedded in the stucco of window grills. This kind of glass was found during the Kubadabad Palace excavation on the shore of Lake Beyşehir (*c.* 1236).[47] Similar glassware was also found at the Alaeddin Kiosk at Konya. This cobalt-blue, yellow and green-coloured glass is very thick and slightly convex; it has an eyelike ring in the centre. A glass plate decorated with enamel and 30 centimetres in diameter — with an inscription placing it in the reign of Gıyaseddin Keyhusrev II (1237–47) — was discovered in the Kubadabad Palace excavation at Beyşehir; it was most probably made to order in Syria.[48] The inscription is in the three-line Syrian-style Sülüs script on a white background with gilt, which has now darkened to black. In the centre on a yellow background was placed a rosette with arabesque infill. In Kubadabad, fragments of enamelled glass have been found. During the twelfth and thirteenth centuries, the centres of production for enamelled glass and gold paint in the Islamic world were the cities of Aleppo and Damascus, especially during the Ayyubid, Turkish Atabeg and Zengid periods. There are many examples of goblets, vases, decanters and oil lamps from this period, all decorated in the same technique.

In Syria, much enamelled glassware with inscriptions was produced to order for the sultans of neighbouring countries. A glass pitcher with a border of enamelled inscriptions, found during the 1978 excavations in Samosata (Adıyaman), proves once again that the Seljuks imported Ayyubid glassware from Syria.

The earliest known Turkish glassware dates back to the sixteenth-century Ottoman period.[49] During this period glass vases, sugar bowls, decanters, glasses, goblets, containers, tulip vases, rose-water flasks, chandeliers and lamps were made in Istanbul, at Eğrikapı, Bakırköy and in the Tekfur Palace. Stained glass windows were also made; the stained glass of the Suleymaniye Mosque in Istanbul is very famous. During the reign of Mustafa III (1757–74), all glass manufacturing was concentrated in the Tekfur Palace in Istanbul, and glass workshops were not permitted elsewhere. Products below a certain standard were broken, and the craftsmen responsible were punished.

In the nineteenth century, a workshop was set up at Çubuklu to make high-quality glass and crystal. This workshop was purchased by the State in 1846. Very high-quality plain glassware and *çeşmi bülbül* (nightingale's-eye) ware — so-called because of its spiral decoration — was renowned. In 1849, during the period of Sultan Abdul Mecit (1839–61), a dervish named Mehmet Dede, who had learnt the art of glass-making in Italy, set up a workshop at Beykoz in Istanbul. Good-quality glasswork and crystal in a European-influenced style, as well as *çeşmi bülbül* ware were produced there. This ware was called *Eser-i Istanbul* (Istanbul work).

The same style continued in a glass factory founded in 1899 at Paşabahçe in Istanbul. This glass could not compete with the imported, duty-free European glassware. With the opening of the new factory at Paşabahçe in 1935, there was a revival of glass-making that has continued up to the present. The richest collections of Ottoman glassware are in the Topkapı Sarayı Museum in Istanbul and in the private collection of Fuad Bayramoğlu in Ankara.

NOTES

1 Semra Ögel, *Anadolu Selçuk'lularının Taş Tezyinatı*, Ankara, 1966.

2 Beyhan Karamağaralı, *Ahlat Mezar Taşları*, Ankara, 1972.

3 J. Michael Rogers, 'The Çifte Minare Medrese at Erzurum and the Gök Medrese at Sivas: A Contribution to the History of Style in the Seljuk Architecture of 13th-century Turkey' in *Anatolian Studies* XV (London, 1965): 63–85.

4 Ömür Bakırer, *Önüç ve Ondördüncü Yüzyıllarda Anadolu Mihrabları*, Ankara, 1976.

5 Semra Ögel, 'Bemerkungen über die Quellen der anatolisch-seldschukischen Steinornamentik' in *Anatolica* III (Leiden, 1969–70): 189–94.

6 Gönül Öney, 'Elements from Ancient Civilizations in Anatolian Seljuk Art' in *Anatolica* XII (Ankara, 1970): 17–38.

7 Semra Ögel, 'Der Wandel im Programm der Steinornamentik von den seldschukischen zu den osmanischen Bauten' in *Anatolia* II (Ankara, 1968): 103–11.

8 Gönül Öney, 'Sun and Moon Rosettes in the Shape of Human Heads in Anatolian Seljuk Architecture' in *Anatolia* III (Ankara, 1969–70): 195–212.

9 Gönül Öney, 'Die Figurenreliefs an der Hüdavent Hatun Türbe in Niğde' in *Belleten* XXXI, no. 122 (Ankara, 1967): 143–81.

10 Gönül Öney, 'Mounted Hunting Scenes of Anatolian Seljuks in Comparison with Iranian Seljuks' in *Anatolia* XI (Ankara, 1967): 121–89.

11 Gönül Öney, 'Lion Figures in Anatolian Seljuk Architecture' in *Anatolia* XIII (Ankara, 1971): 1–67.

12 Gönül Öney, 'Anadolu Selçuk Sanatında Kartal, Çift Başlı Kartal ve Avcı Kuşlar' in *Türk Tarih Kurumu Malazgirt Anma Yıllığı* (Ankara, 1972): 139–96.

13 Gönül Öney, 'Tombstones in the Seljuk Tradition with Bird, Double-headed Eagle, Falcon and Lion Figures in Anatolia' in *Vakıflar Dergisi* VIII (Ankara, 1969): 283–311; Gönül Öney, 'Über eine ortukidische Lebensbaum-Darstellung' in *Vakıflar Dergisi* VII (Istanbul, 1968): 117–30.

14 Gönül Öney, 'Das Lebensbaum-Motiv in der seldschukischen Kunst in Anatolien' in *Belleten* XXXII, no. 125 (Ankara, 1968): 25–73.

15 Gönül Öney, 'Dragon Figures in Anatolian Seljuk Art' in *Belleten* XXXIII, no. 130 (Ankara, 1969): 171–216.

16 Güner İnal, 'The Place of the Dragon Relief at Susuz Han in the Asian Cultural Circle' in *Sanat Tarihi Araştırmaları* IV (Istanbul, 1971): 153–84.

17 Eva Baer, 'Sphinxes and Harpies in Medieval Islamic Art' in *Oriental Notes and Studies*, 9 (Jerusalem, 1965): Pls. XVII, 29; XIX, 32.

18 Gönül Öney, 'Bull Reliefs in Anatolian Seljuk Architecture' in *Belleten* XXXIV, no. 133 (Ankara, 1970): 83–138; Gönül Öney, 'The Fish Motif in Anatolian Seljuk Art' in *Sanat Tarihi Yıllığı* II (Istanbul, 1968): 142–68; Richard Ettinghausen, *Studies in Muslim Iconography: The Unicorn*, Washington D. C., 1950; Ernst Diez, 'Zodiac Reliefs at the Portal of the Gök Medrese in Sivas' in *Artibus Asiae*, 12, nos. 1–2 (Ascona, Switzerland, 1949): 99–104; Katharina Otto-Dorn, 'Darstellungen des turco-chinesischen Tierzyklus in der islamischen Kunst' in *Beiträge zur Kunstgeschichte Asiens: In Memoriam Ernst Diez*, Istanbul, 1963, pp. 151–6.

19 Katharina Otto-Dorn, 'Bericht über die Grabung in Kobadabad 1966' in *Archäologischer Anzeiger des deutschen Archäologischen Instituts* LXXXIV, no. 4 (Berlin, 1969): 475–9.

20 Friedrich Sarre, *Der Kiosk von Konia*, Berlin, 1936.

21 Katharina Otto-Dorn, 'Der Mihrab der Arslanhane-Moschee in Ankara' in *Anatolia* I (Ankara, 1956): 21–30; Gönül Öney, *Ankara'da Türk Devri Dini ve Sosyal Yapıları*, Ankara, 1971.

22 Ruçhan Arık, *Batılılaşma Dönemi Anadolu Tasvir Sanatı*, Ankara, 1976; Günsel Renda, *Batılılaşma Döneminde Türk Resim Sanatı: 1700–1850*, Ankara, 1977.

23 Gönül Öney, *Turkish Ceramic Tile Art in Anatolia*, Tokyo, 1975; Gönül Öney, *Anadolu Türk Çini ve Seramik Sanatı*, Istanbul, 1975.

24 Ömür Bakırer, *13.–14. Yüzyıl Anadolu Mihrabları*.

25 Katharina Otto-Dorn, 'Bericht über die Grabung in Kobadabad 1966' in *Archäologischer Anzeiger des deutschen Archäologischen Instituts* LXXXIV, no. 4 (Berlin, 1969): 438–506; Gönül Öney, 'Kubadabad Ceramics' in *The Art in Iran and Anatolia from the 11th to the 13th Century A. D.: Colloquies on Art and Archaeology in Asia* no. 4 (University of London, Percival David Foundation of Chinese Art, London, 1974): 68–84.

26 Sarre, *Konia*.

27 J. Carswell and C. J. F. Dowset, *Kütahya Tiles and Pottery*, 2 vols., Oxford, 1972; Oktay Aslanapa, 'Report on Iznik' in *Anatolian Studies* XVII (London, 1967): 34–5.

28 Kurt Erdmann, 'Ka'ba Fliesen' in *Ars Orientalis* III (Ann Arbor, 1959): 193–7.

29 Oktay Aslanapa, 'Pottery and Kilns from the Iznik Excavations' in *Forschungen zur Kunst Asiens: In Memoriam Kurt Erdmann*, Istanbul, 1970, pp. 140–6.

30 Carswell and Dowsett, *Kütahya*.

31 Oktay Aslanapa, *Türkische Fliesen und Keramik in Anatolien*, Istanbul, 1965.

32 Oktay Aslanapa, 'Turkish Ceramic Art' in *Archaeology* XXIV, no. 3 (New York, June, 1971): 209–19.

33 Carswell and Dowsett, *Kütahya*.

34 Carswell and Dowsett, *Kütahya*.

35 Carswell and Dowsett, *Kütahya*.

36 Gönül Öney, *Türk Devri Çanakkale Seramikleri—Turkish Period Çanakkale Ceramics*. Ankara, 1971.

37 Gönül Öney, 'Die Techniken der Holzschnitzerei zur Zeit der Seldschuken und während der Herrschaft der Emirate in Anatolien' in *Sanat Tarihi Yıllığı* III (Istanbul, 1969–70): 299–305.

38 Katharina Otto-Dorn, 'Seldschukische Holzsäulenmoscheen in Kleinasien' in *Aus der Welt der islamischen Kunst: Festschrift für Ernst Kühnel*, Berlin, 1959, pp. 59–88: idem, 'Die Ulu Dschami in Sivrihisar' in *Anatolia* IX (Ankara, 1965 issued in 1967): 161–8.

39 Gönül Öney, *Ankara'da Türk Devri Dini ve Sosyal Yapıları*, Ankara, 1971.

40 Rudolph M. Riefstahl, 'A Seljuk Koran Stand with Lacquerpainted Decoration in the Museum of Konya' in *Art Bulletin* 15, no. 4 (Providence, 1933): 361–723.

41 Rudolph M. Riefstahl, 'Primitive Rugs of the Konya Type in the Mosque of Beyşehir' in *The Art Bulletin* XIII (Providence, 1931): 177–220; Oktay Aslanapa and Yusuf Durul, *Selçuklu Halıları*, Istanbul, 1973; Şerare Yetkin, *Türk Halı Sanatı*, Istanbul, 1974, pp. 177–220.

42 Kurt Erdmann, *Der türkische Teppich des 15. Jahrhunderts*, Istanbul, 1957.

43 C. J. Lamm, 'The Marby Rug and Some Fragments of Carpets Found in Egypt' in *Svenska Orientsällskapets Arsbok* (Stockholm, 1937): 51–130.

44 Wilhelm von Bode and Ernst Kühnel, *Antique Rugs from the Near East*, New York, 1922; Brunswick, 1958.

45 J. Iten-Maritz, *Turkish Carpets* (Trans. Elisabeth and Richard Bartlett), Tokyo and Fribourg, 1977; Kurt Erdmann, *Der orientalische Knüpfteppich: Versuch seiner Darstellung, seiner Geschichte*, Tübingen, 1955, 1960, 1965.

46 Oktay Aslanapa, *Turkish Art and Architecture*, London, 1971; New York, 1972.

47 Otto-Dorn, 'Grabung in Kobadabad 1966'.

48 Janine Sourdel-Thomine, 'Plat en Verre' in *Archäologischer Anzeiger des deutschen Archäologischen Instituts* LXXXIV, no. 4 (Berlin, 1969): 501–2.

49 Fuat Bayramoğlu, *Turkish Glass Art and Beykoz-Ware*, Istanbul, 1976.

Turkish Metalwork

by Ülker Erginsoy

The Seljuk Period

In the middle of the eleventh century, the Seljuk Turks of central Asia invaded the lands of the Near East and, in a short time, established an empire stretching from Khorassan to Anatolia. It was in the latter half of the same century that the Turks settled in very large numbers in the Near East and formed the third largest language and cultural group in the Islamic world, next to the Arabs and Persians. The reunification—under Seljuk rule—of the Islamic world, which had been suffering from political disintegration in the pre-Seljuk period, led to important developments in the art of metalwork—as it did in every branch of Islamic art. The metal objects of the Seljuk period partly reflect the influence of the ancient cultures of the lands through which the Turks had passed and partly the art of their homeland—central Asia. The extreme variety and the quantity of innovations in materials, techniques, vessel types, shape and decoration are impressive.

Artifacts were produced in both the noble metals (gold and silver) and in copper alloys (bronze and brass) during the Seljuk period. However, vessels made of the noble metals are less frequent than in the early Islamic period. Gold and silver were rarely used as basic materials, except in jewellery, after the middle of the twelfth century. It is generally accepted that, as a religion, Islam was adverse to the use of gold and silver vessels; therefore, few objects were made from the noble metals during that period.[1] The thirty-fourth and thirty-fifth *ayets* of the ninth Surah of the Koran state:

> But to those who treasure up gold and silver and expend it not in the way of God, announce tidings of a grievous torment. On that day their treasures shall be heated in hell fire, and their foreheads, and their sides and backs shall be branded with them.... 'This is what ye have treasured up for yourselves: taste therefore your treasures.'[2]

In the mid-ninth century, these Koranic phrases were interpreted by the hadith (Islamic tradition) as: 'He who drinks from gold and silver vessels, drinks the fire of hell'. Hence, the prohibition of the use of the noble metals became more definite. But despite religious prohibitions, jewellery and vessels of gold and silver continued to be produced both in the early Islamic period and during the first century of Seljuk rule. Islamic sources state that some gold and silver objects were even used within religious edifices.[3] Unfortunately few objects made of the precious metals referred to in the sources have survived. It is thought that some of these objects were taken as spoils and some were melted down to be used in the minting of dinars and dirhems.[4]

The decrease in the number of gold and silver objects in the twelfth century was caused, most probably, by state decisions concerning the economic situation of the country rather than by religious censure. The 'silver famine' that occurred in the eleventh century[5] must have played an important role in shaping official attitudes at the time.

This decrease in the number of artifacts made of noble metals led to their gradual replacement by objects made of copper alloys. From about the last quarter of the twelfth century, brass alloy (which has a lighter and brighter tone than bronze and is particularly suitable for beaten artifacts) began to be used in addition to bronze. Another result of the replacement of the noble metals with copper alloys was a great development in decorative techniques. Seljuk craftsmen developed new techniques that enabled bronze and brass objects to be decorated with sufficient ostentation and magnificence to be used as substitutes for gold and silver artifacts. All the techniques of the ancient Near East, such as engraving, embossing, gilding and niello were skilfully employed during this period. Even *cloisonné* enamel—a technique rare in the Islamic world, which was adopted from Byzantine art—was applied with consummate skill. Pierced-work and inlaying were developed in the mid-twelfth century in Khorassan to an extent hitherto unseen. Pierced-work was used to decorate votive lamps that were beaten from thin sheets of metal, as well as incense-burners, candle-holders and braziers. The latter were produced by

casting; the perforated decoration sometimes covered the whole surface of the object.

After a rapid development in Khorassan in the second half of the twelfth century, the inlay technique was brought to Mesopotamia at the beginning of the thirteenth century by Khorassanian craftsmen fleeing westwards from the Mongol threat in the east. The technique of inlaying was further developed in Mesopotamia (particularly in Mosul) under the Zengids, a Seljuk Atabeg dynasty, and Mosul craftsmen[6] spread it still further to Syria, Egypt and Anatolia. Along with red copper and silver fillings, black niello was also used on the inlaid brass and bronze objects of the Seljuk period. This resulted in a polychrome composition, comparable with the *minai* ceramics and miniatures of the same period.

Cast metal objects sparsely decorated with engraving were the everyday vessels of the Seljuk period. Silverware and bronze and brass objects decorated with pierced-work or inlaying had a higher artistic value, and social prestige attached to them. They were commissioned by the nobility and, after the mid-twelfth century, also for well-to-do merchant families, to be displayed in palaces and mansions. Fine metal artifacts of the Seljuk period, particularly those executed in inlay, often bear inscription friezes. These inscriptions are usually of a benedictory character, but they occasionally include the name of the noble or merchant owner or of the craftsman who produced the object. On some vessels, a date and (on a very few) the name of a city is to be found. Objects bearing a recognizable name, date and provenance are very important as historical documentation and also very helpful in the classification of artifacts whose inscriptions give no information at all. The titles, cognomens and appellations, given together with the owner's and artist's names, provide definite information concerning the social framework of a given period.

Metal objects of the Seljuk period also display great variety in shape and type. In addition to objects like plates, trays, bowls, ewers, jugs, lamps and zoomorphic vessels, which existed in the pre-Seljuk period, new artifacts with various functions appeared: mirrors, mortars, censers, braziers, caskets, pen-cases, inkpots, buckets, candleholders, basins, cauldrons, rose-water sprinklers, pumiceholders, door-knockers, tent standards and drums. Many Seljuk metal objects, especially those produced in Iran, are either completely zoomorphic in form, decorated with animals or inspired by animal forms.

A certain group of ewers show similarity to Seljuk tombs in their general shape and surface modelling.[7] This group of ewers, produced in Khorassan at the end of the twelfth century and the beginning of the thirteenth century, indicates that metal workers of the Seljuk period were as much inspired by monumental architecture as by animal forms.

The development of a multi-coloured inlay technique produced an increase in the variety of motifs and richer figural compositions. Among the new compositions entering the iconograhic repertoire of Islamic metalwork were a great number of Seljuk figural compositions that reflected strong central-Asian influences. These consisted of scrolled stems terminating in animal heads, animal groups interlinked by tails or wing tips forming whorl motifs, a monarchic figure seated cross-legged on a throne and holding a cup or a pomegranate in his hand, mounted figures hunting with falcons or trained cheetahs and various animal compositions including legendary and mythical creatures such as the harpy, sphinx, griffin and dragon (some apparently expressing symbolic meanings related to shamanistic beliefs). Other figural compositions from the Seljuk repertoire included astrological symbols, scenes of court entertainments containing musicians, dancers, acrobats and wrestlers, polo games and genre scenes reflecting everyday life that can be seen especially in the work of Mosul craftsmen.

In the decoration of metal objects from the Seljuk period, particularly on those made in Mesopotamia after 1220, geometric designs began to appear, contrasting greatly with foliate and figural compositions. Geometric patterns were constructed from interlinked or superimposed square, triangular, circular and octagonal units or from straight, curved or chevron lines. Changes in the direction of the lines are developed into endlessly repeating patterns, perhaps suggestive of the idea of infinity.

Apart from figural, foliate and geometric compositions, inscription friezes also occur in the decoration of Seljuk metal objects. Kufic, Naskhi, floriated Kufic, floriated Naskhi and braided Kufic calligraphy, used in other media, were used on metalwork, but craftsmen of this period developed a hitherto unknown form of calligraphy: 'figural script'[8], which is only found in Islamic art in the decoration of metal objects. This script was first developed in Khorassan in the third quarter of the twelfth century and began to spread to other areas of the Seljuk world from the beginning of the thirteenth century onwards. In one of its forms, which is used only for Naskhi and known as 'animated (or talking) script', the vertical strokes of the characters are metamorphosed into human figures involved in various activities: bearing drinking cups, ewers, swords, shields, bows and arrows or musical instruments and engaged in conversation with hand and arm gestures. The lower parts of the characters are linked to one another by birds, dragons or hares. In another type of script adapted to both Naskhi and Kufic, the vertical stems of the letters terminate in human heads. This type is known as 'human-headed Kufic' or 'human-headed Naskhi'. Figural scripts, which impress us with their great variety and creativity, are a very important innovation that Seljuk metalworkers contributed to Islamic art.

Metal objects, coming from various areas of the Seljuk empire with different cultural traditions, display a great variety of regional features. During the Seljuk period in Iran, from the mid-eleventh century to the Mongol invasion in 1221 and 1222, artifacts were produced in both noble metals and copper alloys. Almost all gold and silver pieces date from the Great Seljuk period (before 1157). Among the silver artifacts belonging to Iran, only two objects give important information in their inscription friezes: a salver,[9] dated 1066, made for the Great Seljuk Sultan Alp Arslan (1063–73) and a candleholder,[10] dated 1137, bearing the name of Sultan Sanjar

(1118–57). These pieces indicate that the few Seljuk silver objects were made mostly for the nobility.

Artifacts of copper alloys were produced in much greater quantity in Seljuk Iran. Considering these objects as a whole, the co-existence of two separate schools of metalwork becomes evident. The products of the first school were cast bronze artifacts, worked in moulded relief, engraving or pierced-work. Almost all of the inscriptions on objects of this group contain benedictory phrases of good will; there is no information about the provenance or date of the object. The second school produced cast or beaten bronze or brass objects decorated with inlay. The inscriptions of inlaid artifacts generally give some information about the object. Since many of the inscriptions contain the adjective or *nisba* (meaning 'coming from') 'al-Nishapuri' or 'al-Herati' together with the names of master craftsmen, and since there is an inscription on a bucket in the Hermitage, Leningrad,[11] stating that it was made in 1163 in the city of Herat, inlaid Iranian Seljuk work has been attributed to the Khorassan area. The earliest inlaid article with an inscribed date from the Khorassan school is a pen-case dated 1148.[12] Hence, inlaid objects from Seljuk Iran are datable to the period between 1148 and the Mongol invasion. Khorassanian metalworkers using the inlay technique, gave great importance to the depiction of iconographical themes, such as astrological symbols, court, hunt and entertainment scenes. The type and form of the vessel and the variety of decorative techniques employed were also important; sometimes several techniques were used simultaneously on a single object.

Turkish museums contain no gold or silver artifacts belonging to the Seljuk period in Iran;[13] almost all of the existing pieces are representative of the first school of bronzeware mentioned above. One object belonging to the second school (the Khorassan school) is a circular brass casket in the Hacıbektaş Museum; its lid is decorated with copper and silver inlays.[14] The lower part of this unique piece is engraved with animal compositions, and on the lid are inlaid scenes of entertainments. No information can be gleaned from the benedictory inscriptions encircling the body of the vessel; however, the compositions on the lid are an aid to ascertaining the date and provenance. The figures of revellers seated cross-legged, bearing cups, entertained by dancers and musicians playing tambourines, harps, flutes and lutes bear a considerable ressemblance to those on the bucket from Herat dated 1163 (see note 11). The depiction of the scenes on a plain ground, the ample copper inlay along with that of silver (both unworked with details), the archaic character of the plants representing the garden, the male figures with long hair, and the comparatively oversized fruit bowls and ewers seen among the human figures suffice to give this artifact an even earlier date than the Herat bucket. The casket in the Hacıbektaş Museum is one of the earliest inlaid objects of the Khorassanian school on which human figures are depicted.

After the death of the Great Seljuk Sultan Malik Shah in 1092, the Seljuk lands were divided into small independent regions governed by various Turkish dynasties.

These political divisions did not affect the artistic development of the period; on the contrary, the increase in royal demands for works of art led to an increase in artistic activity. The art of metalwork attained a very high standard in Mesopotamia, which was ruled by the Zengids (Seljuk Atabegs) at that time. The majority of artifacts surviving from the Atabeg period is of inlaid brassware dated between 1220 and 1260. The variety and richness of the iconographical themes used in their decoration and the technical mastery in the use of inlays make these objects the finest in Islamic metalwork.

There is much evidence to suggest that during the Atabeg period master craftsmen in this medium worked in Mosul. This can be assumed from the existence of inlaid objects signed by the master who often used the designation 'al-Mawsili' ('from Mosul'),[15] from a ewer in the British Museum that bears an inscription stating that it was made in the city of Mosul in 1232,[16] and from a group of objects inscribed with the name and royal title of the Mosul Atabeg Badr al-Din Lu'lu' (1233–59).[17] The sudden emergence of inlaid metalwork at Mosul at the beginning of the thirteenth century is attributed to the settling at Mosul of Khorassanian craftsmen to escape from the Mongol threat; there they instigated a new school: the Mosul school. However, all the artifacts bearing the signature of Mosul craftsmen were not necessarily made in the city of Mosul, or indeed in Mesopotamia. From the inscription on some objects it may be deduced that a great number of Mosul craftsmen migrated to Syria, Egypt and Anatolia, where they worked for the Amirs and Maliks of these areas. Hence, as a result of this migration, the inlay technique — Khorassanian in origin — and many motifs and iconographic themes belonging to Khorassan were amalgamated with Mesopotamian characteristics and then spread throughout the various Islamic regions of the Near East.

Mesopotamian craftsmen working in inlay favoured iconographic themes, especially crowded throne scenes, hunting, entertainment and genre scenes, for which they naturally preferred the broad surfaces provided by simply shaped vessels. They chose those shapes most suitable to their preferred figural compositions, avoiding fluted or embossed trunks or animal figurines, which had decorated shoulders, handles and beaks of Khorassanian metalwork — all of which were too complex for their purpose. Multicoloured inlay was adopted by Mosul craftsmen as the medium most suitable for narratives on metalwork and again, unlike Khorassanian craftsmen, they employed this technique exclusively.

Among the Seljuk metal objects in Turkish museums, there are a few important examples of the Mosul school. One of these is a ewer, dated 1229, in the Museum of Turkish and Islamic Art, Istanbul.[18] This piece is one of the very few inlaid Seljuk artifacts in which figural decoration has not been used. The ewer is inscribed on the neck as being the work of İyas, *ghulam* (apprentice or hireling) of the master craftsman Abdul Karim ibn at-Turabi of Mosul. 'At-Turabi' is known to have been the *nisba* of some inhabitants of Merv, in Khorassan, who were engaged in commerce. Abdul Karim, who used both the designation 'al-Mawsili' and 'at-Turabi' appears,

Pl. 140

Pl. 141

therefore, either to have come from Khorassan or to have Khorassanian parentage. The inscription that gives this information strengthens the probability that inlay technique was brought to Mosul by Khorassanian craftsmen. Another fine object belonging to the Mosul school that Pl. 142 can be found in Turkish collections is a brass candleholder in the Hacıbektaş Museum. It bears a great resemblance in shape and decorative technique to other candleholders signed by Mosul craftsmen and dated to the second quarter of the thirteenth century.[19] Thus, it may also be the work of a Mosul craftsman and belong to the same period.

There are very few surviving metal objects of Syrian origin either from the Great Seljuk period or from that of the Syrian Seljuks. One example from this area and Pl. 143 period, a brass votive lamp executed in pierced-work, is in the Museum of Turkish and Islamic Art, Istanbul.[20] This piece, which carries the date 1090, was brought to Istanbul from the Umayyad Mosque in Damascus. Since at that time Damascus was under the domination of Sultan Tutuş, son of the Great Seljuk Sultan Alp Arslan, the lamp is a Syrian object of the Great Seljuk period and is one of the very rare dated pieces of the eleventh century; therefore, it is of great importance despite its uninspired workmanship.

Until recently, very few metal objects were thought to be of Anatolian Seljuk origin. However, recent research has revealed the existence of many bronze and brass objects coming from this area. Furthermore, thirteenth and fourteenth-century sources state that artifacts made from the noble metals existed in Anatolia during the Seljuk period.[21] İbn Bibi writes in his *History of the Seljuks* that the wedding feast of Sultan İzzeddin Keykavus (1211–19) was presented on gold and silver vessels and platters and that the treasury of the Anatolian sultans was stocked with gold artifacts. Unfortunately, no trace of these precious objects remains today, apart from a few small pieces of personal ornament. One Seljuk ornamental object attributable to Anatolia is the very fine Pl. 147 belt with silver buckles in the British Museum[22] which, according to the museum inventory, was acquired in Anatolia. The buckles are decorated with pierced-work and are gilded. One of the mythical animal compositions decorating them—the double-headed eagle—can be found in Anatolian art from 2000 BC, on the seals of Kültepe, Karahüyük and Boğazköy and on the stone carvings of Hittite Yazılıkaya and Alacahüyük. The double-headed eagle motif was frequently found in southeast Anatolia in architectural decoration and in the minor arts of the Anatolian Seljuks towards the end of the Pl. 112 twelfth century and from the thirteenth century onwards in central and east Anatolia. The double-headed eagle can also be seen on coins minted at Diyarbakır by the Artukid princes, Nasreddin Mahmut (1200–22) and Rukneddin Mavdud (1222–31). The belt (which we think was made in the first half of the thirteenth century in the Artukid Emirate) must have belonged to a person of great importance in view of the decoration: double-headed eagle, sphinx, griffin and lion—all royal and solar symbols.

One of the metal artifacts of the Seljuk period, which is Pl. 144 definitely Anatolian in origin, is a bronze lamp bearing an inscription with the provenance Konya and the date 1280. Three other objects bear the names of Artukid princes.[23] The lamp was certainly made in Konya, and the other objects can be attributed with considerable assurance to south-east Anatolian workshops and to the period of the princes (*Maliks*) mentioned in the inscriptions. Apart from these four objects, the bronze door Pl. 148 knocker of the Ulu Cami at Cizre may also be ascribed to south-east Anatolia.

Although the group of objects attributable to Anatolia through the information given in inscriptions is very sparse, these objects display exquisite workmanship and a great variety of decorative techniques including piercedwork, embossing, *cloisonné* enamel, cast relief and inlay, indicating the existence of advanced metal workshops in Seljuk Anatolia that employed several techniques.

Other metal artifacts also exist; they can be ascribed to Anatolia, despite the lack of confirmatory inscriptions, because the form, technique or decorative detail resemble the above-mentioned group of metalware. This second group of objects, mostly found in Turkish collections, further strengthens the hypothesis that there were highly skilled multi-technical metalwork ateliers in Seljuk Pls. 145, Anatolia.[24] This group consists of objects in pierced- 146, 148- work, cast relief, engraving, embossing and inlay. 151, 153

Unlike those of Mesopotamia, who worked almost exclusively in inlay, Anatolian craftsmen experimented —as did Iranian craftsmen—with various decorative techniques, using several simultaneously on a single piece. A *cloisonné* enamelled bowl from the Artukid Emirate, on the other hand, is an example of the influence of the Byzantine heritage on Anatolian craftsmen of the period.

Anatolian Seljuk metalwork is characterized by regional and cultural eclecticism in both motif and decorative technique. Motifs often encountered on the objects from this area—the enthroned royal figure seated cross-legged with one hand on his hip, the other bearing a drinking cup or pomegranate, the mounted hunter with a falcon, mythical creatures guarding the tree of life—are themes of central-Asian origin. Scenes of paired animals in combat, hunting scenes and scenes from the Iranian narrative *Bahram Gur and Azade* are taken from the Iranian iconographical repertoire, as is figural script terminating in human or dragon heads. A strong Byzantine influence can be detected in scenes of St George and the dragon, the ascension of Alexander and classic busts, which, it appears, were employed as astrological symbols. The motifs that occur most frequently on Anatolian Seljuk metalwork are those typical of the region itself: heraldic symbols of royalty, such as the single or doubleheaded eagle, lion, griffin and sphinx; astrological signs that were thought to have a protective significance; 'sun' symbols in the form of the eagle, sphinx or griffin; 'moon' symbols, such as the bull, dragon or hare; amalgamate compositions of 'sun' and 'moon' symbolism (or antagonism). The bull motif can be found in Anatolian art as early as the sixth millennium BC, and the doubleheaded eagle motif from the second millennium BC onwards. These technical and decorative characteristics identify an intelligent artistic synthesis of widely variant influences as the major factor in Anatolian metalwork.

211

The Ottoman Period

From the mid-fourteenth century onwards, Islamic metalwork went through a period of stagnation and then of decline. One of the main reasons for this appears to be a rivalry between metalwork and Chinese blue-and-white porcelain, which gained great popularity at that time in the Near East and in other parts of the world. In addition, technical advances—particularly the use of metals like bronze and brass for making cannons—adversely affected the development of Islamic metalwork.

During the Ottoman period, bronze was hardly used; the great majority of artifacts were made of silver, brass or tinned copper. Some artifacts from the Ottoman period can be attributed to royalty by their inscriptions, which renders them important. The objects with sure attributions in collections outside of Turkey include a small bronze vase in the Louvre, dated 1329, which bears the name of Sultan Orhan (1326–59);[25] a bronze goblet in the Soviet collections, with the name of Sultan Murat II (1421–51);[26] a bronze ewer in the Louvre bearing the name of Sultan Mehmet II the Conqueror (1451–81);[27] a ewer and vase with the name of the same sultan in the Museum of Islamic Art, Cairo,[28] and a second small bronze vase in the Louvre, bearing the name of Sultan Suleyman the Magnificent (1520–66).[29]

To this group may be added a pair of brass candleholders[30] and a brass lantern[31] bearing the name of Sultan Beyazıt II (1481–1512) in the Museum of Turkish and Islamic Art, Istanbul. These engraved pieces, unlike Seljuk artifacts, but like the majority of Ottoman metalware, are decorated solely with inscription friezes,

Pl. 152

arabesques and floral designs and not with figural compositions. The candleholders have the same shape as artifacts developed during the Great Seljuk period, and the polygonal and domed lantern is a repetition of a shape developed in Mameluke Egypt. Although these pieces show little innovation in technique, design and shape, they have been given monumental dimensions reflecting the grandeur of their owners.

Besides the objects bearing the names of Ottoman sultans, there are other artifacts that can be attributed to the Ottoman period. They were executed in various techniques, producing the candleholders, goblets, lamps, ewers, caskets, mirrors, trays, pen-cases, lanterns, censers and rose-water sprinklers that can be found throughout Turkish and world collections. During this period, however, artistry in metalwork was most frequently encountered in military artifacts. Here we are confronted with highly decorated works of exquisite quality: innumerable helmets, shields, swords, daggers, maces and even horse armour, the great majority of which is to be found in Turkish museums. These objects are richly inlaid and gilded; those used for royal ceremonies were encrusted with precious stones. The technique of encrustation—a familiar form of decoration in the Near East from a very early period that continued in Byzantine art—underwent a phase of extensive development in the Ottoman period, especially after the sixteenth century. Encrustation is the most important Ottoman innovation in Islamic metalwork and the surest reflection of the splendour of the period.

Pl. 154

The decoration of Ottoman metal objects became more naturalistic towards the eighteenth century, when motifs typical of Ottoman art such as the pomegranate, tulip,

140 Casket, engraved brass; lid inlaid with red copper and silver, D. 22 cm. Iran (Khorassan School), Seljuk period, 3rd quarter of the 12th cen. Hacıbektaş Museum.

141 Ewer, brass inlaid with red copper and silver, made by İyas of Mosul, H. (without lid) 39 cm. Mesopotamia (Mosul School), Seljuk Atabeg period, dated 1229. Museum of Turkish and Islamic Art, Istanbul.

142 Candleholder, brass inlaid with silver, H. 33.5 cm, D. 32 cm. Mesopotamia (Mosul School), Seljuk Atabeg period, 2nd quarter of the 13th cen. Hacıbektaş Museum.

143 Votive lamp, brass with pierced-work, H. 33 cm. Syria (probably Damascus), Great Seljuk period, dated 1090. Museum of Turkish and Islamic Art, Istanbul.

144 Lamp, gilded bronze with embossing and pierced-work, made by Ali ibn Muhammad of Nusaybin, H. 20 cm. Konya, Anatolian Seljuk (probably Konya), dated 1280. Ethnographic Museum, Ankara.

145 Incense-burner, brass with engraving and pierced-work, D. 18 cm. Anatolian Seljuk (probably Konya), mid 13th cen. Mevlana Museum, Konya.

146 Lantern, gilded bronze with pierced-work, H. 25 cm. Anatolian Seljuk (probably Konya), 2nd half of the 13th cen. Mevlana Museum, Konya.

147 Belt buckles found in Anatolia, silver. Anatolian Seljuk (probably the Artukid Emirate), 2nd quarter of the 13th cen. British Museum, London.

148 Door knocker, bronze with cast relief, Ulu Cami, Cizre, H. 28 cm. Anatolian Seljuk, Artukid Emirate (probably Diyarbakır), early 13th cen. Museum of Turkish and Islamic Art, Istanbul.

149 Plaque, bronze with cast relief, 114 × 11 cm. Anatolian Seljuk, late 13th cen. Museum of Turkish and Islamic Art, Istanbul.

150 Kettledrum, bronze with engraving, H. 65 cm. Anatolian Seljuk, Artukid Emirate (probably Diyarbakır, where it was found), early 13th cen. Museum of Turkish and Islamic Art, Istanbul.

151 Base of a candleholder, brass with embossing and engraving, D. 46.5 cm. Anatolian Seljuk, Artukid Emirate (probably Diyarbakır), early 13th cen. Ethnographic Museum, Ankara.

152 Candleholder, brass with engraving, bearing the name of Sultan Beyazıt II (1481–1512), H. 89 cm, D. 73 cm. Ottoman period, early 16th cen. Museum of Turkish and Islamic Art, Istanbul.

153 Mirror, steel with gold inlay, D. 21 cm. Anatolian Seljuk, early 13th cen. Topkapı Sarayı Museum, Istanbul.

154 Frontal for a horse's head, gilded copper with engraving, stamp of the Imperial Armoury. 61 × 24 cm. Ottoman period, 16th cen. Armoury, Topkapı Sarayı Museum, Istanbul.

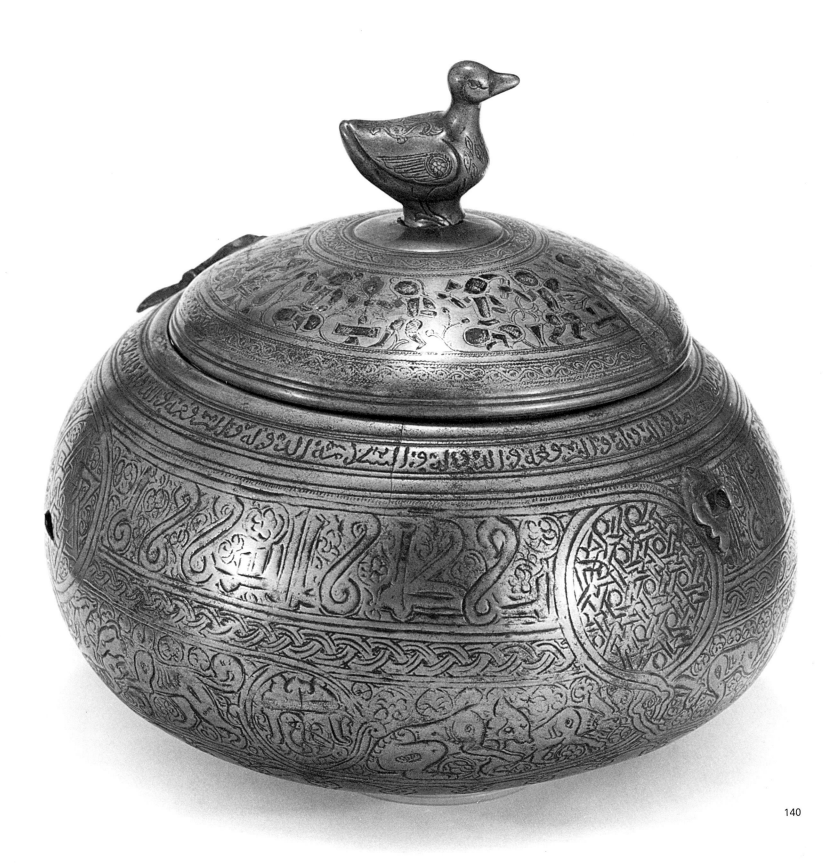

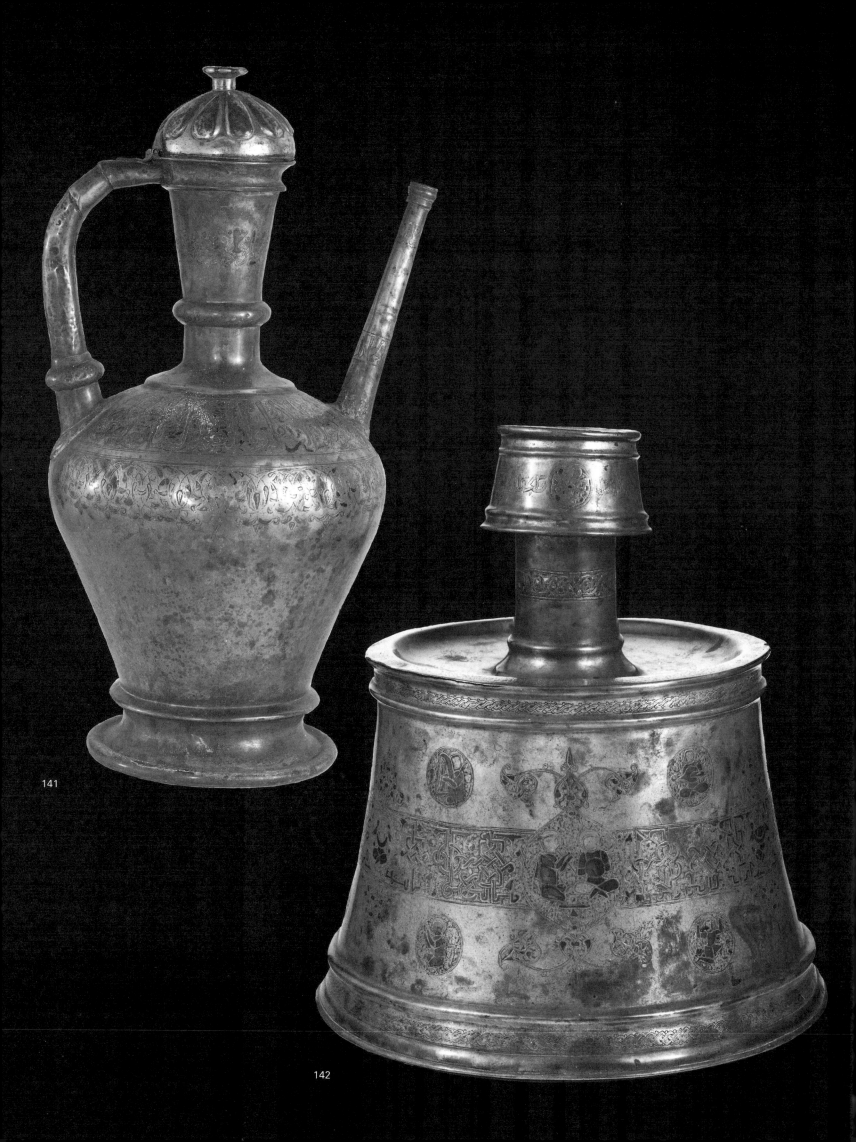

141

142

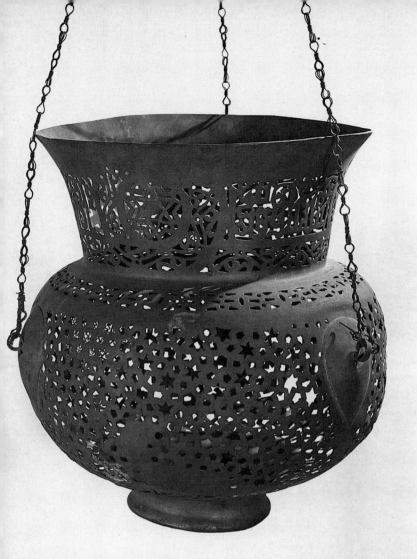

143 △

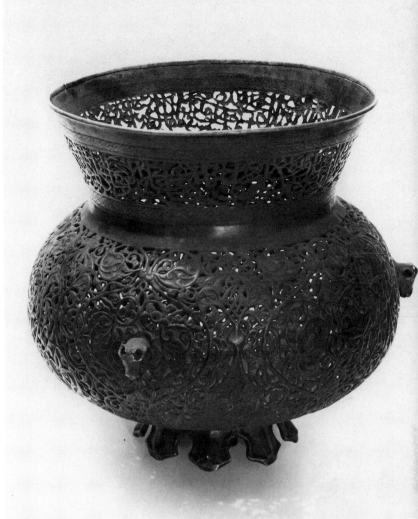

145 ▽

146 ▽

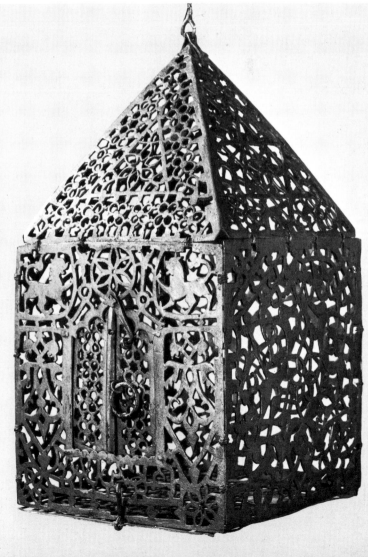

144 △

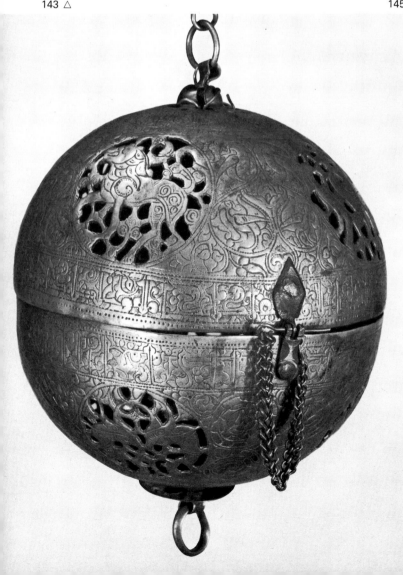

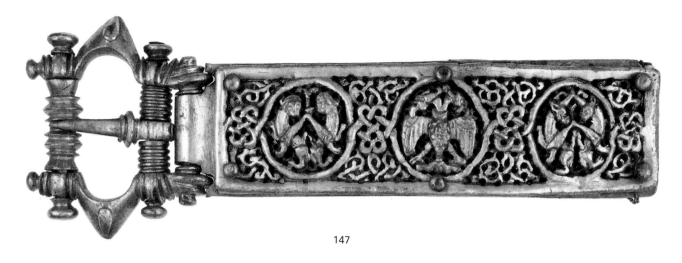

147

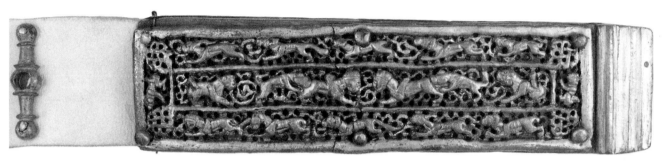

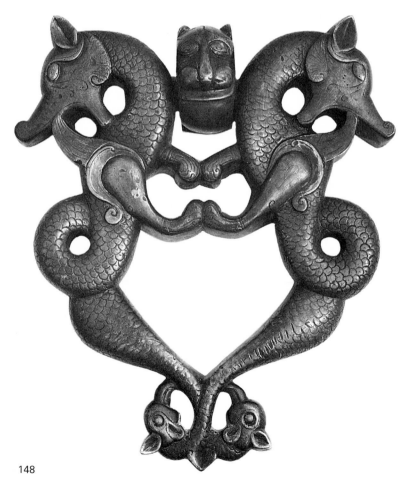

148

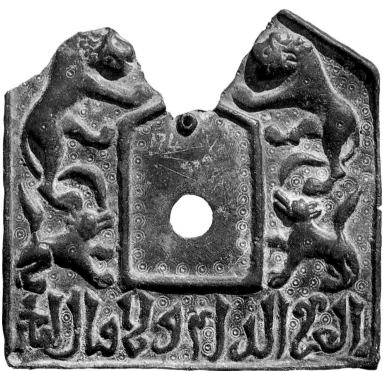

149

150

151

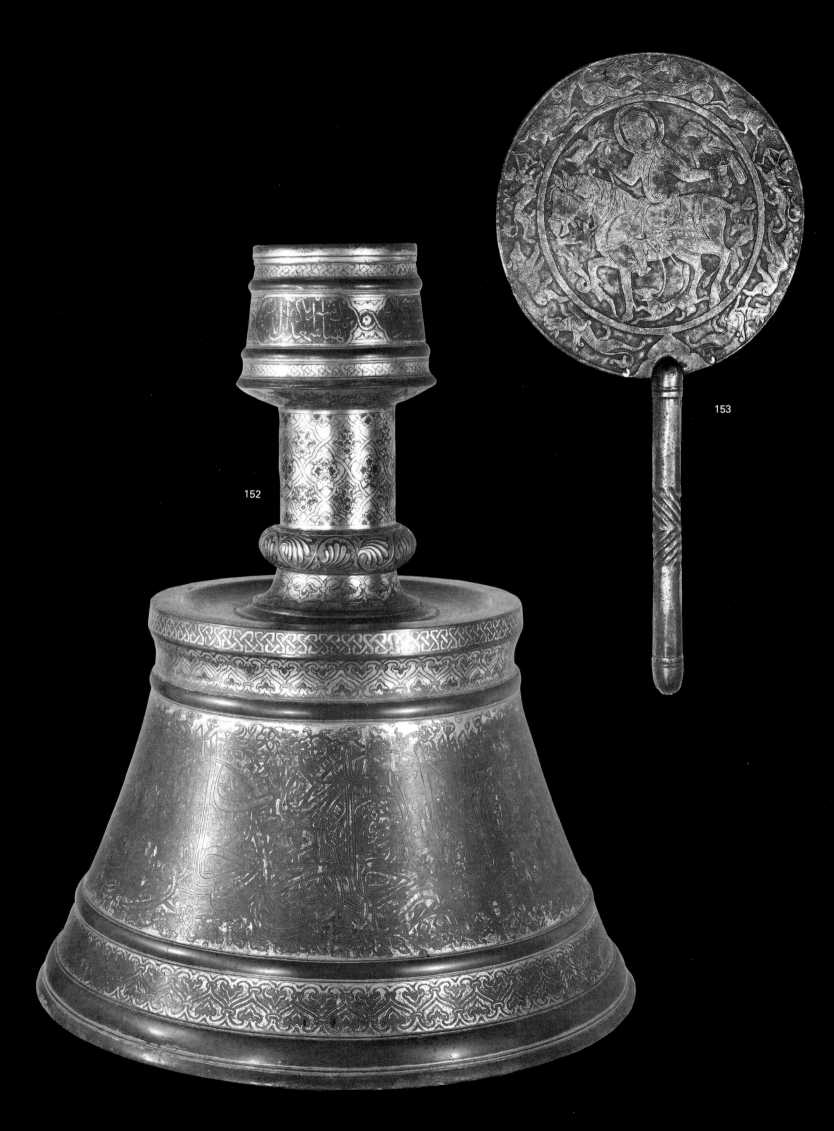

152

153

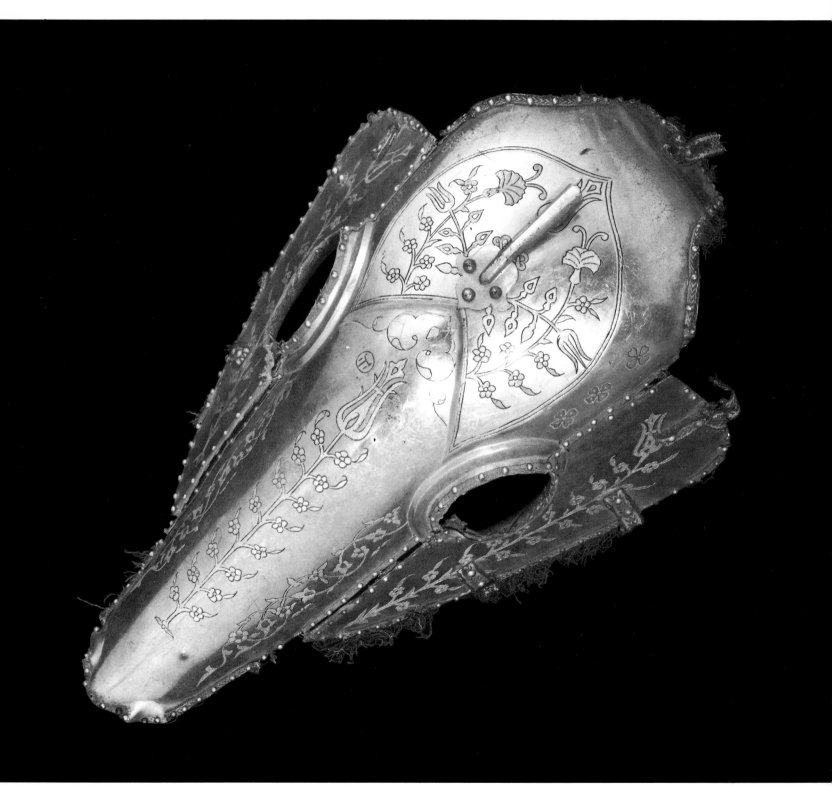

154

eglantine, hyacinth and carnation can be seen. During the nineteenth century, Western influence on Ottoman artifacts can be discerned in the use of the *tombac* (gilded copper) technique and rococo designs.

This short survey explains that the major innovations in Islamic metalwork took place during the Seljuk period. The introduction of new techniques, types of vessels, shapes and decoration gives the Seljuk period a special place in the history of Islamic metalwork, because of the central-Asian elements the Seljuk Turks brought with them to the Islamic world and because of the synthesis they produced of the local elements assimilated in their adopted regions. It was indeed during the Seljuk period that Islamic metalwork reached its peak.

NOTES

[1] M. Dimand, 'Near Eastern Metalwork' in *Bulletin of the Metropolitan Museum of Art* XXI, no. 8 (New York, 1926): 194; R. Ettinghausen, 'The Character of Islamic Art' in *The Arab Heritage* (Ed. by N. A. Faris), Princeton, 1944, pp. 254–5.

[2] From the Koran, trans. by the Rev. J. M. Rodwell, M. A., London, 1950 (1st ed., 1909).

[3] M. Ağaoğlu, 'Remarks on the Character of Islamic Art' in *Art Bulletin* XXXVI, no. 3 (Providence, 1954): 180–4, 187–90.

[4] M. Ağaoğlu, 'Remarks', p. 188, note 91.

[5] J. Orbeli, 'Sasanian and Early Islamic Metalwork' in *A Survey of Persian Art* (Ed. A. U. Popel), vol. II, London and New York, 1967, p. 761.

[6] For the migration of craftsmen see: R. Ettinghausen, 'Interaction and Integration in Islamic Art' in *Unity and Variety in Muslim Civilization* (Ed. E. G. Grunebaum), Chicago, 1955, pp. 110–13.

[7] M. Ağaoğlu, 'The Use of Architectural Forms in Seljuk Metalwork' in *Art Quarterly* VI (1943): 92–8.

[8] For the types of figural script in Seljuk metalwork see: R. Ettinghausen, 'The Bobrinski Kettle' in *Gazette des Beaux Arts* 24 (Paris, 1943): 193–208; D. S. Rice, *The Wade Cup*, Paris, 1955.

[9] A. U. Pope, 'A Seljuk Silver Salver' in *Burlington Magazine* 58 (London, 1933): 223–5; A. Coomaraswamy, 'An 11th Century Silver Salver from Persia' in *Bulletin of the Museum of Fine Arts,* 32 (Boston, 1934): 56–8.

[10] K. Tomita, 'A Persian Silver Candlestick' in *Bulletin of the Museum of Fine Arts* 47 (Boston, 1949): 2.

[11] R. Ettinghausen, 'The Bobrinski Kettle'.

[12] L. T. Giuzalian, 'The Bronze Qalamdan (Pencase) 542/1148 from the Hermitage Collection' in *Ars Orientalis* VII (Ann Arbor, 1968): 95–119.

[13] For the Iranian-Seljuk metal artifacts in Turkish collections see Ü. Erginsoy, *İslam Maden Sanatının Gelişmesi [The Development of Islamic Metalwork]*, Istanbul, 1978, pp. 343–60.

[14] D. S. Rice, 'Studies in Islamic Metalwork – VI' in *Bulletin of the School of Oriental and African Studies = BSOAS* XXI (London, 1958): 239–52.

[15] For a list of the 'Al-Mawsili' *nisba* used on certain works see D. S. Rice, 'Inlaid Brasses from the Workshop of Ahmad al-Dhaki al-Mawsili' in *Ars Orientalis* II (Ann Arbor, 1957): 326.

[16] D. Barrett, *Islamic Metalwork in the British Museum*, London, 1949, pp. 11–12.

[17] D. S. Rice 'The Brasses of Badr al-Din Lu'lu' in *BSOAS* XIII (London, 1949–51): 627–34.

[18] M. Ağaoğlu, 'Two Thirteenth-century Bronze Ewers' in *Burlington Magazine* 57 (London, 1930): 27–8; D. S. Rice, 'Studies in Islamic Metalwork – III' in *BSOAS* XV (London, 1953): 230.

[19] For the candleholder dated 1225, the work of the Mosul craftsman Abu Bakr ibn al-Hajji Jaldak, see D. S. Rice, 'The Oldest Dated Mosul Candlestick' in *Burlington Magazine* 91 (London, 1949): 334–41. For the candleholder dated to the second quarter of the thirteenth century, the work of the inlayer Muhammad ibn Fattuh of Mosul, see *Islamic Art in Egypt 963–1517*, Cairo, 1969, Cat. no. 53.

[20] D. S. Rice, 'Studies in Islamic Metalwork – V' in *BSOAS* XVIII, no. 2 (London, 1955): 217–20.

[21] H. W. Duda, *Die Seldschukengeschichte des Ibn Bibi*, Copenhagen, 1959, pp. 78, 165.

[22] British Museum, London, Inv. no. 1959. 7–22. 1–5.

[23] For Seljuk metal artifacts attributable to Anatolia through information in their inscriptions, see Ü. Erginsoy, 'Türklerin İslam Maden Sanatına Katkıları' in *İslam Sanatında Türkler*, Istanbul, 1976, pp. 187–8, 200.

[24] Metal artifacts attributable to the Anatolian Seljuks by comparison with inscribed objects are given in Ü. Erginsoy, 'Anadolu Selçuklu Maden Sanatı'; G. Öney, *Anadolu Selçuklu Mimarisinde Süsleme ve El Sanatları*, Ankara, 1978, pp. 153–78, 201–5.

[25] *Splendeur de l'art turc*, Exhibition catalogue: Musée des Arts Décoratifs, Paris, 1953, cat. no. 138.

[26] S. Tiouliaev, 'Turkish Applied Arts in Soviet Museums' in *First International Congress of Turkish Art* (Ankara, 1961): 333.

[27] *Arts de l'Islam*, Exhibition catalogue: Orangerie des Tuileries, Paris, 1971, cat. no. 145.

[28] G. Wiet, *Catalogue général du Musée Arabe du Caire: Objects en cuivre*, Cairo, 1932, p. 232.

[29] *Splendeur de l'art turc*, Exhibition catalogue: Musée des Arts Décoratifs, Paris, 1953, cat. no. 139.

[30] Museum of Turkish and Islamic Art, Istanbul, Inv. nos. 139 a, b.

[31] Museum of Turkish and Islamic Art, Istanbul, Inv. no. 168.

Turkish Miniature Painting

by Filiz Çağman

Turkish Anatolian miniatures may be classified as either Ottoman or pre-Ottoman. The miniatures of the Ottoman period have been amply illustrated in publications over the last twenty years, and manuscript illustrations of the Ottoman period, once much neglected or misconstrued as copies of Iranian work, are now accepted in their own right. Before examining the elements which distinguish Ottoman miniature painting from other Islamic schools, a brief survey of Turkish illustration in Anatolia during the pre-Ottoman period is necessary.

Pre-Ottoman Miniature Painting

Few illustrated manuscripts of this period have survived. They are mostly Seljuk works of the twelfth and thirteenth centuries. Rather than being particularly Anatolian, they reflect styles that were widespread throughout the Islamic world during that time. The most important illustrated Islamic manuscripts emerged from areas under the local rule of Turkish Atabegs. During the period under discussion, miniature schools extended their influence across a wide area, from Baghdad to central Anatolia.

A certain number of manuscripts may be attributed to Anatolia during the period when the two most important centres of artistic patronage there were Konya, capital of the Anatolian Seljuks, and the area of south-east Anatolia in and around Diyarbakır, governed by the Artukid dynasty. Scientific treatises — very popular at the time — were illustrated at the Artukid court. They were based on Abbasid translations of ancient texts on subjects related to medicine, botany, astronomy and automata (mechanical devices). The most important and unusual of these was the 'Qitab fi Marifat al-Hiyal al-Handasiya' written in 1205 by the master court engineer Jazari for the Artukid emir of Diyarbakır, Nasreddin Mahmut (1200–22).

The work, otherwise known as the 'Book of Knowledge of Ingenious Mechanical Devices', was based on the mechanical inventions of Archimedes and other Greek scientists, including those of a later period. The book is divided into six sections, describing the construction of up to fifty devices, and illustrated with drawings and diagrams. Among the devices described are water-clocks, drinking bowls, ewers in the form of automata, phlebotomic (blood-letting) measuring devices, fountains, pumps and locks. All the devices were illustrated in detail by Jazari himself, in a style typical of the period, featuring figures common to the Seljuk iconography that was widespread at the time. The work is of considerable interest as a record of thirteenth-century Artukid costumes, metalwork, architectural details such as doors and door knockers and as a record of the machinery, clocks and automata used in the Artukid palace. The earliest copy of this work is in the Topkapı Sarayı Museum (A 3472).[1] The colophon states that it was copied from the original in Jazari's possession, illustrated by the author and dated in the month of Şaban 602 AH (AD 1206).

Two other scientific works are known to have been illustrated under Artukid patronage. One of these, the 'Qitab al-Haşayiş', taken from the 'De Materia Medica' of Dioscorides, a first-century Cilician physician, is in the Imam Riza Ghuzergah at Mashhad. This work, which discusses the properties and medicinal qualities of certain plants, was translated into Arabic from Syriac by Mihran ibn Mansur, for the Artukid emir Nayameddin Alpi (1152–76) and written at Meyyafarikin (Silvan).[2] It was illustrated with botanical and zoological drawings based on late antique miniatures, some stylistically adapted to Islamic art, and became a very popular addition to Islamic libraries. Thirteen copies of Islamic origin dating from the eleventh to the thirteenth centuries are known to exist.

Another copy dated 529 AH (AD 1135) of a work produced at the Artukid court and now in the Suleymaniye Library, Istanbul (no. Fatih 3422), was prepared in

Mardin; it is a copy of the 'Qitab-ı Suvar al-Qavaqib as-Sabita' by Abd ar-Rahman as-Sufi. Sufi's original work was written around 960 at the Buyid court in Shiraz.[3] The illustrations of astrological signs and stellar symbols in this work — a critical evaluation of classical and Arabic sources — are Islamic in character, although they are related to classical prototypes. In the Artukid copy, the illustrations are entirely schematic and punctuated by figures in the tradition of Samarra and Uighur art. These surviving manuscripts, especially the profusely copied work of Jazari, indicate that the Artukid contribution to the art of manuscript illumination was equal to Artukid achievements in other fields of art.

The most important example of Anatolian miniature painting from the pre-Ottoman period is the unique manuscript in the Topkapı Sarayı Museum (H. 841): 'Varka and Gulşah'. This is a Persian version of an Arab tribal romance of the seventh century, presented by the poet Ayyuqi to Sultan Mahmut of Ghazni in the eleventh century. The seventy-one frieze miniatures accompanying the calligraphy are of an epic lyricism no less effective than the text. The name of the artist, Abd al-Mu'min bin Muhammed al-Khoy,[4] is inscribed on one of the miniatures. The same painter, referred to as 'sheik', is mentioned in the donatory text of the madrasah built in Konya by Celaleddin Karatay in 1251. The painter was then resident in Konya, and the title of 'sheik' denotes his advanced years. Such evidence points to the first half of the thirteenth century as the date and to Konya as the provenance of this version of the epic.

These illustrations are invaluable for their detailed information on the life style, form and ornamentation of tents, clothing, horse-trappings and weapons of the period. They are the finest existing examples of the lyric narrative style of illustration peculiar to the Seljuk regions during the twelfth and thirteenth centuries. The figures with moon-shaped faces, slightly slanted almond eyes and hair dressed in four braids reflect the Seljuk aesthetic. The Seljuks had a unique Islamic style characterized by fine contours, rich ornamentation and carefully chosen tones, all drawn into a successful composition. The style, types of figures and compositional dimensions of these miniatures are reminiscent of *minai* ceramics with underglaze decoration and of the faience, metalwork and miniatures simultaneously produced in Iran, Anatolia and Mesopotamia.

An Anatolian style that is quite different is evident in another surviving manuscript: the three part 'Tazkira' written and illustrated by Nasreddin Sivasi.[5] The second part of this manuscript was written at Aksaray in 1271, and the third part at Kayseri for presentation to the Seljuk Sultan Gıyaseddin Keyhusrev in 1272. Although the illustrations of djins, fairies and magical themes are not of outstanding quality, their subject matter is entirely original, and they clearly show the effects of local Anatolian (Byzantine) art. From these manuscripts which have survived, it is evident that the pre-Ottoman illustrative style in Anatolia was close to the style then dominating Islamic art in general and also that some of the most original works produced emerged from the artistic centres of 'Rum'.

Pls. 155-157 (margin note)

Ottoman Miniature Painting

The Early Ottoman Period

The earliest existing Ottoman miniatures date from the period of Mehmet II, the Conqueror of Istanbul (1451–81), although it is known from literary sources that a court school of miniaturists existed before the conquest of Istanbul (1453). Sources from the reign of Murat II (1421–51), father of the Conqueror, refer in particular to the artist Husamzade San'ullah hin.

It was, however, after the conquest of Istanbul during the reign of Mehmet II, that new trends were introduced into Ottoman painting. As a result of the sultan's positive attitude towards western European art, some notable painters were invited to the Porte. Undoubtedly one of the most important of these was Gentile Bellini. During his stay in Istanbul (from September 1479 to December 1480), the artist supposedly completed certain drawings and wall paintings in the palace, as well as a portrait of the young sultan. Among the other Italian artists known to have visited the palace at about the same time were Master Pavli of Venice, Matteo de Pasti of Verona and Constanza da Ferrara, who was in Istanbul from 1478 to 1481 to prepare a medallion of the sultan. The small portrait of Sultan Mehmet in one of the palace albums (Topkapı Sarayı Museum) is attributed to Ferrara.[6] It seems that, sitting for his portrait before Western artists, Mehmet II, like the European royalty, encouraged artists who were so inclined to form a local school of portraiture.

The most valuable contemporary source of information about the Turkish artists of the period is the 'Manakıb-ı Hunarveran' by Ali. It mentions such local artists as Sinan Bey, a student of Master Pavli the Venetian master and at one time an assistant of a Master Damyan. According to Ali, the most highly regarded portrait painter of the period was Shibli-zada Ahmet, a student of Sinan Bey. Although no signed works by these artists have survived, the three-quarters portrait of Mehmet the Conqueror in one of the palace albums (H. 2153 f. 10a) is accepted as the work of Sinan Bey. (In it Mehmet is sitting cross-legged, holding a royal kerchief and smelling a rose.) Here the influence of Western art in discernible in the treatment of the sultan's costume and in his facial features. The disproportion, especially in the lower part of the figure, and the two-dimensional approach to the subject are reminders of the artist's debt to Islamic art.

Pl. 158 (margin note)

During the reign of Mehmet II, the recently founded palace in Istanbul was the centre of activity for both local and Western portrait painters. Quite a different situation prevailed at Edirne, the earlier seat of the sultans. We have evidence of the existence of a court school there before the conquest of Istanbul; however, no manuscripts have survived from this period. Our only indication of the activity of that school are a few surviving post-Conquest manuscripts, one of which is entitled the 'Dilsuznama' by Badieddin at-Tabrizi (Oxford, Bodleian Library, Ousley 133).[7] It was written at Edirne in 860 AH (AD 1455–6) and contains miniatures evidently influenced by the con-

temporary Shiraz school; nevertheless, certain elements of costume, the interpretation of natural details and the firm contours are typical of Turkish art.

Pl. 159 The miniatures in another work by this school, the 'Qulliyat-i Qâtibi' (Topkapı R. 989),[8] were also influenced by the Shiraz school; however, typical Janissary headgear is also evident. Other characteristics frequently encountered in early Ottoman painting, such as a row of cypresses on the horizon and the bold choice of colours, make these miniatures typical of the Ottoman schools of the period.

The most important surviving manuscript, presumably from the court at Edirne, is an undated anthology in the Biblioteca Marciana, Venice.[9] It contains the 'Iskender-nama' by Ahmadi and a section on Ottoman history. Although undated, the miniatures have the characteristics of the Edirne school in the second half of the fifteenth century. The hand of Ottoman artists is particularly evident in the section on Ottoman history, in the treatment of colour and the documentary approach to details such as costume.

After the death of Mehmet the Conqueror, court art in Istanbul broke away from Western influence. Sultan Beyazıt II (1481–1512), Mehmet's successor, had very different tastes and encouraged the growth of a traditionally Islamic school. The majority of artists attracted to the court at that time were exponents of the Islamic school and, gradually, artists from the increasing number of provinces conquered by the Ottomans joined their ranks. It is known that artists and many manuscripts were sent to the palace from Tabriz and Cairo, especially after the eastern conquests of Sultan Selim the Grim (1512–20). Later, many artists of different traditions gathered at the Ottoman court during the long reign of Suleyman the Magnificent (1520–66).

Considerable information concerning the court workshops of the period can be gleaned from documents in the palace archives, especially inventories giving details of the stipends paid to artists. From them we learn that, in addition to artists from Tabriz, some Western artists were also working at the court school. The inventory for 1526, for example, mentions Albanian, Caucasian and Moldavian artists. Inventories for 1545 to 1557 give similar details and, by 1558, it is apparent that besides local artists, Hungarian, Caucasian, Georgian, Austrian, Albanian and Bosnian artists were in great evidence at court, as were Iranian artists.[10]

The extremely interesting and singular developments in early Ottoman art are the result of artists with such stylistically eclectic backgrounds working together. It is very difficult to identify any stylistic unity in the work of this period. In illustrated manuscripts executed at court, the eastern schools were at first predominant; towards the end of the fifteenth century, the influence of the Timurid and Herat schools can be felt. During the Ak Koyunlu (white-sheep tribe) Turkoman period, the Shiraz school was prominent as to a certain extent was Mameluke art. During the Safavid period, the effects of the Tabriz school were strongly in evidence. Parallels can be found in certain formal compositional details and in the portrayal of figures. Works executed almost totally in

a style traditional to a specific artist also occur. In the palace library, there are a number of works of this type which can be identified as court work through various details, despite the lack of a common style.

The influence of eastern Islamic schools on early Ottoman miniature painting was first ascertained and examined by I. Stchoukine.[11] One of the most interesting examples of this influence is the 'Mantiq at-Tayr' by Attar Pl. 160 (Topkapı E. H. 1512), written and illustrated in 921 AH (1515), just one year after the Turkish conquest of Tabriz. These miniatures are strongly influenced by the highly decorative, Herat court style that prevailed during the reign of Hussein Bayqara (1469–1506). After the Safavids occupied Herat under Shah Ismail in 1510, many Herati artists moved to the court at Tabriz. Ultimately, after the Turks occupied Tabriz in 1514, these artists moved from Tabriz to Istanbul.[12]

Despite the strong influence of Herat, the miniatures in the 'Mantiq at-Tayr' display some uniquely Ottoman characteristics: illustrations on both leaves of a double page, a particular kind of pagination and the preference for a certain type of subject matter and composition. The Herat style and that of the various schools of Tabriz can be identified in other works dating from the reign of Suleyman. They are most prevalent in the illustrated works of Ali Şir Navayi, the great Turci (Turkistan dialect) poet, who lived during the reign of Hussein Bayqara, and also in the illustrated works of the renowned Persian poets Nizami, Firdausi and Molla Cami.

Besides these illustrated classics of the Iranian type, works of an unaccustomed sort appeared, describing Ottoman history. These provided the opportunity for new stylistic developments. Here the first topographical sketches of towns and fortresses are encountered as well as the illustrations of political narratives and royal biographies that were to become the chief characteristics of Ottoman painting.

The various campaign chronicles written and illustrated by Nasuh constitute an interesting group of historical manuscripts. Nasuh, called Matrakçı (Matraqi) for his skill with the mace, was a calligrapher, mathematician, artist and writer of various works, including a history in several illustrated volumes. One volume is entitled 'Tarihi Sultan Beyazıt' (Events of the Reign of Sultan Beyazıt). Ten of the miniatures in this manuscript in the Topkapı Sarayı Museum depict fortresses and cities captured by the Ottomans. Another of Nasuh's works in the palace library, known as the 'Suleymannama' is devoted to the Hungarian campaign of Sultan Suleyman Pl. 161 and the Mediterranean campaign of Barbarossa Hayreddin Pasha. It contains illustrations of the Mediterranean ports and bivouacs that the Ottomans passed during the Hungarian campaigns.[13]

The most important of Nasuh's illustrated manuscripts is the 'Mecmua-i Menazil' in the Istanbul University Library.[14] It contains 128 totally non-figurative miniatures depicting post-towns and bivouacs on the route to and from Baghdad via Iran, during Suleyman's Iraqi campaign (1534–5). Cities such as Istanbul, Tabriz, Baghdad, Diyarbakır, Aleppo and Sultaniye are depicted

in great detail, obviously as the result of thorough observation. In fact, the artist has provided a documentary illustration of each place (identifiable by the inclusion of all the major landmarks) as it was in the mid-sixteenth century. Another work concerning the Tabriz campaign of Sultan Selim the Grim is in the Sächsische Landesbibliothek, Dresden.[15] Several stylistic variations in the miniatures of this section, depicting the post-towns on the road to Tabriz, suggest that they were executed by Nasuh together with his assistants. The paintings of Nasuh, who was from a town near Sarajevo, show an obvious familiarity with the 'portulano' or sailing directions to the Mediterranean and with Western representations of medieval cities. In general, the regional decorative details on architecture, elements of the natural environment enhancing castles and towns and the colour composition in Nasuh's work are an enchanting blend of Western and oriental tastes. Later the documentary character of Nasuh's illustrations played an important part in the development of Turkish miniature painting.

The Emergence of the Ottoman 'Shahnama'

During the reign of Suleyman the Magnificent, the historical manuscript, which established the major characteristics of Ottoman painting, appeared in all its various forms. In this period Turkish miniature painting came into its own. The most important evidence of this is the 'Shahnamas' or 'Shahinshahnamas' written in Persian poetic metre. Each Ottoman sultan after Mehmet II appointed a *shahnamaji* or epic poet-chronicler, thus establishing the tradition of recording current and historical events in verse in a 'Shahnama'. Sources reveal that Shahdi, chronicler for Mehmet the Conqueror, was ordered to write an Ottoman history, although the work has not survived. The post of *shahnamaji* was included in court protocol during the reign of Suleyman the Magnificent, when the *Shahnamaji* Fathullah ben katib Dervish (called Arifi) presented the sultan with a monumental history of the Ottoman sultans from their first appearance in history onwards. The fourth illustrated volume of this work (there were presumably five volumes in all) is in the H.P. Kraus Collection, New York, and a manuscript thought to be the first volume is kept in a private collection.[16] The fifth and most important volume — one of the most successful illustrated manuscripts in Turkish history — is the 'Suleymannama' or 'Shahnama of Sultan Suleyman the Magnificent' in the Topkapı Sarayı Museum (H. 1517). It contains sixty-nine miniatures illustrating events from Suleyman's reign, from his enthronement up to the year 1558. The manuscript was a formal prototype for later 'Shahnamas' and a key work in the development of the Ottoman miniature.

Pls. 162-164

The variety of styles encountered in the illustrations of this 'Shahnama' is due to the co-operation of fine artists from different regions and different artistic schools. To unify these varied influences, a totally novel approach was developed, in keeping with the subject matter. The most obvious characteristics of this approach are the artists' position as observers of the subject matter, the use of straight lines framing rows of figures and the arrangement of figures so as to emphasize the grandeur of ceremonial events.

Foreign influence, especially that of the Iranian schools, is only evident in minor details of the 'Suleymannama' miniatures, for example, in the depiction of the circumcisions of Crown Princes Beyazıt and Cihangir. Pl. 162 On these Sultan Suleyman is enthroned in the upper part of the painting, his guards standing behind him, while he receives gifts. In contrast to the solemnity of the upper scene, in the lower part of the miniature musicians can be seen seated around a pool. Although the vertical and diagonal arrangement of lines is typical of Turkish miniatures, the overdecorated architectural elements — or rather the artist's need to fill all available space with decoration — may be regarded as the result of Iranian influence.

Most of the 'Suleymannama' miniatures illustrate royal hunting parties, from which it may be deduced that the Turks regarded the hunt as a war sport. One such Pl. 163 miniature shows the crown princes at the hunt watched by the sultan. This miniature is executed with considerable formal competence, extremely fine draughtsmanship and selective colouring. The scene consists of elements arranged in a similar manner to those in the previous miniature: the sultan, carrying a falcon and accompanied by his suite of guards, is placed in the upper part of the picture in all his ceremonial grandeur. This restrained group contrasts with the unconcerned vigour of the hunters in the lower section of the picture and farthest away from the royal figures.

The 'Suleymannama' manuscript contains many illustrations of historical significance.[17] Representations of successful battles and fortresses made in both the East and West point out that, by this time, such illustrations had become the artistic medium for expressing imperial splendour. Individual artists were allocated a part of each work according to their places of origin, so that the hands of artists from Tabriz are generally discernible in illustrations of the eastern campaigns, while campaigns in the West were usually illustrated by local artists at the campaign sites. However, a new Turkish style dominates the miniatures to such an extent that it is sometimes quite difficult to identify such individual elements.

A miniature from the Chronicles of the Iranian campaign, showing the sultan and his army, clearly illustrates the subservience of individual elements to the new stylistic approach. This miniature, depicting the Ottoman army on the march, should be read vertically Pl. 164 from bottom to top. The forward flank at the foot of the page is separated from the sultan and his advancing forces by a small hill, indicating the distance of this flank from the rest of the army. The sultan, commander-in-chief of the army and the empire, occupies a central position in the miniature. The strong straight lines, typical of Ottoman draughtsmanship, emphasize the might of the army and of its commander. There are traces of oriental 'ornamentalism' in details on the dark-blue background, but natural elements are subordinated to geometrical patterns.

In addition to the unequalled 'Suleymannama' illustrations, the palace school also produced some important portraits. The first Turkish portraitist was Sinan Bey. In this period Haydar Reys, whose pseudonym was Nigari,[18] was the most renowned Turkish portraitist since Sinan Bey. Reys painted portraits of Suleyman the Pl. 166 Magnificent, Selim II and Admiral Barbarossa Hayreddin Pasha. The bust portrait of the admiral shows his head in profile on the dark-green ground much favoured by the artist; the portrait is a characteristic example of Nigari's interpretive skill and shows his familiarity with Western works of the same genre.

In summary, during the reign of Suleyman the Magnificent, the major trends in Ottoman miniatures were represented by the topographical works of Matrakçı Nasuh, the innovative 'Suleymannama' illustrations by the best court artists and by the portraits of Nigari.

The Classical Period

The second half of the sixteenth century is generally referred to as the 'classical' period in Turkish miniatures. Manuscript illustration was totally free of foreign influences by then. Sultan Murat III (1574–95), the most important patron of this period, had little interest in warfare, or indeed in life outside the palace. He was renowned for his epicurean tastes and especially for his love of literature and the arts of the book. Under Murat's patronage the most important examples of Ottoman manuscript art were produced in palace workshops. Turkish miniatures of that period had a 'classic' character and differed totally from the miniatures of other contemporary Islamic schools in the choice of subject matter and in style. The most popular genre of the period was the 'Shahnama', vehicles in rhyming metre for portraying the victories of the powerful and disciplined imperial army, the royal government, various social functions and the sultan's hunting skills and other royal attributes.

Besides such imperial eulogies, chronicles of important campaigns were written in a narrative style based on close observations of details. The main aim was to provide accurate illustrations of historical events. Such developments in art at the Ottoman court were perhaps the result of previous work by the cartographer Piri Reys and the urban topographer Matrakçı Nasuh. Precisely this careful observation, topographical emphasis of the fortresses under seige or the troops on the march, and realism in depicting people and events have become the main characteristics of Turkish Ottoman miniatures. Ottoman subject matter and the approach to work was very different from the work of contemporary Iranian schools. The romantic Iranian miniatures of that period are strewn with colourful flowers; graceful trees are depicted, and decorative springs punctuate the scene; all this is absent from Ottoman art, in which nature is a simple background to heroic activity. Nature was generally present in the form of flat plains or the occasional hill, perhaps enlivened by a few trees. Background colours in Ottoman miniatures were bland and neutral; details such

as rivers, bridges, castles and trees were only illustrated if they were essential to the narrative. Architecture was treated in a totally realistic fashion. The simplicity of Ottoman architecture was expressed by the use of very little ornament and just a layer of silver gilt to highlight the monochrome domes of palaces and monuments. These representations are usually so accurate that the state of specific buildings during that period can be determined. Colours were limited and used in few tones; they were applied in blocks of pure colour without *chiaroscuro*. Mauve, light pink, lilac and light-green plains and fields stretch out endlessly, blending with castles in identical tones. Figures are picked out in brightly coloured clothes, in front of resplendent tents and pavilions painted in dominant colours—mostly red and sienna—to contrast with the pastel shades of the natural surroundings and the architecture.

This period—the most productive for Turkish miniatures—coincides with the reigns of Selim II and Murat III. One of the earliest and most important works of the classical school, indeed the first to be illustrated in this style, is the Chronicle describing the last Hungarian campaign of Suleyman the Magnificent and his death at Szigetvar, followed by the first years of the reign of Selim II (Topkapı H. 1339). The miniatures for this work—written by one of the most notable annalists of the period, Ahmet Feridun Pasha—were completed in 976 AH (1568–9). One of the typically classical miniatures depicts the Prince of Transylvania before Suleyman in his Pl. 165 royal tent. The sultan, obviously aged and infirm, is enthroned in front of his pavilion, flanked by his personal guards on the left and by his viziers on the right. The prince is prostrated before the throne, while others await presentation behind him. Within this composition dominated by straight lines, the artist's interest in the interaction of human figures and their surroundings and in realistic portraits of historical personages is clearly evident. The decorative backgrounds—a result of Iranian influence—that were frequently seen in the miniatures of the previous era are replaced by plain ones.

These miniatures must be the first work of the famous Osman, who was responsible, in a large part, for directing the artistic trends of the period. He made an outstanding contribution to classical Ottoman art and had a hand in almost all the works of this period. Many of them were prepared under his supervision. Although his origins and the date of his entrance into the palace workshop are unknown, archival sources reveal that he was active there until the end of the sixteenth century. Other court artists of the period include Ali (Osman's brother-in-law), Mehmet Bey, Mehmet of Bursa, Molla Kasim, Velijan, Fazlullah and Lütfu Abduhllah.

After Sinan Bey and Nigari, the portraiture of the period took an entirely new turn. Far from losing its importance, portraiture became the subject for the manuscripts. The portraits of all the Ottoman sultans were prepared by Nakkaş Osman for a work written by Seyyid Loqman—the 'Shamailnama' or 'Kiyafet al-Insaniya fi Şamail al-Osmaniya', completed in 1579.[19] Research by Seyyid Loqman and Osman in preparation for this work uncovered authentic portraits of some of

the sultans which, in some cases, were brought from Europe through the intervention of the Grand Vizier.

Written sources indicate that the artist and writer studied the appearance, dress and character of the sultans in depth, before preparing the illustrated work. This was the first Ottoman album with royal portraits. Osman preserved the traditional royal stance: the sultan is seated cross-legged or kneeling in three-quarters profile. The surface approach was two-dimensional, despite Osman's unswervingly accurate depiction and fastidious research into the costume (especially the turban) and the physiognomy of his subject. Generally, Osman had recourse to the work of French and other European artists as visual sources. Many of these portraits were copied and became prototypes for the work of later artists in this field.

Selim II appointed Seyyid Loqman as court chronicler-poet *(shahnamaji)* during a period that is renowned for its proliferation of historical works. Loqman produced many manuscripts during his long years in this post; the first was of the 'Shahnama' type: 'Illustrated History of Sultan Suleyman', written in Persian metre and dated 987 AH (1579). It is in the Chester Beatty Library, Dublin.[20] In it are given the descriptions of Suleyman's Szigetvar campaign, his last years and death. Twenty-five miniatures accompany the text. They are typical of the period. Following this volume, Loqman wrote the 'Shahnama-i Selim Han' (Topkapı, A. 3595, dated 988 AH [1581], some pages missing). It describes the sultanate of Selim II (1566–74) and contains forty-three miniatures. Documents attribute these miniatures to Osman and Ali. Typically the illustrations are spread over a double page and display colours and a narrative style peculiar to Master Osman.[21] The subjects treated include detailed court ceremonies (enthronements, the presentation of envoys), scenes from the war campaigns of the period (land and sea battles) and a series of conquests, including that of Cyprus and of Goletta (Halq al-Wadi) in Africa, as well as scenes of the construction of monuments, for example the building of a bridge or the completion of the Selimiye Mosque at Edirne. Illustrations of military campaigns concentrated more on the topographical details of the conquered regions than on scenes from the fields of battle. In these panoramic regional views, which were the result of such detailed research, only the Janissaries depicted in passive splendour stand out, since the artist's aim was to emphasize the might of the sultan and his army as much as the appearance of the conquered region itself.

Besides traditional Persian 'Shahnamas', Seyyid Loqman also produced works in Turkish. The two-volume 'Hünername' (Book of Accomplishments) is a masterpiece of Ottoman art. The first volume (Topkapı, H. 1523, dated 992 AH [1584]) describes the activities of all the Ottoman sultans from Osman, the founder of the Ottoman state, to Selim the Grim. It illustrates their accessions to power, victories, feats of hunting and war, administration of justice and final demise. This large volume contains forty-five full-page miniatures. The artists, who all worked under Osman, have been identified from literary sources.[22] The majority of the illustrations are scenes of great solemnity and monumentality

Pls. 167-168

Pl. 167

Pl. 168

Pls. 169-171

showing the sultan's accession to power. The sultan, framed by his courtiers who are frozen around him in strict protocol is the dominant figure. The sultan is also the central figure in important battle scenes and in displays of royal strength and imperial accomplishments at the hunt. In contrast to contemporary Iranian Safavid miniatures that depicted court entertainments, Ottoman miniaturists preferred to emphasize the might and power of the sultan and his prowess at the hunt, a war sport. In such miniatures, the sultan's entourage is not shown hunting, as it is in Iranian scenes; it watches the dominant, out-sized figure of the sultan in silent respect. Accurate scenic illustrations can also be found in this volume. Some are devoted to the Topkapı Sarayı, seat of the empire and the sultan's palace. These carefully detailed drawings are important illustrative documents, showing the appearance of the palace in the sixteenth century.

The section of the 'Hünernama' related to the conquest of Istanbul provided the artist — most probably Osman — with an excellent opportunity to display his topographical talent. The result was a double-page plan of the city on an axonometric projection (angled from above). The plan is in pink and silver gilt, with occasional touches of green. This type of plan is consistent with the urban illustrations of Matrakçı Nasuh and with Ottoman cartography in general and the result of a world view unique in Islamic culture.

The second volume of the 'Hünernama' (Topkapı, H. 1524, dated Safer 986 AH [1588]), entirely devoted to the forty-six year reign of Suleyman the Magnificent, also contains masterpieces of a uniquely Turkish character.[23] The sixty-five miniatures of this volume are solely concerned with the important events of Suleyman's reign, his displays of prowess and his administrative powers. The miniatures were executed by a group of artists working under Nakkaş Osman. A large number of these miniatures are devoted, justifiably, to the sultan's European campaigns and victories. One such miniature illustrates the Battle of Mohács on the Danube in 1526. The sultan defeated the king of Hungary and annexed his kingdom. This work (undoubtedly by Osman) is yet another masterful example of the world view of Turkish artists and of the characteristics typical of Ottoman art. The artist has chosen to portray the advancing army rather than the moment of battle. Only a small section in the lower left-hand corner of the picture depicts a small group of Ottoman and Hungarian soldiers in combat. At first glance, it is obvious that the artist's major aim was to portray the might and magnificence of the Ottoman sultan and his troops: all details are arranged to emphasize the strength and discipline of his forces.

Another group of miniatures in this volume is concerned with Suleyman's final campaign and with his illness and death at Szigetvar. In important scenes that are historical documents, Selim II is shown attending the corpse of his father Suleyman at Belgrade, after the latter's death prior to the battle of Szigetvar; the concealment of Suleyman's death from the army is also shown. In the miniature Sultan Selim II can be seen in prayer accompanying the funeral carriage; grief is easy to read

Pl. 169

Pl. 170

Pl. 171

on the faces of the sultan and those around him. This effect of mourning was emphasized by the use of blue and green tones.

The 'Hünernama' was written to coincide with the celebration of the circumcision of Crown Prince Mehmet, son of Murat III. This was an occasion of unequalled magnificence that took place in Istanbul in 1582. The circumcision, to which all the foreign powers were invited, was to be a display of imperial Ottoman might on a world scale. The festivities were held on the grounds of the Sultan Ahmet Meydanı (the old Hippodrome), which could be observed from the Palace of İbrahim Pasha that overlooked the arena. Guests were seated in loggia set up against the palace walls. The festivities that lasted fifty-two days and nights gave all the artisans of Istanbul an opportunity to display their wares in a grand parade. Most of them appeared on wagons, engaged in their various crafts. There was a place in the festivities for all levels of society from theological scholars, musicians and glass-workers, to archers, bakers, kebab-sellers and beggars. The celebrations were terminated abruptly on the fifty-second day, after several unfortunate incidents—

155 Scene in the bazaar from the 'Varka and Gulşah' by Ayyuqi: Seljuk style (probably Konya), 1st half of the 13th cen., 5.8×18.5 cm. Topkapı Sarayı Museum (=TSM), no. H. 841, fol. 3b.

156 Gulşah, disguised as a soldier, watches Varka and Rebi fighting for her hand, from 'Varka and Gulşah' by Ayyuqi: Seljuk style (probably Konya), 1st half of the 13th cen., 7.5×18 cm. TSM no. H. 841, fol. 20a.

157 Gulşah fainting on learning that she is to be wed to the king of Damascus, from the 'Varka and Gulşah' by Ayyuqi: Seljuk style (probably Konya), 1st half of the 13th cen., 7.5×18 cm. TSM no. H. 841, fol. 43b.

158 Portrait of Sultan Mehmet the Conqueror, attributed to Sinan Bey: Court School, Istanbul, c. 1475, 39×27 cm. TSM no. H. 2153, fol. 10a.

159 Eyup and Salman participating in a scene of court entertainment, from the 'Qulliyat-i Qâtibi': Court School, Istanbul, c. 1460, 11.5×7 cm. TSM no. R. 989, fols. 229b–230a.

160 Mecnun approaching Leyla's tent, from the 'Mantiq at-Tayr' by Attar: Court School, Istanbul, dated 1515, 15×7.5 (17) cm. TSM no. E.H. 1512, fols. 108b–109a.

161 Fortress and part of the Serbian city of Nish, from the 'Suleymannama', written and illustrated by Matrakçi Nasuh; Istanbul, dated 1537, 25×34 cm. TSM no. H. 1608, fols. 27b–28a.

162 The presentation of gifts and congratulations to Sultan Suleyman the Magnificent in honour of the circumcision of Crown Princes Beyazıt and Cihangir, from the 'Suleymannama' by the court poet Arifi: Court School, Istanbul, dated 1558, 27.5×16.5 cm. TSM no. H. 1517, fol. 412a.

163 Sultan Suleyman the Magnificent watching the crown princes hunting near Hama, from the 'Suleymannama' by the court poet Arifi: Court School, Istanbul, dated 1558, 26.7×16 cm. TSM no. H. 1517, fol. 575a.

164 Sultan Suleyman the Magnificent gathering the troops of 'Rum' and the departure of the Ottoman army, from the 'Suleymannama' by the court poet Arifi: Court School, Istanbul, dated 1558, 23×15.7 cm. TSM no. H. 1517, fol. 592a.

165 Sultan Suleyman the Magnificent receiving the Prince of Transylvania, from the Chronicle 'Nuşat al-Asrar al-Ahbar der Sefer-i Szitgetvar' by Ahmet Feridun Pasha (probably illustrated by Osman): Court School, Istanbul, classical period, 1568–9, 30.5×20 cm. TSM no. H. 1339, fol. 16a.

166 Portrait of Barbarossa Heyreddin Pasha by Haydar Reys, called Nigari, mid 16th cen., 26×19.5 cm. TSM no. H. 2139/9.

167 Accession of Selim II to the throne in Baghdad, from the 'Shahnama-i Selim Han' by the court epic-chronicler Seyyid Loqman; miniature by Osman: Court School, Istanbul, classical period, dated 1581, 33.5×20 cm. TSM no. A. 3595, fol. 26b.

168 The capture of Goletta in Tunisia, from the 'Shahnama-i Selim Han' by the court epic-chronicler Seyyid Loqman (miniature probably by Osman): Court School, Istanbul, classical period, dated 1581, 27×19.5 cm. TSM no. A. 3595, fols. 147b–148a.

169 Istanbul, from the 'Hünernama', vol. 1, by the court epic-chronicler Seyyid Loqman: Court School, Istanbul, dated 1584, 49.2×63 cm. TSM no. H. 1523, fols. 158b–159a.

170 The Mohács campaign, from the 'Hünernama', vol. 2, by the court epic-chronicler Seyyid Loqman: Court School, Istanbul, in Osman's style, dated 1588, 39×23.1 cm. TSM no. H. 1524, fol. 256b.

171 Funeral of Suleyman the Magnificent at Belgrade, from the 'Hünernama', vol. 2, by the court epic-chronicler Seyyid Loqman: Court School, Istanbul, in Osman's style, dated 1588, 35.5×24 cm. TSM no. H. 1524, fol. 294a.

172 Procession of craftsmen held in honour of the circumcision of Crown Prince Mehmet (1582), from the 'Surnama': Court School, Istanbul, in Osman's style, c. 1582–3, 32×44 cm. TSM no. H. 1344, fols. 32b–33a.

173 The Ottoman army under the command of Ferhat Pasha, approaching the Fortress of Revan, from the 'Shahinshahnama', vol. 2, by the court epic-chronicler Seyyid Loqman, late work of N. Osman: Court School, Istanbul, 1594–7, 30.2×20 cm. TSM no. B. 200, fol. 101b.

174 The Archangel Gabriel visiting Mohammed; on the left, the Prophet's wife, Hatice, from the 'Siyar-i Nabi' by Darir: Court School, Istanbul, last quarter of the 16th cen., 20.5×18.5 cm. TSM no. H. 1222, fol. 167a.

175 The Death of Mohammed, from the 'Siyar-i Nabi', vol. 6, by Darir: Court School, Istanbul, in the style of Nakkaş Hasan Pasha, last quarter of the 16th cen., 20.5×18 cm. TSM no. H. 1223, fol. 414a.

176 Masked dancers, from an album of Sultan Ahmet I: Court School, Istanbul, early 17th cen., 17×24.8 cm. TSM no. B. 408, fol. 19a.

177 The triumphant return of the Turkish navy under the command of Admiral Ali Pasha, from the 'Shahnama-i Nadiri' by the court epic-chronicler Nadiri: Court School, Istanbul, c. 1622, 26×20 cm. TSM no. H. 1124, fol. 29a.

178 Portrait of Sultan Ahmet III and his son Prince Mustafa, from the 'Silsilnama', an album of portraits by Levni: Court School, Istanbul, Tulip period, c. 1720, 25.5×17.5 cm. TSM no. A. 3109, fol. 22b.

179 Acrobats performing during the circumcision celebrations for the sons of Ahmet III (1720), from the 'Surnama-i Vehbi' by the poet Vehbi, illustrated by Levni: Court School, Istanbul, Tulip period, after 1720, 32×20.5 (42) cm. TSM no. A. 3593, fols. 92b–93a.

صفت صورت حجی بنی شیبه

برخ بلدران وحسنه دید
توکنی کاتش رفروخند
مرکب می حایت شد سرنگون
بسوی ربع این عدنان نگاه
زباوش گشته دوان سیل خون
غم ورقه برجانش خوش بود

چوین بشر رفتان نگار بدیع
زبعد ظاه نجا ایستا د
بسوی ربع وسوی ورقه چشم
که ناچک ازهردوان جون بود
میدان ازوان دران هردو کرد
جو دوشیر آشفته نزدیک در

جو آمد به پیش سیاه ربیع
که اندر چلی بود سخت اوستاد
نهادان دل رامزبرکرد بخشم
ازان دومردی یک افزون بود
بنودگله هردو می جست بود
که این جله اور گه ان جمله بن

جو مردم نمجلس پرالله کشت
بزوگفت جه دهی حق دخرم
ازدوسیم اسب وشتر با رنه
غلامان خدمت کروخوب روی
که ورقه بی دل خسته تن
دهم مروراد کنیزک جوماه
ملاکش گفت ای شه هوشمند
لوجز دخترمن نزابود جفت
که ورقه اکه شود زین بحر
جوان وانک بود ازشمار جوان
که نادندام این بخن پیش کس
باز داد گلشاه دل خسته را

ملال خردمند گوید کشت
جواز کنت گزاری نوبکردم
زمن هرج خوای بیانی همه
کنیزان شیرین لب وجعد موی
بنودمرابد ستاند شمن
کنم من سیند ثرکلیم سیاه
خسین بسوکندخوذ ببند
باری نوازبازار درد رنجت
شود باست با مریان کهن
لخورد ند سوکندهای گران
نکوبسیم جای یک بودم و بس
باز خسرو وحزین سته با

نوحه کردن گلشاه

خبر یافت گلشاه کازمنجلا
جداکردش ازورقه برده دل

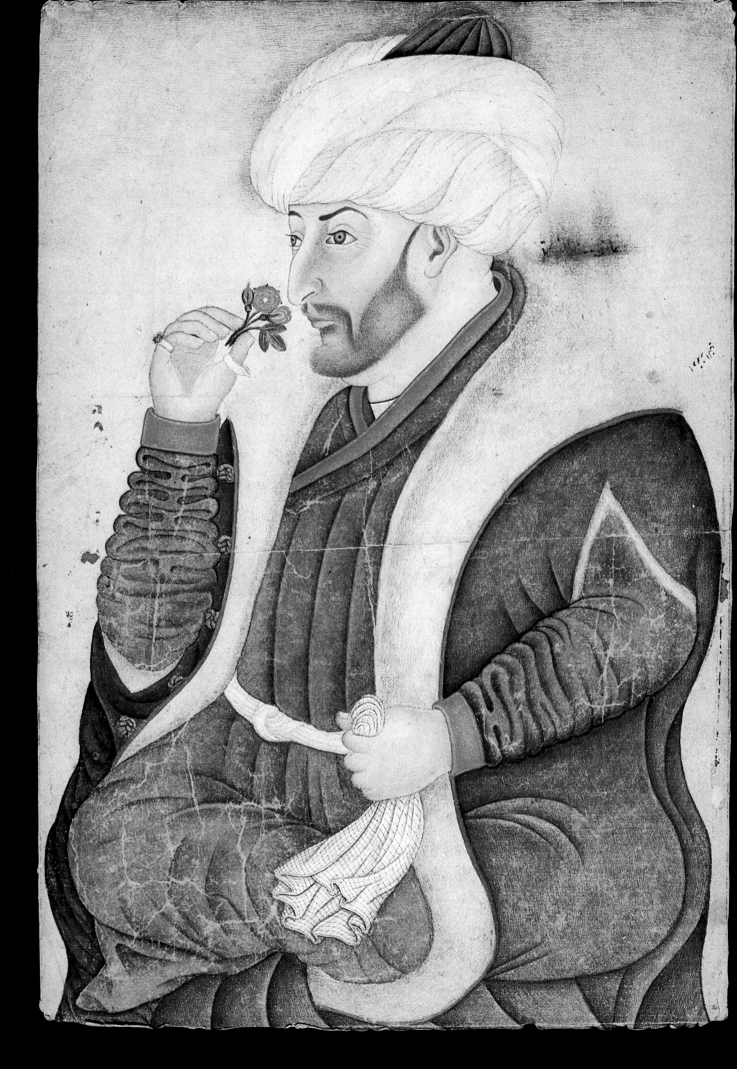

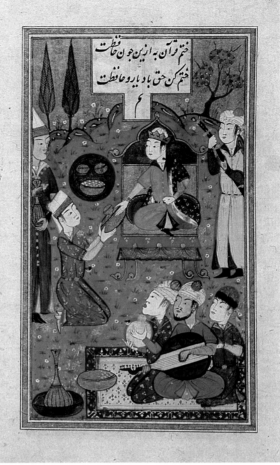

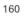

159

160

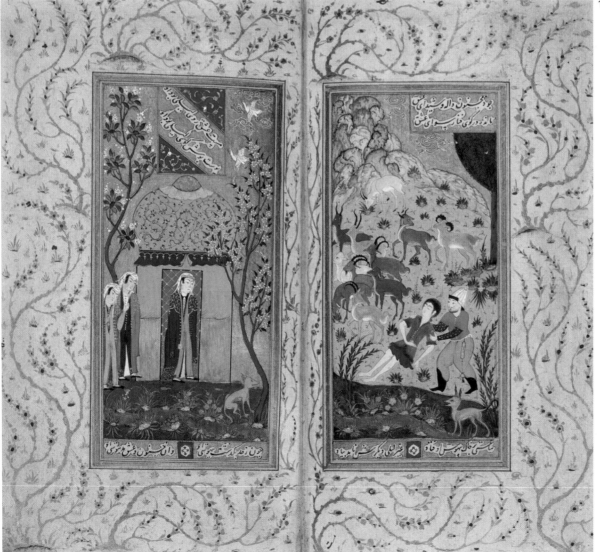

161

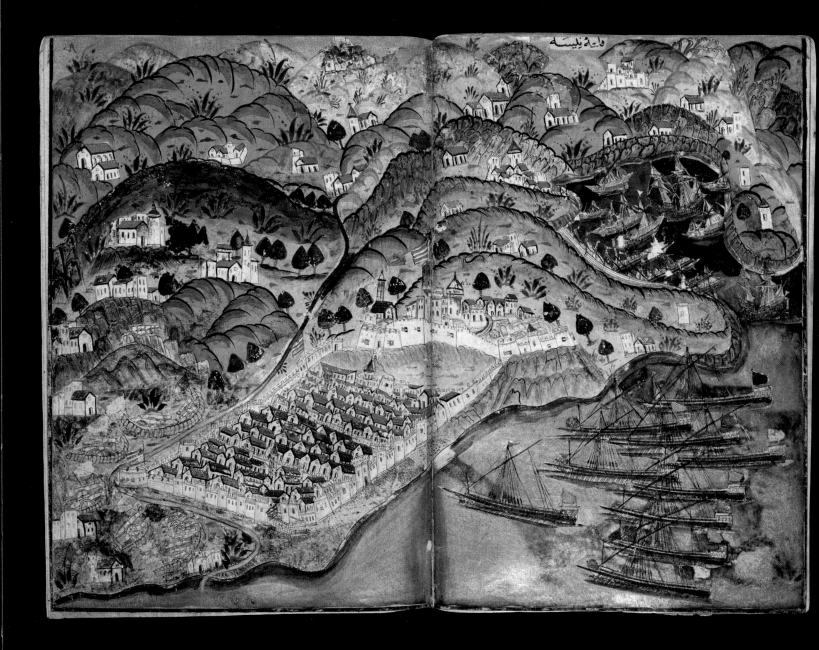

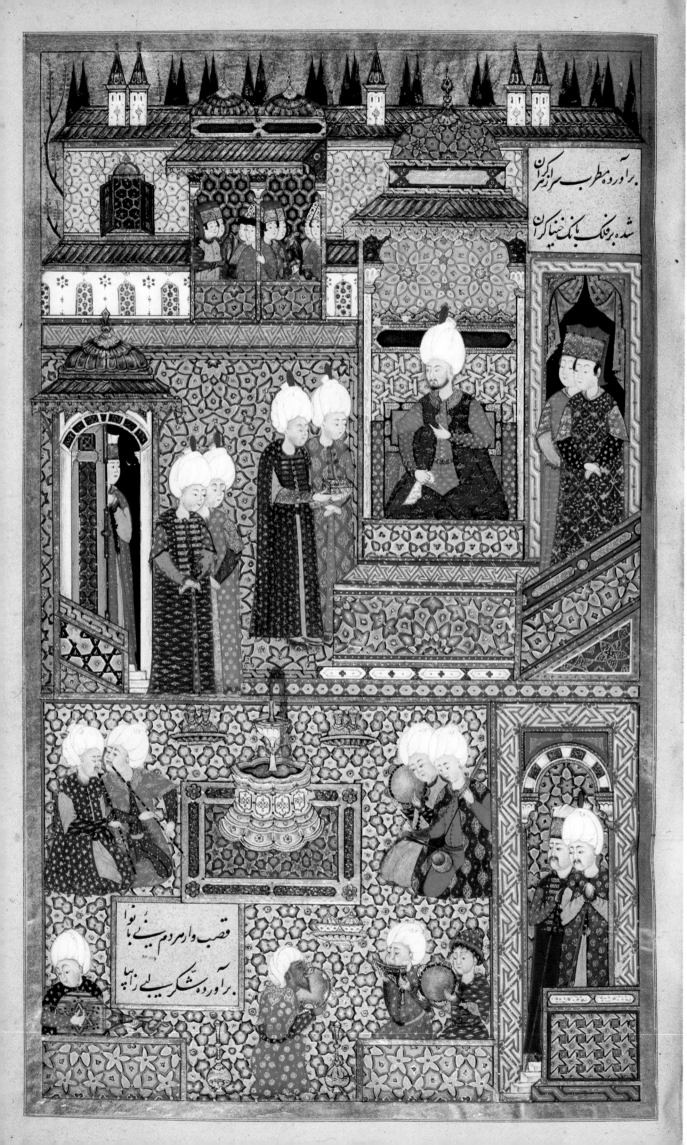

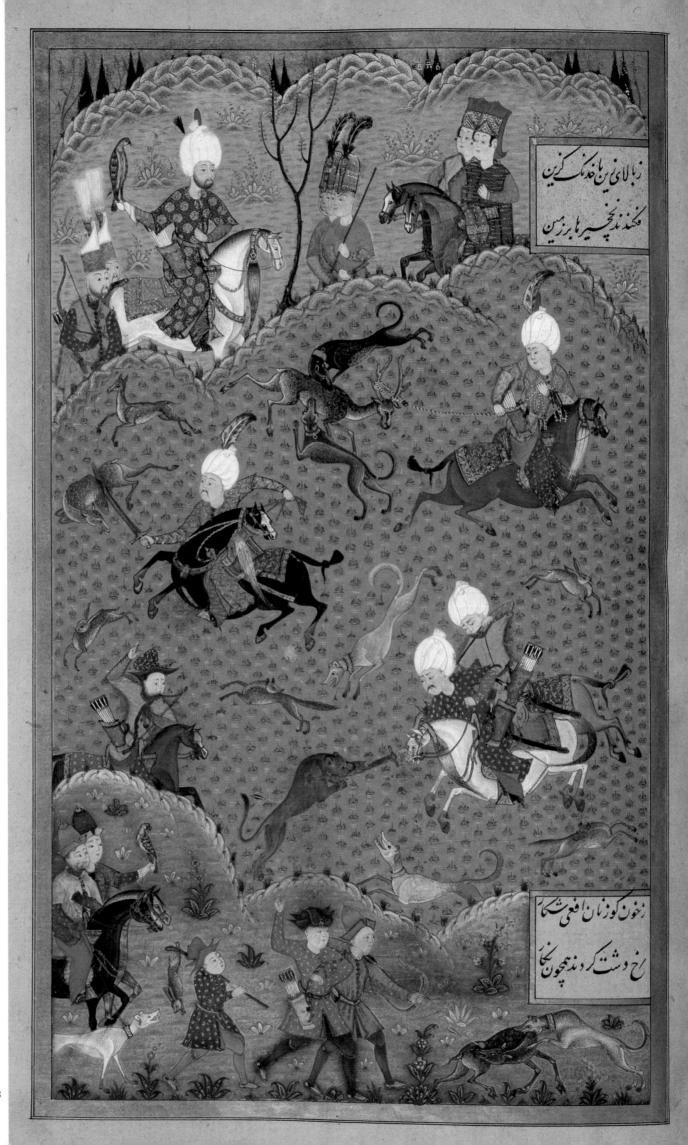

163

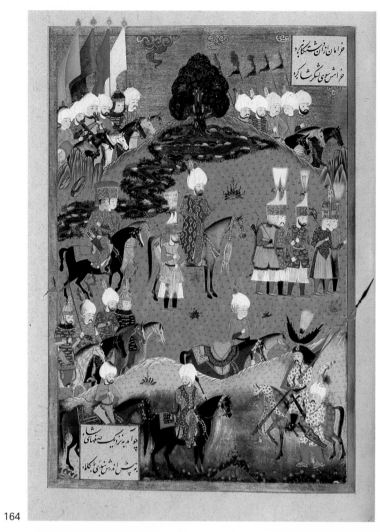

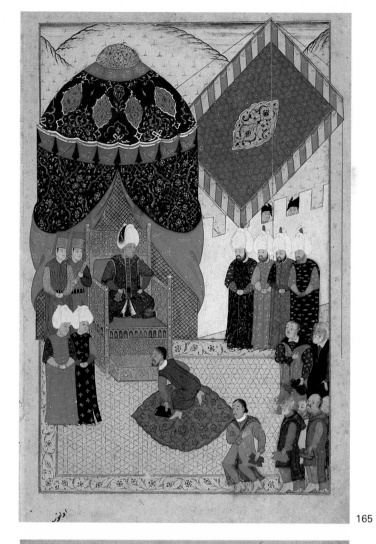

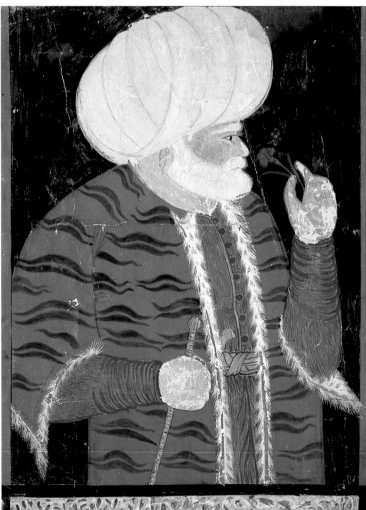

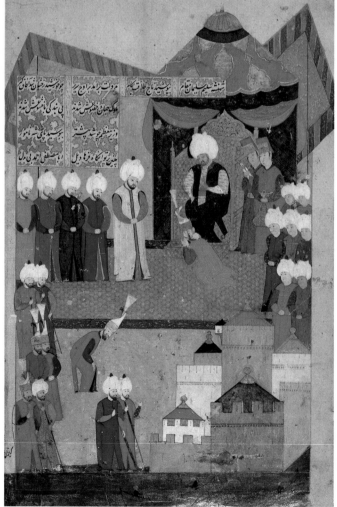

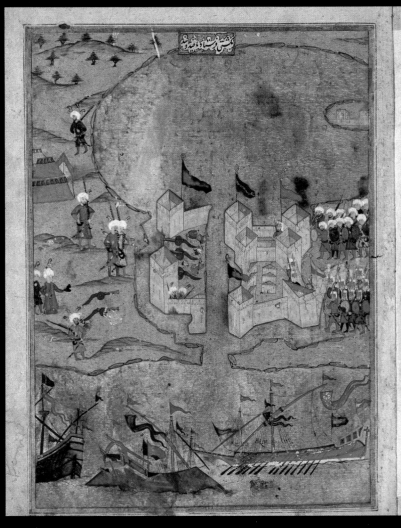
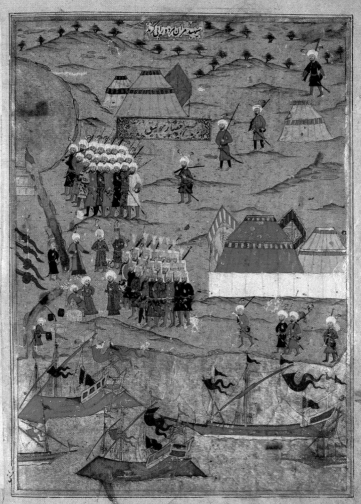

168

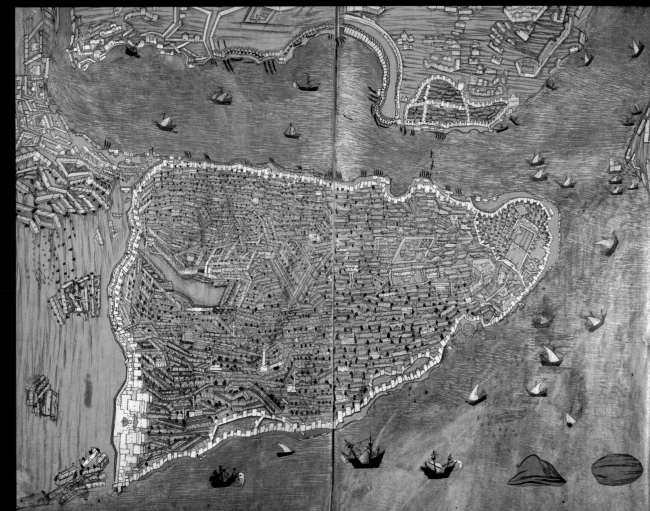

169

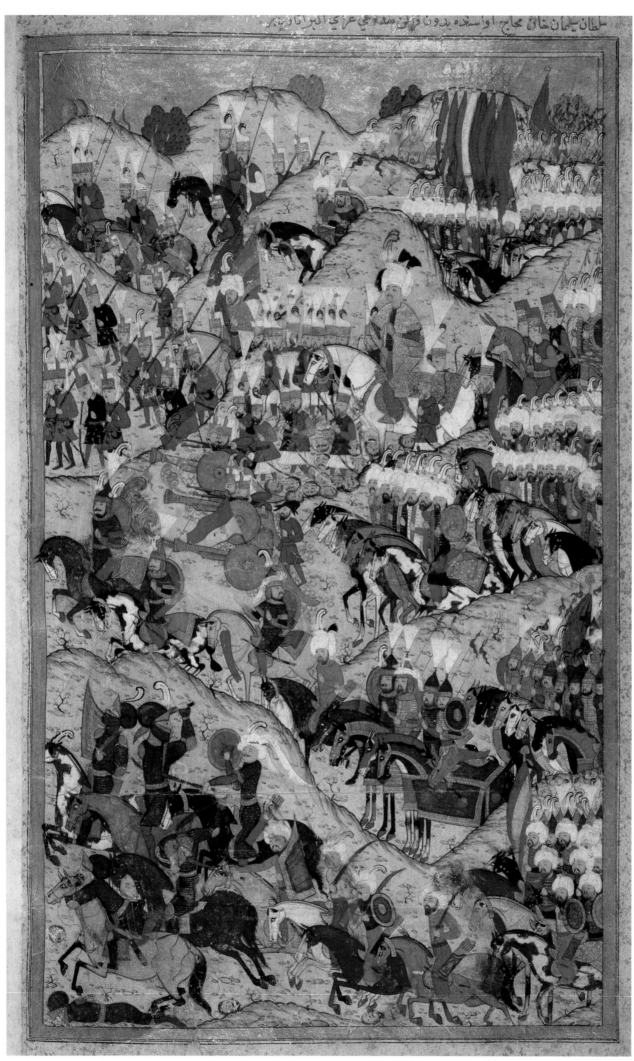

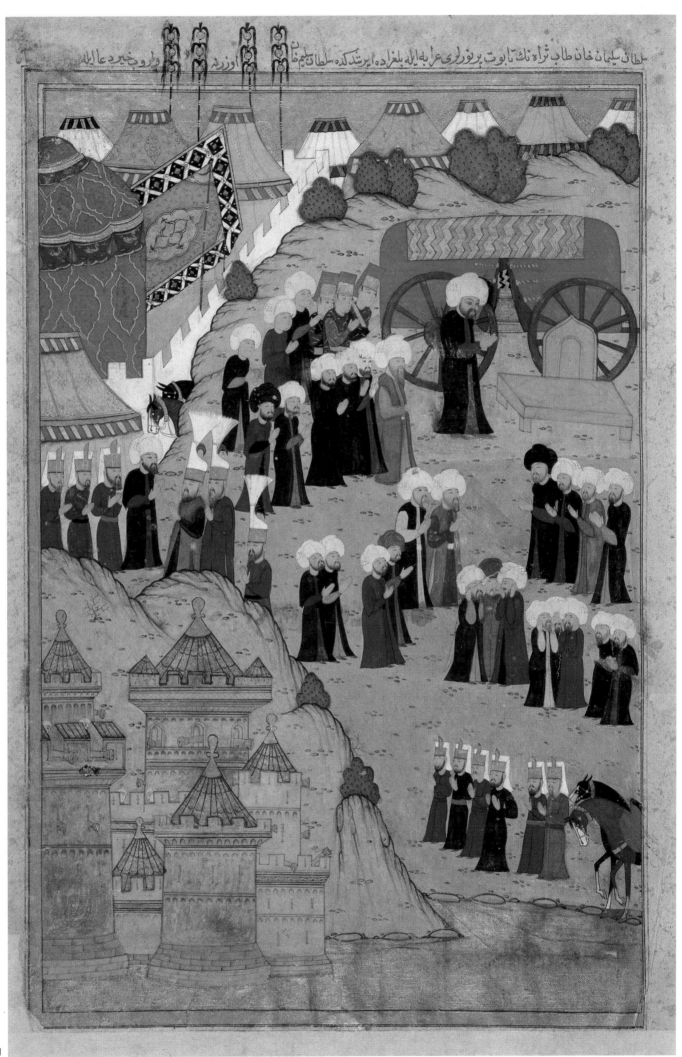

171

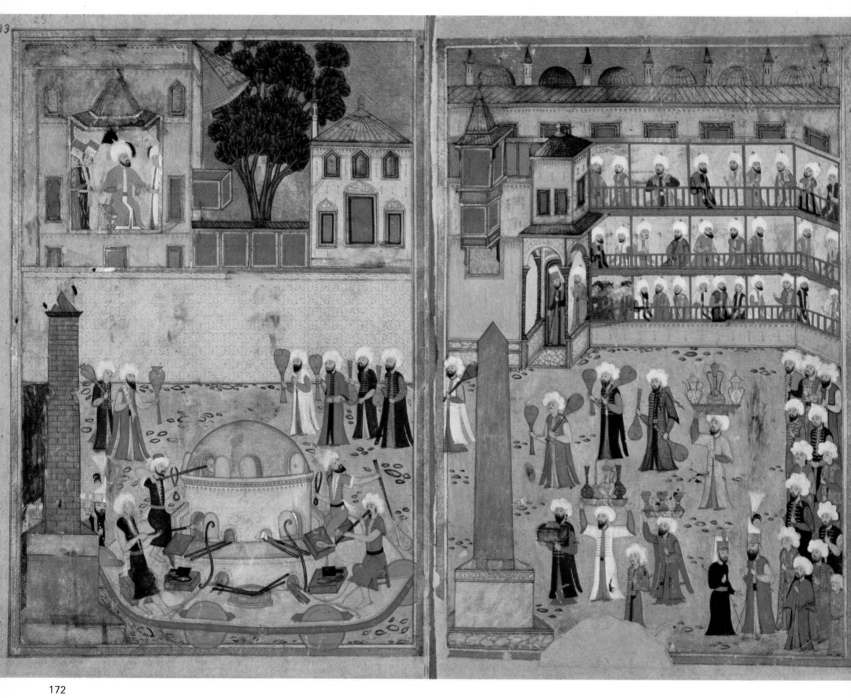

172

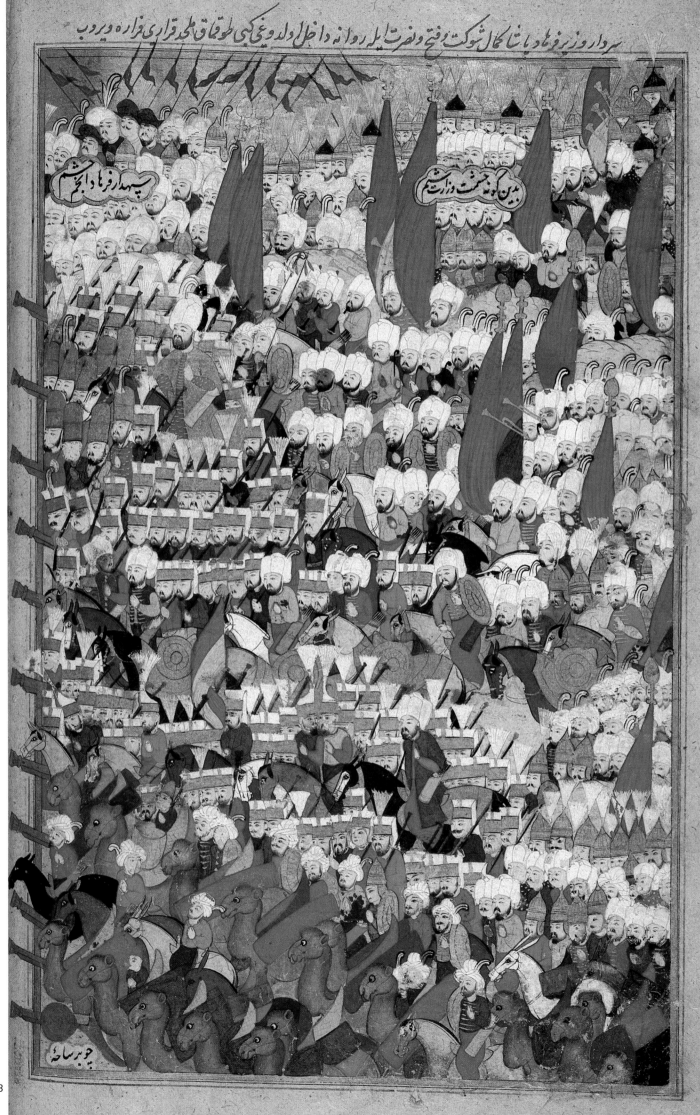

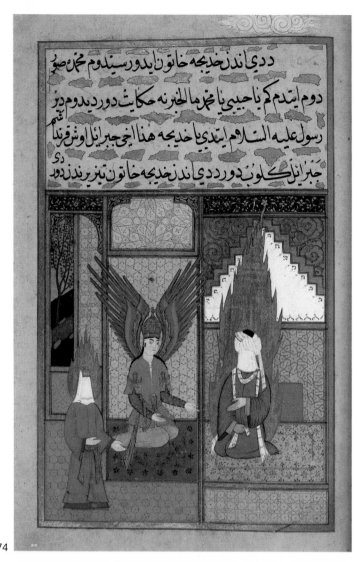

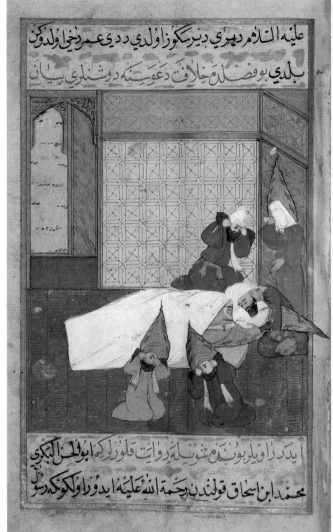

174

175

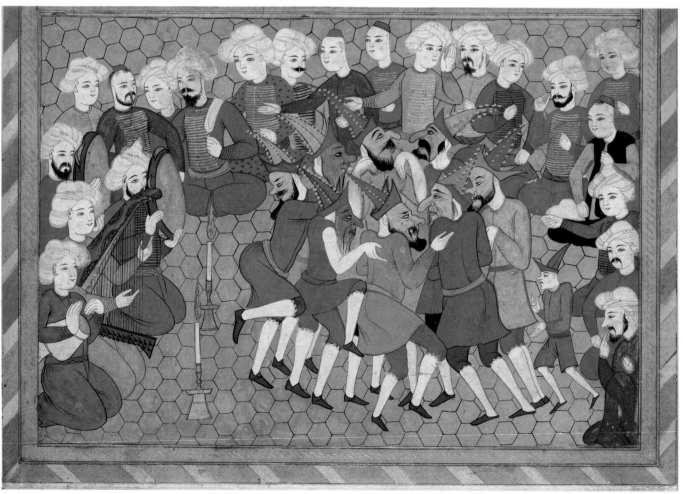

176

177 / 178

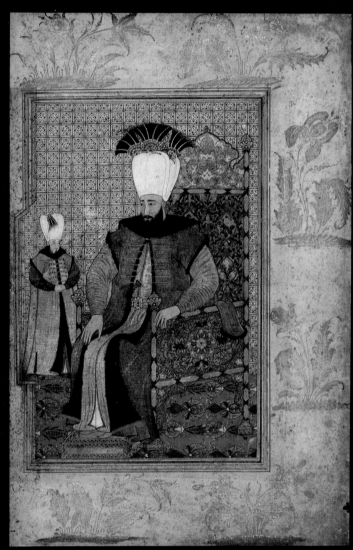

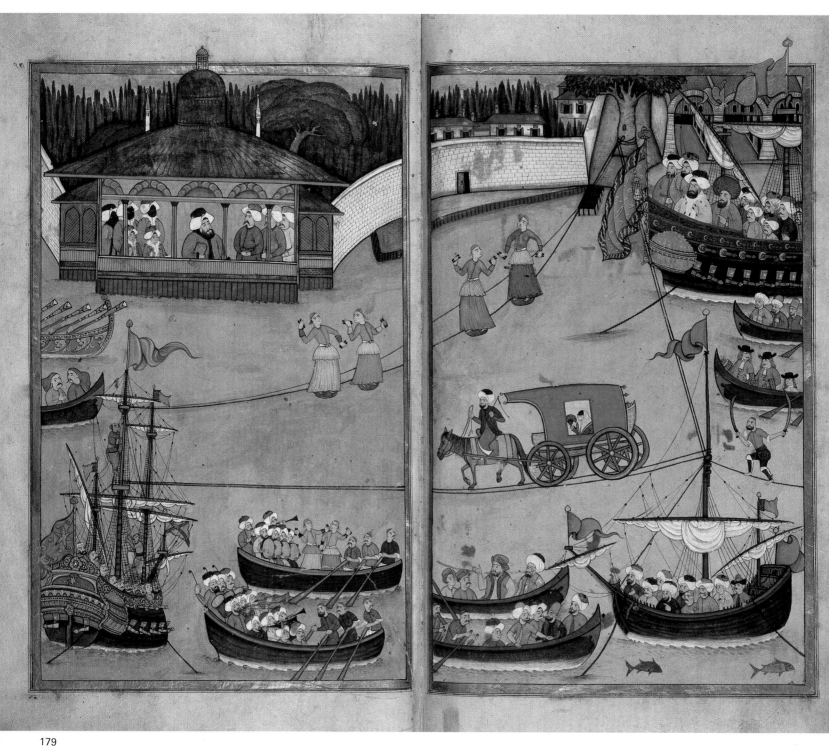

179

a fight between the Janissaries and the cavalry and the death of a newly born prince — whereupon the sultan returned to the palace.

Both Western chroniclers and local scholars recorded the event. An illustrated manuscript was prepared in the palace workshop in honour of the occasion — the 'Surnama' (Book of Festivities). It was prepared in the months proceeding the ceremony and is now kept in the Topkapı Sarayı Museum (H. 1344). The text states that it was prepared by a group of scribes and artists under the supervision of Master Osman and that it contained two hundred and fifty miniatures. However, the first and last sections of the manuscript and some illustrated pages from it are now lost.

Illustrating these events gave Ottoman artists an entirely new medium for their skills. Osman arranged the illustrations of the procession of all the guilds of Istanbul displaying their talents and of the attendant celebrations within a monotonous, unchanging framework of the arena and the loggia of guests. This simple backcloth lent significance to each variation in the figures passing in the foreground and unified the whole work.

The reign of Murat III also produced important works: chronicles of specific campaigns, general world histories, including the history of the Prophet, and contemporary chronicles or 'Shahnamas'.[24] Seyyid Loqman wrote a contemporary history of this type. The first volume of this two-volume work (in the Istanbul University Library, F. 1404) was devoted to the period from Murat's accession to power in 1574 to the year 1581. It contains fifty-eight miniatures of a typical style.[25] The second volume (in the Topkapı Sarayı Museum, B. 200) was devoted to events that occurred between the years 1581 and 1588. These two volumes were the joint work of Seyyid Loqman and Nakkaş Osman, who generally worked together. They are the last product of their co-operative effort and of the traditional Persian 'Shahnama' type. This work was entitled 'Shahinshahnama' and was completed in 1592 after long preparation. It was finally presented to the new sultan, Mehmet III, in 1597 with ninety-five additional full-page miniatures that in all probability are the last works of Osman. They are highly crowded scenes of war, of the storming and restoration of various fortresses, of palace ceremonies and of scenes related to the circumcision celebrations in 1582.

In these miniatures the typical composition of the classical period is developed to the fullest. Events are arranged and interlinked across the page in a series of crowded scenes that provides a panoramic view. Although these miniatures are not of outstanding quality, they are masterpieces of composition. One of the finest examples is the Ottoman army storming Revan Fortress. This miniature should be compared with the illustration by the same artist of the Mohács campaign mentioned above, in order to demonstrate his change in style. Both miniatures have basic similarities; the figures are arranged in horizontal and diagonal rows. In the Mohács miniature, the sultan and the various ranks of the army are easily identifiable and arranged on an undulating field. In Osman's later work, it becomes impossible to distinguish the type of terrain over which the army is

passing; every inch of the field is hidden by marching troops. In comparison to the balanced spaciousness of the Mohács composition, the later miniature is extemely, but effectively, confused: the might and proliferation of the army are more explicitly implied.

New Subjects

A new subject for illustrated manuscripts began to appear in court workshops towards the end of the reign of Murat III; the 'Siyar-i Nabi' (Life of the Prophet). The original lengthy text was written by the blind writer Darir of Erzurum in pure Turkish during the fourteenth century. It was derived from earlier works in Arabic. A six-volume work of this type was commissioned by the sultan. The text was completed by 1003 AH (1594–5). Of these six volumes, three are in the Topkapı Sarayı Museum (H. 1221–3); one is lost, and the remaining volumes are in the Chester Beatty Library, Dublin, and the Spencer Collection, New York.[26] From palace accounts of the period, it appears that a total of 814 miniatures were paid for. This was to be the first and last work which illustrated the entire life of the Prophet.

The 'History of the Prophets' and the 'Miradjnama' (Book of the Ascension) of the Mongol and Timurid periods were previous works on the subject, but such a monumental project was only executed in totality under the auspices of the Ottoman sultans, who combined religious and secular authority in their person. The artistic approach to this subject was to be somewhat different from that of the historical manuscripts and 'Shahnamas'. Illustrations were plainly constructed, contained few figures and an unusual colour scheme. The large number of illustrations somewhat encouraged repetition; however, the important scenes from the Prophet's life were illustrated with great care and feeling. The depiction of the revelation to the Prophet on Mount Hira, one of the important events of his life, is typical. The artist has chosen to portray the moment of revelation, when the Prophet is engulfed in mystic light upon hearing the voice of the Archangel Gabriel.[27] The entire ground of the picture is gilded, the area around the Prophet, trees, mountains, hills — in short earth and sky — are submerged in light, and the Prophet himself, draped in white, is contained in a flaming mandala. The effect of such gilding with patches of white and touches of green is most successful. The totally human scenes such as the death of the Prophet are rendered in complete contrast to the supernatural displays. There, pious belief must be held responsible, in large part, for the unelaborate expression of grief.

Despite close similarity between 'Siyar-i Nabi' illustrations and other miniatures of the period, the 'Siyar-i Nabi' illustrations grew swiftly in popularity because they provided an opportunity for the development of a new artistic style — and therefore for new artists. The artist most highly regarded during the reign of Mehmet III was Nakkaş Hasan, a palace dignitary who rose to the post of vizier. His style was somewhat removed from that of Master Osman and the classical period. Characteristics of

Hasan's work are sparsely populated scenes, plain structures and discriminate colour compositions — frequently on a burnt sienna background. Hasan illustrated the 'Eghri Fetihnama' or the 'Shahnama-i Mehmet Han', written by Ta'liq-i Zada Suphi Çelebi, the chronicler of the period. It concerns the Erlau (Hungarian) campaign of Mehmet III.[28] After this period all the 'Shahnamas' of the Ottoman sultans were written in Turkish.

Many illustrated manuscripts were prepared during Mehmet III's brief reign (1595–1603). One of the distinguishing features of the works of that period was the varied subject matter. The classics, especially anthologies translated from Persian and Arabic, were preferred to historical chronicles.[29]

The change in subject matter that occurred towards the end of the sixteenth century was reinforced during the seventeenth century by the addition of new iconographical subjects such as descriptions of the preparation of court manuscripts. The most renowned album (Topkapı, B. 408) of the seventeenth century was prepared by Kalandar Pasha for Ahmet I (1603–17). It contains illustrations from everyday life in the various strata of Ottoman society and, as in Iran, studies of single figures from various social levels.[30] The depiction of a group of men engaged in an evening's entertainment is one of the most

Pl. 176 well-known miniatures from this album. In it, masked men are engaged in a comical dance; seated on one side are musicians, and an enraptured audience is seated on the other side. The scene reflects the simple, narrative outlook that is so thoroughly Ottoman.

Such novel themes as the preparation of manuscripts and 'Falnamas' (Books of Fortune-telling) did not totally dislodge 'Shahnama' illustrations until the mid-seventeenth century. Historical manuscripts of some importance were prepared for Ahmet I, Osman II (1618–22) and Murat IV (1623–40).[31] The most outstanding of these was the 'Shahnama-i Nadiri' (Topkapı, H. 1124), prepared for Osman II by Nadiri and written in Turkish metre. This work, which is considerably damaged at present, contains twenty documentary miniatures; these are generally concerned with the major events of the Khotin (Bessarabian) campaign and with other important contemporary occasions. One of the most successful

Pl. 177 miniatures illustrates a naval victory of Admiral Ali Pasha. Brightly coloured vessels are picked out against a sea of oxidized silver gilts and captured foreign galleys are being towed behind the victorious ships.

During the second half of the seventeenth century, the preparation and illustration of 'Shahnamas' and other historical works were entirely discarded. This was a result either of the growing weakness and consistent defeats of the Ottoman Empire or of a change of taste due to Western influences. The paucity of surviving works from the second half of the seventeenth century may be linked to the removal of the royal seat to Edirne, which regained an importance lost in former years, after the royal palace was enlarged. Although there was a court workshop at Edirne at that time, there is very little extant evidence of its activity. Surviving manuscripts prove that books of genealogy, genre illustrations and albums of costume were all produced there.

246

The Tulip Period

The final flowering of Ottoman miniature painting took place in the first half of the eighteenth century, under Sultan Ahmet III (1703–30). He was a true patron of the arts and a skilled poet and calligrapher. Ahmet was greatly concerned with the art of the book and miniatures; his vizier, İbrahim Pasha, was also interesting in the arts. This period, known as the 'Tulip' period (1718–1830) in Ottoman history, was a period of Westernization. French court life, especially, began to influence the palace, and French art was largely copied in architecture and in all branches of the arts. A familiarity with Western art developed as a result of close diplomatic ties with the West. Superficial appreciation of Occidental taste was encouraged by the work of foreign artists invited to Turkey and by the foundation of the first Turkish publishing house in 1727.

The creativeness of this second classical period, as it is generally called, resulted in the final revival of Turkish book illustration. The most important and talented miniaturist of the time was Abdul Celil Çelebi, who worked under the pseudonym of Levni. He and other court artists produced illustrations for many works that were responsible for the final revival of Turkish book illustration. Their works were characterized by the influence of new tastes and by an attachment to traditional forms. One such manuscript is the 'Surnama-i Pl. 179 Vehbi' (Topkapı, A. 3593), a book on circumcision celebrations, written by the poet Vehbi in honour of the circumcision of the sons of Ahmet III in 1720. This type of book, describing the circumcision celebrations on the Golden Horn and the Ok Meydanı (archery field), which lasted fifteen days and nights, was the first of the type to appear during the classical period. It was illustrated with 137 miniatures by Levni. The artist chose to illustrate the parades, the presentation of gifts, the various entertainments and dances. He did not place all the emphasis on the performing figures, nor encase them in a monotonous background as in the classical illustrations. He used a different composition for each event, and the surroundings varied according to the event portrayed. The figures in the audience were given as much importance as the participants. The sultan and his entourage were sometimes even depicted on a larger scale than the performers.

Although Levni employed traditional illustrative and formal techniques, he was innovative in giving a certain depth to his paintings with an undulating arrangement of figures, with particular architectural details, and especially with his treatment of the natural background: buildings were drawn in perspective at the rear of the picture; trees gradually diminished in size, and a new method of colouring enhanced this impression. In these miniatures, performing artisans, acrobats and dancers are portrayed parading before the sultan and his guests on the Ok Meydanı. Levni's successful rendering of the various banquets, presentations of gifts, arrivals and departures of participating celebrants to and from the field, nightly fireworks and incredible marine displays on the Golden Horn are important documents of the occasion itself (events typical of that era which was obsessed

by entertainment). They demonstrate the development of the illustrative style of the 'Surnama'.

A second illustrated copy of the 'Surnama-i Vehbi' (Topkapı, A. 3594) was prepared at the same time, most probably for presentation to Vizier İbrahim Pasha. This manuscript contains 140 miniatures by a contemporary but unknown artist, who was more innovative than Levni. The unknown artist was both keenly observant and amenable to Western artistic influences. This is especially evident in his arrangement of figures, representations of nature and the occasional variation in tones of colour which is quite different from those of Levni. This artist preferred green and blue tones, in contrast to Levni's yellows, and he employed a great deal of silver gilt—a traditional feature of miniature painting. Other work by the same unknown artist, dated 1728, can be found in the manuscript of the three 'Mesnevi' by the Turkish poet Atay (Topkapı, R. 816).[32]

After the 'Surnama', the most important work of the period is an album of royal portraits known as the 'Silsilnama' (Topkapı, A. 3109). It was also illustrated by Levni and contains portraits of all the Ottoman sultans from Pl. 178 Osman Ghazi, the founder of the dynasty, to Ahmet III. Later sultans added their own portraits to it. (It is not altogether unreasonable that Levni should produce works in this branch of art, as it is one that had preserved its importance in Ottoman painting for over two hundred years.) The artist portrayed the sultans seated cross-legged in the traditional pose but with the addition of some avant-garde features borrowed from contemporary art. Despite Levni's preference for classicism, the abundance of rounded contours and the emphasis on certain draperies produce a three-dimensional quality and monumentality hitherto unseen. The portrait of Sultan Ahmet III is singular in style and treatment. The sultan is shown seated on a chair-like throne, attended in the background by the standing figure of his submissive son. The decorative details in costumes and surroundings in this portrait reflect contemporary Ottoman taste and the artist's skill.

The remainder of Levni's work embodies all the sensual delight of the Tulip period: the characteristic obsession with numerous extravagances, the typical profusion of gardens with multi-coloured tulips. This work was collected in an album and is kept in the Topkapı Sarayı Museum. It contains portraits of costumed nobles—male and female—and studies of European and Iranian costumes; young maidens in promenade costumes, dressing their hair or engaged in dancing, and smart young youths bearing a single blossom.[33] The notorious aristocratic obsession with dress at that time may be easily surmised from these drawings, while the artist's skilled observations and his outstanding line and brushwork are quite evident. The absence of chronicles of the sultan's life and achievements ('Shahnamas') from this period is not unaccounted for: such themes were easily replaced by works reflecting the desire for amusement and the new taste prevalent at the Ottoman court.

The Tulip period—a period of real rejuvenation for the Turkish miniature—ended abruptly with an insurrection that led to the dethronement of Ahmet III (1730). Levni died shortly afterwards in 1732. The most significant artist of subsequent years was Abdullah Buhari, who executed many costume studies of single figures, especially of young girls in a firm but finely contoured style. He also produced many erotic drawings and highly skilled still-lifes and scenic studies.

The Decline in Miniature Painting

In the second half of the eighteenth century, Ottoman art was almost totally devoid of miniatures. Only one or two illustrated astrological works (very popular in the West) and anthologies of verse, illuminated with motifs from still-lifes and from scenic art of a highly decorative nature such as non-figural landscapes and bouquets of flowers and fruit, were given a place in the royal workshop. Despite the lack of other traditional illustrated works connected with the sultans, royal portrait albums were still painted until Abdul Mecit's reign (1839–61). This reprieve for portrait painting may be due to the strong influence of Western art, which especially encouraged portraiture. At the same time, Western influence encouraged the wide and rapid production of non-figural, scenic murals in palaces, mansions and mosques. These in turn were replaced (as was portraiture) by an art thoroughly Westernized in both style and medium.

NOTES

[1] R. Ettinghausen, *Arab Painting*, Geneva, 1962, pp. 93–6; E. Atıl, *Art of the Arab World*, Washington D.C., 1975, pp. 102–11; G. Öney, *Anadolu Selçuklu Mimarisinde Süsleme ve El Sanatları* (Architectural Decoration and Minor Arts in Seljuk Anatolia), Ankara, 1978, pp. 149–51, Figs. 124–30; F. Çağman and Z. Tanındı, *Islamic Miniature Painting*, Istanbul, 1979, no. 4. Al-Jazari's work has been translated in full by Donald Hill, *The Book of Knowledge of Ingenious Mechanical Devices*, Dortrecht and Boston, 1974.

[2] E. Grube, 'Materialien zum Dioskorides Arabicus' in *Aus der Welt der islamischen Kunst: Festschrift für Ernst Kühnel*, Berlin, 1959, pp. 163–94.

[3] See Ettinghausen, *Painting*, pp. 130–1; E. Wellesz, 'An Early al-Sufi Manuscript in the Bodleian Library in Oxford: A Study in Islamic Constellation Images' in *Ars Orientalis* III (Ann Arbor, 1959): 1–26.

[4] A. S. Melikian-Chirvani, 'Le Roman de Varqé et Golśâh' in *Arts Asiatiques*, special issue (Paris, 1970); M. K. Özergin, 'Selçuklu Sanatçısı Nakkaş Adbülmü'min el Hoyi Hakkında' in *Belleten* XXXIV (Ankara, 1970): 219–30.

[5] O. Aslanapa, *Turkish Art and Architecture*, London, 1971, pp. 311–12; E. Blochet, *Les Enluminures des Manuscrits orientaux, turcs, arabes, persans*, Paris, 1926, pp. 70–2, Pls. XVIII–XIX.

[6] For miniature painting of the period of Mehmet the Conqueror, see

E. Atıl, 'Ottoman Miniature Painting under Sultan Mehmed II' in *Ars Orientalis* IX (Ann Arbor, 1973): 103–20.

[7] I. Stchoukine, 'Miniatures turques du temps de Mohammad II' in *Arts Asiatiques* XV (Paris, 1967): 47–50.

[8] F. Çağman, 'Sultan Mehmed II Dönemine Ait Bir Minyatürlü Yazma' in *Sanat Tarihi Yıllığı* VI (Istanbul, 1976): 333–46.

[9] The manuscript has 75 miniatures (MS Orientali Turcici XC [57]). This unpublished work was first mentioned by Basil Gray at the 1st Congress of Turkish Art ('Unpublished Miniatures from Turkish Manuscripts in the British Museum' in *The First Congress of Turkish Arts* [Ankara, 1961]: 149–52), and was later discussed by E. J. Grube at the 2nd International Congress of Turcology, Istanbul.

[10] For additional information, see R. M. Meriç, *Türk Nakış Tarihi Araştırmaları, Vesikalar*, Vol. I, Ankara, 1953, pp. 3–7.

[11] I. Stchoukine, *La Peinture turque d'après les Manuscrits illustrés*, Part I: *De Suleyman 1er à Osman II (1520–1622)*, Paris, 1966, pp. 50–65.

[12] For this work in the Topkapı Sarayı Museum Library (E. H. 1512) and other works in this style, together with information on the origins of this style, see F. Çağman, 'The Miniatures of the Divan-ı Husyni and the Influence of their Style' in *5th International Congress of Turkish Arts (1975)*, Budapest, 1979, pp. 231–59.

[13] For the Topkapı manuscripts (R. 1272, H. 1608) thought to have been written between 1540–5, see H. G. Yurdaydın, 'Matrakçı Nasuh'un Minyatürlü İki Yeni Eseri' in *Belleten* XXVIII (Ankara, 1964): 229–33; H. Yurdaydın, 'Two New Illuminative Works of Matrakçı Nasuh' in *Atti del secondo congresso internazionale di arte turca (Venezia 1963)* (Naples, 1965): 284–6, Pls. CXLV–CXLVI; Z. Akalay, 'Tarihi Konuda İlk Osmanlı Minyatürleri' in *Sanat Tarihi Yıllığı* II (Istanbul, 1968): 102–15.

[14] The facsimile of this work has been published by Türk Tarih Kurumu, 'Nasuh's Silahi (Matrakçi)' in *Beyan-ı Menazil-i Sefer-i Irakeyn-i Sultan Suleyman Han* (Ed. and intro. by H. G. Yurdaydın), Istanbul Universitesi Türkçe Yazmalar Bölümü. Ankara, 1976; see also M. And, *Turkish Miniature Painting: The Ottoman Period*, Ankara, 1974, pp. 33–43; Atasoy and Çağman, *Painting*, Istanbul, 1974, Pl. 6.

[15] For manuscripts numbered E. 391, E. 70, E. 2, see Ahmed Uğur, 'Dresden'de Kemal Paşa-Zade'ye Atfedilen Yazma Eserleri' in *Islam İlimleri Enstitüsü Dergisi* III (Ankara, 1977): 313–43. Section E 2 of this three-section illustrated work, recently recognised as the work of Matrakçı, is as yet unstudied.

[16] The fourth volume of Arifi's work contains 34 miniatures (E. J. Grube, *Islamic Painting from the 11th to the 18th Century: The Collection of Hans P. Kraus*, New York, 1972, pp. 216–39, Pls. XLII–XLV). The first volume of Arifi's work is the 'History of the Prophets', now in the collection of A. Bruschettin in Geneva. This volume, entitled 'Anbiyanamah' and dated March, 1558, is of high quality and contains nine unusual miniatures (*Christie's Islamic and Indian Manuscripts and Miniatures: November 17, 1976*, London, pp. 12, 13, Lot 24).

[17] The miniatures relating important historical events in a European context were published for this purpose by G. Feher, *Turkish Miniatures from the Period of Hungary's Turkish Occupation*, Budapest, 1978, Pls. VII–XIIB, XIV, XV, XVII, XVIII, XXI, XXVII, XXIX–XXXI, XXXV.

[18] For the works of Nigari, see A. S. Ünver, *Ressam Niğâri Hayatı ve Eserleri*, Ankara, 1946; Çağman and Tanındı, *Painting*, nos. 137–40; Edwin Binney, III, *Turkish Treasures from the Collection of Edwin Binney 3rd*, Exhibition catalogue: Portland Art Museum, Portland, Oregon, 1979, pp. 22–5, Cat. nos. 11, 12.

[19] This work was copied many times at different periods, and the first copies (illustrated by Osman) are now in the Topkapı Sarayı Museum (H. 1563) and in the Istanbul University Library (T. 6087). See Stchoukine, *Peinture turque*, Part I, p. 69, Pls. XL, XLI; N. Atasoy, 'Nakkaş Osman'ın Padişah Portreleri Albümü' in

Türkiyemiz 6 (Istanbul, 1972): 2–14.

[20] V. Minorsky and J. W. S. Wilkinson, *The Chester Beatty Library: A Catalogue of the Turkish Manuscripts and Miniatures*, Dublin, 1958, no. 413, Pls. 5–12; Stchoukine, *Peinture turque*, no. 33, Pls. XXXI–XXXVII; Atasoy and Çağman, *Painting*, Pls. 14–16.

[21] For sources giving reference to the artists working on this work and notes on the missing miniatures see F. Çağman, 'Şahname-i Selim Han ve Minyatürleri' in *Sanat Tarihi Yıllığı* V (Istanbul, 1973): 411–43; Atasoy and Çağman, *Painting*, Pls. 12, 13.

[22] A document in the palace archives gives the names of the painters and the number of scenes each one painted. According to this source, Osman painted 19 miniatures, Ali 6, Mehmed Bey 10, Veli Can 2, Molla Tiflisi 5, Mehmet of Bursa 3. See N. Anafarta, *Hünername Minyatürleri ve Sanatçıları*, Istanbul, 1969; see also Atasoy and Çağman, *Painting*, pp. 44–7.

[23] For detailed information on this volume, which palace documents state was completed in 1588 (Safer, 996 AH), see T. Öz, 'Hünername ve Minyatürleri' in *Güzel Sanatlar Mecmuası*, no. 1 (Istanbul, n. d.): 3–16.

[24] Among the important historical chronicles of the period are Lala Mustafa Pasha's eastern Iranian campaign 'Nusretnama' (Topkapı Sarayı Museum Library, H. 1365) and Ferhad Pasha's siege of Gence (Topkapı Sarayı Museum Library, R. 1296); for these works, see Atasoy and Çağman, *Painting*, pp. 49–50; Stchoukine, *Peinture turque*, nos. 44, 48.

Another important work of the period, the 'Zubdet üt-Tevarih' by *Shahnamaji* Seyyid Loqman, was illustrated in three copies. One is in the Museum of Turkish and Islamic Art (no. 1973), one in the Topkapı Sarayı Museum (H. 1321) and one in the Chester Beatty Library, Dublin (no. 414). See G. Renda, 'The Miniatures of the Zubdat al-Tawarikh' in *Turkish Treasures*, vol. I, Istanbul, 1978, pp. 26–35.

[25] For the first volume of the 'Shahinshahnama' (F. 1404), dated 1581 (989 AH), prepared by a group of chosen artists under Nakkaş Osman, see Atasoy and Çağman, *Painting*, pp. 36–8, Pls. 17–19.

[26] The volumes of this work in the Topkapı Sarayı Museum are as follows: volume I, no. H. 1221, contains 139 miniatures; volume II, no. H. 1222, 85 miniatures: volume VI (the last volume), no. 1223, 125 miniatures. It is noted at the end of this work that the manuscript was copied in 1594–5 (1003 AH). For the volumes see Stchoukine, *Peinture turque*, vol. I, nos. 57–8, Pls. LXXX–LXXXVIII; Atasoy and Çağman, *Painting*, pp. 52–4; Çağman and Tanındı, *Painting*, no. 162. The third volume of the work is in the Spencer Collection, New York; the fourth volume, dated 1594 (1003 AH), is in the Chester Beatty Library, Dublin, no. 419.

[27] See M. S. Ipşiroğlu, *Das Bild im Islam: Ein Verbot und seine Folgen*, Vienna and Munich, 1971, Pl. 103.

[28] For this work (Topkapı Sarayı Museum, H. 1609) and the artist Nakkaş Hasan, see Atasoy and Çağman, *Painting*, pp. 55–7; Z. Tanındı, 'Nakkaş Hasan Paşa' in *Sanat* 6 (Istanbul, 1977): 114–25.

[29] For the variety of subjects in the period of Sultan Mehmet III, see Stchoukine, *Peinture turque*, vol. 1, no. 75; Atasoy and Çağman, *Painting*, p. 58; F. Çağman, 'Illustrated Stories from a Turkish Version of Jami's Baharistan' in *Turkish Treasures*, Vol. 2, Istanbul, 1978, pp. 21–7.

[30] See S. Ünver, 'L'Album d'Ahmed Ier', in *Annali dell'Instituto Universitario Orientale di Napoli* (Naples, 1963): 127–62. Another album from the same period is in the Chester Beatty Library, Dublin; see Minorsky and Wilkinson, *Catalogue*, p. 439.

[31] See Atasoy and Çağman, *Painting*, pp. 64–70.

[32] See Stchoukine, *Peinture turque*, vol. 2, Pls. LIV–LVII; G. Renda, *Batılılaşma Döneminde Türk Resim Sanatı 1700–1850*, Ankara, 1977, Res. 4.

[33] See Atasoy and Çağman, *Painting*, Pl. 50; Stchoukine, *Peinture turque*, vol. 2, Pls. LXXIX–LXXXII; Çağman and Tanındı, *Painting*, nos. 184–94.

Select Bibliographies

The following bibliographies have been arranged according to the chapters of the book. Each author has made his own choices and, therefore, general works may appear more than once.

Anatolia from the Neolithic Period to the End of the Roman Period

by Ekrem Akurgal

THE PREHISTORIC CIVILIZATIONS OF ANATOLIA

Alkım, U. Bahadır. *Anatolien*. Vol. 1. Geneva, 1968.
Belgen, Carl W. *Troy and Trojans*. London and New York, 1963.
Lloyd, Seton. *Early Anatolia*. London, 1956.
– *Early Highland Peoples of Anatolia*. London, 1967.
Mellaart, James. *Earliest Civilizations of the Near East*. London, 1965.
– *Çatal Hüyük: A Neolithic Town in Anatolia*. London, 1967.

HITTITE ART AND CULTURE

Akurgal, Ekrem. *The Art of the Hittites* (Trans. Constance MacNab). London, Florence and Munich, 1962; 2nd German ed. Munich, 1976.
Bittel, Kurt. *Les Hittites* (Trans. A. François-Poncet). Paris, 1976.
Goetze, Albrecht. *Kleinasien*. 2nd ed. Munich, 1957.

URARTIAN ART

Akurgal, Ekrem. *Urartäische und altiranische Kunstzentren*. Ankara, 1968.
Piotrovski, B. B. *Iskusstvo Urartu*. Leningrad, 1962; German ed. Geneva, 1969.
Loon, M. N. van. *Urartian Art*. Istanbul, 1966.

PHRYGIAN, LYDIAN AND LYCIAN ART

Akurgal, Ekrem. *Phrygische Kunst*. Ankara, 1955.
– *Die Kunst Anatoliens*. Berlin, 1961, pp. 70–159.
Herodotus (Trans. J. Enoch Powell). 2 vols. Oxford, 1949.

GREEK AND ROMAN ART

Akurgal, Ekrem. *Die Kunst Anatoliens*. Berlin, 1961, pp. 175–279.
– *The Birth of Greek Art* (Trans. Wayne Dynes). London and New York, 1968. [Published in the U.S.A. as *The Art of Greece: The Origins*.]
– *Ancient Civilizations and Ruins of Turkey* (Trans. John Whybrow and Molie Emre). 4th ed. Istanbul, 1978.
İnan, Jale and Elisabeth Alföldi-Rosenbaum. *Roman and Early Byzantine Portrait Sculpture*. Oxford, 1966.
Metzger, Henri. *Anatolia* (Trans. James Hogarth). Vol. 2, Geneva, 1969.
Rodenwaldt, Gerhart. *Griechische Reliefs in Lykien*. Berlin, 1933.

Byzantine Art in Turkey

by Semavi Eyice

ISTANBUL

GENERAL WORKS

Janin, R. *Constantinople byzantine*. 2nd ed. Paris, 1964.
Müller-Wiener, W. *Bildlexikon zur Topographie Istanbuls*. Tübingen, 1977.
Schneider, A. M. *Byzanz: Vorarbeiten zur Topographie und Archäologie der Stadt*. Berlin, 1936.

WALLS

Milligen, A. van. *Byzantine Constantinople: The Walls of the City*. London, 1899.
Krischen, F.; Schneider, A. M. and B. Meyer-Plath. *Die Landmauer von Konstantinopel*. 2 vols. Berlin, 1938; 1943.

MONUMENTS AND HIPPODROME

Bruns, G. *Der Obelisk und seine Basis auf dem Hippodrom zu Konstantinopel*. Istanbul, 1935.
Casson, S. and D. Talbot Rice. *Report upon the Excavations Carried out in the Hippodrome of Constantinople*. 2 vols. London, 1928; 1929.
Kollwitz, J. *Oströmische Plastik der theodosianischen Zeit*. Berlin, 1941.

PALACES

Ebersolt, J. *Le grand palais de Constantinople et les livres des cérémonies*. Paris, 1910.
Eyice, S. 'Bryas sarayı' in *Belleten* XXIII (Ankara, 1959): 79–99 [French résumé pp. 101–4].
Demangel, R. and E. Mamboury. *Le quartier des Manganes*. Paris, 1939.
Mamboury, E. and T. Wiegand. *Die Kaiserpaläste von Konstantinopel*. Berlin, 1934.
Miranda, S. *Etude de topographie du palais sacré de Byzance*, Mexico City, 1971.
Walker Trust. *The Great Palace of the Byzantine Emperors*. 2 vols. London; Edinburgh, 1947; 1958.
Wulzinger, K. *Byzantinische Baudenkmäler zu Konstantinopel*. Hanover, 1925.

IRRIGATION SYSTEMS

Dalman, K. O. *Der Valens-Aquädukt in Konstantinopel*. Bamberg, 1933.
Eyice, S. 'Byzantinische Wasserversorgungsanlagen in Istanbul' in *Mitteilungen des Leichtweiss-Instituts für Wasserbau* LXIV (Brunswick, 1979): 1–16.
Forchheimer P. and J. Strzygowski. *Die byzantinischen Wasserbehälter von Konstantinopel*. Vienna, 1893.

HAGIA SOPHIA

Mango, C. *Materials for the Study of the Mosaics of St. Sophia at Istanbul*. Washington D. C., 1962.

Nice, R. van. *Saint Sophia in Istanbul: An Architectural Survey*. Washington D. C., 1968.

Swift, E. H. *Hagia Sophia*. New York, 1940.

Whittemore, T. *The Mosaics of St. Sophia at Istanbul*. 4 vols. Oxford, 1933–52.

CHURCHES

Belting, H.; Mango, C. and D. Mouriki. *The Mosaics and Frescoes of St. Mary Pammakaristos (Fethiye Camii) at Istanbul*. Washington D. C., 1978.

Ebersolt, J. and A. Thiers. *Les églises byzantines de Constantinople*. 2 vols. Paris, 1913.

Janin, R. *La géographie ecclésiastique de l'empire byzantin*. Vols. 1, 3. 2nd ed. Paris, 1969.

Mathews, T. F. *The Byzantine Churches of Istanbul: A Photographic Survey*. Pennsylvania and London, 1976.

Millingen, A. van. *Byzantine Churches of Constantinople*. London, 1912; Reprint. London, 1974.

Naumann, R. and H. Belting. *Die Euphemia-Kirche am Hippodrom zu Istanbul und ihre Fresken*. Berlin, 1966.

Peschlow, U. *Die Irenenkirche in Istanbul*. Tübingen, 1977.

Schäfer, H. *Die Gül Camii in Istanbul*. Tübingen, 1973.

Underwood, P. A. *The Kariye Djami*. 4 vols. New York, 1966–75.

MUSEUMS

Fıratlı, N. 'Deux nouveaux reliefs funéraires d'Istanbul et les reliefs similaires' in *Cahiers Archéologiques* XI (Paris, 1960): 73–92.

Grabar, A. *Sculptures byzantines de Constantinople*. Paris, 1963.

Grierson, P. 'The Tombs and Obits of the Byzantine Emperors (337–1042)' in *Dumbarton Oaks Papers* XVI (Washington, D. C., 1962): 1–63.

Müfit (Mansel), A. *İstanbulda bulunan bir prens lâhti* (The Sarcophagus of a Prince from Istanbul). Istanbul, 1934.

Mendel, G. *Catalogue des sculptures grecques, romaines et byzantines des Musées Impériaux Ottomans*. 3 vols. Istanbul, 1912–14.

Ouspensky (Uspenskij), F. 'L'Octateuque de la Bibliothèque du Sérail' in *Izvestija (Bulletin) de l'Institut Archéologique Russe de Constantinople* XII (Sofia and Munich, 1907).

THRACE AND ANATOLIA

GENERAL WORKS

Eyice, S. 'Monuments anatoliens inédits ou peu connus' in *XVIII. Corso d. Cultura sull'arte ravennate e bizantina*. (1971): 275–98.

Guyer, S. *Grundlagen mittelalterlicher abendländischer Baukunst*. Einsiedeln, Zürich and Cologne, 1950.

Mango, C. *Byzantinische Architektur*. Stuttgart and Milan, 1974.

Rott, H. *Kleinasiatische Denkmäler aus Pisidien, Pamphylien, Kappadokien und Lykien*. Leipzig, 1908.

Swoboda, H.; Keil, J. and F. Knoll. *Denkmäler aus Lykien, Pamphylien und Isaurien*. Brünn, Prague and Leipzig, 1935.

Thierry, N. 'L'art monumental byzantin en Asie Mineure du XIᵉ siècle au XIVᵉ' in *Dumbarton Oaks Papers* XXIX (Washington, D. C., 1975): 75–111.

EASTERN THRACE

Dirimtekin, F. 'Adduction de l'eau à Byzance' in *Cahiers Archéologiques* X (Paris, 1959): 217–43.

Eyice, S. and N. Thierry. 'Le monastère et la source sainte de Midye en Thrace turque' in *Cahiers Archéologiques* XX (Paris, 1970): 47–76.

Eyice, S. 'Les monuments byzantins de la Thrace turque' in *XVIII. Corso d. Cultura sull'arte ravennate e bizantina*. (1971): 299–314.

Harrison, R. M. 'The Long Wall in Thrace' in *Archaeologia Aeliana*. XLVII (1969): 33–8.

BYZANTINE BITHYNIA

Buchwald, H. *The Church of the Archangels in Sige near Mudania*. Vienna, Cologne and Graz, 1969.

Eyice, S. 'Two Mosaic Pavements from Bithynia' in *Dumbarton Oaks Papers* XVII (Washington, D. C., 1963): 373–83.

Mango, C. and I. Ševčenko. 'Some Churches and Monasteries on the Southern Shore of the Sea of Marmara' in *Dumbarton Oaks Papers* XXVII (Washington, D. C. 1973): 235–77.

Schmitt, T. *Die Koimesiskirche von Nikäa*. Berlin, 1927.

Schneider, A. M. and W. Karnapp. *Die Stadtmauer von Iznik (Nicaea)*. Berlin, 1938.

WESTERN ANATOLIA

Eyice, S. 'Le palais byzantin de Nymphaion près d'Izmir' in *Akten des XI. Internationalen Byzantinisten-Kongresses* (Munich, 1960): 150–53.

Fıratlı, N. 'Découverte d'une église byzantine à Sébaste de Phrygie' in *Cahiers Archéologiques* XIX (Paris, 1969): 151–66.

Foss, C. *Byzantine and Turkish Sardis*. Cambridge, Mass. and London, 1976.

Keil, J. *Führer durch Ephesos*. 5th ed. Vienna, 1964.

Müller-Wiener, W. 'Mittelalterliche Befestigungen im südlichen Jonien' in *Istanbuler Mitteilungen* XI (Istanbul, 1960): 5–122.

Verzone, P. 'Le chiese di Hierapolis in Asia Minore' in *Cahiers Archéologiques* VIII (Paris, 1956): 37–61.

– 'Il martyrium ottagono a Hierapolis di Frigia' in *Palladio* X (1960): 1–20.

Wiegand, T. and Schaeder, H. *Priene*. Berlin, 1904, pp. 475–92.

Wiegand, T. *Der Latmos*. Berlin, 1913.

SOUTHERN ANATOLIA

Ballance, M. H. 'Cumanun Camii at Antalya' in *Papers of the British School at Rome* XXIII (Rome, 1955): 99–114.

Budde, L. *Antike Mosaiken in Kilikien*. 2 vols. Recklinghausen, 1969–72.

Djobadze, W. 'Vorläufiger Bericht über die Grabungen und Untersuchungen in der Gegend von Antiocheia am Orontes' in *Istanbuler Mitteilungen* XV (Istanbul, 1965): 218–42.

Eyice, S. 'Kanlıdivan (=Kanytelleis, Kanytelideis) basilikaları' in *Anadolu Sanatı Araştırmaları* IV–V (Istanbul, 1976–7): 411–42.

Feld, O. 'Bericht über eine Reise durch Kilikien' in *Istanbuler Mitteilungen* XIII–XIV (Istanbul, 1963–4): 88–107.

Gough, M. 'Alahan' in *Anatolian Studies* V (London, 1955): 115–23; XII (London, 1962): 173–83; XIII (London, 1963): 106–15; XIV (London, 1964): 185–90; XVII (London, 1967): 37–47; XVIII (London, 1968): 159–67.

– 'Early Churches in Cilicia' in *Byzantinoslavica* XVI (1955): 201–11.

– 'The Emperor Zeno and Some Cilician Churches' in *Anatolian*

Studies XXII (London, 1972): 199–212.

– 'A Church of the Iconoclast (?) Period in Byzantine Isauria (Aloda)' in *Anatolian Studies* VII (London, 1957): 153–61.

Harrison, R. M. 'Churches and Chapels of Central Lycia' in *Anatolian Studies* XIII (London, 1963): 117–51.

Herzfeld, E. and S. Guyer. *Meriamlik und Korykos: Zwei christliche Ruinenstätten des Rauhen Kilikiens.* Manchester, 1930.

Keil, J. and Wilhelm, A. *Denkmäler aus dem Rauhen Kilikien.* Manchester, 1931.

Levi, D. *Antioch Mosaic Pavements.* 2 vols. Princeton and London, 1947.

Lloyd, S. and D. Storm Rice. *Alanya ('Alā' iyya).* London, 1958.

Müfit (Mansel), A. *Side: 1947–1966 yılları kazıları ve araştırmaları sonuçları.* Ankara, 1978.

Morganstern, J. and R. E. Stone. 'The Church at Dereağzı' in *Dumbarton Oaks Papers* XXII (Washington, D. C., 1968): 217–25; XXIII–XXIV (Washington, D.C., 1969–70): 383–93.

Peschlow, U. and O. Feld. 'Die Nikolaoskirche in Myra' in Borchhardt, J. *Myra: Eine lykische Metropole.* Berlin, 1975.

CENTRAL ANATOLIA

Bell, G. L. and W. M. Ramsay. *The Thousand and One Churches.* London, 1909.

Eyice, S. *Karadağ (Binbirkilise) ve Karaman çevresinde arkeolojik incelemeler.* Instanbul, 1971.

– 'Akmanastır (S. Chariton) in der Nähe von Konya und die Höhlenkirchen von Sille' in *Polychordia: Festschrift F. Dölger.* Vol. 1. Amsterdam, 1967, pp. 162–85.

– 'La ruine byzantine dite "Üçayak" près de Kırşehir en Anatolie centrale' in *Cahiers Archéologiques* XVIII (Paris, 1968): 137–55.

Gough, M. 'The Monastery at Eski Gümüş' in *Anatolian Studies* XIV (London, 1964): 147–61; XV (London, 1965): 157–64.

Gürçay, H. and M. Akok. 'Yeraltı şehirlerinde bir inceleme ve Yeşilhisar ilçesinin Soğanlıdere köyünde bulunan kaya anıtları' in *Türk Arkeoloji Dergisi* XIV (1965): 35–68.

Jerphanion, G. de. *Mélanges d'archéologie anatolienne.* 2 vols. Beyrouth, 1928.

– *Une nouvelle province de l'art byzantin: Les églises rupestres de Cappadoce.* 4 vols. of text and 3 vols. of albums. Paris, 1925–42.

Restle, M. *Die byzantinische Wandmalerei in Kleinasien.* 3 vols. Recklinghausen, 1967.

Thierry, N. and M. *Nouvelles églises rupestres de Cappadoce: Région du Hasan Dağı.* Paris, 1963.

EASTERN ANATOLIA

Bell, G. L. *Churches and Monasteries of the Tûr Abdîn and Neighbouring Districts.* Heidelberg, 1913.

Middle East Technical University, Faculty of Architecture (Ed.). *Doomed by the Dam.* Ankara, 1967.

Segal, J. B. *Edessa: The 'Blessed City'.* Oxford, 1970.

Monneret de Villard, Ugo. *Le chiese della Mesopotamia.* Rome, 1940.

THE BLACK SEA COAST

Ballance, S. 'The Byzantine Churches of Trebizond' in *Anatolian Studies* X (London, 1960): 141–75.

Eyice, S. 'Trabon yakınında Meryem Ana (Sumela) manastırı' in *Belleten* XXX (Ankara, 1966): 243–64.

– 'Deux anciennes églises byzantines de la citadelle d'Amasra' in *Cahiers Archéologiques* VII (Paris, 1954): 97–105.

Hoepfner, W. *Herakleia Pontike-Ereğli: Eine baugeschichtliche*

Untersuchung. Vienna, 1966.

Millet, G. and D. Talbot Rice. *Byzantine Painting at Trebizond.* London, 1936.

Rice, D. Talbot and collaborators. *The Church of Hagia Sophia at Trebizond.* Edinburgh, 1968.

Winfield, D. 'A Note on the South-eastern Borders of the Empire of Trebizond' in *Anatolian Studies* XII (London, 1962): 163–72.

– and J. Wainwright. 'Some Byzantine Churches from the Pontus' in *Anatolian Studies* XII (London, 1962): 119–30.

Anatolian-Seljuk Architecture

by Aptullah Kuran

Akok, Mahmut. 'Kayseri Huand Mimarî Külliyesinin Rölövesi' in *Türk Arkeoloji Dergisi* XVI, no. 1 (1967): 5–44.

– 'Diyarbakır Ulucami Mimarî Manzumesi' in *Vakıflar Dergisi* VIII (Ankara, 1969): 113–140.

Arık, M. Oluş. 'Türbe Forms in Early Anatolian-Turkish Architecture' in *Anatolia* XI (Ankara, 1967): 57–119.

– Malatya Ulu Camiinin Aslî Plânı ve Tarihi Hakkında' in *Vakıflar Dergisi* VIII (Ankara, 1969): 141–8.

– *Bitlis yapılarında Selçuklu Rönesansı.* Ankara, 1971.

Arık, Rüçhan. 'Erzurum'da İki Cami' in *Vakıflar Dergisi* VIII (Ankara, 1969): 157–9.

Arseven, Celâl Esad. *Türk Sanatı Tarihi.* 3 vols. Istanbul, 1954–9.

Aslanapa, Oktay. *Turkish Art and Architecture.* London, 1971.

Balkan, Kemal. 'Ani'de İki Selçuklu Hamamı' in *Anatolia* XII (Ankara, 1970): 39–57.

Bakırer, Ömürıs. 'Hacı Ferruh Mescidi' in *Vakıflar Dergisi* VIII (Ankara, 1969): 171–184.

– *Anadolu Mihrabları.* Ankara, 1977.

Bates, Ülkü. *The Anatolian Mausoleum of the Twelfth, Thirteenth and Fourteenth Centuries.* Ann Arbor, Michigan, 1970.

Berchem, M. van and Joseph Strzygowski. *Amida.* Heidelberg, 1910.

Beygu, Abdürrahim Şerif. *Erzurum Tarihi, Anıtları, Kitabeleri.* İstanbul, 1936.

Cahen, Claude. *Pre-Ottoman Turkey.* New York, 1968.

Dilaver, Sadi. 'Anadolu'daki Tek Kubbeli Selçuklu Mescitlerinin Mimarlık Tarihi Yönünden Önemi' in *Sanat Tarihi Yıllığı* IV (Istanbul, 1971): 17–28.

Diez, Ernst. *Türk Sanatı.* Istanbul, 1946.

Erdmann, Kurt. *Das anatolische Karawansaray des 13. Jahrhunderts.* 2 vols. Berlin, 1962.

Eyice, Semavi. 'Kırşehir'de Karakurt (Kalender Baba) Ilıcası' in *Tarih Enstitüsü Dergisi*, no. 2 (Istanbul, 1971): 229–54.

– 'Anadolu'da Orta Asya Geleneklerinin Temsilcisi olan bir Eser: Boyalıköy Hankâhı' in *Türkiyat Mecmuası* no. 16 (Istanbul, 1971): 39–56.

Gabriel, Albert. *Monuments turcs d'Anatolie.* 2 vols. Paris, 1931; 1934.

– 'L'architecture seldjoukide' in *II. Türk Tarih Kongresi.* Ankara, 1937.

– *Voyages archéologiques dans la Turquie orientale.* Paris, 1940.

Godard, André. 'Origine de la Madrasa, de la mosquée et du Caravansérai à quatre iwans' in *Ars Islamica* XV–XVI (Ann Arbor, 1951): 1–9.

– *The Art of Iran.* London, 1965.

Grabar, Oleg. *The Formation of Islamic Art.* New Haven and London, 1973.

Hoag, John D. *Western Islamic Architecture.* London and New York, 1963.

Kafesoğlu, İbrahim. *Selçuklu Tarihi.* Istanbul, 1972.

Karamağralı, Haluk. 'Ahlat'da Bulunan Tümülüs Tarzında Türk Mezarları' in *Önasya* 5, nos. 59/60 (Ankara, 1970): 4–5.

– 'Eriszurum'daki Hâtuniye Medrese'sinin Tarihi ve Bânîsi Hakkında Mülâhazalar' in *Selçuklu Araştırmaları Dergisi* no. 3 (Ankara, 1971): 209–47.

Katoğlu, Murat. '13. Yüzyıl Konyasında bir câmi gurubunun plân tipi ve son cemaat yeri' in *Türk Etnografya Dergisi* IX (Ankara, 1966–7): 81–100.

– 'XIII. Yüıszyıl Anadolu Türk Mimarisinde Külliye' in *Belleten* XXXI, no. 123 (Ankara, 1967): 335–44.

Konyali, İbrahim Hakkı. *Akşehir*. Istanbul, 1945.

– *Alanya*. Istanbul, 1946.

– *Abideleri ve Kitabeleri ile Erzurum Tarihi*. Istanbul, 1960.

– *Konya Tarihi*. Konya, 1964.

Kuban, Doğan. *Anadolu–Türk Mimarisinin Kaynak ve Sorunları*. Istanbul, 1965.

– 'The Mosque and Hospital at Divriği and the Origin of Anatolian Turkish Architecture' in *Anatolica II* (Leiden, 1968): 122–30.

– 'Anadolu-Türk Şehri: Tarihî Gelişmesi, Sosyal ve Fizikî Özellikleri Üzerinde Bazı Gelişmeler' in *Vakıflar Dergisi* VII (Ankara, 1968): 53–74.

– *Muslim Religious Architecture*. Part. I. Leiden, 1974.

Kuran, Aptullah. *Anadolu Medreseleri*. Vol. 1. Ankara, 1969.

– 'Thirteenth- and Fourteenth-century Mosques in Turkey' in *Archaeology* 24, no. 3 (New York, 1971): 234–53.

– 'Anadolu'da Ahşap Sütunlu Selçuklu Mimarisi' in *Malazgirt Armağanı* (Ankara, 1972): 179–86.

Kühnel, Ernst. *Islamic Art and Architecture*. London, 1966.

Lloyd, Seton and D. Storm Rice. *Alanya ('Alā'iyya)*. London, 1958.

Oral, M. Zeki. 'Kayseri'de Kubadiye Sarayları' in *Belleten* XVII (Ankara, 1953): 501–17.

– 'Konya'da Alâ üd-din Câmii ve Türbeleri' in *Yıllık Araştırmalar Dergisi* I (Ankara, 1956): 45–74.

Otto-Dorn, Katharina. 'Seldschukische Holzsäulenmoscheen in Kleinasien' in *Aus der Welt der islamischen Kunst: Festschrift für Ernst Kühnel*. Berlin, 1959, pp. 58–88.

– and M. Önder. 'Bericht über die Grabung in Kobadabad (1965)' in *Archäologischer Anzeiger des deutschen Archäologischen Instituts*. (Berlin, 1966): 170–83.

– 'Die Uludschami in Sivrihisar' *Anatolia* IX (Ankara, 1965): 161–70.

Öney, Gönül. 'Akşehir Ulu Camisi'. in *Anatolia* IX (Ankara, 1965): 171–84.

– 'Kayseri'de Hacı Kılıç Camii ve Medresesi' in *Belleten* XXX (Ankara, 1966): 377–87.

Önge, Yılmaz. 'Çankırı Hasbey Darüşşifası' in *Vakıflar Dergisi* V (Ankara, 1962): 251–5.

– 'Konya-Beyşehir'de Eşrefoğlu Süleyman Bey Hamamı' in *Vakıflar Dergisi* VII (Ankara, 1968): 139–44.

– 'Anadolu'da XIII–XIV. Yüzyılın Nakışlı Ahşap Camilerinden bir örnek: Bey-şehir Köşk Köyü Mescidi' in *Vakıflar Dergisi* IX (Ankara, 1971): 291–6.

Özgüç, Tahsin and Mahmut Akok. 'Melik Gazi Türbesi ve Kalesi' in *Belleten* XVIII (Ankara, 1954): 331–6.

– 'Sarıhan' in *Belleten* XX (Ankara, 1956): 379–84.

– 'Alayhan, Öresun Han ve Hızırilyas Köşkü' in *Belleten* XXI (Ankara, 1957): 139–48.

– 'Üç Selçuklu Abidesi: Dolay Han, Kesik Köprü Kervansarayı ve Han Camii' in *Belleten* XXII (Ankara, 1958): 251–9.

– 'Afşin Yakınındaki Eshâb-ı Kehf Külliyesi' in *Yıllık Araştırmalar Dergisi* II (Ankara, 1958): 77–92.

Pope, Arthur Upham. *Persian Architecture*. London, 1965.

Rice, Tamara Talbot. *The Seljuks*. London, 1961.

Rogers, J. M. 'The Çifte Minare Medrese at Erzurum and the Gök Medrese at Sıvas' in *Anatolian Studies* XV (London, 1965): 63–85.

Sözen, Metin 'Anadolu'da Eyvan Tipi Türbeler' in *Anadolu Sanatı Araştırmaları* I (Istanbul, 1968): 167–210.

– *Anadolu Medreseleri*. 2 vols. Istanbul, 1970; 1972.

– *Diyarbakır'da Türk Mimarisi*. Istanbul, 1971.

– and collaborators. *Türk Mimarisinin Gelişimi ve Mimar Sinan*. Istanbul, 1975.

Turan, Osman. 'Seljuk Kervansarayları' in *Belleten* X, no. 41 (Ankara, 1946): 471–96.

– 'Selçuklu Devri Vakfiyeleri 1: Şemseddin Altun-aba Vakfiyesi ve Hayatı' in *Belleten* XI, no. 42 (Ankara, 1947): 197–235.

– 'Selçuk Devri Vakfiyeleri 2: Mûbarizuddin Ertokuş ve Vakfiyesi' in *Belleten* XI, no. 43 (Ankara, 1947): 415–29.

– 'Selçuk Devri Vakfiyeleri 3: Celâleddin Karatay Vakıfları ve Vakfiyeleri' in *Belleten* XII, no. 45 (Ankara, 1948): 17–171.

– *Selçuklular Tarihi ve Türk-İslâm Medeniyeti*. Ankara, 1965.

Tükel, Ayşıl. 'Alara Han'ın Tanıtılması ve Değerlendirilmesi' in *Belleten* XXXIII, no. 132, (Ankara, 1969): 429–91.

Ülgen, Ali Saim. 'Kırşehir'de Türk Eserleri' in *Vakıflar Dergisi* II (Ankara, 1942): 253–61.

– 'Divriği Ulucamii ve Dar üş-şifası' in *Vakıflar Dergisi* V (Ankara, 1962): 93–8.

– 'Siirt Ulu Camii' in *Vakıflar Dergisi*, V (Ankara, 1962): 153–4.

Ünal, Hüseyin Rahmi. *Les monuments islamiques anciens de la ville d'Erzurum et de sa région*. Paris, 1968.

– 'Monuments islamiques pré-Ottomans de la ville de Bayburt et de ses environs' in *Revue des Etudes islamiques* (Paris, 1972): 99–127.

Ünsal, Behçet. *Turkish Islamic Architecture in Seljuk and Ottoman Times 1071–1923*. London, 1959.

Ünver, A. Süheyl. 'Büyük Selçuklu İmparatorluğu zamanında Vakıf hastahanelerinin bir kısmına dair' in *Vakıflar Dergisi* I (Ankara, 1938): 17–23.

– 'Anadolu Selçuklularında Sağlık Hizmetleri' in *Malazgirt Armağanı* (Ankara, 1972): 9–32.

Yetkin, Şerare. 'Anadolu Selçuklu Şifahaneleri' in *Türk Kültürü* X (Ankara, 1963): 23–31.

– 'Alara Kalesindeki Hamamlı Kasır ve 13. Yüzyıl Anadolu Mimarisindeki Yeri' in *Malazgirt Armağanı* (Ankara, 1972): 119–29.

Yetkin, Suut Kemal. 'Mama Hatun Türbesi' in *Yıllık Aratırmalar Dergisi* I (Ankara, 1956): 75–81.

– 'The Turbeh of Gumaç Hatun: a Seljuk Monument' in *Ars Orientalis* IV (Ann Arbor, 1961): 357–60.

– *L'Architecture turque en Turquie*. Paris, 1962.

– *İslâm Mimarisi*. Ankara, 1965.

– Özgüç, T.; Sümer, F.; Ülken, H. Z.; Çağatay, N. and H. Karamağralı. *Turkish Architecture*. Ankara, 1965.

Yurdakul, Erol. 'Son Buluntulara Göre Kayseri'deki Hunat Hamamı' in *Selçuklu Araştırmaları Dergisi* II (Ankara, 1970): 141–51.

– 'Kayseri Külük Camii ve Medresesinde Yapılan Hafriyat ve Araştırma Sonuçları ile İlgili Yeni Görüşler' in *Rölöve ve Restorasyon Dergisi* I (Ankara, 1974): 167–207.

Turkish Architecture in Asia Minor in the Period of the Turkish Emirates

by M. Oluş Arık

Akarca, A. 'Beçin' in *Belleten* XXXV, no. 137 (Ankara, 1971): 1–37.

– *Milas Coğrafyası: Tarihi ve Arkeolojisi*. Istanbul, 1954.

Akın, H. *Aydınoğulları Tarihi Hakkında Bir Araştırma*. Istanbul, 1946.

Altun, A. *Mardin'de Türk Devri Mimarisi*. Istanbul, 1971.

– *Anadolu'da Artuklu Devri Türk Mimarisinin Gelişmesi*. Istanbul, 1978.

Arel, A. 'Menteşe Beyliği Devrinde Peçin Şehri' in *Anadolu Sanatı Araştırmaları* I (Istanbul, 1968): 60–9.

– 'Üç Şerefeli Cami ve Osmanlı Mimarisinde Tipolojik Sınıflandırma Sorunu' in *Mimarlık* no. 116 (Istanbul, 1973): 17–20.

Arık, M. O. 'Erken Devir Anadolu-Türk Mimarisinde Türbe Biçimleri' in *Anatolia* XI (Ankara, 1967): 57–100; 'Turbeh Forms in Early Anatolian Turkish Architecture' in *Anatolia* XI (Ankara, 1969): 101–19.

– *Bitlis Yapılarında Selçuklu Rönesansı*. Ankara, 1971.

Aslanapa, O. *Turkish Art and Architecture*. London, 1971.

– 'Kazısı Tamamlandıktan Sonra Van Ulu Camii' in *Sanat Tarihi Yıllığı* V (Istanbul, 1972–3): 1–25.

– *Yüzyıllar Boyunca Türk Sanatı: (14. Yüzyıl)*. Istanbul, 1977.

Aslanoğlu, I. *Tire'de Camiler ve Üç Mescid*. Ankara, 1978.

Bakırer, Ö. *Anadolu Mihrabları*. Ankara, 1976.

Cezar, M. *Anadolu Öncesi Türklerde Şehir ve Mimarlık*. Istanbul, 1977.

Cahen, C. *Pre-Ottoman Turkey*. London and Dublin, 1968.

Creswell, K. A. C. *Early Muslim Architecture (Umayyads, Early Abbasids and Tûlûnîds)*. Part 2. Oxford, 1940.

Demiriz, Y. *Osmanlı Mimarisinde Süsleme I (Erken Devir 1300–1453)*. Istanbul, 1979.

Emre, N. 'Aydınoğulları ve Eserleri' in *Arkitekt* X–XI (Istanbul, 1973): 307–20.

Erdmann, K. 'Weitere Nachträge zu den Beobachtungen auf einer Reise in Zentralanatolien' in *Archäologischer Anzeiger des deutschen Archäologischen Instituts* LXXI (Berlin, 1957): 361–72.

– 'Zur türkischen Baukunst seldschukischer und osmanischer Zeit' in *Istanbuler Mitteilungen* VIII (Istanbul, 1958): 1–39.

– 'Vorosmanische Medresen und Imarets vom Medresentyp in Anatolien' in *Studies in Islamic Art and Architecture: In Honour of K. A. C. Creswell*. London and Cairo, 1965, pp. 49–62.

Ethem, H. *Niğde Kılavuzu*. Istanbul, 1936.

Evliya Çelebi. *Seyahatname*. Vol. 4. Istanbul, 1314 (1896).

Eyice, S. 'Quatre édifices mal connus' in *Cahiers Archéologiques* X (Paris, 1959): 246–58.

– 'Zaviyeler ve Zaviyeli Camiler' in *İktisat Fakültesi Mecmuası* XXIII, nos. 1–2 (Istanbul, 1962–3): 3–80.

Gabriel, A. *Monuments turcs d'Anatolie: I (Kayseri-Niğde)*. Paris, 1931.

– *Monuments turcs d'Anatolie: II (Amasya–Tokat–Sivas)*. Paris, 1934.

– *Voyages archéologiques dans la Turquie orientale*. Paris, 1940.

– *Une capitale turque: Brousse (Bursa)*. Paris, 1958.

Goodwin, G. *A History of Ottoman Architecture*. London, 1971.

Kızıltan, A. *Anadolu Beylikerinde Cami ve Mescidler*. Istanbul, 1958.

Kuban, D. *Anadolu Gezilerinden İzlenimler: Bir Batı Anadolu Gezisi (Şubat 1962)*. Istanbul, 1962.

Kuran, A. *The Mosque in Early Ottoman Architecture*. Chicago, 1968.

– *Anadolu Medreseleri*. Vol. 1. Ankara, 1969.

– 'Thirteenth and Fourteenth Century Mosques in Turkey' in *Archaeology* 24, no. 3, (New York, June, 1971): 234–53.

Otto-Dorn, K. *Kunst des Islam*. Baden-Baden, 1964.

Ögel, S. *Der Kuppelraum in der türkischen Architektur*. Istanbul, 1972.

Öney, G. *Ankara'da Türk Devri Yapıları*, Ankara, 1971.

Ötüken, Y. 'Orhan Gazi (1326–1359) Devrinden Kanuni Sultan Süleyman (1520–1566) Devrinin Sonuna Kadar Osmanlı Medreseleri' in *Atatürk Üniversitesi Edebiyat Fakültesi Araştırma Dergisi: In Memoriam Prof. Albert Louis Gabriel* IX (Ankara, 1978): 337–72.

Özgüç, T. 'Monuments of the Period of Taşkın Paşa's Principality' in *Atti del secondo congresso internazionale di arte turca (Venice, 1963)* (Naples, 1965): 81–5.

Riefstahl, R. M. *Turkish Architecture in Southwestern Anatolia*. Cambridge, Mass., 1931.

Sayılı, A. 'The Wâjidiyya Madrasa of Kütahya' in *Belleten* XII, no. 47 (Ankara, 1948): 667–77.

Sözen, M. *Anadolu Medreseleri*. 2 vols. Istanbul, 1970; 1972.

– *Diyarbakır'da Türk Mimarisi*. Istanbul, 1971.

Sümer, F. *Safevî Devletinin Kuruluşu ve Gelişmesinde Anadolu Türklerinin Rolü*. Ankara, 1976.

– 'Bozok Tarihine Dair Araştırmalar' in *Cumhuriyetin 50. Yıldönümünü Anma Kitabı*. Ankara, 1974, pp. 309–81.

Şikârî. *Karamanoğulları Tarihi*. (Ed. Mes'ud Koman). Konya, 1946.

Tabak, N. *Ahlat Türk Mimarisi*. Istanbul, 1972.

Turan, O. *Doğu Anadolu Türk Devletleri Tarihi*. Istanbul, 1973.

Uzunçarşılı, İ. H. *Anadolu Beylikleri*. Ankara, 1937.

– *Kitabeler*. 2 vols. Istanbul, 1927; 1929.

Ülgen, A. S. 'Kırşehirde Türk Eserleri' in *Vakıflar Dergisi* II (Ankara, 1942): 253–61.

Ünal, R. H. 'Notes sur l'ancien réseau routier entre Malatya et Diyarbakır' in *5th International Congress of Turkish Art (1975)*. Budapest, 1979, pp. 881–9.

Vakıflar Genel Müdürlüğü. *Türkiye'de Vakıf Abideler ve Eski Eserler*. 2 vols. Ankara, 1972; 1977.

Varlık, M. Ç. *Germiyanoğulları Tarihi*. Erzurum, 1974.

Wittek, P. *Das Fürstentum Mentesche*. Istanbul, 1934.

Architecture of the Ottoman Period

by Doğan Kuban

Ağaoğlu, M. 'The Fatih Mosque at Constantinople' in *Art Bulletin* XII, no. 4 (Providence, December, 1930): 179–95.

Akozan, F. 'Türk Han ve Kervansarayları' in *Türk Sanatı Tarihi Araştırma ve İncelemeleri* I (Istanbul, 1963): 133–67.

Aksoy, O. *Osmanlı Devri İstanbul Sıbyan Mektepleri Üzerine Bir İnceleme*. Istanbul, 1968.

Aktepe, M. 'Abide ve Sanat Eserlerimize Ait Türk Tarihlerinde Mevcut Bilgiler' in *Sanat Tarihi Yıllığı* II (Istanbul, 1968): 169–83.

Altınay, A. R. *Mimar Sinan*. Istanbul, 1931.

– *Türk Mimarları*. 2nd ed. Istanbul, 1937.

Anhegger, R. 'Beiträge zur frühosmanischen Baugeschichte' in *Istanbuler Mitteilungen* VI (Istanbul, 1955): 89–108; VIII (Istanbul, 1958): 40–56; XVII (Istanbul, 1967): 312–30.

– 'Beiträge zur frühosmanischen Baugeschichte: I Vielkuppelige Stützenhallenmoscheen; II Moscheen vom Bautyp der Üç Şerefeli Cami in Edirne; III Zum Problem der alten Fatih Moschee in Istanbul' in *Zeki Velidi Togan Armağanı*. Istanbul, 1950–5, pp. 315–25.

– *Zur Stellung einiger Städte innerhalb der osmanischen Baugeschichte vor Sinan*. Istanbul, 1953.

Arel, A. *Onsekizinci Yüzyıl İstanbul Mimarisinde Batılılaşma Süreci*, Istanbul, 1975.

Arseven, C. E. *L'art turc depuis son origine jusqu'à nos jours*. Istanbul, 1939.

– *Les arts décoratifs turcs*. Istanbul, 1950.

Aru, K. A. *Türk Hamamları Etüdü*. Istanbul, 1949.

Aslanapa, O. *Edirne'de Osmanlı Devri Abideleri*. Istanbul, 1949.

– *Turkish Art and Architecture*. London, 1971.

Atasoy, N. *İbrahim Paşa Sarayı*. Istanbul, 1972.

Ayverdi, E. H. *Fatih Devri Mimarisi*. Istanbul, 1953; 2nd ed., Istanbul, 1973.

– *Osmanlı Mimarisinde Çelebi ve II. Sultan Murad Devri*. Istanbul, 1972.

– *Osmanlı Mimarisinin İlk Devri (1260–1402)*. Istanbul, 1966.

Balducci, H. *Architettura turca in Rodi*. Milan, 1932.

Barkan, Ö. L. *Süleymaniye Camii ve İmareti İnşaatı*. Vol. 1. Ankara, 1972.

Batur, A. 'Osmanlı Camilerinde Almaşık Duvar 'Üzerine' in *Anadolu Sanatı Araştırmaları* II (Istanbul, 1970): 135–208.

– *Osmanlı Camilerinde Kemer-Strüktür-Biçim İlişkisi Üzerine Bir Deneme (1300–1730)*. Istanbul, 1974.

Batur, S. 'Osmanlı Camilerinde Sekizgen Ayak Sisteminin Gelişmesi Üzerine' in *Anadolu Sanatı Araştırmaları* I (Istanbul, 1968): 139–66.

Baykal, K. *Bursa ve Anıtları*. Bursa, 1950.

Çakıroğlu, N. *Kayseri Evleri*. Istanbul, 1952.

Çetintaş, S. *Türk Mimari Anıtları Osmanlı Devri / Bursa'da İlk Eserler*. Istanbul, 1946.

– *Türk Mimari Anıtları Osmanlı Devri / Murad I ve Beyazıt I Binaları*. Istanbul, 1952.

Davis, F. *The Palace of Topkapı in Istanbul*. New York, 1970.

Diez, E. and O. Aslanapa. *Türk Sanatı*. Istanbul, 1946.

Egli, E. *Sinan, der Baumeister osmanischer Glanzzeit*. Zurich, 1954.

Eldem, S. H. *Köşkler ve Kasırlar*. 2 vols. Istanbul, 1969; 1973.

– *Türk Evi Plan Tipleri*. Istanbul, 1968.

– *Koçeoğlu Yalısı Bebek*. Istanbul, 1977.

– *Sa'dabad*. Istanbul, 1977.

– '17. ve 18. Asırlarda Türk Odası' in *Güzel Sanatlar Mecmuası V* (Istanbul, 1944): 1–28.

Erdmann, K. 'Zur türkischen Baukunst seldschukischer und osmanischer Zeit' in *Istanbuler Mitteilungen* VIII (Istanbul, 1958): 1–39.

Erdoğan, M. 'Mimar Davut Ağa'nın Hayatı Eserleri' in *Türkiyat Mecmuası* XII (Istanbul, 1955): 179–204.

– 'Mehmet Tahir Ağa, Hayatı ve Mesleki Faaliyetleri' in *Tarih Dergisi* VII, no. 10 (1954): 157–80; VIII, no. 11 (1955): 159–78; IX, no. 13 (1958): 161 ff.; XI, no. 15 (1960): 25–46.

Ergin, O. *Türk Şehirlerinde İmaret Sistemi*. Istanbul, 1939.

Erginbaş, D. *Diyarbakır Evleri*. Istanbul, 1954.

Eser, L. *Kütahya Evleri*. Istanbul, 1955.

Eyice, S. 'İlk Osmanlı Devrinin Dinî-İçtimai Bir Müessesesi Zâviyeler ve Zâviyeli Camiler' in *İktisat Fakültesi Mecmuası* XXIII, nos. 1–2 (Istanbul, 1963): 1–80.

– 'İstanbul Minareleri' in *Türk Sanatı Tarihi Araştırma ve İncelemeleri* I (Istanbul, 1963): 131–82.

– 'İznik'te Büyük Hamam ve Osmanlı Devri Hamamları Hakkında Bir Deneme' in *Tarih Dergisi* II, no. 15 (1960): 99–120.

– 'Türk Mimarisinde Bedestenler' in *Atti del secondo congresso internazionale di arte turca (Venice, 1963)* (Naples, 1965): 113–22.

Gabriel, A. 'Bursa'da Murad I. Camii ve Osmanlı Mimarisinin Menşei Meselesi' in *Vakıflar Dergisi* II (Ankara, 1942): 37–43.

– *Châteaux turcs du Bosphore*. Paris, 1958.

– 'Les mosquées de Constantinople' in *Syria* VII (Paris, 1926): 359–419.

– *Les monuments turcs d'Anatolie*. 2 vols. Paris, 1931; 1934.

– *Une capitale turque, Brousse (Bursa)*. Paris, 1958.

Glück, H. *Die Kunst der Osmanen*. Leipzig, 1922.

– *Die Bäder von Konstantinopel: Probleme des Wölbungsbaues*. Part I. Vienna, 1921.

– *Türkische Kunst*. Budapest and Constantinople, 1917.

Goodwin, G. *A History of Ottoman Architecture*. London, 1971.

Gurlitt, C. *Die Baukunst Konstantinopels*. 2 vols. Berlin, 1912.

– 'Die Bauten Adrianopels' in *Orientalisches Archiv* I (Leipzig, 1910–11): 51–70.

– 'Die islamischen Bauten von Iznik (Nicäa)' in *Orientalisches Archiv* III (Leipzig, 1912–13): 49–60.

Hoag, J. D. *Western Islamic Architecture*. New York, 1963.

Klinghardt, K. *Türkische Bäder*. Stuttgart, 1927.

Konyalı, İ. H. *Mimar Koca Sinan. Vakfiyeleri, Hayır Eserleri Hayatı,* Istanbul, 1948.

Kömürcüoğlu, E. *Ankara Evleri*. Istanbul, 1950.

Kuban, D. 'Les mosquées à coupole à base hexagonale' in *Beiträge zur Kunstgeschichte Asiens: In Memoriam Ernst Diez*. Istanbul, 1963, pp. 35–47.

– 'Mimar Sinan ve Türk Mimarisinin Klasik Çağı' in *Mimarlık* XL (Istanbul, 1967): 13–34.

– 'On the Interpretation of Islamic Art' in *Anadolu Sanatı Araştırmaları* I (Istanbul, 1968): 28–47.

– *Osmanlı Barok Mimarisi Hakkında Bir Deneme*. Istanbul, 1954.

– *Osmanlı Dini Mimarisinde İç Mekân Teşekkülü (Rönesansla Bir Mukayesa)*. Istanbul, 1958.

– 'An Ottoman Building Complex of the Sixteenth Century: The Sokollu Mosque and its Dependencies in Istanbul' in *Ars Orientalis* VII (Ann Arbor, 1968): 19–39.

– *Türkiye Sanatı*. Istanbul, 1970; 2nd ed., 1973; 3rd ed., 1977.

– 'Une analyse stylistique de l'espace dans l'architecture ottomane' in *First International Congress of Turkish Arts (1959)*. Ankara, 1962, pp. 219–24.

Küçükerman, Ö. *The Rooms in the Traditional House of Anatolia from the Aspect of Spatial Organization*. Istanbul, 1973.

Kumbaracılar, İ. *İstanbul Sebilleri*. Istanbul, 1938.

Kuran, A. *The Mosque in Early Ottoman Architecture*. Chicago, 1968.

Mantran, R. *Istanbul dans la seconde moitié du XVII^e siècle*. Paris, 1962.

Martiny, G. 'Die Piyale Pasha Moschee' in *Ars Islamica* I, no. 3, part 2, (Ann Arbor, 1934): 131 ff.

Meriç, R. M. *Mimar Sinan, Hayatı, Eseri Eserlerine Dair Metinler*. Ankara, 1965.

Montani Efendi. *L'architecture ottomane* (Ed. Edhem Pasha; Text M. de Launay), Constantinople, 1873.

Nayır, Z. *Osmanlı Mimarlığında Sultan Ahmet Külliyesi ve Sonrası (1609–90)*. Istanbul, 1975.

Ögel, S. *Der Kuppelraum in der türkischen Architektur*. Istanbul, 1972.

Otto-Dorn, K. *Die Kunst des Islam*. Baden-Baden, 1964.

– *Das Islamische İznik*. Berlin, 1941.

Öz. T. *Istanbul Camileri*. 2 vols. Ankara, 1962; 1965.

Penzer, N. M. *The Harem: An Account of the Institution as It Existed in the Palace of the Turkish Sultans, with a History of the Grand Seraglio from its Foundation to the Present Time*. London, 1936.

Peremeci, O. N. *Edirne Tarihi*. Istanbul, 1939.

Riefstahl, R. M. 'Selimiyeh in Konia' in *Art Bulletin* XII, no. 4 (New York, 1930).

Saladin, H. *Le yalı des Keupruli à Anatoli-Hissar* n.p., 1915.

Shaw, S. J. *History of the Ottoman Empire and Modern Turkey*. 2 vols. Cambridge, 1976; 1977.

Sözen, M. *Diyarbakır'da Türk Mimarisi*. Istanbul, 1971.

– *Türk Mimarisinin Gelişimi ve Mimar Sinan*. Istanbul, 1975.

Sudalı, M. *Hünkâr Mahfilleri*. Istanbul, 1958.

Şehsuvaroğlu, H. *İstanbul Sarayları*. Istanbul, 1954.

Täschner, F. and P. Wittek. 'Die Vezirfamilie der Gandarlysade und ihre Denkmäler' in *Der Islam* XVIII (Berlin, 1929): 60–115.

Tanışık, İ. H. *İstanbul Çeşmeleri*. 2 vols. Istanbul, 1954.

Ülgen, A. S. 'İznik'te Türk Eserleri' in *Vakıflar Dergisi* I (Ankara, 1938): 53–69.

– 'Topkapı'da Ahmet Paşa Heyeti' in *Vakıflar Dergisi* II (Ankara, 1942): 169–71.

– 'Yeni Cami' in *Vakıflar Dergisi* II (Ankara, 1942): 388–97.

Ünsal, B. *Turkish Islamic Architecture in Seljuk and Ottoman Times 1071–1923*. London, 1959.

Vogt-Göknil, U. 'Die Kulliye von Beyazıt II in Edirne' in *Du / Atlantis* XXV, no. 294 (Zurich, August, 1965).

– *Türkische Moscheen*. Zurich, 1953.

– *Living Architecture: Ottoman*. London, 1966.

Yoldaş, Y. *İstanbul Mimarisi İçin Kaynak Olarak Evliya Çelebi Seyahatnamesi*. Istanbul, 1977.

Yücel, E. 'Bursa Ulucami'i Restorasyonu' in *Arkitekt* no. 312 (Istanbul, 1963).

Wilde, H. *Brussa*. Berlin, 1909.

254

Architectural Decoration and the Minor Arts

by Gönül Öney

[Entries marked * have also been published in English (E) or German (G).]

GENERAL WORKS

Arseven, C. E. *Les Arts décoratifs turcs*. Istanbul, 1952.

Aslanapa, O. *Turkish Art and Architecture*. London, 1971.

– *Yüzyıllar Boyunca Türk Sanatı (14. Yüzyıl)*. Istanbul, 1977.

Demiriz, Y. *Osmanlı Mimarisinde Süsleme I (Erken devir 1300– 1453)*. Istanbul, 1979.

Ettinghausen, R. *Art Treasures of Turkey; The Islamic Period*. Washington, D. C., 1966.

Kühnel, E. *Islamische Kleinkunst*. Berlin, 1925; 2nd ed. Brunswick, 1963.

– *Die Sammlung türkischer und islamischer Kunst im Tchinili Köschk*. Leipzig, 1938.

Öney, G. *Anadolu Selçuklu Mimarisinde Süsleme ve El Sanatları*. Ankara, 1978.*E

– 'İslam Süsleme ve El Sanatlarına Türklerin Katkısı' in *İslam Sanatında Türkler*. Istanbul, 1976, pp. 131–79.*E

STONE DECORATION

Bayburtluoğlu, Z. 'Anadolu Selçuklu Devri Büyük Programlı Yapılarında Önyüz Düzeni' in *Vakıflar Dergisi* XI (Ankara, 1976): 64–106.

Baer, E. 'A Group of Seljuk Figural Bas Reliefs' in *Oriens* XX (Leiden, 1969): 107–24.

Bakırer, Ö. *Onüç ve Ondördüncü Yüzyıllarda Anadolu Mihrabları*. Ankara, 1976.

Diez, E. 'The Zodiac Reliefs at the Portal of the Gök Medrese in Sivas' in *Artibus Asiae* XII, nos. 1, 2 (Ascona, Switzerland, 1949): 99–104.

Hartner, W. and R. Ettinghausen. 'The Conquering Lion: The Life Cycle of a Symbol' in *Oriens* XVII (Leiden, 1964): 161–71.

Karamağaralı, B. *Ahlat Mezar Taşları*. Ankara, 1972.

– 'Sivas ve Tokat Mezar Taşlarının Mahiyeti Hakkında' in *Selçuklu Araştımaları Dergisi* II (Ankara, 1970): 75–109.

Ödekan, A. *Osmanlı Öncesi Anadolu Türk Mimarisinde Mukarnaslı Portal Örtüleri*. Istanbul, 1977.

Ögel, S. 'Einige Bemerkungen zum Sternsystem in der Steinornamentik der anatolischen Seldschuken' in *Beiträge zur Kunstgeschichte Asiens: In Memoriam Ernst Diez*. Istanbul, 1963, pp. 166–72.

– 'Bemerkungen über die Quellen der anatolisch-seldschukischen Steinornamentik' in *Anatolica* III (Leiden, 1969–70): 189–94.

– 'Der Wandel im Programm der Steinornamentik von den seldschukischen zu den osmanischen Bauten' in *Anatolica* II (Leiden, 1968): 103–11.

– *Anadolu Selçuklularının Taş Tezyinatı*. Ankara, 1966.

Öney, G. 'Anadolu Selçuklu Mimarisinde Antik Devir Malzemesi' in *Anatolia* XII (Ankara, 1970): 17–38. *E

– 'Anadolu Selçuk'lularinda Heykel, Figürlü Kabartma ve Kaynakları Hakkında Notlar' in *Selçuklu Araştırmaları Dergisi* I (Ankara, 1969): 187–91.

– 'Niğde Hüdavent Hatun Türbesi Figürlü Kabartmaları' in *Belleten* XXXI, no. 122 (Ankara, 1967): 143–81.*G

– 'Anadolu Selçuk Sanatında Hayat Ağacı Motifi' in *Belleten* XXXII, no. 125 (Ankara, 1968): 25–73. *G

– 'Anadolu Selçuk Sanatında Balık Figürü' in *Sanat Tarihi Yıllığı* II (Istanbul, 1968): 142–68.*E

– 'Artuklu Devrinden bir Hayat Ağacı Kabartması Hakkında' in *Vakıflar Dergisi* VII (Ankara, 1968): 117–30.*G

– 'Anadolu'da Selçuk Geleneğinde Kuşlu, Çift Başlı Kartallı, Şahinli ve Arslanlı Mezar Taşları' in *Vakıflar Dergisi* VIII (Ankara, 1969): 283–311.*E

– 'İran Selçukluları ile Mukayeseli Olarak Anadolu Selçuk'lularında Atlı Av Sahneleri' in *Anatolia* XI (Ankara, 1967): 121–89.*E

– 'Anadolu Selçuk Sanatında Ejder Figürleri' in *Belleten* XXXIII, no. 130 (Ankara, 1969): 171–216.*E

– 'Anadolu Selçuk Mimarisinde Boğa Kabartmaları' in *Belleten* XXXIV (Ankara, 1970): 83–138.*E

– 'Sun and Moon Rosettes in the Shape of Human Heads in Anatolian Seljuk Architecture' in *Anatolica* XIII (Leiden, 1969–70): 195– 212.

– 'Anadolu Selçuk Mimarisinde Arslan Figürü' in *Anatolia* XIII (Ankara, 1971): 1–67.*E

– 'Anadolu Selçuk Sanatında Kartal, Çift Başlı Kartal ve Avcı Kuşlar' in *Türk Tarih Kurumu Malazgirt Anma Yıllığı* (Ankara, 1972): 139–96.

Otto-Dorn, K. 'Darstellungen des turco-chinesischen Tierzyklus in der islamischen Kunst' in *Beiträge zur Kunstgeschichte Asiens: In Memoriam Ernst Diez*. Istanbul, 1963, pp. 151–6.

– 'Türkische Grabsteine mit Figurenreliefs aus Kleinasien' in *Ars Orientalis* III (Ann Arbor, 1959): 63–76.

Rogers, M. 'The Çifte Minare Medrese at Erzurum and the Gök Medrese at Sivas: A Contribution to the History of Style in the Seljuk Architecture of 13th Century Turkey' in *Anatolian Studies* XV (London, 1965): 63–85.

– 'Seljuk Architectural Decoration at Sivas' in *The Art of Iran and Anatolia from the 11th to the 13th Century A. D.: Colloquies on Art and Archaeology in Asia*. Unversity of London, Percival David Foundation of Chinese Art, London, 1974, pp. 13–27.

Roux, J. P. 'Essai d'interpretation d'un relief figuratif seldjoukide' in *Arts Asiatiques* XXIII (Paris, 1971).

– 'Le décor animé du Caravansérail de Karatay en Anatolie' in *Syria* XLIX, nos. 3, 4 (Paris, 1972).

Schneider, G. 'Vereinigung von geometrischen und pflanzlichen Formen in der seldschukischen Bauornamentik Anatoliens' in *Erzurum Atatürk Üniversitesi: In Memoriam Prof. Albert Louis Gabriel*. Ankara, 1978, pp. 433–52.

BRICKWORK, STUCCO DECORATION AND FRESCOES

Arık, R. *Batılılaşma Dönemi Anadolu Tasvir Sanatı*. Ankara, 1976.

Bakırer, Ö. 'Anadolu'da XIII. Yüzyıl Tuğla Minarelerinin konum, şekil, malzeme ve tezyinat özellikleri' in *Vakıflar Dergisi* IX (Ankara, 1971): 337–62.

Öney, G. 'İran'da Erken Devir Alçı İşçiliğinin Anadolu Selçuk Sanatında Akisleri' in *Belleten* XXXVII, no. 147 (Ankara, 1973): 257–79.*E

– 'Comparison of a Group of Anatolian Seljuk Türbes with Great Seljuk and Ilkhanid Türbes in Iran' in *5th International Congress of Turkish Art (1975)*. Budapest, 1979, pp. 665–90.

Otto-Dorn, K. 'Osmanische ornamentale Wandmalerei' in *Kunst des Orients* Vol. 1. Wiesbaden, 1950, pp. 45–54.

– 'Bericht über die Grabung in Kobadabad (1966)' in *Archäologischer Anzeiger des deutschen Archäologischen Instituts* LXXXIV, no. 4 (Berlin, 1969): 438–506.

Renda, G. *Batılılaşma Döneminde Türk Resim Sanatı: 1700–1850*. Ankara, 1977.

Sarre, F. *Der Kiosk von Konia*. Berlin, 1936.

Yetkin, Ş. 'The Bath-Kiosk of Sultan Alaeddin Kaykubat and its Wall Paintings at the Alara Fortress' in *IVe congrès international d'art turc (1971)*. Aix-en-Provence, 1976, pp. 243–7.

TILE AND CERAMIC ART

Anhegger, R. 'Quellen zur osmanischen Keramik' in Otto-Dorn, K. *Das Islamische Iznik*. Berlin, 1941.

Aslanapa, O. *Osmanlılar Devrinde Kütahya Çinileri*. Istanbul, 1949.

– *Türkische Fliesen und Keramik in Anatolien*. Istanbul, 1965.

– 'Erster Bericht über die Ausgrabungen des Palastes von Diyarbakır' in *Istanbuler Mitteilungen* XII (Istanbul, 1962): 115–28.

– 'Die seldschukischen Fliesen im Museum von Antalya' in *Cultura Turcica* II, no. 2 (Ankara, 1965): 153–77.

– 'Pottery and Kilns from the Iznik Excavations' in *Forschungen zur Kunst Asiens: In Memoriam Kurt Erdmann*. Istanbul, 1970, pp. 140–6.

– 'Turkish Ceramics' in *Archaeology* XXIV, no. 3 (New York, 1971): 209–19.

Atıl, E. *Turkish Art of the Ottoman Period*. Exhibition Catalogue: Freer Gallery of Art, Washington, D. C., 1973.

Carswell, J. and C. J. F. Dowsett. *Kütahya Tiles and Pottery*. 2 vols. Oxford, 1972.

Denny, W. B. 'Ceramic Revetment of the Mosque of Ramazanoğlu Adana' in *IVe congrès international d'art turc (1971)*. Aix-en-Provence, 1976, pp. 57–66.

– 'Ceramic Revetments of the Mosque of Rüstem Pasha' in *5th International Congress of Turkish Art (1975)*. Budapest, 1979, pp. 269–90.

Erdmann, K. 'Die Fliesen am Sünnet odası des Topkapı Saray in Istanbul' in *Aus der Welt der islamischen Kunst: Festschrift für Ernst Kühnel*. Berlin, 1959, pp. 144–53.

– 'Ka'ba Fliesen' in *Ars Orientalis* III (Ann Arbor, 1959): 193–7.

– 'Neue Arbeiten zur türkischen Keramik' in *Ars Orientalis* V (Ann Arbor, 1963): 191–219.

Fehérvári, G. *Islamic Pottery: A Comprehensive Study Based on the Barlow Collection*. London, 1973.

Lane, A. *Early Islamic Pottery*. London, 1947.

– *Later Islamic Pottery*. London, 1957.

– 'The Ottoman Pottery of Iznik' in *Ars Orientalis* II (Ann Arbor, 1957): 241–81.

Meinecke, M. *Fayencedekorationen seldschukischer Sakralbauten in Kleinasien*. 2 vols. Tübingen, 1976.

Meinecke-Berg, V. 'Marmorfliesen und Architektur in der osmanischen Baukunst' in *Kunst des Orients* VIII, nos. 1, 2 (Wiesbaden, 1958): 35–59.

Öney, G. 'Akşehir Ulu Camii' in *Anatolia* IX (Ankara, 1965): 171–84. *E

– 'Die Karreefliesen im Grossen Palast von Kobadabad' in *Archäologischer Anzeiger des deutschen Archäologischen Instituts* LXXXIV, no. 4 (Berlin, 1969): 496–500.

– *Türk Devri Çanakkale Seramikleri*. Ankara, 1971. *E

– *Turkish Ceramic Tile Art in Anatolia*. Tokyo, 1975.

– 'Ceramic Tiles in Islamic Architecture' in *The World of Tiles*, Vol. 1. Kyoto, 1976.

– *Türk Çini Sanatı*. Istanbul, 1977. *E

– 'Kubadabad Ceramics' in *The Art of Iran and Anatolia from the 11th to the 13th Century A. D.: Colloquies on Art and Archaeology in Asia*. 4. University of London, Percival David Foundation of Chinese Art, London, 1974, pp. 68–84.

Otto-Dorn, K. *Türkische Keramik*. Ankara, 1957.

– 'Der Mihrab der Arslanhane Moschee in Ankara' in *Anatolia* I (Ankara, 1956): 21–30.

– 'Bericht über die Grabung in Kobadabad (1966)' in *Archäologischer Anzeiger des deutschen Archäologischen Instituts*. LXXXIV, no. 4 (Berlin, 1969): 438–506.

– 'Die menschliche Figurendarstellung auf den Fliesen von Kobadabad' in *Forschungen zur Kunst Asiens: In Memoriam Kurt Erdmann*. Istanbul, 1970, pp. 111–39.

– and M. Önder. 'Bericht über die Grabung in Kobadabad (1965)' in *Archäologischer Anzeiger des deutschen Archäologischen Instituts* LXXXI (Berlin, 1966): 170–83.

Paker, M. 'Anadolu Beylikleri Devri Keramik Sanatı' in *Sanat Tarihi Yıllığı* I (Istanbul, 1964–5): 155–82.

Yetkin, Ş. 'Türk Çini Sanatında Bazı Önemli Örnekler ve Teknikleri' in *Sanat Tarihi Yıllığı* II (Istanbul, 1968): 36–48.

– *Anadolu'da Türk Çini Sanatının Gelişmesi*. Istanbul, 1972.

Zick-Nissen, J. 'Beobachtungen zur Lokalisierung, Datierung und Historie osmanischer Feinkeramik des 17. Jahrhunderts' in *5th International Congress of Turkish Art (1975)*. Budapest, 1979, pp. 927–42.

WOODWORK

Kerametli, C. 'Osmanlı Ağaç İşleri, Tahta, Oyma, Sedef, Bağ ve Fildişi Kakmalar' in *Türk Etnoğrafya Dergisi* IV (Ankara, 1962): 5–13.

Mayer, L. A. *Islamic Woodcarvers and their Works*. Geneva, 1958.

Ögel, B. 'Selçuk Devri Ağaç İşçiliği Hakkında Notlar' in *Yıllık Araştırmalar Dergisi* I (Ankara, 1956): 199–220.

Öney, G. 'Anadolu'da Selçuklu ve Beylikler Devri Ahşap Teknikleri' in *Sanat Tarihi Yıllığı* III (Istanbul, 1969–70): 135–49. *G

Oral, Z. 'Anadolu'da Sanat Değeri Olan Ahşap Minberler, Kitabeleri ve Tarihçeleri' in *Vakıflar Dergisi* V (Ankara, 1962): 223–77.

Otto-Dorn, K. 'Seldschukische Holzsäulenmoscheen in Kleinasien' in *Aus der Welt der islamischen Kunst: Festschrift für Ernst Kühnel*. Berlin, 1959, pp. 59–88.

– 'Die Ulu Dschami in Sivrihisar' in *Anatolia* IX (Ankara, 1965): 161–8.

CARPETS

Arık, R. 'Turkish Landscape Carpets' in *Halı* I (London, 1978): 123–7.

Aslanapa, O. 'Ein anatolischer Tierteppich vom Ende des 15. Jahrhunderts' in *Beiträge zur Kunstgeschichte Asiens: In Memoriam Ernst Diez*. Istanbul, 1963, pp. 173–83.

– and Y. Durul. *Selçuklu Halıları*. Istanbul, 1973.

Erdmann, K. *Der orientalische Knüpfteppich: Versuch einer Darstellung seiner Geschichte*. Tübingen, 1955; 2nd ed. 1960; 3rd ed. 1965.

– *Oriental Carpets: An Essay on their History*. New York, 1960.

– *Europa und der Orientteppich*. Wiesbaden, 1966.

– *Der türkische Teppich des 15. Jahrhunderts (15. Asır Türk Halısı)*. Istanbul, 1957.

– *Siebenhundert Jahre Orientteppich: Zu seiner Geschichte und Erforschung*. (Ed. H. Erdmann) Wiesbaden, 1966.

– *Seven Hundred Years of Oriental Carpets*. London, 1970.

– 'Weniger bekannte Uschak-Muster' in *Kunst des Orient* IV (Wiesbaden, 1963): 79–97.

Ettinghausen, R. 'New Light on Early Animal Carpets' in *Aus der Welt der islamischen Kunst: Festschrift für Ernst Kühnel*. Berlin, 1959, pp. 93–116.

McMullan, J. V. *Islamic Carpets*. New York, 1965.

Riefstahl, R. M. 'Primitive Rugs of the Konya Type in the Mosque of Beyşehir' in *Art Bulletin* XIII (Providence, 1931): 177–220.

Spuler, F. 'Konya Teppiche' in *Die Kunst des Islam: Propyläen Kunstgeschichte*. Vol. 4. Berlin, 1973.

Yetkin, Ş. 'Yeni Bulunan Hayvan Figürlü Halıların Türk Sanatındaki Yeri' in *Sanat Tarihi Yıllığı* V (Istanbul, 1972): 291–307.

– *Türk Halı Sanatı*. Istanbul, 1974.

– 'İstanbul Türk ve İslam Eserleri Müzesinde Bulunan bazı Halılar ve Rönesans Ressamlarının Eserleri' in *Türk Kültürü Araştırmaları* II (Ankara, 1964): 208–22.

– 'Osmanlı Saray Halılarından Yeni Örnekler' in *Sanat Tarihi Yıllığı*

VII (Istanbul, 1976–7): 143–64.

– *Early Caucasian Carpets in Turkey.* 2 vols. London, 1978.

Zick, J. 'Eine Gruppe von Gebetsteppichen und ihre Deutung' in *Berliner Museen* (new series) XI, no. 1 (Berlin, 1961): 6–14.

Zick-Nissen, J. 'Das Wolkenbandmotiv als Kompositionselement aus osmanischen Teppichen' in *Berliner Museen* (new series) XVI, no. 1 (Berlin, 1966): 11–17.

FABRICS

Denny, W. B. 'Ottoman Turkish Velvets' in *Textile Museum Journal* III, no. 3 (Washington, D. C., 1972).

Ettinghausen, R. 'An Early Ottoman Textile' in *First International Congress of Turkish Arts.* Ankara, 1961, pp. 134–41.

Öz, T. *Turkish Textiles and Velvets, 14th–16th Centuries.* Ankara, 1950.

Özbel, K. *Eski Türk Kumaşları.* Ankara, 1945.

Wace, A. J. B. and C. E. C. Tattersall. *Brief Guide to the Turkish Woven Fabrics.* Victoria and Albert Museum, London, 1931.

Yatman, N. *Türk Kumaşları.* Ankara, 1945.

GLASSWORK

Bayramoğlu, F. *Turkish Glass Art and Beykoz-Ware.* Istanbul, 1976.

Lamm, C. H. *Mittelalterliche Gläser und Steinschnittarbeiten aus dem Nahen Osten.* 2 vols. Berlin, 1930.

Önder, M. 'Selçuklu Devrine Ait Bir Cam Tabak' in *Türk Sanatı Tarihi Araştırma ve İncelemeleri* (Istanbul, 1969): 1–5.

Sourdel-Thomine, J. 'Plat en Verre' in *Archäologischer Anzeiger des deutschen Archäologischen Instituts* LXXXIV, no. 4 (Berlin, 1969): 501–2.

Turkish Metalwork

by Ülker Erginsoy

Ağaoğlu, M. 'A Brief Note on Islamic Terminology for Bronze and Brass' in *Journal of the American Oriental Society* 64, no. 4 (Baltimore, 1944): 218–23.

– 'About a Type of Islamic Incense Burner' in *Art Bulletin* XXVII (Providence, 1945): 28–45.

Arts de l'Islam. Exhibition catalogue: Orangerie des Tuileries. Paris, 1971.

Baer, E. 'An Islamic Inkwell in the Metropolitan Museum of Art' in *Islamic Art in the Metropolitan Museum of Art.* (Ed. R. Ettinghausen) New York, 1972, pp. 199–210.

– 'A Brass Vessel from the Tomb of Sayyıd Battal Ghazi' in *Artibus Asiae* XXXIX, nos. 3, 4 (Ascona, Switzerland, 1977): 299–335.

Barrett, D. *Islamic Metalwork in the British Museum.* London, 1949.

Diakonov, M. M. 'Un aquamanile en bronze daté de 1206' in *Mémoires: IIIᵉ congrès international d'art et d'archéologie iraniens (Léningrad, 1935).* Moscow and Leningrad, 1939, pp. 45–52.

Dimand, M. 'Metalwork' in *A Handbook of Muhammedan Art.* 3rd ed. New York, 1958.

Erginsoy, Ü. 'The Turkish Contribution to Islamic Metalwork' in

The Turkish Contribution to Islamic Arts. Istanbul, 1976, pp. 180–204.

– *İslam Maden Sanatının Gelişmesi.* Istanbul, 1978.

– 'Anatolian Seljuk Metalwork' in Öney, G. *Architectural Decoration and the Minor Arts in Seljuk Anatolia.* Ankara, 1978, pp. 153–78; 201–5.

Ettinghausen, R. 'The Bobrinski Kettle' in *Gazette des Beaux-Arts* XXIV (Paris, 1943): 193–208.

– 'The Wade Cup in the Cleveland Museum of Art: Its Origin and Decorations' in *Ars Orientalis* II (Ann Arbor, 1957): 327–66.

– 'Turkish Elements on Silver Objects of the Seljuk Period in Iran' in *First International Congress of Turkish Art* (1959). Ankara, 1962, pp. 128–34.

– 'The Islamic Period' in *Treasures of Turkey.* Geneva, 1966, pp. 131–240.

Fehérvári, G. *Islamic Metalwork of the Eighth to the Fifteenth Century in the Keir Collection.* London, 1976.

Giuzalian, L. T. 'Bronzovoi Kufshin 1182 g' in *Pamyatniki Epokhi Rustaveli.* Leningrad, 1938, pp. 227–36.

– 'The Bronze Qalamdan (Pencase) 542/1148 from the Hermitage Collection' in *Ars Orientalis* VII (Ann Arbor, 1968): 95–119.

Grabar, O. *Persian Art before and after the Mongol Conquest.* Exhibition catalogue: University of Michigan Museum of Art. Ann Arbor, 1959.

Gray, B. 'A Seljuk Hoard from Persia' in *British Museum Quarterly* XIII (London, 1938–9): 73–9.

Harari, R. 'Metalwork after the Early Islamic Period' in *A Survey of Persian Art.* (Ed. A. U. Pope) Vol. VI. London and New York, 1967, pp. 2466–529.

Kocabaş, H. 'Une collection de cuivres seldjoukides' in *Atti del secondo congresso internazionale di arte turca (Venice, 1963).* (Naples, 1965): 177–80.

Kühnel, E. 'Die Metallarbeiten auf der mohammedanischen Ausstellung in München 1910' in *Die Ausstellung von Meisterwerken muhammedanischer Kunst in München 1910.* (Ed. F. Sarre and F. R. Martin) Vol. 2. Munich, 1912.

– 'Metallarbeiten' in *Islamische Kleinkunst.* 2nd ed. Brunswick, 1963, pp. 134–60.

Mayer, L. A. *Islamic Metalworkers and their Works.* Geneva, 1959.

Melikian-Chirvani, A. S. *Le Bronze Iranien.* Exhibition catalogue: Musée des Arts décoratifs. Paris, 1973.

Migeon, G. *Manuel d'art musulman.* 2 vols. Paris, 1927.

Pal, P. 'The Art of Metalwork' in *Islamic Art: The Nasli M. Heeramaneck Collection, Los Angeles County Museum of Art.* Los Angeles, 1973, pp. 149–72.

Rice, D. S. 'The Oldest Dated Mosul Candlestick' in *Burlington Magazine* XCI (London, 1949): 334–41.

– 'The Brasses of Badr al-Din Lu'lu' in *Bulletin of the School of Oriental and African Studies* = BSOAS XIII (London, 1949–51): 627–34.

– 'Studies in Islamic Metalwork–I–IV' in *BSOAS* XIV, no. 3 (London, 1952): 569–78; XV (London, 1953): 61–79, 229–38, 489–503; XVIII, no. 2 (London, 1955): 206–31; XXI (London, 1958): 225–53.

– *The Wade Cup.* Paris, 1955.

– 'Inlaid Brasses from the Workshop of Ahmad al-Dhaki al-Mawsili' in *Ars Orientalis* II (Ann Arbor, 1957): 283–326.

Sarre, F. and M. Berchem. 'Das Metallbecken des Atabeks Lulu von Mosul in der Königlichen Bibliothek zu München' in *Münchner Jahrbuch der bildenden Künste.* Vol. 1, Munich, 1907, pp. 18–37.

Sarre, F. and E. Mittwoch. *Erzeugnisse islamischer Kunst: Sammlung F. Sarre.* Part 1: *Metall.* Berlin, 1906.

Sceratto, U. *Metalli Islamici.* Milan, 1966.

Splendeur de l'Art turc. Exhibition catalogue: Musée des Arts décoratifs. Paris, 1953.

Wiet, G. *Catalogue général du Musée Arabe du Caire: Objects en cuivre.* Cairo, 1932.

257

Turkish Miniature Painting

by Filiz Çağman

Alî, Mustafa. *Menakıb-ı Hünerveran*. Istanbul, 1926.

Anafarta, N. *Hünername Miniyatürleri ve Sanatçıları*. Istanbul, 1969.

And, M. *Turkish Miniature Painting: The Ottoman Period*. Ankara, 1974; Rev. ed. 1979.

Arnold, T. W. *Painting in Islam*. Oxford, 1928; New ed. New York, 1965.

Art Treasures of Turkey. Exhibition catalogue: Smithsonian Institute, Washington D. C., 1966.

Aslanapa, O. *Turkish Art and Architecture*. London, 1971.

Atasoy, N. '1558 tarihli Süleymanname ve Macar Nakkaş Pervane' in *Sanat Tarihi Yıllığı* III (Istanbul, 1970): 167–9.

– 'Nakkaş Osman'ın Padişah Portreleri Albumu' in *Türkiyemiz* VI (Istanbul, 1972): 2–14.

– *Türk Minyatür Sanatı Bibliografyası*. Istanbul, 1972.

– and F. Çağman. *Turkish Miniature Painting*. Istanbul, 1974.

Atıl, E. *Surname-i Vehbi: An Eighteenth Century Ottoman Book of Festivals*. (Doctorial diss.) Ann Arbor, Michigan, 1969.

– 'Ottoman Miniature Painting under Sultan Mehmed II' in *Ars Orientalis* IX (Ann Arbor, 1973): 103–20.

– *Turkish Art of the Ottoman Period*. Exhibition catalogue. Washington D. C., 1973.

Binney (III), E. *Turkish Miniature Painting and Manuscripts*. Los Angeles and New York, 1973.

– *Turkish Treasures from the Collection of Edwin Binney, 3rd*. Exhibition catalogue: Portland Art Museum. Portland, Oregon, 1979.

Çağman, F. 'Sahname-i Selim Han Minyatürleri' in *Sanat Tarihi Yıllığı* V (Istanbul, 1973): 411–43.

– 'Sultan Mehmed II Dönemine Ait Bir Minyatürlü Yazma Külliyatı Katib tibî' in *Sanat Tarihi Yıllığı* VI (Istanbul, 1976): 333–46.

– 'The Place of the Turkish Miniature in Islamic Art' in *The Turkish Contribution to Islamic Arts*, Istanbul, 1976, pp. 85–117.

– 'Illustrated Stories from a Turkish version of Jami's Baharistan' in *Turkish Treasures*. Vol. 2. Istanbul, 1978, pp. 21–7.

– and Z. Tanındı. *Topkapı Saray Museum-Islamic Miniature Painting*. Istanbul, 1979.

Denny, W. B. 'A Sixteenth Century Architectural Plan of Istanbul' in *Ars Orientalis* VIII (Ann Arbor, 1971): 49–63.

Edhem, F. and I. Stchoukine. *Les Manuscrits orientaux illustrés de la Bibliothèque de l'Université de Stamboul*. Paris, 1933.

Esin, E. *Turkish Miniature Painting*. Rutland, Vermont and Tokyo, 1960; 2nd. ed., London, 1965.

Ettinghausen, R. *Turkish Miniatures from the 13th to the 18th Century*. Milan, 1965.

Feher, G. *Turkish Miniatures from the Period of Hungary's Turkish Occupation*. Budapest, 1978.

Grube, E. J. 'The Siyar-ı Nabi of the Spencer Collection in the New York Public Library' in *Atti del secondo congresso internazionale di arte turca (Venice, 1963)*. (Naples, 1965): 149–76.

– 'Materialien zum Dioskurides Arabicus' in *Aus der Welt der islamischen Kunst: Festschrift für Ernst Kühnel*. Berlin, 1959, pp. 163–94.

– *Islamic Paintings from the 11th to the 18th Centuries in the Collection of Hans P. Kraus*. New York, 1972.

– *Miniature islamiche nella collezione del Topkapı Sarayı*. Istanbul and Padua, 1975.

– Çağman, F. and Z. Akalay. *Islamic Painting: Topkapı Sarayı Collection*. Tokyo, 1978.

Ipşiroğlu, M. Ş and S. Eyüboğlu. *Turkey: Ancient Miniatures*. (Preface R. Ettinghausen) New York, 1961.

– *Das Bild im Islam: Ein Verbot und seine Folgen*. Vienna and, Munich, 1971.

– 'Das Buch der Feste' in *DU 23* (Zurich, 1963): 57–89.

– 'Das Hochzeitsbuch Murad III' in *Deutsch-Türkische Gesellschaft* III (Bonn, 4 June, 1960.).

– *İslamada Resim Yasağı ve Sonuçları*. Istanbul, 1973.

Karatay, F. E. *Topkapı Sarayı Müzesi Kütüphanesi Türkçe Yazmalar Kataloğu*. 2 vols. Istanbul, 1961.

– *Topkapı Sarayı Müzesi Kütüphanesi Farsça Yazmalar Kataloğu*. Istanbul, 1961.

Melikian-Chirvani, A. S. 'Le Roman de Varqé et Golşâh' in *Arts Asiatiques* special issue (Paris, 1970).

Meredith-Owens, G. M. *Turkish Miniatures*. London, 1963.

– 'Ottoman Turkish Painting' in *Islamic Painting and the Arts of the Book: The Keir Collection*. Part IV. London, 1976, pp. 223–30.

– 'Kenan Pasha's Expedition against the Cossacks' in *British Museum Quarterly* XXVI (London, 1962): 33–5.

Meriç, R. M. 'Nakiş Tarihi Vesikaları' in *İlahiyat Fakültesi Dergisi* IV (Ankara, 1952): 32–47.

– *Türk Nakiş Tarihi Araştırmaları. Vesikalar I*. Ankara, 1953.

Minorsky, V. *The Chester Beatty Library: A Catalogue of the Turkish Manuscripts and Miniatures*. (Introduction J. W. S. Wilkinson) Dublin, 1958.

Öğütmen [Çağman], F. *Miniature Art from the 12th to the 18th Century: A Guide to the Miniature Section of Topkapı Sarayı*. Istanbul, 1966.

Öney, G. *Anadolu Selçuklu Mimarisinde Süsleme ve El Sanatları* (Architectural Decoration and Minor Arts in Seljuk Anatolia). Ankara, 1978.

Özergin, M. K. 'Selçuklu Sanatçısı Nakkaş Abdülmü'min el Hoyi Hakkında' in *Belleten* XXXIV (Ankara, 1970): 219–30.

Renda, G. *Batılılaşma Döneminde Türk Resim Sanatı: 1700–1850*. Ankara, 1977.

– 'The Miniatures of the Silsilename No. 1321 in the Topkapı Saray Museum Library' in *Sanat Tarihi Yıllığı* V (Istanbul, 1972–3): 481–95.

– 'The Miniatures of the Zubdat al-Tawarikh' in *Turkish Treasures* Vol. 1. Istanbul, 1978, pp. 26–35.

Stchoukine, I. *La Peinture turque d'après les manuscrits illustrés. I: De Suleyman 1er à Osman II (1520–1622)*. Paris, 1968.

– *La Peinture turque d'après les manuscrits illustrés. II: De Murad IV à Mustafa III (1623–1773)*. Paris, 1971.

Tanındı [Akalay] Z. 'Nakkaş Hasan Paşa' in *Sanat* VI (Istanbul, 1977): 114–25.

Ünver, A. S. *Ressam Nigârî: Hayatı ve Eserleri*. Ankara, 1946.

– *Ressam Levni: Hayatı ve Eserleri*. Ankara, 1949.

– *Ressam Nakşi: Hayatı ve Eserleri*. Istanbul, 1949.

– 'L'Album d'Ahmed Ier' in *Annali dell' Istituto Universitario Orientale di Napoli*. (Naples, 1963): 127–62.

Yetkin, Ş. K. *L'Ancienne peinture turque du XIIe au XVIIIe siècle*. n. p., 1970.

Yurdaydın, H. G. *Matrakçı Nasuh*. Ankara, 1963.

– 'Matrakçı Nasuh'un Minyatürlü İki Yeni Eseri' in *Belleten* XXVIII (Ankara, 1964): 229–33.

GLOSSARY

AMBONES the pulpit or reading desk in early Christian churches

AMBULATORY a sheltered place to walk in: the gallery portion of a cloister, the apse aisle of a church

ANASTASIS a representation of Christ's descent into Limbo and his freeing of the souls waiting there; part of the Resurrection

APODYTERIUM the dressing room in ancient Greek or Roman baths

APSE a projecting part of a building, for instance a church, usually semicircular in plan and vaulted

ASHLAR a hewn or squared stone; also masonry made from it or a thin squared or dressed stone for facing a wall of rubble or brick

ATABEG or ATABEY a Seljuk provincial governor or any of various Turkish high officials, e.g. vizier, etc.

BAITYLOS a meteor, somewhat human in shape, honoured as a god in some ancient civilizations; called *huwashi* in Hittite

BAKLAVA KUŞAĞI ('lozenge-shaped belt') a type of transition element composed of triangles, each divided into double triangles and arranged so as to form a facetted belt

BASILICA a Roman building consisting of a central hall with aisles having roofs lower than the central hall's; also a Byzantine church composed of a nave and two or four aisles also having roofs lower than the nave's

BEDESTAN covered bazaar or hall where luxury goods are sold

BEYLIKS or *BEYLICS* the territory ruled by a *bey*, the governor of a district or minor province in the Ottoman Empire, hence principalities or emirates

BIMARHANE a large hospital, particularly a lunatic asylum

BLIND ARCH architectural decoration composed of arch-shaped members that have walls between the supports of the arches

CALDARIUM *see sıcaklık*

CAP overlaying or covering structure that is constructed above another part of a building; also the uppermost of any assemblage of architectural parts

CAPITAL the topmost member of a column

CARTOON a full-scale preliminary design for a carpet, tapestry, etc.

CASTRUM an old Roman fortress or encampment

CELLA the main chamber of a Greek temple containing the cult statue

CEŞMİ BÜLBÜL ('nightingale's eye') a type of glassware with spiral decoration

CHAHR TAQ or *CHAHÂR TÂK* originally a tent with four entrances, from *chahr* meaning 'four' and *taq* meaning 'arch' or 'grotto'

CHEVET the apsidal eastern termination of a church choir, typically having a surrounding ambulatory that opens onto a number of radiating apses or chapels

CHOIR the part of a church separated from the nave and also from the sanctuary

'CIBORIUM' a type of plan for a building, usually a church, having at its centre a roof canopy supported by four columns

CLOISONNÉ enamel poured into compartments *(cloisons)* formed by a network of metal bands that remain visible on the surface of the object and divide one colour from the other

CORBEL a projection of stone or timber jutting out from a wall to support weight

CORNICE a moulded and projecting horizontal member that crowns an architectural composition; also the upper member of an entablature

CUERDA SECA a technique of decorating pottery tiles: outlines of the decorative pattern are drawn in a mixture of manganese and grease to prevent coloured glazes mixing

DAĞ the Turkish term for 'Mount'

DAR-ÜS-ŞIFA ('house of cure') a hospital

DEISIS a representation of Christ Glorified, enthroned between Mary (left) and John the Baptist (right): the central part of the Last Judgment

DIPTEROS the Greek term for a temple surrounded by two rows of columns; *see also* pseudo-*dipteros*

EMIR an Arab prince, governor of a province or military commander; a title of Muslim rulers of emirates

ESER-I İSTANBUL ('Istanbul work') a designation for glassware made in Istanbul; *see also* p. 206

EXEDRA a large, nearly semicircular seat or bench with a solid back; in ancient Greece and Rome, a room for conversation, usually open and furnished with seats

EXONARTHEX the outer narthex of a church having two narthexes; also the whole atrium or outer court

EX-VOTO a votive offering, often a picture or small statue

GHULAM the Turkish term for an 'apprentice' or 'hireling'

GREEK-CROSS PLAN a plan for a building having a square central mass and four arms of equal length

HADITH or HADIT a narrative record of the sayings or customs of Muhammed and his companions; the collective body of traditions relating to Muhammed and his companions

HAGIA SOPHIA the great church in Istanbul (Constantinople) dedicated to the Holy Wisdom

HAGIASMA a holy well in a monastery or convent

HALKA ('ring') a type of Muslim school in a mosque, dating from Muhammed's time; it takes its name from the students that gathered in a circle in front of a teacher sitting in the mosque; provides a combination of primary and secondary schooling

HALVET small private room in a Turkish bath, equipped with hot and cold water

HAMAM a Turkish bath, similar in organization to the public thermae in Rome

DOUBLE HAMAM a Turkish bath with separate sections for men and for women in the same building

HAN an inn or caravanserai where caravans or travellers could rest at night, commonly a large bare building surrounding a court

HAYAT a large open gallery dominating the main floor of traditional Turkish houses

HERM a statue in the form of a square stone pillar surmounted by a bust or head

HIPPODROME an oval stadium for horse and chariot races in ancient Greece

HUWASHI see baitylos

ICONOCLAST member of a religious party in the Byzantine Empire of the eighth and ninth centuries who opposed the use of icons

ILICA a spa: an establishment at a mineral spring resorted to for cures

ILIKLIK the tepidarium or warm room in ancient Greek and Roman baths; used to sit in

İMARET a public kitchen that provided food for the needy, usually part of a waqf complex

İWAN or EYVAN a large hall or audience chamber, often open on one side, and found in Abbasid, Sassanian and Parthian architecture; hence a vaulted recess that served as a vestibule in mosques

JIHAD or JEHAD a holy war, waged on behalf of Islam as a religious duty

KAABA or KA'BA(H) or CAABA the Islamic shrine in Mecca that incorporates a sacred black stone and is the goal of Muslim pilgrimage and the point toward which all Muslims turn in praying; see also qiblah

KALMUSH a curved crook, the emblem of the Hittite king

KAPLİCA a spa over a hot spring

KHANKAH from the Persian khāna ('a house'), a dervish monastery

KHUTBAH or KHUTBA a pulpit address of prescribed form, read in mosques on Fridays at noon prayer; it contains an acknowledgment of the sovereignity of the reigning prince

KNOTS USED IN CARPET-MAKING:

GÖRDES (Ghiordes) or TURKISH KNOT is tied in a symmetrical manner on two adjacent warp threads; it cannot be used for very fine close pile carpets

SENNEH (Sine), SEHNA or PERSIAN KNOT is tied by twisting the yarn to encircle one warp thread and pass under the one next to it; gives a very close pile

KOIMESIS a representation of the death, termed dormition, of the Virgin Mary

KÖŞK a kiosk, pavilion or small private residence, especially in a garden

KÜMBET see turbeh

KÜNDEKARI a woodworking technique based on tongue-and-groove construction; see also explanation on pp. 201–2

KÜLLİYE ('complex') a Muslim socio-religious complex with theological and philanthropic aims, usually attached to a mosque

KUFIC or CUFIC a script using a highly angular form of the Arabic alphabet, employed especially at Kufa (Qufa) for making costly copies of the Koran

LABARNA a Hattian word, the name of the ancestor of the royal Hittite house (also written Tabarna), that came to be used as a title by later Hittite kings, as was Caesar by the Romans

LUSTRE an iridescent metallic surface used for the decoration of ceramics called lustre ware, especially Islamic pottery. The pigments were made from metallic oxides and applied to the glazed surface of pottery that was refired at a relatively low temperature in a muffle kiln.

LYDION a pottery vessel from Lydia, used for holding ointment

MADRASAH or MADRASA a Muslim school, theological college or mosque-university and the building that houses it; an endowed establishment with a structured curriculum; a Muslim institution of higher learning

MAKSURA the domed square space in front of a mihrab; also a wooden lattice or the room formed by such a partition

MALİK ('prince') from the Hindi term for 'chief' or 'leader'; Maliki is an orthodox school of Muslim jurisprudence, predominating in North Africa and Upper Egypt

MASJİD a small neighbourhood mosque; in Turkey it does not have a pulpit

MEGARON the Greek term for a long, narrow, isolated house consisting of a front room that serves as an entrance and a hall with a hearth in the middle of it

MIHRAB the niche or chamber in a mosque indicating the direction of Mecca, usually containing a copy of the Koran; it gives the direction for prayers

MINARET a slender lofty tower attached to a mosque and surrounded by one or more projecting balconies from which the summons to prayer is cried out

MINAI ('enamel') WARE a type of overglaze-painted Islamic pottery made originally in Seljuk Iran (twelfth and thirteenth centuries); the decoration is applied over an opaque white or turquoise glaze and fixed by a second firing

MINBAR or MIMBAR the pulpit for the Muslim preacher in a mosque

MOSQUE (Turkish CAMİ) an Islamic place of public religious worship; see also masjid

GREAT MOSQUE (Turkish: ULU CAMİ) the largest mosque in a town; the place where the Friday's Khutbah is read

MUKARNAS a niche of stalactites or honeycombs, projecting in a corner and forming the transition from a square to either an octagon or a circle; the covering of a niche or the decoration of a moulding employing stalactites or honeycombs

NAOS the Greek term for a temple; also used as an equivalent of cella

NAISKOS the Greek term for a small temple without a ring of columns around it

NARTHEX the western porch in early Christian churches, used by penitents or catechumens who did not enter the church itself; usually forms one side of the atrium or outer court surrounded by ambulatories; also the vestibule in early Christian churches

NASKHI or NESKHI or NESKI rounded Arabic script used in writing scientific or religious books

NAVE the main part of the interior of a church; the long, narrow, central hall in a cruciform church that rises higher than the aisles flanking it; it is not considered to include the central part of the transept and the choir

NIELLO a black substance made of powered lead, copper,

sulphur and often borax; used to fill incised decoration on silver; it is fixed by heating

NİSBA designation signifying 'coming from' followed by a place name (e.g. al-Herati), generally used in metalwork inscriptions with the name of the master craftsman

NİZAMİYA a state-supported school of high standard that is not solely theological; named for Nizam al-Mulk, a vizier in the Great Seljuk period

OCULUS in a dome, a round opening resembling an eye

OPISTHODOMOS the Greek term for a porch at the rear of a temple

OPUS SECTILE stone inlay, tiling or mosaic, using pieces cut to follow the outline of the design; often done in coloured marble

PANKUS the community of Hittite nobles

PANTOKRATOR Christ Almighty as ruler of the world

PENDENTIVE one of the triangular spherical sections of vaulting that spring from the corner of a rectangular ground plan and serve to allow the room enclosing it to be covered by a cupola; any supporting member at the corner of a square or polygonal plan for making a transition to a circular or octangonal plan

PERIPTEROS the Greek term for a temple surrounded by row of columns

PERISTASIS the Greek term for the row of columns surrounding a temple

PIER a pillar that carries a major load; also a post or other vertical member that supports the end of an arch or the wall between two windows, doors or other openings

PITCH (of a roof) the inclination of a roof as determined by the ratio of the height to the span: the degree of slope
DOUBLE-PITCH sloping in two directions: gabled

PITHOS a large earthenware jar with a wide round mouth, used throughout the ancient Greek world for holding and storing large quantities of food or liquids, and sometimes for the burial of the dead

PRONAOS the porch in front of a cella in a Greek temple

PSEUDO-*DIPTEROS* a dipteral temple in which the inner row of columns is omitted; *see also dipteros*

QUATREFOIL a plan for a building based on the four-lobed shape that is a conventionalized representation of a flower with four petals

QIBLAH or QIBLA or KIBLA(H) the direction of the Kaaba shrine in Mecca toward which all Muslims turn in ritual prayer

RAHLE a wooden lectern used to hold the Koran in mosques

RIBAT a Muslim monastery; at first a fortified military installation; then (tenth century) a guest house and finally synonymous with khankah or *zaviye:* a dervish monastery

RIWAQ arcades in a mosque, sometimes synonymous with iwan

RUMI abstract floral or vegetal motifs

SAF a long rectangular prayer rug on which a series of mihrabs are depicted

SAHN prayer room or inner court of a mosque

SARAY(İ) Turkish term for a 'seraglio' or 'palace'

SHAHNAMAJİ the epic poet-chronicler appointed by each sultan after Mehmet I to record current and historical events in verse in a 'Shahnama' or chronicle

SHEREFE Turkish term for a 'balcony'

SICAKLIK the caldarium or actual warm bath of ancient Greek and Roman baths, usually symmetrical in plan

ŞİFAİYE hospital

SKYPHOS or SCYPHUS a drinking vessel with a deep body, flat bottom and two small horizontal handles near the rim

SOFA a raised platform or small veranda, found in mosques

SQUINCH a straight or arched support across an interior angle that carries a dome or other superstructure

SUFISM a Muslim philosophical and literary movement that emerged among the Shiites in the late tenth and early eleventh centuries and borrowed ideas from Neoplatonism, Buddhism and Christianity. The Ahi guilds belong to this movement.

SÜLÜS or THULUTH one of the chief forms of Arabic and Persian script, more rounded and elegant than Naskhi

TABARNA *see* Labarna

TABHANE a hostel or hospice, often part of a mosque complex *(külliye)*

TEKKE a dervish convent

TEMENOS a sacred enclosure containing one or more temples

TEPIDARIUM *see ılıklık*

THEOPHYLAKTOS ('city protected by God') epithet given by the Byzantines to their capital Byzantium (Constantinople), now Istanbul

THEOTOKOS the Mother of God

TOMBAC or *TOMBAK* an alloy of copper and zinc and sometimes arsenic, used for gilding, especially gongs, bells and inexpensive jewellery

TRANSEPT the transversal part of a cruciform church that crosses at right angles to the greatest length between the nave and the apse or choir

TRIBUNE the raised platform at one end of a Roman basilica; also a dais or platform

TROGLODYTE adjective referring to monuments in caves hewn out of the living rock and found especially in Cappadocia

TURBEH or TURBE a Muslim tomb, mausoleum or funerary building; also called *kümbet*

TURKISH TRIANGLES a means of transition employing a smooth three-dimensional triangular support placed between squares and octagons

ULU CAMİ *see* mosque

VAULT an arched structure of masonry usually forming a ceiling or roof
BARREL VAULT a semicylindrical vault having parallel abutments and the same section throughout; also a similar vault that is curved in plan or rampant
CLOISTER VAULT a cupolalike vault on a square or polygonal base with diminishing courses to the top and of similar horizontal section throughout
CROSS VAULT a vault formed by the intersection of two or more simple vaults
GROIN VAULT a vault having projecting edges forming the curved line along which two intersecting vaults meet

WAQF (*vakıf* in Turkish) an Muslim religious or charitable foundation created by private endowment and forming the basis of the Muslim social welfare system; the forerunner of modern social centres

YALI a summer residence on the seashore or waterfront, especially on the Bosphorus

YEŞIL the Turkish word for 'green'

ZAVİYE small dervish monastery or chapel

ZEMZEM holy water

Index

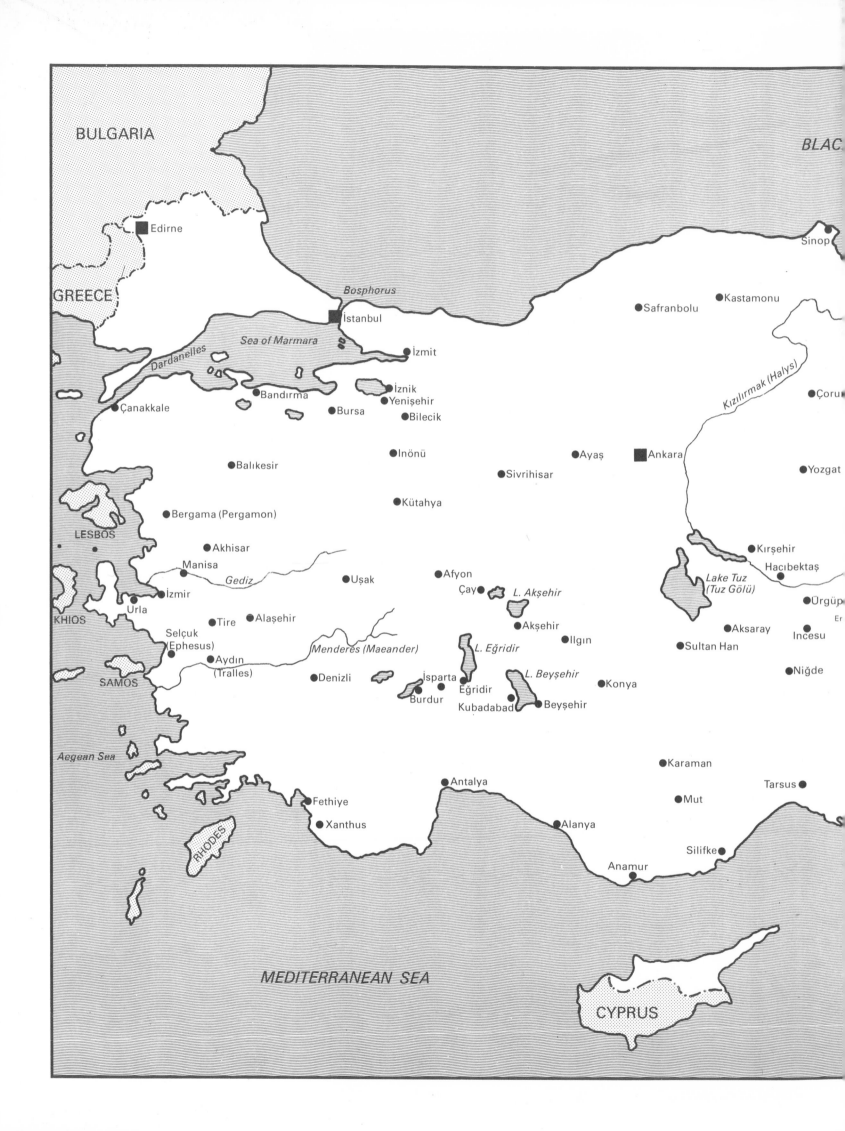